The Encyclopedia of Jewish Symbols

The Encyclopedia of Jewish Symbols

by
Ellen Frankel
and
Betsy Platkin Teutsch

A JASON ARONSON BOOK

ROWMAN & LITTLEFIELD PUBLISHERS, INC.
Lanham • Boulder • New York • Toronto • Oxford

A JASON ARONSON BOOK

ROWMAN & LITTLEFIELD PUBLISHERS, INC.

Published in the United States of America
by Rowman & Littlefield Publishers, Inc.
A wholly owned subsidary of The Rowman & Littlefield Publishing Group, Inc.
4501 Forbes Boulevard, Suite 200, Lanham, Maryland 20706
www.rowmanlittlefield.com

PO Box 317, Oxford, OX2 9RU, UK

British Library Cataloguing in Publication Information Available

Library of Congress Cataloging-in-Publication Data

Frankel, Ellen.
 The Encyclopedia of Jewish symbols / by
Ellen Frankel and Betsy Platkin Teutsch.
 p. cm.
 Includes bibliographical references and index.
 ISBN 0-87668-594-7 (hardcover: alk. paper)
 ISBN 1-56821-742-0 (softcover: alk. paper)
 1. Judaism—Encyclopedias. 2. Jewish art and symbolism—
Encyclopedias. 3. Jews—Folklore—Encyclopedias. I. Teutsch,
Betsy Platkin. II. Title.
BM50.F74 1992
296.4'03—dc20 91-39033

Printed in the United States of America
⊖™ The paper used in this publication meets the minimum requirements of American
National Standard for Information Sciences—Permanence of Paper for Printed Library
Materials, ANSI/NISO Z39.48-1992.

To Herbie and David
Anshei Hayil
אנשי חיל

CONTENTS

CONTENTS

PREFACE

Jewish symbols reflect the interaction of word and image within Jewish culture. Jews have always studied, interpreted, and revered sacred texts; they have also adorned the settings and occasions of sacred acts. Calligraphy and ornamentation have transformed Hebrew letters into art; quotation, intepretation, legend, and wordplay have made ceremonial objects into narrative.

This book represents just such a collaboration between art and language. From start to finish, the two of us, writer and artist, worked together to create *The Encyclopedia of Jewish Symbols*. We conceptualized, researched, and structured the book jointly, consulting with each other almost daily to ask questions, test out ideas, and solve the many puzzles we encountered. Once the bulk of the research was done, Ellen wrote the text and Betsy illustrated the entries and added the calligraphy. Throughout the collaboration, we continued our conversations—over cups of tea, on the phone, and during long walks through our neighborhood in the Mount Airy section of Philadelphia—gradually coming to an increased understanding and appreciation of the fascinating dynamic of Jewish symbolism.

What especially enriched this project were our complementary perspectives and experiences. As a designer of *ketubot* (marriage contracts) and other Jewish ceremonial texts and objects, Betsy brought to the project an appreciation of why and how contemporary Jews might use Jewish symbols. Over fifteen years, she has guided hundreds of couples in choosing Jewish symbols to express their unique family, personal, and religious circumstances, thereby enriching and enhancing their Jewish life. The idea for creating the *Encyclopedia* initially grew out of her own need for such a resource to make these symbols more readily accessible to her and her clients.

Ellen came to the project after immersing herself for several years in the world of Jewish folktales. In the course of writing *The Classic Tales: 4,000 Years of Jewish Lore* and then telling these stories to a wide variety of audiences, she came to appreciate how the Jewish folk imagination has enriched and transformed the rabbinic tradition. The tales taught her to look for stories buried within the mute world of objects. Ellen also has been intrigued by her study of Kabbalah, as reflected in our book. Her computer expertise made a project of this scope possible.

Above all, we have brought to this project our deep love of teaching. In previous years, we have both taught in classrooms; we now continue to teach through our crafts and public speaking. We view this book as our effort to transmit the riches of our tradition to future generations. It is our hope that this book will make the Jewish symbol tradition available to a wide variety of lay people and specialists—teachers, rabbis, feminists, folklorists, non-Jewish scholars, and artists, who

will use and expand upon this tradition of "visual *midrash*."

In compiling the many entries that make up this encyclopedia, we have defined "symbol" quite loosely, including not only ceremonial objects and images, but also personalities, places, concepts, motifs, and events that have come to represent central Jewish ideas. While our list may not be considered comprehensive by all readers, it reflects our ideas about which symbols within the tradition continue to play a meaningful role in defining Jewish experience today.

It is our belief that the symbol tradition is a dynamic process through which most symbols continue to evolve. Most entries trace a symbol's history from its ancient roots to its modern expression, noting its transformation under the pressures of rabbinic, mystical, folk, and contemporary influences. We have been respectful of both traditional and liberal interpretations of these symbols. We have been especially eager in seeking within the tradition both new and old symbols that reflect the experiences of Jewish women and other concerns pertinent to our time.

To create such an eclectic work, we have been fortunate in obtaining the help of many talented individuals with a wide range of expertise. First we would like to thank our four readers—Rabbi Mitch Chefitz, Norman Shore, Rabbi Michael Strassfeld, and Dr. Arthur Waskow—whose comments throughout the manuscript added many valuable insights. Norman's help was also invaluable in checking the nearly 1,500 footnotes for accuracy. Dr. David Golomb assisted in the vocalization of the Hebrew text. Adina Newberg and Rabbi Leila Berner gave additional help with Hebrew translation. We would also like to thank Dr. Howard Schwartz, Rabbi Julie Greenberg, Rabbi Mark B. Greenspan, Rabbi Susan Harris, Mitch Marcus, Rabbi Marcia Prager, Dr. Shalom Sabar, Rabbi Zalman Schachter-Shalomi, Rabbi Jeffrey Schein,

Libbie Soffer, Mr. and Mrs. Paul Steinfeld, and Dr. David Weiss for their interpretations of several individual symbols. In addition, we are indebted to Sue Fendrick, Dr. Miles Krassen, the Los Angeles Women's Center, and Rivka Walton, for their help in pointing us toward sources we had overlooked. Ellen especially thanks Dr. David Teutsch and Dr. Steven Levine for helping her develop the theoretical framework for the introduction, and Sarah White and Charlotte Weaver for critiquing the manuscript in progress. Of course, our mistakes are our own.

Throughout the conceptualization and composition of the book, our editor and publisher Arthur Kurzweil has been a stalwart supporter, encouraging us to imagine the book more ambitiously than we had first envisioned it, extending our deadline when that ambitious vision evolved beyond our expectations, and giving us his confidence throughout the project. We also thank Muriel Jorgensen, our managing editor, for shepherding such a complex book through to its completion.

Above all, we want to thank our families—David, Nomi, and Zachary; Herbie, Sarah, and Les—for bearing with us as we immersed ourselves in our offices, lost in the consuming world of Jewish symbols. We know that it's been difficult living in a world inhabited by talking objects; we promise that they will soon regain their normal reticence. We can't promise that about us, though.

If we've left out your favorite symbols, we apologize—and we'd love to hear from you!

ומעשה ידינו כוננהו
U'maasei yadeynu koneneihu.

Establish for us the work of our hands.

Ellen Frankel and Betsy Platkin Teutsch
Philadelphia, Pennsylvania
1992/5752

INTRODUCTION

A symbol speaks to the whole human
being and not only to the intelligence.
— Mircea Eliade,
The Sacred and the Profane

Symbols without faith are unnecessary
baggage.
— Abraham Joshua Heschel,
Man's Quest for God

I

Every culture has its dictionary of symbols.
Members of that culture do not need to be
intellectuals to grasp the meaning of such
symbols, nor do they need to be schooled in
difficult religious texts or doctrines to ap-
preciate a symbol's truth. Symbols consti-
tute a universal language. They exercise an
extraordinary hold over us. They serve as a
culture's consciousness and conscience.
They contain a people's memory, its values,
and its dreams. And yet, they are often
inarticulate or indecipherable to the con-
scious mind. They cast us under their dra-
matic spell, but elude our comprehension.

Perhaps the most singular trait possessed
by symbols is their interpretive variety. Just
as God was said to speak in a different
voice to each Israelite assembled at the foot
of Mount Sinai, so, too, symbols speak in
different voices to those who encounter
them. Often these voices harmonize to-
gether in a common song; other times they
create dissonance.

Over thousands of years, the Jewish
People has accumulated an extraordinary
treasury of symbols, rich in interpretive
complexity. Some symbols have been cre-
ated out of the unique circumstances of
Jewish history. Others have been borrowed
from neighbors and adapted for Jewish
use. Over time, the origins of many of these
symbols have been lost or deliberately ob-
scured. Sometimes new symbols have
blended with older ones, absorbing some of
their flavor. Sometimes they have replaced
these older symbols altogether. Other times
new symbols enjoy only momentary popu-
larity before being replaced or discarded.

Jewish symbols today continue to exert a
powerful influence, and these symbols con-
tinue to speak in their many voices. Thus,
for example, the Passover *matzah* does not
only conjure up the story of the redemption
from Egyptian slavery, but also represents
the vanity of human pride. It also evokes
the warm feelings of an annual family
gathering. All of these interpretations are
valid. For like the four children spoken
about in the *Haggadah* — the sage, the skep-
tic, the ignoramus, and the simple soul — all
of us bring to our interpretation of the
tradition our many ways of asking ques-
tions and our many ways of hearing an-
swers.

II

Throughout human history, societies have
attempted to represent the world around

them, to interpret and to affect that world by depicting it symbolically. Anthropologists have suggested that such symbol systems fulfill two basic functions: they provide models *for* as well as models *of* reality for any given society.[1] As the former, symbols express the ethos of a particular society, its values and aesthetic style. Members of that society learn its rules and taboos not only through formal religious and legal codes, but also by absorbing its symbols, which communicate aspects of those same rules through potent sensory or emotional imagery. Symbols convince people that their way of life is both natural and desirable.

Symbols perform a second important cultural function. They serve as representations of reality for a society. They bring order to the chaos of the physical world. They legitimize the intolerable ambiguities of human experience. They convince us that it is possible to live a meaningful, reasonable life, because the world itself makes sense and behaves according to rules.

Symbols possess an additional dimension: not only do they frame and order the visible world, but they also make visible what is beyond the grasp of the senses — the transcendent reality that kabbalists call "*Ein Sof*," the Ultimate, that is, God. In so doing, symbols perform the function originally attributed to them by the Greeks. When two cities in ancient Greece wished to contract a commercial treaty, they would divide a coin or other token between them, signifying their commitment to safeguard mutual trade. This divided token was called a "symbolos," from two Greek words meaning "to throw together." In similar fashion, religious symbols bring together all the pieces of the universe into a coherent whole, decipherable to the human mind.

A similar contractual procedure was followed in ancient Near Eastern cultures. To establish a mutual covenant, two parties would pass between the severed parts of a slaughtered animal. This symbolic act represented both the potential punishment for breach of contract — being torn to pieces — as well as the two parties' interdependence in keeping the peace, similar to the Greek "symbolos."

When Abraham enacted such a "covenant of pieces" with God (Genesis 15:17–21), this social contract bore an added dimension, that of religious ritual. An invisible God assumed concrete form, passing between the pieces as "a smoking oven and a flaming torch." Indeed, throughout the Torah, God's covenant is repeatedly represented through symbols, *ot* in Hebrew: the rainbow, signifying the end of universal devastation; sheep's blood on the Israelites' doorposts in Egypt, guaranteeing that their firstborn would be spared from the Angel of Death; the observance of circumcision; the eating of unleavened bread; the hallowing of the Sabbath. Thus, from its inception, Judaism has acknowledged that symbols provide a vital link between the human and divine worlds.

III

Practitioners of many disciplines have sought to claim symbolism as their special province: anthropologists, linguists, philosophers, literary critics, psychologists, art historians, folklorists, artists, writers, theologians, and educators, not to mention all the nonspecialists who have their own perspectives on the various symbols of their culture. Each "expert" would argue that his or her understanding of a particular symbol or symbol system is definitive.

Rather than drawing battle lines among contending forces, we can benefit from the combined wisdom of all these perspectives; their common ground overrides their differences. Theories of the symbol agree that

1. its character is cultural, not natural;

2. its interpretation is inexhaustible;

3. its significance is expressed within a social context;

4. its content is both emotional and cognitive;

5. its sum equals more than its parts.

Many theorists make a crucial distinction between signs and symbols. Unlike symbols, signs are finite. A sign explains, often *after the fact*, what a symbol means. For example, the lion signifies bravery or royalty or power. In the Jewish tradition, it also signifies the tribe of Judah, the House

of David, the Jewish People, messianic redemption, and the Divine Spirit.

But when Jews see a pair of rampant lions flanking a Torah ark in the synagogue, they might not think of any of these things. Instead, they might be moved by the emotional resonances evoked by this image. They might remember, consciously or unconsciously, all the other lions they have ever seen in a Jewish setting. They might feel the power of being part of a lionlike people. They might feel affirmed by the long history embodied in this familiar image. Although they might not be able to express any of this in words, they would unhesitatingly attest to the intensity of their response. That is the enchantment of symbols.

There is another crucial distinction to make in understanding various approaches to symbols. Most theorists trained in the secular approach to ideas restrict themselves to describing the rationale behind symbol systems within cultures. Theirs is a *humanistic* perspective. According to their understanding, symbols emerge out of a particular culture, expressing the worldview of that culture. Such worldviews are not *objectively* true, only *relatively* so. Secular theorists would argue that each culture has its own demons, its own ideas about nature, evil, the supernatural. Each has its own rituals designed to order that society according to certain fundamental principles of trespass and sanctity. The goal of such theorists is to explain a cultural system, not to validate or invalidate it.

In the other camp are the symbol-users, those who view symbols from *within* a particular tradition. Even though they may allow that their system is not universal or even superior to others, nonetheless they believe in the efficacy and truth of their tradition's symbols. Theirs is a *religious* as opposed to a humanistic perspective. Within this perspective, symbols not only influence people to behave according to certain constructive ethical and aesthetic principles, they also express a reality beyond human limits. They are perceived not as the conventional artifacts that they actually are but as natural phenomena, like climate or terrain.

This book acknowledges both important distinctions in the study of symbols. First, it distinguishes between sign and symbol.

Each entry provides numerous interpretations of Jewish symbols, derived both from classical sources and from folk wisdom. In addition, the reader will find at the end of each entry a list of the major concepts signified by that symbol. Yet no claim is made that any single interpretation is definitive: what a symbol *signifies* never exhausts all that it means.

Secondly, it is acknowledged that these symbols have emerged out of history. Each entry charts this history, tracing a symbol's evolution from its biblical origins to its rabbinic, mystical, and folk reinterpretation, its migration from ancient Israel throughout the Diaspora to modern Israel and America, its status as an archaeological record of the Jewish psyche. But this encyclopedia does not pretend to be value-free. The symbols it contains are presented from a vantage point within the Jewish tradition. They are treated not only as emotionally compelling, but also as sacred.

One last distinction needs to be made about symbols. Mordecai Kaplan, the founder of Reconstructionism, argues that what distinguishes primitive from modern religions is the former's belief in the *theurgic* power of symbols, that is, the idea that a symbol can affect the world, can control dangerous forces, can force God's hand, as it were. In contrast, modern religion acknowledges that symbols only *express* a higher reality, what Kaplan calls "the Power that makes for salvation"; they are powerless to influence that transcendent reality.[2]

Some readers will agree with Kaplan's assessment of symbols; others will not. Some will come to this book seeking intellectual explanations. Others will come for religious confirmation or guidance. Some will come from within the Jewish tradition; others will remain outside it. It is our hope that all will find what they seek within. For symbols are by their nature inexhaustible.

IV

To understand traditional Jewish attitudes toward symbols, it is first necessary to determine traditional Jewish attitudes toward art.

In the Bible, two very different views are expressed:

You shall not make for yourself a sculptured image, or any likeness of what is in the heaven above, or on the earth below, or in the waters under the earth. (Exodus 20:4)

The Lord has singled out by name Bezalel, son of Uri son of Hur, of the tribe of Judah. He has endowed him with a divine spirit of skill, ability, and knowledge in every kind of craft and has inspired him to make designs for work in gold, silver, and copper, to cut stones for setting and to carve wood — to work in every kind of designer's craft — and to give directions. (Exodus 35:30-34)

These contradictory statements highlight a fundamental tension within the Bible — indeed, within all of Jewish history. On the one hand, Judaism has always demonstrated an unambiguous abhorrence of graven images, that is, the worship of animal and human forms. The basis of Judaism is faith in an invisible God, not in an idol, a word derived from *eidulos,* Greek for "visible." Nothing is more central to Jewish belief than the unity and intangibility of a transcendent God.

And yet the Ark of the Covenant housing the Ten Commandments carried upon it the twin figures of the cherubim, winged creatures with human faces. The Holy Temple in Jerusalem had many such images on its walls and doors in addition to bronze oxen and a brazen serpent on a pole once used to safeguard the Israelites against scorpions in the wilderness. The ten northern tribes worshiped two golden calves. During the Hellenistic period, synagogues in Israel and the Diaspora boasted beautiful mosaic floors displaying images of the Zodiac and Apollo in his sun chariot. Through the centuries, images of animals, humans, mythological creatures, and even of God have adorned synagogue interiors. In our own day, Jewish ceremonial art, including representational sculpture, flourishes in numerous sacred settings.

How can we explain such inconsistency between theory and practice? How were the rabbis able to reconcile the second commandment with the incontrovertible presence of winged cherubim perched directly over these divine commandments in the Holy of Holies?

Modern scholars have provided several insights into this apparent contradiction. Erwin Goodenough, whose monumental *Jewish Symbols in the Greco-Roman Period* broke important ground in this field, argues that religious symbols fundamentally differ in their outward and inner forms. For although pagan symbols such as the Dionysian goblet, the Syrian solar eagle, or the Mesopotamian ziggurat would seem to affront the religious sensibilities of Jews and Christians of the same period, their symbolic *value* might in fact have resonated powerfully with these other faiths. Goodenough maintains that "in taking over the symbols, while discarding the myths and explanations of the pagans, Jews and Christians admitted, indeed confirmed, a continuity of religious experience."[3]

Goodenough's study of Jewish decorative art of the Hellenistic period discloses that Jews adopted the essentially "funerary vocabulary" of the dominant Greek culture, that is, they shared their Greek contemporaries' preoccupation with questions of mortality, life after death, and individual salvation. Synagogues and Jewish tombs of the period abounded with images of grapevines, birds, trees, mythological fertility figures, and animals and plants associated in the pagan world with immortality. But when Jews appropriated these foreign symbols, they promptly "Judaized" them by explaining them in traditional Jewish terms, often even attributing to them biblical origins.

A similar process had occurred during earlier periods when Jews had come under the influence of Mesopotamian, Canaanite, and Egyptian cultures. And in later times, other foreign influences helped transform the Jewish symbol system: Greek and Egyptian number magic; alchemy; the dualistic mythology of Gnosticism; the fatalism of Eastern astral religions; the folk beliefs of Eastern Europe rife with demons, succubi, and black magic; the evil eye superstitions of northern Africa; the imagery of Christian salvation. In addition, Jews, like the peoples around them, drew from the universal symbols of the natural world — the elements, the heavens, agriculture, flora, and fauna. These ideas and images infiltrated Jewish symbolism through the back door of popular culture as well as through the front door of rabbinic interpretation.

But those borrowed symbols that infil-

trated Jewish culture then underwent a transformation, whereby the alien content of the *symbol* was translated into a Jewish *sign* whose explanation placed it squarely within the mainstream of the tradition.

Similar to the literary process of *midrash*, a "seeking out" whereby biblical or rabbinic texts yield up additional meanings under the pressure of creative interpretation, Jewish symbols have likewise undergone an evolution under the pressure of Jewish history. Various processes have been involved in these creative "transvaluations" of borrowed symbols:

1. *The imposition of a "prooftext"* — a biblical or rabbinic quotation, upon a borrowed symbol to legitimize the symbol's Jewish status. For example, the Jewish custom of *Tashlikh*, throwing crumbs into flowing water to symbolize the casting off of sins, probably derives from a medieval German custom designed to appease the river demons. The rabbis "Judaized" this custom by citing a verse from the prophet Micah: "You will cast all their sins into the depths of the sea" (Micah 7:19).

2. *A homiletical explanation of the symbol* — illustrative of its Jewish moral or religious lesson. For example, the rabbis argued that eggs and lentils are traditionally eaten by Jewish mourners because these foods have no openings or "mouths," a reminder to mourners that one must not open one's mouth to complain in the face of death.

3. *A folk etymology* — fancifully tracing a symbol's linguistic roots back to an earlier incident or personality in Jewish history. For example, one rabbi justified using iron to protect against demons (a widespread European custom) because the Hebrew word for iron, *"barzel,"* is an acronym for "Bilhah, Rachel, Zilpah, Leah," Jacob's four wives, whose merits afford protection against evil.

4. *Folklore* — such as a story or saying that purports to explain how a particular custom or symbol was first introduced. So, for instance, Jewish tradition declares that the custom of decorating synagogues with flowers on Shavuot, the holiday commemorating the giving of the Torah, harks back to the legend that Mount Sinai burst into bloom when God gave the Ten Commandments.

5. *Number play (Gematria)* — whereby two words or phrases are equated solely because the value of their Hebrew letters is numerically equivalent. For example, the five knots and eight strings of the *tzitzit*, the fringe at the corner of the *tallit* (prayer shawl), add up to thirteen, the same value as the letters of *ehad*, the Hebrew word meaning one. *Ehad* is also the final word of the *Shema*, the prayer affirming God's unity.

6. *Appropriation without explanation* — by which a foreign image or idea enters the lexicon of Jewish symbols unconsciously. What Jew would deny the Jewishness of the Star of David? Yet this symbol infiltrated Jewish culture from other traditions, and only in recent times has come to represent Judaism exclusively.

Besides this internal dynamic of symbol acquisition, fueled by the Jewish People's natural attraction to the various foreign cultures among which they have lived during their many sojourns and exiles, there has been a second external process that has contributed to the shaping of Jewish symbolism. Counterbalancing the pull of assimilation has been the push of persecution and the attendant isolationist reaction within the Jewish community.

Initially the Jews eagerly swallowed Egyptian culture; in time, they themselves were almost swallowed up by it. How fitting, then, that Moses, who bore an Egyptian name and grew up in Pharaoh's palace, should reverse the process, bringing down plagues upon the Egyptians' sacred Nile and other gods. Similarly, modern scholars have proposed that the Israelites derived their sacred architecture, law codes, and literature from the dominant Mesopotamian culture, and then fought many wars of the spirit and the sword to avoid that culture's domination. To assert their uniqueness, the Israelites made many sym-

bolic distinctions between their own practices and those of their neighbors, such as abhorring the pagan ritual of seething goats in milk or recasting the Babylonians' unlucky seventh day, "Shabbatu," as a holy day of rest.

In Hellenistic times, Greek culture came very close to swallowing up Jewish identity altogether. Most Jews, especially in the scattered Mediterranean Diaspora, knew no Hebrew, paid little or no attention to rabbinic teachings, and freely mixed pagan and Jewish customs. But in the 6th to 8th centuries, persecution from Christian authorities, coupled with the passionate iconoclasm of rising Islam, led to a reaction within the Jewish community. Pagan images that adorned so many synagogues and tombs were systematically chiseled off by zealous Jews. Jews again learned Hebrew and embraced the Talmud as their authoritative guide, yet passionately clung to the transvalued pagan symbols they had borrowed from the Greeks.

Indeed, it is not the uniqueness of their symbolism that has distinguished Jews from their neighbors—for many Jewish symbols are borrowed from elsewhere—but the Jewish People's adherence to the Torah and its commandments that has ensured its survival as a separate people.

But in the face of the relentless onslaught of foreign influences, Jewish religious authorities developed a category of practice known as *Hukkat Ha-Goi*, the Law of the Gentiles, derived from the biblical injunction: "You shall not walk in the customs of the nations" (Leviticus 20:23), designed to keep Jews separate from the outside world. Thus, at various times, distinctive Jewish dress was prescribed by leaders of the Jewish community so that Jews would not mix with their neighbors; at other times, it was imposed from without for the very same reason. At times, Jews were forced into ghettos; at other times, they themselves chose isolation. And so it continues to our own day.

These ebbs and flows characterize the entire history of Jewish symbolism. Foreign symbols—the chariot, the *dreidl*, the Zodiac—drift into the Jewish sea, and then their sources recede, leaving behind resonant shells in their wake. It is not surprising that these shells, when lifted to ears uniquely attuned to Jewish history, murmur familiar tales.

V

Throughout the long history of Jewish symbolism, parallel to the history of Judaism itself, several cycles have repeatedly recurred. Besides the dynamic process of assimilation and reaction mentioned above, three other ideological polarities have coexisted in creative tension: (1) rationalism vs. mysticism, (2) messianism vs. this-worldliness, and (3) patriarchal monotheism vs. male/female religious imagery. At various points in history, Judaism has positioned itself at one or the other end of each continuum, but never has it totally rejected the other end of the spectrum.

The talmudic rabbis were at the same time both mystics and legalists, but many of their heirs chose only one or the other camp. Although this polarity has been reconciled within particular individuals, it has largely continued to our day. Fortunately, Jewish symbols never experienced such a rift.

Similarly, although the belief in messianic redemption has been a strong theme within Jewish liturgy, ritual, and theology, most modern Jews, especially in the liberal community, maintain that Judaism primarily focuses on the here-and-now, not the later-and-after. But most Jewish symbols straddle both dimensions.

From its beginnings, Judaism waged its greatest battle not with mysticism or with messianism but with idolatry, that is, the notion that many, not a single invisible God, direct the course of cosmic and human events. To this day, the *Shema*, the six-word creed of Jewish faith recited several times each day by observant Jews, proclaims that "God is one." Many of the major Jewish symbols—the fringes of the *tallit*, the *tefillin*, the *mezuzah*—daily reinforce this cornerstone of Jewish belief.

Though polytheism finally disappeared as a threat to Jewish belief, a more insidious problem has remained: how to speak of God as One when human language is grammatically and semantically divided into male and female? Throughout the centuries, Judaism has grappled with this dilemma and has come up with numerous solutions: mystics derived both female and male images of God; Maimonides offered an apology: "The Torah speaks in the language of men"; modern feminists have sought to transform male references to God

as well as to add new symbols to the incomplete vocabulary of Jewish symbolic experience.

This book attempts to represent all these creative tensions in their richness and diversity. Most entries include rationalist and mystical, traditional and modern, messianic and this-worldly explanations. We have also included several new symbols and interpretations of traditional symbols that have emerged out of Jewish feminism.

As one studies the history of Jewish symbolism, it becomes quite obvious that a religion is much more than its texts, much more than its articulated theology. It lives and develops through the inexhaustible creativity of its adherents, whose diverse life experiences press continuously against its borders, forcing them to expand and yield. It is this tension above all, the push and pull of the people and its leaders, that gives a tradition its distinctive voice.

VI

Symbolism is a language. Like spoken languages, which have formal characteristics such as tense, case, and person, symbolism also has certain formal characteristics. Most important to this study are bivalence, density, and clustering.

Strange as it may seem, a symbol sometimes signifies two antithetical notions. Words, too, sometimes behave that way. For example, "cleave" means both to split apart and to stick to. Similarly, a symbol can be "bivalent," that is, have two opposite connotations, although each individual generally will identify with only one of them. So, for example, in ancient times, the eagle was a symbol of imperial Rome, the oppressor of the Jewish People. In much later times, the Prussian eagle represented for the Jews a similar oppressive regime. Yet in the Bible, God is represented as an eagle: "You have seen what I did to the Egyptians, how I bore you on eagles' wings and brought you to Me" (Exodus 19:4). And to Jewish immigrants in the early part of this century, the American eagle signified coveted freedom and a new life.

Although not all symbols embody opposites, all true symbols are characterized by interpretive "density." That is, they carry not one, but a variety of meanings. This interpretive richness, also called multivocality ("many voices") and condensation by anthropologists, endows symbols with a special power. Unlike doctrinal orthodoxy, which usually presents a single interpretation of a particular tradition and demands allegiance to that interpretation, symbols are remarkably flexible, allowing people with different understandings of the tradition to find shelter under the same roof.

Finally, symbols rarely exist alone, but tend to gather in "clusters." They emit ripples of meaning that reverberate against other symbols. For instance, in ancient times, synagogue and funerary mosaics would often feature a symbol cluster consisting of the *lulav* (palm branch), *etrog* (citron), incense shovel, *menorah*, and *shofar*. Taken together, these five symbols represented the Temple, and by extension, Judaism itself. They were particularly evocative because together they appealed to all five senses. Another ancient symbol cluster was grain, wine, and oil, mentioned together in the Bible and in the daily *Shema*. Together these three crops represent God's protection, since they provide essential sustenance. Following the loss of the land of Israel, these symbols continued to play a crucial role as the key elements of the Sabbath table: *hallah* (grain), *Kiddush* wine, and candlelight (originally provided by olive oil lamps). Each holiday has its own symbol cluster, as do life cycle events, sacred places, and many rituals.

Sometimes the clusters form a chain of meaning. Thus, the Sabbath candles symbolize the Sabbath, which itself is called "a foretaste of the World to Come," that is, a symbol of both heaven and the messianic redemption. Even these images are only symbols of the divine spirit as it manifests itself in the material world. Thus, like a growing plant, symbols foliate into intricate webs of connection, enriching our lives with meaning.

VII

Symbols give us the ability to shape time and space for ourselves. Otherwise, time and space would extend endlessly in all directions. We live our lives in cycles, but such divisions only gain true meaning when they are marked. A sacred calendar, celebrated through ritual and symbol, provides such punctuation to our endless round of

days. To an agricultural people, this calendar is synchronized with the solar cycle of harvests, winds and rains, and with the lunar cycle of waxing and waning. The Jews gave to the world a third cycle, the seven-day week, punctuated by a day of rest, adding to the natural rhythms of sun and moon a human rhythm on a smaller scale.

The Jewish People has lived in both agricultural and historical cycles, and its calendar reflects both these realities. All its sacred moments carry naturalistic and historical interpretations. Once in exile, the people carried the sacred calendar with them as a reminder of the rhythms of the land, but also of their rootless history, marked by singular events instead of predictable cycles.

In addition to the collective life of the community, each individual life is marked by special moments that demand public acknowledgment and interpretation. Birth, circumcision, *Bar* and *Bat Mitzvah*, weddings, deaths — each represents a transition from one status to another, a dangerous journey through spiritual limbo into a new kind of security, as provisional as that may prove to be.

In addition to marking time, symbols mark spaces, both public and private. In the life of the Jew, the synagogue is the center of ritual and spiritual life, as was the Temple under the First and Second Commonwealths in ancient Israel (1000 B.C.E. to 70 C.E.). The synagogue serves as a place of prayer, of study for adults and children, of meeting, of public ceremony, of social identity. Because of its centrality, it has accrued many symbols through its long history.

For centuries, Jewish tombstones have often borne various symbols, identifying the status, both religious and professional, of the deceased, as well as his or her family story and hopes for the life to come.

The Jewish home, the other axis of Jewish study, ritual, prayer, and social life, features many symbols — *mezuzot*, *Seder* plates, *Kiddush* cups, candlesticks, *Havdalah* sets, many of them ornamented with great imagination and skill — which often constitute the prized possessions of that family.

In addition, several places have acquired such importance in the imagination and

memory of the Jews that they have become symbols in themselves. Foremost among them is Israel and, in particular, Jerusalem, symbol of the tragedy and hope of Jewish history, and in our own time, the focus of Jewish pride and pain.

Historical personalities, too, can acquire meaning as symbols. Although Judaism does not practice ancestor worship as Oriental cultures do, many ancient figures, such as the matriarchs, patriarchs, Moses, David, and Elijah, have come to represent abstract qualities such as glory or messianic hope. In the kabbalistic tradition, several ancient personalities are identified with divine attributes.

Times and places, shaped and bounded by symbols, allow us to orient ourselves in the world, turning the world, in Mircea Eliade's words, from "chaos into cosmos."[4]

VIII

Where does Judaism turn to find its symbols?

Three sources have provided almost all the grist for their mill: nature, culture, and history. Nature has yielded animals, plants, natural phenomena, geological forms, the human body, and colors. Culture has provided architecture, agriculture, animal husbandry, the family, monarchy, cuisine, numbers, the arts, and industry. And four thousand years of Jewish history have provided a multitude of places, people, and events. Together these sources have supplied abundant material for a rich and varied symbol system.

To these metaphors and images, Judaism has added the religious imperative known as *hiddur mitzvah*, the idea that it is praiseworthy to beautify the performance of a divine commandment: "This is my God whom I will adorn" (Exodus 15:2).

Throughout the ages, Jewish artisans, beginning with Bezalel in the wilderness, have brought skill and dedication to this task. Solomon's Temple was one of the wonders of the ancient world. Synagogues, first developed in Babylonian exile, became and continue to be showpieces of Jewish art. Folk artists have brought love and imagination to Jewish religious symbols. Christian artists, whose guilds for centuries excluded Jews, brought consummate craft

to their manufacture of Jewish religious objects. And modern creativity, in Israel and in the Diaspora, continues this extraordinary tradition to the present day.

Enhancing the beauty of these physical objects is the dance of ritual, symbolic gestures designed to transform natural functions—washing, eating, mating, dying—into holy acts, all performed in the service and imitation of God.

IX

Why has Judaism, founded upon the principle of an invisible God, developed such a sensuous symbol system? Why has a people who has borne so much suffering in opposing idolatry given birth to such a cornucopia of symbolic objects to enhance its ritual life? Does this phenomenon constitute a breach of the second commandment?

Perhaps the answer to this riddle can be found in the heart of Judaism—in the Torah itself. We read that Abraham and Sarah were commanded to leave their homes to found a new faith, to abandon the rich civilization of Mesopotamian culture for the simple landscape of the nomad. Centuries later, Moses led a slave people into the sun, sand, and wind of the wilderness to encounter God on a bare mountaintop. Out of this experience emerged a pure, abstract monotheism.

But once the people settled into the land, such purism apparently proved too spare a diet. The Israelites longed to be like their neighbors, to surround themselves with physical reminders of God's protection, to act as if their own behavior could influence

the rains and harvests, to create models of heaven on earth. They needed a way to interpret—both intellectually and emotionally—the baffling experiences of death, scarcity, and evil. An invisible God was too far away for them to reach without mediating symbols. They craved the intimacy of symbols.

Yet from the beginning, the Jewish People recognized that symbols posed a serious danger to those who embraced them: people might mistakenly worship the symbols, not the reality behind them. Therefore, symbols were successively weighted down with moral teachings and historical explanations, designed to guide symbol-users along the right path.

The danger that the rabbis feared has not diminished with time. Idolatry—that is, the worship of symbols as ends in themselves—continues to inform the practice of many Jews. The contemporary Jewish thinker Abraham Joshua Heschel cautioned that "God asks for the heart, not for the symbol; he asks for deeds, not for ceremonies." He further warned that "the heart of faith dies of an overdose of symbolism."[5]

We invite you to bring to the symbols within these pages your heart, your mind, your imagination, and your experience. For it is our experiences that give life to symbols, just as symbols in turn shape that experience and render it meaningful.

[1]Geertz, *The Interpretation of Cultures*, 93; [2]Kaplan, "The Future of Religious Symbolism—a Jewish View," in *Religious Symbolism*, ed. F. Ernest Johnson, 212; [3]Goodenough, *Jewish Symbols in the Greco-Roman Period*, ed. Jacob Neusner, xviii; [4]Eliade, *The Sacred and the Profane*, 117; [5]Heschel, *Man's Quest for God: Studies in Prayer and Symbolism*, 139, 143.

HOW TO USE THIS BOOK

Entries are listed alphabetically by their English translation or transliteration from the Hebrew or Yiddish, whichever is more common. The English headings are accompanied by their precise Hebrew equivalents, unless the Hebrew does not exist. For the most part, terms having entries elsewhere in the *Encyclopedia* are indicated by an asterisk (*).

The notes at the end of each entry include source footnotes, cross-references to other entries, the generic categories into which the symbol fits (listed in Appendix A), and a number of abstract concepts signified by the symbol (listed in Appendix B). Readers can also look up a specific concept in Appendix B to discover which entries represent that concept.

Entries generally trace a symbol's evolution from biblical to modern times. Although not always noted explicitly, material derived from Jewish texts—biblical, rabbinic, kabbalistic, hasidic—present that material as *traditionally*, not historically authoritative. The term *rabbis,* unless otherwise noted, refers to the sages of the talmudic period. *Rabbinic tradition* refers more generally to the continuous line of rabbinic interpretation beginning in the talmudic period.

At the end of the *Encyclopedia,* the reader will find a glossary of Hebrew, Aramaic, Yiddish, and technical terms; three appendixes; a list of secondary sources in English; and a general index.

The appendixes are designed to give the reader many pathways into the book. Appendix A, "Symbols Listed by Generic Categories," provides twenty-six indexes, such as "Animals," "Food," "Holidays," "Holocaust," "Life Cycle," "Personalities," "Women," to help the reader find symbol clusters associated with a particular theme. Appendix B, "Symbols Listed by Abstract Concepts," provides a second way into the *Encyclopedia.* Appendix C, designed for readers relatively unfamiliar with Jewish tradition, provides a brief time line of Jewish history. The general index can also guide readers to relevant entries.

A NOTE ON SOURCES

Hebrew sources are noted in the footnotes, but they are not included in the list of secondary sources at the end of the book. All biblical quotations in English are from the Jewish Publication Society translation of the *Tanakh*, 1985 edition, used by special permission. Talmudic references are to the Babylonian Talmud unless noted otherwise by "JT" to indicate Jerusalem Talmud. Hebrew vocalization and spelling are from Even Shoshan's *Ha-Milon He-Hadash* (Jerusalem: Kiryat Sepher, 1972).

The Encyclopedia of Jewish Symbols

AARON—אַהֲרֹן. Aaron was the older brother of *Moses, the younger brother of *Miriam, the son of Amram and Yoheved. A member of the tribe of Levi, he was the founder of the priesthood of Israel, which is called by his name: the House of Aaron.

Although Jewish tradition has come to revere Moses as the greatest teacher, prophet, and liberator of the Jewish People, it was Aaron who captured the hearts of the Israelites as they wandered through the *wilderness toward the Promised Land. It was Aaron and his sons who guided the spiritual life of the people, who offered up their sacrifices and sought their atonement. It was Aaron's hands that blessed the people with the priestly benediction. When the *Temple stood in *Jerusalem, it was Aaron's descendants who tended the *altar.

Despite Aaron's complicity in the incident of the *Golden Calf, God affirmed his priestly authority through a series of miracles in the wilderness, among them the pit that swallowed up the rebellious Korah, and Aaron's rod that wondrously sprouted *almond blossoms. As with Moses, God ended Aaron's life with a divine kiss.

According to the rabbis, Aaron was a model peacemaker. The sage Hillel declared: "Be of the disciples of Aaron, loving peace and pursuing peace, loving one's fellows and bringing them close to the Torah."[1] So much did Aaron love peace, taught the rabbis, that he was willing to risk God's displeasure over the Golden Calf rather than cause dissension among his fellow Israelites.

Aaron also went to great lengths to restore peace among husbands and wives, personally mediating between them in domestic squabbles. In previous times, he was sometimes depicted on ornate betrothal rings as a symbol of marital harmony.

Because of his association with the levitical priesthood and with the Sanctuary in the wilderness, Aaron has also been a traditional symbol of holiness. In ancient *synagogue art in Israel and the Near East, the figure of Aaron appears alongside the *ark, the *menorah, and other symbols of the Temple.

Mystics include Aaron as one of the *ushpizin (symbolic guests) invoked during the holiday of *Sukkot and as one of the *Sefirot (emanations of the divine spirit), representing Hod, God's Majesty.

[1]Pirke Avot 1:12.

Signifies: CHOSENNESS, DIVINE GRACE, HOLINESS, MARRIAGE, PEACE, PRIESTHOOD, PROPHECY

Generic Categories: Kabbalistic Symbols, Personalities, Temple

See also: Almond Tree, Golden Calf, Miriam, Moses, Priestly Blessing, Priestly Cult, Rod, Sefirot, Temple, Ushpizin

ABRAHAM—אַבְרָהָם. According to the *Torah, Abraham was the first Jew, the first patriarch of the people of Israel. At God's command, he and his wife *Sarah left Mesopotamia to start a new religion in Canaan: the worship of one God. As the father of both *Isaac and *Ishmael, Abraham is the common ancestor of both the Arab and Jewish peoples.

The Torah interprets Abraham's name to mean "father of a multitude," signifying his role as the founder of the Jewish People, to whom God promised descendants as "numerous as the stars of heaven."[1] Abraham is credited with instituting the practice of *circumcision to symbolize the Jews' covenant with God.[2] According to later tradition, God gave the Jewish People the practices of tzitzit and *tefillin as a reward for Abraham's righteousness.[3] In addition, Abraham is credited with instituting Shaharit, the daily morning service.[4]

Because he so readily accepted God's command to sacrifice his son Isaac, Abraham has become a symbol of wholehearted faith in God. To medieval philosophers, Abraham was a model of the righteous man and the philosopher. Maimonides claimed that Abraham's power as a prophet was second only to that of *Moses. To *kabbalists, Abraham represented the *Sefirah of Loving-kindness, Hesed, one of the emanations of the divine spirit.

Because Abraham's tent was always open to strangers, he and his wife Sarah were models of hospitality. He also converted many non-Jews to a belief in one God, earning him the title "the father of all proselytes."[5] To this day, a new convert is

known as "the child of Abraham and Sa-rah."

[1]Genesis 17:4–5; 22:17; [2]Genesis 17:9–14; [3]Sotah 17a; [4]Berakhot 26b; [5]Hagigah 3a.

Signifies: CONVERSION, COVENANT, FAITH, FELLOWSHIP, HOSPITALITY, KINDNESS, PHILOSOPHY, PROPH-ECY, RIGHTEOUSNESS

Generic Categories: Brit, Conversion, Personalities

See also: Akedah, Circumcision, Isaac, Ishmael, Kabbalah, Sarah, Sefirot, Ushpizin

ADAM – אָדָם. According to the *Torah, Adam was the first human being. Adam's name—אדם—derives from the Hebrew words, adamah—אדמה, meaning *earth, and adom—אדום, meaning *red, for Adam was created out of the primal clay.

Adam is created in the image of God, and given dominion over all other living things. But tempted by the *serpent, Adam and his companion Eve sin by rebelling against God's command not to eat from the *Tree of Knowledge.[1] Adam thus symbol-izes both godliness and rebellion against God.

According to the Hellenistic Jewish phi-losopher Philo, Adam was the perfect crea-ture of God. The rabbis praised his extraor-dinary beauty: "The ball of Adam's heel outshone the glory of the sun. How much more so the brightness of his face!"[2] But when Adam sinned, his beauty was dimin-ished, as was the perfection of all things on earth.

According to one biblical version, the original Adam embodied both genders: "male and female God created them."[3] In addition, Adam represented all races, for God created his body out of *dust from every corner of the earth. Another version designates Adam as the first man, and Eve, the first woman formed out of his rib.[4]

To medieval philosophers, Adam repre-sented intellectual perfection (Maimo-nides), the vessel of divine power (Judah Ha-Levi), and the prototype of humankind (Joseph Albo). The story of his temptation and fall in the Garden of *Eden was seen as an allegory for human nature.

The midrashic tradition claims that the original Adam was a superhuman creature,

Adam Kadmon, Primordial Adam, whose body "extended from one end of the world to the other." When he sinned, God "placed a *hand upon him and diminished him."[5] The *kabbalists explain that this first Adam came into being when God contracted and allowed divine light to emanate into pri-meval space. Adam Kadmon symbolizes God's Presence in the material world.

According to the Bible, Adam was the first farmer. As a consequence of his dis-obedience in Eden, he and his descendants were destined to earn their *bread by the sweat of their brow, eating the grasses of the field, and working the soil.[6]

Within the sanctioned context of the Jewish family, Adam and Eve symbolize the first marriage, arranged and celebrated by God and the *angels.

[1]Genesis 1:26–28; 3:1–7; [2]Pesikta de-Rav Ka-hana 4:4; [3]Genesis 1:27; Genesis Rabbah 8:1; [4]Genesis 2:7, 21–22; [5]Hagigah 12a; Genesis Rabbah 8:1; [6]Genesis 3:17–19 .

Signifies: AGRICULTURE, BEAUTY, DIVINE PRESENCE, DOMINION, FARMING, GODLINESS, HUMAN-KIND, INNOCENCE, INTELLECT, PERFECTION, REBELLION, SIN, UNITY

Generic Categories: Botany, Colors, Kab-balistic Symbols, Personalities

See also: Earth, Eden, Eve, Kabbalah, Light, Lilith, Serpent, Tree

AFIKOMAN – אֲפִיקוֹמָן. At the *Passover *seder, the leader breaks the middle of the three *matzahs before the start of the festive meal and hides the larger half. This piece of matzah is known as the afikoman; the seder cannot conclude until all guests have eaten a piece of it.

Afikoman is a Greek word meaning ei-ther "aftermeal songs and entertainment" or "dessert."[1] The Mishnah states that "one may not add 'afikoman' after the paschal meal."[2] Since the destruction of the *Temple, the broken half of the middle matzah has come to replace and symbolize the paschal sacrifice, which was the last food permitted to be eaten at the seder meal.

Because of its essential role in the seder, the afikoman has taken on special meaning in folk custom. It protects against the *Evil

Eye and ensures longevity. In the Middle Ages, it was carried in a pouch as a protective *amulet. To the Jews of Iran, Afghanistan, Salonika, Kurdistan, and Bukhara, keeping the *afikoman* in one's pockets or house brings good luck. In some communities, pregnant women carry it to ensure a safe delivery. If kept for *seven years, the *afikoman* acquires the power to stop a flood when thrown into a turbulent river. In Kurdistan and among the Sephardi Jews of Hebron, fathers tie the *afikoman* around their sons' arms and say: "May you so tie the *ketubah* to the arm of your bride." In some Eastern European communities, eating a piece of the *afikoman* guarantees unmarried women a husband during the coming year.

Because the *afikoman* is created through breakage and then reappears to make the meal whole, it is a symbol of completion and of messianic *tikkun*, repair of our broken world. Among the Jews of Djerba (Tunisia), the leader of the *seder* gives a piece of the *afikoman* to one of the guests who carries it on his shoulder to visit relatives, thereby symbolizing the hope of messianic redemption. Since the *afikoman* is created from the middle of the *three *matzahs*, which represents the Levites, its disappearance signifies the Levites' exile from the *Temple. In retrieving the *afikoman*, the children, whom tradition regards as "messiahs of humankind," symbolically redeem the exiled Levites and return them to service at the *altar, symbolized by the family *table.[3]

For children, the *afikoman* represents the hope of a reward, since it can be ransomed for presents or money. Because of its special role for children, the *afikoman* has come to symbolize family continuity and the hope of future generations.

[1]JT *Pesahim* 10:6, 37d; [2]*Mishnah, Pesahim* 10:8; [3]Fredman, *The Passover Seder: Afikoman in Exile*, 119, 123.

Signifies: CONTINUITY, GOOD LUCK, HOPE, LONGEVITY, REDEMPTION, SACRIFICE, TIKKUN OLAM

Generic Categories: Food, Messiah, Natural Phenomena, Passover, Temple, Wedding

See also: Evil Eye, *Matzah*, Messiah, *Seder*, Temple

AKEDAH – עֲקֵדָה. In the ancient Near East, human sacrifice was a universal practice. The *akedah*, literally "the binding" of *Isaac, highlights Judaism's revolutionary departure from this practice. It is also the story of a supreme test of faith. Having been granted a son by Sarah in old age, *Abraham is then commanded by God to sacrifice this beloved son on Mount Moriah. Only at the last moment does God command Abraham to spare Isaac's life, declaring that "now I know that you fear God, since you have not withheld your son, your favored one, from Me." [1] According to one legend, *Sarah dies of grief when Abraham takes Isaac off supposedly to be sacrificed. According to another legend, her heart bursts from joy upon learning that he has been spared.

One tradition claims that Isaac was actually sacrificed upon the *altar. The Talmud reports that on public fast days, *ashes were placed on the *Ark in the *Temple and on the heads of the leaders of the Jewish community as a reminder of the "ashes of Isaac."[2] A later tradition claims that Isaac was not only sacrificed but then resurrected. This medieval story was no doubt a reaction to the prevailing Christian interpretation of the *akedah* as a foreshadowing of the crucifixion of Jesus.[3] In times of persecution, the *akedah* has been regarded as a symbol of Jewish martyrdom.

For centuries, the *akedah* has been a favorite motif in Jewish ceremonial art. In the synagogue mosaics of Dura-Europos (Babylonia, 3rd century C.E.) and Beit Alpha (Israel, 6th century C.E.), the Binding of Isaac is prominently represented. It has also been a favorite scene on the handles of *circumcision knives and on circumcision plates used to bring male children to the *mohel* (circumcisor). Depicting the *akedah* on these latter objects represents the parents' hopes that their willingness to circumcise their son will be seen as equivalent to Abraham's willingness to sacrifice his. In addition, folk custom has long subscribed to the belief that surrendering a part of something safeguards the rest from harm.

The *kabbalists saw in Abraham a symbol of Loving-kindness, *Hesed*, and in Isaac, a symbol of Divine Justice, *Gevurah*. According to their interpretation of the *akedah*, Abraham needed to display hardness of heart in order to initiate the process

of reconciliation between *Hesed* and *Gevurah*, Mercy and Judgment, fire and water, preparing the way for *Jacob, the harmonizing principle of *Tiferet* (Glory or Beauty). Furthermore, the human story of the *akedah* mirrors the processes in the divine realm among the *Sefirot*, the divine emanations.

The story of the *akedah* is read in synagogue on the second day of *Rosh Hashanah (the first day in Reform synagogues), perhaps reminding us of our own vulnerability to death, a theme reflected also in the central High Holiday image of the *Book of Life as well as in the *white garments worn during this period. The *shofar*, *ram's horn, blown on this holiday recalls the ram sacrificed in place of Isaac.

[1]Genesis 22:12; [2]*Taanit* 16a; [3]For an in-depth study of these traditions, see Shalom Spiegel, *The Last Trial* (1967).

Signifies: FAITH, HOLINESS, KINDNESS, LOVE, MARTYRDOM, REBIRTH, RESURRECTION, SACRIFICE, SUBMISSION TO GOD'S WILL, TEST OF FAITH, VULNERABILITY

Generic Categories: *Brit*, Holocaust, Kabbalistic Symbols, Rosh Hashanah, Temple

See also: Abraham, Altar, Ashes, Circumcision, Isaac, Jacob, Kabbalah, Ram, Rosh Hashanah, Sacrifice, Sarah, *Sefirot*, *Shofar*

ALEPHBET – אָלֶף־בֵּית. The
Hebrew alphabet is one of the oldest in the world, deriving from the same Phoenician system which also gave rise to the Greek and Latin alphabets. It consists of twenty-two letters (plus *five "final" letter forms) and is vocalized by a system of diacritical marks inserted above, below, or within the letters.

The rabbis invested the letters of the alphabet with tremendous creative power, citing as proof that "By the word of God were the heavens made."[1] When Moses broke the first set of Tablets at *Sinai, the holy letters were said to fly back up to their heavenly source; so likewise did the letters of the *Torah when Rabbi Hananiah ben Teradyon was later martyred by the Romans, wrapped in a burning scroll.[2]

Traditional interpreters of the Bible attribute great significance to individual letters, especially if they appear superfluous or out of order. Where a modern scholar might see only grammatical utility or even error, a traditional Jewish reader sees instead a hidden message awaiting decipherment. For instance, Rabbi Akiva (50–135 C.E.) maintained that the word *et* (used only to indicate a direct object) in the first line of the Torah conclusively proves that God alone created the universe.[3]

In addition, influenced by Greek practice and the Pythagorean theory of *numbers, numerical values were later added to the letters, giving rise to an elaborate interpretive tradition. (See chart.) With this formula, originally devised to number coins, interpreters created an ingenious system called *gematria* (derived either from the Greek word for "geometry" or from *gamma tria*—the third letter equals three). This system sets up equivalences between words of equal numerical value. Using these equivalences, the rabbis derived moral, ritual, and philosophical principles. For instance, pointing to the numerical equivalence of the Hebrew words *yayin* (wine) and *sod* (secret), which both equal seventy, they taught that "when wine comes in, a secret goes out."[4] Although to some, *gematria* is no more than a game, others take it quite seriously as a divine code revealing a master system of symbolic correspondences at work in our world. To this day, the Jewish year is written in this alphabetic-numeric system: 5759 (1999) = תשנ״ט. (The Hebrew designation excludes the initial *heh*, which would represent 5,000, thus adding up only to 759.)

ל Lamed =30		א Aleph =1	
מ Mem =40		ב Bet =2	
נ Nun =50		ג Gimmel =3	
ס Samekh =60		ד Dalet =4	
ע Ayin =70		ה Heh =5	
פ Peh =80		ו Vav =6	
צ Tzadi =90		ז Zayin =7	
ק Kuf =100		ח Het =8	
ר Resh =200		ט Tet =9	
ש Shin =300		י Yud =10	
ת Tav =400		כ Khaf =20	

ץ Final Tzadi		ך Final Khaf	
ף Final Feh		ם Final Mem	
		ן Final Nun	

The 22 letters of the Hebrew alphabet with their numerical equivalents and final forms.

Individual letters making up a word are sometimes treated as abbreviations, which can be decoded to reveal an entire moral teaching. Thus, the Hebrew month *Elul* (אלול), which precedes *Rosh Hashanah, stands for *Ani Le-Dodi Ve-Dodi Li*, אני לדודי ודודי לי — "I am my beloved's and my beloved is mine," an affirmation of love between Israel and God.[5] Even calligraphy can have moral import. A famous legend credits the great talmudic scholar Rabbi Akiva with understanding even the decorative flourishes — the *crowns — atop the letters of the Torah scroll.[6]

In fact, to the *kabbalists, the letters of the Hebrew alphabet embody within them the divine energies directing and creating the material universe. The letters came into being as emanations of God, and human manipulations of them carry great peril and redemptive power. When we pronounce a letter of the Hebrew alphabet, we awaken its spiritual essence and create sacred forms which return to the heavenly sources of emanation from which they arose. The letters are the garments of the Torah, "woven from all the colors of the *light, *white, *red, green, and black."[7]

According to the mystics, the four letters of the Tetragrammaton, God's unpronounceable *Name — *yud* (י), *heh* (ה), *vav* (ו), *heh* (ה) — have unparalleled power to create and destroy. Cain was protected from the wrath of avengers by the letter *vav* imprinted on his brow by God.[8]

In Jewish magic, combining Hebrew letters has always been one of the major techniques in casting spells and working charms. Many *amulets contain permutations of the names of God, angels, and biblical verses.

Several letters have special significance in Jewish thought:

Aleph is the first letter of the Hebrew alphabet, and hence signifies beginnings. Unless vocalized, it has no sound. In Jewish numerology, it represents the number "1" and "1000." According to the kabbalists, the *aleph* encompasses all the other letters and is the primary source of speech, a symbol of unity and perfection.

The talmudic expression "from *aleph* to *tav*"[9] symbolizes completeness, in the same way as does our English expression "from A to Z."

Aleph is the first letter of *Elohim* (אלהים), the name of God associated with the crea-

tion of the world. It also begins all three words of the divine name revealed at the *burning bush: *Ehyeh Asher Ehyeh* (אהיה אשר אהיה). It begins the first word of the Ten Commandments: "*Anohi*" (אנכי), "I am the Lord your God."[10] And its three pen strokes, taken separately, correspond to two *yuds* and a *vav* whose numerical value equals 26, the same value as YHVH, God's four-letter name. Because of such powerful associations with God's name, the *aleph* has been commonly used in magic. Even the popular formula "abracadabra" (possibly derived from the Hebrew *bara ke-davar*, created according to the word) may owe its multiple a's to this association with the primal *aleph*. *Aleph* also appears frequently in amulets and other examples of letter magic in Jewish folk custom.

Heh is often used as a substitute for writing God's Hebrew name, and is shorthand for "*HaShem*," the Name.

Yud, the smallest letter in the *alephbet*, derives from the word *yad*, meaning *hand. It is most important symbolically as one of the *four letters in the sacred *Name of God or one of the two letters in the abbreviated form of the Name: "*Yah*." Its numerical value is *ten. Two *yuds* together also spell a name of God. It can also represent the highest dimension of the divine spirit (*Atzilut*).

Shin, with the numerical value of 300, begins another of God's names, *Shaddai* (שדי), meaning Almighty. This letter appears on many Jewish emblems, such as *mezuzah, *tefillin, and amulets. Some Jews place the three middle fingers of their right hand upon their forehead when reciting the *Shema*, either symbolizing the first letter of this prayer or *Shaddai*. When binding *tefillin* on the hand, the straps are formed into the letter *shin*. The priests reciting the *Priestly Blessing spread out the fingers of both hands in the form of one or two *shins*. When clothing the dead for burial, it is customary to loop the ties of the shroud into *shins* rather than knot them. This letter is also frequently used in ornamental and architectural designs for synagogues and ritual objects.

[1]Psalm 33:6; [2]*Pesahim* 87b; *Avodah Zarah* 18a; [3]*Genesis Rabbah* 1:14; [4]*Numbers Rabbah* 10:8; [5]Song of Songs 6:3; [6]*Menahot* 29b; [7]Foreword to *Tikkunei Zohar*; [8]Ginzberg, *Legends of the Jews* 1:111–112; [9]*Shabbat* 55a; [10]Exodus 3:14; 20:2.

Signifies: **ALEPHBET**: CREATIVITY, DANGER, DIVINE SPIRIT, GOD, HOLINESS, LEARNING, LIFE, MAGIC, MYSTERY, PERIL, POWER, REVELATION, SOUL
ALEPH: BEGINNING, COMPLETION, CREATION, DIVINE MYSTERY, HUMILITY, MAGIC, PERFECTION, PRIMACY, SILENCE, UNITY
HEH: GOD
YUD: GOD, HOLINESS
SHIN: DIVINE POWER, DIVINE PROTECTION

Generic Categories: Numbers, Shavuot

See also: Amulet, Burning Bush, Crown, Kabbalah, Light, *Mezuzah*, Names, Name of God, Numbers, Ten Commandments, Torah

ALMOND TREE – שְׁקֵדִיָּה.

The almond tree has both positive and negative associations in Jewish tradition. On the one hand, it symbolizes divine favor, as evidenced in the story of *Aaron's rod, which miraculously sprouted almond blossoms, identifying Aaron as the one God had chosen to lead the people as High Priest.[1] It also signifies spring and rebirth, since the almond is the first tree to flower in Israel, blooming as early as January or February. It derives from the Hebrew root meaning "wakeful." On the other hand, the almond tree has been used to represent the brevity of human life, since it blossoms early yet ripens late, hence its name *shaked*, which also can be translated "to hasten." And because it is so vulnerable to late frosts, it is a symbol of fragility.

Almond trees have the unique property of flowering before leaves appear on their branches. This eruption of life out of the stark winter landscape reminds us of God's miraculous power to revive the dead. The rabbis chose this moment when the almond trees flower to mark *Tu B'Shevat, the New Year of the Trees. Accordingly, almonds play a prominent role in the cuisine and songs of this holiday. In modern Israel, the almond, prized for its sweet flavor and fragrance, is a symbol of beauty and hope.

Ecclesiastes offers the image of the almond tree as a symbol of the fleeting nature of human life.[2] Similarly, in an ancient Aramaic folk work, the hero Ahikar warns his son: "Be not like the almond tree, for it blossoms before all trees, and produces fruit after them." In these references, the almond's unusual natural cycle symbolizes the vanity rather than the fruitfulness of life.

Magical properties were first associated with almonds in connection with Aaron's rod, which not only burst into almond blossoms but also, at an earlier time, had swallowed the rods of the Egyptian magicians.[3] Because of this miracle and the almond's unique botanical properties, it became a symbol of divine prophecy.

Almond tree, A MYGDALUS COMMUNIS, annually the first tree in Israel to flower, often in a dramatic transformation that takes place overnight.

Because the nuts of the almond tree are shaped like *eyes, they have sometimes been used as protection against the *Evil Eye. The Hebrew word for almond, *shaked*, also means "to watch."[4]

Another name for almond – *luz* – is also the name of a legendary city in Israel whose inhabitants were said to live forever. According to the *midrash*, there is a bone at the bottom of the spine, likewise called the "*luz*" or "the nut of the spinal column," from which human beings "will blossom forth at the Resurrection."[5] In the Middle Ages, this bone, which can neither be dissolved in water nor burned with fire, was known as the "os resurrectionis."

[1]Numbers 17; [2]Ecclesiastes 12:5; [3]Exodus 7:11–12; [4]Jeremiah 1:11–12; [5]*Ecclesiastes Rabbah* 12:5.

Signifies: BEAUTY, BREVITY OF HUMAN LIFE, DIVINE GRACE, FRAGILITY, HOPE, MIRACULOUSNESS, PROPHECY, REBIRTH, RESURRECTION, SPRING, VANITY, VULNERABILITY

Generic Categories: Body Parts, Botany, Food, Trees, Tu B'Shevat

See also: Aaron, Israel (Land of), Jerusalem, Tree, Tu B'Shevat, White

ALTAR — מִזְבֵּחַ.

In most religions, the altar represents the meeting place between heaven and earth, an artificial mountain bringing worshipers close to the divine and the divine closer to earth. Throughout Jewish history, the altar has played a central role as a symbol and focal point. Evolving from a private to a communal site of sacrifice, the altar, especially as it became permanent and centralized on the *Temple Mount in *Jerusalem, represented the Jewish People's channel to the holy. Its *four *corners represented in microcosm the four corners of earth. Here the individual came to make expiation, to offer thanksgiving, to confess sins, and to seek asylum from human wrath.[1]

In ancient pagan religions, the altar was the place where the gods received their meals in the form of sacrifices. Judaism radically altered the focus: sacrifices established a spiritual connection between divine expectations and human behavior, as well as providing food for the supplicants and priests. Sacrificing an animal at the altar and pouring out the *blood symbolically returned that animal's life to its divine source and expiated for the individual's sin in taking the animal's life: "For the life of the flesh is in the blood, and I have assigned it to you for making expiation for your lives upon the altar; for it is the blood, as life, that effects expiation."[2]

In recognition of this expiatory quality, Rabbi Yohanan ben Zakkai explained that the Israelites were prohibited from using *iron to build the altar, because the sword represents catastrophe, and the altar, atonement. That is why the altar is built of whole stones (sh'lemot — שלמות): "to bring peace — shalom — between Israel and their Father in Heaven."[3] Elsewhere the rabbis taught that the Hebrew word for altar — MiZBe'aH (מזבח) — is a notarikon (acronym) for "forgiveness-merit-blessing-life" ("Mehilah"-"Zekhut"-"Berakhah"-"Hayyim").[4]

In Jewish legend, the altar on the Temple Mount resided on the site of all previous altars: those of *Adam, Cain, Abel, *Noah, and the *akedah.[5] Another legend claims that Adam himself was formed from *earth taken from this site, so that the power of his atonement could help him endure his exile from the Garden of *Eden. In addition, legend identifies this site as the place where *Jacob had his *dream of *angels ascending and descending the heavenly *ladder, another symbol of the vertical axis between heaven and earth.

Because of its association with the akedah and sacrifice, the altar became a symbol of Jewish martyrdom. The rabbinic phrase "building an altar" referred to those who died to sanctify God's name.[6] Expressions such as "the altar sheds tears" and "as if an altar was erected in his heart" symbolize human suffering.[7]

After the destruction of the Temple, the family *table came to replace the altar, the *salt and *hallah symbolizing the sacrificial offering. The rabbis referred to the table as mikdash me'at, a small sanctuary, explaining that "now that there is no altar, a man's table atones for him."[8] The many laws, blessings, rituals, and customs associated with eating reinforce this notion that the Jewish table is a place where God's Presence dwells.

[1]Exodus 21:14; 1 Kings 1:50-51; 1 Kings 2:28-29; [2]Leviticus 17:11; [3]Tosefta Bava Kamma 7:7; [4]Tanhuma Terumah 10; [5]Pirke de-Rebbe Eliezer 31; [6]Lamentations Rabbah 1:16, 50; [7]Sanhedrin 22a; Otiyyot de-Rabbi Akiva 8; [8]Berakhot 55a.

Signifies: ATONEMENT, CELEBRATION, HOLINESS, LIFE, MARTYRDOM, PEACE, SACRIFICE, SAFETY, SUFFERING, THANKSGIVING

Generic Categories: Food, Temple

See also: Adam, Blood, Corners, Hallah, Iron, Jacob, Jerusalem, Ladder, Mountain, Rock, Sacrifice, Salt, Table, Temple

AMALEK — עֲמָלֵק.

In Jewish history and legend, the name Amalek has become synonymous with Israel's enemy. Amalek was both the grandson of *Esau and the nation of his descendants, who attacked the Children of Israel from the rear as they crossed the *wilderness en route to the Promised Land. So heinous was Amalek's crime against the Israelites — to attack the women, the children, and the elderly who lagged behind in the rear of the camp — that the Torah commands the Jews never to

forget or to forgive: "You shall blot out the memory of Amalek from under heaven. Do not forget!"[1]

*Haman the Agagite, the villain of the Book of *Esther, is identified as a descendant of Amalek, once ruled by King Agag.[2] The *Shabbat before *Purim is known as "Shabbat Zakhor," the Sabbath of Remembrance, during which the story of Amalek's betrayal is read in synagogue. During the *Megillah reading on Purim, it is traditional to make noise upon hearing Haman's name, and to stamp out his name written on the bottom of one's shoe, in fulfillment of the biblical injunction to "blot out the memory of Amalek."

A rabbinic legend also identifies Amalek with *Rome.[3] The rabbis warned that it was forbidden to show mercy foolishly to those who, like Amalek, were bent on Israel's destruction.

[1]Deuteronomy 25:19; [2]1 Samuel 15:2-33; [3]Ginzberg, *Legends of the Jews* 5:272, n. 19.

Signifies: BETRAYAL, ENEMY, EVIL, PURIM, REVENGE

Generic Categories: Personalities, Purim

See also: Esau, Haman, *Megillah*, Purim, Rome

AMULET – קָמִיעַ.

Every culture invests certain objects with potent magical powers. These charms, talismans, and amulets serve to protect individuals against the equally potent forces of evil which threaten to harm them. Scholars have suggested that

Three angels invoked to secure protection against Lilith: Senoy, Sensenoy, and Semangelof, used on birth amulets. The inscription above reads "Adam and Eve, barring Lilith" (from *Sefer Raziel*).

all ornaments were originally intended as amulets. From ancient times, Jews have been attracted to such magical safeguards. Although the rabbis insisted that the *mezuzah* and *tefillin* were to serve only as *reminders* of God's commandments,[1] rather than good luck charms against demons, such objects invariably acquired magical properties among the people.

The Hebrew word for amulet is *kame'a*, which derives either from the Hebrew root "to bind" or from the Arabic "to hang," since amulets are usually either worn or displayed in a house. (It is possible that the Italian word "cameo" derives from the same root.) Although no direct evidence of their use can be found in the Bible, amulets have played an important role in Jewish folk custom from earliest times. They have taken two principal forms: written texts, and objects such as herbs, animal tails, stones, and crafted artifacts. Throughout the ages, amulets have been very popular, particularly to effect cures, to insure good health and fertility, to protect pregnant women, and to ward off disasters and the *Evil Eye.

Despite their objections to regarding ritual objects such as *tefillin* and *mezuzot* as magical, the rabbis acknowledged that other sorts of amulets could be effective against the Evil Eye. They describe two sorts of amulets, one written on parchment with biblical and other relevant quotations, the other made out of the root of a certain plant. Later amulets contained quotations relevant to their function, such as the *Priestly Blessing,[2] thought particularly effective against the Evil Eye; permutations of the *names of God; and names of *angels. Some of these later amulets were made of parchment, some of silver. The Talmud maintains that an effective amulet – one which has cured three illnesses – may even be taken into the public domain on *Shabbat*,[3] a practice normally prohibited. It was a widespread belief that the more pious the wearer of these amulets, the more effective would be the charm.

Throughout the ages, religious disputes arose over the permissibility and efficacy of amulets. Some rabbis allowed them, others vehemently opposed them as idolatrous or false. Maimonides, for instance, ridiculed "the folly of amulet writers"[4] and warned against using the *Torah scroll and *tefillin*

to cure sickness. Nahmanides, on the other hand, permitted the use of amulets. In the Middle Ages, early traditions of magic, including the use of amulets, combinations of letters, and names of angels, merged with the mystical teachings of *Kabbalah to create "the practical Kabbalah," that is, Jewish magic, which spread from Spain to Eastern Europe, and from the mystical center of Safed to the rest of the Holy Land. The most common functions of these amulets were to protect pregnant women and their unborn babies against miscarriage and the demon *Lilith, to protect women during childbirth (these amulets were called *kimpetbriefel* in German), to cure sickness, and to prevent disaster. Amulets have often been associated with transitional periods, when individuals are considered most vulnerable to natural or supernatural danger.

Amulets have been used in Jewish communities for many centuries and still enjoy a degree of popularity, as evidenced by the widespread custom (even among non-Jews) of wearing "good luck charms" such as the *hamsa*, *mezuzah*, and other objects which have long been associated with Jewish magic. Although amulets come in many forms and materials, the most common are geometric shapes such as the *circle, square, triangle, crescent, and hexagram (the *Star of David); the *menorah; animals; and the *hand (*hamsa*). Religious objects, such as a *shiviti*, *mizrah*, or *omer-counter sometimes "double" as amulets with the addition of divine or angelic names, biblical verses, or graphic ornamentation, such as *menorahs* or *hamsas*. Because amulets are usually small, the quotations inscribed upon them are often abbreviated or reduced to acronyms, making them almost indecipherable to the uninitiated. Because amulets have been especially popular among Jewish women, contemporary Jewish feminists have taken a special interest in their study and revival.

[1]Deuteronomy 6:8–9; 11:18, 20; [2]Numbers 6: 24–26; [3]*Shabbat* 61a; [4]*Guide of the Perplexed* 1:61.

Signifies: DIVINE PROTECTION, GOOD LUCK, MAGIC, TRANSITION

Generic Categories: Birth, Clothing, Kabbalistic Symbols, Women

See also: Alephbet, Amulet, Angels, Evil Eye, Hand, Kabbalah, Lilith, *Menorah*, *Mezuzah*, Names, Name of God, Priestly Blessing, Star of David, *Tefillin*

ANGEL OF DEATH – מַלְאַךְ הַמָּוֶת.
In Judaism, only God is the Master of Life and Death. Thus the Angel of Death, *Malakh Ha-Mavet* in Hebrew, is only a messenger, charged with carrying out divine decrees. In later times, this *angel was often identified as *Satan or Samael, the Evil One. The Angel of Death symbolizes those demonic forces, which have been responsible for humankind's woes from the fall of *Adam and *Eve to our present misfortunes.

In the Bible, the Angel of Death is called "the Destroyer," *Ha-Mashkhit*[1]; "the cruel messenger," *Malakh Ahzari*[2]; and "the king of terrors," *Melekh Balahot*.[3] He is pictured as a giant angel standing between heaven and *earth with a drawn sword in his hand stretched out over *Jerusalem.[4] However, in these and other biblical references, the Angel of Death is only an allegorical figure, an attribute of God's power.

In later folklore, the Angel of Death takes on a life of his own. He is pictured as full of *eyes, for nothing escapes his gaze; as a zealous reaper; and as an old man holding a sword dripping poison into the mouths of mortals. He also appears as a fugitive, a beggar, a peddler, and a nomad. Drawing from the cultures among which they lived, medieval Jews identified the Angel of Death with demons, ogres, the devil, and other supernatural beings.

In general folk belief, the Angel of Death can only be defeated with the aid of magic weapons or powerful elixirs. But in Jewish tales, the Destroyer can sometimes be fended off through study, prayer, or acts of extraordinary charity. Because the Angel of Death, unlike God, has limited powers, he can sometimes also be thwarted. Mortals can deceive him by a deathbed change of name or a trick. Many Jewish customs associated with death and burial derive from the belief that the soul of the deceased also needs protection from the Angel of Death or his agents.

The image of the Angel of Death continues to play a central role in the *Passover *Haggadah*, both in the story of the Ten

Plagues as well as in the folksong, *Had Gadya*.

[1]Exodus 12:23; [2]Proverbs 17:11; [3]Job 18:14; [4]1 Chronicles 21:16.

Signifies: CRUELTY, DEATH, EVIL, REVENGE, SIN

Generic Categories: Death, Passover

See also: Angels, Evil Eye, *Had Gadya*, Passover, Satan

ANGELS – מַלְאָכִים.

In Hebrew, angels bear many *names: messenger (*malakh*); children of God or gods (*bnei elohim* or *bnei elim*); holy beings (*kedoshim* or *hayyot ha-kodesh*); *cherubim; *seraphim*. Although the term "*malakh*" can mean both human and divine messenger – and meant both in the Hebrew Bible – it gradually came to imply only the latter, as angels assumed a more prominent role in Jewish thought and lore. As foreign influences cross-fertilized with Jewish culture, angelology became more elaborate, with angels taking on names, personalities, realms, and specific functions. (However, Jewish tradition did not borrow Christian pictorial imagery such as *wings and halos.) The mystics, especially, developed a complex mythology involving good and evil angels, characterizing these supernatural beings as emanations of divine light. In modern times, angels have largely lost their supernatural status, becoming merely poetic symbols or metaphors.

Perhaps the most famous angels in the Bible are the three who visit *Abraham and *Sarah to predict the birth of their son *Isaac and the imminent destruction of Sodom and Gomorrah,[1] and the angel who wrestles with *Jacob.[2] In both cases, the divine emissaries are called *ish*, man, and in Abraham's case, also *malakh*, messenger. Although their behavior marks them as special – they prophesy, strike men blind, and appear and disappear without warning – they are not characterized in the text as supernatural or immaterial. Throughout the Bible, except for the Books of Ezekiel, Zechariah, and *Daniel, angels serve as executors of God's will but have no independent life of their own. They are symbolic embodiments of God's power.

Under Hellenistic influence, pagan mythology began to compromise the monotheism of the Bible (which had already been touched by earlier mythological sources). Judaism reconciled these competing world views by populating heaven with a diverse pantheon of angels, such as Gabriel, Raphael, and Michael, who assumed roles as guardians, patrons of individual nations, and angels of *Light and Darkness.

In the Talmud and *midrash*, the rabbis accepted the existence of angels as supernatural beings and created fanciful stories about their creation, their roles in biblical stories, and their behavior in the divine world. Angels speak Hebrew, fly, foretell the future, and control prayer, hail, *rain, anger, and birth, among other things. They look human, attain the size of one third of the world, and are made half of *fire, half of *water. Their main function is to praise God and to mediate between the human and divine worlds, sometimes interceding on behalf of humanity, other times carrying out God's judgments. On special occasions, they may appear in human or animal form. On the *Sabbath, two angels, one bad and one good, are said to accompany each Jew home from synagogue, blessing or cursing his *table depending upon the honor – or dishonor – he accords the Sabbath *Queen.[3] This legend forms the basis of the popular Sabbath hymn, "*Shalom Aleikhem*." Yet despite this elaborate attention to angels, the rabbis were careful not to approve their *worship*.

Another foreign influence that crept into Judaism was that of dualism. Although originally conceived as messengers of God's justice and mercy, angels gradually became divided into two camps, one on the side of good; the other, of evil. Legends arose about the Fallen Angels who came to earth to consort with the daughters of men and fell into sin (the Book of Enoch). There are also rabbinic legends of *Satan's rebellion and fall at the creation of human beings. The rabbis developed an elaborate demonology derived from the folklores of Egypt, Babylonia, and Persia.

In the Middle Ages, belief in angels and demons became widespread. It was held that everything on earth had its own angelic deputy above. The names of angels were frequently invoked to protect against evil

spirits, to aid in childbirth and to cure illness, and to bless a venture. Demons were warded off with spells, *amulets, and special rituals. The female demon *Lilith was especially feared.

Among *kabbalists, especially in 16th-century Safed, angels assumed an even more prominent role. Angels were thought to intercede between the human and spiritual worlds, bringing humanity's prayers to the Heavenly *Throne, thus helping to redeem the world. Made of divine light, angels manifest God's various attributes: mercy and severe judgment, destruction and grace. In some mystical circles, angels were used to perform magic, through the use of *names and secret rituals.

In the traditional liturgy, mystical teachings about angels have exerted a permanent influence. The prayer book includes numerous references to "the heavenly hosts," the "seraphim," and the "holy ophanim" (literally, "wheels").[4] References to angels and their role in prayer reflect the kabbalistic notion that prayer is redemptive both for the individual and the world.

Not all Jewish thinkers have enthusiastically embraced these notions about angels. There has always been a strong rationalist strain within the tradition which has sought to defend monotheism against mythological influences. The medieval philosopher Maimonides argued that angels were nothing more than figurative expressions denoting "intelligences," that is, all natural and psychic forces at work in the world. Thus, the "angel of lust" was only a man's libido; the "angel of birth" only the generative forces shaping the embryo.[5] Since the Enlightenment, Maimonides' ideas have gained ascendancy among most Western Jews. Among some Oriental and hasidic communities, however, belief in angels persists.

[1]Genesis 18–19; [2]Genesis 32:25–33; [3]Shabbat 119b; [4]El Adon, the Kedushah; Ezekiel 10:9; [5]Guide of the Perplexed 2:6–7.

Signifies: ATONEMENT, COMPASSION, DIVINE COMPASSION, DIVINE JUDGMENT, DIVINE POWER, EVIL, HOLINESS, INTERCESSION, NATURE, PEACE, PROPHECY, REDEMPTION, REPENTANCE

Generic Categories: Kabbalistic Symbols, Prayer, Shabbat

See also: Amulet, Angel of Death, Cherubim, Kabbalah, Light, Lilith, Names, Queen, Satan

APPLE – תַּפּוּחַ. The apple has long been regarded as a symbol of desire. The Romans associated the apple with Venus, Goddess of Love. At the heart of the cross-section of an apple are *five seeds in the shape of a pentagram, which corresponds symbolically to the human being with its five fingers, five senses, and five extremities (arms, legs, and head). These associations may account for the ancient equivalence of the apple with human sensuality.

Cross-section of apple showing pentagonal configuration of its seeds.

The apple is noted in the Bible for its sweet fragrance, taste, and shapeliness. A lover is compared to the fragrance of apples[1] and a beloved son to the smell of a blessed field, which the rabbis identified as an apple orchard.[2] The Book of Proverbs compares a well-spoken word to "apples of gold in pictures of silver" (25:11), and indeed the apple has served as a model for artistic ornamentation from ancient times.

Although the Bible uses only the generic term for fruit, peri, to refer to the forbidden food in *Eden, non-Jewish art and folklore came to identify this fruit as the apple. Jewish tradition, on the other hand, has generally regarded the apple in only a positive light. The rabbis compared the Jewish People to an apple tree: "The apple tree blossoms before it shoots forth its leaves. So did Israel who awoke to good deeds before enjoined to do them, [saying] 'All that the Lord has spoken, we will do and obey.' "[3]

The rabbis also compared Mount *Sinai to an apple tree. Just as the apple tree ripens its fruit in the month of Sivan, so was the *Torah given to Israel during Sivan. When the Bible says, "Under the apple tree I awakened you," the rabbis claim that this refers to Mount Sinai.[4] They interpreted another verse in the Song of Songs –

"As an apple tree among the trees of the wood, so is my Beloved"—as an image of God.[5]

Ashkenazi Jews eat apples at the *Passover *seder as part of the *haroset (fruit paste), because legend maintains that the pious Hebrew women went into the apple orchards of Egypt to give birth so as not to surrender their babies to Pharaoh's executioners.

Kabbalists use the phrase the "orchard of holy apples" to describe the supreme holiness attainable by mortals. This phrase refers to the *Shekhinah, God's feminine aspect. The great mystic Isaac Luria, the Holy *Ari*, composed a hymn for Friday night, whose first stanza reads: "I sing in hymns to enter the gates of the field of apples of holy ones."[6]

Because of its perfect shape, its sweet taste, and its fragrance, the apple has come to symbolize beauty, sweetness, and the hope for prosperity. It is also one of the most hardy and universal of fruits. Accordingly, apples dipped in *honey have become the central feature of the *Rosh Hashanah table, signifying the wish for a prosperous and sweet new year.

[1]Song of Songs 7:9; [2]Genesis 27:27; *Taanit* 29b; [3]*Shabbat* 88a; Exodus 24:7; [4]*Shabbat* 88a; *Song of Songs Rabbah* 8:2; [5]Song of Songs 2:3; [6]Scholem, *On the Kabbalah and Its Symbolism*, 140, 143.

Signifies: BEAUTY, HOLINESS, HOPE, JEWISH PEOPLE, LOVE, PERFECTION, SENSUALITY, SWEETNESS

Generic Categories: Food, Kabbalistic Symbols, Passover, Rosh Hashanah, Women

See also: Eden, Five, Honey, Kabbalah, *Shekhinah*, Sinai, Tree

ARK — אָרוֹן.

Among the ancient Israelites, perhaps no symbol was more powerful than the Ark of the Covenant. Housing both the shattered first Tablets and the whole second Tablets of the *Ten Commandments, as well as an *omer of *manna and *Aaron's rod,[1] it was carried by the people on their journey through the *wilderness as a visible reminder of the covenant and of God's Presence among them. When the Ark traveled with the people, God accompanied it in a *cloud.[2]

Ashkenazi-style ark with textile *parokhet and *ner tamid flanked by columns reminiscent of *Jakhin and Boaz. (The Hebrew inscription, "Know before Whom you stand," is frequently featured on arks.)

The original Ark was housed in the *Mishkan*, a portable tent which served as the spiritual center of the community. An oblong cabinet made of acacia wood and inlaid with pure *gold inside and out, the Ark inspired the people's awe and trust, especially when they were threatened by war. Atop the Ark was the Mercy Seat, *Kapporet*, a slab of gold flanked by the golden *cherubim, two divine beings representing the *Throne of God, whose *wings arched over the Mercy Seat and covered it. In front of the Ark stood a pot of manna and Aaron's rod, symbols of divine protection.[3]

When the Israelites entered the land of Canaan, they brought the Ark with them into battle. When the Philistines once succeeded in capturing it, the Ark wrought such vengeance upon its captors that they were forced to return it.[4] For a time it rested in the sanctuary at Shiloh until *David brought it to *Jerusalem; eventually *Solomon built a magnificent *Temple there to house it. Before the destruction of the First Temple in 586 B.C.E., the Ark disappeared. Legend claims that it was hidden by King Josiah,[5] but no trace of it has ever been found.

In Solomon's Temple, the Ark was kept in the Holy of Holies, a perfect cube of twenty cubits called the *Devir* (דביר). This small room, entered only once a year—on *Yom Kippur—by the High Priest, was separated by a veil from the outer sanctuary, the Holy Place, called the *Heikhal*, literally "palace." To this day, Sephardi Jews call the Torah ark the "*heikhal*" in remembrance of this part of Solomon's Temple. According to the *Aggadah*, the location of the Ark marks the exact center of the world, or God's footstool.

In time, Jews created a symbol to substitute for the original Ark of the Covenant. This was a cabinet, originally movable, later built into the wall of the synagogue, which housed the *Torah. The Mishnah refers to this cabinet as the *tevah*, the same word used for *Noah's *ark and Moses' *basket. In time, Ashkenazi Jews called it after the original Ark of the Covenant: *aron*. From ancient times, synagogues oriented the ark toward Jerusalem, and synagogues in Jerusalem, toward the Temple Mount. Within the synagogue, the ark has become the architectural focal point and the holiest object outside the Torah itself.

An elaborate tradition of decoration has evolved around the ark. Originally, the scrolls were laid down, but in the Middle Ages, they stood erect in a taller niche. Seventeenth-century Dutch synagogues added a model of the Ten Commandments to the top of the ark, a style which soon became very popular. Widely varying decorative traditions emerged, often influenced by the artistic trends of a particular host culture. Eighteenth-century German arks boasted columns, pilasters, pediments, and vases after the dominant baroque style of the day. Eastern European arks displayed more playful motifs: *lions, *birds, dolphins, stags, and *eagles. Some arks, especially those in 19th-century America, were Moorish in style with bulbous domes and arches covered with geometric patterns.

Despite this wide variation in design, most arks have several features in common: the *ner tamid* or eternal light, which represents God's continual Presence; a curtain called a *parokhet*, usually elaborately decorated; and the Torah scrolls themselves, also richly ornamented. Most have doors in front of or behind the *parokhet*. Many arks are flanked by two pillars called *Jakhin and Boaz, reminiscent of the pillars set up in the sanctuary of Solomon's Temple. Some have a strip of material above the *parokhet* reminiscent of the Mercy Seat, the *Kapporet*. Classic ark door motifs are *crowns, replicas of the Ten Commandments, a pair of rampant lions representing the Lion of *Judah and God's sovereignty, and the *Tree of Life.

In past times, it was common for individual Jews to regard the ark as possessing a special power which could be enlisted to beseech heaven in times of trouble. Women would sometimes grab hold of the ark curtain to pray for a sick relative or for children. To this day, prayers offered before the open ark are believed to carry a special urgency and to unlock the heavenly *gates. The ark itself is perceived as a channel to heaven.

[1]Exodus 16:32; Numbers 17:25; *Berakhot* 8b; *Bava Batra* 14b; [2]Numbers 10:33-34, 14:14; [3]Exodus 16:33, 25:22; Numbers 17:25; [4]1 Samuel 4:3-11; 5:1-7:1; [5]*Shekalim* 6:1-2; *Yoma* 52b.

Signifies: CENTER, COMPASSION, COVENANT, DIVINE ABODE, DIVINE POWER, DIVINE PRESENCE, DIVINE PROTECTION, HEAVEN, HOLINESS, PERFECTION, PRAYER

Generic Categories: Dwellings, Prayer, Synagogue, Temple, Yom Kippur

See also: Aaron, Ark (Noah's), Cherubim, Crown, East, Gates, Jakhin and Boaz, Lion, Manna, *Mishkan*, *Ner Tamid*, *Parokhet*, Rod, Synagogue, Ten Commandments, Torah, *Yad*

ARK, NOAH'S — תֵּבָה.

In many cultures, the nautical ark is a feminine symbol, representing the womb or the embryo floating in the waters of birth or rebirth. Encasing its cargo and passengers like a seed pod, it carries the potential for new life. It also symbolizes the earth, suspended between the upper waters of heaven and the waters of the deep.

The Bible relates in Genesis that God, despairing of the world's wickedness, resolved to destroy it and begin anew. God commanded Noah to build an ark to save a remnant of living things from the Flood

that was to engulf the world. This three-story vessel made of gopher wood, covered with pitch inside and out, served as a lifeboat for Noah's family and the animals they protected inside, and gave birth to a new human order. The *rainbow which greeted the ark's safe arrival on Mount Ararat completed the circle formed by the ark's keel, symbolizing the restoration of wholeness to the earth.[1]

The rabbis regarded the ark and Noah's care for the animals inside it as a model of compassion.

The only other place the Hebrew word *tevah* appears in the Bible is in the story of the baby *Moses, who was cast upon the Nile in a *basket — *tevah* — made of rushes. This ark, like Noah's in Genesis, was covered with pitch inside and out,[2] and similarly served as a sanctuary.

In the Mishnah, the *ark where the *Torah scrolls were kept was called the *tevah*, which also meant box or chest. Our English word "ark" likewise carries both meanings, referring to Noah's ark as well as to the Torah cabinet. Among Sephardi Jews, the pulpit in the synagogue, known to Western Jews as the *bimah*, is called the *tevah*. Perhaps the choice of this term, so reminiscent of earlier symbols of divine sanctuary, reflects a wish for heavenly protection of prayer, synagogue, and Torah.

In the 20th century, Jews began to add the image of a ship to Rosh Hashanah cards as a symbol of hope for the New Year, reflecting their successful journey to America as new immigrants.[3]

[1]Genesis 6:11–9:17; [2]Exodus 2:3; [3]Braunstein and Weissman, ed., *Getting Comfortable in New York: The American Jewish Home 1880–1950*, 38.

Signifies: COMPASSION, DIVINE PROTECTION, FERTILITY, HOPE, KINDNESS TO ANIMALS, LIFE, REBIRTH, SANCTUARY, SURVIVAL, WHOLENESS

See also: Ark, Basket, Moses, Noah, Rainbow, Rosh Hashanah

ASHES — עֵפֶר.

Ashes, the residue of something consumed by *fire, are a universal symbol of mourning. Traditionally, Jewish mourners have placed ashes upon their heads as a visible sign of grief, not only at the death of a relative or friend, but also at times of communal mourning such as at the destruction of the *Temple or in times of famine. According to the Mishnah, on public fast days and in time of drought, the *ark was brought into the town square and covered with ashes as a symbol of the community's penitence, of God's suffering on account of the people, and of their hope for divine mercy.[1] In some mystical interpretations, these ashes symbolize the community's atonement, recalling the ashes of *Isaac, who according to one legend actually died at the *akedah.[2]

More generally, ashes symbolizes the fragility of life. *Abraham refers to himself as "but dust and ashes," as does *Job.[3] It has long been traditional to recite the phrase "ashes to ashes, dust to dust" at funerals. Ashes are also a symbol of bitterness and defeat. As the Psalmist says: "I have eaten ashes like bread, and mixed my drink with tears."[4]

Perhaps because of their close association with death, ashes also possess a certain power. One of the most mysterious rituals of ancient Israel was the ceremony of the *Red Heifer, in which a young cow without blemish that had never been yoked was slaughtered and burned with a mixture of *cedar, hyssop, and crimson material outside the Israelite camp. These ashes were then combined with spring *water — *mayim hayyim* — which was used to purify those defiled by contact with death.[5] Paradoxically, those who prepared the ashes were themselves defiled through contact with them. The rabbis pointed to this paradox as evidence of the holy mystery of some of God's laws. We might also see in this paradox the inescapable intimacy between death and life, purity and defilement. Ashes mark the ambiguous boundary between the two realms.

Ashes also symbolize rebirth and renewal. In some European communities, it was customary to place ashes on the groom's forehead to symbolize his new life as a married man. (His *white *kittel* conveys a similar idea.) This custom has also been interpreted as a sign of mourning for *Jerusalem.

[1]*Taanit* 2:1; [2]*Taanit* 16a; see Shalom Spiegel, *The Last Trial*, chapter 4; [3]Genesis 18:27; Job 30:19; [4]Psalm 102:10; [5]Numbers 19:1–22.

Signifies: ATONEMENT, BITTERNESS, BOUNDARIES, DEATH, DEFEAT, IM-

PURITY, MOURNING, PURIFICA-
TION, REBIRTH, REPENTANCE, SIN,
TRANSITION, VULNERABILITY

Generic Categories: Death, Wedding

See also: Ark, *Akedah*, Isaac, *Kittel*, Red,
Temple

ASS — הֲמוֹר. As in most folk tradi-
tions, the ass in Jewish tales is often a
symbol of foolishness or stubbornness, de-
picted as "having no heart" (brains). But it
has many positive associations as well.

In the ancient Near East, the horse was
associated with war; the ass, with peace and
labor. When *Jacob blesses his sons at the
end of his life, he praises Issachar, who has
chosen the life of a modest farmer, by
likening him to a "strong-boned ass" who
has "bent his shoulder to the burden."[1]

The *Torah applies similar laws to the
wild ass and the resident alien, who lived
among the Israelite people with an ambig-
uous status, entitled to some of the same
rights but excluded from others. For in-
stance, both the ass and resident alien were
to rest on the Sabbath: "Six days you shall
do your work but on the seventh day you
shall cease from labor, in order that your
ox and your ass may rest, and that your
bondman and the stranger may be
refreshed."[2] But both were forbidden inti-
mate contact with the Israelites: the ass
could not plow yoked to an Israelite herd
animal; the resident alien could not marry
an Israelite. Thus when the Canaanite She-
hem, the son of Hamor (the Hebrew word
for ass), wished to marry Jacob's daughter
Dinah, her brothers put a bloody stop to
the forbidden liaison.[3]

The most famous ass in Jewish lore is
Balaam's talking ass, which legend claims
was created at twilight on the Sixth Day of
Creation along with the other miracles.
Although the ass saved her master's life by
swerving aside from the *angel of the Lord
who stood in the path with a drawn sword,
Balaam struck her three times and would
have killed her had not God opened Ba-
laam's eyes and rebuked him for his lack of
patience and understanding.[4]

The ass was also a symbol of royalty.
Saul, *David, *Solomon, and Absalom rode
asses or mules, as will the *Messiah in the
End of Days. Zechariah prophesies that the
Messiah will ride into *Jerusalem "victori-
ous, triumphant, yet humble, riding on an
ass, on a donkey foaled by a she-ass."
Seated upon this symbol of peace and hu-
mility, "he shall banish *chariots from Eph-
raim and horses from Jerusalem."[5] The
Talmud states that "he who sees an ass in a
dream may hope for salvation." [6]

[1]Genesis 49:14–15; [2]Exodus 23:12; [3]For a full
development of this comparison, see Howard
Schwartz, *The Savage in Judaism*, 126–127;
[4]Numbers 22:21–35; [5]Zechariah 9:9–10; [6] *Be-
rakhot* 56b.

Signifies: FOOLISHNESS, HUMILITY,
INDUSTRIOUSNESS, LABOR, MIRAC-
ULOUSNESS, PATIENCE, PEACE, RE-
DEMPTION, ROYALTY, STUBBORN-
NESS

Generic Categories: Animals

See also: Messiah, Twelve Tribes

AUSCHWITZ. Auschwitz, located in
the Galician region of Poland, was Nazi
Germany's largest concentration and exter-
mination camp. From January 1942 until
November 1944, between 1,000,000 and
2,500,000 Jews from Poland, Czechoslova-
kia, France, Holland, Belgium, Yugosla-
via, Germany, Norway, Greece, Italy, Lat-
via, Austria, Hungary, and North Africa
were murdered in Auschwitz, most in gas
chambers through the use of the poison gas
Zyklon B. Thousands of Gypsies and many
other prisoners were also killed there. Be-
cause Auschwitz's victims accounted for
such a large percentage of the *Six Million
Jews killed during the Holocaust, this camp
has become a symbol of the death of Euro-
pean Jewry, extermination, and of the Ho-
locaust itself.

Signifies: DESTRUCTION OF EURO-
PEAN JEWRY, HOLOCAUST

Generic Categories: Holocaust, Places

See also: Numbers, Six Million, Warsaw
Ghetto, Yellow

**BAR / BAT MITZVAH — בַּר
מִצְוָה / בַּת מִצְוָה.** From time imme-
morial, cultures throughout the world have
marked a child's entry into puberty and
adulthood with public ceremony and ritual.
According to Jewish tradition, a boy

reaches religious and legal maturity at the age of *thirteen plus one day, a girl at the age of twelve plus one day. At that point, each is responsible for fulfilling all the commandments, *mitzvot*, hence the name of the ceremony marking that occasion: *Bar*, Aramaic for "son of," and *Bat*, Hebrew for "daughter of" *mitzvah*. Although the actual public celebration of this event is fairly recent (the 15th century for boys and the 20th century for girls), the concept of a religious rite of passage dates back to ancient times.

In former times, thirteen was not only the age that a boy physically matured, but was often when he married and assumed family responsibilities. In Jewish communities, the *Bar Mitzvah* represented not only the onset of puberty and the imminence of marriage, but also the boy's attainment of full membership within the community with all its responsibilities and privileges, and his new status as a link in the *chain of tradition. It also symbolized his graduation from intellectual apprenticeship to the more rigorous lifelong pursuit of Jewish scholarship incumbent upon all (male) Jews. And at this age, he became responsible for his own sins and atonement.

According to the *midrash*, thirteen was the age at which *Abraham rejected idolatry and set out on his own spiritual path, as well as the age that *Jacob committed himself to a life of *Torah study.[1] Since medieval times, a boy's being called to the Torah for the first time has been symbolic of his assumption of an active role in the spiritual life of the community. His delivery of a *derashah* (interpretive sermon) of the Torah portion is symbolic of his new intellectual status; his donning of *tefillin* for the first time, of his adult commitment to God.

In more contemporary liberal congregations, the formal *Bar* and *Bat Mitzvah* ceremony usually includes the bestowal of gifts symbolizing the young man or woman's admission into the adult community: *Shabbat* *candlesticks, a *Kiddush* *cup, a prayer book, a Bible, and *tallit*.

In modern times, religious, intellectual, and social maturity is rarely attained by age thirteen. The Reform Movement attempted to replace the *Bar Mitzvah* with the ceremony of confirmation, celebrated by religious school students upon completion of their studies at age sixteen. But this innovation, a symbol of completion rather than of initiation, became a supplement rather than a substitute for the earlier rite of passage, which is now universally celebrated in Jewish communities throughout the world.

Even when the *Bar/Bat Mitzvah* no longer signifies the attainment of full adult status within the community, it still carries considerable symbolic weight as a milestone in the Jewish life cycle and a transmission of tradition from one generation to the next. It continues to symbolize the civil values of the Jewish People: democracy, in that all Jews are eligible for full membership in the community; informed citizenship, in that all Jews are expected to acquire literacy and knowledge of the tradition; and communal responsibility, in that each Jew is called upon to participate in and sustain the institutions which serve the community.

It has now become common for adult Jews, primarily women who were denied religious training in their childhoods, to celebrate a *Bat* or *Bar Mitzvah* as adults, symbolizing their full membership in the community. Many Jews chant their Torah or *haftarah* portion annually on the anniversary of their *Bar* or *Bat Mitzvah*. Those reaching the age of 83 – the *seventieth anniversary of this occasion – often celebrate by chanting their original portions at a Sabbath service and sponsoring a *Kiddush* in honor of their symbolic recommitment to the tradition.

[1]*Pirke de-Rebbe Eliezer* 26; [2]*Genesis Rabbah* 63:10.

Signifies: CITIZENSHIP, COMMITMENT, COMPLETION, CONTINUITY, DEMOCRACY, EMPOWERMENT, INITIATION, MATURITY, RESPONSIBILITY, TRANSITION, TRANSMISSION

Generic Categories: *Bar/Bat Mitzvah*

See also: Chain, *Tallit*, *Tefillin*, Thirteen, Torah

BARLEY – שְׂעוֹרָה. Barley, whose Hebrew name – *se'orah* – derives from the long hairs (*se'ar*) of its ears, is one of the *seven species symbolizing the fertility of the Land of Israel.[1] In biblical times, barley

bread was the mainstay of the Israelite diet; barley's hardiness, especially in drought, made it the foremost crop. In mishnaic times, *wheat replaced barley as the flour of choice, and barley became the bread of the poor and of livestock.

Because barley is the first grain to ripen, it symbolizes spring.[2] In ancient times, the first *omer* of barley was reaped on the second day of *Passover, marking the beginning of the spring harvest season.[3] Barley is also associated with the holiday of *Shavuot,

Barley on the stalk. In Israel, barley is sown in fall or winter and harvested in spring.

which marks the end of the barley harvest and the beginning of the wheat harvest. The Book of *Ruth, which is read on this holiday, takes place during the barley harvest.

Sheaves of barley have been a popular ornamental motif in Jewish art from ancient times. The barleycorn was used as a unit of measure.

[1]Deuteronomy 8:8; [2]Ruth 1:22; [3]Leviticus 23:9-15; *Menahot* 84b.

Signifies: AGRICULTURE, BEGINNING, POVERTY, SPRING, SUSTENANCE

Generic Categories: Botany, Food, Passover, Shavuot

See also: Bread, Israel (Land of), Ruth, Seven Species, Wheat

BASKET – סַל.

Many cultures have tales about heroes or gods being cast adrift in a basket. Anthropologists interpret the basket as symbolizing the womb. In the Bible, the baby *Moses is cast adrift on the Nile in a *tevah*, translated as "wicker basket," although this term suggests something more sturdy than a basket, since it also is used for *Noah's *ark.[1] In each case, the basket/ark holds the future, which emerges from it: the world, from Noah; Jewish life,

from Moses. Because Pharaoh's daughter adopted Moses after finding him in a basket, the basket has become a contemporary symbol of adoption.

In ancient *Greece, an ivy-covered basket, often portrayed on coins, signified the cult of Dionysus, god of fertility and immortality. Among the Jews, baskets were similarly symbols of harvest and fertility. Both Noah, together with his family and all the animals, and Moses were reborn after being protectively encased like seeds. God promised the

Folk-art object known as a Moses Basket.

Israelites that if they observed the commandments, "Blessed [will] be your basket and your kneading bowl"; but if not, "Cursed [will] be your basket and your kneading bowl."[2]

While the *Temple still stood in *Jerusalem, the people would bring offerings there in baskets, especially first fruits (*bikkurim*) on *Shavuot. Jews would march in procession from the countryside to the Temple carrying their offerings: rich pilgrims with silver and *gold baskets, and the poor with peeled *willow baskets. On top of the fruit perched pigeons, which were then sacrificed at the Temple altar.[3] In modern Israel, *kibbutz* children carry baskets of fruit in similar *bikkurim* processions on Shavuot. In Jewish confirmation ceremonies, held at Shavuot, young Jews carry baskets filled with *flowers.

[1]Exodus 2:3; [2]Deuteronomy 28:5, 17; [3]*Bikkurim* 3.

Signifies: ADOPTION, AGRICULTURE, FERTILITY

Generic Categories: Botany, Shavuot, Temple, Water

See also: Moses, Seven Species, Shavuot, Willow

BEAR – דֹב.

From biblical times until World War II, the golden Syrian bear roamed wild in the forests of the Middle East, menacing farmers and travelers. A symbol of power in biblical lore, it was especially noted for its ferocity.

The young *David boasted that he would slay Goliath as he had single-handedly slain the bear and *lion that had once threatened his flock.[1] David himself was later compared to an enraged she-bear, "as desperate as a bear in the wild robbed of her whelps."[2] The prophet Hosea used the same image to describe God's wrath against the wayward Israelites: "like a bear robbed of her young."[3]

In later writing, the bear became a symbol of Persia, the most powerful kingdom in the period of *Daniel. In a vision, Daniel sees a "beast, which was like a bear but raised on one side, and with three fangs in its mouth among its teeth."[4] The rabbis extended this image to describe the Persians themselves who "eat and drink like the bear, are fat like the bear, are hairy like the bear, and are restless like the bear."[5] Hence, the bear is associated with *Purim, the holiday celebrating the Jewish triumph over Persian persecution.

The bear motif, prominent in Slavic folklore, was incorporated into Eastern European Jewish folk art, sometimes in micrographic (miniature calligraphy) representations of a *Megillah. In addition to its associations with Purim, the bear in search of a *honey *tree became a symbol of the Jewish People seeking the sweetness of *Torah, one of whose symbols is the *Tree of Life.

Like the *lion and the *leopard, the tame bear is a messianic symbol: "The cow and the bear shall graze; their young shall lie down together."[6]

[1]1 Samuel 17:34–6; [2]2 Samuel 17:8; see also 2 Kings 2:23–24; [3]Hosea 13:8; [4]Daniel 7:5; [5]Kiddushin 72a; [6]Isaiah 11:7.

Signifies: FEROCITY, POWER, STUDY

Generic Categories: Animals

See also: Daniel, David, Lion, Megillah, Purim

BEARD – זָקָן.
Beards have always been highly symbolic for Jews. In the ancient Near East, the priests of pagan cults shaved certain areas of their faces to designate their sacred status. As a way of differentiating Israel from these cults, the *Torah prohibited shaving the *corners of the beard,[1] as well as practicing divination and mutilating the face, other common pagan practices. Only in rites of purification – for lepers, those defiled through contact with the dead, and in consecrating the *altar – was the body shaved.

The beard was regarded as a symbol of manly beauty and virility, as an adornment of the face. The medieval commentator Abravanel claimed that God gave men beards specifically to distinguish them from women. Only those who had frequent dealings with the Romans were permitted to clip their beards. In later times, styles varied. Jews in Muslim countries wore long beards; in Eastern Europe, they clipped them with scissors. Some European rulers (Nicholas I of Russia, for example) tried to force Jews to shave their beards; others (such as Maria Theresa of Austria) forced Jews to wear them to distinguish them from Christian subjects.

Because the beard was considered so vital to a man's image, shaving it off was an ancient sign of mourning or great sorrow. Thus, when *Job learned of the death of his children, he tore his robe and shaved off his beard.[2] But shaving only half the beard was a symbol of humiliation.[3] Rabbinical courts in the Middle Ages punished adulterers by completely shaving off their beards. In modern times, because many Jewish men are cleanshaven, growing a beard has become a sign of mourning.

*Kabbalists ascribed mystical power to the beard and *hair. They sometimes called God Atika Kadisha – the Holy Ancient One, symbolizing God's most transcendent manifestation as a beard with *thirteen curls, representing the attributes of divine mercy.[4] As Kabbalism spread throughout Eastern Europe, so did the practice of not trimming the beard at all, especially among the hasidim (even though it is halakhically permissible to shave as long as one doesn't use a single-edged implement). To this day, some observant Jews refuse to shave their beards as a sign of their wholehearted commitment to tradition. Although beards are no longer universal among Jewish men, American sign language attests to the lasting symbolism of the beard in Jewish culture: the signs for "Hebrew," "Jew," and

"Israel" all include a gesture representing a beard.

[1]Leviticus 19:27; 21:5; [2]Job 1:20; [3]2 Samuel 10:4; [4]*Zohar* 3:289b–290a, in Tishby, *The Wisdom of the Zohar* 1:334, n. 264.

Signifies: ALLEGIANCE TO TRADITION, BEAUTY, DISTINCTION, MASCULINITY, MOURNING, MYSTICAL POWER, PURITY, SEPARATENESS, SPIRITUAL STRENGTH

Generic Categories: Body Parts, Kabbalistic Symbols

See also: Corners, Hair, Kabbalah, Priestly Cult

BEHEMOTH – בְּהֵמוֹת.

Behemoth is a legendary monster, the King of the Land Beasts [*behemot*—Hebrew], created at the beginning of time and destined to feed the righteous at the *messianic banquet at the End of Days. Probably inspired by the hippopotamus or elephant which lived in the ancient Near East, Behemoth was said to live among lotuses in the swamps and to devour huge quantities of food. According to the *midrash*, Behemoth's task while on earth is to keep the *lion, the *leopard, and the *bear at bay each summer so that the gentler beasts can nurture their young in peace. At the end of time, God will summon Behemoth to mortal combat with the sea monster *Leviathan,[1] and the two beasts will slash each other to death with their fierce horns and fins.

So impressive was Behemoth that it served as God's own proof to *Job of the majesty of divine power: "Take now Behemoth whom I made as I did you. . . . His strength is in his loins, his might in the muscles of his belly. He makes his tail stand up like a *cedar; the sinews of his thighs are knit together. His bones are like tubes of bronze, his limbs like *iron rods."[2]

[1]*Leviticus Rabbah* 13:3; *Pirke de-Rebbe Eliezer* 11; [2]Job 40:15–18.

Signifies: POWER, REDEMPTION, RESURRECTION

Generic Categories: Animals, Messiah

See also: Leviathan

BERURIAH – בְּרוּרְיָה.

Beruriah, a talmudic scholar who lived in Palestine in the second century, was the only woman whose legal judgments and ethical teachings were taken seriously in the Talmud. Daughter of the rabbi and martyr, Hanina ben Teradyon, she became the wife of Rabbi Meir, one of the leading sages of his generation. She is noted for her great learning, wit, piety, and compassion.[1]

According to a legend recorded by the 11th-century commentator Rashi, Rabbi Meir was somehow persuaded to test his wife's moral character by sending one of his young students to seduce her. She finally succumbed to his advances, and then hanged herself in disgrace.[2] This misogynist legend reflects the tremendous resistance traditional Judaism has demonstrated toward granting women access to Torah study, the source of religious authority and power.

In recent times, Beruriah has become a symbol of women's achievement, learning, teaching, and leadership as well as their suppression.

[1]Cf. *Midrash* Proverbs to 31:1; *Berakhot* 10a; [2]Commentary to *Avodah Zarah* 18b.

Signifies: COMPASSION, LEADERSHIP, LEARNING, MISOGYNY, PIETY, WISDOM, WOMEN'S LEARNING, WOMEN'S SUPPRESSION

Generic Categories: Personalities, Women

BEZALEL – בְּצַלְאֵל.

To supervise the construction of the *Mishkan*, the portable sanctuary in the *wilderness, and to design the priests' vestments, *Moses appointed Bezalel, a member of the tribe of *Judah who was an expert in metalwork, stonecutting, and woodcarving. The *Torah describes Bezalel as "endowed with a divine spirit of skill, ability, and knowledge in every kind of craft."[1] The Hellenistic Jewish philosopher Philo considered Bezalel a symbol of pure knowledge. Tradition generally regards him as the ancestor and prototype of the artist.

The Academy of Arts and Design in *Jerusalem, founded in 1906, was originally called the Bezalel School of Arts and

Crafts, named after this first known artist of the Jewish People.

[1]Exodus 31:3.

Signifies: ARTISTRY, INSPIRATION, KNOWLEDGE, WISDOM

Generic Categories: Personalities, Temple

See also: Ark, *Mishkan,* Priestly Cult

BIMAH — בּימה.

The *bimah,* from the Hebrew word for "high place," is the platform upon which the prayer leader, cantor, or rabbi stands to conduct services and read from the *Torah scroll. Like a *mountain or *altar, it symbolizes access to the divine, the spiritual center of the *synagogue. Sephardi Jews call this platform the *tevah,* the biblical term used to refer to both Noah's *ark and *Moses's *basket, and in the Mishnah and Talmud, to the *Ark of the Covenant.

The position, function, and design of the *bimah* have changed greatly over the centuries. For most of Jewish history, the *bimah* has been located in the center of the sanctuary, or occasionally on or near the western wall, so that the prayer leader could be as close as possible to the largest number of worshipers. Sometimes the *bimah,* contrary to its name, has been constructed lower than the main floor of the sanctuary, either to symbolize the spiritual humility of the worshiper—"Out of the depths I cry to You, O Lord"[1] — or to add the illusion of height since Church regulations in the Middle Ages often restricted the height of synagogues. The *ark, on the other hand, has traditionally been located in the *eastern wall, oriented toward *Jerusalem. This architectural polarity between the *bimah* and the ark influenced synagogue design through the ages.

In the 19th century, the Reform Movement introduced into synagogue architecture the innovation of locating the *bimah* in front of the ark, a plan modeled on the church pulpit. This is now the dominant style in North America among liberal and many Orthodox congregations, though Sephardi and many traditional congregations maintain the central *bimah.*

Moving the *bimah* to the front of the sanctuary has had profound consequences for Jewish prayer. Because the *bimah* now

resembles a theater stage, the worshipers in the congregation tend to become spectators, watching the drama occurring in front of them, reminiscent of ancient Temple times. (It is interesting to note that the Israeli national theater is called *Habimah.*) In addition, the prayer leader, cantor, or rabbi usually stands with his or her back to the ark, contrary to the age-old custom of facing the ark as a sign of respect and of addressing prayers eastward toward Jerusalem. Some contemporary congregations and *havurot* have returned to earlier models of syngagogue architecture by reorienting prayer toward the center of the worship space, or have omitted the *bimah* altogether as a way of making the entire prayer community the center of worship.

[1]Psalm 130:1.

Signifies: ACCESS TO DIVINE, CENTER, HONOR, PRAYER

Generic Categories: Dwellings, Synagogue

See also: Altar, Ark, East, Jerusalem, Mountain, Synagogue

BIRD — צִפּוֹר.

In most cultures, birds symbolize freedom, because of their capacity to escape the fetters of gravity. They also suggest grace, because of their aerial acrobatics, and beauty, because of their colorful plumage, most notable in the peacock, a favorite motif in Jewish folk art. In Jewish folk art through the ages, birds have represented all these things.

But they also represent much more. Because they seem free of material constraint, they often symbolize the soul, which after death flies up to paradise. Associated with this notion of the soul's innocence, most often symbolized by the *dove, is the idea of its immortality. Birds were also thought to foretell the future by their cries and flight patterns. During the Hellenistic period when Jews were heavily influenced by foreign ideas, they often put images of birds on their tombs, probably borrowing motifs from pagan and early Christian art, where birds eating *grapes symbolized eternal life.

Jewish legend tells of several fabulous birds: the giant King of the Birds, *Ziz-Shaddai,* who protects weaker birds during the autumn month of *Tishrei* and whose

flesh will feed the righteous at the Messianic Banquet; the *Milham*-Bird, a Jewish version of the Phoenix, with lion's feet, a crocodile head, and twelve purple wings, whose refusal to eat of the Tree of Knowledge in *Eden earned her immortality in the magic city of Luz; and the Hoopoe, who guarded God's miraculous *shamir* worm until Solomon stole it by deceit.[1]

In traditional liturgy and poetry, God is frequently described as the *Shekhinah, the indwelling Presence, a primarily feminine image often pictured as having *wings — *kanfei ha-Shekhinah*. God shelters Israel under these wings as a sign of loving-kindness and compassion. The prophet Isaiah drew upon this image in describing God's concern for Israel: "As birds hovering, so will the Lord of Hosts protect Jerusalem."[2] Inspired by this verse, some Jews place a bird's head of dough atop the *Rosh Hashanah *hallah or shape the entire loaf like a bird, hoping that God will protect them and forgive their sins. Similarly, on *Yom Kippur, this special *hallah* is eaten before the fast to symbolize the hope that one's prayers will rise quickly to heaven.

Hand represented as a bird, "drawn" with letters.

The *Birds' Head Haggadah,* a masterpiece of Jewish illuminated folk art from 13th-century Germany, replaced human heads with birds' heads in order to observe the proscription against making graven images.

One of the most humane laws within Jewish tradition is known as "the bird's nest," "*Kan Tzippor,*" the principle that one must send off the mother bird before capturing her fledglings. So important is such kindness to animals that the *Torah promises long life as its reward.[3] Some people observe the custom of feeding birds on *Shabbat Shirah* in appreciation of their song, through which they continuously praise God and creation.[4]

[1]Ginzberg, *Legends of the Jews* 1:4, 28-9, 32-3; [2]Isaiah 31:5; [3]Deuteronomy 22:6-7; [4]Strassfeld, *The Jewish Holidays*, 182.

Signifies: BEAUTY, COMPASSION, DIVINE PRESENCE, DIVINE PROTECTION, FREEDOM, GOD, GRACE, IMMORTALITY, INNOCENCE, KINDNESS, KINDNESS TO ANIMALS, MOTHERHOOD, MUSIC, SOUL

Generic Categories: Animals, Food, Rosh Hashanah, Yom Kippur

See also: Dove, Eagle, *Haggadah, Hallah, Shekhinah,* Wings

BLOOD — דָּם. Throughout the world, blood has always been a powerful symbol of both life and death. Because this ambiguous status makes it uncanny, cultures devise numerous rituals and laws to protect human beings who come into contact with it. As a visible reminder of our mortality, it has been used in sacred ritual and magic to purify, to curse, to protect, and to mark sacred space. In many cultures, *wine serves as a symbolic substitute for sacrificial blood.

In the Hebrew Bible, there is an absolute prohibition against consuming blood. So fundamental was this taboo to the Israelite ethos that it was universally mandated, although in a less restrictive form.[1] Over and over again, the *Torah warns: the blood of an animal must be completely drained before it is eaten.[2] Anyone who disobeyed this injunction would be cut off from the people. The Jewish dietary laws, *kashrut*, which require that kosher meat first be salted to drain out the blood, remind Jews of this biblical prohibition against consuming blood, and sensitize them to the fact that a life was taken to provide their sustenance.

Blood, says the Torah, symbolizes life. That is why the spilling of blood, even when commanded by God in the priestly sacrifices, carries with it a certain element of sin, for all life is holy, God-given. Sacrificial blood was to be spilled out upon the *altar because "it is the blood as life that effects expiation."[3]

Blood also symbolizes holiness. The priests used sacrificial blood to purge ritual impurity and to consecrate the members of the *Priestly Cult.[4] Moses used it as "the blood of the covenant" to reconfirm the commitment between God and the people,[5] a compact symbolically reenacted each time a Jewish boy is circumcised.

In most traditional societies, women, because of their regular contact with blood through both menstruation and childbirth, have been regarded with a mixture of awe and suspicion. The same has been true in Judaism, although tradition has tried to humanize its special treatment of women by creating an ethical and spiritual framework around the rituals of purification. After her menstrual period, a married woman traditionally immerses herself in a ritual bath — *mikvah — and recites a blessing before being permitted to resume intercourse with her husband. This ritual is not meant to cleanse *physically* (the woman needs to bathe before coming to the *mikvah*), but rather symbolically: it purifies the woman from her monthly contact with death — the missed opportunity to bear life, and allows her to make the transition back to everyday life.

Similarly, when a woman gives birth, she is considered ritually impure because of the birthing blood and is required to immerse herself in the *mikvah* after a prescribed period of time. In ancient times, she was required to bring a sacrifice to mark the end of her "blood purification" (*demei taharah*).[6]

Because of its powerful associations with life — through birth and circumcision — death and holiness, blood has been regarded as having great protective power. In Egypt, the Children of Israel were commanded to spread blood on the doorposts of their houses on the night of the Tenth Plague so that the *Angel of Death would "pass over" them and not slay their firstborn.[7] So powerful, in fact, was this symbol that anti-Semites in later centuries accused Jews of using the blood of Christian children to make *matzahs* for *Passover, a practice clearly anathema to Jewish tradition. These false accusations, known as "blood libels," persisted into the 20th century.

[1]Genesis 9:4; [2]Leviticus 3:17; 7:26–7; 17:10–14; Deuteronomy 12:16, 23–25; [3]Leviticus 17:11, 14; Deuteronomy 12:23; [4]Leviticus 14:4–7, 18–29; Exodus 29:20–1, 33; [5]Exodus 24:6–8; [6]Leviticus 12:4–5; [7]Exodus 12:7, 13, 22–23.

Signifies: ATONEMENT, COVENANT, DEATH, DIVINE PROTECTION, HOLINESS, LIFE

Generic Categories: Birth, *Brit*, Food, Menstruation, Temple, Women

See also: Altar, Angel of Death, *Brit*, *Kashrut*, *Matzah*, *Mikvah*, Passover, Priestly Cult, Red, Salt, Water, Wine

BLUE — תְּכֵלֶת ,כָּחֹל. Because blue is the color of the sky and sea, it has often symbolized divinity, as well as height and depth. It can also represent equilibrium, since its hue suggests a shade midway between *white and black, day and night. To the ancient Egyptians, blue was the color of truth. To many Jews, because of its associations with religious tradition, popular folklore, and the modern state of Israel, it has become the quintessential Jewish color.

In the *Torah, the Israelites were commanded to put fringes, *tzitzit*, on the *corners of their garments, and to weave within these fringes a "twisted thread of blue (*tekhelet*)." In ancient days, this blue thread was made from a dye extracted from a Mediterranean snail called the *hilazon* (see *tallit*).[1] Maimonides claimed that this blue was the color of "the clear noonday sky"; Rashi, the color of the evening sky.[2]

From ancient times, blue has been considered a lucky color among the peoples of the Middle East and North Africa. Like their Arab neighbors, Jews of this region have painted their doorposts, heads, and other parts of their bodies with blue dyes; have ornamented their children with blue ribbons and markings; and have used this color in protective *amulets. Blue has been considered especially effective against the *Evil Eye, perhaps because blue eyes are such a rarity among Semitic peoples and because blue is so rare in the plant and animal world.

According to several rabbinic sages, blue is the color of God's Glory.[3] Staring at this color aids meditation, bringing us a glimpse of the "pavement of sapphire, like the very sky for purity," which is a likeness of the *Throne of God.[4] (The Hebrew word for glory, *kavod*, means "blue" in Arabic.) Many items in the *Mishkan*, the portable sanctuary in the *wilderness, such as the *menorah*, many of the vessels, and the *Ark of the Covenant, were covered with a blue cloth when they were transported from place to place.[5]

The Israeli flag has two blue stripes and a blue *Star of David against a white background. An early Zionist poem explains that the color white symbolizes great faith; blue, the appearance of the firmament.[6] (The original dark blue stripes were later lightened to heighten visibility at sea.) Because of its association with the State of Israel, blue has become very popular in contemporary Jewish design. Modern *tallitot*, for example, often have blue stripes on a white background.

[1]Numbers 15:38; [2]*Mishneh Torah, Tzitzit* 2:1; Commentary on Numbers 15:38; [3]*Numbers Rabbah* 14:3; *Hullin* 89a; [4]Exodus 24:10; Ezekiel 1:26; *Hullin* 89a; [5]Numbers 4:6–12;[6]*"Zivei Eretz Yehudah"* (1860), L.A. Frankl.

Signifies: COMMITMENT, DIVINE GLORY, DIVINE PROTECTION, HEAVEN, HOLINESS

Generic Categories: Colors, Israel (State of)

See also: Amulet, Colors, Evil Eye, Flag, Israel (State of), *Tallit*, Water

BODY – גוף.

In the beginning, says the *midrash*, God fashioned a single androgynous being, "Adam," created *be-tzelem Elohim* — "in the image of God."[1] Jewish tradition teaches that this fundamental quality of "godliness" characterizes all dimensions of human life: body, soul, mind, actions. The human body is regarded as the precious vessel of the soul, to be cared for and cherished.[2] Although the soul leaves the body after death, the two will be rejoined at the End of Days.

Traditionally, the human body has been viewed as a symbol of God, in whose image it was created. The kabbalistic theory of the *Sefirot*, the *ten divine emanations, often represent them as the symbolic body of God. The four-letter *Name of God, the Tetragrammaton, is also pictured vertically as a human form, with the *yud* as the head, the first *heh* as the arms, the *vav* as the trunk, and the second *heh* as the legs. According to *Kabbalah, creation began with *Adam Kadmon*, the primordial *Adam, whose immense body filled the universe prior to our world's creation and out of whose head streamed rays of divine *light.

The body is also a symbol of the Torah, whose 248 positive precepts are equivalent to human bones and organs, and the 365 negative commandments to the sinews. The Torah is often described as wearing garments or as itself a garment covering God's body.

Because of its holiness, the body is to be clothed modestly and surrounded with signs of its intimate connection to God: *tzitzit*, *kippah* or other head covering, *tefillin*, and *kittel*. At death, the body is treated with absolute respect. A special "holy society" (*Hevrah Kadisha*) bathes and dresses (and veils a female) body before laying it in the casket. Any mutilation of the body, such as through autopsy, is forbidden.

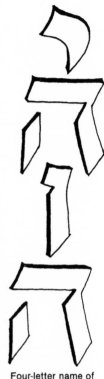

Four-letter name of God pictured vertically, suggesting a human form.

The land of Israel is compared to a body. *Moses promised the Israelites that if they followed God's commandments, God would bless the "fruit of your body and the fruit of your soil."[3] An early Zionist song proclaimed: "The land of Israel without Torah is like a body without a soul."

Besides the symbolism of the whole body, various body parts carry their own symbolic significance: the *beard, *blood, the *eyes, *face, *hair, the *hand, the *head, and the *heart.

[1]Genesis 1:27; *Genesis Rabbah* 8:1; [2]*Leviticus Rabbah* 34:3; [3]Deuteronomy 28:4.

Signifies: GOD, HOLINESS, TORAH, WORLD

Generic Categories: Body Parts

See also: Adam, Beard, Blood, Body, Clothing, Crown, Eye, Five, Hair, Hand, Head, Heart, Israel (Land of), Kabbalah, *Kippah, Kittel*, Name of God, *Sefirot, Tallit*, Torah

BOOK— סֵפֶר. For centuries Jews have been known as "the People of the Book." Throughout their history, Jews have revered the written word, first recorded in parchment scrolls, then later bound in pages between covers. Within the synagogue, the holiest object is the *Sefer* *Torah, the scroll (literally, "book") of the Torah. As early as the 2nd century B.C.E., Jews owned their own books; even schoolchildren of the talmudic period had them. The rabbis designed special laws about the finding, borrowing, and depositing of books, and the Talmud even discusses whether and in what circumstances one can sell them.[1] Commenting on the verse in Psalms: "Wealth and riches are in his house," the Talmud says: "True wealth is books, and it is charity to loan them out."[2]

In English we call the Torah "the Five Books of Moses," and refer to each section of the Bible as a "book." The word for scribe in Hebrew—*sofer* (סופר)—comes from the same root. So does story—*sippur* (ספור)—and literature, *sifrut* (ספרות). A school is a *beit sefer* (בית ספר), a "house of books," and *sefarim* (plural) often refers specifically to "holy books." When one of these holy books—a prayer book or a Bible—drops on the floor, it is customary to kiss the binding as a sign of respect and atonement.

One of the most popular symbols among Jews today is the Book of Life, an image that is quite ancient, probably tracing its roots back to the Mesopotamian notion that the gods possessed tablets recording people's deeds and destinies. The actual phrase—*Sefer Hayyim*, the Book of Life— first appears in the Bible, referring to an enemy: "May they be erased from the Book of Life, and not be inscribed with the righteous."[3] Similarly, Isaiah speaks of "all who are inscribed for life in Jerusalem."[4] And after the incident of the *Golden Calf, when God threatens to destroy the Children of Israel, Moses asks to be erased from God's book.[5]

The Mishnah teaches: "Know what is above you—a seeing *eye, and a hearing ear, and all your deeds written in a book."[6] The Talmud speaks of three heavenly books: one for the thoroughly wicked, one for the thoroughly righteous, and one for those in between the two extremes.[7] These passages are the basis for much of the

imagery of the High Holy Days. Many contemporary *synagogues use the image of the Book of Life in their wall and window decorations, literature, and memorial plaques. It has been a custom to place holy books in a baby's cradle to safeguard the child and instill a love of Torah.

In Renaissance Italy, a renowned center of Jewish publishing, the frontispieces of *Jewish books often featured pillars and *gates, welcoming the reader into the world of learning, and evoking the *Torah and the *Temple, likewise typically flanked by pillars and gates. This design was adapted by designers of ark draperies (the *parokhet*), reinforcing the intimate connection between books and Torah.

[1]JT *Bava Metzia* 2:8; *Bava Metzia* 29b; *Megillah* 27a; [2]*Ketubot* 50a on Psalm 112:3; [3]Psalm 69:29; [4]Isaiah 4:3; [5]Exodus 32:32; [6]*Pirke Avot* 2:1; [7]*Rosh Hashanah* 16b.

Signifies: DEATH, DESTINY, DIVINE JUDGMENT, JEWISH PEOPLE, KNOWLEDGE, LEARNING, LIFE, PRAYER, PROTECTION, REMEMBRANCE, REPENTANCE, SIN, TEACHING, TORAH, WEALTH, WISDOM

Generic Categories: Birth, Prayer, Rosh Hashanah, Yom Kippur

See also: Gates, Jakhin and Boaz, *Megillah*, Rosh Hashanah, Scales, Torah, Yom Kippur

BREAD — לֶחֶם. In most of the Western world, bread is the mainstay of the diet. Often referred to as the "staff of life," bread has become a symbol for material, and by extension, spiritual, sustenance.

In the Bible, the term bread, *"lehem,"* refers to food in general.[1] Such bread was usually made of *wheat or *barley, which was baked into cakes. When it was leavened, it was called **hametz*; when unleavened, **matzah*. When the Israelites called out for bread in the *wilderness, God rained down *"bread from the sky" called *manna.[2] The phrase "bread and water" denotes a person's fundamental nutritional needs[3]; "scant bread and water" indicates poverty.[4]

To the rabbis, no meal was complete without bread. Thus, the grace after meals

(*Birkat Ha-Mazon*) can only be recited if bread has been eaten. The blessing recited before eating a meal is the specific blessing for bread: "*ha-motzi lehem min ha-aretz*" (Who has brought forth bread from the earth). In thanking God for bringing forth *bread*, the work of human hands, rather than wheat from the ground, we acknowledge our partnership with God in our material survival.

The *midrash* regards bread sprinkled with *salt as the poor person's food,[5] adequate for a humble student of the Torah.[6] Some people sprinkle salt on bread before each meal, especially on the *Sabbath, perhaps to symbolize the salt sprinkled on the *Temple sacrifices, the tears of Jewish suffering, or the sweat by which we earn our daily bread. Because folk belief ascribes special preservative and protective power to the combination of bread and salt, it is customary to give a loaf of bread and a jar of salt to a newly married couple or to people moving into a new house as a symbol of prosperity and good luck.

A special bread, called *hallah, reminiscent of the twelve unleavened showbreads once displayed in the Temple and eaten by the priests each Sabbath, is eaten on Sabbaths and festivals. On *Passover, only unleavened bread, "*matzah,*" is permitted, symbolic of the haste of the *Exodus, of humility, and of the paschal sacrifice itself which ceased with the destruction of the Temple.

On the holiday of *Rosh Hashanah, it is customary to fill one's pockets with bread crumbs which are then cast into a stream or lake to symbolize the casting off of the year's sins, a custom known as *Tashlikh.* Similarly, before Passover, bread crumbs are sometimes hidden and searched out, to symbolize ridding the home of *hametz,* leavened bread.

[1]Genesis 37:25; Numbers 28:2; 1 Kings 5:2; [2]Exodus 16:4; [3]Genesis 21:14; 1 Kings 19:6; [4]1 Kings 22:27; 2 Chronicles 18:26; Isaiah 30:20; [5]*Berakhot* 2b; [6]*Pirke Avot* 6:4.

Signifies: ATONEMENT, GOOD LUCK, LABOR, PARTNERSHIP, PROSPERITY, SURVIVAL, SUSTENANCE

Generic Categories: Food, New Home, Rosh Hashanah, *Shabbat*, Temple, Wedding

See also: Barley, *Hallah, Hametz,* Manna, *Matzah,* Priestly Cult, Rosh Hashanah, Salt, *Shabbat,* Table, Temple, Wheat

BREASTPLATE – חשן.

As a mark of his sacred office, the High Priest in the *Mishkan* and later in the *Temple wore special clothing, described in minute detail in the *Torah. One of these vestments was the breastplate, the *hoshen mishpat,* a

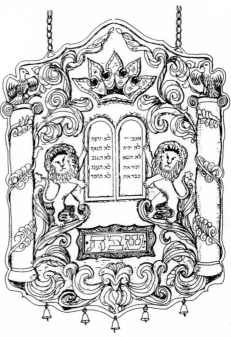

Traditional Torah breastplate with label indicating when Torah is to be read.

square tablet or pouch made of *gold and a mixture of linen and wool, worn over the priest's chest.[1] Set in the breastplate were twelve semiprecious stones, engraved with the names of the *Twelve Tribes. Inside the pouch were the *Urim* and *Tummim,* an oracular device for divining the future, hence the name "*mishpat,*" Decision or Judgment.

To echo this ancient priestly vestment, Ashkenazi Jews adorn the Torah scroll with a metal breastplate, usually made of silver, also called a shield, *tas,* which hangs over the mantle covering the scroll. Over time, these Torah ornaments have become showpieces of Jewish ceremonial art, often decorated with twelve semiprecious stones

reminiscent of the High Priest's breastplate or displaying other popular symbols such as the *Lion of *Judah or the *Tree of Life. During the Middle Ages, it became customary for synagogues which owned several Torahs to engrave plates to be inserted into breastplates indicating the occasion or festival on which a particular Torah scroll was to be used.

[1]Exodus 28:15-30; 39:8-21.

Signifies: HOLINESS, PRIESTHOOD, PROPHECY

Generic Categories: Clothing, Ritual Objects, Synagogue, Temple

See also: Clothing, Priestly Cult, Torah, Twelve Tribes, *Urim* and *Tummim*

BRIT – בְּרִית־מִילָה. One of the primary signs of Jewish identity is male circumcision, *Brit Milah*, performed on the eighth day of a boy's life. The Hebrew word *brit* literally means "covenant." The ceremony of removing the foreskin from a boy's penis symbolizes his entrance into the covenant with God, first made with *Abraham four thousand years ago. The *brit* is also connected with sacrifice, notably the *akedah* (the binding of *Isaac), a scene traditionally depicted on the circumcision knife. By cutting off the foreskin and ritually offering it to God, the Jew symbolically safeguards the whole body by sacrificing part of it. The baby thus marks his transition from a purely natural state into the social community. Only at the circumcision does he formally receive his Hebrew name.

Many cultures practice the rite of circumcision, but almost all perform it at puberty as a symbol of a boy's sexual maturity. Because of this difference, many Jewish commentators have claimed that *Brit Milah* spiritualizes human sexuality, representing the Jew's commitment to sublimating his passion, sanctifying his body in the service of God, and dedicating himself to the continuity of future generations. In the ancient Near East, the cults of Astarte and Dionysus embraced orgiastic excess; Greek and Roman culture revered the naked body and physical pleasure. Accordingly, circumcision came to represent a symbolic distinction between Jewish and pagan culture. Indeed, tyrants such as Antiochus and Hadrian forbade circumcision, hoping thereby to obliterate Jewish separateness, only to discover that Jews were willing to defend this symbol with their lives. In later times, circumcision became a significant distinction between Jewish and Christian culture as well.

Recently, anthropologists have suggested that circumcision represented to the ancient Israelites a symbolic wish for fertility.[1] Indeed, the biblical language describing circumcision is the same used to describe the practice of pruning fruit *trees to increase their future yield: "When you enter the land and plant any tree for food, you shall regard its fruit as its foreskin. Three years it shall be uncircumcised for you, not to be eaten...only in the fifth year may you use its fruit—that its yield to you may be increased."[2] Thus, God's covenant with Abraham—to "make you exceedingly fertile" and to make your descendants "as numerous as the *stars of heaven and the sands on the seashore"[3]—is symbolically enacted each time a Jewish male child is circumcised.

From its earliest times, Judaism has regarded circumcision as the primary symbol of male membership within the Jewish People. Abraham circumcised himself—at age 99 (along with *Ishmael, age *13)—in preparation for the birth of Isaac, whom he circumcised at eight days.[4] Tradition claims that Abraham's circumcision took place on the Tenth of *Tishrei*, which later became *Yom Kippur, the day when God forgives sins and welcomes the Jewish People back into the covenant.[5] According to traditional rabbinic authorities, a non-Jewish male wishing to become a Jew must undergo circumcision, or if he is already circumcised, must experience a symbolic circumcision, "*hatafat dam*," the drawing of a drop of *blood from the penis.

One possible reason that the eighth day was designated for circumcision is that the *number eight, representing one more day than the period of Creation, symbolizes eternity or infinity. It also symbolizes the Jewish People, whose creation within history supplements the creation of the natural world.[6] Thus, the *brit* represents the Jew's eternal covenant with God.

According to the *midrash*, circumcision also symbolizes human partnership with God,[7] an example of our role in completing

the divine work of creation. By extension, the word "uncircumcised" often refers in the Bible to *body organs that are spiritually incomplete or obstructed: uncircumcised lips, hearts, and ears.[8]

Some of the special objects used during the circumcision ceremony are themselves symbolic and have often been elaborately decorated: the *mohel* (circumcisor's) knife, often engraved with scenes of the *akedah*; the *chair of *Elijah, who is symbolically invited to all circumcisions as the legendary guardian angel of babies[9]; the plate upon which the *mohel's* tools are placed; and the binding cloth, "*wimpel*," traditionally embroidered and donated afterward to the synagogue as a Torah binder.

In our own time, many Jews have introduced the ceremony of "*Brit Ha-Bat*" — covenant for a daughter — to serve as a parallel to the male ceremony, although without the physical rite of circumcision. This ceremony usually includes blessings, songs, readings drawn from classical and modern sources, as well as rituals inspired by Jewish tradition.

[1]Schwartz, *The Savage in Judaism*, 141–176; [2]Leviticus 19:23; [3]Genesis 17:6; 22:17; [4]Genesis 17:9–14; 23–27; 21:4; [5]*Pirke de-Rebbe Eliezer 29*; [6]Hirsch, "*A Basic Outline of Jewish Symbolism*" in *Timeless Torah*, ed. Jacob Breuer, 413–416; [7]*Genesis Rabbah* 11:6; [8]Exodus 6:12; Deuteronomy 10:16; Jeremiah 6:10; 9:25; Ezekiel 44:7; [9]Malachi 3:1; see also *Pirke de-Rebbe Eliezer* 29.

Signifies: COVENANT, DISTINCTION, ETERNITY, FERTILITY, JEWISH IDENTITY, PARTNERSHIP, SELF-RESTRAINT, SEPARATENESS

Generic Categories: Birth, *Brit*, Body Parts, Conversion, Messiah, Ritual Objects, Women, Yom Kippur

See also: Abraham, *Akedah*, Blood, Candles, Chair, Elijah, Isaac

BURNING BUSH — סְנֶה.

After *Moses fled *Egypt and became a shepherd in Midian, God appeared to him on Mount Horeb "in a blazing fire out of a bush (*seneh*) . . . yet the bush was not consumed."[1] For millennia, the Burning Bush has symbolized for Jews God's eternal Presence and miraculous power. To the rabbis,

God's selection of a lowly bramble, like the choice of lowly *Mount Sinai as the site of an even greater revelation, also symbolized the virtue of humility, demonstrating that God acts in the world "not by might, and not by power, but by spirit alone."[2]

The *midrash* claims that the wicked *Haman was hanged on a thornbush, precisely because it has no virtues.[3]

In more recent times, as flames have increasingly come to symbolize the Holocaust, the Burning Bush has assumed a new meaning, representing the eternity of the Jewish People, which was engulfed by manmade flames and miraculously was not consumed.

In America, the Burning Bush was chosen as the emblem of the Conservative Movement, symbolizing the continuity of Jewish tradition.

[1]Exodus 3:2; [2]*Shabbat* 67a; Zechariah 4:6; [3]*Esther Rabbah* 9:2.

Signifies: CONSERVATIVE JUDAISM, CONTINUITY, DIVINE POWER, DIVINE PRESENCE, DIVINE PROTECTION, ETERNITY, HUMILITY, JEWISH PEOPLE, MIRACULOUSNESS, REVELATION

Generic Categories: Botany, Holocaust

See also: Moses, Fire, Wilderness

CALENDAR — לוּחַ.

Just as the rising and setting of the *sun regulates our daily life, so the coming and going of the seasons regulates the life of the earth. And just as hours, a social convention, are marked by clocking the whereabouts of the sun, so, too, are days clocked by the calendar, which is a symbolic representation of the sun's yearlong rising and setting as well as a symbol of order within the universe.

In Judaism, both the lunar and solar cycles are coordinated within a single annual calendar. The new *moon constitutes a minor festival in its own right, and determines the celebration dates of that month's festivals. But the sun rules the four seasons whose agricultural rhythms, especially spring and autumn, mark the transitional holidays of *Passover and the monthlong festival season of *Rosh Hashanah, *Yom Kippur, and *Sukkot.

In Jewish history, the calendar has been

more than a device for keeping track of time; it has also symbolized religious authority. Because the 365-day solar year does not separate neatly into equal divisible segments, ancient calendars needed to be adjusted (with leap days or months) to keep holidays in synch with the appropriate agricultural seasons. Until the Jewish calendar was permanently fixed (as late as the 10th century), the rabbis jealously guarded the secrets of such adjustments. Disputes over who controlled the calendar contributed to major schismatic rifts, most notably between the Essenes and the Karaites, both of whom were ultimately cut off

תִּשְׁרִי, תִּשְׁרֵי
Tishri · Tishrei

חֶשְׁוָן (מַרְחֶשְׁוָן)
Heshvan Marheshven

כִּסְלֵו
Kislev

טֵבֵת
Tevet

שְׁבָט
Shevat

אֲדָר (אֲדָר ב׳)
Adar (Adar II, added in leap years)

נִיסָן
Nisan

אִיָּר
Iyyar

סִיוָן
Sivan

תַּמּוּז
Tammuz

אָב (מְנַחֵם אָב)
Av Menahem Av

אֱלוּל
Elul

Months of the Hebrew calendar year.

from the Jewish People in part because their holy days were out of step with the rabbinic system. Thus, to belong to the Jewish People has meant to follow a common Jewish time frame.

Throughout their history, Jews have often lived with two calendars — their own and that of the dominant culture. Famous synagogue floor mosaics of the Hellenistic period, for example, feature the Hebrew seasons as well as the pagan *Zodiac. Similarly, most Western Jews, including those in Israel, live by Christian and secular as well as Jewish calendars. Thus, the year "2000" in the Gregorian calendar, marking two millennia since the birth of Jesus, is equivalent to "5760" in the Jewish calendar, whose counting begins, according to tradition, with the creation of the world.

The calendar is thus more than an index

of time; it is a symbol of how that time is perceived, controlled, celebrated, and represented. The Jewish calendar — with its months named after ancient Babylonian gods, but its observance still faithful to the rhythms of the Jewish festivals — symbolizes the Jewish People's adaptability and continuous acculturation throughout the ages.

Signifies: ADAPTABILITY, ASSIMILATION, AUTHORITY, ORDER, PERFECTION, TRANSITION

Generic Categories: Astronomy, Holidays, Numbers

See also: Four, Moon, Seven, Stars, Sun, Zodiac

CANDLES – נֵרוֹת.

Candles play an important role in many religious traditions, symbolizing by their *light the divine light or spirit. In Judaism, the use of candles is a relatively late phenomenon, because before the invention of paraffin, candles were usually made from the fat of ritually forbidden animals. In biblical and mishnaic times, only *oil *lamps and torches were used for lighting and for religious celebration. Even after the introduction of candles made of paraffin or tallow mixed with palm oil or wax, Jews still preferred to use oil lamps for *Hanukkah, symbolic of the miracle of the cruse of oil and for the *ner

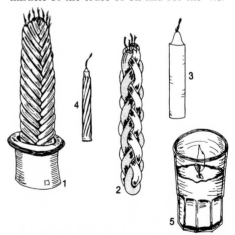

Ceremonial candles: 1. and 2. *Havdalah* candles. 3. Typical *Shabbat* candle (minimum of two are lit on Friday at sundown). 4. Hanukkah candle. 5. Memorial *"yahrzeit"* candle.

tamid (eternal light), symbolic of God's Presence and a reminder of the **menorah* in the ancient **Temple*. However, candles gradually assumed tremendous importance in Jewish observance and have superseded oil lamps.

Today candles are an integral part of Jewish custom and ceremony, symbolizing joy, spirituality, life, and its passing. They are used only on holy days as well as most life cycle events. Candles serve to inaugurate and conclude the **Sabbath* and holidays; to mark the eight days of Hanukkah; to help search for leaven—**hametz*—and burn a symbolic portion before **Passover*; to set the solemn atmosphere for the reading of Lamentations on the evening of **Tisha B'Av*; to represent the **Six Million* during Yom Ha-Shoah (Holocaust Memorial Day); and to memorialize the dead on **Yom Kippur* and holidays when a special memorial service (*Yizkor*) is recited in synagogue. In a few communities, candles even accompany the **Torah* on Mondays and Thursdays from the **ark* to the **bimah*, symbolizing the "light of the Law."

From birth to death, candles serve as central symbols of important transitional moments in a person's life. From ancient times, candles were lit at a **brit*, marking the entrance of a new Jewish soul into the community.[1] In America, thirteen candles are sometimes lit at **Bar* or *Bat Mitzvah* celebrations to mark this milestone birthday. In some communities, candles are held under the **huppah* to symbolize the departed parents of the bride or groom.

Since light has traditionally symbolized the soul, candles are often used to mark the passing of a soul from life. In folklore, candles ward off evil spirits and guide the soul to its final resting place. It has long been customary to light candles at a deathbed; during the week of mourning (*shivah*), using a special candle that burns for seven days; to commemorate the anniversary of a death, called a *yahrzeit*, using a candle that burns for twenty-four hours. These candles symbolize that "a person's soul is the lamp of God."[2] In some European communities, it was once customary to measure a new grave with wicking, which was then inserted into memorial candles to be burned in memory of the deceased. It is still customary in some communities to light can-

dles on the grave of famous scholars and leaders, such as **David* and Shimon bar Yohai, as well as during *hillula* ceremonies to commemorate their *yahrzeit*.

Lighting the Sabbath and holiday candles—along with observing the laws of family purity through immersion in the *mikvah* (ritual bath) and separating out a portion of dough, **hallah*, when baking **bread*—have traditionally been regarded as the three "women's commandments," although many men light *Shabbat* candles as well.

Generally, simple white candles with a single wick are used. But for the special ceremony of **Havdalah* marking the end of the Sabbath or a festival, a candle with two or more wicks or two single-wick candles are customarily used, in keeping with the blessing: "*borei meorei ha-esh*"—"Who creates the flaming lights (plural)." Unlike Sabbath, festival, and memorial candles, the *Havdalah* candle is extinguished at the end of the ceremony.

[1]*Sanhedrin* 32b; [2]Proverbs 20:27.

Signifies: DIVINE LIGHT, ETERNITY, FAITH, HOLINESS, HOPE, LAW, LEARNING, LIFE, REMEMBRANCE, SOUL, SPIRIT, TORAH

Generic Categories: Death, Hanukkah, Holocaust, Holidays, Ritual Objects, *Shabbat*, Wedding, Women

See also: *Hametz*, Hanukkah, *Havdalah*, Light, *Menorah*, Oil, *Ner Tamid*, *Shabbat*, Six Million, Tisha B'Av, Wedding

CAROB – חָרוּב.

The carob—"*bokser*" in Yiddish—is a fruit-bearing evergreen tree that grows wild in the Mediterranean regions of Israel. Although never mentioned in the Bible, this tree may be alluded to in the verse: "And God fed him **honey* from the rock," since carobs grow among rocks and exude a honey when ripe.[1]

Most notable about the carob tree is that it matures more slowly than most other fruit trees. Although in reality, the rich, flavorful fruit is ready for harvest in ten years, the *Aggadah* stretches this number to **seventy* years, the span of a human life. One of the most popular rabbinic legends builds upon this exaggeration: The wonder-

working rabbi, Honi the Circle-Maker, once chided a man for planting a carob in his old age, since he would surely not live to see it bear fruit. The old man told him: "Just as I found carob trees when I came into the world, so I am now planting carob trees for my grandchildren to enjoy."[2] Carobs here symbolize the continuity of generations and hope in the future.

The carob tree, CERATONIA SILIQUA, and its pods.

According to the Talmud, carob is the poor person's fruit. Hanina ben Dosa was said to have lived from Sabbath to Sabbath on carobs alone.[3] And carobs sustained Shimon bar Yohai and his son for twelve years when they hid in a cave from the Romans.[4] Because of Bar Yohai's association with *Lag B'Omer and because carob pods are especially abundant in late spring, carob is traditionally eaten on this holiday.

Carob is also eaten on the holiday of *Tu B'Shevat, the New Year of the Trees, to symbolize the land of Israel and its fruitfulness.

[1]Deuteronomy 32:13; JT *Pe'ah* 7:4; [2]*Taanit* 23a; [3]*Taanit* 24b; [4]*Shabbat* 33b.

Signifies: BITTERNESS, CONTINUITY, FAITH, FERTILITY, HOPE, LONGEVITY, POVERTY, SUSTENANCE, SWEETNESS

Generic Categories: Botany, Food, Israel (Land of), Lag B'Omer, Trees, Tu B'Shevat

See also: Honey, Israel (Land of), Lag B'Omer, Tree, Tu B'Shevat

CEDAR – אֶרֶז. Of all the trees that grow in the Land of *Israel, the cedar is singled out for its majesty, exemplified by its strength, height, fragrance, and hardiness. The famous cedars of Lebanon were used to build the First and Second *Temples. In ancient Israel, cedars provided palaces for kings, masts for ships, and walls and ceilings for houses. The wood was used to light the beacon *fires

announcing the New *Moon. Legend claims that cedars can live a thousand years.

The Bible mentions cedar trees seventy times. They are called "the trees of the Lord,"[1] and invoked as a symbol of God's power, whose "voice" — thunder — can shatter even the mighty cedar.[2] Contrasted with the lowly hyssop, the cedar represents the tallest of the trees.[3] In the Talmud, a great sage is compared to the cedar; the common people, to the hyssop.[4]

Several times in the Bible, the cedar is used in parables to represent royalty or power. King Yehoash of Israel compares himself to a cedar of Lebanon and his challenger, Amaziah of Judah, to a thistle trampled by a wild beast.[5]

In talmudic times and for many centuries after, it was customary for parents to plant a cedar at the birth of a boy and a *cypress (or *pine or other evergreen) at

Cedar of Lebanon, CEDRUS LIBANI. Some existing cedars of Lebanon are over 1,000 years old. Cedars bear cones only in old age.

the birth of a girl, and to cut branches from these trees for the poles of their *huppah, the marriage canopy.[6] Both trees symbolize beauty and longevity. And like all trees, they symbolize life.

[1]Psalm 104:16; [2]Psalm 29:5; [3]1 Kings 5:13; [4]*Moed Katan* 25b; [5]2 Kings 14:9; [6]*Gittin* 57a.

Signifies: BEAUTY, DIVINE POWER, HEIGHT, LIFE, LONGEVITY, OLD AGE, POWER, ROYALTY, STRENGTH

Generic Categories: Birth, Botany, Dwellings, Natural Phenomena, Temple, Trees, Wedding

See also: Cypress, *Huppah*, Moon, Pine, Temple, Tree, Wedding

CHAIN – שַׁלְשֶׁלֶת. In Jewish symbolism, a chain, *shalshelet*, represents transmission of the tradition, sometimes called the Golden Chain (the *goldeneh keyt* in Yiddish). The popular mishnaic work, *Pirke Avot*, begins by setting out such a chain of rabbinic transmission: "*Moses

received (*kibeil*) *Torah from Sinai and passed it on to Joshua, and Joshua to the Elders, and the Elders to the Prophets, and the Prophets delivered it to the Men of the Great Assembly."[1] The *Kabbalah – literally, "that which is received" – came to designate specifically the chain of the mystical tradition.

The image of the chain represents the transmission of the Jewish tradition "*mi-dor la-dor*," from one generation to the next. At *Bar* and *Bat Mitzvah* ceremonies, the boy or girl is often referred to as a link in that ongoing chain.

[1]*Pirke Avot* 1:1.

Signifies: CONTINUITY, TRADITION

See also: Kabbalah

CHAIR – כִּסֵּא. Empty chairs represent someone missing from the table. In Jewish history, two individuals have been notable in their absence as well as their presence. The first is *Elijah the Prophet, whose miraculous appearances and disappearances throughout the Jewish world have been the subject of innumerable legends. It is customary to place an empty chair at a *circumcision, called Elijah's chair, *kissei Eliyahu*, to represent the prophet's presence and protection of the newborn child.

The other absent presence in Jewish folklore is the hasidic rabbi Nahman of Bratzlav, great-grandson of the movement's founder, the Baal Shem Tov. Nahman's followers, the Bratzlavers, are the only hasidic sect who have never appointed a successor to replace their first spiritual leader, earning them the title the "dead *hasidim*." They have restored Nahman's chair and brought it from Uman (Russia) to Israel, where it sits empty as a symbol of their rebbe's continued spiritual guidance of his followers.

Some synagogues leave an empty chair on the pulpit to symbolize Jews who have been refused religious freedom and permission to emigrate from repressive regimes.

Sephardi Jews set aside a chair for their *ushpizin* guests in the *sukkah*.

In biblical, rabbinic, kabbalistic, and liturgical texts, God is often described as seated upon *Kissei Ha-Kavod*, the *Throne of Glory, a poetic figure suggesting divine power.

Signifies: ABSENCE, DIVINE POWER, PRESENCE, DIVINE PROTECTION, SPIRITUAL GUIDANCE

Generic Categories: Birth, *Brit*, Kabbalistic Symbols, Ritual Objects

See also: *Brit*, Elijah, Throne, *Ushpizin*

CHARIOT – מֶרְכָּבָה. In myths the world over, the chariot symbolizes the life force, the sun, and the soul, because of its associations of speed, power, and conquest. In classical mythology, the sun god was pictured as crossing the heavens in a chariot. Many ancient synagogue mosaics depict Helios, the sun god, in his chariot with *four horses, known as the Quadriga. The famous synagogue floor in Beit Alpha (6th-century Palestine) places this image at the center of the *Zodiac. In the Hellenistic world, Helios represented the order and goodness of the cosmos under the guidance of Sol, that is, the supreme God. Philo, a Hellenistic Jewish philosopher, said of God: "Like a charioteer grasping the reins or a pilot the tiller, God guides all things in what direction he pleases as law and right demand."[1] It is probable that by the Hellenistic period, Jews had come to use the sun god in his chariot merely as a conventional calendar symbol, much as we use pagan symbols today for purely illustrative, rather than religious, purposes.

In the Bible, Pharaoh's chariots are a symbol of the vanity of worldly power; God sinks them into the sea like lead.[2] Yet the chariot is also a sign of divine power: The prophet *Elijah does not die but is conveyed to heaven in "a fiery chariot with fiery horses."[3] This image, suggestive of Elijah's immortality and ability to perform miracles, has long captivated the Jewish folk imagination.

As a symbol of divine mystery, the kabbalists drew upon another biblical image: the *merkavah* described in Ezekiel's vision as four creatures, each with four faces – human, *lion, ox, and *eagle – and four *wings, fused together into a fiery four-wheeled vehicle whose rims were covered with *eyes, and whose spirit "was in the wheels."[4] Inspired by this vision, an entire

school of Jewish mysticism arose called *Maaseh Ha-Merkavah*, the mysticism of the Divine Chariot, or the *Heikhalot* (Palaces) School. This esoteric discipline exposed its initiates to both extraordinary holiness and peril, and was reserved for a select elite. Those who practiced its methods were called "*yordei merkavah*," those descending in the chariot. In his *Guide of the Perplexed*, Maimonides suggests that Ezekiel's vision of the chariot is an image of human "ensoulment," the investment of spirit within the body.

[1]Philo, *On the Account of the World's Creation Given by Moses*, 46; [2]Exodus 15:1-18; [3]2 Kings 2:11; [4]Ezekiel 1:4-21.

Signifies: DANGER, DIVINE MYSTERY, GOD, HOLINESS, IMMORTALITY, MIRACULOUSNESS, MYSTICISM, POWER, VANITY

Generic Categories: Astronomy, Kabbalistic Symbols

See also: Calendar, Elijah, Fire, Kabbalah, Sun, Zodiac

CHELM. One of the oldest communities in Poland, Chelm assumed in Jewish folklore the reputation of being a city of fools, famous for its absurd "wisdom." Stories about the "wise men of Chelm" circulated throughout Eastern Europe: how the Chelmites tried to capture the moon by trapping its reflection in a tub of borscht (beet soup); how they foolishly tried to milk a billy goat to cure their ailing rabbi; how one Chelmite tried to travel to the great city of Warsaw but ended up back at his own table eating his wife's burnt soup. These satirical stories are generally told with affectionate humor and are infused with traditional customs and values. In the Jewish folklore tradition, Chelm has become synonymous with both foolishness and humor.

Signifies: FOOLISHNESS, HUMOR, SELF-DELUSION

Generic Categories: Places

CHERUBIM – כְּרוּבִים. One of the most puzzling features of ancient Israelite religion is the nature of the cherubim, semi-divine *winged creatures whose im-

Phoenician-style cherub in relief.

ages perched above the *Ark of the Covenant and later figured prominently in the decoration of the *Temple as well as in prophetic visions. For a religion seemingly so opposed to graven images, the enthronement of the cherubim in the Holy of Holies seems a striking aberration.

The first mention of the cherubim is in Genesis after the expulsion of *Adam and *Eve from the Garden of *Eden. God sets "the cherubim and the fiery ever-turning sword, to guard the way to the *Tree of Life."[1] According to the *midrash*, sometimes these beings appear as men, sometimes as women, other times as *angels.[2] Such guardian *angels were probably modeled upon Near Eastern deities such as the winged bulls of Babylonia and Assyria or the sphinxes of Egypt, which guarded temples and palaces. The Akkadian word "*karibu*" designates an intermediary who presents human prayers to the gods. In Ezekiel's ecstatic visions, the cherubim have *four faces — of a *lion, ox, *eagle, and human — and four or six wings, making such resemblances even clearer.[3] Elsewhere, Ezekiel depicts a cherub as a fallen angel, representative of the enemies of Israel.[4]

God commanded *Moses to place upon the Ark "two cherubim of gold . . . shielding the cover with their wings," their faces "confront[ing] each other." There "between the two cherubim," God met with Moses.[5] In addition, the Israelites were commanded to weave images of the cherubim into the *veil and curtains of the *Mishkan*, the portable sanctuary in the *wilderness.[6] When *Solomon later built the *Temple in *Jerusalem, the motif of the cherubim was repeated throughout the design: on the inner and outer walls, the doors of the inner and outer sanctuary, and on the huge brass

bowl called the "Molten Sea."[7] According to the Talmud, the Second Temple, rebuilt after the Babylonian Exile, no longer contained the original gold cherubim but probably had pictures of them.[8] When Herod later refurbished the Second Temple, he added statues of the cherubs; when Titus destroyed the Temple in 70 C.E., he set these statues up as trophies on the city gates of Antioch.

Traditionally, the cherubim represented several things, foremost among them God's Presence among the people. According to the Talmud, when the people sinned, the cherubim's faces turned away; when they repented, the cherubim faced each other and embraced, "like a male who embraces a female," a sign that Israel was once again beloved of God.[9] The cherubim also represented God's *chariot[10] and the divine *throne over which the *Shekhinah hovers.

The image of a cherub as a plump, rosy-cheeked infant with wings, made popular through Western art, may derive from an aggadic play upon the word cherub as ke-ravia, Aramaic for "like a child."[11] Or it may derive from depictions of Greek "erotes," cupids, which also had wings. Whatever their source, it is clear that these puckish cherubim in no way resemble the fearsome, holy creatures described by Israel's prophets and priests.

Although cherubim are no longer depicted in synagogue art and are now largely an archaic symbol, some art historians speculate that the rampant *lions found on many ark doors and curtains are symbolic replacements of the original cherubim.

[1]Genesis 3:24; [2]Genesis Rabbah 21:9; [3]Ezekiel 1:5–12; 10:1–22; [4]Ezekiel 28:16–17; [5]Exodus 25:18–22; [6]Exodus 26:1, 31; [7]1 Kings 6:29, 32, 35; 7:29, 36; [8]Yoma 54a; [9]Bava Batra 99a; Yoma 54a; [10] 2 Samuel 22:11; [11]Sukkah 5b.

Signifies: DIVINE PRESENCE, GUARDIANSHIP, HOLINESS, LOVE

Generic Categories: Kabbalistic Symbols, Temple

See also: Angels, Ark, Chariot, Eden, Lion, Mishkan, Temple

CHICKPEA — חִמְצָה.

Chickpeas, long a staple in the Jewish diet, have been known by many names: nahit, arbes, himtza, hummus, bub, ceci, kara, garbanzo beans. They are traditionally eaten on the *Shabbat after the birth of a son, and at the Seudah Shlishit, Shal'shudes, the third Sabbath meal.

Jewish legend recounts that when Queen *Esther lived in the palace of King Ahashverosh she was careful to observe the laws of *kashrut by eating only vegetarian foods, particularly peas and beans.[1] *Daniel, another Persian Jew, similarly restricted his diet to "legumes and water" in order not to violate the dietary laws.[2] In honor of their piety, it is traditional to eat chickpeas on *Purim.

Some Sephardi Jews from Middle Eastern countries refrain from eating chickpeas on *Passover because "himtza" sounds too much like *"hametz," leaven, which is proscribed during this holiday. Many North African Jews eat this legume on Rosh Hashanah because kara, another name for chickpeas, derives from the Hebrew meaning "cold," symbolizing their hope that God's stern judgment will be cooled down on this day. Eastern European Jews also customarily eat chickpeas during this holiday.

In folklore, eating chickpeas is supposed to promote fertility.

[1]Megillah 13a; [2]Daniel 1:12.

Signifies: COMPASSION, FERTILITY, PIETY, VEGETARIANISM

Generic Categories: Birth, Food, Passover, Purim, Rosh Hashanah, Shabbat, Women

See also: Daniel, Esther, Hametz, Kashrut, Purim

CIRCLE — מַעְגָּל.

In traditional cultures the world over, the circle is a powerful icon representing wholeness, perfection, center, and balance as well as the *sun and *moon. In Eastern cultures, it represents the reconciliation of opposites, as depicted in the well-known yin-yang symbol. The mandalas of India and Tibet often take the form of circles within squares. Western cultures also revere the circle as an emblem of the world, the cosmos, and cyclical time.

In Judaism, the circle has been used widely in ceremonial art. The Hebrew words for *crown — keter and atarah — most probably derive from a verb meaning to

"encircle." Circles also represent the "round" cycle of the year. The Greek *Zodiac, which is shorthand for "circle of zodia" (small animals), was a popular decorative motif among Jews in the Hellenistic period and later again in Polish synagogue design and in Italian illuminated manuscripts. The *rose, whose petals are configured in a circular mandala, has been a popular motif in Jewish folk art.

*Jerusalem, encircled by walls, was envisioned as the center of the world, the pupil of the world's *eye, the navel and *heart of the universe. In medieval maps, it was often pictured as the center of a circle.

Circular foods have also been used symbolically. The round *hallah served on *Rosh Hashanah symbolizes the start of a New Year and the wish for fulfillment. *Eggs, often served at the *Passover *seder, also represent completion or perfection because of their quasi-round shape and role in the life cycle. It is traditional to serve *lentils and eggs in a house of mourning to symbolize the wheel of life. *Apples have also been prized for their perfect spherical shape.

In addition to their function as symbols of wholeness, circles can also possess magical power, providing protection from demons. When Joshua and the Children of Israel encircled Jericho for *seven days, climaxing their siege with seven circles on the seventh day, the walls came thundering down. The talmudic sage Honi, known as "Ha-Maagel," the Circle-Maker, forced God's hand by drawing a circle around himself, refusing to move until God brought rain to the parched land.

The wedding ring, used universally to symbolize a bond as well as the unity of marriage, plays the same role in the Jewish wedding ceremony. The custom of the bride walking *seven times around the groom under the *huppah (or each walking around the other in turn) probably derives from folk beliefs in the protective power of the circle.

During Torah processions, especially during the seven "hakkafot" of Simhat Torah, the scroll makes a circle around the synagogue, much as a *king or *queen parades before the people. On *Sukkot, the *four species are similarly carried in circles ("hoshanot") around the synagogue. These circles may have originally represented the

people's desire to be brought under the protection of God.

It is customary in some families to join hands around the *Shabbat* and holiday table, a gesture symbolizing the strength and unity of the family circle.

Signifies: COMPLETION, CONNECTION, CYCLE, FAMILY, LIFE CYCLE, MAGIC, PERFECTION, UNITY, WHOLENESS

Generic Categories: Astronomy, Clothing, Food, Passover, Rosh Hashanah, Sukkot, Wedding, Women

See also: Apple, Crown, Egg, Four Species, *Hallah*, Jerusalem, Lentil, Rose, Rosh Hashanah, Seven, Sukkot, Sun, Wedding, Zodiac

CLOTHING – בְּגָדִים.

As the expression goes, clothes make the man—and woman. A person's clothing symbolizes vocation and material circumstances, and in many traditional societies, religious affiliation, nationality, ritual status, age, and marital status as well.

According to the Torah, the first human garments consisted of *fig leaves donned by *Adam and *Eve when they realized they were naked.[1] The *midrash* claims that the first couple originally wore garments of *light, but God removed these garments when they sinned, replacing them with the skin of the *serpent or of *Leviathan.[2] When the Israelites wandered in the desert, says another legend, their garments never wore out but were laundered and ironed by the divine *Clouds of Glory.[3] At the End of Days, the Righteous will be resurrected fully clothed.[4]

Jewish clothing has undergone a complex evolution through history, alternating between imitation of and difference from non-Jewish dress. During talmudic times, clothing largely reflected Greek fashion, except that all Jewish men wore fringes (*tzitzit*), and scholars wore a *tallit, modeled on the Roman "pallium," and a turban. In addition, Jews wore special clothes for *Shabbat as a sign of honor.

Women's clothing has typically reflected their modesty and subordinate status. In talmudic and medieval times, they bound their *hair and covered most of their body.

It is uncertain whether they wore veils, which has long been the custom among many Middle Eastern cultures. The Torah states that *Rebecca covered herself with a veil (*tza'if*) when she met her future husband *Isaac, the probable origin of the *bedeken* (veiling) ceremony at Jewish *weddings.[5]

As Jews began to travel more and more in foreign cultures, Jewish leaders demanded a distinct dress to differentiate Jew from Gentile. Jewish dress thus became deliberately conservative. In Eastern Europe, many Jews adopted the Persian caftan which became the hasidic *"kapote"*; and in the sixteenth century, many adopted the discarded dress of Polish nobility.

Conversely, in many countries, non-Jewish rulers demanded that Jews wear distinctive dress to differentiate themselves: hats, usually pointed, and badges, usually *yellow *circles, to distinguish them from Gentiles. Sometimes Jews continued to wear these hats even after they were no longer required, through force of custom. By the French Revolution, distinctive Jewish dress had largely disappeared. But Jews continued to wear special *Shabbat* clothing such as three-cornered hats and buckled shoes. Many rabbis continued to wear special rabbinic clothing; to this day, many rabbis and cantors wear special robes and hats in synagogue.

Today, what remains of special Jewish dress is the *tallit katan*, an undergarment with ritual fringes worn daily by many observant men and boys; the larger *tallit* worn for morning prayer; the *kittel*, worn on certain holidays, at one's wedding, and in death; the *kippah*; and the *tikhel*, head scarf, and *sheitl*, wig, worn by many traditional women. Many observant Jews obey the biblical law called *shatnez*, being careful not to mix linen and wool in their garments, so as to distinguish secular clothing from the sacred garments of the priests.[6] Degrees and fashions of religious observance among Jewish men are often signaled by the type of hat worn—from stringent "black hat" to more modern knitted or suede *kippah*. In many liberal congregations, women often wear *kippot* (plural of *kippah*) as well, symbolic of their religious equality. *Hasidim* still wear the distinctive clothing of 18th-century Poland, the fur hat and *"kapote."*

Many Jews reserve their finest clothing for the Sabbath and festivals. It is also customary at Jewish camps, *kibbutzim* in Israel, and in some communities to wear *white on *Shabbat* as a sign of holiness. White clothing is also traditionally worn on *Yom Kippur.

When a death occurs, it is traditional to tear one's clothing—*keriah*—as a sign of mourning. Many Jews today prefer to wear a black ribbon pinned to their lapel or dress to symbolize this act.

In the mystical tradition, garments are symbolic of God's hiddenness in the world. The *Torah is said to be clothed in many outer garments and must be undressed to lay bare its secrets. On the other hand, the kabbalist, to withstand the dazzling *light of the higher worlds, must dress himself in the Torah's garments for protection.

[1]Genesis 3:7; [2]Ginzberg, *Legends of the Jews* 5:97, n. 69; 103–104, n. 93; [3]*Deuteronomy Rabbah* 7:11; [4]*Sanhedrin* 90b; [5]Genesis 24:65; [6]Leviticus 19:19; Deuteronomy 22:11.

Signifies: CELEBRATION, DISTINCTION, HIDDENNESS, HOLINESS, HONOR, JEWISH IDENTITY, MODESTY, MOURNING, PERSECUTION, PROTECTION, RESPECT, SEPARATENESS, STATUS

Generic Categories: Clothing, Death, Kabbalistic Symbols, *Shabbat*, Wedding, Women, Yom Kippur

See also: Beard, Body, Colors, Corners, Hair, *Kippah*, *Kittel*, Priestly Cult, *Shabbat*, *Tallit*, Wedding, White, Yellow

CLOUD – עָנָן.
Hovering halfway between heaven and *earth, clouds symbolize an intermediate zone between God and human beings. They also signify hiddenness and mystery. Because they hold life-giving *rain, they are also a symbol of potentiality.

In the Bible, God's Presence is often identified with a cloud. When the Israelites were pursued by the Egyptian army after leaving *Egypt, a cloud protected them from danger.[1] At *Sinai, God appeared to *Moses and the Children of Israel in a cloud.[2] As the people traveled through the *wilderness, God guided them on their way with a pillar of cloud by day, and a pillar of

*fire by night.[3] The rabbis considered this cloud God's sheltering *sukkah, protecting the people from the harsh elements.[4] Rabbi Akiva even suggested that the Israelites did not dwell in *sukkot in the *wilderness, but in clouds of glory.[5] When God "came down" to speak to Moses, *Aaron, or the priests, a cloud filled the *Mishkan and later, the *Temple.[6] God is sometimes depicted as riding upon a cloud as on a *chariot.[7]

According to the *midrash*, God's Cloud of Glory hovered over *Sarah's and *Rebeccah's tent.[8] This same Cloud of Glory exists in Paradise sheltering the righteous.[9] In the *Kabbalah, the Cloud of Glory is an image of the *Shekhinah, God's feminine Presence protecting the Jewish People.

[1]Exodus 14:20; [2]Exodus 19:9; 24:15–18; 34:5; [3]Exodus 13:21–22; [4]Ginzberg, *Legends of the Jews* 2:374–375; [5]*Mekhilta de-Rabbi Ishmael* 1:182; [6]Exodus 40:34; 1 Kings 8:10; [7]Isaiah 19:1; Psalm 104:3; [8]*Genesis Rabbah* 60:16; [9]Ginzberg, 1:21.

Signifies: DIVINE MYSTERY, DIVINE PRESENCE, DIVINE PROTECTION, GOD, HIDDENNESS, MATRIARCHS, POTENTIALITY, SHELTER

Generic Categories: Kabbalistic Symbols, Natural Phenomena

See also: Fire, Kabbalah, *Shekhinah*, Sinai, Sukkot

COLORS – צְבָעִים.

Most cultures have developed a color symbolism, based originally on the physical characteristics of astronomical, chemical, or biological phenomena. In the course of time, however, color symbolism has tended to become formalized as cultural convention, often losing its original import. The perception of colors has also changed over time, since many of the colors that beautify our world today were not available to earlier cultures. Scholars speculate that color sensitivity greatly increased in the wake of Renaissance art and its technical innovations in color.

In the Bible, *Jacob gives a coat of many colors to his son *Joseph as a sign of special favor, an act which provokes Joseph's jealous brothers to take vengeance and brings him into captivity in *Egypt.[1] To simple shepherds, a garment of many colors represents privilege and extravagance.

Ancient Judaism devised a complete system of color symbolism to represent the *Twelve Tribes, expressed in their *flags and in the stones on the High Priest's *breastplate. In the Middle Ages, *Kabbalah developed the most complete system of color symbolism, identifying each *Sefirah (divine emanation) with a different color, and basing allegorical meanings and meditative practices upon these various colors.[2]

The *rainbow, the composite of all colors, has long been been regarded as a symbol of God. Similarly, the complete spectrum symbolizes humanity; according to legend, God created *Adam from *red, black, *white, and green dust gathered from the *four *corners of the world.[3]

[1]Genesis 37:3–4, 23; [2]Kaplan, *Meditation and Kabbalah*, 179–186; [3]Ginzberg, *Legends of the Jews* 1:55.

Signifies: GOD, HOLINESS, HUMAN-KIND, STATUS

Generic Categories: Colors

See also: Blood, Blue, Clothing, Flag, Joseph, Kabbalah, Rainbow, Red, *Sefirot*, Twelve Tribes, White, Yellow

CORNERS – פֵּאֹת, כַּנְפוֹת.

If the *circle represents completion and perfection, the square, with its sharp edges and definite end points, represents the opposite: stasis and limits. "Squaring the circle" — placing a circle around a square — has traditionally symbolized the unity of the material world (the square earth) and the spiritual world (the heavenly spheres).

In Jewish tradition, corners, *pe'ot* — the *four points of the square — symbolize boundaries, between holy and profane, between the divine and human worlds, between Jew and Gentile. The *Torah forbids Israelite men to shave the corners of their *beards and *faces, and then repeats the injunction for the priests.[1] Similarly, *Moses consecrated *Aaron and his sons as priests by sprinkling sacrificial *blood on their right ears, right thumb, and right big

toe,[2] symbolic of the "corners" of their bodies. The corners of the *altar, defined by four *horns, constituted the borders of sacred space.

Another commandment enjoined the community to leave the corner of their fields unharvested for the poor and the stranger.[3] The rabbis later expanded this biblical law to make it even more far-reaching, protecting the needs and sensitivities of poor nursing mothers, children, and Gentiles. In so doing, the tradition affirmed the notion that communal responsibility transcends property boundaries. *Pe'ah*, the practice of leaving a corner, has thus become symbolic of Jewish philanthropy.

In the liturgy, the psalmist's declaration that the Jewish People is God's "chief cornerstone" has become an image of *messianic redemption.[4]

The motif of corners also extends to Jewish *clothing. Jews are commanded to put fringes on the corners of their garments to remind them of God's commandments and to keep them from lusting after foreign gods.[5] Here again corners mark the boundaries of holy space. They also mark the interconnectedness of private and public space, as well as the four corners of the world.

Hasidic youth with earlocks grown long.

In modern times, it is still customary among the hasidic and Yemenite communities for boys and men to leave the corners of their hair uncut (*pe'ot* or *pe'os*) as symbols of their allegiance to tradition.

[1]Leviticus 19:27; 21:5; [2]Leviticus 8:22–24; [3]Leviticus 19:9; [4]Psalm 118:22; [5]Numbers 15:38–39.

Signifies: ALLEGIANCE TO TRADITION, BOUNDARIES, CHARITY, CONNECTION, DISTINCTION, HOLINESS, LIMITS

Generic Categories: Body Parts, Clothing

See also: Circle, Clothing, Hair, Priestly Cult, *Tallit*, Wings

CROWN – כֶּתֶר, עֲטָרָה.

In the Bible, a crown, called either *atarah* or *keter*, symbolizes royalty, power, and honor. To the rabbis, the crown was the ultimate symbol of honor: "There are three crowns: the crown of *Torah, the crown of priesthood and the crown of royalty; but the crown of a good name excels them all."[1] The first three crowns refer to physical as well as symbolic crowns: the ornamental crown of the scroll (*keter Torah*), the miter of the High Priest, and the diadem of royalty.

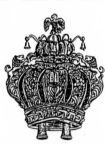

Torah crown, which fits onto the two staves of the Torah scroll.

These three crowns are often represented on the Torah curtain covering the *ark.

Originally, *kings were crowned with *oil. It is thought that *Solomon modeled his royal diadem after the crownlike knob of the *pomegranate.

The ornamental Torah crown, the *keter Torah*, is placed upon the two staves of the scroll, symbolizing that the Torah is a representative of God, the King of Kings. This silver or *gold crown was originally reserved for special holidays, but eventually came to be a permanent fixture on the scroll. Torah crowns are often masterpieces of Jewish ceremonial art, typically richly decorated with symbols such as fruits, shells, *flowers, *menorahs, the *Ten Commandments, *lions, griffins, stags, the *Zodiac, the *Twelve Tribes, and semiprecious stones. A crown often appears on Torah *breastplates and mantles as well. Many of the Hebrew letters of the Torah parchment itself are ornamented with *tagin*, decorative crowns.

God as the King of Kings is also said to wear a crown, made of human prayers woven together by the *angel Sandalfon. The *Zohar*, the mystic Book of Splendor, declares that the Sabbath *Queen is "crowned below by the holy people" of Israel.[2] At the End of Days, the Messiah will wear this wreath of prayers upon his head. And in the World to Come, the righteous all wear wreaths.[3] The image of God's crown may also derive from ancient

depictions of the *sun, source of *light and power, as a diadem of golden rays.

Among pagan cults, wreaths of corn were used to adorn idols. To make a distinction, the rabbis forbade their use by Jews.[4] However, wreaths of *olive leaves garlanded the sacrificial ox in the Procession of *First Fruits on *Shavuot, and the *baskets of fruit carried by the pilgrims were ornamented with wreaths made of the *seven species.

It was customary in ancient Israel for men and women to wear flowered wreaths on all joyous occasions, especially on their wedding day, reflecting their temporary symbolic status as *queen and king. Many brides wore "a Jerusalem of gold," a gold crown with a design of *Jerusalem. The custom of wearing bridal wreaths was largely discontinued after the destruction of the *Temple, although it is still practiced in some Sephardi communities. Because the Bible calls a good wife "the crown of her husband," it has been customary to include crowns in an illuminated *ketubah (marriage contract).[5]

In the liturgy and in song, the *Shabbat is frequently called Israel's crown: "You gave Your people a crown of distinction, a crown of triumph, a day of rest and holiness."[6]

[1]Pirke Avot 4:17; [2]Zohar 2:135a-b (Daniel Matt's translation, p. 132); [3]Berakhot 17a; [4]JT Avodah Zarah 4:2; [5]Proverbs 12:4; [6]Amidah for Shabbat Minhah.

Signifies: BEAUTY, CELEBRATION, HONOR, LEARNING, MARRIAGE, POWER, PRIESTHOOD, REDEMPTION, ROYALTY, TORAH, WISDOM

Generic Categories: Clothing, Ritual Objects, Synagogue, Temple, Wedding

See also: Circle, Clothing, David, First Fruits, Flowers, Light, Messiah, Pomegranate, Seven, Shavuot, Solomon, Sun, Synagogue, Tallit, Torah, Wedding

CUP — כּוֹס.

In the ancient world, *wine played a central role in religious ritual. It was natural that the cup that held the wine would acquire its own sacred status, as indeed it has in both Jewish and Christian traditions. Like the wine it con-

tains, the cup has come to symbolize life itself.

The special Kiddush cup (from kadosh, meaning "holy"), used in so many Jewish ceremonies, dates back to the Second *Temple period (6th century B.C.E.-1st century C.E.). Throughout the ages, this cup, often ornately decorated and made of silver or gold, has come to symbolize holiness, solemnity, and the happiness of family life. In some families, Kiddush cups

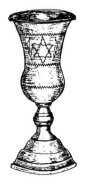

Traditional silver Kiddush cup used on the Sabbath and holidays.

are given as gifts at the birth of a child, a *Bar or Bat Mitzvah, or a *wedding; often, these cups become family heirlooms. Many cups are engraved with biblical verses referring to the *Sabbath and festivals, or with the blessing over wine.

Special cups are used for various occasions. Besides the Kiddush cup for Sabbath and festivals, there is the cup of *Elijah at the *Passover *seder, symbolic of the *messianic redemption hoped for at this season; the cup used during *Havdalah, also representing redemption—kos yeshuot (the cup of salvation)[1]; the wedding cups shared by bride and groom under the *huppah, symbolic of their union; and the two-handled cup used for netilat yadayim, hand-washing before meals, especially on the Sabbath and festivals.

It is a tradition to overfill one's cup for Kiddush and Havdalah to symbolize one's thankfulness: "My cup runs over."[2]

[1]Psalm 116:13; [2]Psalm 23:5.

Signifies: CELEBRATION, HOLINESS, JOY, LIFE, REDEMPTION, SOLEMNITY, UNION

Generic Categories: Food, Holidays, Ritual Objects, Shabbat, Wedding

See also: Blood, Havdalah, Wine

CYPRESS — הָאַשׁוּר.

Traditional sources identify the cypress with either the gopher tree, out of which *Noah built his *ark, or the box tree (te'ashur, from yashar—straight), so descriptive of this tall,

graceful evergreen, used often in the ancient world to build ships. Isaiah prophesied that this tree would blossom at the Redemption and would be used to rebuild the *Temple.[1] In modern Israel, cypresses are now used ornamentally for their beauty.

In talmudic times and for many centuries after, it was customary for parents to plant a cypress (or *pine or other evergreen) at the birth of a girl and a *cedar tree at the birth of a boy, and to cut branches from these trees for the poles of their *huppah, the marriage canopy.[2]

The cypress tree, CUPRESSUS SEMPERVIRENS.

[1]Isaiah 41:19; 60:13; [2]Gittin 57a.

Signifies: BEAUTY, REDEMPTION

Generic Categories: Botany, Temple, Trees, Wedding

See also: Cedar, Huppah, Pine, Temple, Tree, Wedding

DANIEL — דָּנִיֵּאל.

Daniel, whose name means "God has judged (or vindicated)," is the hero of the biblical book which bears his name. He is most famous for surviving the lions among whom he was cast by the Babylonian king Nebuchadnezzar. In Jewish legend, he was celebrated for his faith and piety, for which he was willing to risk his life; his skill at interpreting dreams; and his prophecies regarding the End of Days, the Last Judgment. Although the rabbis did not consider him a true prophet, they did praise him as the wisest man in the world.[1] The tradition credits Daniel as the first Diaspora Jew to orient his prayers toward Jerusalem.[2]

While Daniel was in the king's service, he adhered faithfully to the laws of *kashrut, restricting his diet to "legumes and water."[3] Because Daniel is associated with Persia as is Queen *Esther, whose diet was similarly vegetarian, it is traditional to eat legumes,

especially *chickpeas, on the holiday of *Purim to commemorate their piety.

[1]Yoma 77a; [2]Daniel 6:11; [3]Daniel 1:12.

Signifies: COURAGE, DIVINE PROTECTION, FAITH, PIETY, PROPHECY, VEGETARIANISM, VISION, WISDOM

Generic Categories: Messiah, Personalities

See also: Chickpea, Dreams, East, Esther, Jerusalem, Lion, Purim

DAVID — דָּוִד.

The Bible tells more stories about David than about any other king of Israel. In his own day—three thousand years ago—he was beloved of his people; he still is today. Within the Jewish imagination, David's name is associated with many central Jewish images and symbols. He is the young shepherd, who brought down the giant Goliath. He is the sweet singer of Israel, who as a youth soothed the melancholy Saul with his lyre and later composed the Psalms. He is the founder of the House of David, the royal line of kings, whose descendant will be Mashiah ben David, the *Messiah (anointed one), son of David. His name is frequently linked with the *Temple, which the liturgy calls "the fallen *Sukkah of David." *Jerusalem, which David made the capital of Israel, is traditionally called "the City of David." In the prayer book, in the Grace After Meals, and throughout the vast repertoire of Jewish song, references to David abound. In the liturgy, God is called "Magen David," the shield of David, and the Jewish *star now bears the same name. In short, David has become the quintessential symbol of Israel's past glory and future hope.

Yet even David had his shortcomings: he so lusted after the beautiful Bathsheba that he contrived her husband's death in order to marry her. The rabbis interpreted this incident as a divine test that David failed because of his pride.[1] Although David's blind love for his children, especially Absalom, almost lost him his kingdom, tradition remembers him as the model of fatherly love. The exemplary love between David and Saul's son Jonathan is regarded as a model of male friendship, especially among gay Jews.[2]

In the mystical tradition, David is identified with the tenth *Sefirah of *Malkhut*, royalty, the divine emanation most accessible to human experience, a designation David shares with the *Shekhinah*, God's feminine aspect. The kabbalists also identified this lowest *Sefirah*, and therefore David, with the *moon, since both reflect light from higher sources. According to legend, David's very life was a reflection of another's, for when Adam learned that this great future soul was destined to die soon after birth, he bequeathed to David 70 of his allotted 1,000 years. Because of David's association with royalty, the Messiah, and *Kabbalah, the fourth *Shabbat* meal — the *Melaveh Malkah*, "escorting the Queen" — is also called "David's Banquet."

[1]*Sanhedrin* 107a; [2]1 Samuel 18:1–3; chapter 20; 2 Samuel 1:26.

Signifies: BEAUTY, COURAGE, FRIENDSHIP, LOVE, GLORY, HOPE, MUSIC, PRIDE, REDEMPTION, ROYALTY

Generic Categories: Messiah, Kabbalistic Symbols, Personalities, *Shabbat*, Temple

See also: Harp, Jerusalem, Kabbalah, King, Star of David, Messiah, *Sefirot*, Solomon

DEBORAH — דְּבוֹרָה.

According to the Bible, Deborah ("bee") was a judge before the period of the Israelite monarchy, the only woman to hold such a position. Together with the general Barak, she led the Israelites to victory against Sisera's army.[1] The victory poem she composed after the battle is known as "the song of Deborah," whose poetic merits, according to the *Zohar*, are unequaled by any praises written by men.[2] She is one of *seven women prophets mentioned in the Talmud,[3] and has been admired as a model of spiritual and military leadership, poetic genius, and courage.

[1]Judges, chapters 4–6; [2]*Zohar*, Leviticus 19b; [3]*Megillah* 14a.

Signifies: COURAGE, FEMINISM, JUSTICE, LEADERSHIP, STRENGTH, VICTORY, WISDOM

Generic Categories: Personalities, Women

DEER — אַיָּל, צְבִי.

Just as English has many names for this swift, graceful animal — gazelle, hart, hind, antelope — so, too, Hebrew identifies many different species of deer native to ancient Israel, some of which survive to this day. The most commonly used Hebrew term is "*tzevi*."

When used symbolically, the deer represents grace and speed. The tribe of Naftali is compared to a wild deer (*ayalah*) which yields lovely fawns.[1] In depictions of the *Twelve Tribes, Naftali is represented by a deer. In the Mishnah, the deer's speed is invoked as one of the qualities needed to perform God's will: "Be as strong as a *leopard, as light as an *eagle, as swift as a deer, as brave as a *lion to do the will of your Father in heaven."[2] For many centuries, these four animals have been represented in paintings, weavings, and ceremonial objects in synagogues and Jewish homes. In the popular *Sabbath hymn, *Yedid Nefesh* ("Beloved of My Soul"), the soul "runs like a deer" (*ayal*) to be close to God, so ardent is the soul's desire for intimacy with the *Shekhinah*. Deer are sometimes depicted on ritual objects as an allusion to Psalm 42: "Like a deer crying for water, my soul cries for You, O God."[3]

A deer in repose. In folk art, deer antlers are often exaggerated for decorative effect.

Under the influence of medieval and Renaissance European art, the Jewish folk imagination added elks and unicorns to its bestiary. (The unicorn probably entered Jewish art even earlier, as a result of a mistaken translation. The Septuagint, the popular Greek translation of the Bible, translated *re'em*, the two-horned wild ox, which was the symbol of Ephraim and Manasseh, as "unicorn."[4] Indeed, the wild ox, depicted in profile, appears to have a single horn.)

In modern Israel, the deer, usually the wild gazelle, frequently appears on stamps or publications representing the country and is the symbol of the Israeli postal service.

[1]Genesis 49:21; [2]*Pirke Avot* 5:23; [3]Psalm 42:1; [4]Deuteronomy 33:17.

Signifies: BEAUTY, GRACE, SPEED

Generic Categories: Animals, Israel (State of)

See also: Flag, Israel (State of), Twelve Tribes

DEW — טַל.

In most cultures, natural phenomena that descend from the heavens — lightning, *rain, falling *stars, and dew — carry with them a sacred aura. In addition, because dew presages the dawn, it also symbolizes *light, both natural and spiritual illumination.

On the first day of *Passover, Jews the world over recite the special "Prayer for Dew" (*tal*), asking God to end the winter rains in Israel and to send dew. In this beautiful poem, dew operates on two levels: as a natural as well as a spiritual symbol. In spring the land experiences a rebirth; dew represents the blessing of new life and the *waters of birth. So, too, the spring festival of *Passover celebrates the rebirth of the Jewish People. And the historical rebirth of the Jewish People foretells a future rebirth, the final resurrection of the dead. To the rabbis, this *tal shel tehiyah*, the spiritual dew of life, awaits us in the *Messianic Age.[1] According to the *midrash*, dew served both as a *table and a protective cover for the *manna which fell each morning in the *wilderness.[2]

In contrast to rain whose blessing has traditionally been linked to human merit, dew is seen as a gift of grace, unconditionally granted to the earth.

According to the kabbalists, dew represents the Feminine *Waters, the source of spiritual energies which rise from below, in contrast to *rain, which represents the Masculine Waters, raining down spiritual energies from above.

[1]*Hagigah* 12b; [2]*Mekhilta de-Rabbi Ishmael, Va-Yassa*, 4.

Signifies: BIRTH, BLESSING, DIVINE SPIRIT, DIVINE GRACE, REBIRTH, RESURRECTION

Generic Categories: Messiah, Natural Phenomena, Passover

See also: Manna, Passover, Water

DOVE — יוֹנָה, תּוֹר.

Throughout the world, the dove, traditionally depicted as *white, symbolizes purity, vulnerability, and innocence. It is also a traditional symbol of fidelity and affection. Like all *birds, the dove symbolizes the soul striving toward God.

In Jewish tradition, the dove similarly symbolizes purity, innocence, and beauty. In the Song of Songs, the lover calls his beloved a "faultless dove."[1] While the *Temple still stood, doves were brought as sacrificial offerings by the poor and the Nazirite.[2] The rabbis considered doves suitable for

A stylized dove.

sacrifice because "there is none among the birds more persecuted than doves."[3] They were also less costly than herd animals, and thus a symbol of simplicity and modesty.

Doves are the gentlest of birds, unable to fight either with their claws or beaks. In the story of *Noah's *ark, it was a dove who brought back an *olive leaf in her mouth, letting Noah and his family know that the waters had subsided enough for life to reappear on earth.[4] This dove with an olive branch in its mouth, together with the *rainbow, has long been an emblem of peace.

The persecuted dove, an indefatigable flyer, also symbolizes the Jewish People, who perseveres despite continuous suffering. Above *Solomon's *throne perched a dove with a hawk in its talons, symbolizing the ultimate victory of Israel over its enemies.[5]

The turtledove, sometimes called "turtle" in archaic English translations of the Bible, has long been considered a harbinger of spring in Israel, returning in large flocks at the onset of warm weather and filling the woods with song: "The blossoms have appeared in the land; the time of pruning has come; the song of the turtledove is heard in our land."[6] Because of their association with spring, turtledoves have therefore come to symbolize hope and rebirth. A pair of doves are a classic emblem of love, often adorning illuminated manuscripts.

The turtledove, noted for its sweet song and its colorful plumage, was once sacrificed as a sin offering in the *Temple. Because of its vulnerability, it has been a

symbol of innocence in the midst of wickedness.[7]

[1]Song of Songs 5:2; [2]Leviticus 5:7; Numbers 6:10; [3]*Bava Kama* 93a; [4]Genesis 8:11; [5]Ginzberg, *Legends of the Jews* 4:157; [6]Song of Songs 2:12; [7]Psalm 74:19.

Signifies: BEAUTY, HOPE, INNO-CENCE, JEWISH PEOPLE, LOVE, MODESTY, PEACE, PURITY, RE-BIRTH, SIMPLICITY, SOUL, SPRING

Generic Categories: Animals

See also: Bird, Ark (Noah's), Noah, Olive, Rainbow

DREAMS – חֲלוֹמוֹת.
From ancient times, dreams have perplexed, awed, and sometimes alarmed the dreamer. In the ancient world, dreams were regarded as passageways to realms otherwise inaccessible to the wakeful mind: the heavens, the world of evil spirits, the future. In ancient Mesopotamia and *Egypt, there were dreambooks to interpret dreams. Oneiro-mancers, "dream diviners," were revered for their awesome powers. In our own time, dreams still fascinate us, and we continue to consult our own oneiromancers, notably Freud, Jung, and their disciples.

The Bible is full of dreamers and dream-interpreters. *Jacob dreams of a *ladder full of *angels. Samuel and *Solomon dream of God's voice calling them to sacred missions. *Joseph, perhaps the most famous dreamer and interpreter in the Bible, makes his fortune because of his skill in deciphering dreams. *Daniel, too, was famous for interpreting dreams that foretold the future. But not all dreams are true, the prophets warned. According to the Bible, a dream is true only if its prophecies come to pass,[1] for true dreams only come from God, who has the power to fulfill them.[2]

In the Talmud, dreams were regarded with a mixture of respect and suspicion. Rabbi Jonathan claimed that the stuff of dreams was "only what is suggested by [a man's] own thoughts."[3] But others granted real power to dreams, calling them "a variety of prophecy."[4] Accordingly, some rabbis observed a special fast — *taanit halom* — after a bad dream, or recited a special prayer: "If they are good dreams, confirm and reinforce them like the dreams of Joseph, and if they require a remedy, heal them . . . turn all my dreams into something beneficial for me."[5] To this day, some people recite this talmudic blessing after a bad dream.

According to the *Zohar*, dreams contain a mixture of prophecies from both the higher world and the "*Sitra Ahra*," the Other Side. The dreams of sinners derive from impure forces; those of the righteous, presided over by the *angel Gabriel, consist mostly of visions and prophecies seen by the soul in the higher worlds.

Maimonides, anticipating Freud, claimed that dreams are a by-product of the human imagination. But only the prophet, because of his or her developed spiritual abilities, can safely use dreams to divine truth.[6]

[1]Zechariah 10:2; [2]Genesis 40:8; [3]*Berakhot* 55b; [4]*Genesis Rabbah* 17:5; [5]*Berakhot* 55b; [6]See Maimonides, *Guide of the Perplexed* 2:36–38.

Signifies: DIVINE GUIDANCE, IMAGI-NATION, PROPHECY, TRANSITION

Generic Categories: Kabbalistic Symbols

See also: Daniel, Jacob, Joseph

DREIDL – סְבִיבוֹן.
The *dreidl*, a four-sided top inscribed with Hebrew letters, is one of the best-known symbols of Hanukkah. Although gambling is traditionally forbidden during the rest of the year as a waste of time which could be better spent on Torah study, the rabbis relaxed their strictness for this festival of joy.

The history of the *dreidl*'s letters aptly illustrates the tangled evolution of Jewish folkways and symbolism. In medieval Germany, gambling dice had four letters inscribed on their sides —

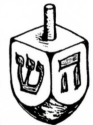

Dreidl showing letters *heh* and *shin*.

N, G, H, and S — representing the words "nichts" (nothing), "ganz" (all), "halb," (half) and "stell ein" (put in). Jews translated these letters into their Hebrew equivalents: *nun* (נ), *gimmel* (ג), *heh* (ה), and *shin* (ש), and then made up a verse using the four letters to commemorate the miracle of Hanukkah: "*nes gadol hayah*

sham" — "A great miracle happened there." The borrowers also argued that the numerical value of these four Hebrew letters equals 358, the same as the value of *Mashiah* (Messiah). But when Ashkenazim play *dreidl*, they usually use the Yiddish words similar to the original German. So, the wheel has come back full circle. Thus, a secular custom was successfully "Judaized," metamorphosing from a symbol of gambling into one of celebration and commemoration. Given its fascinating history, we might also consider the little *dreidl* a symbol of Jewish adaptability.

In Israel, the Hebrew letters on the *dreidl* are slightly different: *"nes gadol hayah po"* (substituting a *peh* for a *shin*) — "A great miracle happened *here*." The *dreidl* itself has received a name change in modern Israel: *"sevivon,"* Hebrew for a "spinning" top.

This originally European game has been adapted by Sephardi children in Israel. Yemenites make *dreidls* called "duame," out of *nutshells.

Signifies: ADAPTABILITY, CELEBRATION, JOY, MIRACULOUSNESS, REMEMBRANCE, REVERSAL OF FATE

Generic Categories: Hanukkah, Messiah

See also: *Alephbet*, Four, Hanukkah

EAGLE — נֶשֶׁר.

The eagle, like many animals mentioned in the Bible, is a bivalent symbol, that is, one with both positive and negative associations. As the mightiest winged predator, it symbolizes power, victory, and royalty. Its counterpart among the beasts is the *lion; among human beings, the *king or *queen.

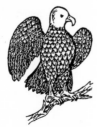

The eagle is also the symbol of imperial *Rome. Jupiter, the

A stylized eagle.

chief god of the Romans, is often depicted as an eagle with thunderbolts clasped in its talons. During Herod's reign, a *golden eagle perched above the *Temple *gates, a source of continuous tension between Herod and the Jews under his jurisdiction. In Eastern European Jewish folk art, eagles, the national emblems of both Poland and Prussia, represented these two regimes oppressive to their Jewish citizens.

On the other hand, the Bible also uses the image of the eagle to represent God's mercy and protectiveness. Eagles carry their young to teach them to fly. So, too, God reminds the Israelites: "You have seen what I did to the Egyptians, how I bore you on eagles' *wings and brought you to Me."[1] When the Jews of Yemen were brought to Israel after the establishment of the state in 1948, they regarded the airplanes that flew them to the Holy Land as a modern version of these same "eagles' wings," a symbol of God's salvation. When used in synagogue art, the eagle symbolizes God's power, superior to that of earthly monarchs.

In the Mishnah, the eagle's lightness is cited as one of the qualities needed to perform God's will: "Be as strong as a *leopard, as light as an eagle, as swift as a *deer, as brave as a lion to do the will of your Father in heaven."[2] For many centuries, these *four animals have been represented in paintings, weavings, and ceremonial objects in synagogues and Jewish homes.

Because of its speed and ability to soar higher than other birds, the eagle symbolizes prayer. "Were our hands outspread like eagle's wings," declares the morning liturgy, we would still be unable to give adequate thanks for God's blessings.

For Jews who have come as immigrants to the United States, the American eagle, the national emblem of this country, has become a symbol of religious freedom and economic opportunity, and has been incorporated into American Jewish folk and ritual art.

[1]Exodus 19:4; [2]*Pirke Avot* 5:23.

Signifies: DIVINE COMPASSION, DIVINE PROTECTION, FREEDOM, GRACE, OPPORTUNITY, OPPRESSION, POWER, POLAND, PRAYER, PRUSSIA, ROYALTY, SALVATION, UNITED STATES, VICTORY

Generic Categories: Animals

See also: King, Lion, Queen, Rome, Wings

EARTH — אֶרֶץ.

Although the ancients did not know that our planet consists primarily of ocean, they were nonetheless con-

vinced of the fragility of solid ground as a human habitat. Most early creation myths imagined the earth as a thin platform suspended between *water and sky. The first chapter of Genesis states that God separated the lower and upper waters to create dry land which, according to later legend, consists of *seven layers below to mirror the seven heavens above. In the Bible, the land rests on pillars[1] and has *four *corners; in rabbinic legends, the earth rests on the Foundation Stone—*Even Ha-Shitiyyah*—which is the bedrock of the *Temple, and the center of the earth toward which all water sources flow.

Early biblical tradition, like most ancient cultures, regarded the earth as the mother of humanity, worthy of respect and love. The first humans, *Adam (from *adamah*—earth) and *Eve (from *havvah*—living), were given dominion over the Garden of *Eden, but in betraying God's trust, they brought a curse upon the ground. As a result, human beings have been condemned to return to the earth from which they came: "From dust you are, and to dust you shall return."[2] Likewise, Cain, in making the earth an accomplice in hiding his brother's *blood, cursed it.[3]

Yet despite its curse, the earth is still our primary source of blessing. Therefore, the Bible mandated that the land of Israel be granted its own *Shabbat every seven years, during which nothing was to be planted, symbolically returning the land to its original Edenic state. And every fiftieth year—the Sabbath of seven sabbatical cycles—was to be a Jubilee (from the Hebrew *Yovel*), during which slaves would go free, debts would be annulled, and tribal lands would revert to original ownership. This restoration of social order would thus imitate the restoration of natural order enacted each sabbatical year. In modern Israel, many Jews still observe the agricultural sabbatical year.

The earth is also the instrument of God's will. According to legend, it opened up to hide Hebrew babies from *Pharaoh's wrath and the Temple vessels from the Romans, and carried out God's punishments by swallowing up the Tower of Babel, Korah, and Nineveh.

The Land of *Israel has always been regarded in Jewish tradition as sacred. To this day, Israel is called the "Holy Land" or simply "the Land" (*Ha-Aretz*), and many Jews still kiss the ground when they arrive there. It has become customary to bury Jews in the Diaspora with a bag of earth from Israel to symbolize their burial there, and to ensure them a speedy resurrection in the *Messianic Age when all the dead will return to Zion. Also in the Messianic Age, Adam's curse will be reversed and the earth will regain its former fertility.

[1]Psalm 75:4; Job 9:6; [2]Genesis 3:17–19; [3]Genesis 4:11–13.

Signifies: BLESSING, CURSE, DEATH, DIVINE WILL, FERTILITY, REBIRTH, RESURRECTION, SIN, SOURCE OF LIFE

Generic Categories: Astronomy, Messiah, Natural Phenomena, Temple

See also: Adam, Ashes, Corners, Eden, Eve, Israel, Jerusalem, Messiah, Temple, Water

EAST — מִזְרָח. Before the invention of clocks and electricity, the *sun ruled people's lives. They rose and slept to its daily rhythms, planted and harvested by its seasons, and depended upon its *light and warmth. It is no wonder that many peoples worshiped it as a god.

In Judaism, the east, where the sun rises, became synonymous with beginning time; the Hebrew word *kedem*, "early," derives from the word meaning east. The more common word for east—*mizrah*—similarly comes from the root "to cast forth rays" as the sun does each morning.

On the sacred compass of Judaism, east, not north, is the direction of primal "orientation" (from Latin, "to rise"). East represents origins and salvation. The Garden of *Eden was planted "in the east."[1] The plague of *locusts and the *wind that split the Sea came from the east.[2] The Israelites journeyed east toward the Promised Land. And *Jerusalem, the heart of the world and

Mizrah: enlarged letters spell *mizrah*, east, an acrostic that translates "from this side comes the spirit of life."

the site of the future redemption, lies to the east of most communities in the Diaspora.

From biblical times to the present, Jews have faced Jerusalem when they pray.[3] As Jews moved westward away from Israel, east came to symbolize Jerusalem, the source of Jewish faith and national memory. The *ark was placed in the eastern wall, so worshipers could face the Holy City. (Synagogues to the east, north, or south of Jerusalem face toward the city, not eastward.) But because pagan temples were likewise oriented toward the east, the rabbis reminded Jewish worshipers that God existed everywhere, not only in the east. Facing east, they explained, serves only to focus one's prayers on God's Presence, symbolized by the *Temple, not toward the sun. Some authorities even recommended facing southeast, rather than due east, to avoid this possible confusion with sun-worship.[4] But despite the rabbis' warnings, east became a holy direction in Jewish prayer; a seat on the eastern wall of the synagogue became a sign of high social status.

The bride and groom face east under the *huppah. Traditional Jews bury their dead with their feet facing east so that they can be on their way toward Jerusalem when the *Messiah comes to resurrect them.

In many Jewish homes, a calligraphic design called a mizrah hangs on the eastern wall to aid meditation and prayer, much like an oriental mandala. (A similar ornamental plaque called a shiviti sometimes hangs on synagogue walls as an aid to prayer.) The mizrah also symbolizes divine protection of one's home. Traditionally, a mizrah has the Hebrew word מזרח – "mizrah," written on it, as well as the biblical verse: "From the rising (mi-mizrah) of the sun unto its going down, the Lord's name is to be praised."[5] Other biblical, liturgical, and *kabbalistic verses are also common, such as "from this direction comes the spirit of life" [Hebrew: "mi-tzad zeh ruah hayyim"], a verse whose acronymnic form spells "mizrah." Mizrahim are frequently decorated with images of animals, pictures of holy places, or kabbalistic symbols, sometimes rendered in micrography. In Eastern Europe, mizrahim were sometimes paper-cut.

The Israeli national anthem, "Hatikvah" ("The Hope"), declares that "as long as the eye looks eastward, gazing toward Zion, our hope is not lost."

[1]Genesis 2:8; [2]Exodus 10:13; 14:21; [3]1 Kings 8:29, 44; 2 Chronicles 6:34; Daniel 6:11; Berakhot 30a; [4]JT Sukkah 5:4; Isserles, Orah Hayyim 94:2; [5]Psalm 113:3.

Signifies: BEGINNING, EXILE, GOD, HOLINESS, HOPE, KAVVANAH, PRAYER, SALVATION, STATUS

Generic Categories: Israel (Land of), Prayer, Synagogue, Temple

See also: Ark, Jerusalem, Messiah, Sun, Synagogue

EDEN – גַּן עֵדֶן.

Most peoples tell stories about an idyllic realm set in the mythic past when the earth and humankind were in their infancy, innocent and without blemish. This past Golden Age often prefigures a future paradise, either on this earth or in some supernatural realm, when the original harmony will be restored.

In Jewish tradition, Gan Eden, the Garden of Eden, refers to both realms: the idealized birthplace of humanity and the paradise of the righteous, the closest Judaism comes to a notion of heaven.

Chapters two and three of Genesis describe the original Garden of Eden as a place of fertility, harmony, and ease, watered by *four great rivers. God gives the first two gardeners *Adam and *Eve dominion over the garden and commands them to tend it. Later legend situates Eden either in the Land of *Israel, Arabia, or in the center of Africa.[1] After Adam and Eve are expelled from the garden, *cherubim with fiery swords ban the way back.

In time, the garden acquired more symbolic significance. Ezekiel called it "God's holy mountain" filled with "stones of fire."[2] Often the distinction between the biblical Garden of Eden and the dwelling place of the righteous after death, also called the Garden of Eden, Paradise, or the World to Come, was blurred. The phrase "Garden of the Lord" came to mean an ideal realm of extraordinary fertility and blessing.[3] Maimonides turned the story of the Garden of Eden into an allegory dramatizing humanity's fall from intellectual perfection into the baser world of the body and its passions.[4]

The weekly experience of *Shabbat* reminds humanity of what life was originally like in the Garden; in the Messianic Age, God will reveal Eden's location, and humanity will once again experience an eternal *Shabbat* in Paradise.

The Garden of Eden is also a symbol of peace. All the original dwellers, including Adam and Eve, were vegetarians. God was the caring Gardener, and disease and death were unknown. This is also the image of the Messianic Age.

After a *wedding banquet, *seven blessings are recited, one of which asks God to gladden the newlyweds as *Adam and Eve gladdened each other in the Garden of Eden, here invoked as a symbol of perfect marital bliss.

[1]*Eruvin* 19a; *Tamid* 32b; [2]Ezekiel 28:13–14; [3]Genesis 13:10; Isaiah 51:3; Ezekiel 36:35; [4]*Guide of the Perplexed* 1:2.

Signifies: BEGINNING, BIRTH, BLESSING, DEATH, ETERNITY, FERTILITY, HARMONY, HEAVEN, IMMORTALITY, PEACE, PERFECTION, REDEMPTION, VEGETARIANISM

Generic Categories: Messiah, Places

See also: Adam, Eve, Orchard, *Shabbat*, Serpent, Tree

EGG – בֵּיצָה. In most religious traditions, the egg symbolizes life and continuity, because its shape suggests the round of days; immortality, because it magically yields life; and occult knowledge, because its opaque shell conceals mysteries. In ancient Egypt, the egg was the hieroglyph of potentiality. The World Egg is an image found in numerous creation myths.

Jewish tradition expresses some of these ideas in its ceremonial and festival diet. The egg has long been a symbol of mourning and consolation, because its round shape as well as its role in the cycle of life reminds us of "the wheel [of life] which continually revolves in the world." And its lack of an outer opening teaches us that "one must not open one's mouth in complaint" about our ultimate destiny as mortal beings.[1] Mourners traditionally eat eggs at the *Seudat Havraah*, the meal after the burial.[2] Eggs are also eaten at the meal before the fast of *Tisha B'Av, as well as at the

*Passover *seder, as a sign of mourning for the destruction of the *Temple and for the loss of the paschal sacrifice.

A second reason hard-boiled eggs are eaten at the Passover *seder* is to symbolize spring and rebirth. A roasted egg, placed upon the *seder* plate but not eaten, is a symbol of a second sacrifice once performed at this season, the *hagigah* or festival offering.

Because of its *whiteness, symbolic of purity, and its associations of life and rebirth, the egg is also a good luck charm. In Eastern Europe, whoever ate the egg from the *seder* plate would see his wishes come true. Hence, the practice of serving an extra plate of hard-boiled eggs at the *seder*.

According to the sages, eggs, because of their association with reproduction, stimulate sexuality.

[1]*Bava Batra* 16b; [2]*Yoreh De'ah* 378:9 of *Genesis Rabbah* 63:14.

Signifies: BEGINNING, CONTINUITY, DEATH, GOOD LUCK, LIFE, MOURNING, MYSTERY, POTENTIALITY, PURITY, REBIRTH, SACRIFICE, SEXUALITY, SPRING

Generic Categories: Food, Passover, Death, Temple, Tisha B'Av

See also: Circle, Passover, *Seder*, Tisha B'Av, White

EGYPT – מִצְרַיִם. The Hebrew word for Egypt, *Mitzrayim*, sounds like other Hebrew words meaning "narrow place" (*meitzar*) and "troubles" (*tzarot*–"*tzuris*" in Yiddish), a similarity often noted by commentators. In Jewish history, Egypt represents the archetypal experience of oppression, and *Pharaoh, its master architect. The *Exodus from Egypt marked the beginning of Jewish nationhood, and is commemorated throughout the liturgy and festival cycle with the phrase: "*zekher litziyat Mitzrayim*," a memorial of the Exodus from Egypt.

Egypt also represents the stage upon which God's power and justice were first demonstrated to the world. "With signs and wonders, with a strong hand and an outstretched arm," God brought the Children of Israel forth from bondage into freedom.[1] Every year at *Passover, Jewish

families reenact the story of Egyptian bondage and God's redemption by reciting the *Haggadah* at the *seder. Many of the rituals and symbols on the seder table refer to events that took place long ago in Egypt. Psychologically, the ceremony is designed so that each participant can personally re-experience the Exodus from Egypt. The expression, "getting out of Egypt," has come to mean liberation from other experiences of enslavement and despair.

[1]Exodus 13:14.

Signifies: DIVINE POWER, FREEDOM, LIBERATION, OPPRESSION, REDEMPTION, SLAVERY

Generic Categories: Passover, Places

See also: Chariot, Exodus, Passover, Pharaoh, *Seder*

EIGHTEEN – שְׁמוֹנָה עֶשְׂרֵה, יֹ"ח.

According to *gematria*, the rabbinic system of numerical symbolism, each letter of the Hebrew alphabet represents a number. These equivalences are seen not merely as coincidental; they represent purposeful conjunctions of the higher and lower worlds.

Hai (equaling eighteen in *gematria*) means "life," and is a popular good luck charm.

The word *hai* (also written *chai*), meaning life, consists of two Hebrew letters: het, equivalent to the number 8, and *yud*, equivalent to ten, which together equal 18. Because the value of these two letters "adds up to" life, 18 has become a lucky number for Jews. Many Jews wear the word *"hai"* as a pendant or charm, and give $18.00 (or multiples of $18.00) as gifts or charity to ensure good luck and long life.

This number has long been important in Jewish liturgy. According to the rabbis, the eighteen blessings of the *Amidah* or "Shemoneh Esrei" (literally "the Eighteen"), the central prayer of the service, derive their inspiration from the eighteen mentions of the *Name of God in the *Shema* and Psalm 29, as well as from the fact that there are eighteen vertebrae in the spinal column.[1] There are also eighteen mentions of God's name in the Song of the Sea (Exodus

15:1-21). One of the mystical names of God, the Name of Seventy-Two, is the product of the Four-Letter Name—YHVH—times *four.

Matzah must be baked no longer than eighteen minutes, a number possibly chosen due to its associations with holiness and luck. (It is likewise easier to remember than other numbers because of its significance in Jewish tradition.)

An ancient tradition maintains that in every generation there are thirty-six hidden *tzadikim* (righteous people)—two times eighteen—called *"lamed-vavniks"* (the Hebrew letter *lamed* equals thirty; *vav* equals six), for whose sake the world continues.

[1]*Berakhot* 28b; *Leviticus Rabbah* 1:8.

Signifies: GOOD LUCK, LIFE, LONGEVITY

Generic Categories: Numbers

See also: *Alephbet*, *Matzah*, Name of God, Numbers

ELIJAH – אֵלִיָּהוּ.

No other biblical figure, not even *Moses, has enjoyed as much popularity in the Jewish folk imagination as *Eliyahu Ha-Navi*, Elijah the Prophet. Paradoxically, the biblical Elijah—prophet of wrath and intolerance—bears little resemblance to this popular Elijah, whom later legend transformed into a compassionate champion of the poor and a herald of the *Messiah.

Elijah lived in the 9th century B.C.E. during the corrupt reign of King Ahab and his foreign queen Jezebel. Elijah's zeal for God—his name means "my God is YHVH"—led him into direct confrontation with the powerful priests of Baal, whom he defeated on Mount Carmel by invoking heavenly *fire. Forced to flee, Elijah came to Mount Horeb, as had Moses before him, to encounter "the still small voice" of God.[1] When it came time for Elijah to die, God took him up to heaven in a fiery *chariot, leaving behind Elijah's magic mantle for his disciple Elisha.[2]

By the time of Malachi, the last of the prophets, Elijah had already achieved legendary stature as a harbinger of Messianic redemption: "Behold, I will send the prophet Elijah to you before the coming of the awesome, fearful day of the Lord."[3]

The early Christians claimed Elijah for their own legendary tradition. Jesus declared that John the Baptist was Elijah reincarnated. Because of this Christian appropriation, the rabbis made some efforts to demythologize Elijah's image, debating his heavenly ascension[4] and criticizing his impatience with the Jewish People.[5] They tried to limit his role to that of the future arbiter of insoluble halakhic questions.

But Elijah's reputation was not so easily diminished. The tradition accords him many more roles than did the talmudic sages. He is characterized as a peacemaker; the recorder of marriages decreed in heaven; blesser of barren women; interpreter of cryptic passages in the *Torah and Talmud; intercessor with heaven to bring *rain and other blessings; protector of slaves, the poor, and the oppressed. He customarily appears to people disguised as a beggar or vagabond.

Two roles in particular have earned Elijah an honored place at many Jewish rituals and celebrations. Tradition assigns him the task of upholding Brit Ha-Dorot, the covenant between the generations. Accordingly, he serves as the guardian *angel of newborn children and young people fated to die prematurely. In the Messianic Age, "he shall reconcile parents with their children and children with their parents, so that, when I come, I do not strike the whole earth with utter destruction."[6] His presence as protector and messianic herald is invoked at *circumcisions, where a special *Chair of Elijah is reserved for him.

Even more central is his role as messianic herald. At the End of Days, Elijah, at the Messiah's command, will blow the *shofar, revealing the Primal *Light of Creation, reviving the dead, and rebuilding the *Temple. His arrival will banish all evil from the earth.[7] At the *Passover *seder, a full cup of wine, called Elijah's *Cup, is set out on the table, but not drunk, in expectation of the prophet's arrival to announce the dawn of the Messianic Age. At the *Havdalah ceremony, Elijah's name is invoked in the hopes that he will come to usher in the final eternal *Shabbat of the Messianic Age.

The kabbalists elaborated on the supernatural qualities of Elijah, claiming the prophet was originally an angel, created from the Tree of Life.[8] Periodically, he returns to earth to reveal himself to tzaddikim (holy souls), and expounds to them the secrets of the Torah. According to some hasidic teachings, Elijah integrates the male and female aspects within each human being.[9]

Folk tradition abounds with tales of Elijah's mysterious appearances and disappearances, usually in the service of common people in need. The midrash traces his ancestry back to *Rachel, who was praised for her mercy and concern for her exiled children.[10] He frequently plays the role of miracle-worker or fairy godfather, intervening to make peace between husbands and wives, to bestow wishes, and to right wrongs. His name is often invoked in *amulets and practical *Kabbalah (magic), especially to protect children. The expression, "until Elijah comes," is a folk expression meaning "a very long time."

[1] 1 Kings 19:8–18; [2] 2 Kings 2:11–12; [3] Malachi 3:23; [4] Sukkah 5a; [5] Song of Songs Rabbah 1:6, no. 1; [6] Malachi 3:24; [7] Ginzberg, Legends of the Jews, 4:233–235; [8] Ginzberg, 4:201, 6:325, n. 39; [9] Gottlieb, Lamp of God, 403–405; [10] Genesis Rabbah 71:9.

Signifies: BLESSING, COMPASSION, ETERNITY, GUARDIANSHIP, INTERCESSION, MAGIC, MIRACULOUSNESS, PEACE, PROTECTION, RECONCILIATION, REDEMPTION, ZEALOUSNESS

Generic Categories: Brit, Kabbalistic Symbols, Messiah, Passover, Personalities

See also: Amulet, Angels, Brit, Chair, Chariot, Cup, Havdalah, Kabbalah, Messiah, Passover

ESAU – עֵשָׂו.

Esau was *Jacob's twin brother, the elder by only a matter of moments, but because of the ancient laws of inheritance, *Isaac's sole legitimate heir. The Bible translates Esau's name as meaning *red and hairy, an indication, according to later commentators, of his bloodthirsty nature and wildness.[1] Esau's other name, "Edom" (from adom, red), refers to the porridge of red *lentils for which Esau sold his birthright.[2]

In legend, Esau became the archetype of Israel's enemy, the ancestor of *Amalek and *Haman, and the symbol of *Rome.

Although occasionally portrayed as penitent,[3] Esau usually symbolizes unregenerate evil. After the abortive Bar Kokhba revolt against Rome in 135 C.E., the rabbis declared: "The voice of Jacob cries out at what the hands of Esau did to him at Betar."[4]

Edom, the nation supposedly descended from Esau, was also a symbol for Israel's eternal enemy.[5] Edomites participated in the destruction of the First *Temple, and their legendary descendants, the Romans, destroyed the Second. Herod, the despised agent of Rome, was also an Edomite. When Rome embraced Christianity, Edom became a symbol for Christian Rome, and then for Christianity in general.

[1]Genesis 25:25; *Genesis Rabbah* 63:8; [2]Genesis 36:1; [3]*Genesis Rabbah* 78:9; [4]JT *Taanit* 4:5, 68d; [5]Amos 1:11; Ezekiel 35:5.

Signifies: CHRISTIANITY, CRUELTY, ENEMY, EVIL, HUNTING, JEALOUSY, SIBLING RIVALRY, VIOLENCE, WILDNESS

Generic Categories: Personalities, Temple

See also: Amalek, Haman, Jacob, Red, Rome

ESTHER — אֶסְתֵּר.

Esther, whose name, even according to Jewish tradition, is derived from Ishtar, the Persian equivalent of Venus, Goddess of Beauty[1] as well as the morning *star, is the heroine of the biblical book which bears her name. Another of her names is *Ayelet Ha-Shahar* ("Morning Star"). According to legend, when the Jews of Persia were in danger, she recited Psalm 22, which begins with these words. She is also known as Hadassah, which means "*myrtle."[2]

According to Jewish legend, Esther was one of the four most beautiful women in the world, of perfect height like a myrtle, with a necklace of loving-kindness strung around her neck.[3] Because of her courage, the Jews of Persia were saved from the massacre contrived by the wicked *Haman. Her name also suggests hiddenness — "*seter*" (סתר) — an attribute that allowed Esther to disguise her Jewish identity until she had won King Ahashverosh's heart and could thus save her people. Her name also

suggests modesty, another one of her traditional attributes.

On *Purim, the holiday which celebrates the Jews' victory over Haman, it is traditional for girls to dress up as Queen Esther. It is also traditional to eat *chickpeas to commemorate Esther's vegetarian diet while in Ahashverosh's palace. Both the minor fast before the holiday and the scroll — the *Megillah* — containing the biblical book, bear Esther's name.

[1]*Megillah* 13a; [2]Esther 2:7; [3]*Megillah* 15a, 13a.

Signifies: BEAUTY, CLEVERNESS, COURAGE, HIDDENNESS, KINDNESS, MODESTY, VEGETARIANISM

Generic Categories: Personalities, Purim, Women

See also: Bear, Chickpea, Crown, Haman, *Megillah*, Myrtle, Purim, Queen

ETROG — אֶתְרוֹג.

In the Torah, Jews are commanded to take *Four Species: "the fruit of a goodly tree" — "*peri etz hadar*" — together with the *lulav (*palm branch), and branches of *myrtle and *willow, as part of the celebration of *Sukkot.[1] Tradition has identified this fruit as the *etrog*, or citron, a yellow citrus fruit similar in size and taste to a lemon.

During the Second *Temple period and for several centuries thereafter, the *etrog* was a central ornamental motif on Israelite coins, *synagogue walls, and mosaic floors. In later periods, it was a messi-

The *etrog*, or citron, CITRUS MEDICA.

anic symbol, especially on sarcophagi, because of its association with the supremely joyous Sukkot celebrations in the ancient Temple and the messianic themes of this holiday. It is customary to protect the fruit, especially the *pittam*, its fragile stem, during the holiday of Sukkot in a special box, often ornately decorated.

Compared to the *heart and admired both for its pleasant taste and sweet smell, the *etrog* has become a popular homiletic symbol, representing the Jew who has both learning and good deeds to his or her credit. The *etrog* is unique among fruits because

its female organ, the *pittam*, through which it is fertilized, does not drop off when the fruit is ripe, and because the tree bears fruit throughout the year. In addition, the *etrog* is shaped like a woman's uterus and cervix. Accordingly, the *etrog* is a symbol of female fertility and generativity. When joined with the *lulav*, which is a phallic symbol, the two represent sexual duality and balance, a fitting symbol for the harvest festival of Sukkot.

According to legend, the *etrog*, also called "the apple of Paradise," may have been the forbidden fruit eaten by *Adam and *Eve in the Garden of *Eden, based on a wordplay with the Hebrew verb "to desire" (*ragag*).[2] Because Eve's punishment for eating this fruit was to bear children in pain, popular folklore recommends that pregnant women eat an *etrog* to ease the pain of childbirth. Women would sometimes bite off the *pittam* (stem) after Sukkot and place it under the pillow of a woman experiencing difficult labor. The Talmud claims that a pregnant woman who eats an *etrog* produces "fragrant children."[3]

[1]Leviticus 23:40; [2]Nahmanides on Leviticus 23:40; [3]*Menahot* 27a.

Signifies: BEAUTY, FEMININITY, FERTILITY, LEARNING, SWEETNESS

Generic Categories: Botany, Food, Sukkot, Women

See also: Four Species, *Lulav*, Messiah, Myrtle, Palm, Sukkot, Temple, Tree, Willow

EVE — חַוָּה. *Havvah*, Eve's Hebrew name, means "life" (related to *hayyim* and *hai*). As the first woman and mother, Eve symbolizes the mother of life.[1]

The Bible provides two competing stories about the origin of the sexes: the first account states that both male and female beings were created simultaneously.[2] A second account claims that woman was created out of Adam's rib. In this latter version, Eve symbolizes women's subordination to men: her birth from Adam's body is a mirror image of female childbearing.[3] (To reconcile the two versions, Jewish legend granted Adam two wives: Eve and *Lilith.)

In the story of the Garden of *Eden, the *serpent tempted Eve to eat from the forbidden *Tree of the Knowledge of Good and Evil, and she in turn gave Adam a bite of the deadly fruit. Her punishment for disobeying God was to bear children in pain and to be ruled by her husband.[4] After Adam and Eve's expulsion from the Garden, Eve bore two sons, Cain and Abel, and then Seth, to replace the murdered Abel.[5] Although the Torah states that Adam later had many more sons and daughters, Eve is not mentioned as their mother. In fact, after the birth of Cain and Abel, Eve's name is never again mentioned in the Bible.

Within the sanctioned context of the Jewish family, Adam and Eve symbolize the first marriage, arranged and celebrated by God and the *angels. They are invoked in the *seven *wedding blessings as the ideal couple rejoicing together.

In the *midrash*, the rabbis paint a notably unflattering portrait of Eve, characterizing her as morally and spiritually flawed, concluding that these deficiencies typify her sex. They even make a pun of her name, connecting it with the Aramaic "*hivya*" — serpent, calling her "Adam's serpent."[6] To modern sensibilities, the biblical story of Eve epitomizes a strain of misogyny within the rabbinic tradition.

[1]Genesis 3:20; [2]Genesis 1:27; [3]Genesis 2:21-23; [4]Genesis 3:16; [5]Genesis 4:25; [6]*Genesis Rabbah* 20:11.

Signifies: EQUALITY, LIFE, MARRIAGE, MISOGYNY, MOTHERHOOD, SUBORDINATION

Generic Categories: Personalities, Women

See also: Adam, Eden, Lilith, Serpent, Wedding

EVIL EYE—עַיִן הָרַע, עַיִן רָעָה.
The belief in the Evil Eye, *ayin raah*—that is, the notion that a malevolent glance can bring harm to another person—is a part of many folk traditions. Even people who pride themselves on being modern rationalists still respect this ancient superstition. Today, many Jews continue to mutter "*kaynahora*," Yiddish for "against the Evil Eye," when expressing a positive sentiment

or hope, lest their own good fortune provoke retribution from evil forces.

The Talmud credits several sages with the power to "transform people into a heap of bones" with a glance. The ancient rabbis believed in the Evil Eye, citing jealousy as its most frequent cause.[1] In Jewish folk belief, many practices have evolved whose purpose is either to avert or to deflect the Evil Eye. Since the Evil Eye is activated by jealousy, one can forestall its effects by abstaining from praise, veiling beauty (the possible origin of the bridal veil), avoiding excessive celebration such as a double *wedding, not calling relatives to the *Torah consecutively, hiding the display of riches, and giving children ugly names. The custom of breaking a precious glass at Jewish *weddings may have originally symbolized the couple's spurning of wealth, a gesture designed to avert the envious Evil Eye. As the Talmud says: "Blessing comes only upon those things which are hidden from the eye."[2]

If, however, the Evil Eye has been activated in the absence of or despite precautions, one can ward off its harmful effects by taking various measures: using a *mirror or something colored *red or *blue to deflect it; putting it to shame with an obscene gesture or a holy verse in an *amulet; distracting it with an attractive decoy such as a precious stone; or holding up one's *hand or a *hamsa, the symbol of an outstretched hand, often with an eye depicted in the palm, the good eye counteracting the evil one.

Where does the power of the Evil Eye come from? It has long been believed that some people are born with the capacity to inflict harm on others simply by gazing upon them. The Maharal of Prague, reputed creator of the *Golem, claimed that such a cursed eye could cast off consuming fire.[3] Some have claimed that the Evil Eye originates from supernatural sources—avenging *angels or the *Sitra Ahra*, literally, the Other Side, i.e., Satan's dominion—provoked by envy of human happiness. Rationalist explanations have suggested that the fear of the Evil Eye originates within the human psyche itself.

[1]*Genesis Rabbah* 45:5; *Genesis Rabbah* 84:10;
[2]*Taanit* 8b; [3]Trachtenberg, *Jewish Magic and Superstition*, 56.

Signifies: ANXIETY, BAD LUCK, EVIL, JEALOUSY, REVENGE

See also: Angels, Blue, Eye, *Hamsa*, Hand, Mirror, Red

EXODUS – יְצִיאַת מִצְרַיִם.

The *Exodus from Egypt marked the beginning of Jewish nationhood, and is commemorated throughout the liturgy and festival cycle with the phrase, "*zekher li-tziyat Mitzrayim*," a memorial of the Exodus from Egypt. Each year at the *Passover *seder*, Jews recall this divine redemption by reciting biblical and rabbinic passages from the *Haggadah* and using various symbols and rituals to reenact the events. Psychologically, the *seder* is designed so that each participant can personally reexperience the Exodus. The *Haggadah* states: "In every generation one is obligated to look upon himself as if he or she personally had gone forth out of Egypt."[1]

In more modern times, the black slaves in the American South took the biblical Exodus as a symbol for their own hopes for freedom. After the *Holocaust, Jewish survivors of the Nazi death camps tried to gain illegal entry into Israel aboard a ship named *Exodus*, but most were turned back by the British. Their courageous actions, captured in popular song and fiction, became a symbol of Jewish survival and hope. The international Jewish community's effort to help hundreds of thousands of Jews emigrate from the Soviet Union to Israel and America has been dubbed "Operation Exodus."

[1]*Pesahim* 10:5.

Signifies: FREEDOM, HOPE, LIBERATION, REDEMPTION, SURVIVAL

Generic Categories: Passover

See also: Egypt, *Haggadah*, Passover, Pharaoh, *Seder*

EYE – עַיִן.

The human eye has always been considered a passageway between interior and exterior, the window of the soul, a conduit of worldly knowledge. And because the eye sees *light, and light originates from the *sun, the natural source of all life on earth, the eye has also been

equated with illumination and spiritual "insight." In many cultures, the eye is depicted embedded within the *hand or in the center of the forehead, symbolizing superhuman powers, often of clairvoyance ("seeing clearly") or supernatural action. A single eye suggests power, often destructive. Multiple eyes suggest both evil and vulnerability.

In Jewish folk tradition, eyes represent many of these ideas. It is through the eye that evil forces can invade a person's soul and turn his own eyes into transmitters of misfortune, the *Evil Eye. *Satan, the Evil Adversary, and the *Angel of Death are sometimes depicted as covered with many eyes. The *hamsa, symbol of the hand used as a good luck charm, sometimes has an eye embedded in its palm, to protect its users from harm.

Blindness is often symbolic of the loss of spiritual vision or power. The wicked people of Sodom lost their sight when they tried to assault the *angels who sought refuge with Lot. Samson's eyes were put out when he succumbed to Delilah's wiles. In contrast, *Adam and *Eve's "eyes were opened" when they ate from the *Tree of Knowledge, symbolizing that they gained insight at the same time they lost their innocence.[1]

The eye is often associated with divine protection. Tradition teaches that God's eyes never close. Because the eyes of *fish also appear never to close, they have long been a symbol of God. The prophet Zechariah declared that the *seven branches of the *menorah were "the eyes of the Lord, ranging over the whole earth."[2]

*Jerusalem is considered the eye of the world. One text claims that "the world is like a human eyeball . . . and the image in the pupil is the Holy *Temple."[3]

Eyes are also the symbol of insatiable human desire. The prayer known as the Shema concludes with the warning: "Do not follow after what your heart and your eyes lust for."[4] And the world-weary Ecclesiastes laments: "The eye never has enough of seeing."[5] When Alexander the Great came to the *Gates of *Eden to demand tribute, he was handed an eyeball sprinkled with dust to teach him that his eye would never be satisfied until it returned to the dust.[6]

One of God's attributes, enumerated daily in the liturgy, is the One Who opens the eyes of the blind, interpreted both literally and figuratively. According to tradition, when the dead are resurrected at the End of Days, God will open up the eyes of all who were blind in this life.[7]

[1]Genesis 19:11; Judges 16:21; Genesis 3:7; [2]Zechariah 4:10; [3]Derekh Eretz Zuta 9:13, 59a; [4]Numbers 15:39; [5]Ecclesiastes 1:8; [6]Tamid 32b; Tales of Alexander the Macedonian, trans. Rosalie Reich, 85; [7]Isaiah 29:18.

Signifies: DESIRE, DIVINE PROTECTION, EVIL, GOD, INSIGHT

Generic Categories: Body Parts

See also: Evil Eye, Fish, Hand, Light

FACE — פָּנִים.

Although Judaism has long subscribed to the principle of an invisible God, the tradition abounds with anthropomorphic imagery characterizing the divine. God's face symbolizes grace, favor, and glory.

Just as the *sun blinds one who looks at it directly, so, too, God's face, radiating the *light of the Presence in all its power, would blind anyone who gazed into it. Even *Moses, who met God on a holy mountain to receive the *Torah, was only allowed to see God's back, for "You cannot see My Face . . . and live."[1] Yet elsewhere the Bible describes Moses as the only human being who talked with God "panim el panim," face to face.[2] After encountering God on *Sinai, Moses's own face shone so brightly that he had to wear a veil to protect the people from harm.[3]

When God withholds favor from the Jewish People, this is traditionally described as hester panim, hiding the face.[4] When God favors the people, the face is said to shine upon them. The *Priestly Blessing invokes the radiance of God's face as a sign of grace and peace, an image repeated often in the liturgy.

In his vision of the Divine *Chariot, the prophet Ezekiel envisions God as a composite of *four creatures, each with four faces: the face of a human in front; of a *lion on the right; of an ox on the left; and of an *eagle at the back.[5]

The *Kabbalah draws heavily upon face imagery in characterizing God. According to its cosmology, the Primal Vessels of

Light containing the *Sefirot, the divine Emanations, were shattered at the beginning of time. As a result, God reconfigured the divine energies into "Partzufim" (faces), which reflect the dynamic relationship among the Sefirot. Two of these Partzufim are known as the "Long Face" ("Arikh Anpin") and the "Small Face" ("Ze'er Anpin").

[1]Exodus 33:20; [2]Deuteronomy 34:10; [3]Exodus 34:29; [4]Psalm 10:11; [5]Ezekiel 1:10.

Signifies: BLESSING, DIVINE GRACE, DIVINE POWER, GLORY, PEACE

Generic Categories: Body Parts, Kabbalistic Symbols

See also: Body, Eye, Kabbalah, Light, Moses, Priestly Blessing

FIG – תְּאֵנָה.

In ancient Israel, virtually every private garden boasted a fig tree, often located in one corner, whose broad, decorative leaves provided copious shade, and whose sweet fruit nourished the body and delighted the tongue twice each summer, in June and again in late August.

In the Bible, the fig is the first fruit mentioned.[1] The Torah includes figs among the *seven species that exemplify the bounty of Israel.[2] Throughout the Bible and in later literature, the fig symbolizes the promise and blessing of the land. It also represents peace and security in Israel.

When *Adam and *Eve ate the forbidden fruit in the Garden of *Eden and became ashamed of their nakedness, they covered themselves with the broad leaves of a fig tree.[3] The rabbis claimed that the reason this tree shielded them was because the fig tree itself

The fig, FICUS CARICA. Fig trees are famous for their broad leaves, which provide shade (and clothing for Adam and Eve).

had been the source of the forbidden fruit.[4]

The prophets declared that in the *Messianic Age, everyone would sit under his *vine and fig tree, and none would be afraid.[5] In their prophecies of doom, they evoked the ruined fig tree to symbolize Israel's future desolation.[6]

Because of its association with the Holy Land, its attractive shape and beautiful foliage, the fig has long been a popular ornamental motif in Jewish ceremonial art.

As one of the *seven species representing the land of Israel, figs are traditionally eaten on the holiday of *Tu B'Shevat, which celebrates the reawakening of agricultural life in Israel after winter dormancy.

[1]Genesis 3:7; [2]Deuteronomy 8:8; [3]Genesis 3:7; [4]Genesis Rabbah 15:7; [5]Micah 4:4; [6]Hosea 2:14.

Signifies: BLESSING, PEACE, PROSPERITY, REDEMPTION, SIN

Generic Categories: Botany, Food, Israel (Land of), Messiah, Trees

See also: Eden, Honey, Israel (Land of), Tree, Seven Species, Tu B'Shevat

FIRE – אֵשׁ.

Many ancient cultures believed that the world was made up of *four basic elements – fire, *water, air, and *earth. Fire was regarded as the force of transformation, since it possesses the power to change matter from one form to another. Fire has also been regarded as a symbol of passion, energy, and regeneration. It is associated with the most powerful, frequently destructive natural forces: the *sun, lightning, and volcanoes. Like life itself, it derives its strength by feeding upon energy outside itself. Like water, it is bivalent, both a positive and negative symbol, capable of sustaining as well as of destroying life.

In Jewish tradition, fire, both in its benevolent and destructive aspects, has been intimately associated with the divine Presence in the world. The *Torah as God's blueprint of creation was originally fashioned out of black fire written upon *white fire.[1] God sealed a covenant with *Abraham by sending "a smoking oven and a flaming torch" to pass between a row of

severed animals.[2] God first appeared to *Moses in a *Burning Bush, and later descended upon Mount *Sinai in a vision suggestive of a volcanic eruption: "Now Mount Sinai was all in smoke, for the Lord had come down upon it in fire; the smoke rose like the smoke of a kiln, and the whole mountain trembled violently."[3] When the Israelites wandered through the *wilderness, God guided them with a pillar of fire by night and a cloud by day.[4] Significantly, one of the Hebrew words for *angel—seraph—derives from the root meaning "to burn."

Fire also symbolizes God's anger and judgment. The Torah characterizes God as a "consuming fire."[5] The sinful cities of Sodom and Gomorrah were destroyed by a rain of "sulfurous fire."[6] When *Aaron's sons tried to offer "strange fire" upon the *altar in the *Mishkan, they were consumed by divine fire.[7] The prophets constantly warned the wayward people that God would punish them with fire; yet they also prophesied that Israel's enemies would feel that same fiery wrath.[8] Israel itself is described as "a brand plucked from the fire," a remnant saved by God's grace.[9] The sinners in *Gehinnom experience a fire of darkness, and rivers of fire.

The prophet *Elijah is especially associated with fire. He defeated the false prophets of Baal by calling down heavenly fire to consume his sacrifice. But God later reprimanded him for mistaking this fire for the Divine Presence, revealing to him that God more often speaks in "a still small voice." At the end of his life, Elijah was transported alive to heaven in a fiery *chariot.[10]

Sometimes fire serves as a test of faith. According to legend, *Abraham escaped from Nimrod's fiery furnace through his faith in God; *Daniel's three companions, Shadrakh, Mishakh, and Abednego likewise survived the flames of Nebuchadnezzar's furnace.[11]

According to *Kabbalah, God's original unity was shattered at the beginning of time, and the shards scattered throughout the world in the form of divine sparks, which became embedded in all matter. Humanity's task is to liberate these sparks from their shells so that they can return to the divine source and redeem God from exile. Such redemptive action is achieved

through prayer, meditation, study, and mitzvot (divinely ordained commandments), all performed with proper spiritual intent.

In effecting this tikkun—repair of the broken world—many kabbalists seek union with God, a process symbolized by fire. Just as the single flame disappears into the heart of the fire, so too the Jew cleaving to God merges with the divine and is consumed in spiritual ecstasy.

Fire also symbolizes the dangers of untempered passion. Rabbi Akiva taught that the Hebrew words for man, ish, and woman, ishah, share in common two letters, aleph and shin, which spell the word fire—esh, and that each word has a letter unique to it, yud and heh, which together spell Yah, one of the *names of God. From this we learn that physical desire which excludes the Divine Presence will consume a relationship in its own flames.[12]

Fire is a means of purification. In ancient times, a perpetual fire blazed on the *Temple altar and burned incense within the holy precincts. Fire consumed the *red heifer to provide the *ashes of purification.

In its property as a source of *light, controlled fire has symbolized joy and holiness in Jewish tradition. *Candles, *oil *lamps, and the *menorah have long been a central part of Jewish holiday and *Shabbat observance.

Because fire reveals such diverse colors and properties, the tradition characterizes God as the Creator of the "Lights of the Fire" at the *Havdalah ceremony.[13]

In our own time, fire has become synonymous with the mass destruction represented by the Holocaust—literally, "burnt offering"—and by nuclear weapons, which have the potential to bring about another Holocaust.

[1]Midrash Tehillim 90:12; JT Shekalim 6:1, 48d; [2]Genesis 15:17; [3]Exodus 3:2; 19:18; [4]Exodus 13:21-22; [5]Numbers 11:1; [6]Deuteronomy 4:23-24; [6]Genesis 19:24; [7]Leviticus 10:1-2; [8]Isaiah 10:17; 66:15; Ezekiel 39:6; [9]Zechariah 3:2; [10]1 Kings 18:38; 19:12; 2 Kings 2:11; [11]Yashar Noah 23b-26b; Daniel 3:1-30; [12]Sotah 17a; [13]Berakhot 52b; see also Yoma 21b.

Signifies: ANGER, APOCALYPSE, DESTRUCTION, DIVINE ANGER, DIVINE JUDGMENT, GOD, HOLINESS, HOLOCAUST, JOY, PASSION, PURITY, TEST OF FAITH

Generic Categories: Holocaust, Kabbalistic Symbols, Natural Phenomena

See also: Burning Bush, Candles, Elijah, *Gehinnom*, Hanukkah, *Havdalah*, Kabbalah, Lamp, Light, *Menorah*, Sinai, Sun, Water

FISH — דָּג.

Because fish dwell in the depths, they have traditionally been associated with awe and mystery. Many peoples have worshiped them as gods. When the prophet Jonah sought to escape God's ever-watchful *eye, a great fish, acting as a divine emissary, swallowed him until he accepted his prophetic mission. Indeed, fish have often been a symbol of God's watchful protection because their eyes, like God's, never close.

דָּגִים

Fish, based on the Zodiac sign Pisces, as they sometimes appear in Jewish folk art.

Fish are also associated with fertility because of the vast quantity of *eggs they lay. When *Jacob blesses *Joseph's two sons, *Ephraim and Manasseh, he says: "Let them multiply in the midst of the earth." The Hebrew word for "multiply" — *ve-yidgu* (וידגו) — is derived from fish — *dagim* (דגים). Because of their association with fertility, fish have often been represented on ceremonial art and were sometimes eaten by women wishing to conceive.

In the story of Creation, the phrase "And God blessed them"[1] is used for fish, human beings, and the *Sabbath, linking them as sources of blessing. The Sabbath is further connected with fish because in the *Messianic Age, of which the Sabbath is a foretaste, the righteous will all feast upon *Leviathan, the great sea monster. Furthermore, the numerical value of *dag* equals *seven. It is therefore traditional to eat fish on *Shabbat*. Sephardi Jews eat fish heads on *Rosh Hashanah to symbolize their wish to be at the "head" of the community in righteousness. Ashkenazi Jews associate fish with delicacy, luxury, and feasting, especially on *Shabbat* and holidays.

The rabbis pointed out that just as the sea protects fish from the *Evil Eye by covering them, so too the Evil Eye has no power over "the seed of Joseph," the Jewish People, because Jacob blessed Joseph's two sons, and all their descendants, by comparing them to fish.[2] Fish also bring good luck because Pisces is usually the *Zodiac sign for the month of *Adar*, during which the joyous and lucky holiday of *Purim occurs. To celebrate this connection, *shalah manot* plates, used for sending gifts of food during this holiday, are often engraved with fish motifs. In Eastern Europe, it was considered lucky to name a boy "Fishl" to protect him from the Evil Eye. In North African, Middle Eastern, and in some Eastern European communities, *amulets and *Havdalah* boxes are often shaped like fish to symbolize divine protection.

The laws of *kashrut* specify that only fish with fins and scales — a definition that excludes sea creatures such as shellfish, sharks, and marine mammals — may be eaten. These kosher fish are the only ones depicted in Jewish folk art, with the exception of the crab (*sartan* in Hebrew), which has remained as the Zodiac symbol of Cancer and of the Tribe of Reuben.

[1] Genesis 1:22; 1:28; 2:3; [2] *Berakhot* 20a.

Signifies: BLESSING, DIVINE PROTECTION, FERTILITY, GOD, GOOD LUCK, LUXURY, REDEMPTION

Generic Categories: Animals, Food, Messiah, Purim, *Shabbat*

See also: Amulet, Evil Eye, Eye, *Kashrut*, Leviathan, Purim, Water, Zodiac

FIVE — חָמֵשׁ.

Human beings have always been attracted to the number five and its multiples — *10, 25, 100, 1,000, etc. — because we are five-fingered creatures whose art and artifacts depend upon the work of our hands. We also possess five extremities (arms, legs, and head) and five senses. Representations of hands, five-pointed stars (pentacles) and flowers, five stripes, and even the number "5" itself, have appeared throughout the world as symbols of good luck and protection. Some Oriental *ketubot* (Jewish marriage contracts) include portrayals of five windows or *gates to deter the *Evil Eye.

In Jewish folklore, hands symbolize protection against the Evil Eye. The *hamsa,

an amulet or pendant in the shape of a hand, derives its name from the Arabic word for "five," similar to the Hebrew *hamesh*. In Oriental Jewish communities, *hamsas* have long been popular, often given as a bridal gift to ensure good luck. Sometimes, an *eye is represented in the palm of the *hamsa* to reinforce the notion of divine watchfulness and protection. The Blessing of the *Priests, *Birkat Kohanim*, a ceremony during which the *Kohanim* spread out their fingers to bless the people, may have derived from this belief.

The number five also represents the Five Books of *Moses, the *Torah, often called the *Humash*, from *hamesh*, Hebrew for five.

The *apple, a traditional focus of Jewish legend, mysticism, and holiday cuisine, may have fascinated the ancients because its seeds, seen in cross-section, form a perfect pentagram at its core.

Signifies: DIVINE PROTECTION, GOOD LUCK, TORAH

Generic Categories: Numbers

See also: Amulet, Apple, Evil Eye, *Hamsa*, Hand, Numbers, Star of David, Ten, Torah

FLAG — דֶּגֶל. From ancient times, people have carried banners or flags upon poles to identify themselves as social or military units. So, too, when the Jewish People ceased being slaves and became a nation, they hoisted flags in their camps — *otot le-veit avotam* — signifying their tribal identities.[1] According to the *midrash*, the flag — "*mappah*" — of each tribe corresponded to one of the twelve stones on *Aaron's *breastplate (see chart under "*Twelve Tribes").[2]

When Israel became a nation in its own land, its ships displayed colored silk flags with distinctive insignia.

In the Middle Ages, Christian rulers sometimes awarded flags to individual Jews or communities for service to the crown. The Jews of Prague, for instance, received a *red flag with a *Star of David from Charles IV in 1354. But it wasn't until the 17th century that the Star of David became a recognized Jewish symbol, often incorporated into family coats of arms, such as

those of the Rothschild or the Montefiore families.

Theodor Herzl's first design for a Zionist flag was a *white background with *seven *gold stars representing the seven working hours of the day. In his diary, he wrote: "We shall enter the Promised Land in the sign of work."[3] Herzl's design was scrapped by other Zionist leaders in favor of the Magen David, but he still insisted that six stars appear opposite the six points of the Magen David with a seventh above. This design, with the inscription "*Aryeh Yehudah*" — *Lion of *Judah — embroidered in the center, became the first Zionist flag. Later, the flag was changed to represent a *tallit*. An early Zionist poem explains that the color white symbolizes great faith; *blue, the appearance of the firmament.[4] (The original dark blue stripes were later lightened to enhance visibility at sea.) This flag was adopted as the Zionist flag in 1933, and became the official flag of the *State of Israel.

On the holiday of Simhat Torah, children march around with the Torah scrolls waving paper flags, reminiscent of the tribal flags of ancient Israel.

[1]Numbers 2:2; [2]*Numbers Rabbah* 2:7; [3]Diary, June 14, 1895; [4]"*Zivei Eretz Yehudah*" (1860), L. A. Frankl.

Signifies: JEWISH PEOPLE, MILITARY POWER, RECOGNITION, SERVICE, SOVEREIGNTY, ZIONISM

Generic Categories: Colors, Israel (State of), Numbers, Sukkot, Twelve Tribes

See also: Ass, Breastplate, Colors, Deer, Egypt, Israel (State of), Judah, Lion, Mandrakes, Moon, Numbers, Olive, Red, Serpent, Star of David, Sukkot, Sun, *Tallit*, Twelve Tribes, *Urim* and *Tummim*, White

FLOWERS — פְּרָחִים. Because of their beauty, fragrance, and transience, flowers have long been a decorative motif and a religious symbol throughout the world. They continue to serve as popular tokens of love and honor. Their appearance in the spring symbolizes hope and renewed life. In their budding and blossoming phase, they symbolize potential; in full flower, accomplishment, maturity, and perfection. Although flowers are plentiful

today, they were relatively rare in ancient times, their color and fragrance providing welcome relief from the stark natural environment.

Biblical references to flowers probably refer to indigenous plants of ancient Israel, which do not correspond to contemporary species. Botanists continue to debate the proper identification of certain flowers, especially the *shoshanah*, usually translated as *rose of Sharon or lily, although the word may just as plausibly refer to the lily of the valley, hyacinth, anemone, crocus, narcissus, or mountain tulip. (The red rose did not grow in Israel during biblical times.) Ibn Ezra claimed that the word *shoshanah* comes from *shesh*, meaning six, referring to the six petals of the white madonna lily.[1] In most cases, names of biblical flowers are used generically to symbolize beauty, fragrance, fragility, and miraculousness.

In the *Temple, flowers were used as ornamental motifs on the sacred vessels, furnishings, and *crown of the High *Priest. In the Diaspora, floral motifs appeared on *Torah ornaments, illuminated manuscripts and *ketubot, ritual objects such as *Havdalah boxes, and synagogue furnishings, textiles, and windows. In ancient times, floral wreaths were worn by virgins, brides and bridegrooms, military victors, and by the people as a whole when they celebrated the joyous holiday of *Sukkot. In some communities, it is customary to crown parents with a floral garland when they marry off their last child. Valued as much for their fragrance as for their appearance, flowers also provided oils and perfumes for the Temple service and for the general populace.

In the Bible, the *shoshanah* is an image of feminine beauty, particularly in the Song of Songs, where the lover compares his beloved to "a *shoshanah* among thorns."[2] Since this poem has traditionally been interpreted as an allegory of the love between God and Israel, this flower came to represent the Jewish People and its betrothal to God. Accordingly, it is customary to adorn the synagogue with flowers on *Shavuot to symbolize the Israelites gathered around Mount *Sinai to receive the Torah, God's "wedding gift." Legend also claims that Mount Sinai burst into bloom when the Torah was given.

In America and Israel, it has become customary to use flowers to decorate the *huppah, the *sukkah, and the *bimah* for ceremonial events such as *Bar and *Bat Mitzvahs, confirmations, and special commemorative Sabbaths. In the home, they adorn the *Shabbat and holiday table. The wildflowers of Israel have come to symbolize the natural bounty and beauty of the land.

[1]Commentary on Song of Songs 2:1; [2]Song of Songs 2:2.

Signifies: BEAUTY, BETROTHAL, CELEBRATION, FRAGILITY, HOPE, JEWISH PEOPLE, LOVE, MATURITY, MIRACULOUSNESS, POTENTIALITY, RENEWAL, VULNERABILITY

Generic Categories: Botany, Ritual Objects, *Shabbat*, Shavuot, Sukkot, Synagogue, Temple

See also: Colors, Crown, *Huppah*, Jacob, *Ketubah*, Rose, Shavuot, Sukkot, Temple

FORTY – אַרְבָּעִים. Numbers such as *"three" and *"seven" have widespread symbolic significance, but the significance of the number "forty" seems peculiar to the Judeo-Christian tradition. Starting with the biblical story of *Noah, during which *rain poured down for forty days and nights, this number recurs with remarkable frequency: *Isaac was forty years old when he married *Rebecca[1]; *Esau was forty when he married his two foreign wives[2]; *Moses remained on Mount *Sinai twice for forty days[3]; the Children of Israel wandered in the *wilderness for forty years[4]; when Joshua was forty, he and the other eleven spies spent forty days reconnoitering the land of Israel[5]; King *David reigned for forty years,[6] as did his son *Solomon.[7]

Forty and its multiples are especially important in the life of Moses: according to tradition, he was forty when he killed the Egyptian taskmaster and fled *Egypt; eighty when he saw the *Burning Bush and appeared before *Pharaoh; one hundred and twenty when he died. *Elijah fasted for forty days in the wilderness.[8] The forty-day penitential period beginning with the month of *Elul* and culminating with *Yom Kippur recapitulates Moses' forty days of repentance on Mount Sinai after the de-

struction of the first tablets of the *Ten Commandments.[9]

Why does the number forty recur so many times in the Bible? Scholars can only conjecture. Perhaps it once reflected the natural cycles of Near Eastern rivers which flooded each year. Conversely, it may have derived from the forty-day period each spring when the Pleiades constellation disappeared, corresponding to the end of the winter rains and the onset of drought. Or it may have represented the average lifespan or generation.

Whatever its origins, once the number acquired sacred status through its association with ancient holy figures, legends continued to associate this number with later heroic figures. For instance, Rabbi Akiva was said to have begun studying Torah at age forty. In the Jewish mystical tradition, forty is considered the appropriate age at which to begin the study of *Kabbalah.[10]

[1]Genesis 25:20; [2]Genesis 26:34; [3]Exodus 24:18; Deuteronomy 10:10; [4]Deuteronomy 29:4; [5]Numbers 13:25; Joshua 14:7; [6]2 Samuel 5:4; [7]1 Kings 11:42; [8]1 Kings 19:8; [9]*Pirke de-Rebbe Eliezer* 46; [10]*Pirke Avot* 5:24.

Signifies: GENERATION, MATURITY

Generic Categories: Numbers

See also: Numbers, Wilderness

FOUNTAIN – מַעְיָן .
The fountain has traditionally been a symbol of life, youth, and wisdom. Heroes, from Gilgamesh to Ponce de Leon, have gone in quest of such miraculous waters.

In the Bible, fountains sometimes represent this universal source of life,[1] but usually as a symbol of the divine. Jeremiah describes God as "the fountain of living waters."[2] Medieval philosophers, such as Saadiah Gaon and Maimonides, also used this nonanthropomorphic image to describe God.

Because women are a source of *blood which issues from them every month and a source of *milk to sustain new life, many cultures have symbolized them with the image of the fountain. Leviticus describes a women's menstrual flow as "the source (*makor*) of her blood."[3] Another biblical passage depicts a women as a "locked fountain," symbolic of both virginity and potential sexuality.[4]

The Hebrew word for fountain, *ein* or *ayin* (עַיִן) sometimes appears in Jewish art, often accompanied with a picture of a fountain, to represent *Torah or God. This image has been especially popular because of the pun with *ayin* (עַיִן), *eye.

In recent times, Jewish feminists have substituted the neutral "*Mekor ha-hayyim*," Source of Life, or "*Ein Ha-Berakhah*," Fountain of Blessing, as *names of God when reciting blessings.[5]

[1]Psalm 36:16; Proverbs 5:18; [2]Jeremiah 2:13; 17:13; [3]Leviticus 20:18; [4]Song of Songs 4:12; [5]The phrase "*Ein Ha-Hayyim*" ("Wellspring of Life") was coined by Marcia Falk. See her forthcoming *The Book of Blessings*.

Signifies: FEMININE, GOD, JEWISH PEOPLE, LIFE, SEXUALITY, TORAH

Generic Categories: Women

See also: Blood, Milk, Name of God, Water, Well

FOUR – אַרְבַּע .
The number four has always been associated with the *earth and its rhythms: four *corners, four seasons, four directions, four *winds, four elements. According to the Bible, four rivers flowed out of the Garden of *Eden.[1] Although the ancients imagined our world embedded within concentric spheres, they imagined the earth itself as a flat surface defined by edges, representative of firmness and stability. With some exceptions, human dwellings have imitated this model of a square bounded space.

The square Jewish garment known as the *tallit, which itself is bounded by a four-stringed fringe, *tzitzit*, at each corner (doubled over to make eight), reflects this notion of quaternary boundaries defining human space, the home as well as the four corners of the world. *Arba kanfot* (literally "four corners"), an undergarment with fringes that some Jewish boys and men wear daily, also embodies this idea. Within the daily liturgy, Jews pray that the scattered remnants of Israel be gathered in "from the four corners of the earth" (*arba kanfot ha-aretz*), to be sheltered under the *wings (a second meaning of *kanfot*) of the *Shekhinah in *Jerusalem, the center of the square. "Four" here represents dispersion contrasted to the One, i.e., God and the Holy Land.

God's holiest *name, the Tetragrammaton, YHVH (יהוה), which is unvocalized

and therefore unpronounceable, is called "the four-letter name" and is considered the source and summation of all the other divine names. In Ezekiel's holy vision of the *Chariot, which symbolizes the divine spirit, there are four *cherubim, each with four *faces and four wheels.

Another "four" significant in Jewish tradition are the four biblical matriarchs, *Sarah, *Rebecca, *Rachel, and *Leah, or in another configuration, Jacob's four wives: Rachel, Leah, Bilhah, and Zilpah, who gave birth to the *Twelve Tribes, ancestors of the Jewish People.

The holiday of *Passover abounds with fours: four cups of *wine, four questions, four children, and in some communities, four *matzahs. Modeled on the Passover *seder, the *Tu B'Shevat seder is also structured on the number four: four cups of wine and four kabbalistic worlds. In both seders, "four" symbolizes completeness: the four cups of Passover represent national redemption[2]; the four cups of Tu B'Shevat, natural redemption through the cycle of the seasons. And the four questions at the seder represent a life of study; the four kinds of children, a complete family; the four matzahs, the People of Israel; and the four kabbalistic worlds, a divinely ordered universe. This image of wholeness is also suggested by the *four species used on *Sukkot, which variously represent the Jewish People and the human body.

The rabbinic anthology known as Pirke Avot, "Ethics of the Fathers," contains many lists of fours, among them human character types, temperaments, qualities of students, and charitable dispositions.[3]

*Kabbalists speak of four worlds in which God's presence is manifest: the World of Action (Asiyah), which is the physical world we inhabit; the World of Formation (Yetzirah); the World of Creation (Beriah); and the World of Emanation (Atzilut), the highest domain, beyond which the Ein Sof (the Infinite) dwells.

[1]Genesis 2:10–14; [2]Exodus 6:6–8; [3]Pirke Avot 5:12–18.

Signifies: BOUNDARIES, COMPLETION, EXILE, GOD, MATRIARCHS, SHELTER, STABILITY, WHOLENESS

Generic Categories: Kabbalistic Symbols, Numbers, Passover, Sukkot, Tu B'Shevat, Women

See also: Clothing, Corners, Four Species, Kabbalah, Name of God, Numbers, Passover, Seder, Tallit, Tu B'Shevat

FOUR SPECIES – אַרְבָּעָה מִינִים.

In the Torah, the Israelites were commanded to collect *four species of plants as part of their celebration of *Sukkot: "the fruit of a goodly tree, branches of *palm trees, boughs of leafy trees, and willows of the brook,"[1] and to build a *sukkah in which to dwell during this holiday.[2] At one time, Jews probably used these four species to construct the booths. Eventually, the four species became the focus of a separate ritual. The rabbis interpreted the "fruit of a goodly tree" as an *etrog, and "boughs of a leafy tree" as a *myrtle.[3]

The four species: lulav (palm) with myrtle and willow, and the etrog.

Although originally the *priests in the Temple and the people outside its precincts observed different rituals with the four species, the rabbis decreed after the *Temple's destruction that all the people should observe the priestly ceremonials in remembrance of the Temple.

Although the Torah does not explain why these four plants are connected with this harvest holiday, it is likely that they symbolize the fertility of the land and the hope for a fruitful harvest in the coming year. Four is a *number universally associated with the earth: four *winds, four directions, four seasons. The four species can also be regarded as representing the four agricultural areas of Israel. The *lulav (palm branch) represents the lowland; the willow, the river; the myrtle, the *mountains; and the etrog, the irrigated areas.

The four species also symbolize the historical progression of Jewish settlement in the land of Israel. The date palm recalls the period in the *wilderness; the willow, the *water found upon entering the land; the myrtle, the plantings of the settled areas; and the etrog, the fruit harvested after establishing roots in the land.

The *midrash* gives many symbolic interpretations for using these four species. The *etrog*, having both pleasant fragrance and good taste, symbolizes a person who has both good deeds and learning; the *lulav*, the date palm, having only taste, symbolizes the person with only learning; the myrtle, having only fragrance, symbolizes the person with only good deeds; and the willow, having neither taste nor fragrance, symbolizes the person with neither deeds nor learning. Taken together, they make up the whole community of Israel,[4] which embraces all kinds of Jews.

The four species also represent the human body: the *lulav* is shaped like the spine; the *etrog*, like the *heart; the myrtle leaves, like the *eyes; and the willow leaf, like the mouth. Held together, they teach us that we should serve God with our whole physical being.[5] They also suggest human fertility: the *etrog* is shaped like a womb; the *lulav*, like a phallus. *Kabbalists maintain that the four species embody the *ten *Sefirot* (divine emanations), together comprising the "body" of God. Taken together, they spell the name of God: the *etrog — yud*; the myrtle — *heh*; the *lulav — vav*; and the willow — *heh*.

When blessing the four species, one holds the *etrog* in the left hand and the three other plants in the right, and waves them in six directions: east, south, west, north, up, and down, symbolizing God's rule over nature and the idea of omnipresence. On Sukkot, one marches in a *circle around the synagogue, singing praises to God and waving the plants, symbolizing Israel's joy in a good harvest. In Temple times, Sukkot was the most joyous festival celebrated by the people; the four species continue to convey that joy to this day.

[1]Leviticus 23:40; [2]Leviticus 23:42; [3]*Sukkah* 32b, 35a; [4]*Leviticus Rabbah* 30:12; [5]Psalm 35:10; *Leviticus Rabbah* 30:14.

Signifies: DIVINE PRESENCE, FERTILITY, JEWISH PEOPLE, JOY, REMEMBRANCE

Generic Categories: Body Parts, Botany, Israel (Land of), Numbers, Sukkot, Synagogue, Temple

See also: Circle, *Etrog*, Four, Kabbalah, *Lulav*, Myrtle, *Sefirot*, *Sukkah*, Sukkot, Willow

GATES—שְׁעָרִים.

In ancient Egyptian, Canaanite, Phoenician, and Oriental religions, a doorway or gate to a temple symbolized the entrance to the divine realm, the transition between sacred and profane space. The gods' abode was often pictured as a great *palace with imposing gates. The Tower of Babel was intended as a stairway to "Bab El," the Gate of God.

Similar ideas pervade the Bible. When *Jacob awoke from his *dream of the heavenly *ladder, he declared: "How awesome is this place! This is none other than the abode of God, and that is the gateway to heaven."[1] The numerous gates and entryways into the various spaces within the *Temple were meant to mirror the architecture of the heavenly palace. The psalmist pictured God passing through these sacred earthly gates to dwell among the people: "O gates, lift up your heads! Lift them up, you everlasting doors, so the King of Glory may come in!"[2]

Another psalm may have given rise to the tradition that the righteous will enter the gates of the rebuilt Temple at the End of Days.[3] These "Gates of Righteousness," *Shaarei Tzedek*, have become popular as a name for synagogues.

The cultures of the Middle East conceived of the *sun as entering and leaving the celestial gates in its course through the heavens. Jewish liturgy has retained this ancient cosmology in the evening prayers, praising God who "in wisdom opens the gates" to let out the sun and usher in the twilight.

Gates also signify boundaries, and by extension, community. In ancient walled cities such as *Jerusalem, the city gates served as business and social centers. The Israelites were commanded to care for the widow, orphan, and stranger "within their gates."[4] They were also commanded to affix a *mezuzah* on their gates as a sign of their covenant with God,[5] a custom still generally observed to mark a Jewish home or institution.

In the walled city of Jerusalem, gates symbolized power, security, and sovereignty. After the destruction of the Temple, many legends arose about the fate and future of the various gates surrounding the Temple precincts.[6]

The tradition teaches that prayer enters heaven through the gates of compassion.

On *Yom Kippur, these gates stay open throughout the day to accept Israel's repentance. The final twilight service on this day, called *Neilah*, literally "closing," coincides with the setting of the sun and the closing of the Temple gates in ancient times to mark the end of Yom Kippur.[7] In time, this image became a powerful symbol of human repentance and divine compassion, investing the *Neilah* service with a special solemnity. These gates, slightly open, have often been depicted in Jewish art as symbols of *teshuvah*, repentance.

Kabbalists describe the period between *Passover and *Shavuot as an ascent through forty-nine "gates of impurity," leading the Jewish People from Egyptian bondage to the Revelation of the *Torah at Mount *Sinai.

In Renaissance Italy, a center of Jewish publishing, gates and *portals often appeared on the frontispieces of *books, welcoming the reader into the world of learning.

Many synagogues, particularly within the Sephardi community, feature gates within their interior architecture. Often the *bimah* is surrounded by a single or multiple sets of gates, symbolizing the worshiper's entrance into a holy space for prayer. The doors of the *ark represent a gateway leading toward Torah and God.

[1]Genesis 28:17; [2]Psalm 24:9; [3]Psalm 118:19-20; Isaiah 26:2; [4]Exodus 20:10; Deuteronomy 5:14; 14:29; 15:7; [5]Deuteronomy 6:9; 11:20; [6]Vilnay, *Legends of Jerusalem*, 98-105; [7]JT *Taanit* 4:1.

Signifies: BOUNDARIES, COMMUNITY, DIVINE COMPASSION, HEAVEN, HOLINESS, POWER, REPENTANCE, SECURITY, SOVEREIGNTY, SPIRITUAL ENLIGHTENMENT, TRANSITION, WELCOME

Generic Categories: Prayer, Synagogue, Temple, Yom Kippur

See also: Ark, *Mezuzah*, Portal, Synagogue, Temple, Yom Kippur

GEHINNOM – גֵּיהִנּוֹם.

In the Bible, the netherworld is referred to by many names: *Sheol*, the Pit, the Grave, or *Eretz*, the Underworld. In rabbinic times, these names were replaced by *Gehinnom* or Gehenna, a name derived from *Gei ben Hinnom* (גיי בן הנם), the Valley of the Son of Hinnom, which was located south of *Jerusalem and made infamous by pagan Molech worship, which may have included child sacrifice by fire.

Jewish images of the underworld are largely derived from Babylonian and Greek myths. Sometimes *Gehinnom* is represented as a place of *fire; sometimes, as a place of eternal darkness. It is a vast realm, filled with suffering sinners. According to one tradition (the House of Shammai), intermediate souls descend to *Gehinnom* to be purged before going to Paradise; sinners remain there forever. According to another tradition (the House of Hillel), sinners descend there for twelve months, and only great sinners are condemned there for eternity.[1]

Although the idea of *Gehinnom* as the place where God punishes sinners has remained in popular folklore, mainstream Judaism tends to minimize its importance.

[1]*Rosh Hashanah* 16b-17a.

Signifies: PUNISHMENT, REVENGE, SIN

Generic Categories: Places

See also: Fire

GOAT – שָׂעִיר, גְּדִי, עֵז, עַתּוּד, תַּיִשׁ.

In ancient Israel, goats were a vital part of the economy. The people used goat hides for *clothing, parchment, tents, and water vessels; ate their meat and *milk; and used them for ritual sacrifice in the *Temple. The Jewish *Zodiac sign for Capricorn is the goat, *Gedi*.

One of the most solemn ceremonies of the Jewish year was the scapegoat ritual, during which the High *Priest took two he-goats (*se'ir*), sacrificed one to God, and over the other confessed "the iniquities and transgressions of the Israelites . . . putting them on the head of the goat," before sending the animal into the *wilderness of Azazel as expiation for the people's wrongdo-

A nanny goat.

ing.[1] Most likely, this goat was the Nubian ibex, whose black color was regarded as a symbol of sin.

Among the Jewish dietary laws is the prohibition against eating milk and meat products together. This is based on the biblical verse, repeated *three times in the Torah: "You shall not boil a kid in its mother's milk."[2] Traditionally, this prohibition has been interpreted as a symbolic act to represent compassion for animals.[3] (Archaelogists have uncovered evidence that boiling a kid in its mother's milk was a common pagan fertility rite, suggesting that the prohibition was originally meant to differentiate Jews from their pagan neighbors.)

Isaiah prophesies that in the *Messianic Age, the "leopard shall lie down with the *kid."[4] This image has become a symbol of messianic redemption.

In folklore, the kid is a symbol of the Jewish People, most notably in the popular song at the conclusion of the *Passover *Haggadah, *"Had Gadya," "One Little Kid." This song, similar in form to "The House That Jack Built," enumerates the trials undergone by the People of Israel throughout its history, ending with the triumph of God over the *Angel of Death.

[1]Leviticus 16:5–22; [2]Exodus 23:19; 34:26; Deuteronomy 14:21; [3]Ibn Ezra, commentary to Exodus 23:19; [4]Isaiah 11:6.

Signifies: ATONEMENT, COMPASSION, JEWISH PEOPLE, REDEMPTION, SIN

Generic Categories: Animals, Food, Passover

See also: *Had Gadya, Haggadah, Kashrut, Leopard, Passover, Sacrifice, Zodiac*

GOLD — זָהָב.

Gold has long been valued for its durability, scarcity, and beauty. In the ancient world, it was used principally in the making of sacred objects and royal adornments.

Scholars have remarked on the striking similarity between the Hebrew word, *or*, meaning "light," and the Latin word for gold, *aurum* (*or* in French). In most languages, the sun is described as "golden." So, too, in the Bible: "By the north wind the golden rays (*zahav*) emerge."[1] The Greek word "aura," meaning a luminous emanation, and the Latin word "aurora," meaning dawn, similarly suggest a common origin. The *lion's prominence as a royal symbol may be due in part to its golden *color.

There are six different words for gold in the Bible, indicating its value in ancient Israelite culture.[2] The sacred vessels and much of the furnishing of the *Mishkan and *Temple were made of gold. However, gold was also used to fashion the *Golden Calf and later, the two golden calves of the Northern Kingdom. Because of its potential to bedazzle the people into idolatry and greed, gold symbolizes both preciousness and vanity in the Bible. As Proverbs says: "How much better to acquire wisdom than gold."[3]

Traditionally, Jewish ceremonial objects have been fashioned of silver rather than of more costly gold, perhaps as a result of sumptuary laws (self-imposed restrictions designed to prevent conspicuous consumption and government taxation) or to commemorate the loss of the Temple and its golden accouterments. Hebrew illuminated manuscripts, however, use gold ornamentation, as do depictions of *Jerusalem, which often feature the golden domes and towers dominating the city's skyline.

In *Kabbalah, gold symbolizes the divine quality of Judgment, *Din*, while silver, paradoxical to the alchemical system of value, symbolizes the higher quality of Mercy, *Hesed*.

[1]Job 37:22; [2]1 Kings 9:28; Job 28:17; Job 22:24; Psalm 68:14; Job 28:15; Job 28:19; [3]Proverbs 16:16; see also Job 23:10; Psalm 19:10.

Signifies: BEAUTY, IDOLATRY, PRECIOUSNESS, ROYALTY, VANITY, WEALTH

Generic Categories: Ritual Objects, Temple

See also: Golden Calf, Jerusalem, Kabbalah, Lion, Temple

GOLDEN CALF — עֵגֶל הַזָּהָב.

In *Egypt, Babylonia, and Assyria, the bull was worshiped as a god or as the *throne of a god. In Egyptian art, the bull symbolized strength, loyalty, and courage. The Israelites, newly emerged from Egyptian bondage, naturally seized upon this image to represent their Divine Redeemer when,

despairing of *Moses' return from Mount *Sinai, they enlisted *Aaron's help in forging an idol—the Golden Calf—out of their *gold jewelry.[1] According to legend, the women refused to participate in this idolatry, and were rewarded by God for their faithfulness by being granted the New Moon as a day off from work.[2]

Although the rabbis partially rationalized the Israelites' actions by explaining that they were only trying to replicate the bull of the Divine Throne and tried to excuse Aaron's actions by attributing them to his peaceful nature, they nonetheless condemned this idolatry as a calamitous sin: "There is not a misfortune that Israel has suffered which is not partly a retribution for the sin of the calf."[3]

When Israel later split into two kingdoms, the rebel Jeroboam, king of northern Israel, attempted to rival *Jerusalem's centrality as the religious capital of southern *Judah by setting up holy places at Beth El and Dan, each of which centered around a golden calf. Echoing the Israelites' cry over the first Golden Calf, Jeroboam proclaimed: "This is your god, O Israel, who brought you up from the land of Egypt!"[4] In time these molten figures, probably originally intended to replace the golden *cherubim over the *Ark, became fetishes that were worshiped in their own right,[5] and as such were denounced by the prophets.[6]

[1]Exodus, chapter 32; [2]Tosefta to *Rosh Hashanah* 23a; [3]*Sanhedrin* 102a; [4]Exodus 32:4; 1 Kings 12:28; [5]2 Kings 17:16; [6]Hosea 8:5-6.

Signifies: BETRAYAL, GUILT, IDOLATRY, REBELLION, SHAME, SIN

See also: Cherubim, Gold

GOLEM – גלם.

There are many legends about autonomous creatures made by human hands: Pygmalion, Paracelsus's Homunculus, Mary Shelley's Frankenstein. In Jewish legend, there is the *Golem*.

The word *golem* appears only once in the Bible in what is known as "Adam's Psalm": "Your eyes saw my unformed limbs—'golmî'; they were all recorded in Your book."[1] From this and several other biblical references grew the legend of the *Golem*, a creature fashioned by human hands to serve its creator.[2] Although there is an early

story about a *Golem* in the Talmud,[3] it was not until the Middle Ages, under the influence of *Kabbalah and European folklore, that the legend was fully developed.

According to *Sefer Yetzirah* and other mystical books, one can create beings out of *earth by using secret combinations of Hebrew letters, the names of the ten *Sefirot*, and the mystical *names of God, together with certain magical actions. However, such practices are fraught with danger and must be restricted to pious students of the divine mysteries. Although the Jewish mystics of the 16th century forbade any further experimentation in *golem*-making, the power of the legend survived their censure.

The most famous legend involves the 16th-century Rabbi Judah Loewe, known as the MaHaRaL (*Moreinu Ha-Rav Liva*) of Prague, who supposedly created a *Golem* to defend the Jews of his city against false charges of *blood libel. Fashioning a giant creature out of clay taken from the banks of the Moldau, he and three disciples brought it to life through incantations, invocations of the *four elements, and magical motions. Endowed with superhuman strength and the power to become invisible, but lacking speech, the *Golem* repeatedly saved the Prague Jewish community from pogroms. When Emperor Rudolph I finally outlawed accusations of blood libel against his Jewish subjects, the Maharal reversed the spell, returning the *Golem* to inert matter, and buried the remains under old *tallitot* and prayer books in the synagogue attic.

Legend attributes the following properties to the *Golem*: He is exempt from all *mitzvot* (divine commandments), has no sexual urge or free will, never falls ill, has extraordinary vision, but lacks a soul (*neshamah*). The great scholar of Kabbalah, Gershom Scholem, once compared an early Israeli computer, "*Golem Aleph*," to its legendary namesake, noting their common origin in letters and *numbers, and their shared lack of spontaneous intelligence.[4]

[1]Psalm 139:16; [2]Genesis 12:5; Daniel, chapter 3; [3]*Sanhedrin* 65b; [4]Scholem, *The Messianic Idea in Judaism*, 335–340.

Signifies: CREATIVITY, DANGER, IDOLATRY, MAGIC, POWER, PROTECTION, REDEMPTION, SILENCE

Generic Categories: Kabbalistic Symbols

See also: *Alephbet*, Blood, Kabbalah, Lion, Numbers

GRAGGER – רַעֲשָׁן. One of the most popular features of the joyous holiday of *Purim is the custom of making noise in synagogue, a practice normally frowned upon during religious services. Based upon the biblical commandment to "blot out the name of *Amalek,"[1] reputed ancestor of *Haman,[2] this custom involves drowning out Haman's name each time it occurs during the reading of the *Megillah.

Traditional wooden *gragger* with gears, used to blot out the name of Haman, the Purim villain.

In Ashkenazi synagogues, special noisemakers called "graggers," *raashanim* in Hebrew, are used to obliterate Haman's name. These usually have a wooden or metal gear at the top of a handle, and a tongue which rattles against the teeth of the gear when the *gragger* is swung around. *Graggers* are often decorated with illustrations and verses from the Book of *Esther. Homemade *graggers* – paper or metal containers filled with dried beans, or pots and pans, as well as musical instruments – add to the cacophony.

[1]Deuteronomy 25:19; [2]1 Samuel 15:8–9; Esther 3:1.

Signifies: CELEBRATION, DESTRUCTION, JOY, VICTORY

Generic Categories: Purim, Ritual Objects

See also: Amalek, Esther, Haman, *Megillah*, Purim

GRAPES – עֲנָבִים. Grapes constitute a vital part of Israel's economy, both in ancient and modern times. They have provided food, shelter (as a vine), and *wine for both sacramental and general uses. Throughout the ancient world, the grapevines of Palestine were renowned for their luxuriance, productiveness, and quality of vintage.

The grapevine is the first cultivated plant mentioned in the Bible in connection with *Noah.[1] Grapes ("the vine") are third among the *seven species symbolizing the fertility of the land of Israel.[2] When the twelve spies returned from their mission to Canaan, it took two of them to bear on a pole a single cluster of grapes, symbolizing the extraordinary fruitfulness of the Promised Land.[3] This image of two men bearing an oversized cluster of grapes appears frequently promoting tourism in modern Israel; it is also popular on wine labels.

The vine is also a symbol of human fertility. Throughout the ages, the image of the vine has appeared on *wedding *"*ketubot*" (contracts) along with the biblical verse: "Your wife shall be as a fruitful vine, in the innermost parts of your house."[4]

Grapes have also been vital to other Mediterranean cultures. The centrality of grapes, vines, and wine within ancient Hellenistic culture had a profound effect on the Jewish symbolism of this period. For the Greeks, wine played a pivotal role in the popular Dionysian and Bacchanalian cults. Perhaps reflecting these influences, young unmarried women in ancient Israel developed the custom of dancing in the vineyards on the fifteenth day of *Av* (July/ August) and on the afternoon of *Yom Kippur, during which time they found husbands for themselves.[5]

In Greek art, which later influenced early Christian art, vines and clusters of grapes represented fertility and sacrifice, because of the *blood-colored wine they yielded, and immortality, because they invigorated the spirit and seemed to endow the body with new youth. *Birds eating

The grapevine, VITIS VINIFERA.

The giant grape cluster requiring two men to lift it (Numbers 13:23), a popular motif of Israel's productivity.

grapes symbolized the soul attaining eternal life. Hellenized Jews borrowed these motifs for *synagogue mosaics and tomb decorations, presumably to convey similar hopes for life after death. In time, the religious content of these images faded, and grapevines and clusters became merely ornamental.

Grapes are also a symbol of harvest. In ancient times as in the present, the fall grape harvest was a time of great joy and celebration. Grapes symbolize the joyous *Kiddush* ritual and are often depicted on *cups and other *Shabbat* and holiday objects. Clusters of grapes are often hung in the *sukkah* as decorations. Indeed, there may be an ancient connection with Sukkot ("*Zeman Simhateinu*"—"the time of our rejoicing") and the grape harvest, which occurs in the fall.

Vines are used metaphorically throughout the Bible. Besides evoking Israel's fertility, they are an image of peace and messianic redemption: "Every man shall sit under his grapevine and *fig *tree and no one shall make him afraid."[6] The phrases "sour grapes" and "grapes of wrath" originate in biblical imagery where grapes represent the harvest—that is, the consequences—of a person's deeds.[7] The prophets often use the grapevine as a symbol of the Jewish People.[8]

As one of the seven species representing the land of Israel, grapes are traditionally eaten on the holiday of *Tu B'Shevat, which celebrates the reawakening of agricultural life in Israel after winter dormancy.

[1]Genesis 9:20–21, 24; [2]Deuteronomy 8:8; [3]Numbers 13:23; [4]Psalm 128:3; [5]*Taanit* 4:8; [6]Micah 4:4; [7]Deuteronomy 32:32–35; Jeremiah 31:29–30; Ezekiel 18:1–4; [8]Psalm 80:9, 15; Jeremiah 2:21; 6:9; Hosea 10:1.

Signifies: CELEBRATION, FERTILITY, IMMORTALITY, JEWISH PEOPLE, JOY, MARRIAGE, VINICULTURE

Generic Categories: Botany, Food, Israel (Land of, State of), Messiah, Sukkot, Tu B'Shevat

See also: Bird, Cup, Israel (Land of), Noah, Seven Species, Sukkot, Tu B'Shevat, Wine

GREECE — יָוָן. Legend claims that when Alexander the Great approached *Jerusalem during his campaign of world conquest, an *angel came to him in a *dream, ordering him to bow down before the Jewish High *Priest when he reached the city gates. The relieved Jews repaid Alexander's "noblesse oblige" by naming all boys born to priests during that year after him.[1]

But less than two centuries after these events, *Judah Maccabee led the Jews in a revolt against Greek rule in Palestine.

During the Hellenistic period, Jewish attitudes toward Greece vacillated between admiration and hostility. Greece came to symbolize both the fruits of civilization—art, music, philosophy, literature, sports—and also the dangers of idolatry and hedonism. This period gave rise to an extraordinary flowering of Jewish culture, as well as widespread assimilation. Jews borrowed freely from Greek language (over 3,000 loan-words, grammatical adaptations, proper names), art, science, philosophy, logic, political thought, legend, and religious traditions. But such extensive acculturation threatened to undermine the uniqueness of Jewish practice and belief, especially when the Hellenized Syrian and then Roman rulers of Palestine limited or banned the observance of Jewish law.

In the Hellenized Jewish communities of the Diaspora, especially Alexandria, *Rome, the Greek cities, and Greek military outposts, Greek replaced Hebrew as a spoken language; Greek symbols, such as Helios the Sun God, Orpheus with his lyre, and the *Zodiac, adorned *synagogue walls, floors, and tombs; and Greek ideas infiltrated Jewish theology. Although growing rabbinic authority and the transvaluation of Greek symbols eventually neutralized Hellenistic influence, Greek culture left a profound impression upon Jewish thought, literature, and symbolism.

Many Jews today regard the Hellenistic experience in ancient Palestine as a prototype of the Jewish experience in contemporary America, symbolizing both the promise and the threat of acculturation.

[1]*Tales of Alexander the Macedonian*, trans. Rosalie Reich, 69.

Signifies: ASSIMILATION, CIVILIZATION, CULTURE, ENEMY, EXCESS, IDOLATRY, TEMPTATION

Generic Categories: Places

See also: Zodiac

HAD GADYA — אַד גַּדְיָא.

The *Passover *Haggadah ends with the song, *Had Gadya*, Aramaic for "An Only Kid." In *ten stanzas, the song relates what happens to this little *goat bought by a father for two coins (*zuzim*): it is devoured by the cat, who is bitten by the dog, who is beaten by the stick, which is burned by the *fire, which is quenched by the *water, which is drunk by the ox,

Had Gadya.

which is butchered by the slaughterer, who is killed by the *Angel of Death, who is destroyed by the Holy One of Blessing. Of medieval origin and written in Aramaic (a variant of Hebrew), *Had Gadya* has long been a favorite at Ashkenazi *seders, although it is unknown in the Sephardi community.

One traditional interpretation of this song views it as allegory of Jewish history: God redeemed (bought) the Jewish People (the kid) with two coins (*Moses and *Aaron). Then along came Assyria (the cat), which was in turn conquered by Babylonia (the dog), which was struck down by Persia (the stick), which was defeated by *Greece (the fire), which was conquered by *Rome (the water), which was overturned by the Saracens (the ox), who were defeated by the Crusaders (the slaughterer), who were conquered by the Turks (the Angel of Death), who at the time of the song's composition (late 16th century) still ruled Palestine. The song ends with the hope that the *Messiah will come to redeem the Jews from this last oppressor.

Mystics have interpreted the song as an allegory of the relationship of the body to the soul.

The modern Israeli poet Yehuda Amichai coined the phrase, "the terrible *Had Gadya* machine," to symbolize the relentless cycle of killing which has always plagued humanity, especially the peoples of the Middle East.[1]

[1] "An Arab Shepherd Is Searching for His Goat on Mount Zion" in Amichai, *Selected Poetry of Yehuda Amichai*, 138.

Signifies: JEWISH HISTORY, JEWISH PEOPLE, PUNISHMENT, REDEMPTION, REVENGE

Generic Categories: Animals, Kabbalistic Symbols, Messiah, Passover

See also: Angel of Death, Goat, *Haggadah*, Passover

HAGGADAH — הַגָּדָה.

The book known as the *Haggadah*, which means "telling," contains the blessings, prayers, legends, commentaries, psalms, and songs traditionally recited at the *Passover *seder. Spanning almost four thousand years of Jewish history, this anthology of biblical, talmudic, and midrashic passages; ritual instructions and blessings; the Grace After Meals; and the festival service known as *Hallel*, gradually also became a repository of popular folklore, filled with songs, legends, religious poetry, and a rich treasury of symbolic art. Since the 15th century alone, almost three thousand editions of the *Haggadah* have appeared.

Because the *Haggadah* is used at home, it has not been subject to close rabbinic scrutiny, and thus it has afforded Jews a rare opportunity to express themselves through representational art. Beginning in the 13th century, lavishly decorated *Haggadot*, many inspired by Greek and Latin illuminated psalters and Bibles, began to appear, some becoming the prized possessions of the princely courts of Europe. These medieval *Haggadot* are considered masterpieces of illuminated manuscript art.

Through the centuries, four subjects have primarily engaged the Jewish visual imagination: the text (the letters themselves as well as elements unique to the *Haggadah*, such as the "Four Sons" or the symbols on the *seder* plate), the ritual elements (observances associated with the holiday), biblical scenes (the *Exodus and the legends surrounding it), and eschatological scenes (such as *Elijah redeeming Israel).

More than any other single ceremonial object or document, the *Haggadah* exemplifies the continuous evolution of the Jewish symbolic tradition. Animals, plants, biblical and rabbinic personalities, places, ritual objects, and significant scenes from Jewish history have all found vivid pictorial expression within its pages. In contempo-

rary Israel as well as in the Diaspora, new *Haggadot* continue that evolution, demonstrating the ongoing creativity of the Jewish imagination.

Signifies: CELEBRATION, COMMUNITY, CONTINUITY, CREATIVITY, JEWISH HISTORY

Generic Categories: Passover

See also: Book, Elijah, Exodus, *Had Gadya*, Passover, *Seder*

HAIR – שְׂעָרָה. Hair has always possessed a special mystique. On the one hand, its continuous growth connects it with a person's vital spirit. But its absence of sensation also connects it with death. In many cultures, an individual offers up his hair as a substitute for his life, or tries to gain possession of another's hair in order to have power over him.

Although Judaism never encouraged asceticism, the Torah did make an exception in the case of the Nazirite, an individual who took an oath not to cut his hair, drink *wine, or come into contact with the dead.[1] Such an individual acquired a holy status similar to that of the High *Priest. The most famous Nazirite was Samson, whose unshorn hair held the secret to his extraordinary strength.

Just as the fruit of a *tree is harvested only after the first *three years of growth, some traditional families wait until a boy is three to cut his hair for the first time, symbolizing the beginning of his religious, moral, and academic education.[2]

In ancient times, the head was shaved as a sign of mourning, although eventually the custom was reversed, requiring the mourner to let his hair grow during the thirty days of mourning.[3]

A woman's hair carries different symbolic meaning than a man's. It is considered a vital part of her beauty,[4] and has been traditionally regarded as a source of temptation to men. Accordingly, some ultra-Orthodox women cut off their hair after their wedding. The demon *Lilith is usually described as having long, unkempt hair. The rabbis claimed that women needed to cover their hair as a sign of their shame, resulting from Eve's sin.[5] Some even compared a married woman's exposed hair as

equivalent to the exposure of her genitalia,[6] and forbade the recital of a blessing in the presence of a bare-headed woman.

Married Orthodox women wear a hat, kerchief, or *"sheitl"* (wig), as a sign of modesty. Ironically, modern *sheitls* often rival or even surpass the beauty of the woman's natural hair, thus undermining the purpose of the symbolic substitution. Perhaps that is why Orthodox authorities so vehemently opposed *sheitls* when they were first introduced in the 18th century. In some liberal congregations, married women cover their hair during prayer services.

[1]Numbers 6:1–21; [2]Leviticus 19:23; [3]Deuteronomy 21:12; Isaiah 22:12; Jeremiah 16:6; Ezekiel 7:18; Amos 8:10; Job 1:20; *Moed Katan* 14b; [4]Song of Songs 4:1; [5]*Genesis Rabbah* 17:8; *Eruvin* 100b; Rashi; [6]*Berakhot* 24a.

Signifies: BEAUTY, HOLINESS, LIFE, MOURNING, SHAME, STRENGTH, SUBSTITUTION, TEMPTATION

Generic Categories: Body Parts, Death, Wedding, Women

See also: Beard, Clothing, Head, *Kippah*

HALLAH – חַלָּה. The Torah commanded that the Israelites set aside a certain portion of their *bread – *hallah* – for the *priests.[1] When the *Temple was destroyed, and with it most of the rituals of the *Priestly Cult, the rabbis ruled that Jews must still set aside a small piece of each loaf of bread and burn it to symbolize the portion once given to the priests. This symbolic donation is called *hallah*. Separating out *hallah*, along with lighting the *Sabbath candles and observing the laws of family purity through immersion in the *mikvah* (ritual bath), have traditionally been regarded as the three "women's commandments."

Hallah also refers to the loaf itself, which in ancient times was typically an unleavened bread made of grain native to the land of Israel, but gradually came to designate the special eggbread eaten in Eastern Europe on the Sabbath. The Sabbath *hallah* represents the twelve unleavened showbreads, symbolic of the *Twelve Tribes, which were displayed on a golden table in the Temple and eaten by the priests

Varieties of *hallah* shapes. 1. Traditional braid, suggesting a stalk of wheat. 2. Six-knot loaf. 3. Outstretched hand awaiting God's decree. 4. Spiral/beehive/crown for the High Holiday. 5. Ladder, suggesting ascent to heaven. 6. *Menorah* for Hanukkah. 7. Elaborate large *hallah* with six-strand braid, for special occasions.

each Sabbath.[2] It is a custom to braid the two *hallah* loaves to display six *knots of dough on each, representing the twelve showbreads. Traditionally, two loaves are placed on the Sabbath *table to symbolize the double portion of *manna provided each Friday in the *wilderness so that the Israelites would not have to gather food on the Sabbath.[3]

Many symbolic customs have evolved around these special loaves. The braided form of the Sabbath *hallah* resembles the configurations of the *wheat kernels on the stalk, symbolizing human partnership with God in "bringing forth bread from the earth." Among some *hasidim*, it is customary to form one of the two loaves out of twelve rolls, called the "*yud bet*" (12), symbolizing the Twelve Tribes. Often the breads are covered with poppy or sesame seeds to represent the manna which fell in the desert.

Hallot are sometimes baked in special shapes on holy days. For Rosh Hashanah, the *hallah* is often shaped as a *circle, domed spiral, beehive, or *crown to symbolize the cycle of the year and the hope for a complete, harmonious New Year. Sometimes it is formed into a *bird's *head, inspired by a passage in Isaiah,[4] to repre-

sent God's protection. It is also customary to include raisins in the dough on Rosh Hashanah to symbolize hopes for a sweet New Year. For the meal before *Yom Kippur, some communities form a ladder atop the *hallah* to signify the hope that one's prayers for forgiveness will ascend swiftly to heaven. On Hoshana Rabba (the last day of *Sukkot), the top of the *hallah* is sometimes shaped into a *hand reaching up, symbolizing God's Judgment, decreed on Yom Kippur and confirmed on Hoshana Rabba. On the Sabbath of *Hanukkah, it may be shaped like a *menorah*. On *Purim, the bread is shaped into a single giant braid called a "*keilish*," to represent the long rope used to hang *Haman, or is made into a triangular loaf resembling a *hamentash*. Throughout the ages, *hallah* bakers have exercised great creativity and taken pride in their beautiful loaves, considered offerings in honor of the Sabbath.

The *hallah* is covered by a special embroidered cloth, which symbolizes the *dew that covered and protected the manna in the desert. A popular folk interpretation claims that the cover spares the *hallah* embarrassment since its blessing comes last in the ceremony before the Sabbath meal. The *hallah* also represents the Sabbath bride, who is veiled until her blessing is recited.

[1]Numbers 15:19–20; [2]Leviticus 24:5–9; [3]Exodus 16:22; [4]Isaiah 31:5.

Signifies: CREATIVITY, PRIESTHOOD, SACRIFICE, SUSTENANCE

Generic Categories: Food, Hanukkah, Purim, Rosh Hashanah, *Shabbat*, Sukkot, Women, Yom Kippur

See also: Bird, Bread, Circle, Crown, Dew, Hand, *Hamentashen*, Hanukkah, Knots, Ladder, Manna, Priestly Cult, Purim, Rosh Hashanah, Salt, *Shabbat*, Sukkot, Wheat, Yom Kippur

HAMAN – הָמָן. Haman is one of the most well known villains in Jewish history, not only because of his dastardly deeds but also because of his fitting comeuppance. In the Book of *Esther, Haman plots to murder all the Jews of Persia to avenge his wounded pride. His plot is foiled by Queen Esther, whose cousin Mordecai has been

Haman's nemesis. In the end, Haman and his *ten sons are hanged on the gallows intended for Mordecai.

Traditionally, Haman is considered a descendant of *Amalek, an ancient enemy of Israel whose roots reach back to *Esau. Haman's name has become a generic term for any enemy of the Jews.

On *Purim, it is traditional to stamp out or drown out Haman's name by making noise each time the name is read from the *Megillah.

Signifies: ENEMY, EVIL, SELF-AG-GRANDIZEMENT

Generic Categories: Personalities, Purim

See also: Amalek, *Gragger*, *Hamentashen*, *Megillah*, Purim

HAMENTASHEN – אָזְנֵי־הָמָן.

Hamentashen, literally "*Haman's pockets," are pastries traditionally eaten by Ashkenazi Jews on *Purim. They represent the bribes stuffing this corrupt villain's pockets. Usually *hamentashen* are filled with "*mohn*" (Yiddish for poppy seeds), which sounds very much like "Haman" (as well as "manna") in Ashkenazi Hebrew.

Hamentashen, three-cornered pastries baked for Purim.

Other names for this Purim delicacy are "Haman's ears"—*oznei Haman* (Hebrew), "*orecchie de Aman*" (Italian), and "*Hamansoren*" (Dutch)—a name allegedly derived from the old practice of cutting off a criminal's ears before hanging him. (At the end of the Book of *Esther, Haman and his ten sons are hanged.)

Sometimes the pastry is called "Haman's hat," because it is shaped like the triangular hat supposedly worn by Haman. Medieval depictions of this ancient Persian villain often anachronistically portray him in a three-cornered hat popular in Europe at that time.

A recent American custom is to bake gingerbread Hamans—to eat up the villain.

Signifies: ENEMY, VICTORY

Generic Categories: Food, Purim

See also: Amalek, Esau, Esther, Haman, *Megillah*, Purim

HAMETZ – חָמֵץ.

In the *Torah, *hametz*, leaven, is forbidden under two circumstances: it is proscribed upon the *sacrificial *altar,[1] and it is prohibited during the festival of *Passover.[2] The first prohibition probably represents a distinction between pagan and Israelite practices. The second is meant as a memorial of the *Exodus, when "the people took their dough before it was leavened, their kneading bowls wrapped in their cloaks upon their shoulders,"[3] and left *Egypt in great haste.

On *Passover, Jews are forbidden to eat or even to possess *hametz*. To rid the household completely of any substance containing leaven, the rabbinic tradition has devised the legal fiction of "selling *hametz*" to a non-Jew for the duration of the holiday and then buying it back. *Hametz* includes not only leavening agents, but also flour which might leaven when exposed to moisture. Originally, the prohibition applied only to the five grains native to Israel—three species of *wheat and two of *barley—but Ashkenazi authorities later added a second prohibited food group called *kitniyyot*, including rice, millet, and legumes, whose ground form might be mistaken for wheat or barley flour. Sephardi Jews, whose diet is not based primarily upon wheat, allow rice and legumes.

The rabbis regarded *hametz* as a symbol of corruption and the evil inclination. The yeast in the dough is one of the things that "prevents us from performing the will of God."[4]

Hametz is also a symbol of arrogance. Just as leaven puffs up dough, so too human pride puffs us up, making us think that we, not God, are the masters of our fate. During this festival celebrating redemption from bondage, the absence of *hametz* reminds Jews that they were once slaves until redeemed by God's mighty *hand.

Before Passover begins, one is commanded to search for bread (*Bedikat Hametz*) and burn it in the morning (*Biur Hametz*"), symbolically clearing the house

of *hametz*. For the kabbalists of 16th-century *Safed, *ten pieces of hidden *hametz* symbolized the ferment of base desires and evil impulses that had to be purged by being burned.

[1]Leviticus 2:11; [2]Exodus 12:15; [3]Exodus 12:34; [4]*Berakhot* 17a.

Signifies: ARROGANCE, CORRUPTION, DISTINCTION, IMPURITY, PRIDE, REMEMBRANCE, SIN

Generic Categories: Food, Passover

See also: Bread, *Matzah*, Passover, Wheat

HAMSA – חַמְסָה.

HAMSA – חַמְסָה. The *hamsa* — from the Semitic root meaning "five" — is a *hand-shaped *amulet worn to ward off the *Evil Eye. This practice may have originated among the ancient Canaanite peoples — Philistines and Phoenicians — who would make the "hand of Baal" (*horns using the index finger and pinky) over their heads, to protect against the *Evil Eye. It is likely that Israelite traders carried this gesture (also used to mock a cuckold) east and west to enter European, Indian, and Chinese folklore.

Representing the protective hand of God, hand amulets, known variously as "the hand of Miriam," "the hand of Fatima," and "the hand of Mary," have long been used in Mediterranean cultures. Although Muslims named the *hamsa* after Fatima, the daughter of Muhammed, the tradition predates Islam by at least 1,000 years. It is speculated that Jews were among the first to use this form as a protective amulet.

Often a *hamsa* has a single *eye embedded in the middle of the palm to symbolize the watchful eye of God or to deflect the gaze of the Evil Eye. Occasionally, Jewish *hamsas* have a sixth finger, perhaps to observe the prohibition against making

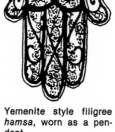

Yemenite style filigree *hamsa*, worn as a pendant.

"a sculptured image of . . . what is on the earth below,"[1] that is, a human hand.

Still respected as powerful amulets among Jews originating in Muslim countries, *hamsas* have in modern times become quite popular as good luck charms without overt magical significance. Through the influence of Sephardi Jews in Israel, *hamsas* have become common among Western Jews as well.

[1]Exodus 20:4.

Signifies: DIVINE POWER, DIVINE PROTECTION, GOD, GOOD LUCK

Generic Categories: Body Parts

See also: Amulet, Evil Eye, Eye, Five, Hand

HAND – יָד.

HAND – יָד. One of the most distinctive characteristics of our species is the hand, equipped with a prehensile thumb, capable of fashioning tools, weapons, and art, a symbol of our strength and creativity. Many cultures have regarded the hand not only as the source of human power, but also as representative of a higher power. The *numbers *five and *ten, derived from our "digits," have likewise become sacred numbers in many religions, as has the five-pointed star.

In Judaism, the hand symbolizes divine might and protection. God redeemed the Israelites from *Egypt with "a strong hand and an outstretched arm."[1] God's hand holds "every living soul and the breath of all humankind,"[2] and receives the soul at death.[3] The prayer book affirms: "You [God] open up Your hand and satisfy every living thing with favor."[4] In *synagogue mosaics of Dura Europos (3rd century C.E.) and Beit Alpha (6th century C.E.), God's hand is depicted reaching out of the *clouds in scenes of the *akedah*, the *Exodus, and the Resurrection. (Depicting God as a hand technically respects the taboo of the Second Commandment.) The *Torah reader uses a hand-shaped pointer called a *yad* so as not to touch the sacred scroll.

Human hands are created in the divine image, and thus serve as conduits of divine blessing and power. The *priests blessed the people by stretching out their fingers, forming the letter *shin* of the divine *name, *Shaddai*, or suggesting the *horns of *light radiating from *Moses's head when he de-

scended from Mount *Sinai.[5] Moses stretched forth his hand to split the *Red Sea, and lifted up his hands to ensure divine aid in the battle against *Amalek[6] (parallel to the "thumbs up" sign for victory). But when he lifted up his hand against the rock at Meribah against God's express orders, he was severely punished.[7]

Just as God's hand redeems, bestows blessing, and protects, so too the human hand enacts power in the world. In the Bible, hands are used to take oaths, ordain judges, make alliances, ask for blessing, and acknowledge submission. From rabbinic times, rabbis have been ordained by "semikhah," the laying on of hands. Like the ancient priests, Jewish parents lay their hands upon their children's heads to invoke God's blessing.

The notion that God's hand protects human beings has led to the popular use of this symbol in folklore, most commonly in the form of a *hamsa, worn to protect the wearer against the *Evil Eye.

In micrography and manuscript art, the closed fingers of a hand often become transformed into the image of a *bird, symbolizing the unity of the body and soul, or God's protection of the soul.

[1]Exodus 6:1, 6; 13:3; Deuteronomy 4:34; [2]Job 12:10; [3]Pesahim 119a; [4]"Ashrei"; [5]Exodus 34:29–30; Numbers 6:22–27; [6]Exodus 14:21, 27; 17:11–12; [7]Numbers 20:8, 11–12.

Signifies: BLESSING, CREATIVITY, DIVINE POWER, DIVINE PROTECTION, GOOD LUCK, PRODUCTIVITY, REDEMPTION, UNITY

Generic Categories: Body Parts, Kabbalistic Symbols

See also: Evil Eye, Eye, Five, Hamsa, Horn, Light, Priestly Blessing, Ten, Yad

HANUKKAH — חֲנֻכָּה.
Hanukkah, which falls on the twenty-fifth of the winter month of Kislev, is an eight-day festival commemorating the historic victory of the Maccabees over the Syrian tyrant Antiochus and his army. Called also "the Festival of *Lights," it celebrates the miracle of the tiny cruse of *oil which burned for eight days. Most significantly, Hanukkah, which means "dedication," marks the reclamation of the *Temple from paganism and Helle-

nism. In Israel today, Hanukkah has become a symbol of national liberation and the triumphant Jewish spirit.

Many customs have evolved around this holiday. The oldest involves lighting a *menorah or hanukkiah, an eight-branched candelabrum, adding one light (oil or *candle) on each night, to symbolize the increase of holiness as the festival reaches its fulfillment. One traditionally eats foods fried in oil to commemorate the miracle of the oil. It is also customary to eat dairy foods, in honor of *Judith, whose bravery was said to have inspired *Judah Maccabee. It is customary to gamble for *nuts or pennies with a *dreidl. In Europe, it was traditional to give children a coin, called Hanukkah "gelt," to reward Torah study. In modern Israel, runners participate in a torchlight marathon from Modin, where the Maccabean revolt began, to *Jerusalem, where it triumphed.

Because of its association with military power and nationalism, the rabbis tried to deemphasize the importance of Hanukkah. The name of Judah Maccabee, for instance, does not appear at all in the Talmud. The celebration of the holiday includes no proscriptions of work and no special synagogue service. However, influenced by the coincidental American celebration of Christmas, Hanukkah has in contemporary times assumed the status of a major holiday, in which gift-giving has become a central focus. In Israel, recent historical events, notably the Holocaust and the wars against the British and the Arabs, have likewise imparted increased significance to this festival, making it a popular national celebration.

Because of Judith's association with Hanukkah, this holiday has traditionally been regarded as especially sacred to women, who perform no household duties while the candles burn. The new month which begins during the festival is sometimes called "the New Moon of the Daughters," a time for girls and brides to receive gifts.

On the natural level, both Christmas and Hanukkah descend from ancient celebrations of the winter solstice. Like the *sunlight which begins to increase after this moment of seasonal transition, the lights of the menorah increase in number each night, symbolizing the strengthening of the Jewish spirit as it moves from moments of dark-

ness into light. The single cruse of oil, which lasted for eight days instead of one, likewise symbolizes the enduring Jewish spirit.

Signifies: FREEDOM, HOLINESS, JEWISH PRIDE, MIRACULOUSNESS, NATIONALISM, REDEMPTION, TRIUMPH, VICTORY

Generic Categories: Hanukkah, Women

See also: Candles, *Dreidl*, Judah Maccabee, Judith, Light, *Menorah*, Moon, Oil, Sun

HARE. In the Bible, the hare is among the unkosher animals forbidden for consumption.[1] According to the Talmud, when *seventy Jewish elders were summoned to Alexandria to translate the Bible for King Ptolemy Philadelphus, they independently rendered the Hebrew word for "hare" as "slender-footed" so as not to offend Ptolemy's wife Lagos, whose Greek name meant "hare."[2]

In the Middle Ages, Jewish artists began to depict local hare-hunting scenes in manuscripts, especially illuminated *Haggadot*, and on ceremonial objects, based on a pun: the Hebrew abbreviation "YKNHZ" (יקנה״ז) — standing for *yayin* (*wine), *Kiddush* (the blessing over wine), *ner* (*candle), *Havdalah*, *zeman* (the blessing "Shehehiyanu") — is an acronym designed to remind Jews in which order to recite these five blessings on the Saturday night of a festival. It was pronounced "yak'ne'haz," phonetically similar to *"Jag den Has"* — "hunt the hare" in German. Deriving artistic license from this pun, Jewish artists proceeded to illuminate sacred texts with hare hunts, a practice forbidden by Jewish law, but obviously delighting the Jewish imagination.

The hunted hare also represented the persecuted Jewish People in Eastern European folk art.

[1]Leviticus 11:6; Deuteronomy 14:7; [2]*Megillah* 9a-b.

Signifies: CREATIVITY, IMAGINATION, JEWISH PEOPLE

Generic Categories: Animals

See also: *Haggadah*

HAROSET — חֲרֹסֶת. *Haroset*, one of the symbolic foods eaten at the *Passover *seder*, represents the mortar made by the Jewish slaves in *Egypt. In texture and color, *haroset* resembles the mixture of clay and straw out of which the slaves made bricks for the treasure-cities of the *Pharaoh; the word itself probably derives from "*heres*," meaning clay. Among Ashkenazi Jews, *haroset* consists of ground *apples, *nuts, spices, and *red *wine. Among Sephardim, the paste also includes fruits native to the land of Israel, such as *grapes, *wheat (in the form of *matzah* meal), dates, *figs, *olives, apricots, *pomegranates, or *almonds. By eating *haroset*, Jews reexperience the slavery endured by their ancestors. The food's sweetness represents both the savor of freedom and the temptations of captivity.

The apples, nuts, wine, and other fruits which make up the *haroset* connect the fall New Year of *Rosh Hashanah with the spring New Year of Passover, called by the Torah "the first of the months of the year."[1]

[1]Exodus 12:2.

Signifies: FREEDOM, SLAVERY

Generic Categories: Food, Passover

See also: Apple, Egypt, Nut, Passover, *Seder*, Seven Species, Wine

HARP — כִּנּוֹר. In ancient Israel, music played a vital role in religious worship and public celebration. Musicians, who often were members of the *Priestly Cult, used strings, wind, and percussion. Although the stringed instruments differed in their number of strings, shape, and size, they were all variations of the same ancient form, which, according to the Bible, was invented by Jubal, an early descendant of Cain.[1]

The harp figures prominently in the Psalms, which were sung — probably to musical accompaniment — by the Levites as part of

Ancient Israelite stringed instrument.

the sacrificial service. According to the Bible, when the people of Israel were carried off to Babylonian exile, the priests hung their harps in the *willows alongside the Euphrates rather than sing before Nebuchadnezzar.[2] A later legend claims that the Levites slashed their fingers rather than play their harps before the Babylonian king. Because of these ancient associations, the harp traditionally symbolizes the Levites.

The most famous harpist in Israel was the young *David, whose sweet playing soothed the depression of King Saul.[3] According to legend, the strings of David's harp were made from the gut of the *ram sacrificed by *Abraham on *Mount Moriah. Each night at midnight, the strings would begin to vibrate, awakening David to prayer and study.[4] In Jewish pictorial art, the harp often symbolizes David or the House of David, that is, the Davidic dynasty, which is the line of the *Messiah.

[1]Genesis 4:21; [2]Psalm 137:2; Eldad Ha-Dani 42-43; [3]1 Samuel 16:23; [4]Pirke de-Rebbe Eliezer 21; Berakhot 3b.

Signifies: BEAUTY, CELEBRATION, JOY, LEVITES, MUSIC, PRIESTHOOD, WORSHIP

Generic Categories: Temple

See also: David, Messiah, Priestly Cult, Temple, Willows

HAVDALAH – הַבְדָלָה. Traditionally, the end of *Shabbat is a time of foreboding and sadness, when the Jew must surrender his or her extra Sabbath soul—"neshamah yeterah"—and become an ordinary being again. According to the Zohar, *Joseph, *Moses, and *David all died just before sundown on the Sabbath day. With the appearance of *three *stars, the burdens and anxieties of the workday world reclaim their power over humankind.

To mark this transition between holy and secular time, Jewish tradition created the ceremony of Havdalah, which means "separation," the same word used in the Bible to signify God's original creative act of distinguishing *light from darkness, the primordial waters from the heavens, day from night.[1] The ceremony is a very ancient one, going back over two thousand years.

Havdalah set consisting of Kiddush *cup, Havdalah *candle, and *spicebox.

According to the midrash, as darkness fell at the end of the first Sabbath, *Adam became frightened, for he knew that he and *Eve would now have to leave *Eden and face the dangers outside the Garden. God then taught them how to strike two flints together to make fire, and they uttered a blessing over it. From this arose the custom of kindling *fire at the end of the Sabbath.

Havdalah is a mirror image of the ceremony welcoming in the Sabbath. Just as Shabbat is ushered in with *candles and *wine (and in a previous age, with two bouquets of fragrant *myrtle, and later, *flowers), so too it is escorted out with a braided *candle, *wine, and spices. Lighting the Havdalah candle also marks the first act of labor after the day of rest. Smelling the spices revives the spirits after the loss of one's extra soul.[2]

Many of the customs, words, and objects associated with this ceremony symbolize the hope for blessing in the coming week. The special Havdalah prayer is an anthology of *seven scriptural quotations, alluding to divine blessing and good fortune.[3] It is customary to overfill the wine *cup to symbolize one's wish for abundant blessing. Some Jews look at their fingernails by the candle's light, not only to

distinguish (le-havdil) between light and darkness, but also to read the lines of good luck on the palm. At the end of the ceremony, some Jews dampen their fingertips with the wine and touch them to their eyelids and pockets to bring good luck; the former gesture also symbolizes the belief that God's commandments "enlighten the eyes."[4]

According to tradition, the *Messiah will appear at the time of Havdalah. As the braided candle burns, many Jews sing the song, "Eliyahu Ha-Navi" (*Elijah the Prophet) which expresses the hope that the Messiah will arrive. To prolong this bittersweet moment of longing for redemption, some Jews celebrate a fourth meal after sundown called "Melaveh Malkah" (Escorting of the Queen). This meal is associated with David, ancestor of the Messiah.

Feminists have introduced the custom of singing "Miriam Ha-Neviah" (*Miriam the Prophet), inspired by an ancient folk tradition that Miriam's *well fills all wells at the end of Shabbat. It was believed that drinking from well *water drawn at this time would cure one of illness.[5]

[1]Genesis 1:4, 1:6-7, 1:14; [2]Taanit 27b, Soferim 17:5; [3]Isaiah 12:2-3; Psalm 3:9, 46:12, 84:13, 20:10; Esther 8:16; Psalm 116:13; [4]Psalm 19:9; [5]Kitov, The Book of Our Heritage 2:162.

Signifies: BLESSING, DISTINCTION, GOOD LUCK, SADNESS, SEPARATENESS, TRANSITION

Generic Categories: Messiah, Prayer, Shabbat

See also: Candle, David, Elijah, Fire, Light, Messiah, Miriam, Myrtle, Queen, Shabbat, Spicebox, Stars, Well, Wine

HEAD – רֹאשׁ.

In the Bible, the head represents a person's dignity. To lower, cover, or put *ashes on one's head is an expression of submission or shame; to raise one's head, a sign of exultation.[1] Jewish men—and many women—cover their heads, especially when involved in religious ceremonies, as a sign of submission before God. Many traditional women cover their head after marriage as a sign of modesty.

Because it sits atop the body, the head represents mastery or control. Thus, the leader of the people is called its "head." Two thousand years ago, when Palestine was under *Roman domination, the rabbis counseled, contrary to a popular Roman proverb, that it was wiser to be "a tail to *lions than a head to foxes."[2] Similarly, the *crown, because it sits upon the head, represents kingship. The dean of a rabbinical academy is called the "rosh yeshivah," literally, "the head of those sitting down."

The expression "the *blood will be upon your head," which occurs frequently throughout the Bible, refers to a person's conscience, which will be "bloodied" if he is found responsible for wrongdoing, particularly in the case of murder.[3]

In the Bible, the expression, "God's *face," usually refers to divine mercy, as in the *Priestly Blessing: "May God shine the divine face upon you."[4] When God is angry with the people, the Bible speaks of God's face being hidden.[5] *Moses is praised as the only human being ever to meet God "face to face."[6]

The head also symbolizes beginning. It is usually first to emerge from the birth canal and is the origin of most sensation (although in biblical and rabbinic literature, the *heart, not the head, is considered the seat of intelligence). Thus, the Jewish New Year is called *Rosh Hashanah, the head of the year, and the beginning of each month is called *Rosh Hodesh, the head of the month.

In kabbalistic literature, the human *body is seen as a microcosm of the *Sefirot, the *ten divine emanations of God. The head represents the first *three (and highest) Sefirot—Keter (Crown), Binah (Understanding), and Hokhmah (Wisdom). According to Lurianic Kabbalah, the material world originally emerged from lights emanating from the head of *Adam Kadmon, the primordial Adam. But the energy from these lights was so powerful that it shattered the divine order, scattering sparks throughout the material world. The mechanism of cosmic repair, tikkun, will be accomplished through the structures of the Partzufim, Divine Faces, various combinations of holy energy, which will reestablish the original unity of the Godhead.

[1]Exodus 4:31; Isaiah 58:5; Psalm 24:7,9; [2]Pirke Avot 4:20; [3]2 Samuel 1:16; [4]Numbers 6:24-26; [5]Isaiah 64:6; [6]Deuteronomy 34:10.

Signifies: BEGINNING, DIGNITY, DI-
VINE COMPASSION, DIVINE SPIRIT,
LEADERSHIP, MASTERY, REPUTA-
TION, ROYALTY

Generic Categories: Body Parts, Kabba-
listic Symbols, Rosh Hashanah

See also: Body, Crown, Face, Heart, Kab-
balah, Light, *Sefirot, Tefillin*

HEART – לֵב.

In traditional cultures,
the heart was considered the center of the
*body; the *earth, the center of the physical
universe; and love, often symbolized by the
radiating petals of the *rose, the center of
the human universe. In Jewish tradition,
*Jerusalem is considered the heart of the
world; the *Temple, the heart of Jerusa-
lem; and the Holy of Holies, the heart of
the Temple.

In Jewish tradition, the heart is similarly
seen as the center of the inner life, which
includes both feeling and thought. Al-
though other organs such as the intestines
and the kidneys were also credited with
directing a person's emotional life,[1] it was
the heart alone that was considered respon-
sible for the intellect. As the Psalmist says:
"Teach us to number our days, so that we
may obtain a heart of wisdom."[2] Someone
"wise of heart" was skillful; one who "had
no heart" was a simpleton. A "whole" or
"perfect" heart signified an undivided
spirit; a "broken" heart, a conflicted or
defeated one.

According to the Talmud, the heart con-
tains all human desires, both good and bad.
Thus when the Torah commands: "You
shall love the Lord your God with all your
heart," it uses the longer form, *levav* (לבב),
indicating by its double *bet* that one
should serve God with both good and evil
inclinations.[3]

In prayer, which the rabbis call "the
service of the heart,"[4] tradition places as
much emphasis on one's intention, "*kav-
vanat ha-lev*," the directing of the heart, as
it does on the recitation of the words.[5] This
idea is one of the central beliefs of Hasid-
ism.

In *Kabbalah, God's heart corresponds
to the *Sefirah (divine emanation) of *Tife-
ret*, Beauty, at the center of the sefirotic
*tree. This aspect of God harmonizes and

connects all the opposing divine energies
into a loving unity.

The *etrog* (citron) used on *Sukkot is
said to represent the human heart, because
of its round shape as well as its perfection.

Contemporary images of the heart – ei-
ther as a physical organ or as a red "valen-
tine" – are unknown in Jewish tradition.

[1]Jeremiah 4:19; [2]Proverbs 23:15–16;
[3]Deuteronomy 6:5; *Berakhot* 54a; [4]JT *Berakhot*
4:1, 7a; [5]JT *Berakhot* 2:1.

Signifies: CENTER, COMPLETION, IN-
NER LIFE, INNERNESS, INTELLECT,
PERFECTION, SPIRIT, WISDOM

Generic Categories: Body Parts, Kabba-
listic Symbols, Prayer

See also: Body, *Etrog*, Head, Jerusalem,
Kabbalah, Rose, *Sefirot*, Temple

HONEY – דְּבַשׁ.

In the Bible, honey
usually refers to a thick syrup made from
dates, *figs, or *grapes, but not to bee's
honey, which is much rarer in that region.
When God promised the Children of Israel
that the Promised Land would be "flowing
with *milk and honey," it was this fruit
syrup, not bee's honey, that was meant.[1]

Fruit honey was considered a delicacy in
ancient times, the epitome of sweetness.
(Refined sugar, from beets or cane, did not
exist.) The *Torah states that *manna
tasted like "wafers in honey," although the
Talmud claims that was true only for
children.[2] In the Bible, the phrase "as sweet
as honey" applies to the words of God,[3] the
wisdom of the Torah,[4] the speech of a
friend,[5] and the seductive words of a
strange woman.[6]

In many cultures, honey – the product of
a mysterious and complex natural pro-
cess – is a symbol of rebirth or personal
growth. The honey bee, known for its
industriousness, is a model of virtue and its
reward and, to the ancient Greeks, a
symbol of wisdom. Similarly, Jews have
used honey to mark two important mo-
ments of personal development and
change: the beginning of a child's education
and *Rosh Hashanah, the New Year, when
a person returns from sin toward life. Be-
ginning in the Middle Ages until our own
day, it has been a custom to write the

Hebrew *alephbet in honey on a child's slate when he or she begins school, symbolizing the parents' hope that the words of the Torah will be as sweet as honey and that he or she will in turn make its teachings fruitful.[7] It has also long been customary among Ashkenazi Jews to eat honey cake — "honig lekakh" — and to dip *apples in honey on Rosh Hashanah, to symbolize hope for a sweet New Year. This is also the reason for dipping *hallah in honey instead of *salt during this festival period.

[1]Exodus 13:5; Deuteronomy 6:3, 11:9 inter alia; [2]Exodus 16:31; Yoma 75b; [3]Psalm 19:11; [4]Proverbs 24:13; [5]Proverbs 16:24; [6]Proverbs 5:3; [7]Psalm 119:103.

Signifies: GROWTH, HOPE, REBIRTH, SWEETNESS

Generic Categories: Botany, Food, Israel (Land of), Rosh Hashanah

See also: Bear, Apple, Fig, Grape, Israel (Land of), Rosh Hashanah, Torah

HORN — קֶרֶן.
Animal horns have traditionally functioned as adornment, weaponry, and musical instruments, especially in combat and ceremonial ritual. Because of their military and political associations, horns have come to symbolize courage, honor, power, and strength. Battle helmets have long been crowned with horns, as have *kings' *crowns. From ancient times, the hollowed horn has trumpeted declarations of war and victory, coronations, alarms, and calls to assembly. In many cultures, the loud noise of the horn is thought to drive away or deter demons. Because of its crescent shape, the horn was frequently associated with the new *moon in pagan cults. The first and second months of the *Zodiac cycle feature horned animals — Aries the *Ram and Taurus the Bull — suggesting the horn's role as a symbol of beginnings.

In many cultures, the horn has traditionally been associated with fertility, because its form embodies both phallic and receptive imagery. It often symbolizes agricultural fertility in the form of the cornucopia, the "horn of plenty." Perhaps this association reinforced the horn's importance in the autumnal Jewish holidays, the period of the harvest.

The generic term for "horn" in Hebrew is keren. In ancient Israel, the *altar, representing God's presence among the people, had horns on its *four *corners, which were often anointed with *blood, much as the Israelite kings were anointed with a horn of *oil. The phrase "horn of *David" (keren David), refers to the *Messiah, who like David will be anointed with a horn of oil.

The most important animal horn in Jewish tradition is the *shofar, the ram's horn. From ancient times until now, the shofar has been principally identified with *Rosh Hashanah, which the Bible called Yom Teruah, a "day of blowing."[1] As the "Birthday of the World," Rosh Hashanah is also connected with the horn because of its associations with initiation and fertility.

In late medieval times, the artistic motif of the ram's horn gave way to a new image borrowed from Christian art: the solitary horn of the white unicorn, often depicted in combat with a *lion. Jewish artists justified the unicorn's inclusion by deriving its origins from the biblical verse: "Deliver me from a lion's mouth; from the horns of wild oxen rescue me."[2] (Indeed, the wild ox, depicted in profile, appears to have a single horn.) Because this is a psalm of *David and because the House of David is associated with the Lion of *Judah, David is sometimes depicted in these scenes. David's connection also lends this symbol a messianic dimension.

When Moses came down from Mount *Sinai with the *Ten Commandments, the Torah reports that "the skin of his face was radiant."[3] The Hebrew verb karan, to shine, has the identical spelling as keren, horn. Latin translators of the Bible thus mistakenly attributed to Moses "horns of light," which found pictorial expression in many sculptures and paintings of the Israelite leader, most notably the statue by Michelangelo in Rome. In later periods, this depiction of the horned Moses fused with European images of the Devil to create the anti-Semitic stereotype of "the Jew with horns."

[1]Numbers 29:1; [2]Psalm 22:22; [3]Exodus 34:29.

Signifies: ANTIDEMONIC, COURAGE, FERTILITY, HONOR, INITIATION, POWER, REDEMPTION, ROYALTY, STRENGTH

Generic Categories: Animals, Messiah, Personalities, Rosh Hashanah, Temple

See also: Altar, David, Deer, Goat, Moses, Oil, Ram, Rosh Hashanah, *Shofar*, Zodiac

HUPPAH – חֻפָּה.

In ancient Israel, at the end of the betrothal period, a new bride was escorted in a festive procession to the groom's room or tent—the *huppah*—where the marriage was consummated. The term "*huppah*" referred to the chamber, to the bridal canopy, or to the marriage ceremony itself[1]; today only the latter two meanings survive.

In talmudic times, it was customary for the father of the bridegroom to erect the *huppah*, in some cases using as poles the *cedar and *cypress (or *pine) *trees planted at the birth of the wedding couple.[2] The *huppah* thus represented the ful-

Wedding canopy decorated with garlands.

fillment of the parents' hopes for their children. To this day, when children receive their Hebrew names, they also are blessed with the hope that they will grow "to Torah, the wedding canopy, and good deeds."

Although the *huppah* was a rarity in the early Middle Ages, by the late Middle Ages it had become customary to cover the bridal couple with a cloth canopy held up by four poles.

In medieval France and North Africa, the groom covered the bride's head with his *tallit*, symbolizing his sheltering protection. This custom was based upon *Ruth's words to Boaz: "Spread your robe over your handmaid, for you are a redeeming kinsman,"[3] an act which in ancient times constituted a formal betrothal. Nowadays, a *tallit* is frequently used as a *huppah*.

The *huppah* symbolizes the couple's first home. Its frailness suggests the fragility of *shalom bayit*, peace within the household. It also symbolizes the shelter of their new home and an emotional, physical, and spiritual transition in their lives. *Ketubot* often reflect this metaphor, framing the wedding contract within a doorway.

[1]*Genesis Rabbah* 9:4; *Pirke Avot* 5:21; [2]*Genesis Rabbah* 28:6; *Gittin* 57a; [3]Ruth 3:9.

Signifies: COMPLETION, FRAGILITY, HOME, MARRIAGE, PROTECTION, SECURITY

Generic Categories: Wedding

See also: Candles, Cedar, Cypress, *Ketubah*, Pine, Portal, Ruth, *Tallit*, Wedding

IRON – בַּרְזֶל.

In the Bible, iron is a symbol of strength, war, and violence. The Israelites were commanded to build God's holy *altar not out of stones quarried with iron tools, but out of natural stones.[1] When *Solomon later built the *Temple in *Jerusalem, he too was constrained from using iron tools, a prohibition which gave rise to the colorful legend of the *shamir*, a miraculous worm which cut the entire stone edifice of the Temple.[2]

As in many other cultures, Jewish folklore has long regarded iron as powerful protection against demons. Since, according to ancient beliefs, evil spirits dwell in caves, *mountains, and under stones, iron has power over them, because "rock is hard but iron cuts it."[3] In the Middle Ages, several theories were advanced as to why iron is effective against demons: Eleazar of Worms (12th–13th century) claimed that metals, being the products of civilization, are inimical to spirits which originated in pre-metal society. Another explanation derived from the fact that the first plague of *blood was restricted to *water in "vessels of wood and in vessels of stone,"[4] but not of iron. A third explanation suggests that the four letters in the Hebrew word for iron, *barzel*, stand for Bilhah, *Rachel, Zilpah, and *Leah, *Jacob's four wives and the mothers of the *Twelve Tribes, whose spiritual merits protect against evil spirits.[5]

For centuries, it was the custom to place a piece of iron—a knife, sword, or synagogue key—near a person who was considered especially vulnerable to evil spirits: under the pillow of a pregnant or childbearing woman or someone near death, in a child's cradle, or in a nest of chicks during a thunderstorm. It was also believed that human beings were in particular danger during the *tekufot*, the equinoxes and solstices, when demons were likely to poison water with blood. To ward off their mis-

chief, a piece of iron was suspended in water in a sealed vessel.

[1]Deuteronomy 27:5-6; [2]1 Kings 6:7; *Gittin* 68a-b; *Sotah* 48b; [3]*Bava Batra* 10a; [4]Exodus 7:19; [5]Trachtenberg, *Jewish Magic and Superstition*, 313, n. 14.

Signifies: MAGIC, PROTECTION, VIOLENCE, WAR

Generic Categories: Birth, Women

See also: Altar, Blood, Evil Eye, Temple

ISAAC — יִצְחָק. Of the three patriarchs, Isaac is the most enigmatic. *Abraham had the distinction of starting a new people; *Jacob wrested the name "Israel" from an *angel and fathered the *Twelve Tribes. But Isaac's most notable claim was to be spared the sacrificial knife — to be a failed offering. Most of the rest of his story is similarly marked by passivity: Abraham sends his servant Eliezer to find a wife for Isaac; and in his old age, Isaac is hoodwinked by his wife *Rebecca and their clever son Jacob.

Because of these stories, Isaac has become a traditional symbol of submission to God's will. The rabbis claimed that heaven's harsh judgments against Israel are always softened when God recalls "Isaac's *ashes heaped upon the altar," an allusion to a legend that Isaac actually died during the *akedah and was then resurrected.[1] He is depicted as the patriarch with the deepest compassion for Israel, pleading for them even when they sin. Inspired by this depiction, early Christianity regarded Isaac as a prefiguration of Jesus.

Tradition credits Isaac with instituting the afternoon service of *Minhah*, based on the verse: "And Isaac went walking — *la-suah* (לשוח) — in the field toward evening."[2] The rabbis interpreted "*la-suah*" to mean "meditate."[3]

*Kabbalists say that Isaac represents the *Sefirah* of Judgment — *Gevurah* or *Din* — since it was God's Judgment that he experienced at the *akedah.

[1]*Leviticus Rabbah* 36:5; *Taanit* 16a; *Pirke de-Rebbe Eliezer* 31; see also Shalom Spiegel, *The Last Trial* (Pantheon, 1967), passim; [2]Genesis 24:63; [3]*Berakhot* 26b.

Signifies: DIVINE COMPASSION, DIVINE JUDGMENT, FAITH, PASSIVITY, SACRIFICE, SUBMISSION TO GOD'S WILL

Generic Categories: Personalities, Prayer, Rosh Hashanah

See also: Abraham, *Akedah*, Ashes, Esau, Ishmael, Jacob, Rebecca

ISHMAEL — יִשְׁמָעֵאל. Ishmael was *Abraham's firstborn child, the son of Hagar, *Sarah's Egyptian handmaid. Although it was Sarah's own suggestion that Abraham father a son through Hagar since Sarah herself was barren,[1] Sarah eventually came to regret her action, ordering Abraham to send Hagar and Ishmael away into the *wilderness. Despite Abraham's distress, God accepted Sarah's decision, promising Abraham that "as for the son of the slave-woman, I will make a nation of him, too, for he is your seed."[2] This disturbing story is read from the Torah every *Rosh Hashanah.

Because Sarah's actions appear unusually severe, the rabbis sought to justify them by making Ishmael into a villain worthy of expulsion. Building on the biblical description of Ishmael as "a wild *ass of a man" and a master bowman, they claimed that he also dishonored women, worshiped idols, and attempted to kill *Isaac with his arrows.[3] But elsewhere in the *midrash*, Ishmael was depicted as the model of the true penitent.[4] The Talmud says that one who sees Ishmael in a *dream will have his prayers answered.[5]

In the Torah, Ishmael's descendants were a nomadic people known as the Ishmaelites, who later carried off *Joseph into Egyptian captivity. In later tradition, Ishmael became a symbol of the Arabs, who are often called "the children of Ishmael." Muslim tradition claims "Ismail" as an early ancestor. In some Muslim interpretations, it was Ishmael, not Isaac, who was bound upon the *altar.

In our own time, a prayer has been added to the liturgy for peace between the children of Sarah and Hagar, or between the children of Isaac and Ishmael — that is, between Jews and Arabs in the Middle East.

[1]Genesis 16:2; [2]Genesis 21:13; [3]Genesis 16:12, 21:20; *Genesis Rabbah* 53:11; [4]*Bava Batra* 16b; [5]*Berakhot* 56b.

Signifies: BROTHERHOOD, ENEMY, HOPE, IDOLATRY, REPENTANCE

Generic Categories: Personalities, Rosh Hashanah

See also: Abraham, *Akedah*, Isaac, Rosh Hashanah, Sarah

ISRAEL — יִשְׂרָאֵל. "Israel" means many things within Judaism. In the Bible, Israel is first associated with the patriarch *Jacob. His name was changed to Israel, "one who struggles with God," after his encounter with an *angel on the banks of the Yabbok.[1] The phrase, "Children of Israel—*Bnei Yisrael*," which first referred to Jacob's twelve sons, eventually came to mean the entire Jewish People.[2] The inhabitants of ancient Israel are called "Israelites" in English; of modern Israel, Israelis.

The *Twelve Tribes were known as "Israel" until their division into Northern and Southern Kingdoms after the reign of *Solomon. From then on, the *ten northern tribes were known as Israel; the two southern ones (*Judah and Benjamin), as Judah. After the Northern Kingdom was conquered and dispersed by Assyria in 722 B.C.E., "Israel" came to designate the surviving remnant, both in Palestine and throughout the world. After their conquest of the Jews, the Romans renamed the land "Judea."

Tradition has ascribed countless names and qualities to the People of Israel, among them the Nation of Israel (*Am Yisrael*), the Chosen People, God's Portion, the House of Israel, Kingdom of Priests, Holy Nation, and God's Beloved.

The Twelve Tribes were actually *thirteen, since Joseph was awarded a double portion through his two sons, Ephraim and Manasseh. The thirteenth tribe was Levi, which received no land as its tribal inheritance but instead inherited the priesthood. Descendants of this tribe became known as Levites; those descended directly from Aaron's family have a special designation: *Kohen*. All the descendants from the other twelve tribes are known simply as "Israel." This distinction is still traditionally used today when calling Jews to the Torah.

Israel also refers to the land itself, *Eretz Yisrael*, symbol of God's promise and covenant, of the nation's past glory and future redemption. Before the Israelite conquest under Joshua, the land was known as Canaan; under Jewish sovereignty, it was usually called Israel; in later centuries, non-Jews usually called the region "Palestine," a name derived from the ancient coastal kingdom once occupied by the Philistines. Throughout two millennia of dispersion, Jews have continued to refer to the area as Israel or "the Holy Land," maintaining their belief in this region of the world as the central source of holiness for the Jewish People.

Since the establishment of the State of Israel in 1948, Israel has come to symbolize the rebirth of the Jewish Homeland and a haven from persecution, especially in the wake of the Holocaust. The dramatic in-gathering of Jews from Arab countries, the Soviet Union, Ethiopia, and other parts of the world has been interpreted by some as a political redemption, by others as a harbinger of messianic redemption. In modern idiom, the State of Israel, *Medinat Yisrael*, is called simply *Ha-Aretz*, "The Land." Israel Independence Day, *Yom Ha-Atzmaut*, is celebrated on the fourth of *Iyyar* (May) both in Israel and in the Diaspora with much festivity.

In the *Kabbalah, "*Knesset Yisrael*," the Community of Israel, refers to the *Shekhinah*, God's feminine aspect, which of all the divine *Sefirot*, is most accessible to human experience. Like the Jewish People, *Knesset Yisrael* is in exile, waiting to be redeemed.

[1]Genesis 32:29; [2]Genesis 46:5; Exodus 1:7.

Signifies: COMMUNITY, COVENANT, HOLINESS, JEWISH PEOPLE, REBIRTH, REDEMPTION, SOVEREIGNTY

Generic Categories: Israel (Land of, State of), Messiah, Personalities

See also: Earth, Jacob, Jerusalem, Judah, Kabbalah, Messiah, Priestly Cult, *Sabra*, Sefirot, Shekhinah, Twelve Tribes

JACOB — יַעֲקֹב. Jewish tradition often speaks of Jacob in superlative terms.[1] The rabbis even went so far as to claim that "the heaven and the earth were only created for the sake of Jacob."[2] He was the father

of the *Twelve Tribes, and his name, especially his second name, "Israel," which he received after his transformative encounter with an *angel,[3] became synonymous with the People of Israel. Because of this identification, Jacob's life is sometimes interpreted as an allegory of Jewish history, especially his struggles with his brother *Esau, who later became a symbol of *Rome. The phrase *Shoshanat Yaakov* ("*rose of Jacob") signifies the Jewish People, the beloved of God.

Yet Jacob's character was certainly not without blemish. His name, *Yaakov*, is a pun on two Hebrew words: "*ekev*," heel, for Jacob emerged from his mother *Rebecca's womb grasping his brother's heel,[4] and the verbal root "AKV," meaning "to supplant," for he stole his older brother Esau's birthright, thereby wresting from him leadership of the clan. (The English idiom—"He's a heel"—conveys a similar meaning.) Yet despite Jacob's misdeeds— stealing Esau's portion, deceiving and then deserting his aged father, favoring *Rachel over *Leah, and *Joseph over his other children—the *midrash* nonetheless considers him a model of virtue and righteousness, building him up by deflating his father *Isaac and grandfather *Abraham who, unlike Jacob, fathered unworthy sons,[5] as well as by depreciating Esau and Lavan, whose antagonism forced Jacob into uncharacteristic behavior. Compared to Esau, who represents the corruption of paganism, Jacob represents the spiritual beauty of Israel.

Jacob is credited with having invented *Maariv*, the evening prayer, during his vision of the heavenly *ladder,[6] following in the footsteps of Abraham and Isaac, who had previously introduced the morning and afternoon prayers. And like his father and grandfather before him, Jacob was not under the dominion of the *Angel of Death but died through a divine kiss. One tradition even maintains that Jacob never died, just as the Jewish People will never die.[7] More than the other two patriarchs, Jacob is seen as the compassionate champion of Israel, rejoicing and suffering with them throughout history.[8]

Because Jacob labored fourteen years to win Rachel's hand, he is held up as a symbol of romantic love and fidelity.

In *Kabbalah, Jacob represents the

Sefirah of *Tiferet*, Glory or Beauty, reconciling the *Hesed*, Loving-kindness, of Abraham, with the *Din*, Judgment, of Isaac.

To this day, observant Jews adhere to the Torah's prohibition against eating the sciatic nerve of kosher animals, in order to commemorate Jacob's struggle with the angel, who wounded him in this spot before blessing him with a new name.[9]

[1]*Genesis Rabbah* 76:1; [2]*Leviticus Rabbah* 36:4; [3]Genesis 32:25-33; [4]Genesis 25:26; [5]*Leviticus Rabbah* 36:5; [6]Genesis 28:11; *Berakhot* 26b; [7]*Taanit* 5b; [8]*Midrash Tehillim* 14:7; [9]Genesis 32:26, 33.

Signifies: BALANCE, CLEVERNESS, COMPASSION, FAITH, JEWISH HISTORY, JEWISH PEOPLE, LOVE, PRAYER, RIGHTEOUSNESS, ROMANCE, SIBLING RIVALRY, SPIRITUAL BEAUTY, STRUGGLE

Generic Categories: Personalities, Prayer

See also: Angels, Esau, Isaac, Joseph, Ladder, Leah, Lentil, Rachel, Rebecca, Rose, Twelve Tribes

JAKHIN AND BOAZ – יָכִין/בֹּעַז.

In the biblical descriptions of *Solomon's *Temple, two great bronze columns flanked the portico of the Great Hall, topped by double capitals engraved with lilies and 200 *pomegranates arrayed in rows. The right column was called "Jakhin" (pronounced "*yakhin*" in Hebrew); the left, "Boaz."[1] When the Babylonians destroyed the Temple in 586 B.C.E., they broke apart these columns and carried the bronze pieces off to Babylon.[2] In the Middle Ages, Italian Jewish ceremonial art often depicted these Temple features as twisted columns, stemming from the folk belief that the twisted columns adorning St. Peter's Cathedral came from the Temple in *Jerusalem.

The function of these pillars is still unclear. They were probably freestanding, as was the fashion in temple architecture of the region, and they may have symbolized the *Tree of Life, the cosmic pillars upholding the world, or the dwelling place of God, after the model of Egyptian obelisks.

The derivation of the pillars' names is also unclear. Some scholars have suggested that the names refer to God; others, to the members of the royal household or other

patrons who donated the money to construct the columns. They may also be the initial words of a longer text beginning "*be-oz*," with strength.

After the destruction of the Temple and the creation of *synagogues, replicas of these two columns, likewise called "Jakhin and Boaz," flanked the *ark containing the *Torah scrolls, and were often depicted on the *parokhet* and *breastplate. Among Sephardim, the ark itself is called the *heikhal* (*"palace") after the original Holy of Holies in the Temple, reinforcing this memorial function. The two rollers of the

Stylized depictions of the Temple pillars, as used on ceremonial textiles.

Torah scroll, called either *ammudim* (pillars) or *atzei hayyim* (trees of life), are modeled on the Temple pillars, as are the silver ornaments (*rimmonim*, literally "pomegranates") set atop the rollers.

[1]1 Kings 7:15-22; [2]2 Kings 25:13.

Signifies: DIVINE ABODE, GOD, HOLINESS, REMEMBRANCE

Generic Categories: Synagogue, Temple

See also: Ark, Pomegranate, Temple, Torah, Tree

"For the Torah shall come forth out of Zion, and the word of God from Jerusalem" (Isaiah 2:3).

JERUSALEM – יְרוּשָׁלַיִם .

No place has been more sacred over time to Jews than Jerusalem, one of whose traditional names is *Ir Ha-Kodesh*—"the Holy City." Although for several centuries Jerusalem remained a foreign city within the midst of the *Twelve Tribes, it became, after its conquest by *David (c. 1000 B.C.E.), the administrative center of the country, a symbol of national unity. When David's son *Solomon built the Holy *Temple on Mount Zion, it also became the spiritual center of the nation, where the *Priestly Cult performed sacrifices and where the entire people came three times a year during the pilgrimage festivals.

Jerusalem has acquired many names throughout its long history. Although probably derived from the name of a Canaanite god, "*Yerushalayim*" was reinterpreted by the *midrash* as meaning "Foundation of Peace," derived from the Hebrew root "to found" (*yarah*) and "*shalom*." It also became known as Zion (whose etymology is unclear); God's City; the City of Justice; and the Faithful City. Because of David's role in establishing its centrality to Judaism, it also became known as "David's City," the future site of the restored Davidic monarchy, one of whose descendants will be the *Messiah.

Jewish legend claims that many important spiritual encounters occurred on the Temple Mount in Jerusalem, among them *Adam's first sacrifice, the *akedah*, and Jacob's *dream of the *ladder of *angels.[1] Tradition has attached special sanctity to this particular site, identifying it as the navel or center of the world, source of the earth's underground springs, the dwelling place of God. Many early maps of Jeru-

salem located it at the *heart of the three continents of Asia, Europe, and Africa.

After the destruction of the Temple, the Temple Mount came to be regarded as the future site of the messianic redemption, where the earth's dead would be resurrected, the Jewish exiles would be ingathered, and the Third Temple would be established.[2] The rabbinic tradition also conceived of a heavenly counterpart to the earthly Jerusalem, an ideal city of God.

The Bible attributes exceptional beauty to Jerusalem, calling it "the princess among states"; "perfect in beauty, joy of all the earth."[3] Rose-colored "Jerusalem stone," quarried in the region and central to the city's architecture from biblical times to this day, was famous throughout the ancient world for its beauty and strength. In Jewish liturgy, religious poetry, love poetry, and

song, Jerusalem has been celebrated as the symbol of Israel's past and future glory.

The rabbis instituted special laws to enhance and protect the holiness of the city, especially the Temple Mount. When praying, one was to face Jerusalem (*east for

the majority of Jews). Jews were forbidden to walk upon the Temple Mount for fear of trespassing upon the site of the Holy of Holies. No trash heaps were allowed within the city precincts; neither were graves (with the exception of those of the House of David and Huldah the prophetess).

After the destruction of the Second Temple by *Rome, Jerusalem came to symbolize both the tragedy and hope of the Jewish People. A fast day, *Tisha B'Av, was instituted to commemorate the destruc-

Stylized images of Jerusalem.

tion of both the First and Second Temples and of Jerusalem itself. Prayers for the rebuilding of the Temple and the restoration of the Davidic dynasty were introduced into the liturgy. Most Jewish celebrations sound a note of mourning in remembrance of the Temple, such as breaking a glass at *weddings (although such interpretations sometimes come after these customs first arose). In fact, the rabbis encouraged Jews to commemorate the destruction of the Temple whenever possible: leaving a corner of one's house unfinished, omitting one dish from a festive meal or one ornament from an ensemble of jewels.

The psalmist's lament—"If I forget you, O Jerusalem, let my right hand wither, let my tongue stick to my palate . . . if I do not raise Jerusalem above my chief joy"—has been a dominant motif in Jewish literature and song for centuries.[4] Both the *Passover *seder and the final service of *Yom Kippur end with the cry: "Next year in Jerusalem!" The image of Jerusalem is often depicted on a *ketubah (marriage contract), since marriage is likewise one's chief joy.

The mystics envisioned Jerusalem as the *gateway to the heavens, and the earthly dwelling of the *Shekhinah, God's feminine aspect. The city was often identified as a mother, its inhabitants as daughters.[5] The popular Sabbath evening hymn, "Lekha Dodi," created by the kabbalists of 16th-century *Safed, celebrates the future redemption of "the Sanctuary of the King, the royal city."

Nineteenth-century Jewish writers and political activists focused upon Jerusalem as a symbol of Jewish exile and the hope for national renewal. The Zionist movement, in choosing one of the city's most ancient names as its own, signaled the importance of this historical symbol for modern Jewish identity. Since the establishment of the State of Israel, Zion has regained its earlier meaning designating the entire land and people; and Jerusalem, its capital city. The Israeli national anthem, "Hatikvah" ("The Hope"), sung throughout the Diaspora as well as in Israel, affirms that "as long as the eye looks eastward, gazing toward Zion, our hope is not lost."

Although three world religions share the symbolic heritage of Jerusalem, Judaism alone has made this city the focal point of thirty centuries of literature, song, art, and liturgy. In rabbinic times, a physical replica of the city was fashioned into a "Jerusalem of gold," a coronet worn by women. During the subsequent centuries of exile until our own day, stylized images of the ancient walled city, often featuring the gold towers and domes dominating its skyline, have ornamented books, ritual objects, ketubot, and synagogue interiors.

In our own time, Jerusalem has again resumed its place as the center of Jewish religious and political life, survival, and triumph. In addition, because it serves as the holy place of three faiths and two quarreling cultures, it also symbolizes a divided world yearning for unity. It carries within its own name—Ir Shalom, City of Peace—the suggestion that the world will one day achieve universal redemption and peace.

[1]Genesis Rabbah 34:9; 56:10; 68:9; [2]Ezekiel 45:1–8; Zechariah 14:16–21; Isaiah 24:23; 27:13; 54:11–12; Joel 4:12–21; [3]Lamentations 1:1; 2:15; [4]Psalm 137:5–6; [5]Pesikta Rabbati 26:7.

Signifies: BEAUTY, CENTER, DIVINE ABODE, GLORY, HOLINESS, HOPE, NATIONAL REBIRTH, PEACE, PERFECTION, REDEMPTION, SURVIVAL, UNITY, VICTORY

Generic Categories: Israel (Land of, State of), Kabbalistic Symbols, Messiah, Places, Prayer, Temple, Tisha B'Av

See also: David, Gold, Heart, Israel, Messiah, Mountain, Priestly Cult, Rome, Shekhinah, Temple, Tisha B'Av, Western Wall

JOB — אִיּוֹב. The name Job may have derived from a compound made of two Hebrew words: ai av (אַי אָב) — "Where [is] the [divine] Father?" More than any other biblical character, Job has captured the religious imagination of both Jews and Christians as a symbol of faith in the midst of suffering.

To some of the rabbis, Job was a man who truly feared God,[1] one of the most pious Gentiles who ever lived,[2] more praiseworthy than *Abraham;[3] to others, he was a great blasphemer.[4] To some, he was a Gentile prophet; to others, a model of the righteous proselyte; to still others, an Israelite. He has often been compared to Abraham, who likewise underwent a supreme test of faith.

From the Middle Ages to our own day, the Book of Job has inspired many plays, poems, musical compositions, and works of visual art among both Jews and Christians. Because of his struggles with religious doubt and causeless suffering, he is sometimes regarded as a symbol of the modern condition, especially among existentialist philosophers, or as the challenger of God who demands a response to suffering.

[1]Sotah 31a; [2]Deuteronomy Rabbah 2:4; [3]Bava Batra 15b; [4]Bava Batra 16a.

Signifies: CHALLENGE, FAITH, GRIEF, LOSS, MODERNITY, PIETY, RIGHTEOUS GENTILE, SUBMISSION TO GOD'S WILL, SUFFERING

Generic Categories: Personalities

See also: Abraham, Akedah

JONAH — יוֹנָה. Jonah, whose name means *dove, was an Israelite prophet who tried to flee his heavenly assignment—prophesying the doom of the sinful city of Nineveh—but who was ultimately recalled

to duty from the belly of a great *fish. He is a traditional symbol of the reluctant prophet (although the word "prophet" never once appears in the book which bears his name).

As Jonah had feared, Nineveh did indeed repent after hearing his dire warning, making him seem a false prophet. But through parable, God taught Jonah that mercy outweighs punishment in the divine plan.

In many cultures, being swallowed is symbolic of an experience of faith, redemption, and rebirth, although in Jewish tales of this kind—*Abraham in Nimrod's furnace; *Daniel in the lion's den; Shadrakh, Mishakh, and Abednego in Nebuchadnezzar's furnace; and Jonah—it is prayer, not the hero's prowess, that saves him. The story can also be seen as an allegory of the individual soul, struggling between the desires for self-destruction and rebirth.

The Book of Jonah is read on the afternoon of *Yom Kippur, because of its message of human repentance, divine forgiveness, and the futility of hiding from God's omniscience. The symbolism of *water as source of death and life reflects the major themes of the penitential season.

Depictions of the tempest, the whale swallowing and vomiting out Jonah, and Jonah arguing with God can be found on many early Jewish tombs in the Roman catacombs, symbolic of the hope that God will forgive the sins of the deceased, as the sins of Jonah and Nineveh were forgiven.

Signifies: DIVINE COMPASSION, DIVINE JUDGMENT, FAITH, FORGIVENESS, HOPE, REDEMPTION, PROPHECY, REPENTANCE, SUBMISSION TO GOD'S WILL

Generic Categories: Personalities, Yom Kippur

See also: Fish, Water, Yom Kippur

JOSEPH — יוֹסֵף.
Joseph was the older son of *Jacob's favorite wife *Rachel. Jacob favored Joseph above his other children, singling him out by giving him a coat of many *colors. To add to his brothers' resentment, Joseph dreamed that his brothers' sheaves bowed down to his; and in another *dream, that his parents, in addition to his brothers (the *sun, *moon, and eleven *stars) bowed down to him. Out of jealousy, Joseph's brothers feigned his death and sold him into slavery in *Egypt. Through his talent as a dream-interpreter and administrator, Joseph saved Egypt—and his own family—from famine.

Although Joseph was indirectly responsible for bringing the Jews to Egypt and thus into bondage, he was also responsible for saving them from starvation in his own lifetime and for setting the stage for the triumphant *Exodus hundreds of years later. Thus, Joseph is a symbol of redemption.

Once the Israelite kingdom divided after the reign of *Solomon, Joseph, the House of Joseph, or *Ephraim, Joseph's younger son, became synonymous with the Northern Kingdom.[1] In later legend, probably under influence of apocalyptic writings and in the wake of the abortive Bar Kokhba revolt (135 C.E.), the rabbis developed the idea of a second *Messiah, known as "the son of Joseph," who would precede the Messianic Son of *David, and die fighting the enemies of Israel.[2] This earlier Messiah became a symbol of the reunification of the *Twelve Tribes.

In the midrash, Joseph is described as a model of many positive qualities: virtue in the face of temptation (as exemplified by the episode with Potiphar's wife)[3]; filial love[4]; family loyalty; honorable conduct in office[5]; righteousness[6]; and wisdom in interpreting dreams. But the rabbis also faulted him for his vanity, claiming that as a young man he penciled his eyes, curled his *hair, and walked with a mincing step.[7] In later times, he was the prototype of the court Jew, a role fraught with tension.

Because of his experiences in Egypt, first as a slave, then as viceroy, and ultimately, through his descendants, once again as slaves, Joseph's life is seen as symbolic of Jewish history, characterized by sudden reversals of fortune.

On Friday nights, parents bless their sons with the words bestowed by Jacob upon Joseph's sons ["Through you shall Israel bless, saying]: God make you like Ephraim and Manasseh." [8] Joseph's line thus represents family continuity and hope for the future.

[1]Ezekiel 37:16; Amos 5:6; [2]Sukkah 52a; [3]Genesis 39:7-19; [4]Mekhilta, Beshallah, Proem; [5]Exodus Rabbah 1:7; [6]Avodah Zarah 3a; [7]Genesis Rabbah 84:7; [8]Genesis 48:20.

Signifies: ARROGANCE, CLEVERNESS, CONTINUITY, COURT JEW, FAMILY, FAVORITISM, HONOR, HOPE, JEWISH HISTORY, REDEMPTION, REUNIFICATION, REVERSAL OF FATE, RIGHTEOUSNESS, SIBLING RIVALRY, VANITY, VIRTUE

Generic Categories: Messiah, Personalities

See also: Colors, Dreams, Egypt, Ephraim, Jacob, Judah, Messiah, Twelve Tribes

JUDAH – יְהוּדָה.

The name Judah, the fourth son of *Jacob and *Leah, comes from the Hebrew word meaning thanksgiving or praise.[1] More than any of the other *Twelve Tribes, Judah became synonymous with the People of Israel, giving his name to their descendants – Yehudim (יהודים) (Judaites) – and the religion of Israel – Judaism (יהדות).[2]

The rabbis explained Judah's importance by pointing to his family loyalty in saving *Joseph from death at the hand of his other brothers and in offering himself instead of Benjamin when Joseph later tested the brothers.[3] But because he did not do even more to save Joseph from slavery, he was later punished by losing his wife and two of his sons.[4] Judah and his daughter-in-law Tamar, who deceived him into continuing the family line through her according to Jewish law, are the ancestors of *David, the Davidic dynasty, and the *Messiah.[5]

When the kingdom of Israel divided after *Solomon's reign, the two remaining tribes in the South were Judah and Benjamin. Eventually, Judah became synonymous with the Southern Kingdom, which became known as Judah, renamed Judea by the Romans. The people were referred to as "Judahites," Yehudim in Hebrew. This is the origin of the English word "Jew."

The tribe of Judah was distinguished by its mighty warriors; its symbol was the *lion. In the Bible, Judah is described as "a lion's whelp . . . like the king of beasts."[6] The midrash claims that when Judah became angry, the hairs on his chest pierced his clothes, and that he could chew iron bars to dust.[7] Throughout Jewish history, the Lion of Judah has been one of the most popular symbols of the Jewish People, represented frequently in ceremonial art and synagogue architecture.

[1]Genesis 29:35; [2]Genesis Rabbah 98:6; [3]Genesis 37:26–27; 43:8–9; 44:16–34; [4]Genesis 38:7–12; Genesis Rabbah 85:3; [5]Genesis, chapter 38; Genesis Rabbah 85:9; [6]Genesis 49:9; [7]Genesis Rabbah 93:6.

Signifies: FAMILY, JEWISH PEOPLE, STRENGTH

Generic Categories: Personalities, Twelve Tribes

See also: David, Israel, Jacob, Joseph, Lion

JUDAH MACCABEE – יְהוּדָה הַמַכַבִּי.

Judah Maccabee was the third son of Mattathias, the Hasmonean priest who began the Jewish revolt against Hellenistic domination at the hands of Syria in the 2nd century C.E. Noted for his courage and military genius, Judah led his outnumbered and unskilled guerilla army to victory over the superior Syrian forces.

After he defeated the Syrian army, Judah entered *Jerusalem, cleansed and rededicated the *Temple, and instituted an eight-day festival that became known as *Hanukkah. Although no mention is made of Judah Maccabee in the Talmud, he eventually became a popular folk hero, a Jewish symbol of religious freedom and national liberation. The hero of innumerable Hanukkah plays, poems, and musical compositions, Judah has become the prototype of the Jewish warrior, especially in modern Israel, whose history has been characterized by military victories over great odds.

Tradition has interpreted the name "Maccabee" (מכבי) to mean either "hammer," a symbol of Judah's might, or as an acronym for mi khamokha ba-elim Adonai (מי כמוך באלים יי), "Who is like You, O God!"[1]

[1]Exodus 15:11.

Signifies: COURAGE, LIBERATION, MILITARY POWER, NATIONALISM, STRENGTH, VICTORY, WAR

Generic Categories: Hanukkah, Personalities

See also: Greece, Hanukkah, Menorah, Temple

JUDITH – יְהוּדִית. The Book of Judith has had an uncertain fate in Jewish history. Although relegated to a category called "extraneous books" ("Apocrypha" in later non-Jewish traditions) by the rabbis, it was included in the Septuagint, the *Greek translation of the Hebrew Bible. In later centuries, the figure of Judith, the brave heroine who decapitated the Assyrian general Holofernes and so saved *Jerusalem from defeat, became a central symbol of Jewish courage and victory, and was frequently depicted in Jewish ceremonial art, especially on *Hanukkah *menorahs*, since her story so closely parallels that of *Judah Maccabee. On the Sabbath of Hanukkah, there was once a custom to sing a 12th-century *piyyut* (poem), "*Mi Khamokha Addir Ayom Ve-Nora*," based on the story of Judith. Judith is also a traditional symbol of virtue, since she resisted the lustful advances of Holofernes. Jews customarily eat dairy foods during Hanukkah in honor of Judith's strategy of feeding Holofernes cheese to make him thirsty for *wine.

In more recent times, the story of Judith has become virtually unknown in most Jewish communities, perhaps out of squeamishness or perhaps because there is no religious observance associated with her story. Modern Jewish feminists have revived the story of Judith as a model of heroism and activism.

Signifies: ACTIVISM, COURAGE, VICTORY, VIRTUE

Generic Categories: Hanukkah, Personalities, Women

See also: Hanukkah, Judah Maccabee, *Menorah*, Milk

KABBALAH – קַבָּלָה. Kabbalah means "that which is received." Although the term sometimes refers to the entire Jewish tradition, it most commonly designates the mystical tradition, stretching from the rabbinic period to our own day. It may also refer specifically to the writings and practices of the Jewish mystical schools which arose in 12th- and 13th-century France and Spain and later in 16th-century *Safed.

Although mystical techniques were probably practiced in the schools of prophecy established during biblical times, a systematic Jewish mysticism did not fully develop within mainstream Judaism until talmudic times. Many prominent rabbinic sages were masters of *Heikhalot* (*"Palaces") mysticism, also known as *Maaseh Ha-Merkavah*, the Vision of the Divine *Chariot. The goal of this early mystical movement was to ascend contemplatively through the *seven heavens and palaces to attain a vision of the Divine *Throne of Glory.

For almost a thousand years, Jewish mysticism remained a highly esoteric and marginal movement. But in 12th-century Provence and 13th-century Spain, mystical writings began to appear, most notably the *Zohar*, The Book of Splendor, which articulated a systematic theology based upon the theory of the *ten *Sefirot*, divine emanations of God unfolding in the material world.

Attributed to the authorship of the ancient sage, Rabbi Shimon bar Yohai, the *Zohar* teaches that God's nature is ultimately paradoxical: unitary yet multidimensional; transcendent, in its aspect as "*Ein Sof*" ("the Infinite"), concealed from human view, yet also immanent, in the form of the seven lower *Sefirot*, which interact with our own world. The *Zohar* also teaches that the lower world of matter corresponds to the upper world of the *Sefirot*. These two worlds enjoy a dynamic relationship: the lower world receives divine *light and blessing from above; the upper world, its primal unity shattered at the beginning of creation, achieves reintegration – *tikkun*, literally "repair" – as a result of human actions. Both worlds are linked in a *chain of energy to the *Ein Sof*. Even evil emerges from the sefirotic realm, caused by a lack of balance between Mercy (*Hesed*) and Judgment (*Din*). The mystics of this period believed that the words of the liturgy and *Torah symbolized the life of the sefirotic realm and could effect its repair. They constantly strived for "*devekut*," attachment to God, through contemplation, prayer, and holy deeds.

In 16th-century Safed, after the trauma of the Spanish Expulsion (1492), Jewish mysticism experienced a renaissance. The mystics of this period introduced elements of *messianism into traditional mystical teachings, claiming that the entire Jewish People, not just a select elite, could and

must work for the redemption of God's exiled *Shekhinah. To the basic principles of the *Sefirot* and their interrelationship with the lower world, the mystics of Safed added both ascetic and ecstatic practices. Some of these, such as the *Tu B'Shevat *seder*, the Friday evening *Kabbalat *Shabbat* service, and the study vigil on the eve of *Shavuot, have become part of mainstream Jewish tradition. This movement, known as Lurianic Kabbalah after its most influential teacher, Rabbi Isaac Luria, influenced both the messianic movement, inspired by the "false messiah" Shabbatai Tzevi, and Hasidism.

Kabbalah has developed an elaborate system of symbolism within Judaism, primarily focused upon the doctrine of the *Sefirot*. Each *Sefirah* symbolizes an aspect of the divine personality, which is represented through numerous analogies: human anatomy, natural symbols, biblical figures, language, *colors, *names of God. The *Sefirot* are usually depicted in the form of a *tree, balanced in dynamic relation to each other, representing the life and actions of God. Kabbalistic texts are often difficult to decipher, as if written in secret code, because their authors freely substitute these symbolic analogues for the primary names of the *Sefirot*.

Although not pantheistic, Kabbalah — more than any other strain within the tradition — emphasizes the intimate interconnection between divine and human realms. According to Kabbalah, everything within our world contains divine "sparks" ("*nitzotzot*") imprisoned within the "shells" ("*klippot*") of matter. The goal of the study and practice of Kabbalah is to liberate these sparks in order to effect *tikkun*, the repair of the upper world, and hence of our own.

Over the centuries, esoteric Kabbalah has given rise to a more popular tradition known as practical Kabbalah, that is, Jewish magic. Such practices include the use of *amulets, charms, combinations of letters, words, and *numbers, and various rituals to counter the *Evil Eye, bring about healing, ensure good luck, and tell the future.

Signifies: DIVINE PRESENCE, MYSTERY, MYSTICISM

Generic Categories: Kabbalistic Symbols, Messiah, Shavuot, Tu B'Shevat

See also: Aaron, Adam, *Akedah*, *Alephbet*, Amulet, Angels, Apple, Body, Chain, Chariot, Colors, David, Elijah, Evil Eye, Fire, Gates, Gold, *Golem*, Head, Israel, King, Leah, Light, *Menorah*, Messiah, Moses, Name of God, Numbers, Nut, *Omer*, Palace, *Pardes*, Purim, Queen, Red, Safed, Satan, *Seder*, *Sefirot*, Seven, Seventy, *Shabbat*, *Shekhinah*, *Shofar*, Sinai, Star of David, Sukkot, *Tefillin*, Ten, Thirteen, Throne, Torah, Tree, Tu B'Shevat, *Ushpizin*, Well

KASHRUT — כַּשְׁרוּת.

The Jewish dietary laws, dating back to the *Torah, are among the most ancient practices still observed today by Jews. In the Bible, the laws of *kashrut* — from the root *kasher*, "fit" or "proper" — specify which animals, *birds, and *fish may be consumed by human beings, and how they are to be slaughtered and prepared. In addition, the Bible proscribes mixing *milk products with meat, based on the principle that "You shall not seethe a *kid in its mother's milk."[1] Later generations of rabbinic authorities elaborated on these biblical laws, and continue to do so to the present day as technological developments demand new interpretations of the ancient code.

Some of the symbols used by various organizations for certifying a kosher product.

The dietary laws fall under a general legal category called *hukkim* in the Bible, laws whose only rationale is that they are divinely ordained. No reason is given to observe *kashrut* other than "You shall be holy."[2] Throughout the ages, various commentators, responding to this vacuum in the biblical text, have offered their own interpretations of *kashrut*.

According to tradition, God only permitted the eating of meat after the Flood.[3] But such consumption of flesh must be restrained, for it inevitably exacts a toll on our sensibilities. The prophet Ezekiel associated eating *blood, proscribed by the

dietary laws, with murder and idolatry.[4] Aristeas, a 1st-century B.C.E. Egyptian Jew, likewise claimed that abstention from eating blood tames the human instinct for violence. He also maintained that the laws of *kashrut* instill in people a sense of justice. Abstaining from eating birds of prey, for example, teaches us not to prey on others.[5] The Hellenistic Jewish philosopher Philo suggested that eating creatures with evil instincts might stir such instincts in us.[6]

The rabbis claimed that the purpose of keeping kosher was to refine human nature by teaching self-restraint. Thus, they argued that it was preferable for one to say, "I like [the taste of swine's flesh] but must abstain since the Torah forbids it," rather than professing a distaste for this particular food.[7]

To the list of such moral justifications, the medieval rationalist Maimonides added the argument of hygiene as well as the rationale of making a distinction between Jewish practices and idolatry.[8] Ibn Ezra believed that boiling a kid in its mother's milk is forbidden because it is an act of cruelty. Later interpretations argued that this prohibition symbolically separates the food of life (milk) from that of death (a slaughtered animal).

*Kabbalists have argued that food affects the soul as well as the body. Unkosher foods thus "defile and pollute the soul and blunt the intellectual powers," since they stimulate the baser appetites and lead ultimately to destruction, "defeating the purpose of creation."[9]

Throughout the centuries, Jews have regarded *kashrut* as a symbol of Jewish identity and community. During the Crusades, the Spanish Inquisition, the Chmielnicki pogroms, and the Third Reich, Jews often chose martyrdom or subterfuge rather than abrogate these laws.

In modern times, *kashrut* has occasioned much controversy in the Jewish community. Many nontraditional Jews reject *kashrut* as a symbol of antiquarianism and superstition. In its early days (although its position has softened over the years), the Reform movement rejected such dietary laws as outmoded and "apt to obstruct . . . modern spiritual elevation."[10]

Both the Conservative and Orthodox movements, as well as traditional Sephardi communities, still maintain the dietary laws as they have been articulated by rabbinic authorities over the centuries. "The goal of *kashrut*," writes one Conservative commentator, "is holiness . . . an attempt to hallow the common act of eating which is an aspect of our animal nature." In doing so, *kashrut* fosters holiness in "two ways, both of which are implied in the Hebrew word '*Kadosh*': inner hallowing and outer separateness."[11]

In contemporary culture, the meaning of "kosher" has expanded to include "pure," "allowed," or "proper" behavior as well as food. Some Jews have further expanded its scope to the domain of ecology and political ethics. Jewish vegetarians maintain that their diet is a more spiritual form of *kashrut*, since the original dwellers in the Garden of *Eden were vegetarians.

[1]Exodus 23:19; 34:26; Deuteronomy 14:21; [2]Exodus 22:30; Leviticus 11:44-45; Deuteronomy 14:21; [3]*Sanhedrin* 59b; [4]Ezekiel 33:25; [5]Letter of Aristeas, ed. and trans. Moses Hadas, verses 142-147; [6]De Specialibus Legibus 4:118; [7]Sifra Kedoshim on Leviticus 20:26; [8]*Guide of the Perplexed* 3:48; [9]Isaac ben Moses Arama, *Akedat Yitzhak, Shaar Shemini,* 60-end; [10]Pittsburgh Conference, November 16-18, 1885; [11]Dresner, *The Jewish Dietary Laws,* 54.

Signifies: COMMUNITY, COMPASSION, DISTINCTION, HOLINESS, JEWISH IDENTITY, JUSTICE, SELF-RESTRAINT, SEPARATENESS, SUBMISSION TO GOD'S WILL, VEGETARIANISM

Generic Categories: Food

See also: Altar, Bird, Blood, Fish, Goat, Milk, Table

KETUBAH — כְּתֻבָּה. The Jewish marriage contract, called a *ketubah,* literally "document," is a legal contract recording the financial obligations which a husband undertakes toward his wife. Although the *ketubah* was originally designed to protect the economically vulnerable woman, it gradually evolved into much more than a legal document. To the couple whose marriage it celebrates, the *ketubah* represents their covenant of marriage and their new household.

Beginning in 10th-century Egypt and

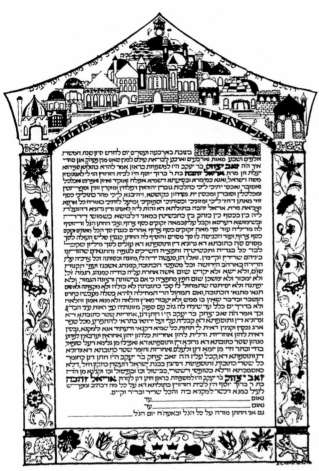

Ketubah from a wedding in Jerusalem, 5744 (1984). Enlarged first word is *"Be-ehad,"* on the first (day of the week). The columns and arch create a portal signifying transition, in this case into matrimony.

Song of Songs. *Ketubot* written in Sephardi communities reflect the Muslim host culture's prohibition against pictorial representation and are usually ornamented with geometric calligraphy.

Because only the written text must conform to specific legal standards, the ornamental frame of the *ketubah* has largely escaped rabbinic scrutiny. More than any other ceremonial object or setting, the *ketubah* has afforded Jewish artists an opportunity to exercise their creativity and imagination, drawing from the rich symbol treasury of Jewish tradition. In modern times, the illuminated *ketubah* has enjoyed a renaissance. For many couples who write their own texts, the *ketubah* symbolizes equality in their marriage.

In Sephardi communities, it is customary to read a special *"ketubah"* on the holiday of **Shavuot, marking the wedding of God and Israel on the occasion of the Giving of the **Torah.

continuing to our own day, it has been the custom to illuminate the Aramaic text of the *ketubah* with a decorated border. Because of their expense and beauty, illuminated *ketubot* have been prized for generations as family heirlooms and works of art.

Some of the more common decorations on traditional Italian *ketubot* are biblical or mythological motifs; portraits of the bride and groom in contemporary costume; the family coat of arms; symbols representing conjugal bliss, occasionally including nude figures; *priestly symbols for the family of a *Kohen* or *Levi*; biblical scenes suggestive of the bride or groom's name or profession; and *crowns. Many of the decorative motifs derive their inspiration from the biblical

Signifies: BLESSING, CELEBRATION, COVENANT, EQUALITY, HOPE, INEQUALITY, LOVE, MARRIAGE, UNION

Generic Categories: Shavuot, Wedding, Women

See also: Circle, Crown, Flowers, Gold, Grapes, *Huppah*, Jerusalem, Pomegranate, Portal, Priestly Blessing, Shavuot, Wedding, Zodiac

KING — מֶלֶךְ. Jews encountered kings long before they had one of their own. *Abraham's native Mesopotamia was governed by a powerful monarch who Jewish tradition identifies as Nimrod, the chief

builder of the Tower of Babel. The land of Canaan was governed by many local chieftains whom the Torah calls "kings."[1] During their long captivity, the Israelite slaves were ruled by the *Pharaohs of *Egypt.

When the Israelites clamored for their own king, the prophet Samuel warned them that they would come to regret it, for kings would rob them of their children, their wealth, and their freedom.[2] But the people insisted, and God granted their wish. In time, Samuel's fateful warning came to pass.

In the history of the Israelite monarchy, kings, with a few notable exceptions such as *David and Josiah, came to symbolize abuse of power. The prophets railed against them; the rabbis later drew cautionary lessons from their failings.

Contrasted to earthly kings, God, the King of Kings, is said to rule the universe with justice and mercy. The rabbis constantly pointed out the discrepancy between human and divine governance: "To an earthly king, a person goes full, and returns empty; to God, one goes empty, and returns full."[3] The Talmud abounds in parables of God as king, and Israel as the king's son or daughter. *Kabbalistic and hasidic literature draw upon this analogy as well, often portraying the Divine King as a loving parent.

In the traditional liturgy, especially the *Mahzor*, the High Holiday prayer book, God is frequently referred to as *Melekh Ha-Olam*, King of the Universe, an epithet which stresses divine majesty and power. This phrase is also part of the ancient formula which characterizes all Jewish blessings: "Blessed are You, *Adonai* our God, King of the Universe." In keeping with this image, Jews "bow the knee," as before a king, when reciting certain prayers, even prostrating themselves on the ground during parts of the High Holiday service. It is also traditional to step back three steps during the *Amidah* prayer, before entering the presence of the King. Some contemporary Jews, dissatisfied with and alienated from the hierarchical and patriarchal connotations of the term "king," have substituted other terms such as "Source of Blessing," "*Ein Ha-Berakhah* (*Fountain of Blessing)," "*Ruah Ha-Olam* (Lifebreath or Spirit of the World)," "*Hai Ha-Olamim* (Life of the Universe)," or "the Eternal One."

The motif of God's kingship receives graphic representation within the *synagogue. The *Torah scroll, symbolic of God's rule on earth, wears a *crown and is dressed in royal finery. The *yad, the Torah pointer, is shaped like a scepter. Often the *chairs flanking the *ark resemble *thrones. Worshipers step backward when descending from the *bimah, and bow toward the *ark during prayers. The hem of the Torah garment is kissed as it makes its processional circuit.

In the *kabbalistic system, the highest *Sefirah* is called *Keter*, Crown, symbolizing God's primal will. The lowest is *Malkhut*, Kingdom, the closest connection of the divine and human worlds. This tenth *Sefirah* is also the special province of the *Shekhinah*, God's female aspect, often called the *Queen.

Because the *lion is considered the king of beasts, and the *eagle, the king of *birds, these two creatures are often symbols of both earthly and celestial kingship. In Jewish tradition, the Lion of *Judah is a common symbol of the Davidic dynasty.

On the holiday of *Purim, many Jewish children choose to dress up as King Ahashverosh, whose foolishness and vanity almost brought an end to the Jews of Persia.

[1]Genesis, chapters 14, 20, 26, 36; [2]1 Samuel 8:11-18; [3]*Pesikta Rabbati* 44:9.

Signifies: ABUSE OF POWER, AUTHORITY, DIVINE KINGSHIP, DIVINE POWER, FOOLISHNESS, GOD, POWER, VANITY

Generic Categories: Kabbalistic Symbols, Messiah, Prayer, Purim, Rosh Hashanah, Synagogue

See also: Crown, Eagle, Kabbalah, Lion, *Megillah*, Pharaoh, Purim, Queen, Rosh Hashanah, *Sefirot*, Throne, Torah, Wind

KIPPAH — כִּפָּה. The word "*kippah*" (pl. *kippot*, also *yarmulke* [Yiddish] or "skullcap") comes from "*kaf*," meaning "palm," describing the shape of the typical *head covering worn nowadays by Jews. Made of cloth, woven or crocheted wool, or leather, the *kippah* is a universally recognized symbol of Jewish identity.

The evolution of head coverings in Jewish tradition is long and complicated. In the Bible, there is no explicit commandment to cover one's head for prayer or other religious functions. The High *Priest wore a special head covering called a *mitznefet* (miter); the ordinary priest, a turban called a *migbaat*.[1] But the ordinary Israelite was given no directions about head coverings. In later biblical times and in talmudic times, covering the head was a sign of mourning.[2]

Different styles of kippot (also called yarmulkes).

The Talmud considered the covered head a sign of awe before the Divine Presence, especially when praying or studying mysticism.[3] Scholars covered their heads to indicate their prominent status; less dignified people who did so were considered presumptuous.[4] The sages of ancient Israel declared it optional to cover one's head for prayer, a position later endorsed by medieval Spanish and French rabbinical authorities. The Babylonian rabbis, however, advocated always covering one's head as a sign of *yirat shamayim* (fear of heaven),[5] and their view was later endorsed—although not mandated—by Ashkenazi rabbinic authorities. The de facto requirement that Jewish men cover their heads for prayer is a relatively recent phenomenon, arising largely as a reaction to the Christian practice of praying bareheaded. A bare head was also traditionally equated with "lightheadedness."

Very traditional Jewish men wear a *kippah* or other head covering all the time as a symbol of their piety and allegiance to tradition. Others wear it only on formal religious occasions, most notably at synagogue services. Degrees and fashions of religious observance are often signaled by the type of hat worn—from stringent "black hat" to more modern "knit *kippah*." Although the early Reform Movement frowned upon the wearing of *kippot*, some Reform Jews now wear them in synagogue and at religious ceremonies; this practice is still considered optional. In many liberal congregations, women wear *kippot* to indicate their religious equality as well as their reverence for God.

Since biblical times, married Jewish women have traditionally covered their heads out of modesty. Conversely, the unveiling of a woman's head has symbolized humiliation or wantonness. Jewish women have covered their heads with hats, kerchiefs, turbans, or wigs. In more recent times, some Jewish women, single as well as married, have chosen to wear a *kippah* to symbolize their religious equality, as well as their respect for God and Jewish identity.

[1]Exodus 28:4, 37, 40; [2]2 Samuel 15:30; Jeremiah 14:3-4; Esther 6:12; [3]*Hagigah* 14b; *Rosh Hashanah* 17b; *Taanit* 20a; [4]*Pesahim* 111b; [5]*KIddushin* 31a; Maharshal, Responsa #72; see also Responsa #5 of the Central Conference of American Rabbis (Reform).

Signifies: ALLEGIANCE TO TRADITION, AWE, EQUALITY, JEWISH IDENTITY, MODESTY, MOURNING, PIETY, RESPECT, REVERENCE FOR DIVINE, STATUS, SUBMISSION TO GOD'S WILL

Generic Categories: Clothing, Prayer, Synagogue, Women

See also: Clothing, Crown, Hair, Head

KITTEL – קיטל .

The *kittel*—from the Yiddish word meaning "gown"—is a *white garment worn in some Ashkenazi communities by worshipers during *Yom Kippur services, by the groom during his *wedding ceremony, by the person conducting the *Passover *seder, and by the *hazzan* (cantor) during the solemn Prayer for *Dew on Passover and the Prayer for *Rain on Shemini Atzeret. It is also customary in some communities to bury men in a *kittel* over the burial *shroud. Occasionally, fathers wear a *kittel* at their son's *brit. Although *kittels* have traditionally been worn by men, many women have begun wearing them.

In ancient times, a white garment was worn every *Shabbat and on most solemn occasions.[1] Eventually, the practice was

restricted to the occasions enumerated above. The color white has traditionally been associated with purity and the forgiveness of sins as well as with solemn joy. Because the day of one's marriage is considered a day of atonement, the bride and groom traditionally fast, and the groom wears a *kittel*. Similarly, it is an ancient belief that rain and dew are withheld

A kittel.

from the community when the people sin; the prayer leader thus dons the white *kittel* to signify his penitence. The entire community garbs itself in white during the High Holiday prayers to symbolize their repentance and purity. Because Yom Kippur reminds Jews of their own mortality, many wear a white *kittel* on this day to solemnize their symbolic death and equality before God, since the *kittel*, like death, obliterates distinctions between rich and poor. The day of one's death also carries with it the hope that one's sins have been forgiven.

The white *kittel* also symbolizes a new beginning. Therefore, it is worn to begin the New Year (Rosh Hashanah), to wipe the slate clean of sin (Yom Kippur), to initiate a child into the covenant (*brit*), to begin a marriage, and to leave *Egypt for a new life of freedom (Passover *seder*).

Some Jews gird the *kittel* with a white rope to symbolically divide the baser from the purer parts of the body. In the 18th and 19th centuries, it was customary to decorate a silver buckle on the *kittel* belt with rampant *lions and a quotation from the Yom Kippur liturgy, although such ornamentation was in marked contrast to the *kittel's* message of simplicity and purity.

[1] JT *Rosh Hashanah* 1:3.

Signifies: ATONEMENT, BEGINNING, DEATH, EQUALITY, HUMILITY, PURITY, REPENTANCE

Generic Categories: Clothing, Death, Prayer, Sukkot, Wedding, Yom Kippur

See also: *Brit*, Clothing, Dew, Passover, Rain, Shroud, Sukkot, Wedding, White, Yom Kippur

KNOTS – קֶשֶׁר.

In many cultures, knots are considered among the magician's most powerful devices. By binding *hair or *clothing, one gains control over another's soul, or prevents that soul from leaving the dead body. In some cultures, midwives untie knots as they cut the umbilical cord to aid childbirth. Many folklores contain stories about the Cosmic Spinner, often an old woman, who weaves and then spins the threads of life. Knots also symbolize one's bond to the community and to God. The expression, "tying the knot," signifies the marriage bond.

The Book of *Daniel lists "loosing knots" as one of the magician's arts.[1] In the Talmud, magic is sometimes called "binding and loosing." A posttalmudic antidemonic spell contains the incantation: "Bound, bound, bound!" Even in modern English, we speak of someone being "spellbound" or "spellbinding."

In the Middle Ages, knot-magic was particularly compelling to the Jewish folk imagination. Since it was believed that one could escape from demonic influences by loosing all knots, it was customary to unbraid the hair and untie all knots in the garments of a woman in labor, perhaps as sympathetic magic to prevent knots in the umbilical cord. One also made sure

The knots and windings of *tzitzit*, attached to each corner of a *tallit*.

that there were no knots in burial shrouds. One *tzitzit* of the deceased's **tallit* was cut to symbolize the severing of the bond of life.

A very different view of knots is represented in the knots of the *tzitzit*, the fringes at the **four corners of the *tallit*. Although only one knot is prescribed in the Bible,[2] ancient practice has long prescribed **five knots in each bundle of eight strings. Commentators have suggested that the five knots represent the five books of the **Torah, the five senses, or the first five words of the *Shema* (whose sixth word, *ehad*, meaning "one," an affirmation of God's unity, is represented by the sum total of the five knots and the eight strings of the fringe, equaling **thirteen, the numerical value of *ehad*).[3] The knots symbolize our connection to God, since they bind the *tzitzit* to the *tallit* as the Torah binds the Jewish People to God.[4] (It is possible that the Catholic rosary, which consists of five sets of ten beads, and other forms of prayer beads originally derived from the *tzitzit*.)

[1]*Daniel* 5:12, 16; [2]Rashi, *Menahot* 39a; [3]*Zohar* 3:228a; Bahya on Numbers 15:38, 83a; *Tikkunei Zohar* 10, 25b; [4]*Kaplan, Tzitzit*, 69.

Signifies: CONNECTION, MAGIC, POWER

Generic Categories: Birth, Clothing, Death, Women

See also: Clothing, Five, Hair, Numbers, *Tallit*

LADDER – סֻלָּם. The symbolism of
an axis linking heaven and **earth – the Axis Mundi – is common to many cultures. A ladder symbolizes this vertical connection, representing spiritual elevation when human beings ascend, a message from heaven when the divine descends.

Certainly the most famous ladder in Jewish tradition is the one **Jacob saw in a dream with "the **angels of God going up and down on it."[1] The ancient rabbis interpreted this ladder symbolically, as the stairway leading up to the **altar in the **Temple; as Mount **Sinai; as Jewish history, with its ups and downs at the hands of foreign empires.[2]

The rabbis also used the image of the ladder to symbolize an individual's fate:

"The Holy One of Blessing sits and makes ladders, raising one person and casting down another."[3]

Before **Yom Kippur, it is traditional among some Ashkenazi Jews to eat **hallah whose top is shaped like a ladder, symbolizing the hope that one's prayers for forgiveness will ascend swiftly to heaven.

On **Shavuot, a ladder is sometimes braided into the *hallah* to symbolize **Moses' ascent up the **mountain to receive the **Torah. The *gematria* (numerical equivalent) of *sullam* (ladder) equals Sinai.

Among *hasidim*, the image of the ladder represents an individual's spiritual development. As an individual acquires spiritual self-mastery, he or she reaches higher rungs – *madregot* – on the ladder of holiness. But the hasidic masters also taught that in order to ascend this ladder, one must at the same time descend: "The top of the ladder leading to perfection is humility."[4]

[1]Genesis 28:12; [2]*Genesis Rabbah* 68:12-14; [3]*Genesis Rabbah* 68:4; [4]Elimelekh of Lizensk, quoted in Newman, *The Hasidic Anthology*, p. 185.

Signifies: ASCENT, FATE, HOLINESS, JEWISH HISTORY, PRAYER, REPENTANCE, SPIRITUAL DEVELOPMENT

Generic Categories: Shavuot, Yom Kippur

See also: Altar, *Hallah*, Jacob, Mountain, Shavuot, Yom Kippur

LAG B'OMER – לַ״ג בָּעֹמֶר. From
the second day of **Passover until **Shavuot, Jews count one measure – **"omer" – of **barley each day, marking the **seven weeks between the two festivals. Since the destruction of the **Temple, the *omer* period has been a time of mourning and restraint. Lag B'Omer, literally, "the thirty-third day in [the counting of] the *omer*," represents a respite from solemnity, a time when marriages may be performed, **hair and **beards trimmed, and music played.

Various reasons have been suggested for the celebration of this minor holiday, which is of relatively late origin (post-6th-century C.E.). One legend claims that on the thirty-third day of the *omer* during the Hadrianic persecutions in 2nd-century Palestine, a

terrible plague ceased, which had killed 24,000 of Rabbi Akiva's students.[1] Another legend states that on this day, Bar Kokhba recaptured *Jerusalem from the Romans. A third explanation maintains that this day commemorates the rabbinic ordination or *yahrzeit* (anniversary of the death) of Shimon bar Yohai, legendary author of the mystical *Zohar*. According to some Sephardi and hasidic mystics, at bar Yohai's death, many of the broken fragments of creation were at last reunited. Accordingly, *kabbalists and *hasidim* in Israel celebrate this day as a *hillula*, a festive celebration at bar Yohai's grave in Meron, singing, studing mystic texts, and lighting bonfires. Many 3-year-old hasidic boys have their hair cut here for the first time. It has also been suggested that the biblical *manna began to fall on this day.[2]

In pagan Europe, it was customary for children to play with bows and arrows during early summer forest festivals to chase away demons. Jewish legend gives its own reasons for the association of bows and arrows with the early summer holiday of Lag B'Omer: (1) Pretending to hunt, Akiva's students took bows and arrows into the woods, only to study Torah; (2) with the end of the plague, Rabbi Akiva's students were once again free to take up their bows and arrows against *Rome; and (3) the *rainbow, symbol of peace and divine favor—whose Hebrew name, *keshet*, also means archer's bow—did not appear at all during Shimon bar Yohai's lifetime because his righteousness made it superfluous.

It is customary to eat foods made from *carob on this day because a carob tree kept bar Yohai and his son alive during their twelve years of hiding from the Romans.

[1]Tur, *Orakh Hayyim,* 493; [2]R. Moses Sofer of Pressburg, *Hatam Sofer, Yoreh De'ah* 233.

Signifies: CELEBRATION, COURAGE, DIVINE GRACE, REMEMBRANCE, VICTORY

Generic Categories: Lag B'Omer

See also: Carob, Kabbalah, *Omer*, Rainbow, Rome

LAMP — נֵר. The lamp has been a central Jewish image from earliest times. As

Ancient clay lamp such as those used in biblical times.

the primary source of artificial *light in the ancient world, the lamp symbolized humankind's triumph over darkness, and by extension, God's illuminating Presence among humankind. In the *Mishkan* and the *Temple, the *menorah*, the seven-branched lamp, remained constantly illumined to symbolize God's faithful Presence among and protection of the people. In the *synagogue today, the *ner tamid*, the eternal light, fulfills the same function.

After the destruction of the Temple, special *oil lamps, placed in Jewish homes and synagogues and often ornamented with an image of a *menorah*, became substitutes for the sacred Temple *menorah*. The original clay was eventually replaced by metal—*gold or silver for the wealthy, brass for the poor. From the Middle Ages on, these oil lamps, usually suspended from the ceiling and often ornamented with biblical scenes or *Lions of Judah, were kindled by women throughout the Jewish world on *Sabbaths and holy days. In Germany, the star-shaped lamps were called *Judenstern* (Jewish *stars); in Holland and England, the lamps usually had *crowns suspended over the

A "*Judenstern*," hanging oil lamp used in Germany as a Sabbath lamp. The ratchet is used to raise and lower the lamp. Overflow oil drips into pan below.

silver bowls that held the oil. (Because most American Jews trace their origins back to Eastern Europe where candlesticks were more popular, these hanging Sabbath lamps are relatively unknown in this country.)

The image of the lamp also assumed great importance as a spiritual symbol. In the Bible, the commandments are referred to as a lamp, as is the *Torah itself.[1] The human soul is compared to a lamp illumined by and reflecting back the "Lamp of God," that is, the divine spirit.[2] Accordingly, when a person dies and on every subsequent anniversary of his or her death, a *yahrzeit* lamp is lit to symbolize that person's departed soul.

[1]Proverbs 6:23; Psalm 119:105; *Deuteronomy Rabbah* 4:4; [2]Joseph Gikatilla, *Gates of Light*, 1, 14b.

Signifies: DIVINE PRESENCE, DIVINE SPIRIT, JEWISH PEOPLE, LEARNING, MITZVOT, PROTECTION, SOUL, TORAH

Generic Categories: Kabbalistic Symbols, Ritual Objects, *Shabbat*, Temple

See also: Candles, Fire, Light, *Menorah*, *Ner Tamid*, Oil

LEAH – לֵאָה. Leah was the elder of Lavan's two daughters, whom Laban tricked *Jacob into marrying instead of the younger *Rachel. Because Jacob preferred *Rachel to Leah, God took pity on Leah and blessed her with fertility.[1] She was the mother of six sons, two of whom, Levi and Judah, were the ancestors of the *priesthood and the monarchy, respectively, ancient Israel's two major hereditary national institutions.[2] She was also the mother of Jacob's only daughter, Dinah.

The Torah describes Leah as having "weak eyes."[3] The rabbis claimed that her *eyes were originally as beautiful as Rachel's, but became weak from weeping over her unfortunate lot; as Lavan's elder daughter, she was fated to marry Isaac's elder son, the wicked *Esau. Her tears reversed her doom, but at the expense of her beauty.[4]

According to the Talmud, Leah had the distinction of being the first person to praise God since the creation of the world.[5]

*Kabbalists claim that the two sisters represent two facets of the *Shekhinah, God's feminine aspect. Leah symbolizes the *Sefirah of Binah (Understanding), God's maternal quality; Rachel, the *Sefirah* of *Malkhut* (Kingship), God's Physicality and Exile. Together they symbolize God's connection to the People of Israel.

In the Book of *Ruth, the two sisters are invoked together in Ruth's *wedding blessing: "May the Lord make the woman who is coming into your house like Rachel and Leah, both of whom built up the house of Israel!"[6]

Feminists, critical of the tradition's bias against Leah, have honored her by reciting her name first when invoking the sisters.

[1]Genesis 29:31; *Genesis Rabbah* 71:1–5; [2]Genesis 29:31–35; *Genesis Rabbah* 70:15; [3]Genesis 29:17; [4]*Genesis Rabbah* 70:16; [5]Genesis 29:35; *Berakhot* 7b; [6]Ruth 4:11.

Signifies: BLESSING, CONNECTION, FERTILITY, JEALOUSY, MOTHERHOOD, REJECTION, SIBLING RIVALRY, UNDERSTANDING, WORSHIP

Generic Categories: Personalities, Wedding, Women

See also: Esau, Jacob, Judah, Kabbalah, King, Mandrakes, Rachel, *Sefirot*

LENTIL – עֲדָשִׁית. The lentil, *adashah*, makes its first appearance in the Bible in the form of the *red porridge that *Jacob sells to *Esau in exchange for his birthright.[1]

Although Esau clearly overvalued lentils, mishnaic and talmudic sources acknowledge them as the most important legume in the region. Because the lentil grows so close to the ground, the rabbis coined the phrase "as lowly as a lentil."[2]

Traditionally, lentils are eaten by Jewish mourners, because "the lentil has no mouth," just as the mourner must not speak of ordinary topics but must remain silent in the face of death. Mourning itself is likened to a wheel, round like the lentil, which symbolizes the inexorable cycle of mortality.[3] (The same is said of *eggs.) Rashi suggested that lentils were also eaten at ancient banquets as a reminder of death.

[1]Genesis 25:34; [2]JT *Sanhedrin* 2:5, 20b; [3]*Bava Batra* 16b; *Genesis Rabbah* 63:14.

Signifies: DEATH, HUMILITY, MOURN-ING, SILENCE

Generic Categories: Botany, Death, Food

See also: Chickpea, Circle, Egg, Esau, Esther

LEOPARD — נָמֵר.

The leopard, whose Hebrew name means "spotted coat," was once one of the most deadly carnivores in the Middle East, noted for its strength and its habit of waiting motionless for its prey.

The leopard.

In the Bible, the leopard symbolizes speed, agility, and aggression. Isaiah prophesies that in the *Messianic Age, the "leopard shall lie down with the *kid."[1] In the Mishnah, the leopard's strength is invoked as one of the qualities needed to perform God's will: "Be as strong as a leopard, as light as an *eagle, as swift as a *deer, as brave as a *lion to do the will of your Father in heaven."[2]

For many centuries, these *four animals have been represented in paintings, weavings, and ceremonial objects in *synagogues and Jewish homes.

[1]Isaiah 11:6; [2]*Pirke Avot* 5:23.

Signifies: AGGRESSION, PEACE, REDEMPTION, SPEED, STRENGTH

Generic Categories: Animals, Messiah

See also: Deer, Eagle, Four, Goat, Lion, Messiah

LEVIATHAN — לִוְיָתָן.

The Bible contains many vestiges of pagan mythology. Among the most obvious are the primordial monsters: *Ziz-Shaddai*, *Behemoth, *Shor Ha-Bar* (the Great Ox), and Leviathan.

According to Babylonian mythology, the world began with a struggle between the creator deity and the forces of the sea—Lotan and the other sea monsters. In the biblical creation story, God created the "great sea monsters—"*Tanninim Gedolim*"—on the fifth day.[1] Throughout the

Bible, these sea-monsters have many names: "*Tannin*" (dragon); "*rahav*" (expanse) and "*yam*" (sea), but the most common name is Leviathan, known in Jewish legend as the King of the Sea.[2] Although they may occasionally refer to crocodiles or whales, these terms most often designate larger-than-life monsters. The name Leviathan itself probably derives from the verb meaning "to coil." Isaiah describes this creature as a "twisting serpent."[3] The *midrash* describes Leviathan as having irridescent skin, a repulsive smell, a voracious appetite, and boiling breath.[4]

According to tradition, the flesh of Leviathan, along with that of Behemoth, *Shor Ha-Bar*, and *Ziz-Shaddai*, will be eaten by the righteous in the World to Come. And at the end of time, Leviathan and Behemoth will fight to their deaths, and their flesh will feed the righteous at the Messianic Banquet.[5] These scenes of combat and heavenly feasting are graphically described in the 11th-century liturgical poem, "*Akdamut*," chanted in *synagogue on *Shavuot.

In Jewish art, Leviathan, together with *Shor Ha-Bar*, symbolizes the reward of the righteous in the World to Come.

[1]Genesis 1:21; [2]Psalm 74:14; 104:26; Job 3:8; 40:25–41:26; [3]Isaiah 27:1; [4]*Bava Batra* 74b–75a; [5]*Leviticus Rabbah* 13:3.

Signifies: DEATH, DIVINE POWER, REDEMPTION, REWARD

Generic Categories: Animals, Death, Messiah, Shavuot

See also: Behemoth, Fish, Messiah, Shavuot, Water

LIGHT — אוֹר.

Just as the light of the *sun nourishes life on *earth, so the image of light nourishes Jewish symbolism. Light imagery pervades the Jewish *calendar, ceremonial art, theology, and sacred texts. It is the primary link between divine and human worlds.

Creation begins with God's command: "Let there be light!" Noting that this primordial light preceded the creation of the sun, *moon, and *stars, the rabbis claimed it was the *Torah, which provided the blueprint for creation; or a special holy light which God concealed in the Garden of *Eden to be enjoyed by the righteous in the World to Come.[1] The *Zohar* declares that

this first created light was a "*Lamp of Darkness."[2] Jewish mystics developed the idea that God first created a primordial *Adam, a superhuman creature, from whose *head radiated divine light. But the energy from these lights was so powerful that it shattered the divine order, scattering sparks throughout the material world.

Light as an expression of the Divine Spirit is central to Jewish teaching. Not only did the material world emerge out of light, but light continues to represent God's Presence and protection in the world. The Psalmist declares that "light is sown for the righteous," implying that they receive special divine favor.[3] *Kabbalists identify light with the *Shekhinah, God's feminine aspect. Light in its various *colors and forms also symbolizes the *Sefirot, the emanations of the Divine Spirit. Kabbalistic works frequently bear names associated with light, such as the Zohar, The Book of Splendor (literally "radiance") or Sefer Bahir, the "Book of Shining."

In the ancient *Mishkan and *Temple, the *menorah was seen as a symbol of God's dwelling among the people. This was also the function of the *ner tamid, the eternal light, which continues to illumine the *ark in *synagogues to this day. The Temple itself was said to "give light to the whole world."[4]

God's emissaries, the *angels, are usually characterized as beings of light. Evil angels are the agents of darkness. Other heavenly phenomena, such as the sun, the moon, *rainbows, lightning, *dew, and *rain, are seen as deriving from light, the source of divine goodness. When human beings are touched by the Divine Spirit, they too radiate light. *Moses descended from Mount Sinai with *horns of light shining from his head. So blinding was this divine radiance that he put a veil over his face when he spoke to the people to shield them from it.[5] It was said of the High Priest that "his *face flamed like torches" when the Holy Spirit rested upon him.[6]

*Shabbat and all Jewish holidays involve the lighting of *candles, symbolizing holiness and spiritual energy. Light also symbolizes the joy of these special holy days. One holiday in particular, *Hanukkah, also known as the "Festival of Lights," features light as its central symbol. Kindling the eight candles of the menorah recalls the miracle of the single cruse of *oil salvaged from pagan desecration. Falling at the end of both the lunar and solar cycles, Hanukkah represents the darkest moment of the year, when light is most appreciated.

Transitions between light and darkness carry special significance within Jewish tradition, marking a time of hopefulness as well as mystery. Legend claims that numerous miracles, such as *Miriam's *Well and Balaam's talking *ass, were created at twilight on the Sixth Day of Creation.[7] The Jewish day begins and ends at sunset. At twilight on Friday night as well as at *Havdalah—the evening ceremony marking the end of Shabbat and holidays—the candle symbolizes transitions between holy and profane time. A sunrise service celebrates the receiving of the *Ten Commandments on the holiday of *Shavuot. Neilah, the special twilight service on *Yom Kippur, marks the closing of the *Gates of Repentance.

The Torah is often described in imagery of light. One of its many names is "Torah Orah," the Teaching of Light. Tradition claims that the Torah's letters were fashioned out of black *fire upon *white fire. The Bible states that "the commandment (mitzvah) is a *lamp, and the Torah is a light."[8]

Light is also a symbol of the soul: "The human spirit (lifebreath [neshamah]) is God's lamp, revealing all its inmost parts."[9] The Hebrew name for the memorial light, also called the yahrzeit candle, is ner neshamah, the lamp of the soul. It is traditional to light this candle at the death of a loved one as well as on the anniversary of his or her death (yahrzeit) and on Yom Kippur. In past times, it was also customary to light candles at a deathbed to symbolize the departure of the soul.

The tradition characterizes the Jewish People as "or la-goyim," a light to the nations, signifying its role as a model of moral behavior as prescribed by the Torah. An endearing term in Yiddish for a Jew is pintele Yid, a Jewish "point of light."

[1]Leviticus Rabbah 11:7; [2]Zohar 1:15a; [3]Psalm 97:11; [4]Exodus Rabbah 36:1; [5]Exodus 34:34-35; [6]Leviticus Rabbah 21:12; [7]Pirke Avot 5:9; [8]Proverbs 6:23; [9]Proverbs 20:27.

Signifies: DIVINE PRESENCE, GOD, GOODNESS, HOLINESS, HOPE, JEWISH PEOPLE, JOY, LEARNING, LIFE, MIRACULOUSNESS, MITZVOT,

MYSTERY, POWER, PURITY, SOUL, SPIRIT, TORAH, TRUTH, WISDOM

Generic Categories: Astronomy, Death, Hanukkah, Kabbalistic Symbols, *Shabbat*, Shavuot, Synagogue, Temple, Yom Kippur

See also: Adam, Angels, Candles, Colors, Dew, Eye, Fire, Gold, Hanukkah, *Havdalah*, Head, Horn, Kabbalah, Lamp, *Menorah*, Moon, *Ner Tamid*, Oil, Rainbow, *Sefirot*, *Shabbat*, Shavuot, *Shekhinah*, Stars, Sun, Temple, Torah, White, Yom Kippur

LILITH – לִילִית.

At the beginning of the Book of Genesis, two differing accounts of human creation are presented: in chapter one, God creates a single being called *Adam, who is characterized as both male and female; in chapter two, God creates a woman out of Adam's rib.[1] This discrepancy gave rise to the legend of Lilith, Adam's first wife before *Eve. Because she was created simultaneously with Adam, Lilith regarded herself as her husband's equal, even in the marriage bed. But Adam refused to share power, and so Lilith left the Garden. God sent *three *angels — Senoy, Sensenoy, and Semangelof — to summon her back, but Lilith refused to return, and was accordingly punished forever after by losing 100 of her children each day. In retribution, Lilith, whom legend describes as a demon with a woman's *face, long *hair, and *wings, threatens women in childbirth and their newborn babies — unless they protect themselves with an *amulet bearing the names of the three angels, Senoy, Sensenoy, and Semangelof. She is also said to prey upon men in their sexual dreams.[2]

This legend, probably derived from the ancient Babylonian myth of "Lilitu," exercised an especially powerful hold on the Jews of medieval Europe. Another legend claimed that Adam had intercourse with Lilith after his expulsion from *Eden, populating the world with demon offspring. Amulets, incantations, and gestures to countermand the influence of Lilith and her minions were quite popular among Ashkenazi Jews until recent times.

The *kabbalists added a new role to Lilith's previous ones: the demonic consort of Samael, or *Satan, lord of the *Sitra Ahra*, the Other Side. As such, Lilith became the mirror image of the *Shekhinah*, God's feminine aspect, the tormentor rather than protector of the People Israel.

In modern times, Jewish feminists have transformed Lilith into a positive symbol of women's equality, arguing that the rabbinic tradition in its patriarchal bias condemned her precisely because she dared to challenge Adam's authority in the Garden. They contend that the legend unfairly characterizes such a woman as a dangerous wife and an unnatural mother, instead of an equal partner in creation.

[1]Genesis 1:27; 2:21; [2]*Eruvin* 100b; *Niddah* 24b; *Alphabet of Ben Sira* 23a–b; 33a–b.

Signifies: DEMONIC, EQUALITY, FEMINISM, PATRIARCHY

Generic Categories: Birth, Personalities, Women

See also: Adam, Amulet, Angels, Eden, Eve, Satan

LION – אֲרִי.

Most cultures revere the lion as a symbol of strength, royalty, and power. In the ancient Near East, the Egyptians and Syrians created a hybrid of human beings and lions, the sphinx, to represent their *kings. The Hittites made lions guardians of their *gates. The *Greeks merged the lion with the *sun to create the Dionysiac Lion, a symbol of immortality. Persia claimed the lion as its national symbol, as did imperial Ethiopia. The *cherubim perched above the *Ark of the Covenant were most probably portrayed as a human-lion hybrid.

Early in its history, the Jewish People identified itself with the lion, which roamed the deserts and mountains of their region until the 19th century. The Bible mentions lions more than 150 times by six different names. Although both the tribes of Dan and *Judah are compared to a lion, it is Judah whose name ultimately became inextricably linked with this symbol.[1] *David, a descendant of Judah, is identified with the lion,[2] as is the Davidic monarchy and the *Messiah who will spring from this royal house.

From ancient times to the present, the "Lion of Judah" has been one of the most popular symbols of the Jewish People.

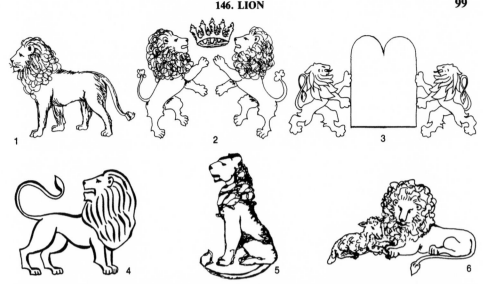

The lion, depicted in many poses and styles, is the most popular animal represented in Jewish art.

In ancient art the hero subduing lions, bulls, or other fierce animals was a common motif, an emblem of superhuman power. In European heraldry, this motif was supplanted by a pair of rampant lions, flanking a shield. In Jewish art, the hero was replaced by a symbol of God, usually a *crown or Tablets of the Law (#2, #3). The lions serve God, the King of Kings.

Heraldic lions are often very stylized (#3), with exaggerated manes and tails, and sinewy torsos. Often they assume a vertical stance, an unnatural position suggesting the human anatomy.

Lions usually evoke tradition. In modern times, however, more formalized images (#4) of lions are associated with the State of Israel.

Lions appear on all fours as well as crouching (#5), reclining (#6), and occasionally lunging. Decorative lions vary in ferocity—from savage and roaring (even represented as dragonlike) to peaceful, an image suggested in prophetic visions of redemption, when "the lion shall lie down with the lamb."

Lions often appear on ritual art connected with the *Torah: mantles, *breastplates, crowns, the *ark, and the *parokhet. They are also commonly depicted on personal ritual objects such as *tallit bags. They are especially associated with *Hanukkah because the lion is the symbol of the tribe of Judah, evocative of *Judah Maccabee.

Lions have enjoyed renewed popularity in modern Israel as a symbol of dominion with ancient roots.

1. A classic lion in repose.
2. Rampant lions.
3. Stylized rampant lions.
4. An abstract lion, based on a detail from an Israeli stamp.
5. A stylized lion representing the tribe of Judah, taken from the 1920 Berlin *Jerusalem Talmud*.
6. The lion lying with the lamb.

Lions are frequently represented on ark and *Torah decorations, particularly rampant lions, a pair of lions rearing on their hind legs, a common European motif found on many noble crests, symbolic of balance, justice, and order, or of guardianship. Art historians speculate that rampant lions may also symbolize the cherubim that once adorned the ark in the *Mishkan and *Temple. "Aryeh" and "Ari" (lion) and "Ariel" (lion of God)—and their Yiddish equivalents, Leib or Loeb—have been common Jewish names. Lions are represented on many Jewish ceremonial objects, especially *menorahs.

The lion is also a general symbol of strength.[3] David and Samson are noted for their prowess in defeating lions.[4] In one of *Daniel's visions, the powerful kingdom of Babylonia is represented as a lion with *eagle's wings.[5] This combination of the lion, king of the beasts, with the eagle, king of the birds, is a common pictorial motif in Jewish art, symbolizing extraordinary strength and dominion.

In the Mishnah, the lion's courage is invoked as one of the qualities needed to perform God's will: "Be as strong as a *leopard, as light as an *eagle, as swift as a *deer, as brave as a lion to do the will of

your Father in heaven."[6] For many centuries, these *four animals have been represented in paintings, weavings, and ceremonial objects in *synagogues and Jewish homes.

In addition to being a symbol of physical strength, the lion represents spiritual strength, especially scholarship. The Talmud describes a number of noted sages, such as Eliezer ben Hyrcanus and Hiyya bar Avin, as lions.[7] The famous MaHaRaL (Moreinu Ha-Rav Liva) of Prague, legendary creator of the *Golem, was named Judah Lavi, Judah the young lion, in the hopes that his spiritual gifts would redeem his people from anti-Semitic persecution.

The great 16th-century *kabbalist, Rabbi Isaac Luria, was known as the *Ari*, the lion, in recognition of his extraordinary learning and spiritual power.

God, as the King of Kings, is also symbolized, albeit indirectly, by the lion. In Ezekiel's vision of the Divine *Chariot, the lion is one of *four figures (with the eagle, ox, and human being) which together symbolize the divine spirit. The rabbis ruled that although it is not permissible to represent all four figures together, or even the human figure by itself, it is permissible to represent the three animals separately, especially the lion, which was already represented in the Holy *Temple and on Solomon's *throne.[8]

[1]Genesis 49:9; Deuteronomy 33:22; [2]2 Samuel 17:10; [3]Lamentations 3:10; Proverbs 28:15; Amos 3:12; Isaiah 31:4; [4]Judges 14:5-6; 1 Samuel 17:34-36; [5]Daniel 7:4; [6]*Pirke Avot* 5:23; [7]*Gittin* 83a; *Shabbat* 111a; *Bava Metzia* 84b; [8]1 Kings 7:29; 1 Kings 10:20; JT *Avodah Zarah* 3:1, 42c.

Signifies: COURAGE, DIVINE SPIRIT, GOD, GUARDIANSHIP, JEWISH PEOPLE, JUSTICE, LEARNING, REDEMPTION, ROYALTY, SPIRITUAL STRENGTH, STRENGTH

Generic Categories: Animals, Messiah, Ritual Objects, Synagogue, Temple

See also: Ark, Cherubim, Crown, David, Eagle, Gold, Judah, King, Messiah, Sun, Throne, Torah

LOCUST – אַרְבֶּה.
In the Middle East, both today and in ancient times, the locust represents the deadly threat of famine. The plague of locusts was the ninth of the ten plagues God visited upon *Pharaoh, after which "nothing green was left, of tree or grass of the field, in all the land of *Egypt."[1]

A cousin to the locust, the grasshopper has a less deadly but no more positive reputation. Because it hides in the high grass, it symbolizes human insignificance when seen from above. The cowardly spies who scouted out the land of Canaan complained to *Moses that "we looked like grasshoppers to ourselves, and so we must have looked to them."[2]

Berakhiah ben Batronai Ha-Nakdan, the 13th-century "Jewish Aesop," borrowed the ancient story of "The Grasshopper and the *Ant" from classic legend and translated it into Hebrew, offering the moral: "Rid yourself of laziness, and you shall not suffer want."

[1]Exodus 10:15; [2]Numbers 13:33; see also Isaiah 40:22; Proverbs 30:27.

Signifies: DESTRUCTION, FAMINE, INSIGNIFICANCE, LAZINESS

Generic Categories: Animals

LULAV – לוּלָב
Part of the celebration of the fall harvest festival of *Sukkot involves waving a *lulav*—a *palm branch, *willows, and *myrtles bound together by a woven handle. In the *Torah, where the laws of this holiday are first detailed, the word *lulav*, which means "shoot," or "a young branch of a tree," does not appear, nor does it appear anywhere else in the Bible. Instead, the people are commanded to take only "branches of palm."[1] The palm's beautiful foliage was a popular ornamental motif in the ancient world.

The *lulav* grows in the heart of the date palm.

In mishnaic times, "*lulav*" referred to all trees, but it was used most commonly to specify the palm used for the Sukkot celebration. The branch of the palm tree is called a "*lulav*" at the initial stage of development when the leaves still cluster together.[2] Using the branches at this stage rather than when they open prevents people from getting hurt from the palm's prickly leaves during the festival processional.

The *lulav*'s tight, upright shape has given rise to many interpretations. The rabbis claim that dreaming of a *lulav* indicates that one is serving God single-heartedly, because the *lulav* has no offshoots.[3] Traditionally, the *four species used on Sukkot represent different body parts; the *lulav*, because of its shape, represents the spine. The Gerer Rebbe equated the *lulav* with spiritual attainments: "You cannot make a myrtle into a *lulav*," he said, but if a man joins himself to someone of more consequence, "he then becomes attached to him, even as the myrtle is to the *lulav*."[4] He also noted that the *gematria* (numerical equivalent) of *lulav* is 68, the same as "*hayyim*," life.

In ancient *Rome, a successful litigant in a law case left the courtroom carrying a palm branch, signifying his victory. Carrying the *lulav* on Sukkot symbolizes that the Jewish People have been cleared of accusations raised against them during the Days of Awe.[5]

*Kabbalists regard the *lulav* as a symbol of "*Yesod*," a *Sefirah* representing the sexual aspect of the Divine Spirit. Furthermore, the *lulav*, which is a phallic symbol, when joined with the *etrog, a symbol of female generativity, represents sexual completion, a fitting symbol for the harvest festival of Sukkot.

[1]Leviticus 23:40; [2]*Sukkah* 32a; [3]*Berakhot* 57a; [4]*Siah Sarfei Kodesh*, J. K. K. Rokotz, Lodz 1929, 2:46, #144; [5]*Pesikta de-Rav Kahana* 27:2.

Signifies: LIFE, SERVICE OF GOD, SEXUALITY, SPIRITUAL STRENGTH

Generic Categories: Botany, Sukkot

See also: *Etrog*, Four Species, Kabbalah, Myrtle, Palm, Sukkot, Willow

MANDRAKE – דוּדָאִים. The mandrake is a poisonous plant found

throughout the Mediterranean region. Because of its unusual botanical features – its tenacious forked root shaped like a miniature lower torso, its powerful fragrance, its narcotic and aphrodisiac properties – it has generated countless legends since ancient times. The *Greeks associated the mandrake with Aphrodite, the Goddess of Love. It was believed to emit a bloodcurdling shriek when uprooted. In folklore, it has been attributed with the power to prophesy, bestow invulnerability, reveal treasures, bewitch, cause death or insanity, and aid conception.

The Hebrew word for mandrakes, *duda'im*, means "love *apples," suggestive of its alleged property as an aphrodisiac. Its talmudic name, *yavrukha* (יברוחא), is Aramaic for "the chaser," because of the belief that mandrakes fend off demons.[1]

In the Bible, Reuben, the oldest son of *Jacob and *Leah, brought mandrakes to his mother as a gift, perhaps to arouse his father's desire for the unloved Leah. The barren *Rachel, jealous of her sister's fertility, bargained for the mandrakes in exchange for giving up Jacob to Leah for the night. With the aid of the mandrakes, Rachel conceived her first child, *Joseph.[2]

The mandrake, MANDRAGORA OFFICINARUM. The English word "mandrake" is from "man-dragon," named after its torso-like root.

Because of this story, the *flag of the tribe of Reuben features in one corner a small figure of a man, symbol of the mandrake. Because of Reuben's connection with mandrakes and fertility, a legend later arose that if a woman grated and tasted a ruby, which was Reuben's stone on the High Priest's *breastplate, she would become pregnant.[3]

The mandrake is also a symbol of spring, because its *flowers give off a powerful fragrance when they emerge at that time.[4]

[1]Ginzberg, *Legends of the Jews* 5:197–198;

[2]Genesis 30:14–18; [3]Ginzberg, 3:169–170; [4]Song of Songs 7:14.

Signifies: ANTIDEMONIC, DESIRE, FERTILITY, LOVE, SPRING

Generic Categories: Botany

See also: Apple, Flag, Rachel, Leah, Twelve Tribes

MANNA – מָן. When the Israelites found themselves without food after leaving *Egypt, God rained down *bread from heaven, which sustained them during their *forty years of wandering in the *wilderness.[1] The *Torah compares this food to coriander seeds, with a taste like wafers in *honey. The Israelites named it "manna," which means "What is it?"[2]

The *midrash* claims that manna was a miraculous substance created at twilight on the sixth day of creation, and thereafter prepared by the *angels.[3] One tradition claims that it first fell on *Lag B'Omer. According to legend, manna had miraculous properties: to children, it tasted like mother's *milk; to youths, like bread; to the old, like honey; to the sick, like *barley soaked in *oil and honey.[4] Other *midrashim* explained that manna assumed any taste the tongue desired.[5] Each morning it rained down upon the desert floor, protected by the *dew. Enough fell each day to feed every Israelite; a double portion fell on Friday so that no one needed to gather it on the *Sabbath.[6] To this day, Jews traditionally place two loaves of *hallah on the Sabbath table to symbolize this double portion of manna.

Manna ceased to fall the day the Israelites entered the Promised Land. A measure of it was kept before the Holy *Ark until the *Temple was destroyed. When the *Messiah comes, *Elijah is expected restore it to its rightful place.

Manna symbolizes the Jewish People's infancy when God nurtured them as a mother nurtures her child. It also represents spiritual as well as physical sustenance.

A common ancient pictorial motif was a messianic meal consisting of a jar of manna. Manna jars were occasionally depicted in Jewish micrographic art (designs consisting of miniature Hebrew letters).

[1]Exodus 16:4; [2]Exodus 16:15; 31; [3]*Pirke Avot*

5:6; *Pirke de-Rebbe Eliezer* 3, 19; Tanhuma (Buber) *Beshallah* 22; [4]*Exodus Rabbah* 5:9; [5]*Exodus Rabbah* 25:3; *Yoma* 75a; [6]Exodus 16:17–30.

Signifies: DIVINE PROTECTION, FREEDOM, INFANCY, MIRACULOUSNESS, RENEWAL, SUSTENANCE

Generic Categories: Food, Lag B'Omer

See also: Bread, Dew, *Hallah*, Honey, Lag B'Omer, Messiah, Wilderness

MAROR – מָרוֹר. The Torah stipulates that the festival of *Passover is to be observed by eating the paschal *sacrifice with *matzah and "maror," bitter herbs.[1] The text does not specify this plant by name, but the Mishnah mentions five possibilities, including lettuce (*hazeret*), chicory, and "maror," which might designate a bitter weed native to the Middle East which the Arabs call "murar."[2] Although the Torah gives no reason for eating *maror*, the *Haggadah* makes the obvious connection between eating bitter herbs and remembering the bitterness of Egyptian slavery.[3] The rabbis preferred Romaine lettuce as a bitter herb, because like the Jews' experience in Egypt, it begins as a sweet taste and then turns bitter. North American Jews usually use horseradish for *maror*.

Horseradish, ARMORACIA LAPATHIFOLIA, commonly used as the bitter herb among North American Jews.

The *maror* also symbolizes general suffering, particularly as experienced throughout Jewish history. Shimon bar Yohai taught that "the Holy One of Blessing gave Israel *three precious gifts [the Torah, the Land of Israel, and the World to Come], and all were given only through suffering."[4] It is only through bit-

terness, taught the sages, that one comes to appreciate blessing. The hasidic master Simhah Bunam taught that we eat the bitter herbs (symbol of slavery) *after* the *matzah* (symbol of freedom), to teach us that the Israelites only became aware of their slavery after *Moses had promised them freedom.[5]

[1] Exodus 12:8; Numbers 9:11; [2]*Pesahim* 39a; [3]Exodus 1:14; [4]*Berakhot* 5a; [5] Simhah Bunam, in *Siah Sarfei Kodesh*, J. K. K. Rokotz, Lodz, 1929, 1:53, #244.

Signifies: BITTERNESS, SLAVERY, SUFFERING

Generic Categories: Food, Passover

See also: Egypt, *Matzah*, Moses, Passover, *Seder*

MASADA – מְצָדָה.

According to the ancient Jewish historian Josephus, after the fall of *Jerusalem in 70 C.E., a band of Jewish zealots took refuge at Masada, a *mountaintop in the Judean desert near the Dead Sea. Once the fortress of Herod, Masada, Aramaic for "stronghold," became the scene of heroic Jewish resistance to imperial *Rome. After many months, the 960 men, women, and children besieged at Masada chose to take their own lives and burn their supplies rather than surrender to become Roman slaves.[1]

In modern times, Masada's status as a Jewish symbol has become equivocal. Many scholars have questioned the reliability of Josephus's account. Some Jews have come to regard Masada as a negative symbol of self-destructive militancy. Others point to it as a symbol of Jewish courage, heroism, self-sacrifice, and pride. Until recently, Israeli army recruits took their oath of allegiance at Masada, swearing that "Masada shall not fall again." Now that ceremony takes place at the *Western Wall.

[1]Josephus, *Wars of the Jews*, Book 8, chapters 8–9.

Signifies: COMMITMENT, COURAGE, JEWISH PRIDE, MARTYRDOM, RESISTANCE

Generic Categories: Places

See also: Mountain, Western Wall

MASK – מַסֵּכָה.

On the holiday of *Purim, it is customary for Jews to don masks and dress in costume, most often masquerading as characters from the *Megillah*, the Book of *Esther.

Masks conceal a person's true identity. In the Book of Esther, such concealment is a major theme. Esther initially hides her identity as a Jew until *Haman's evil plot necessitates its disclosure. The name Esther itself means "I will hide." Even more significant, the name of God does not appear once in the Book of Esther; God is the hidden agent in the story.

On Purim, the Jewish tradition is turned upside down. One is commanded to drink enough so that it becomes impossible to tell the difference between "cursed be Haman" and "blessed be Mordecai."[1] Masks symbolize this inversion, since they permit people to act contrary to their usual personality.

[1]*Megillah* 7b.

Signifies: DECEPTION, HIDDENNESS, INVERSION

Generic Categories: Purim

See also: Esther, Haman, *Megillah*

MATZAH – מַצָּה.

Matzah, unleavened bread made from flour and water, is most commonly associated with *Passover, when leaven is proscribed, although it can be eaten year round. In modern times, *matzah* is usually machine-made into flat square sheets. It was once customary to incise designs on the *matzah* in place of the now standard even

Shemurah matzah, handmade and irregular in shape.

rows of perforations. For Passover, some Jews prefer to use special *"shemurah"* (guarded) *matzah*, whose preparation is carefully supervised from field to oven. *Shemurah matzah's* uneven, round form resembles the original *matzah* baked in ancient times. Because it is uncontaminated by fermentation—it must not be baked longer than *eighteen minutes—matzah

represents spiritual purity. In ancient Israel, *matzah* was the only bread allowed on the sacrificial *altar.[1]

After the *Exodus from Egypt, *matzah* became the quintessential symbol of Passover. Tradition mandates that every Jew not only eat *matzah* at the *seder, but also explain its significance.[2]

The symbolism of *matzah* contains a striking paradox: on the one hand, *matzah* represents freedom. Its flat shape reminds Jews that their ancestors left Egyptian bondage so hastily that their bread did not even have time to leaven.[3] On the other hand, the Torah calls *matzah* "*lehem oni*," the bread of affliction, for this was the meager fare of the Jewish slaves when they labored for *Pharaoh.[4] Its simple composition of flour and water symbolizes the bare minimum of sustenance.

This paradox has given rise to several interpretations: it underscores the thin line between freedom and slavery; it teaches that freedom is not complete until all humanity enjoys it; it reminds us that the world will not be free until the *messianic redemption; it teaches that freedom is often more dependent upon psychological than physical change.

Matzah also symbolizes the Jewish People's trust in God. Without waiting for the dough to rise, the Children of Israel fled Egypt, not knowing where they were going, how long the journey would take, or what provisions they would need to survive. Rabbi Nahman of Bratslav taught that "one who stops to make 'provisions for the way' will never get out of Egypt."

During the *seder*, *three pieces of *matzah* are placed on a plate: these represent either the two festival or Sabbath loaves displayed in the ancient Temple, as well as a substitute for the discontinued paschal sacrifice; or the three divisions of the Jewish People: Kohen, Levi, and Israel. At many modern *seders*, a fourth *matzah* is added to represent Jews still in oppression, who do not currently have religious freedom. The leader breaks the middle of the three *matzahs* at the beginning of the *seder* to represent our still incomplete freedom, and one half of this *matzah* becomes the *afikoman, which is eaten to finish the meal.

Matzah also represents humankind's essential equality before God. Just as the

Jewish People ate *matzah* both as slaves and as free people, so every Jew is commanded to eat *matzah* at the *seder*, and to provide *matzah* for those in need. At the beginning of the *Haggadah, one recites the Aramaic passage, "*Ha Lahma Anya*," "This is the bread of affliction," inviting all who are needy to join in the meal, and acknowledging our shared status as slaves in a not-yet-redeemed world.

[1]*Leviticus* 2:4,5; [2]*Pesahim* 10:5; [3]*Exodus* 12:39; [4]*Deuteronomy* 16:3.

Signifies: EQUALITY, FAITH, FREEDOM, POVERTY, PURITY, REDEMPTION, SLAVERY

Generic Categories: Food, Passover

See also: *Afikoman*, Bread, *Hametz*, Passover, *Seder*

MEGILLAH – מְגִלָּה.

Megillah means "scroll," from the Hebrew root meaning "to roll." Tradition designates *five books of the Bible as "*megillot*": Song of Songs, read on *Passover; *Ruth, on *Shavuot; Lamentations, on *Tisha B'Av; Ecclesiastes, on Sukkot; and *Esther, on *Purim. Generally it is the Book of Esther that is meant when the word "*Megillah*" is used by itself. This story has come to symbolize the miraculous reversal of Jewish fortune.

Because the name of God does not appear once in the Book of Esther, Jewish artists throughout the ages have felt free to exercise their imagination in illuminating the *Megillah*. Sometimes the letters or the spaces around the letters are ornamented; occasionally

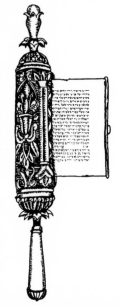

Megillah in elaborate case. The scroll is pulled out as it is read and then rolled back into the case. *Megillah* cases, fashioned from wood or metal, are a Jewish ceremonial art form.

the entire book is written in micrographic letters shaped into a form traditionally associated with Purim, such as a *bear, an ancient symbol of Persia, or a *fish, the Zodiac symbol of the month of *Adar* during which Purim occurs. Some scribes have created "*ha-melekh* scrolls," so called because each column begins with the word "*ha-melekh*," the *king. In the context of the story, this word only designates the Persian king Ahashverosh but it has been reinterpreted to refer to the divine King whose name, though missing in the *Megillah*, directs the events of the story.

In folk parlance, the term *megillah* means a very long story.

Signifies: REVERSAL OF FATE, VICTORY

Generic Categories: Purim

See also: Bear, Esther, Fish, Haman, King, Mask, Purim, Queen

MENORAH – מְנוֹרָה, חֲנֻכִּיָּה.

The *menorah*, the seven-branched candelabrum that once stood in the Holy *Temple, is the most enduring symbol of Judaism, tracing its origins back to the **Mishkan*, the portable sanctuary in the *wilderness. More than any other Jewish symbol, it represents the continuity of the tradition, linking the generations from *Moses to our own day.

In the *Torah, God specifies exactly how the *menorah* is to be made and tended.[1] According to the *midrash*, Moses found the instructions so complicated that God had to make it for him.[2] The *menorah* had *seven arms, ornamented with *golden *almond blossoms. The

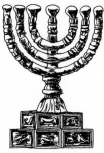

The *menorah* depicted on the emblem of the State of Israel, modeled after the *menorah* on the Arch of Titus.

*light from this *lamp was to come from the purest *olive *oil.

In *Solomon's Temple, according to later tradition, the original *menorah* was lit each day by the High Priest, and *ten other *menorahs* were placed nearby for ornamental purposes.[3] When the Babylonians destroyed the First Temple in 586 B.C.E., the golden *menorahs* were also destroyed, although legend claims that the original *menorah* was hidden away and brought back by the exiles.[4] During the Maccabean revolt,

The Israel moriah (sage), SALVIA PALAESTINAE. Israeli botanists Ephraim and Hannah Hareuveni theorize that this plant, viewed in flat profile, was the botanical model of the Temple *menorah*.

Antiochus captured and removed the Temple *menorah*, but *Judah Maccabee had a duplicate built, whose base was inspired by a temple of Apollo. At the destruction of the Second Temple in 70 C.E., the *menorah* was carried off to *Rome, where it was deposited in Vespasian's Peace Temple. Various traditions speculate that the *menorah* found its way to Byzantium or to *Jerusalem, but its ultimate fate is unknown.

In honor of the Roman victory over Israel, the Arch of Titus was erected in Rome, on the inside of which was carved a replica of the *menorah* being borne by defeated Jewish slaves. Scholars have noted that the double octagonal base of this *menorah* proves that Titus did not capture the original *menorah*, which had a three-legged stand, but merely one of the ornamental lamps. To this day, observant Jews do not walk under that arch, which symbolizes Jewish exile, tragedy, and defeat.

After the Temple's destruction, the *menorah* became a central emblem of Jewish survival and continuity. According to the Talmud, it is forbidden to duplicate the *menorah* exactly, so later replicas have for the most part lacked the elaborate detail specified in the Bible.[5] In classical times, *menorahs* were widely depicted in *synagogue mosaics, walls, and paintings; on tombs; on vessels, lamps, *amulets, seals, and rings. In the Middle Ages, *menorahs* were popular emblems in illumi-

nated manuscripts and bookplates. In modern times, *menorahs* figure prominently in synagogue art, notably in stained glass windows, *ark and Torah decorations, and architectural details.

למנצח בנגינת מזמור שיר:

Psalm 67, the *Menorah* Psalm.

The State of Israel has taken the *menorah* as its own emblem, reproduced frequently on stamps, coins, and souvenirs. A large sculptured *menorah*, by Benno Elkan, depicting major events of Jewish history, stands outside the Knesset (Parliament) building in Jerusalem, signifying the rebirth of the Jewish People after its long exile and defeat.

Botanists have suggested that the original shape of the *menorah* may have been inspired by the moriah plant (salvia palaestinae), a fragrant plant that grows in the Sinai desert and Israel. When pressed flat, its branches resemble the six arms and central stem of the *menorah*.

There have been many interpretations of the mystical significance of the *menorah*, especially its seven branches. In the ancient world, it was believed that the heavens consisted of seven planets and seven spheres. The Hellenistic Jewish philosopher Philo applies this notion to the *menorah* as well, claiming that the seven planets are the highest objects perceptible by the senses. He also explains that its gold and light symbolize the divine light, or the Logos (the Word). It has been suggested that the seven branches represent the seven

Style of *menorah* common in Eastern European folk art. The flames on the side branches facing the center illustrate the talmudic description (*Menahot* 98b) that the middle lamp was especially prized. (See also Rashi's commentary on Exodus 25:37.)

days of creation. The branches of the *menorah* also resemble a *tree, and thus symbolize the Tree of Life. Or the *menorah* can be seen as an inverted tree, whose branches are roots drawing sustenance from heaven. If the arms of the *menorah* swivel, they form a *Star of David when seen from above.

*Kabbalists have focused on the *menorah* as a major symbol of the *Sefirot (divine emanations). The seven branches represent the seven lower *Sefirot*. The central stem represents *Tiferet*, Splendor, the Middle Line, the Source of Abundance which flows into the other six *Sefirot*. The oil symbolizes the inner soul of the *Sefirot* which flow from the *Ein Sof*, the Eternal Source. Psalm 67, designated by a 15th-century mystic as the "*Menorah* Psalm," which according to legend was engraved in the form of a *menorah* on David's shield, has been frequently reproduced in the form of a *menorah* in *amulets, *shivitim*, and Sephardi prayer books. In practical Kabbalah, the *menorah* is regarded as having antidemonic properties.

Hanukkiah (Hanukkah *menorah*) of the eight-lights-in-a-row genre. Originally hung, this style evolved into a free-standing lamp.

A hasidic tradition teaches that the *menorah* derives its form from six-winged *angels, the "*seraphim*," whose name derives from a Hebrew word for *fire. God showed Moses an image of the Upper Seraph, and commanded him to reproduce it in an earthly version.

Similar to the seven-branched Temple *menorah*, but different in origin and function, is the nine-branched *Hanukkah *menorah*, "*hanukkiah*." Eight of the branches, originally containing olive oil but now more typically holding *candles, represent the miracle that took place at the time of *Judah Maccabee, when the only undefiled oil found in the desecrated Temple, a one-day supply, lasted a full eight days. A ninth light, called the *shammash* (helper), is used to light the other candles, since Jewish law forbids making practical use of the Hanukkah candles. Initially, Hanukkah lamps

hung on the left side of the front door, opposite the *mezuzah*, because Jews were commanded to publicly affirm the Hanukkah miracle. When such public display became dangerous, Jewish law permitted lighting the *menorah* inside the house.

Nine-branched *hanukkiah*, modeled on the configuration of the Temple *menorah*.

For centuries, Hanukkah *menorahs* typically consisted of a straight row of oil or candle holders with a backplate for hanging it on the wall or door. The earliest European hanging *menorahs* (13th century), from Spain and southern France, featured backplates with *rose windows and other influences from Gothic architecture. In the Middle Ages, synagogue replicas of the seven-branched Temple *menorah*, usually found to the right of the ark, were often lighted for the benefit of the poor and the stranger who did not have their own Hanukkah *menorah*. Eventually, this second *hanukkiah* design, modeled on the Temple *menorah* but supplemented with two additional arms, found its way into Jewish homes.

Hanukkah *menorahs* sometimes carry other symbolic imagery besides the light symbolizing the ancient miracle: the *Lion of *Judah, representing both the Jewish People and Judah Maccabee; *Judith, whose story parallels that of Hanukkah; the *hamsa*, to ward off evil spirits; *eagles, *deer, and other animals; Jerusalem or the Temple; biblical, classical, or decorative motifs. Any shape is ritually acceptable as long as the eight individual lights are on the same level and do not seem to merge into a single flame.

The extraordinary variety of *menorah* and *hanukkiah* designs throughout the centuries testify to the continuing creativity of the Jewish artistic imagination.

[1]Exodus 25:9, 30–40; 30:7–8; 37:17–24; Numbers 8:2–4; [2]*Numbers Rabbah* 15:4; [3]1 Kings 7:49; 2 Chronicles 4:7; *Menahot* 98b; [4]2 Kings 24:13; Ginzberg, *Legends of the Jews* 4:321; [5]*Rosh Hashanah* 24a; *Avodah Zarah* 43a; *Menahot* 28b.

Signifies: AFFIRMATION, ANTIDEMONIC, CONTINUITY, DIVINE LIGHT, DIVINE PROTECTION, EXILE, JEWISH PEOPLE, JUDAISM, LIFE, MIRACULOUSNESS, REBIRTH, SURVIVAL

Generic Categories: Hanukkah, Israel (State of), Kabbalistic Symbols, Ritual Objects, Synagogue, Temple

See also: Almond Tree, Amulet, Angels, Fire, *Hallah*, Hanukkah, Israel (State of), Judah Maccabee, Judith, Kabbalah, Light, *Mishkan*, Oil, *Sefirot*, Seven, Temple

MESSIAH – מָשִׁיחַ.

Messiah is a transliteration of the Hebrew word *mashiah*, which means "anointed." In the ancient Near East, kings were invested by having *olive *oil, a symbol of purity, honor, and holiness, poured over their *heads. Israelite priests were consecrated in the same way. Over the centuries, "Messiah" came to designate a divinely appointed redeemer who would appear at the End of Days.

When King *David first established the monarchy in *Jerusalem, it was believed that his descendants would rule Israel forever.[1] When the kingdom split after the reign of his son *Solomon, there arose the hope that one of David's descendants would reunite the divided *Twelve Tribes. The prophets, especially Isaiah, foretold of a messianic age characterized by peace and justice, during which Israel would again be ruled by a descendant of the House of David.[2]

In the first centuries of the common era, in response to Christianity's belief that the Messiah had already come, Jewish notions about an imminent messianic redemption became more urgent and elaborate. Jews began to dream of two Messiahs – a high priest and a *king. In 135 C.E., a messianic figure, Bar Kokhba ("Son of the Star"), led an abortive Jewish rebellion against *Rome. Gradually, the idea of Messiah crystallized into a vision of a Davidic king ("*Mashiah ben David*") who would redeem Israel at the end of history, defeat its enemies, bring the people back from exile, rebuild the *Temple, and establish the kingdom of God, which would be characterized by material and spiritual well-be-

ing. There also arose the notion of a second Messiah—"*Mashiah ben Joseph*"—who would precede the messianic king and die in battle with Israel's enemies.

In Jewish tradition, the Messiah is conceived as a human agent of divine redemption. He is imagined riding into Jerusalem on an *ass; sitting among the lepers in Rome; riding the *clouds; ascending the *Mount of Olives heralded by *Elijah's *shofar blast.[3] According to one legend, he was born in Bethlehem on the day that the Temple was destroyed and was carried off by a whirlwind.[4] Among his many names are Shalom, David, and Menahem (Comfort).

From the Middle Ages on, Jewish messianic thought focused on divining the signs of the Messiah's appearance, determining the date of the Redemption (possible dates included 1096, the onset of the Crusades; 1492, the Expulsion from Spain; and 1648, the Chmielnicki pogroms), and describing the apocalyptic End of Days. Many philosophers, such as Maimonides, tried to demystify messianic ideas by focusing on a vision of political redemption for the Jewish People. Beliefs about individual redemption competed with those of national redemption, and often overshadowed them. Eventually, messianic speculation became the province of the mystical schools of Judaism. Periodically, self-proclaimed "messiahs," such as Shabbatai Tzevi in the 17th century, attracted thousands of followers, whose hopes were subsequently dashed when such messianic claims proved false.

In modern times, liberal Judaism has largely depersonalized the idea of the Messiah, focusing instead on a future Messianic Era, characterized by universal justice and spiritual fulfillment. Orthodox Judaism still adheres to traditional beliefs of a personal Messiah, who will reign in Jerusalem, rebuild the Temple, and reinstitute the sacrificial system. Zionism has often been interpreted as a secular messianic movement; many prayer books include a prayer describing the establishment of the State of Israel as "the dawn of our deliverance." Some extreme Orthodox sects do not recognize the Jewish state because the Messiah has not yet come to redeem the nation.

Many natural symbols, ceremonies, holidays, biblical figures, and objects are as-sociated with the Messiah and the hope for messianic redemption.

Among these are the animals: the ass, upon which the Messiah will ride; the mythical monsters, *Leviathan, *Behemoth, *Ziz-Shaddai*, and the Great Ox (*Shor Ha-Bar*), upon which the righteous will dine—along with *manna; the *lion, symbol of Judah, the tribe of David; the unicorn, associated with Psalm 22, a Psalm of David; the lion lying down with the lamb, and the *leopard with the kid, symbols of universal peace. The plants symbolic of the Messianic Age are the vine and *fig tree.[5] Oil, because of its role in anointing, and *dew, the agent of resurrection, are also messianic symbols.

Figures associated with the Messiah are David, and his ancestor *Ruth; Elijah the Prophet; Joseph; *Rachel, who weeps for her children in exile; and *Daniel, whose book is filled with apocalyptic visions. *Kabbalists identify the *Shekhinah*, God's feminine aspect, as the divine counterpart of the exiled Jewish People, awaiting her own redemption.

Most holidays have a messianic element: *Rosh Hashanah focuses on the *shofar*, which will ultimately herald the Messiah's arrival. *Yom Kippur ends with a single, long *shofar* blast and the cry, "Next year in Jerusalem!" The ruined Temple is called "the fallen *sukkah* of David," which God will rebuild in the Messianic Age. *Myrtle, one of the *four species used on *Sukkot, is a symbol of messianic redemption.[6] The *haftorahs* (prophetic portions) read during Sukkot, look forward to the day of ultimate world unity under divine kingship.[7] The numerical value of the letters of the *dreidl* add up to the Hebrew word "*Mashiah*" (Messiah).

*Passover is laden with messianic symbolism. It commemorates the first redemption of the Jewish People from Egyptian slavery, celebrates the earth's resurrection from its winter sleep, and anticipates ultimate universal redemption. Elijah's *cup symbolizes the hope of the Messiah's arrival. The broken middle *matzah* and *afikoman* express the idea that the world is still broken, awaiting messianic repair. The popular final song in the *Haggadah*, *"Had Gadya*," ends with the messianic vision of God triumphing in Jewish history. As on Yom Kippur, the *seders* end with

the declaration: "Next year in Jerusalem!"; Jerusalemites proclaim: "Next year in Jerusalem rebuilt!" There is a tradition that the Messiah will be born on *Tisha B'Av, the anniversary of the destruction of the Temple.

The *Sabbath has always been associated with messianic hope as well. Tradition teaches that the Messiah will come during *Havdalah, the final ceremony ushering out the Sabbath. As the braided *candle burns, Jews sing the song, "Eliyahu Ha-Navi" (Elijah the Prophet) which expresses the hope that the Messiah will come soon. The Sabbath is called "a foretaste of the World to Come" when every day will be Shabbat. It is traditional to eat *fish on this day, symbolic of the messianic meal of Leviathan.

Elijah is also invoked at a *brit, suggesting the possibility that this new Jewish child may be the Messiah.

The *moon is associated with the Messiah, because legend claims that the moon, whose light was diminished at creation, will be restored to its full radiance at the End of Days. The moon also symbolizes the Jewish People, whose glory likewise will be restored during messianic times. "Kiddush Levanah," the ceremony celebrating the New Moon, abounds with messianic imagery. Feminists interpret this legend as symbolic of the future equality of Jewish women, one of whose symbols is the moon.

The dead are buried with their feet facing *east toward Jerusalem, in anticipation of the final resurrection which will occur when the Messiah comes. They are also buried with *earth from the Holy Land, symbolic of their return there.

Several places in Israel are associated with the messianic redemption: the Mount of Olives, where the Messiah will first appear; Mount *Sinai and Mount Moriah, which will then merge together at the Temple Mount; the Garden of *Eden, which will reemerge from hiding; and of course, Jerusalem, where the Third Temple will be built.

[1]2 Samuel 7:13; [2]Isaiah 16:4–5; [3]Zechariah 9:9; Sanhedrin 98a; Daniel 7:13; Ginzberg, Legends of the Jews 4:233–235; 6:438; [4]Lamentations Rabbah on 1:16, 51; [5]Micah 4:5; [6]Isaiah 55:12–13; [7]Zechariah 14:9.

Signifies: END, HARMONY, HOPE, JUSTICE, PEACE, REDEMPTION, REUNIFICATION, RIGHTEOUSNESS, SALVATION, SPIRITUAL FULFILLMENT

Generic Categories: Animals, Astronomy, Botany, Death, Food, Hanukkah, Kabbalistic Symbols, Passover, Prayer, Rosh Hashanah, Shabbat, Sukkot, Temple, Tisha B'Av, Yom Kippur, Women

See also: Afikoman, Behemoth, Brit, Cup, Daniel, David, Dew, Dreidl, Earth, Eden, Elijah, Fig, Fish, Goat, Grapes, Had Gadya, Havdalah, Horn, Israel, Jerusalem, Joseph, Kabbalah, King, Leopard, Leviathan, Lion, Manna, Moon, Mountain, Myrtle, Oil, Passover, Rachel, Rosh Hashanah, Ruth, Sefirot, Shabbat, Shekhinah, Shofar, Sukkot, Temple, Tisha B'Av, Yom Kippur

MEZUZAH — מְזוּזָה.

Doorposts are liminal (Latin for "threshold") symbols, representing transitions between public and private, community and family, outer and inner realms. In the ancient world, it was a common custom to mark the doorposts of one's house to protect oneself against evil spirits. A trace of this idea may be found in the biblical story of *Passover, when the Children of Israel were commanded to smear *blood on their doorposts to ward off the *Angel of Death from their firstborn.[1]

Forty years later, when the Israelites prepared themselves to enter the Promised Land, they were commanded to affix "these words" — the commandments and instructions of the Torah — on the doorposts of their houses and on their *gates.[2] These mezuzot, literally "doorposts," were to serve both as constant reminders of the people's loyalty to God as well as sources of divine protection.

Decorated mezuzah with parchment rolled inside.

The earliest evidence of the use of the mezuzah dates from the Second *Temple period (4th century B.C.E.). Very little has

been added to its observance since then. A *mezuzah* consists of a case containing a piece of parchment inscribed with the two biblical passages ordaining its use, usually laid out in twenty-two lines, equaling the number of letters in the Hebrew *alephbet*.[3] On the back of the parchment (*klaf*) is the word *Shaddai* (שדי), a divine *name meaning Almighty, but also an acronym for "the Guardian of Israel's Gates" (שומר דלתות ישראל—*Shomer Daltot Yisrael*). In the Middle Ages, other passages, usually the names of *angels, and symbols such as the pentagram and the *Star of David were added, but Maimonides forbade such additions, and his opinion has been honored.[5] However, upside down at the bottom of the obverse side, the words *Kozu Be-Mokhsaz Kozu* (כוזו במוכסז כוזו) appear, a cryptogram for "*YHVH Elohenu YHVH*" ("the Lord, our God, the Lord"), made by substituting the next letter of the *alephbet* for the original letters. *Mezuzah* cases are frequently ornamented with traditional symbols and usually have the letter *shin* (ש) on the front, standing for "*Shaddai*" (Almighty).

Although Maimonides frowned upon regarding the *mezuzah* as an *amulet, it is clear that this protective function has always been a part of its appeal.[6] Many Jews kiss the *mezuzah* upon entering and leaving a house. In our own day, *mezuzah* charms, usually lacking the inner parchment, are often worn as a necklace or bracelet for good luck.

The *mezuzah* symbolizes not only a Jew's dedication to the commandments, sanctification of the home, and love of God, but also an affirmation of Jewish identity.

[1]Exodus 12:7, 22–3; [2]Deuteronomy 6:9; 11:20; [3]Deuteronomy 6:4–9; 11:13–21; [5]*Mishneh Torah, Tefillin* 5:4; [6]JT *Pe'ah* 1:1; *Genesis Rabbah* 35:3; *Avodah Zarah* 11a.

Signifies: ALLEGIANCE TO TRADITION, DIVINE PROTECTION, GOOD LUCK, HOME, JEWISH IDENTITY

Generic Categories: Dwellings, New Home, Ritual Objects

See also: *Alephbet*, Amulet, Gates, Name of God, Portal

MILK – חָלָב.

Like *wine, milk was an important source of dietary liquid in ancient Israel, where water was scarce and often contaminated. In recognition of its great value, pagan worshipers would offer gifts of milk and cheese to the gods or king. Because of its connection with the miracle of reproduction, milk was often used in pagan religious rites, one of which was boiling a kid in its mother's milk. Jewish law explicitly prohibits this practice.[1]

In the Bible, milk usually symbolizes abundance and fertility. God promises to take the Israelites to a land flowing with milk and *honey.[2] In the End of Days, the Judean hills will flow with milk.[3]

In the creation myths of many cultures, milk is instrumental in bringing forth life on earth. The *four primordial rivers in the Garden of *Eden may echo an earlier myth in which rivers of milk issued forth from the four teats of the Cow-Goddess's udder. One of the Edenic rivers, "Hiddekel," possibly derives its name from the Akkadian word for the Milky Way, "Hiddagal," literally, "River of the Divine Lady."[4] Speaking about his own creation, *Job proclaims: "You poured me out like milk, curdled me like cheese."[5]

Milk is especially associated with the holiday of *Shavuot, during which it is customary to eat milk products. A number of explanations have been suggested for this enigmatic custom: late spring is the time when dairy animals give birth to new life and find rich grazing, which makes them produce an abundance of milk; the rabbis interpret the biblical verse, "Honey and milk are under your tongue," as a reference to the words of the *Torah whose revelation is celebrated on this festival[6]; the Jews received the laws of *kashrut on this day, and had to abstain from eating meat until they could cleanse their old vessels of impurity; milk's *white color symbolizes purity, appropriate to the holiness associated with the events at *Sinai; the numerical value of *halav*, the Hebrew word for milk, equals *forty, the number of days *Moses spent on Mount *Sinai.

Milk products, especially cheese, are also eaten on *Hanukkah in remembrance of *Judith's courageous deeds. Feeding General Holofernes great quantities of thirst-provoking cheese, Judith got the enemy

drunk, then cut off his head, thereby saving *Jerusalem from enemy siege.

[1]Exodus 23:19; 34:26; Deuteronomy 14:21; [2]Exodus 3:8; [3]Joel 4:18; [4]Genesis 2:14; Walker, *The Woman's Dictionary of Symbols and Sacred Objects*, 343-344, 489; [5]Job 10:10; [6]Song of Songs 4:11; [7]Lamentations 4:7.

Signifies: FERTILITY, LEARNING, LIFE, PURITY, TORAH

Generic Categories: Food, Hanukkah, Israel (Land of), Shavuot, Women

See also: Hanukkah, Honey, *Kashrut*, Judith, Shavuot, White

MINYAN – מִנְיָן.

A *minyan* (literally "number") consists of *ten Jews over the age of *thirteen, the minimum quorum necessary to recite certain prayers and perform certain ceremonies. Traditionally, these ten are male, but the Reform, Reconstructionist, and Conservative Movements include women as well.

The Talmud, citing the biblical verse, "God stands in the divine congregation," declares that if ten pray together, God is present.[1] The rabbis derive the number ten from several sources: the ten spies (described as a "wicked community") who brought back a negative report from Canaan and thus condemned the people to *forty years of wandering[2]; the ten elders mentioned in the Book of *Ruth; and the (hypothetical) ten righteous souls of Sodom for whose sake *Abraham pleaded that God spare the sinful city.[3]

A *minyan* symbolizes the minimum number that constitutes a viable Jewish community. Many contemporary congregations are strengthened by the requirement that a *minyan* be present in order for a mourner to recite the *Kaddish*, a rite which continues to be widely observed, even by nonobservant Jews.

"*Minyan*" also describes a group which regularly prays together, usually in a space other than a formal sanctuary.

[1]Psalm 82:1; *Berakhot* 6a; [2]Numbers 14:27; *Berakhot* 21b; *Megillah* 23b; [3]Ruth 4:2; Genesis 18:32; *Ketubot* 7a-b.

Signifies: COMMUNITY, JEWISH COMMUNITY, PRAYER, SURVIVAL

Generic Categories: Numbers, Prayer, Synagogue

See also: Numbers, Synagogue, Ten

MIRIAM – מִרְיָם.

Miriam, the sister of *Moses and *Aaron, was one of the leaders of the Jewish People both in *Egypt and in the *wilderness. In recent times, Miriam has become a prominent symbol for Jewish feminists of Jewish women's political and spiritual leadership.

According to the *midrash*, Miriam was a prophet who began her prophetic career while still a child. In response to *Pharaoh's edict ordering the slaying of Hebrew male children, her father Amram persuaded all the Hebrew men to divorce their wives. Miriam accused her father of exceeding even Pharaoh's murderous designs by cutting off the next generation, and prophesied that he and Yoheved would give birth to their people's redeemer.[1]

When the infant Moses was rescued from the Nile by Pharaoh's daughter, Miriam persuaded her to hire Yoheved as the baby's wet-nurse, thus preserving Moses's Jewish identity.[2] Some commentators identify Miriam as *Puah, one of the midwives who rescued many Hebrew babies.[3]

After the crossing of the Red Sea, Miriam, tambourine in hand, led the Israelite women in a victory dance.[4] Because of her abilities as a singer, dancer, and musician, Miriam became a symbol of Jewish artistry and dance, the legendary ancestor of *Bezalel, architect of the *Mishkan*, and of *David, sweet singer of Israel.[5]

To many contemporary Jewish feminists, Miriam symbolizes not only women's leadership but also, paradoxically, the suppression of that leadership. The Torah states that Miriam was stricken with leprosy for challenging Moses over his marriage to a Cushite (Ethiopian) woman.[6] Some interpreters argue that the Torah censured Miriam because she challenged Moses's exclusive claims in speaking to God. Certain biblical scholars have also suggested that the compilers of the Torah, disapproving of Miriam's ecstatic mode of worship and celebration, edited out evidence of her spiritual experience and leadership.

Jewish legend claims that at twilight on the Sixth Day of Creation, God created a

miraculous *well, which because of Miriam's merits, accompanied the Children of Israel in their wanderings, and disappeared at her death.[7] Like her two brothers, Miriam died with a divine kiss rather than at the hand of the *Angel of Death.[8]

Jewish feminists have introduced the custom of singing "Miriam Ha-Neviah" (*Miriam the Prophetess) during the *Havdalah ceremony, inspired by an ancient folk tradition that Miriam's Well fills all wells at the end of Shabbat and gives such water curative powers.[9]

[1]Sotah 12a; [2]Exodus 2:7; [3]Exodus Rabbah 1:13; [4]Exodus 15:20-21; [5]Exodus Rabbah 1:17; 48:4; [6]Numbers 12; [7]Pirke Avot 5:6; Taanit 9a; [8]Bava Batra 17a; [9]Kitov, The Book of Our Heritage 2:162.

Signifies: DANCE, MUSIC, PROPHECY, SUSTENANCE, WOMEN'S LEADERSHIP, WOMEN'S SUPPRESSION

Generic Categories: Personalities, Women

See also: Aaron, Bezalel, David, Exodus, Moses, Shifra and Puah, Water, Well

MIRROR – רְאִי. The rabbis taught that prophecy involves gazing into a mirror — "aspaklaria" — to attain spiritual insight. *Moses gazed through a clear mirror; the other prophets, through a dull one. Moses required only one mirror; the other prophets, nine.[1] This mirror serves as a necessary barrier between human and divine vision.[2] This image was used by early mystics as an aid to meditation. Abraham Abulafia (13th century) claimed that the *Urim and Tummim, ancient luminous oracles consulted by the High *Priest, granted the priest both a transcendental and a personal vision of God.[3]

In folklore, mirrors are connected with the spirit. During mourning, mirrors in the home of the deceased are covered. This symbolizes the diminishment of the image of God through the death of one of God's creatures; the inappropriateness of personal vanity in the face of mortality; the disruption of sexual intimacy between husband and wife because of a death in the family; the withdrawal into loneliness after loss. It has been taught that focusing on the

mirror's silvered coating results in vain self-absorption and greed.

[1]Yevamot 49b; Leviticus Rabbah 1:14; [2]Rashi, Sukkah 45b; [3]Gottlieb, The Lamp of God, 290-291.

Signifies: GREED, INSIGHT, PROPHECY, SELF-ABSORPTION, SPIRIT, VANITY, VISION

Generic Categories: Death, Kabbalistic Symbols

See also: Kabbalah, Light, Moses, Urim and Tummim

MISHKAN – מִשְׁכָּן. The Mishkan, literally "dwelling place," was the portable sanctuary in the *wilderness which housed the sacred objects of the Jewish People: the *Ark of the Covenant with its *cherubim and the *Ten Commandments, the *menorah, and the sacrificial *altar. For the *forty years that the Children of Israel wandered through the desert, this sacred tent functioned as the center of their communal religious life.

The Torah provides an elaborate blueprint of the Mishkan's design, function, and care. The raw materials — woven goods, animal skins, *gold, silver, and bronze — were donated by the people as free-will offerings; the master artisan *Bezalel supervised the construction.[1] An inner tent called the Holy of Holies sheltered the ark, in front of which was a pot of *manna and *Aaron's miraculous rod as well as the seven-branched menorah.[2] The *priests who ministered within the Mishkan's precincts wore special garments. This first Tabernacle (from the Latin meaning "tent") served as the prototype of the *Temple built centuries later in *Jerusalem.[3]

The Mishkan was also called the "Ohel Moed," the Tent of Meeting, for it was here that God "came down" to talk with the people, through their leader *Moses. The word Mishkan itself shares the same root as *Shekhinah, God's Presence in the world. The Mishkan symbolized divine protection and guidance, for when "the *cloud of the Lord" filled the tent, it was a sign that the people were to stay encamped; when it moved, they were to continue their journey. At night, *fire lit up the cloud.[4]

In its particulars, the *Mishkan* mirrored the heavens.[5] Its architecture symbolized a hierarchy of access to the Divine: the people could enter only the court; the priests, only the Holy Place inside the outer tent; the High Priest alone could enter the Holy of Holies, but only on *Yom Kippur. Similarly, the materials of the inner tent were made of pure gold; of the outer, of ordinary gold, silver, and bronze. The measurements of the *Mishkan* consisted in large part of multiples and fractions of *sevens and *tens, *numbers symbolizing completion and perfection.

According to the *midrash*, the *Mishkan* symbolizes God's love for Israel, a sign that God had forgiven the people for making the *Golden Calf.[6]

[1]Exodus, chapters 25-31; 35-40; [2]Exodus 16:33-34; Numbers 17:25; [3]1 Kings, chapter 6; [4]Exodus 40:34-38; [5]*Exodus Rabbah* 35:6; [6]*Exodus Rabbah* 33:2.

Signifies: ACCESS TO DIVINE, CENTER, COMPLETION, DIVINE GUIDANCE, DIVINE LOVE, DIVINE PRESENCE, DIVINE PROTECTION, HEAVEN, HOLINESS, MEETING, PERFECTION

Generic Categories: Dwellings, Temple

See also: Altar, Ark, Cherubim, Gold, Moses, Numbers, Temple, Ten Commandments

MOON – יָרֵחַ, לְבָנָה. From earliest times, people were fascinated by the moon. They realized the vital connection between a woman's monthly menstrual (from "mensis," Latin for "moon") cycle, and the waxing and waning of the moon. They also recognized that the moon controls the tides, whose ebb and flow parallels the organic rhythms of female fluids. Because of these connections, the moon has been universally associated with femininity and women's procreative power. Within Jewish tradition, women have long celebrated the special female symbolism of the moon.

The lunar cycle also marked time for ancient peoples before the adoption of the *seven-day week. Moon and month are etymologically related; so are "hodesh" (Hebrew for month) and "hadash" (new [moon]). The full moon provided ample light for evening celebrations in a pre-electric world, a welcome relief from long, dark nights.

Although the Torah forbids idolatrous worship of the moon[1], a popular practice among neighboring peoples, Judaism sanctifies this heavenly body by calibrating its *calendar according to both lunar and solar cycles. *Passover and *Sukkot begin at the full moon; *Rosh Hashanah, at the new moon. The midwinter festival of *Tu B'Shevat and the midsummer holiday of Tu B'Av, spaced exactly six months apart, are also full moon holidays. Besides providing sufficient light for festival celebrations, full moons also provided greater security for celebrants who had to travel home in darkness. The *Hanukkah celebration lasts from the waning moon through the new moon to the growing moon.

In ancient Israel, the appearance of the new moon was announced by the Sanhedrin, the highest court, and then broadcast by mountaintop signal *fires throughout the land. (Like the *four species of Sukkot, these signal torches consisted of four species— *cedar, reeds, *pine, and flax—bound together with twine.)[2] Since Second Temple times, Rosh Hodesh, the festival of the New Moon, has constituted a minor holiday, celebrated with special blessings, psalms, and readings.

From the talmudic period to our own day, Rosh Hodesh has been especially sacred to Jewish women. According to legend, the women in the *wilderness refused to contribute their jewelry to make the

Phases of the moon and the Hebrew months: 1. New moon—Rosh Hodesh. 2. Moon increases, called a waxing moon. 3. Full moon, 15th of Hebrew month (Sukkot and Pesah begin at the full moon). 4. Moon decreases, called a waning moon. 5. Moon will shortly disappear, the last days of the month.

*Golden Calf, and were rewarded for their faithfulness by being granted the New Moon as a day off from work.[3] For many centuries, Jewish women refrained from doing heavy work on this day. In recent years, Rosh Hodesh has been revived as a special women's festival. Women have formed Rosh Hodesh groups, which meet on the New Moon to celebrate and study together. These groups have created new rituals which bring together ancient and modern symbolism of moon, *water, and women.[4]

Among the kabbalists, the moon has traditionally represented the *Shekhinah, God's feminine aspect, whose exile is symbolized by the moon's monthly waning. Rosh Hodesh, marking the moon's return, symbolizes the renewal of hope in the restoration of Divine Unity. A special ceremony evolved for blessing the New Moon, called "Kiddush Levanah," which is recited at the reappearance of the lunar crescent. The text alludes to an ancient midrash predicting that in the Messianic Age, the moon, diminished in radiance at the beginning of time, will regain its former luminosity.[5] The moon also symbolizes the Jewish People, whose glory likewise will be restored during messianic times. A contemporary reading has reinterpreted the midrash to refer to a future time when Jewish women will acquire full equality within the tradition.[6]

According to the rabbis, the moon represents *Jacob, a symbol of the Jewish People; the *sun, *Esau, a symbol of Israel's enemies. Although the sun is the brighter of the two heavenly bodies, only the moon shines both day and night. So, too, only Israel has a portion in this world and the World to Come.[7] Similarly, the waxing and waning of the moon is a symbol of the vacillating fortunes of Jewish history. The period of the waxing moon is considered to be a time of good luck.

[1]Exodus 20:4; Deuteronomy 4:19; 17:3–5; [2]Rosh Hashanah 2:3; [3]Tosafot to Rosh Hashanah 23a; [4]See Adelman, Miriam's Well; [5]Psalm 89:38; Hullin 60b; [6]Waskow, Seasons of Our Joy, 229; [7]Genesis Rabbah 6:3.

Signifies: DIVINE SPIRIT, FEMININE, FEMINISM, FERTILITY, GOOD LUCK, JEWISH HISTORY, JEWISH PEOPLE, REDEMPTION, RENEWAL

Generic Categories: Astronomy, Messiah, Prayer, Rosh Hodesh, Women

See also: Calendar, Circle, Hanukkah, Messiah, Passover, Shekhinah, Sukkot, Sun, Water, Zodiac

MOSES – מֹשֶׁה.
No other figure in Jewish history has commanded center stage like Moses. For thousands of years, in every *synagogue throughout the world, the story of his life and death has been repeated in the weekly and holiday readings of the *Torah. Indeed, one of the Torah's names is the *Five Books of Moses, although only four of the five books feature Moses as the main character. Judaism itself has been called the "Mosaic faith." In the *Thirteen Articles of Faith, the closest Judaism has to a religious creed, the author, medieval philosopher Moses Maimonides, stipulates that every Jew must believe that "in Israel none like Moses has arisen again,"[1] the greatest prophet the Jewish People has ever known. (In recognition of Maimonides' own extraordinary influence on Judaism, the tradition proclaims: "From Moses to Moses, there is none like Moses.")

According to the Torah, Moses means "drawn out," the name given him by *Pharaoh's daughter Bitiah when she drew the infant Moses out of the Nile.[2] (Archaeologists have discovered that in ancient Egyptian, "moses" means "son of," as in Ramses, "son of Ra.") As his people's redeemer, Moses was later to draw Israel out of slavery, redeeming them from the waters of the Red Sea.

Moses represents the paradigmatic Jewish leader, as nearly perfect as a human leader can be. The tradition calls him "Moshe Rabbeinu," Moses Our Teacher/Master. Like a shepherd, which indeed he was during his years in Midian, he led his flock for *forty years in the *wilderness. He brought them the *Ten Commandments, chastised them when they sinned through the *Golden Calf, sustained them with *manna and meat which he entreated from heaven, solved their quarrels, inspired their faith.

From the moment God spoke to him out of the *Burning Bush until God claimed his soul with a divine kiss, Moses came closer to God's Holy Spirit than any mortal has ever come. The Torah states that Moses

was the only person with whom God spoke "face to face."[3] Orthodox Jews maintain that God revealed not only the Torah to Moses, but also the entire interpretive tradition known as the Oral Law, from which all Jewish practice derives. He symbolizes the Man of God, a vessel of holiness.

But despite his special status as divine confidante and national leader, Moses was a man of extraordinary humility. When God first commands him to go to *Pharaoh, he protests that he is inadequate to the task.[4] The tradition often refers to him as "God's servant," *eved*, the same Hebrew word as "slave."

For all his extraordinary qualities, Moses always remains a human being, not a saint or god. He is shown to have flaws, occasionally losing faith in the people and once even in God, a failing that results in his being forbidden entry into the Promised Land.[5] From this, the tradition teaches that the greater the leader, the more exemplary must be his behavior. Not his own children, but his brother *Aaron's children inherit the priestly dynasty. Moses' grave is unmarked, and thus has not become a shrine. In the *Passover *Haggadah*, which tells the dramatic story of the *Exodus from *Egypt, Moses is mentioned only once, lest he, not God, be regarded as the Redeemer of the story.[6]

But despite these measures, Moses remains the most beloved and revered of Jewish heroes. His name is cited at circumcisions and *weddings. To this day, out of respect for his memory, Jews wish each other longevity by citing Moses's age at his death: "May you live to 120!" His *yahrzeit* (anniversary of his death) is commemorated on the *seventh of *Adar* by Jewish burial societies (*Hevrah Kadisha*).

According to *Kabbalah, Moses was the prototype of the mystic. He and Aaron represent the *Sefirot* of *Netzah*, Eternity, and *Hod*, Splendor, respectively, together constituting the sources of prophecy. *Netzah* is the divine aspect that expresses instinctive impulses, perhaps reflecting Moses' natural instincts for appropriate action and thought.

[1]Deuteronomy 34:10; "*Yigdal*" liturgy; [2]Exodus 2:10; [3]Deuteronomy 34:10; [4]Exodus 4:10, 13; [5]Numbers 20:12; *Numbers Rabbah* 19:12; [6]Exodus 14:31 in section beginning, "Rabbi Yose the Galilean said . . ."

Signifies: HOLINESS, HUMILITY, INTIMACY WITH DIVINE, LAW, LEADERSHIP, LONGEVITY, MYSTERY, PATIENCE, PROPHECY, REDEMPTION, REVELATION, SUBMISSION TO GOD'S WILL

Generic Categories: Personalities

See also: Aaron, Basket, Burning Bush, Exodus, Face, Forty, *Haggadah*, Kabbalah, Miriam, Mirror, Passover, *Sefirot*, Shavuot, Sinai, Ten Commandments, Torah

MOUNTAIN — הַר.

In most religious traditions, mountains symbolize the place where heaven and earth meet — the world axis (Axis Mundi) — an idea also conveyed by the Cosmic *Tree or *Ladder. In the ancient Near East, the pyramid and the ziggurat architecturally embodied this concept. Upon mountaintops, religious seekers achieved communion with the divine and spiritual authority. The sacrificial *altar, situated on a high place and approached via a staircase, also represented the divine mountain.

In Jewish tradition, several mountains have assumed central importance:

According to tradition, Mount Moriah is not only the site of the *akedah* (the Binding of *Isaac), but also where *Adam, Cain, Abel, and Noah performed their first sacrifices. It is also the place where the Holy *Temple once stood, and where it will rise again when the *Messiah comes.[1]

Mount Zion, also known as the City of *David, was a hill near the Temple Mount in the southeast of *Jerusalem. It later became identified with Jerusalem, the Temple, and the Jewish People as a whole.

The Temple Mount, identified in legend with Mount Moriah, is the holiest place in Judaism, the site of the ruined Temple. Since the destruction of the Second Temple in 70 C.E., the rabbis have forbidden Jews to walk here, lest they accidentally step within the area of the Holy of Holies, committing an act of supreme desecration. This belief has caused considerable tension over current archaeological excavation in the Old City and over competing Muslim claims to the Temple Mount. Some legends maintain that the Temple vessels are still buried under this site. Other legends describe this

mountain as the center of the world, site of the *Even Ha-Shitiyyah*, the Foundation Stone, toward which all the subterranean wellsprings of the world flow. Tradition teaches that when the Messiah comes, all the dead will roll underground to this spot to be resurrected.

*Masada, the Herodian fortress in the Judean desert, became the last stand of Jewish zealots fighting the Romans in the first century. It has come to symbolize Jewish resistance, martyrdom, and courage.

The most famous mountain in the tradition is Mount *Sinai, also known as Mount Horeb, where God was first revealed to *Moses in the *Burning Bush and later revealed the *Ten Commandments to Moses and the Children of Israel.[2] Significantly, it is the only mountain sacred to Judaism that lies outside of Israel, yet its precise location is unknown. The prophet *Elijah also experienced a theophany upon this mountain.[3] The fact that Mount Sinai has not become a pilgrimage site for Jews affirms the notion that God is everywhere in the world, and that the Torah was given to all of humankind.

The Mount of Olives is a mountain that overlooks Jerusalem from the east. According to legend, the *dove sent out by Noah after the flood brought an *olive branch back from this mountain.[4] King *David worshiped here.[5] In the days of the Second Temple, this site was a religious center, where the *red heifer was burnt, and beacon fires were lit announcing the New *Moon. In later centuries, festivals, administrative appointments, and bans of excommunication were issued from this spot.

The prophets assign the Mount of Olives an important role in the messianic redemption. According to Zechariah, at that cataclysmic moment, this mountain will split in two.[6] A later legend claims that the Messiah will ascend the mountain, and from its summit Elijah, the *angel Gabriel, or God will sound the trumpet announcing the resurrection of the dead.[7] Because of its association with resurrection, the Mount of Olives has been a desirable Jewish burial site for centuries.

In modern times, Mount Scopus, a spur in the same mountain ridge as the Mount of Olives, became significant as the site of the first campus of Hebrew University. After several decades under Arab control, it was recaptured during the Six Day War and has come to symbolize the return of Jewish sovereignty to the Holy City.

[1]*Genesis Rabbah* 56:10; *Pesikta Rabbati* 31; *Targum Yerushalmi*, Genesis 22:14; [2]Exodus 3:12; chapter 20; Deuteronomy, chapter 5; [3]1 Kings 19:8–18; [4]Ginzberg, *Legends of the Jews* 1:164; [5]2 Samuel 15:32; [6]Zechariah 14:4; [7]Ginzberg, 6:438, n. 25.

Signifies: CENTER, COMMUNION WITH DIVINE, DIVINE PRESENCE, NATIONAL REBIRTH, REDEMPTION, RESURRECTION, REVELATION, SPIRITUAL AUTHORITY

Generic Categories: Death, Messiah, Places, Temple

See also: *Akedah*, David, Jerusalem, Ladder, Masada, Messiah, Olive, Sinai, Temple, Tree, Well

MYRTLE – הדס.

The *Torah specifies that the Israelites are to take "boughs of thick-leaved trees" to use on the holiday of *Sukkot. The rabbis interpreted this phrase to mean "myrtle branches," an aromatic evergreen which grows wild in Israel.[1] Myrtles are noted for their glossy beauty and sweet fragrance, which is released when the leaves are crushed. Because they withstand drought and remain green even after cutting, they symbolize immortality, good luck, and hope for the nourishment of rain.

To the Greeks and Romans, myrtle was sacred to the goddess Aphrodite/Venus, representing fertility and sacred union. The myrtle was called "the tree of love," and was thought to stimulate sensuality. In ancient Israel, myrtle boughs were worn by

The myrtle, MYRTUS COMMUNIS. The preferred myrtle for the *lulav* on Sukkot is the threefold *"meshulash"* variety, which has three leaves at each joint.

bridegrooms, used in betrothal celebrations, juggled, and made into perfume.[2] Because of her good qualities, especially her devotion to justice, Queen *Esther, whose other name was Hadassah (myrtle), was likened to the myrtle.[3] In the 20th century, a Jewish women's organization, especially devoted to supporting medical care in Israel, took the name Hadassah in honor of the biblical heroine.

In ancient times, the Sabbath was welcomed with two bouquets of myrtle; it was also used, until the 16th century, in the *Havdalah ceremony, to bid the Sabbath farewell. To this day, the Hebrew term for *spicebox is "hadas," commemorating this now lost custom.

The myrtle has also been attributed with special spiritual qualities. The prophet Zechariah had a vision of an *angel "standing among the myrtles in the Deep."[4] Sprigs of myrtle were sometimes buried with the dead to aid the journey of their souls. *Sukkot were covered with myrtle boughs to enhance the visit of the *ushpizin, the mystical guests.

On the holiday of *Sukkot, the myrtle, together with the *lulav, *etrog, and *willow, make up the *four species, with its own rich tradition of symbolism. Because of its biblical associations, the myrtle also ties Sukkot to the theme of *messianic redemption: "Instead of the nettle, a myrtle shall rise . . . [and] shall stand as a testimony to the Lord, as an everlasting sign that shall not perish."[5]

[1]Leviticus 23:40; *Sukkah* 12a; 32b–33a; [2]Tosefta, *Sotah* 15:8; *Ketubot* 17a; [3]Book of Esther 2:7; *Targum Sheni*, Esther 2:7; [4]Zechariah 1:8; [5]Isaiah 55:12–13.

Signifies: BEAUTY, GOOD LUCK, HOPE, IMMORTALITY, JUSTICE, SWEETNESS

Generic Categories: Botany, Messiah, *Shabbat*, Sukkot, Trees

See also: Esther, *Etrog*, Eye, Four Species, *Lulav*, Spicebox, Sukkot, Willow

NAMES — שֵׁמוֹת.

A person's name is thought to help define that person's soul and destiny, and hold power over it. In some cultures, a baby is given a secret name so that evil forces cannot harm him or her. A change in a person's status — through adoption, marriage, religious conversion, political elevation, immigration, spiritual transformation — is often accompanied by a symbolic change of name.

Most biblical names have symbolic resonance. Many people receive new names after they have undergone a transforming encounter with God: Abram becomes *Abraham; Sarai, *Sarah; *Jacob, Israel.[1] Significantly, *Isaac, whose near sacrifice forever altered his relationship with God, does not receive a new name after the *akedah. Occasionally, places also receive new or additional designations after such theophanies. For example, the site of Jacob's dream of the *ladder, formerly called Luz, becomes Bethel, "the house of God."[2]

Names bestowed by parents reflect the circumstances of a child's birth, their hopes for that child's future, or their own experiences. *Rachel and *Leah, vying for Jacob's love through their fertility, named their sons in light of their rivalry.[3] When Rachel, dying in childbirth, named her second son "Ben Oni," "son of my suffering," Jacob changed the name to Benjamin, "son of my right hand," clearly fearful that Rachel's name would curse the child's fate.[4] Pharaoh's daughter named her adopted Hebrew child *"Moses," which according to the Torah means: "I drew him out of the water" (but which archaeologists translate as "son of," as in Ramses, "son of Ra").[5]

Many names carry within them one of the names of God: *El*; abridged forms of the Tetragrammaton (the *four-letter *name of God): *Yah, Yeho, Yehu,* or *Yo*; *Shaddai* (Almighty); *Tzur* (Rock); *Adon* (Lord); *Melekh* (*King); *Baal* (Master). These names express the parents' wish for blessing or protection, their thanksgiving, or their praise of God. In the Bible, someone designated simply as *ish* (literally, man) is often an *angel.

Many women in the Bible are unnamed, suggesting their powerlessness or unimportance. Although the *midrash* later granted many of them names — Naamah (*Noah's wife), Amitlai (*Abraham's mother), Edith (Lot's wife) — Jewish tradition has upheld their nameless status. Contemporary feminists are attempting to reverse this practice.

The rabbis taught that people's names determine their destinies.[6] Reflecting that belief, certain names have been popular throughout Jewish history: those of the patriarchs and matriarchs — Abraham,

Isaac, and Jacob, Sarah, *Rebecca, Rachel, and Leah; several of Jacob's sons—Reuben, Simeon, Levi, *Judah; Moses, *Miriam, and *Aaron; the judges Joshua, Gideon, and *Deborah; prophets such as Samuel, Nathan, and Joel; kings and *queens such as *David, *Solomon, and *Esther. Many Hebrew names are words with positive connotations, such as "*Simhah*" (Happiness), "*Hayyim*" (Life) or "*Ari*" (*Lion).

Under the influence of foreign cultures, non-Jewish names have been added to the biblical and rabbinic repertoire, and traditional Hebrew names have often been respelled, reflecting the acculturation or assimilation of Jews into the majority culture. According to an ancient legend, when Alexander the Great came to Palestine, the Jews honored him by naming every priest's son born that year after him.[7] Many American Jews choose secular names for their children, although biblical names have recently come back into vogue, perhaps reflecting the Jews' security in America. Last names, a relatively recent innovation for Jews, also reflect the itinerant fortunes of the Jewish People. Exceptions are names like Cohen or Levi, which date back to ancient times.

It has long been a custom among Ashkenazi Jews to name children after a deceased family member as a memorial and a symbol of continuity, with the hope of investing the child with that person's spiritual qualities. Thus, certain names recur every few generations within some families. The new bearer of the name often feels a kinship with both the immediate and ancient namesake. Ashkenazim consider it bad luck to name a child after a living relative, probably based on the ancient notion that names give their bearers power over another's soul and destiny. Among Sephardi Jews, on the other hand, it is customary to name children after living relatives, particularly the mother's or father's parents.

A prevalent custom is to give a sick or dying person a new name to confuse and fend off the *Angel of Death.

In modern Israel, many new immigrants "Hebraicize" their Diaspora names to symbolize their rebirth and liberation as Jews in their own land.

[1]Genesis 17:5; 17:15; 32:29; [2]Genesis 22:14; 28:19; [3]Genesis 29:32–35; 30:6–24; [4]Genesis 35:18; [5]Exodus 2:10; [6]*Berakhot* 7b; [7]Nadich, *Jewish Legends of the Second Commonwealth*, 39.

Signifies: ASSIMILATION, BLESSING, CONTINUITY, DESTINY, FAMILY, FREEDOM, JEWISH IDENTITY, JEWISH PRIDE, REBIRTH, REMEMBRANCE, STATUS, TRANSFORMATION

Generic Categories: Birth, Personalities

See also: Angel of Death, *Brit*, Name of God, Priestly Cult; also individual names

NAMES OF GOD — םֵשַה. Pronouncing someone's name is traditionally seen to give the speaker some measure of power over that person. This notion even applies to God: a nameless God is inaccessible; speaking God's name brings the divine closer to earth.

Judaism has coined many names for God over the centuries. At first, Jews borrowed names from their Canaanite and Mesopotamian neighbors: *El* or *El Elyon* ("Most High God," the oldest of these names, ruler and ancestor of the Canaanite pantheon, Creator of the World); *Shaddai* or *El Shaddai* ("Almighty," God of the Mountain, possibly derived from "breast"); *Elohim* (plural of *El*). Unlike their pagan neighbors, however, Jews used these names to designate a single God, even when the name—*Elohim*—was plural.

The holiest name of God, and the one most distinctly Jewish, is the *Four-Letter Name, known as the Tetragrammaton (Greek for "four-letter word") or YHVH (referred to as *Yud-Heh-Vav-Heh*, a transliteration of the word's four consonants). At the *Burning Bush, God was revealed to Moses as *Ehyeh Asher Ehyeh*—"I am who I am" or "I will be who I will be."[1] From this phrase probably derived the name YHVH, a form of the verb "to be." God is thus characterized as "the Being who brings [the world] into being." "*Yah*" is a variant of this name, embodying in its own pronunciation the idea of God as Lifebreath.

Although the Tetragrammaton was originally pronounced by all Israelites, its use was eventually restricted to the *Priestly

Cult. The High Priest pronounced it in the Holy of Holies (the inner sanctum of the *Temple) on *Yom Kippur and the other priests recited it in the *Priestly Blessing.[2] When the Temple was destroyed, even this practice ceased, and the word lost its vocalization. From then on, Jews substituted the names *Adonai* (Lord) and *Elohim* for the Tetragrammaton. Eventually the four consonants of YHVH were vocalized with vowels borrowed from *Adonai*, resulting in the mistaken reading by Christian scholars of YHVH as "Jehovah." In time, out of respect and probably due to a misreading of the Third Commandment (taking God's name in vain, actually a prohibition against swearing false oaths), Jews began substituting *HaShem*, literally "the Name," for the previous substitution of *Adonai*, further strenghtening the taboo against pronouncing the Tetragrammaton. It also became practice not to write down any of the holy names of God (YHVH, *Elohim*, *Adonai*, *Shaddai*) in secular documents, lest one erase or discard them. In more recent times, some Jews have extended this practice even to vernacular translations of the Hebrew names. Documents containing God's Hebrew names are not thrown away, but rather buried out of respect.

The rabbis of the Talmud devised additional divine names, some stressing God's transcendence, others, God's immanence: *Ha-Kadosh Barukh Hu* ("the Holy One Blessed be He," sometimes abbreviated as HKB"H – הקב״ה; *Kudsha Berikh Hu* in Aramaic); *Ribbono Shel Olam* ("Master of the Universe"); *Ha-Makom* ("the Place"); *Ha-Rahaman* ("the Merciful One," derived from *rehem*, womb); *Shekhinah* ("Dwelling Presence," often depicted as God's feminine aspect). They also made reference to twelve- and forty-two-letter names. To the rabbis, the Tetragrammaton referred to God's attribute of Mercy; *Elohim*, to the attribute of Justice.

The *kabbalists further expanded the repertoire of divine names to include *Ein Sof* ("the Infinite" or "Eternal," literally, "without end"); "the Hidden of Hidden" and "Ancient of Ancients" (*Temira de-Temirin*; *Attika de-Attikin*), and the Seventy-Two-Letter Name, a combination of the names of the *Twelve Tribes, the Patriarchs (*Abraham, *Isaac, and *Jacob)

and the Hebrew phrase, *"Shivtei Yisrael"* (the Tribes of Israel). Kabbalistic literature also uses many older names, particularly *Shekhinah* and *Kudsha Berikh Hu*.

Medieval philosophers such as Maimonides, Yehudah Halevi, and Saadiah Gaon, intent on proving the unity of God, insisted that YHVH was the only proper name of God, whereas all the other names referred to God's attributes.

Popular magical practices in the Middle Ages included writing various names of God, especially the forty-two- and seventy-two-letter names (*eighteen times four), on *amulets and *"segullot,"* charms which were believed to have the power to heal, reveal the future, interpret a *dream, or even perform harmful "black magic." *Shaddai* is inscribed on *mezuzot* and *tefillin*, perhaps to enhance their power. In 17th- and 18th-century Eastern Europe, a magician or wonder-worker particularly adept at such charms was called a *Baal Shem* or *Baal Shem Tov,* Master or Owner of the [Holy] (Good) Name. The most famous bearer of such a title was the founder of Hasidism, Israel ben Eliezer, called simply the Baal Shem Tov, or the BeShT.

In modern times, some theologians have stressed God's transcendence by translating YHVH as "Eternal" or "World-Soul." Others, notably Martin Buber and Franz Rosenzweig, have emphasized God's immanence and personal relationship with human beings. In his translation of the Torah, Buber translated *Ehyeh Ahser Ehyeh*: "I again and again stand by those whom I befriend."

In all traditional blessings, God is also called "Ruler of the Universe" (*Melekh ha-Olam*). In the liturgy, especially during the High Holy Days, God is referred to as "Our Father Our King" (*Avinu Malkeinu*) and "Father of Mercy" (*Av Ha-Rahamim*). Contemporary Jewish feminists, unhappy with the generally male, hierarchical references to God within the liturgy, have introduced other names: some, like *Shekhinah*, *Malkah* (Queen), *Rahamima* (Compassionate One), God of *Sarah, *Rebecca, *Rachel, and *Leah, are derived from traditional sources; others, like "Source of Blessing," *Ein Ha-Berakhah* (*Fountain of Blessing), *Ruah Ha-Olam* (Lifebreath or Spirit of the World), *Hai Ha-Olamim* (Life

of the Universe), or "the Eternal One," are new coinages.[3]

[1]Exodus 3:14; [2]*Yoma* 6:2; *Sotah* 7:6; [3]See Marcia Falk, *The Book of Blessings*, for numerous examples of such new names.

Signifies: DIVINE UNITY, GOD, HOLINESS, MAGIC, PATRIARCHY

Generic Categories: Kabbalistic Symbols, Prayer, Women

See also: Amulet, Eighteen, Fountain, Four, Names, Kabbalah, King, *Mezuzah*, Numbers, Queen, *Shekhinah*, *Tefillin*

NER TAMID — נֵר־תָּמִיד.

In the Torah, God commands that the Israelites bring *olive *oil to the *Mishkan* so that *Aaron can set up a *ner tamid*, a continuous or regular *light in front of the *ark.[1] Although most commentators regard this light as synonymous with the *menorah*, it is also possible to interpret the *ner tamid* as a separate light kept burning "from evening until morning before the Lord," symbolic of the divine Presence among the people. It is also said that the *Shekhinah*, God's feminine aspect, is present in the eternal light.

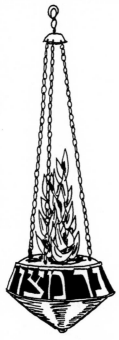

A *ner tamid*, the eternal light in front of an *ark.

After the *Temple was destroyed, Jews began to light a special oil *lamp, first in the western wall of the synagogue, and later above the ark, as a memorial of the Temple *menorah* and a symbol of God's continued presence amid Israel.[2] Nowadays, the oil has been replaced by an electric bulb. The *ner tamid* also symbolizes the eternal faith of the Jewish People.[3]

[1]Exodus 27:20–21; Leviticus 24:2–3; [2]*Shabbat* 22b; [3]*Exodus Rabbah* 36:1.

Signifies: DIVINE PRESENCE, DIVINE PROTECTION, ETERNITY, FAITH, REMEMBRANCE, SPIRITUAL ENLIGHTENMENT

Generic Categories: Ritual Objects, Synagogue, Temple

See also: Ark, Candles, Fire, Lamp, Light, *Menorah*, Oil, *Shekhinah*

NOAH — נֹחַ.

Noah, living *ten generations after *Adam and *Eve and ten before *Abraham and *Sarah, is described in the Bible as "blameless in his generation, [one who] walked with God."[1] The rest of his generation was so corrupt that God resolved to destroy the earth and begin anew. God commanded Noah to build an *ark to save a remnant of living things from the great Flood that was to engulf the world. This vessel served as a lifeboat for Noah's family and the animals they brought with them. After *forty days of *rain followed by months of waiting for the floodwaters to subside, Noah, his family, and the animals returned to dry land to start a new world order. Noah built an *altar and offered sacrifices of thanksgiving; God sent a *rainbow as a sign that never again would the earth be destroyed by *water.[2]

After the Flood, God gave Noah seven universal ethical principles which have become known as the Noahide Laws. These include prohibitions against idolatry, bloodshed, sexual sins, theft, eating from a living animal, blasphemy, and the obligation to establish a legal system.[3] According to some of the rabbis, Noah was a thoroughly righteous man, a true prophet showing compassion to his neighbors and to animals; to others, his virtue was relative — he was righteous only "in his generation."[4]

The *midrash* credits Noah with having introduced technology — plows, sickles, axes, and other tools — to humankind.[5] Noah is also regarded as the first vintner.[6] The Torah portion including this story is read during the fall grape harvest.

Noah's sons were Ham, Shem, and Japhet. According to the Bible (Genesis,

chapter 10), Ham was the ancestor of the-Canaanites; Shem, of the Semites; Japhet, of the Greeks.

[1]Genesis 6:9; [2]Genesis 9:12-17; [3]*Sanhedrin* 56-60; [4]*Tanhuma Noah* 5; *Sanhedrin* 108a-b; [5]*Tanhuma Bereishit* 11; [6]Genesis 9:20.

Signifies: COMPASSION, RIGHTEOUS-NESS, SURVIVAL, TECHNOLOGY, UNIVERSAL ETHICS, VINICULTURE

Generic Categories: Personalities

See also: Ark (Noah's), Dove, Grapes, Greece, Olive, Rainbow, Seven

NUMBERS – מִסְפָּרִים.

Reflecting ancient world views and beliefs, biblical numbers designate much more than quantity or sequence. They symbolize completeness, perfection, power, and holiness; function as an aid to memory; and structurally unify a particular passage or text. Certain numbers – *one, two, *three, *four, *five, *seven, eight (symbolic of infinity or eternity because it is one more than the days of creation, or symbolic of Israel because the Jewish People represents a new creation after the completion of the natural world[1]), *ten, twelve (sons of *Jacob and *Tribes of Israel), twenty-two (letters of Hebrew *alephbet), *forty, *seventy, a thousand – carry symbolic significance as well as numerical value. Rabbinic and kabbalistic commentators, inspired by the biblical model, based much of their interpretative and theological traditions upon numerology.

The most well known interpretive system based on numbers, adopted from the Greeks during the Second Temple Period, is *gematria*, derived either from the Greek word *geometria* (geometry) or from *gamma tria* (the third letter equals three). In this system, two words are equated because their letters, each of which has an assigned value, are numerically equivalent. Although originally valued primarily for mnemonic purposes, *gematria* eventually became a major basis for Jewish teaching, demonstrating the interconnectedness of Jewish texts and the providential design in history. Books of *gematriot*, providing calculations of key Hebrew words and phrases, are still popular. For example,

gematria has given the number *eighteen significance because it is the sum of the letters in the word *hai*, meaning life.

In kabbalistic literature and theology, *gematria* has played a vital role, especially among the *hasidei Ashkenaz* of Germany (12th-13th centuries), Abraham Abulafia and his circle (13th-14th centuries), Lurianic Kabbalah (16th century), and hasidic masters (18th-19th centuries). Although *gematriot* were often used merely to validate a concept, they were also employed in mystical meditation as a path to esoteric knowledge or experience. This was especially true of *gematria* based on the names of God and the *angels.

Besides the primary system of assigning numerical values to Hebrew letters, *gematria* also includes eight other methods of alphabetic permutation, usually involving substitutions and complicated arithmetic calculations.[2]

According to the Talmud, odd numbers are lucky; even numbers unlucky. Pairs invite demonic attack. There were even rabbinic arguments about the advisability about drinking *four cups of *wine at the *Passover *seder*, but it was decided that Passover's status as "a night of protection" would ward off the evil effect of the even number. (Sick people were encouraged to drink a fifth cup nonetheless.[3]) It is also considered unlucky to number people, such as when counting for a *minyan*. Instead, a biblical verse of ten words is usually recited to count heads.

During World War II, numbers took on an especially sinister meaning for Jews whose forearms were etched with numbers by the Nazis, when these Jews were interred in concentration camps. These numbers became symbols of their dehumanization. Because of such highly charged symbolism associated with numbers drawn on human arms, Israeli teams who rescued most of Ethiopian Jewry during Operation Exodus kept track of the thousands of people during the hasty airlift to Israel by attaching numbers to the Ethiopians' foreheads, removing the numbers soon after their planes landed in Israel.

[1]Hirsch, "A Basic Outline of Jewish Symbolism" in *Timeless Torah*, ed. Jacob Breuer, 410-411; [2]See "Gematria" in *Encyclopaedia Judaica*; [3]Trachtenberg, *Jewish Magic and Superstition*, 118; see also *Pesahim* 109b.

Signifies: BAD LUCK, COMPLETION, CONNECTION, DANGER, DEATH, DEHUMANIZATION, DIVINE PROTECTION, DIVINE PROVIDENCE, GOOD LUCK, HOLINESS, PERFECTION, POWER, UNITY

Generic Categories: Numbers

See also: *Alephbet*, Auschwitz, Eighteen, Five, Forty, Four, *Hamsa*, Name of God, One, Seven, Seventy, Six Hundred and Thirteen, Six Million, Thirteen, Three, Ten, Twelve Tribes

NUT — אֱגוֹז. The generic Hebrew word for nut — *egoz* — appears only once in the Bible: "I went down to the nut grove to see the budding of the vale."[1] Like the vines and *pomegranates in the same verse, the nut symbolizes fertility and sexuality. Indeed, one legend claims that the *Tree of Knowledge, which first aroused sexual desire in Adam and Eve, was a nut tree.[2]

Kabbalists interpret this biblical nut grove as referring to God in exile, whose *Torah is hidden from plain view by the "shells" of the visible words.[3] Only by husking these linguistic shells can one derive the innermost kernel of God's word. Nuts are among the symbolic foods eaten at the *Tu B'Shevat *seder*, representing one of the worlds of divine emanation.

It is customary to refrain from eating nuts during the High Holy Days because the *gematria* (numerical equivalence) of "sin" (חטא) equals *egoz* + 1 (added for the word as a whole).

Nuts also symbolize new life. On *Passover, the season of national and natural rebirth, children are often given nuts to play with and eat. Nuts are a main ingredient of *haroset*. *Dreidl* games are also played for nuts.

[1]Song of Songs 6:11; [2]Ginzberg, *Legends of the Jews* 5:97-98; [3]*Tikkunei Zohar*, 24, 68a-b.

Signifies: JEWISH PEOPLE, LIFE, REBIRTH, SIN, TORAH

Generic Categories: Botany, Food, Hanukkah, Passover, Rosh Hashanah, Tu B'Shevat, Trees

See also: *Dreidl*, *Haroset*, Hanukkah, Kabbalah, Numbers, *Pardes*, Passover, Rosh Hashanah, Tu B'Shevat

OIL — שֶׁמֶן. In ancient Israel, oil, primarily made from pressed *olives, was considered one of the three necessities of life together with food and clothing. It was used as a food, cosmetic, fuel, and medicine, as well as an export item. Costly perfumed oil symbolized wealth.[1] Within the ceremonial life of the people, oil played a central role in sacrifices and coronations. Oil is one of the blessings God promises as a reward for faithfulness.[2]

Because of its value and centrality, oil symbolized honor, joy, and favor.[3] Thus, the dead were not anointed with oil, nor was oil used in sacrifices associated with sin or shame. But sacrifices offered on joyous occasions — holy days, the completion of a Nazirite vow, moments of thanksgiving, military victories, cessation of famine, priestly ceremonies — were supplemented by a meal offering (*Minhah*), consisting of a mixture of fine flour, oil, and frankincense.

Oil was also a symbol of life, which was probably why the leper was anointed with oil when he was welcomed back into the community.

Throughout the ancient Near East, anointing with oil indicated a change in status. Israelite priests, prophets, and *kings were consecrated in this manner, as were holy places such as the site of *Jacob's *dream and the *Mishkan*.[4] Eventually, the word "anointed" — *mashiah* — became synonymous with Messiah, the anointed one, descendant of the royal house of *David.

Olive oil is one of the *seven species representing the fruitfulness of the Land of Israel.

As the original source of *light in the *Temple *menorah*, the *Shabbat *lamp, the *ner tamid* (eternal light), and the *Hanukkah *menorah*, oil symbolizes the divine spirit which dwells among the Jewish People.

It is traditional to eat foods fried in oil for Hanukkah, because of the miracle of the oil so central to this holiday.

[1]Judges 9:8-9; [2]Deuteronomy 11:14; Psalm 45:8; Deuteronomy 33:24; Psalm 23:5; [3]1 Chronicles 9:29; 27:28; 2 Kings 20:13; Isaiah 39:2; [4]Leviticus 8:12, 30; 1 Kings 19:16; 1 Samuel 16:13; Genesis 28:18; Leviticus 8:10.

Signifies: BLESSING, DIVINE SPIRIT, FAVOR, FERTILITY, HOLINESS, HONOR, JOY, REDEMPTION, STATUS, WEALTH

Generic Categories: Food, Hanukkah, Israel (Land of), Messiah, *Shabbat*

See also: Candles, Hanukkah, Lamp, Light, Menorah, *Ner Tamid*, Olive, Seven Species

OLIVE – זַיִת. Olive trees were and still are among the most valued *trees in the Middle East. The *oil of this tree's fruit was grouped among the *seven species characterizing the beauty and bounty of the Land of Israel.[1] Olive oil was a mainstay of the Israelite diet and household economy, of commerce, and of *Temple and palace ceremonies.

Because of its potential to live over 1,000 years and still bear fruit, the olive tree has long symbolized longevity and immortality. It propagates by putting out shoots, ensuring its continued survival even as its main trunk becomes hollow. The Psalms compare children to "olive shoots around your table," a symbol of continuity through offspring.[2] Based on this verse, olive branches have been a popular image in *ketubot* (marriage documents). It is also an evergreen, and can flourish in rocky areas.

The olive, OLEA EUROPA.

In the story of the Flood, an olive leaf brought back to the *ark by the *dove proved to *Noah that dry land had once more appeared.[3] Legend claims that this olive branch came from the *Mount of Olives, since *Jerusalem was untouched by the Flood.[4] The image of a *white dove bearing an olive branch in her mouth has become a universal symbol of peace.

The phrase – *ke-zayit*, "[as large] as an olive," signifies a minimum quantity necessary to fulfill certain ritual obligations.

In some Sephardi communities, it is customary for the groom to wear an olive wreath at his *wedding to symbolize mourning for the destroyed Temple, since olives have a bitter taste. It may also symbolize the wish for "*shalom bayit,*" peace in the household.

As one of the seven species representing the Land of Israel, olives are traditionally eaten on the holiday of *Tu B'Shevat, which celebrates the reawakening of agricultural life in Israel after winter dormancy.

[1]Deuteronomy 8:8; [2]Psalm 128:3; [3]Genesis 8:11; [4]Ginzberg, *Legends of the Jews* 1:164.

Signifies: BEAUTY, CONTINUITY, FERTILITY, IMMORTALITY, LONGEVITY, MINIMUM, MOURNING, PEACE

Generic Categories: Botany, Food, Israel (Land of), Trees, Tu B'Shevat, Wedding

See also: Dove, Israel (Land of), *Ketubah*, Mountain, Oil, Seven Species, Tree, Tu B'Shevat, Wedding

OMER – סְפִירַת־הָעֹמֶר. From the second day of *Passover until the festival of *Shavuot, Jews count *seven weeks – seven times seven days – to commemorate the period between the *Exodus from *Egypt and the Revelation at *Sinai. This process of counting is known as *sefirat ha-omer*, the counting of the *omer*, recalling the ancient practice of bringing a sheaf (*omer*) of newly harvested *barley, the first ripening grain, to the *Temple as an offering on Passover.[1] The *omer* period was a time of great vulnerability, since the people's sustenance depended upon the ripening of the grain. This period also marks the spiritual ripening of the Jewish People as they prepare to receive the *Torah at Shavuot.

Each of the *seven species emblematic of Israel's fertility enters a critical growth phase during the *omer* period: *olives, *grapes, *pomegranates, and dates come into flower; *figs begin to develop; and *wheat and barley kernels fill with starch. Their survival depends upon a balance of north and south winds. It is during this vulnerable period that the fate of Israel's harvest is determined. Shavuot celebrates God's blessing and protection of the land and its fruit.

In time, this seven-week period became known as the "*Sefirah*" (counting) or the *Omer*, observed by reciting a special blessing and marking off each day. Special

omer charts, often embellished with folk art motifs, were developed to keep track of the counting. Psalm 67, which has seven seven-word phrases, is traditionally recited when the *omer* is counted each day.

Kabbalists regard these forty-nine days as an ascent from the *gates of Egyptian impurity to the purity of Revelation.

The *Omer* period is observed as a time of semi-mourning, with restrictions placed upon playing music, cutting *hair, and celebrating *weddings. These customs probably originally reflected the general anxiety experienced by the Israelite community during the vulnerable weeks before the harvest. However, several days—*Lag B'Omer, Israel Independence Day, and *Rosh Hodesh—are exempted from these restrictions.

[1]Leviticus 23:9-16; *Menahot* 65.

Signifies: ANXIETY, ASCENT, MOURNING, REMEMBRANCE, SPIRITUAL FULFILLMENT, TRANSITION, VULNERABILITY

Generic Categories: Passover, Shavuot

See also: Barley, Gates, Kabbalah, Lag B'Omer, Numbers, Passover, Seven, Seven Species, Shavuot

ONE — אֶחָד.

One symbolizes wholeness, uniqueness, and indivisibility, all attributes of God. God's oneness is the cornerstone of Jewish monotheism, expressed in the central affirmation of faith: *Shema Yisrael Adonai Eloheinu Adonai Ehad*, "Hear O Israel, YHVH is our God, YHVH is one."[1] Commentators have pointed out that *ehad* here means both "unique" as well as "unitary." The *gematria* (numerical equivalence) of "*ehad*" equals *thirteen, the traditional number of divine attributes.

One is also a symbol of marriage, two beings joined as one. The Bible states: "Therefore a man leaves his father and mother and clings to his wife, so that they become one flesh."[2] *Ketubot* celebrating *weddings on the first day of the week (Saturday night or Sunday) begin *be-ehad*, a word play meaning both "on the first [day]" as well as "in one." After the wedding ceremony, the newly married couple is left alone, a custom called *yihud* (solitude), a time originally set aside for the con-

summation of the marriage. Nowadays, couples use this moment to break their fast and regain their composure before the festivities.

As part of their mystical practice, kabbalists perform *yihudim*, special meditations on the unity of God, designed to bring them closer to God.

[1]Deuteronomy 6:4; [2]Genesis 2:24.

Signifies: GOD, MARRIAGE, UNIQUENESS, UNITY, WHOLENESS

Generic Categories: Numbers, Kabbalistic Symbols

See also: Kabbalah, *Ketubah*, Names of God, Numbers, Thirteen, Wedding

PALACE — הֵיכָל.

In the Bible, a palace, *heikhal*, is the abode of the divine as well as of earthly *kings.[1] God's Palace is the seat of divine glory and power. The Holy *Temple in *Jerusalem, where God's Presence dwelled on earth, was sometimes called the *Heikhal*, Hebrew for palace.

In the 1st century of the common era, a mystical movement known as the *Heikhalot* (Palaces or Chambers) School attracted many prominent talmudic sages, who engaged in esoteric practices of meditation and spiritual exploration. The mystical methods taught by this school involved "descending" contemplatively through *seven heavenly chambers, *gates, and palaces to reach the divine *Chariot and a vision of the *Throne of Glory. Those who practiced these methods were called "*yordei merkavah*," those descending in the chariot.

Among *hasidim*, the image of God and the Divine Palace became dominant symbols. In countless parables about the *king, his children, and their exile from and return to the palace, hasidic masters reassured their followers about God's mercy, forgiveness, and love of the people. Although God is presented as the Supreme King, the palace symbolizes divine accessibility and protection. A popular psalm in the liturgy declares: "One thing I ask of the Lord, only that do I seek: to live in the house of the Lord all the days of my life, to gaze upon the beauty of the Lord, to frequent God's Palace."[2]

[1]1 Chronicles 29:1; [2]Psalm 27:4.

Signifies: ACCESS TO THE DIVINE, DIVINE ABODE, DIVINE GLORY, DIVINE PROTECTION

Generic Categories: Dwellings, Kabbalistic Symbols, Temple

See also: Chariot, Gates, Kabbalah, King, Throne

PALM TREE—תָּמָר. The graceful date palm has always been central to the economy and culture of the Middle East. In

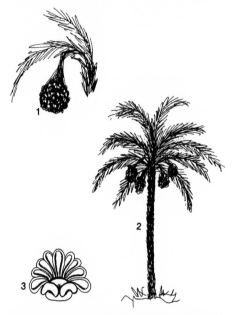

The date palm, PHOENIX DACTYLIFERA. 1. A cluster of dates. 2. The graceful, evergreen date palm. 3. The palmetto, a popular ornamental design in the ancient world, based on the palm tree's growing pattern.

ancient times, date trees covered large areas of Palestine. The Bible includes date *honey as one of the *seven species emblematic of Israel's agricultural fertility.[1] It is this date syrup that is meant in the biblical phrase: "a land flowing with *milk and honey."[2] In ancient Israel, dates were an important export item as well as a prized delicacy, as they still are today. Date palm *wine was made from this fruit as well. The wood and leaves were used in religious ritual, construction, and domestic crafts. Palm branches were carried in victory processions.

Because of its tall, shapely form, the palm has long been a popular motif in art and literature. Palm designs were used in the *Temple and ancient *synagogues. In the rabbinic period, physicians used the palm branch as their insignia. The Maccabees chose the palm as their victory symbol.[3] When the *Romans conquered Israel, their coins represented the subjugated Jews—"Judea capta"—as a woman mourning beneath a palm tree.

In biblical poetry, palms symbolize beauty, grace, and fruitfulness. The psalmist compares the righteous person to a flourishing palm,[4] as does the lover his beloved in the Song of Songs.[5] A number of biblical women were named "Tamar," including the daughter-in-law of *Judah, as well as the daughters of *David and Absalom.

In Jewish religious life, the palm figures most prominently during the festival of *Sukkot, when the unopened palm branch, known as the *lulav, forms part of the *four species carried in procession at synagogue and waved ritually in the home *sukkah. Jews are compared to each of the *four species: the date, having taste but no fragrance, symbolizes the person with only learning but no deeds to his or her credit.[6]

Because all parts of the palm tree are useful—the dates for food, the branches for religious ceremony, the leaves and wood for construction—the rabbis compared the Jewish People to the palm tree, maintaining that "none are worthless in Israel."[7]

As one of the seven species representing the land of Israel, dates are traditionally eaten on the holiday of *Tu B'Shevat, which celebrates the reawakening of agricultural life in Israel after winter dormancy.

[1]Deuteronomy 8:8; [2]Exodus 3:8; [3]1 Maccabees 13:51; [4] Psalm 92:13; [5]Song of Songs 7:8; [6]Leviticus Rabbah 30:12; [7]Genesis Rabbah 41:1.

Signifies: BEAUTY, FERTILITY, GRACE, HEALING, JEWISH PEOPLE, RIGHTEOUSNESS, VICTORY

Generic Categories: Botany, Food, Israel (Land of), Sukkot, Trees, Tu B'Shevat, Women

See also: Four Species, Honey, Israel (Land of), Jakhin and Boaz, Lulav, Seven Species, Sukkot, Tree, Tu B'Shevat

PARDES – פַּרְדֵּס. In the Bible, the word "*pardes*," derived from a Persian root, simply means "park" or "garden." In the New Testament, *pardes*, in its Greek form "paradise," came to mean the heavenly place where the righteous receive their reward after death. This meaning eventually found its way into rabbinic texts as well. Paradise, together with the Garden of *Eden and the World to Come, are usually interchangeable as references to the afterlife enjoyed by the righteous. The biblical phrase, "Garden of the Lord," likewise refers to an ideal realm characterized by extraordinary fertility and blessing.[1]

The rabbis also used "*pardes*" to symbolize the realm of mystical knowledge, that is, the study of *Kabbalah. In a famous talmudic passage, they speak of the *four [sages] who entered *Pardes*: "Ben Azzai gazed upon the *Shekhinah* and died. Ben Zoma gazed and went mad. The Other One [Elisha ben Abuya] betrayed his faith [cut down shoots] and went astray. But Akiva entered in peace and departed in peace."[2] Kabbalists continued to use "*pardes*" in this mystical sense.

In the Middle Ages, "*pardes*" became an acronym for the four levels of interpretation of sacred texts: P = *peshat*, the literal meaning; R = *remez*, the implied meaning; D = *derash*, the homiletic meaning; S = *sod*, the mystical or allegorical meaning.

[1]Genesis 13:10; Isaiah 51:3; Ezekiel 36:35; [2]*Hagigah* 14b.

Signifies: AFTERLIFE, HEAVEN, LEARNING, MYSTERY, MYSTICISM, PEACE, PERFECTION

Generic Categories: Kabbalistic Symbols

See also: Eden, Kabbalah, Palace

PAROKHET – פָּרֹכֶת. In the *Mishkan*, the portable sanctuary in the *wilderness, as well as in its successor, the Holy *Temple in *Jerusalem, the area known as the Holy of Holies, which contained the *ark of the covenant housing the *Ten Commandments, was separated from the more public ritual areas by a veil called the *parokhet*. The Torah explains that this curtain, embroidered with images of the sacred *cherubim, was to serve as a "partition between the Holy and the Holy of

Holies,"[1] that is, a transition between sacred and profane spaces. It was behind the *parokhet* that the High Priest encountered God in holy mystery.

After the destruction of the Temple, the original *parokhet* was replaced by a curtain covering the ark in each *synagogue. In Sephardi congregations, the *parokhet* hangs behind the ark doors; in Ashkenazi congregations, it hangs in front of or behind them. The *parokhet* is usually made of precious material, and ornately embroidered with biblical or holiday scenes, symbols, and biblical verses. For holidays, especially the High Holy Days, the colored *parokhet* is usually replaced with a *white one.

In the 18th century, it became customary to add above the *parokhet* a valance called a "*kapporet*" after the biblical original.[2] This upper curtain was often embroidered with symbols of the ancient Temple such as cherubim, the Ten Commandments, the *menorah*, the golden *altar, or three *crowns representing *Torah, the *priesthood, and royalty.[3]

[1]Exodus 26:33; [2]Exodus 25:17-22; [3]*Pirke Avot* 4:17.

Signifies: BOUNDARIES, MYSTERY, TRANSITION

Generic Categories: Ritual Objects, Synagogue, Temple

See also: Ark, Cherubim, Gates, *Mishkan*, Portal, Synagogue, Temple, Torah, White

PASSOVER – פֶּסַח. The festival of Passover commemorates the Jewish People's redemption from slavery and *Exodus from *Egypt. It also celebrates the spring *wheat and *barley harvest in Israel. Its name derives from the biblical episode of the Tenth Plague when God "passed over"—*pasah*—the homes of the Israelites, only slaying the firstborn of Egypt.[1] Because of its historical and agricultural associations, Passover has two additional names: *Hag Ha-Aviv* (the Holiday of Spring) and *Zeman Heruteinu* (the Season of Our Liberation), which share in common the symbolism of hope and rebirth. It is also called *Hag Ha-Matzot* (the Holiday of Unleavened Bread) in honor of the principal symbolic food of this festival. Pass-

over is one of three pilgrimage festivals (with *Shavuot and *Sukkot), during which Jews in ancient times gathered together in *Jerusalem.

The Torah calls the month of *Nisan*, during which Passover falls, "the first of the months of the year,"[2] because it marks the anniversary of Jewish nationhood and the beginning of the agricultural year. (*Rosh Hashanah is the liturgical New Year.) Besides the special prayers recited in *synagogue during this eight-day holiday (seven days in Israel and among Reform and Reconstructionist Jews), Passover is celebrated in Jewish homes with an evening *seder*, an elaborate festival meal filled with many rituals, symbolic foods, songs, discussion, and prayers. A special book called the *Haggadah* provides the "script" for the ceremony. It is traditional for the *seder* leader to wear a *white garment called a *kittel*. It is also traditional to extend hospitality to those in need at this meal.

Among the special foods central to the *seder* ceremony are *matzah*, unleavened bread, symbolic of freedom and slavery as well as humility; *maror*, bitter herbs, symbolic of the bitterness of Egyptian slavery; *haroset*, a paste of fruits, *nuts, and *wine, symbolic of the mortar made by the Hebrew slaves; the *afikoman*, a broken piece of *matzah* which serves as the final course, symbolic of incomplete redemption; and *four *cups of wine, symbolizing God's four redemptive acts during the Exodus. The paschal sacrifice, no longer performed (except by the Samaritans in Israel), is represented symbolically by a roasted shankbone.

Perhaps more than any other Jewish holiday, Passover requires extraordinary expenditures of time, energy, and material resources. Because all foods that contain *hametz* (leaven) are forbidden during the entire holiday, preparations for Passover involve thorough housecleaning, elaborate kitchen arrangements, and the purchase of special foods. Yet despite — or perhaps because of — its considerable demands, the *seder* continues to be the principal home ritual of the Jewish festival *calendar, serving as a unifying link among Jewish families as well as a symbol of continuity with past and future generations. It symbolizes the constant cycles of Jewish and universal history: from winter to spring, from slavery to freedom, from death to life. It also embodies the ideas of spiritual and political freedom, redemption, and resistance so central to Jewish tradition.

[1]Exodus 12:27; [2]Exodus 12:2.

Signifies: CONTINUITY, FAMILY, FREEDOM, HOPE, HOSPITALITY, JEWISH PEOPLE, LIBERATION, PURIFICATION, REBIRTH, REDEMPTION, RENEWAL, RESISTANCE, SPRING

Generic Categories: Food, Messiah, Passover, Prayer

See also: *Afikoman*, Calendar, Cup, Egg, Egypt, Elijah, Exodus, Four, Goat, *Had Gadya*, *Haggadah*, *Hametz*, *Haroset*, *Kittel*, *Maror*, *Matzah*, Moses, Pharaoh, *Seder*, Sheep, Shifra and Puah, Three, Wine

PHARAOH – פַּרְעֹה.

Like the famous Pharoahs who oppressed the Israelites during their long years of bondage, the Pharaoh of *Egypt has always epitomized Israel's enemy. Each year at the *Passover *seder*, Pharaoh plays out his familiar role as archetypal villain in the story of the *Exodus as set forth in the *Haggadah*.

In the Book of Genesis, Pharaoh first appears as a seducer, when he tries to sleep with *Abraham's "sister," *Sarah.[1] A later Pharaoh under whom Abraham's great-grandson *Joseph served is a much more positive figure, elevating Joseph to Vizier, and welcoming *Jacob and his family to Egypt, where they thrived until a new Pharaoh arose "who did not know Joseph," and enslaved their descendants.[2] But even this benevolent Pharaoh of Joseph's time was later turned into a villain by Jewish tradition, reflecting contemporary political realities in Hellenized Egypt.[3] Throughout Jewish history, Pharaoh has served as an archetype of subsequent oppressors of the Jewish People.

However, there were other voices in the tradition that softened this negative image of Pharaoh. One legend claims that Pharaoh did not drown in the Red Sea with the rest of the Egyptian army but became the king of Nineveh who later led his city to

repentance in response to *Jonah's prophecy.[4]

[1]Genesis 12:10–20; [2]Exodus 1:8; [3]*Sotah* 11a; [4]*Pirke de-Rebbe Eliezer* 43.

Signifies: ENEMY, OPPRESSION, SEDUCTION

Generic Categories: Passover, Personalities

See also: Egypt, Exodus, *Haggadah*, Jonah, King, Passover, *Seder*

PINE – אֹרֶן.

In biblical times, the pine *tree was known as the *etz shemen* – "*oil tree" – because of its high turpentine content. It was valued for its evergreen beauty, rapid growth, and abundant shade. It was used to fashion the doors and *cherubim in the Holy *Temple, to burn the sacrifices on the *altar, and to light the beacon *fires announcing the New *Moon. Its boughs were also used, as they still are today in North America and other temperate zones, to cover the roof of the *sukkah.[1]

In prior times, when a baby girl was born, it was customary in some communities to plant a pine tree (or *cypress or other evergreen), and to cut branches from this tree for her *huppah (marriage canopy). One of the Hebrew words for pine, "tirzah," is popular today as a girl's name.

When a Jew dies, it is customary to bury him or her in a simple pine coffin, the most inexpensive of woods, symbolizing the essential equality of all creatures in God's eyes.

[1]Nehemiah 8:15.

Signifies: BEAUTY, EQUALITY, FEMININE, HUMILITY, SIMPLICITY

Generic Categories: Botany, Death, Trees, Wedding, Women

See also: Cedar, Cypress, *Huppah*, Moon, Tree, Wedding

POMEGRANATE – רִמּוֹן.

The pomegranate is notable for its beautiful *red flowers, shapely fruit, sweet flavor, and prodigious *number of seeds. In the Bible, the pomegranate is mentioned as one of the *seven species emblematic of Israel's agricultural fertility.[1] When the Israelite spies surveyed Canaan, they brought back pomegranates to *Moses as proof of the land's abundance.[2] In the Song of Songs, the pomegranate figures prominently in the imagery of love and sensuality, and its color is associated with *fire and passion.[3]

Because of its decorative form, this fruit has long been a popular motif in Jewish art. Bells shaped like pomegranates, together with lily designs, adorned the capitals of the *Temple columns as well as the hem of the High Priest's robe, which added sound to the priestly rituals as well as dispelling demons.[4] *Solomon's coronet was modeled on the pomegranate's *crown. The pomegranate was also used widely in ancient coins. The modern State of Israel has likewise used this motif in its own coins and stamps.

According to the *midrash*, there are exactly *613 seeds within a pomegranate, corresponding to the number of *mitzvot* prescribed in the Torah. Israel is compared to a pomegranate, as full of good deeds as this fruit is of seeds. Good students are said to model their study habits upon the pomegranate, eating only the good fruit, but discarding the bitter peel.[5]

The pomegranate has become associated with *Rosh Hashanah, the New Year, because it is abundantly available in the market at this season, and because its shape, topped by a "crown," exemplifies the kingship theme central to the holiday. During this period of atonement, each Jew wishes that "my merits be as numerous as its seeds."

The pomegranate, PUMICA GRANATUM.

As one of the seven species representing the Land of Israel, pomegranates are traditionally eaten on the holiday of *Tu B'Shevat, which celebrates the reawakening of agricultural life in Israel after winter dormancy.

In the early Middle Ages, it was customary to decorate the tops of the two wooden *Torah staves or rollers (called *atzei hayyim*, the *trees of life) with ornamental designs. Eventually these ornaments became removable and more elaborate. The earliest examples were shaped like fruit, especially pomegranates, in imitation of the

Temple columns and the bells of the High Priest's robe. In time, the Hebrew word for pomegranates — *rimonnim* — became the generic term for the decorative metal ornaments crowning the Torah rollers. Even though these ornaments were fashioned in a variety of architectural and botanical shapes, most commonly *towers (probably inspired by church bell towers), they continued to be called "*rimmonim*," in memory of their earliest forms.

Rimmonim, generally made of silver, have assumed many shapes throughout the centuries, reflecting the inventiveness, artistic traditions, and pocketbooks of their various communities: *apples (*tappuhim*, the generic name for such ornaments in Spain); Moorish arches (15th-century Sicily); three-tiered steeples or bouquets of *flowers (17th–18th-century Italy); three-storied hexagonal turrets (18th-century Frankfurt-am-Main); baroque turrets (Holland); towers of *three bulbous sections of diminishing size, topped with a crown (18th-century England); cones topped with spheres (20th-century America).

In 15th-century Camarata, Sicily, it became the custom to attach small bells to the square towers of the *rimmonim*. This custom soon spread throughout

Rimmonim, silver decorations placed on the wooden stave handles of the Torah.

Europe and is still popular. The music made by the bells symbolizes the joy of the Torah and serves as a memorial of the ancient priesthood, as well as adding sound to the processional's sensorial display.

[1]Deuteronomy 8:8; [2]Numbers 13:23; [3]Song of Songs 4:3, 13; 6:7, 11; 8:2; [4]Exodus 28:34–35; Jeremiah 52:22; [5]*Hagigah* 15b.

Signifies: BEAUTY, FERTILITY, JOY, LOVE, MITZVOT, PASSION, PRIESTHOOD, REMEMBRANCE, SENSUALITY, STUDY, TORAH

Generic Categories: Botany, Israel (Land of), Ritual Objects, Synagogue, Temple, Tu B'Shevat

See also: Apple, Crown, Jakhin and Boaz, Israel (Land of), King, Number, Priestly Cult, Red, Rosh Hashanah, Seven Species, Six Hundred and Thirteen, Torah, Tower, Tree, Tu B'Shevat

PORTAL. In ancient Near Eastern and Oriental religions, a doorway or *gate within a temple symbolized the entrance to the divine realm, the transition between sacred and profane space. Sometimes the portal was a single doorway; other times, a double one. Often it was flanked by columns, whose upright forms symbolized the pillars of heaven. In these ancient conceptions of the cosmos, the gods' abode was often pictured as a great *palace with imposing *gates. The space delimited by the entry was holy ground.

Early Jewish cosmology reflects similar ideas. When *Jacob awoke from his *dream of the heavenly *ladder, he declared: "How awesome is this place! This is none other than the abode of God, and that is the gateway to heaven."[1] The psalmist praised God for opening "the doors of heaven and rain[ing] *manna upon [Israel] for food."[2] The Holy *Temple in *Jerusalem symbolized these notions with its numerous gates into the spaces within its structure. Worshipers moved from the outer walls surrounding the Temple Mount toward the sacred Holy of Holies demarcated by the *parokhet* curtain.

After the destruction of the Temple, *synagogues imitated these portals both in their outer architecture as well as in the *ark, which commonly has double doors, often flanked by replicas of the Temple columns called *Jakhin and Boaz. Occasionally, portals appear in the design of *parokhet* curtains as well. In many Sephardi synagogues, the *bimah* is flanked by a pair or several pairs of gates. Ancient tombs often included portals symbolizing the entrance to "*Olam Ha-Ba*," the World to Come. In Europe, the title pages of published Hebrew *books were often framed by portal designs.

As the Israelites prepared to leave *Egypt, God commanded them to smear *blood from the paschal sacrifice on their lintels as a signal to the *Angel of Death to "pass over" their homes when striking down the firstborn of Egypt.[3] After the Exodus,

they were commanded to affix a *mezuzah to their "doorposts and upon their gates" as a reminder of their allegiance to God.[4] Both the blood and *mezuzah* mark the boundary between divinely protected space and the unprotected public domain.

The *huppah (wedding canopy) resembles a gateway, perhaps symbolizing the bridal couple's entrance into the holy covenant of marriage. The *huppah* also symbolizes the shelter of their new home and an emotional, physical, and spiritual transition in their lives. *Ketubot often reflect this metaphor, framing the wedding contract within an archway.

In the 20th century, Ellis Island, the processing center for new immigrants to the United States, became the portal to freedom for millions of Jewish immigrants fleeing persecution and poverty in the Old World.

[1]Genesis 28:17; [2]Psalm 78:23; [3]Exodus 12:13; [4]Deuteronomy 6:9.

Signifies: BOUNDARIES, DIVINE PROTECTION, FREEDOM, HEAVEN, HOLINESS, SHELTER, TRANSITION, WORLD TO COME

Generic Categories: Death, Dwellings, Synagogue, Temple, Wedding

See also: Ark, Gates, *Huppah*, Jakhin and Boaz, *Ketubah*, *Mezuzah*, *Parokhet*, Rosh Hashanah

PRIESTLY BLESSING – בִּרְכַּת כֹּהֲנִים.

According to the Torah, when the *Kohanim*, members of the priestly class, invoke God's name, God will bless the people.[1] The biblical text provides a formula for such an invocation, which came to be known as *Birkat Kohanim*, the Priestly Blessing:

> May YHVH bless you and keep you!
> May YHVH deal kindly and graciously with you!
> May YHVH bestow divine favor upon you and grant you peace![2]

This structure, consisting of three verses, may have been typical of ancient incantations. The fact that the verses contain *three, *five, and *seven Hebrew words, respectively, reinforces this speculation.

When the *Temple still stood, the priests would recite this benediction every morning and evening upon the "*duhan*," a special raised platform. Placing their *tallit over their heads and spreading out their fingers in a special fanlike gesture, they would pronounce these fifteen words, including the threefold mention of the Tetragrammaton, the *Name of God. During the Second Temple period, priests in *synagogues outside the Temple would also recite the Priestly Blessing, substituting "*Adonai*" for the sacred name. After the destruction of the Second Temple, the *Birkat Kohanim* became the last significant remnant of the *Priestly Cult, recited on holy days in the Diaspora, on *Shabbat and holy days in Israel, and every day in *Jerusalem. It is also recited at circumcisions and *weddings. Parents recite this blessing over their children on *Shabbat* eve. Over time, this ritual acquired magical potency in the minds of the people, who granted it the power to countermand bad dreams. Some Jews consider it bad luck, even dangerous, to look at the *Kohanim* when they are performing the ritual, called in Yiddish *duhanen*, after the ancient platform. According to one tradition, the *Shekhinah,

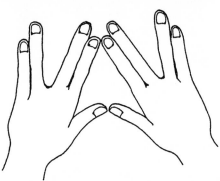

Hand position for the Priestly Blessing.

God's feminine aspect, shines through the *Kohen*'s fingers when the words of the blessing are pronounced.

In the Middle Ages, Jewish mystics derived from the first line of the Priestly Blessing the divine "Name of Twenty-two" (the number of letters in the Hebrew *alephbet), which was frequently used in magic: "*Anaktam Pastam Paspasim Dio Nisim*."[3]

Throughout the centuries, the image of two *hands joined at the thumbs and spread into a fan resembling the Hebrew

letter *"shin"* (or two of these letters) has been the symbol of priestly status, often found on the tombstones of descendants of the priestly tribe of *Kohanim*, bearing such names as Cohen, Cohn, Cowan, Kohn, Kagan, Kahn, or Katz (*Kohen Tzedek*).

[1]Numbers 6:27; [2]Numbers 6:24-26; [3]Trachtenberg, *Jewish Magic and Superstition*, 92.

Signifies: BLESSING, DIVINE PROTECTION, FAMILY, MAGIC, PEACE, PRIESTHOOD

Generic Categories: Prayer

See also: *Brit*, Five, *Hamsa*, Hand, Numbers, Priestly Cult, Numbers, Seven, *Shekhinah*, *Tallit*, Temple, Three

PRIESTLY CULT — כְּהֻנָּה.

When the Israelites built the *Mishkan* (portable sanctuary) in the *wilderness, *Aaron and his family were designated as the priests, "*Kohanim*" (from "*Kohen*"), to minister to God within its precincts. From Aaron's family descended the hereditary priesthood, which supervised the ritual activities in the *Temple in *Jerusalem until the Temple's final destruction. Other members of the tribe of Levi (Levites) supplemented the priestly activities of the *Kohanim*, serving primarily as singers, musicians, gatekeepers, treasurers, and assistants to the priests.

Although the biblical text displays considerable internal contradictions about the membership, functions, and mandate of the Priestly Cult, the following can be said about its principal features: (1) the priests were to be servants of God; (2) their role was to perform ritual duties in the Temple, specifically, to offer sacrifices at the *altar; to pronounce the *Priestly Blessing; to sound the *shofar*; to attend to the *ark, *menorah*, *ner tamid* (eternal light), holy *oil, *hallah*, incense, and other ritual objects in the Temple; to divine God's ways using the *Urim and *Tummim*; to heal and cleanse ritual impurity; and to judge and teach the people; and (3) they were to take extraordinary measures to protect their own ritual purity, such as refusing forbidden marriage partners and avoiding contact with death. The priests did not own land, but instead relied on tithes and sacrifices for sustenance. All of these provisions were designed to enhance the holiness of the priestly class.

To further this aim, the priests wore special vestments, many of which were analogous to contemporary royal garments in color (*gold, *blue, and purple), sumptuous materials, and style. The priests were also anointed with oil in the manner of *kings. Like the *parokhet* and veil of the *Mishkan*, the priestly vestments were made of linen and wool, a mixture ("*shatnez*") forbidden in secular garments because of its special holiness.[1] The High Priest wore eight vestments: *four undergarments — coat, girdle, miter, and breeches; and four outer garments — the *ephod* (an embroidered apron), *breastplate (inscribed with the names of the *Twelve Tribes), robe of the *ephod* (whose rim was adorned with *pomegranates of dyed wool and linen and gold bells which sounded when he walked), and gold plate (attached to the miter and inscribed with the Four-Letter *Name of God). Ordinary priests wore only a miter, coat, and girdle. On *Yom Kippur, the High Priest wore simpler garments of *white linen, regarded as being even holier than his customary garb.[2] All of these special garments were designed to emphasize the beauty, holiness, and purity of God's service.

After the destruction of the Second Temple, most of the functions of the Priestly Cult ceased. The only privileges still pertaining to the descendants of the original *Kohanim* are (1) receiving the first Torah honor (*aliyah*); (2) officiating at the "*Pidyon Ha-Ben*" ceremony (redemption of the firstborn); and pronouncing the Priestly Blessing on holidays. Many *Kohanim* still observe the biblical restrictions associated with marriage and death, such as not entering a graveyard. Liberal congregations have abolished many or all of these customs.

With the demise of the Temple, Judaism generally abandoned the practice of adorning humans who perform ritual functions, reserving such adornment instead for the Torah scrolls. In fulfillment of the biblical injunction to "be a kingdom of priests and a holy nation,"[3] all (male) Jews began wearing the *tallit* during prayer, a symbol of the essential democracy of Jewish worship. In modern times, women have extended this ritual inclusiveness even further.

The *Torah scroll has symbolically replaced the High Priest in Jewish worship. Many of the Torah's vestments—the *crown, breastplate, robe, and girdle—all elaborately ornamented and made of precious materials, derive from the original priestly garments. The rabbis make this connection explicit: "There are three crowns: the crown of Torah, the crown of Priesthood, and the crown of royalty."[4]

Throughout the centuries, descent from a priestly family has often been noted on coats of arms, bookplates, seals, and tombstones. The most common symbol of a *Kohen* is a pair of *hands in the gesture of the *Priestly Blessing; for a Levite, common symbols are a bowl and pitcher, representative of the Levite's auxiliary function during the Priestly Blessing, or a musical instrument.

[1]Exodus, chapter 28; Leviticus 19:19; Deuteronomy 22:11; Exodus 26:1, 31; [2]*Yoma* 3:6; [3]Exodus 19:6; [4]*Pirke Avot* 4:17.

Signifies: BLESSING, HOLINESS, PURITY, SACRIFICE, SERVICE TO GOD

Generic Categories: Clothing, Colors, Death, Prayer, Synagogue, Temple, Yom Kippur

See also: Altar, Breastplate, Clothing, Crown, *Ketubah*, *Mishkan*, Priestly Blessing, Synagogue, Temple, Torah, *Urim* and *Tummim*, Water, Yom Kippur

PURIM — פּוּרִים.

Many cultures have carnival festivals, during which merriment, irreverence, and masquerade turn religion on its head. Such holidays of "inversion" provide psychological release from the confining strictures of traditional law and custom. In the Jewish *calendar, Purim, commemorating the victory of the Jews over the Persian villain *Haman, serves this function.

The whole month of *Adar* (February-March), during which Purim occurs, takes on a festival spirit. The Talmud proclaims that "With the start of *Adar*, our joy greatly increases."[1] According to apocryphal literature, the *Messiah will come during this month. Much folk art has celebrated this season with fanciful posters, papercuts, and calligraphic designs often featuring animals such as the *bear, symbol

of Persia, or the *fish, symbolic of Pisces, Purim's *Zodiac sign. Pisces has long been considered a lucky sign, a good time to become engaged, conduct business, and even to undergo surgery.

The origins of Purim are obscure. The name itself means "lots," recalling the way in which the fate of the Persian Jewish community was determined as recounted in the Book of *Esther. The names of the two heroes of this story, *Queen Esther and her kinsman Mordecai, most probably derive from the Mesopotamian deities "Ishtar" and "Marduk." Because the Book of Esther celebrates the fairy tale triumph of the weak over the mighty, it has proved immensely popular throughout the long Jewish exile. From time to time, other Purims, called "Little Purims," have also been celebrated to commemorate a particular community's deliverance from danger.

The day of Purim, beginning as do all Jewish holidays at sunset, is celebrated by reading the *Megillah*, the Book of Esther, in synagogue; wearing costumes; holding a carnival; creating "Purim Torah" (jests, puns, and jokes based on traditional texts) during a Purim "shpiel" (variety show) or "seudah" (feast); and sending "mishloah manot" or "shalah manos" (at least two prepared food items) to neighbors and charity to the needy. Special foods for this holiday include triangular pastries filled with poppy seeds or fruit called *"hamentashen" (Haman's pockets) or "oznei Haman" (Haman's ears); fine egg noodles called "Haman's hair"; gingerbread Hamans; turkeys, based on a Hebrew pun linking this bird with King Ahashverosh, who ruled from India ("hodu" is Hebrew for both turkey and India) to Ethiopia. Some communities also eat *lentils and *chickpeas, reminiscent of the vegetarian diets of Esther and *Daniel, who both strictly adhered to the laws of *kashrut while in Persian exile. According to folk belief, legumes also protect against evil spirits, which are particularly powerful during periods of seasonal transition such as Purim.

Although some authorities have disapproved of the excessive levity characteristic of this day, tradition mandates that one get so drunk on Purim that "one cannot tell the difference between the blessedness of Mordecai and the wickedness of Haman."[2] In modern Israel, public festivities called "ad

lo yada" ("until one no longer knows") mark this day.

One of the most popular features of the joyous holiday of *Purim is the custom of making noise in synagogue, a practice normally forbidden during religious services. Based upon the biblical commandment to "blot out the name of *Amalek,"[3] reputed ancestor of Haman,[4] this custom involves drowning out Haman's name during the reading of the *Megillah*, either with a special noisemaker called a *"*gragger*" or by stamping out his name written on the sole of one's shoe.

*Kabbalistic and hasidic literature emphasize the mysterious workings of divine providence in the Purim story, for although God's name is never mentioned in the Book of Esther, the hand of God is secretly at work through the agency of Esther and Mordecai.

[1]*Taanit* 29a; [2]Ibid.; [3]Deuteronomy 25:19; [4]1 Samuel 15:8-9; Esther 3:1.

Signifies: DIVINE PROVIDENCE, INVERSION, IRREVERENCE, JOY, LEVITY, REVERSAL OF FATE, SALVATION, VICTORY

Generic Categories: Food, Purim

See also: Amalek, Bear, Chickpea, Esther, Fish, *Gragger*, Haman, Mask, *Megillah*, Myrtle, Queen

QUEEN – מַלְכָּה.

Jewish tradition frequently compares God to a *king. The medieval philosopher Maimonides claimed that such anthropomorphic language was only metaphoric, made necessary by the limitations of the human imagination. Modern apologists have argued that this term is generic, not exclusively masculine. Feminist scholars have suggested a different interpretation, pointing to vestiges of ancient feminine deities within early Judaism. They argue that although Judaism emerged from cultures which featured both feminine and masculine gods—Mesopotamian, Canaanite, Egyptian, and Hellenistic—it systematically eradicated most feminine attributes from its own conception of God.

The prophet Jeremiah castigates Israelite women for making "cakes for the queen of heaven," probably a reference to the ancient Canaanite cult of Ishtar or Astarte, derived from the earlier Sumerian goddess Inanna.[1] In *Greece, the moon goddess Artemis was offered round cakes called "selenai," representing the *moon. It is possible that the Song of Songs is based on pagan sacred marriage rituals, fertility rites enacted between human kings and priestesses to ensure good harvests and flocks from the goddess.

Perhaps the relative rarity of strong female rulers in the ancient world—with such notable exceptions as Cleopatra, the Queens of Egypt, and the Queen of Sheba—made the metaphor of God as queen-ruler unacceptable. Generally, the kings of ancient Israel did not have Israelite queens; they married foreign queens to secure political alliances. During the Hasmonean dynasty, a Jewish queen Salome Alexandra ("Shlomtzion" in Hebrew) ruled the nation briefly, from 76 to 67 B.C.E. The Ethiopian Jewish community also had a queen, Yehudit, who ruled an independent Jewish empire from 850 to 890 C.E. But despite these exceptions, Jews have not lived under female leadership, especially when rabbinic authority replaced the Davidic monarchy after the destruction of the *Temple. In fact, the only queen celebrated in Jewish liturgy and ceremonial life is *Esther, the heroine of the *Purim story, noted for her courage, modesty, and wit, but not for her power, since she was completely dependent upon King Ahashverosh's favor.

However, the image of the Divine Queen, called variously "*matrona*" or *"*Shekhinah*," has played a prominent role in mystical theology. *Kabbalists characterize *Malkhut* (Royalty), the most immanent of the divine *Sefirot*, as God's feminine aspect, the dimension of divinity most accessible to human experience. Unlike God's masculine aspect, characterized by stern Judgment and Transcendent Power, God's feminine side manifests the attributes of Grace, Beauty, and Compassion. These qualities are especially linked with the *Shabbat.

Kabbalists greatly developed the notion of the Sabbath Queen, "*Shabbat Ha-Malkah*," sometimes also called the Sabbath Bride, who accompanies Jews and blesses their homes on the day of rest. The Sabbath evening service, called "*Kabbalat*

Shabbat," Receiving the Sabbath, welcomes in the Sabbath Queen with poetry and song. The popular kabbalistic hymn, "*Lekha Dodi*," sung at this time, beautifully elaborates this image. There is a custom of extending the Sabbath celebration past the closing ceremony of *Havdalah* by adding a fourth meal after sundown called "*Melaveh Malkah*," Escorting the Queen.

[1]Jeremiah 7:18.

Signifies: ACCESS TO THE DIVINE, BEAUTY, GOD, GRACE, HOLINESS

Generic Categories: Kabbalistic Symbols, Purim, *Shabbat*, Women

See also: Esther, Kabbalah, Moon, Purim, *Shabbat*, *Shekhinah*

RACHEL — רָחֵל.
Rachel, whose name means "ewe," was one of the original *four matriarchs of the Jewish People. Her father was Lavan, *Rebecca's brother; her husband was *Jacob, Rebecca's son; and her older sister was *Leah, Jacob's other wife.

Lavan tricked Jacob into marrying Leah before Rachel, citing the local custom that elder daughters must marry first, even though it was Rachel whom Jacob loved. Jacob worked *seven years for Leah, and an additional seven for Rachel. Rachel symbolizes the beloved wife, since her husband labored so many years for her hand. She is also a symbol of beauty.[1]

To compensate Leah for Jacob's rejection of her, God rewarded her with fertility, granting her six sons and a daughter as well as two more sons through her maid Zilpah. Rachel, however, was barren for many years, although her maid Bilhah bore Jacob two sons. At last, God granted Rachel a son, *Joseph, and later, Benjamin, whose birth cost Rachel her life. Because of Rachel's delayed fertility, women having trouble conceiving have traditionally invoked her name to intercede on their behalf. Some even travel to the Tomb of Rachel near Bethlehem, especially during *Elul* (the month before *Rosh Hashanah), on New *Moons, and on the eleventh day of *Heshvan* (the anniversary of Rachel's death), and wind a *red cord around the tomb to receive her blessing of fertility.[2]

The tradition singles out Rachel as the foremost symbol of Jewish Exile. She alone of the matriarchs and patriarchs died in the

*wilderness and is buried alone. After the destruction of the First *Temple, Jeremiah laments: "A cry is heard in Ramah — wailing, bitter weeping — Rachel weeping for her children. She refuses to be comforted for her children, who are gone."[3] This prophetic passage is read in *synagogue on the second day of Rosh Hashanah. Rachel is often called "Rachel our Mother," whose compassion comforts the exiled Jewish People. Pictures of the Tomb of Rachel were hung in Jewish homes throughout the centuries as symbols of messianic hope as well as of mourning for the lost Temple.

[1]Genesis 29:17; [2]Kitov, *The Book of Our Heritage* 1:265; [3]Jeremiah 31:15.

Signifies: BEAUTY, COMPASSION, EXILE, HOPE, INFERTILITY, LOVE, MOTHERHOOD, MOURNING, SIBLING RIVALRY

Generic Categories: Messiah, Personalities, Rosh Hashanah, Women

See also: Jacob, Joseph, Leah, Mandrakes, Red

RAIN — מַלְקוֹשׁ, מָטָר, יוֹרֶה, גֶּשֶׁם.
In agricultural societies, rain is seen as an expression of divine providence. Because it falls from heaven, it symbolizes the descent of spirituality into our world, a material manifestation of the divine.

In the Middle East, rain is the most crucial variable element in the agricultural cycle. Rain typically falls in Israel only between October and May, primarily in the winter months of December, January, and February. So crucial is rain that the Hebrew language differentiates among several kinds of rains — later ("*malkosh*") and early ("*yoreh*"), heavy and light. From ancient times to this day, drought seriously imperils the welfare of the nation. Rain is essential for the preservation and continuation of all life.

At the end of the harvest festival of *Sukkot, it is traditional to recite the Prayer for Rain, "*Tefillat Geshem*," asking God to send fertilizing rain for next spring's harvest. When reciting this prayer, the prayer leader wears a *white *kittel*, symbolic of solemnity, emphasizing the life-and-death consequences of rainfall for the people. In ancient times, a special joyous ceremony called "*Simhat Beit Ha-Sho'evah*" ("The Rejoicing of the House of

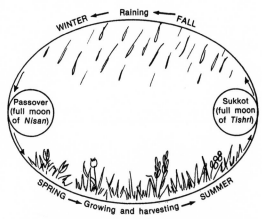

Sukkot comes at the full moon following the fall equinox. Around the conclusion of Sukkot, a seasonal change occurs and the rains arrive. Crops planted in the fall germinate and then lie dormant until the spring.

Passover usually comes at the full moon following the spring equinox, after the rains have concluded. The barley is ripe by Passover. Other crops ripen throughout the growing season, which extends until Sukkot, the fall harvest festival.

The annual cycle of rainy season and dry season in the land of Israel.

Water-Drawing") was celebrated with *candles, dancing, and singing in the *Temple and throughout *Jerusalem during *Sukkot, just prior to the winter rains.[1] This ceremony was the most joyful of the entire year.

A short prayer for rain in the winter (and *dew in the summer) is inserted each day in the portion of the *Amidah* prayer which thanks God for resurrecting the dead, symbolically equating such revivifying rainfall with divine healing, the redemption of captives, and the messianic revival of dead souls.

In Kabbalah, *rain represents the Masculine *Waters, the source of spiritual energies which rain down from above, in contrast to *dew, which represent the Feminine Waters, whose spiritual energies rise up from below.

[1]*Sukkah* 5:1–4; Isaiah 12:3.

Signifies: BLESSING, DIVINE PROVIDENCE, FERTILITY, HOPE, LIFE, RESURRECTION

Generic Categories: Natural Phenomena, Prayer, Sukkot

See also: Dew, Sukkot, Water

RAINBOW – קֶשֶׁת. Many cultures in the ancient world tell of a great primeval flood that came close to destroying all life on *earth. The most famous account is the Akkadian Epic of Gilgamesh upon which the biblical flood narrative is probably based. In the biblical version, God promises *Noah

that "never again shall all flesh be cut off by the waters of a flood." To seal this oath, God sets a rainbow in the *clouds as "a sign of the covenant between Me and the earth."[1] According to the rabbis, this covenantal rainbow, consisting of *seven *colors, was created at twilight on the Sixth Day of Creation together with the other miracles.[2]

Just as a warrior lowers his bow to signal his peaceful intentions, so the biblical rainbow symbolizes the appeasement of divine wrath. In our own time, peace activist and theologian Arthur Waskow has appropriated this ancient symbol of peace for Jewish antinuclear activism. Contemporary environmentalists use the rainbow as a symbol of an ecological covenant to preserve life on earth.

In Hellenistic culture, the bow was the *Zodiac symbol for Sagittarius the Archer. The Hebrew name for this sign was "keshet," meaning both bow and rainbow.

The prophet Ezekiel likened God's Presence to "a rainbow which shines in the clouds on a rainy day."[3] According to the *Zohar*, the mystical Book of Splendor, the rainbow in the clouds that appeared to Noah was God. When *Moses later ascended Mount *Sinai, "the Rainbow took off her garments and gave them to Moses. Wearing that garment, Moses went up the mountain."[4] One interpretation identifies this rainbow with the *Shekhinah*, God's feminine aspect; another with *Yesod*, a male sexual symbol, which unites with the cloud, symbolizing female sexuality.

[1]Genesis 9:8–17; [2]*Pirke Avot* 5:6; [3]Ezekiel 1:28; [4]*Zohar* 2:99a (Daniel Matt's translation).

Signifies: COVENANT, DIVINE PRESENCE, DIVINE PROTECTION, GOD, PEACE, SURVIVAL

Generic Categories: Colors, Kabbalistic Symbols, Natural Phenomena

See also: Ark (Noah's), Cloud, Colors, Lag B'Omer, Light, Noah, Seven, Zodiac

RAM — אַיִל. The ram, a male *sheep boasting two curved *horns, was an important animal in ancient Near Eastern economies and religious traditions. In *Egypt, the ram was one of the signs of Amon-Ra, the sun god, who was sometimes depicted with ram's horns. At the *Exodus, God commanded the Israelites to sacrifice a young sheep for the paschal offering before leaving Egyptian bondage. Thus, their first act of freedom was to slaughter their master's god.

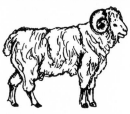

A ram, the male sheep noted for his curved horns (see *shofar).

In the ancient Greek and Roman calendars, Aries (March 22-April 21) was considered the first month, depicted in the pagan *Zodiac as a ram. In early *synagogue mosaics, this Zodiac sign was called *taleh,* Hebrew for "lamb." The spring New Year period, when sheep bear new lambs, coincides with *Nisan,* called in the Bible "the first month of all the months of the year."[1] A number of ancient synagogue mosaics aligned the symbols of Aries and *Nisan,* the month of Passover, in their mosaic floors. Others aligned Aries with *Tishrei,* the month of the other Jewish New Year, *Rosh Hashanah.

It is this fall New Year of Rosh Hashanah with which the ram is chiefly associated in Jewish tradition. On this festival, the *shofar,* the ram's horn, is sounded repeatedly to call the people to repentance. Although the *shofar* can be made from the horn of a gazelle, mountain *goat, domestic goat, or antelope, the ram's horn is preferred because it recalls the *akedah,* the sacrifice of *Isaac, whose submission to God's will is so appropriate to this season of penitence. The ram — and

sheep in general — were primary sacrificial animals on the *Temple *altar, and also symbolize passivity or the slaughter of innocents, that is, Jewish martyrdom throughout the ages.

The ram continues to play a vital role in Jewish ritual, linking the generations from biblical times to the present: its horn provides the *shofar;* its fleece, the threads of the *tzitzit* (fringes of the *tallit*); its hide, the straps of the *tefillin* and the parchment of the *Torah scroll.

[1]Exodus 12:2.

Signifies: BEGINNING, MARTYRDOM, PASSIVITY, REPENTANCE, SPRING, SUBMISSION TO GOD'S WILL

Generic Categories: Animals, Passover, Rosh Hashanah

See also: *Akedah,* Horn, Sheep, *Shofar,* Zodiac

REBECCA — רִבְקָה. Rebecca was the second biblical matriarch, the wife of *Isaac, and the mother of *Jacob and *Esau. Because *Abraham did not wish his son Isaac to marry a Canaanite woman, he sent his servant Eliezer to fetch a wife for him from among Abraham's own family in Aram-Naharayim. Rebecca, Abraham's grandniece, gives Eliezer and his camels *water at the *well, a preordained sign that she is the intended bride. Later, Rebecca's son Jacob marries her nieces *Leah and *Rachel, daughters of her brother Lavan.

Rebecca has traditionally been a symbol of kindness, hospitality, and beauty, the qualities that singled her out to Eliezer as Isaac's intended wife. She is also associated with the bridal veil, symbol of female modesty, because she covered herself with a veil when she first met Isaac.[1] At the "*bedeken,*" the Veiling of the Bride before the *wedding ceremony, it is customary to recite the blessing originally bestowed upon Rebecca when she left her home to marry her cousin Isaac: "O sister! May you grow into thousands of myriads!"[2] This verse is followed by a variation of the traditional Sabbath blessing for daughters: "May God bless you like *Sarah, Rebecca, Rachel, and Leah."

Rebecca is also a symbol of shrewdness, since she helped Jacob deceive his father

into giving him Esau's rightful blessing. But because this deception insured the continuity of the Jewish People — Esau having previously married a Hittite wife — the tradition vindicates Rebecca's actions, although these actions cost her a twenty-year separation from her son and grandchildren.

[1]Genesis 24:65; [2]Genesis 24:60.

Signifies: BEAUTY, CLEVERNESS, FERTILITY, HOSPITALITY, KINDNESS, MODESTY

Generic Categories: Personalities, Wedding, Women

See also: Esau, Isaac, Jacob, Wedding, Well

RED — אדם. In most cultures, red is regarded as having antidemonic properties, perhaps because it signifies sacrificial *blood, which appeases evil spirits. In the Middle Ages, both Jewish and Christian children wore coral necklaces to avert the *Evil Eye. To this day, Oriental Jews paint a bride's *hand with red henna the night before her *wedding to keep demons away. Red was also used in *amulets to protect against hemorrhages and other blood ailments.

Red also symbolizes life, because of its association with blood. In the *Tu B'Shevat *seder, participants begin with a glass of *white *wine and then gradually add red wine in successive cups, symbolizing the reawakening of the *earth after the winter. Over the centuries women having trouble conceiving have traveled to *Rachel's Tomb near Bethlehem, and wound a red cord around the tomb to receive her blessings of fertility.

In ancient times, the priests would take an unblemished red heifer, sacrifice it outside the sanctuary, and use its *ashes to purify a person or object defiled by contact with a corpse.[1] The heifer was then burned together with *cedar wood (which has red bark), crimson material, and hyssop, which was first used to smear blood on the Israelites' doorposts in *Egypt to ward off the *Angel of Death. The combination of all these reds — the cow, the crimson material, the cedar wood, and the blood — served to counteract the power of death threatening the Israelite community.

Red is often associated with sin. The sacrifice of the red heifer was considered a sin offering. Since the Israelites sinned through a *Golden Calf, the sacrifice of the calf's mother, the red heifer, symbolically atones for its sin.[2] Isaiah declares: "Though your sins be like crimson, they shall turn snow-white; though they be red as dyed wool, they shall become like fleece."[3] On *Yom Kippur during *Temple times, a *goat was chosen by lot to bear Israel's sins into the *wilderness of Azazel. A red thread was twisted around its *horns, and another such thread was tied to the entrance of the Temple. The Talmud claimed that this latter thread would turn *white when the goat reached the wilderness.[4]

Red is also the color of the earth. The Hebrew word for earth, *adamah*, derives from *adom*, meaning red. The Bible states that God created the first human being, *Adam, from the *adamah*.[5] Thus, Adam literally means "earthman" or "redman."

In *Kabbalah, the color red is associated with the *Sefirah of Gevurah or Din, Judgment, the divine aspect which counterbalances Mercy.

Red is sometimes associated with royalty. *Torah mantles, *ark curtains, and other ritual objects are sometimes red to symbolize God's *kingship.

Traditionally, the sacramental wine used on most Jewish holidays and *Shabbat is red wine.

Ironically, the name of the most famous "red" of all — the Red Sea, whose waters miraculously parted before the Israelite *Exodus — was the result of a printing accident. "Yam Suf," as it is called in Hebrew, actually means "Reed Sea." It was only a small step, not unusual in the days before the printing press, from the archaic spelling "rede" to "red."

[1]Numbers 19:2–10; [2]Pesikhta Rabbati 14:14; [3]Isaiah 1:18; [4]Yoma 67a; [5]Genesis 2:7.

Signifies: DIVINE JUDGMENT, DIVINE PROTECTION, LIFE, PURIFICATION, ROYALTY, SIN

Generic Categories: Colors, Kabbalistic Symbols

See also: Adam, Blood, Colors, Earth, Kabbalah, King, Pomegranate, Rachel, Sefirot, Tu B'Shevat, Wedding, White, Wine

ROCK — צוּר. Rock is a symbol of stability and strength. Jews have referred to God as "the Rock" ("*Tzur*") since biblical times. In his final address to the people, *Moses chastised the Israelites for "neglect[ing] the Rock that gave you birth."[1] King *David gave thanks to "the Rock in whom I take shelter."[2] The Psalmist frequently addressed God by this name.[3] This image appears throughout the liturgy and in many *Shabbat* and holiday songs. "Rock of Ages" ("*Maoz Tzur*") is still one of the most popular *Hanukkah songs.

The rock also symbolizes divine protection. When the Glory of God passed before Moses on the *mountain, God hid Moses in the "cleft of a rock" so that he would not be harmed.[4] God also sustained the Jewish People with "*honey from the crag, and *oil from the flinty rock."[5]

Although the rock generally is a symbol of divine compassion, it also symbolizes divine judgment. Commanded by God to speak to the rock to yield *water, Moses struck it instead and was thereby condemned to die in the *wilderness before entering the Promised Land. This image of Moses striking the rock has been a frequent motif in Jewish art.

According to legend, all underground springs originate under the Foundation Stone, the exact center of the *earth, located under the Holy of Holies in the center of the *Temple in *Jerusalem, which itself is the center of the world.[6] (This stone is also hallowed in Muslim tradition: according to Muslim legends, the stone slab upon which the golden Dome of the Rock sits on the Temple Mount is the ancient Foundation Stone, upon which Muhammed ascended to heaven.) Jewish tradition regards the Foundation Stone as the site of the *akedah* and the Temple *altar.

For centuries, Jews have marked gravesites with stone markers. It is customary to leave a small rock on the tombstone after visiting a person's grave as a sign of remembrance.

[1]Deuteronomy 32:18; see also 32:4, 30–31; [2]2 Samuel 22:3; [3]Psalm 18:32, 46; 28:1; 42:10; 62:3, 7; 71:3; 78:35; 89:27; 94:22; 95:1; [4]Exodus 33:21–22; [5]Deuteronomy 32:13; [6]Vilnay, *Legends of Jerusalem*, 7–11.

Signifies: CENTER, DIVINE COMPASSION, DIVINE JUDGMENT, DIVINE PROTECTION, GOD, REMEMBRANCE

Generic Categories: Death, Hanukkah, Natural Phenomena, Prayer

See also: *Akedah*, Altar, Moses, Mountain, Temple, Water

ROME — רוֹמָא. For several centuries, Rome ruled the ancient world. Its empire extended from Ireland in the west to the eastern borders of Asia Minor, from Europe to northern Africa. Greek culture and ideas, combined with Roman law and roads, united disparate peoples under one rule. But the price for such unity was the loss of national sovereignty. For the Jews of Palestine, it spelled the loss of religious freedom as well.

After Rome conquered *Jerusalem, it imposed a series of provincial governors upon its Jewish subjects. Chafing under the increasing burden of taxation, corruption, and religious insensitivity, the Jews rebelled in the 1st century. Rome crushed the rebellion in 70 C.E. by destroying the Holy *Temple and the city of Jerusalem, and exiling many of its inhabitants. A second rebellion in 135 C.E. under the leadership of Bar Kokhba resulted in the decimation of the Jewish population and the effective end of the Jewish majority in Palestine. Only a remnant remained, among them rabbis who continued to develop Jewish oral law in the talmudic academies of Palestine, although the chief religious center shifted to the Babylonian academies.

Because of the history of Roman oppression, particularly the destruction of the Temple, Rome came to symbolize Israel's enemy. Throughout the Talmud, the cruelty, moral corruption, arrogance, and idolatry of Rome is pitted against the intellectual resourcefulness, courage, ethics, and faith of the rabbis. To escape censorship and arrest, the rabbis often referred to Rome by the names of other ancient Jewish enemies such as *Esau, Edom, and *Amalek. Rome is often represented in rabbinic texts by the pig and the *eagle, the latter the symbol of Imperial Rome, which the rabbis turned upside down.

After Constantine embraced Christianity as the empire's official religion, Rome became a symbol of Christianity. In time, this symbolic role was assumed by the Vatican. In modern times, the Holy See has been an equivocal symbol for Jews, signifying both

reconciliation because of the reforms of Vatican II and hostility because of the Vatican's silence during the Holocaust and its persistent refusal to recognize the State of Israel.

Signifies: ARROGANCE, CHRISTIANITY, CORRUPTION, CRUELTY, ENEMY, HOSTILITY, IDOLATRY, OPPRESSION, RECONCILIATION

Generic Categories: Places

See also: Amalek, Eagle, Esau, Temple

ROSE – שׁוֹשַׁנָּה. The rose is a common mystical symbol throughout the world, treasured for its perfection, symmetrical form, fragile beauty, and fragrance. The mandala shape of its petals has been used in many mystical traditions for spiritual contemplation. Together with the lotus, it symbolizes source and creation, since its petals radiate out, revealing its center.

The modern Hebrew word for rose is *vered*, although it is sometimes called *shoshanah*, which actually means "lily" or "rose of Sharon" (and in ancient times may have referred to the lily of the valley, hyacinth, anemone, crocus, narcissus, or mountain tulip). The rose as we know it in the West did not exist in Israel in biblical times; it arrived from Persia in the Graeco-Persian period. However, the Song of Songs compares the beloved to "a '*shoshanah*' among thorns,"[1] which suggests that the author had in mind the thorny-stemmed fragrant rose. In the mishnaic period, roses were used not only for decoration, but also as aromatic oils (soaked in *olive *oil), as bath fragrance, and as jam (made from the petals). Although the planting of *trees,

Papercut rose, a traditional folk art window decoration for Shavuot.

*flowers, and crops was forbidden in *Jerusalem because of population pressures, the rabbis made an exception for "the rose garden which existed from the time of the prophets."[2]

The rose's beauty is particularly precious because it is so transient and fragile. Roses were used metaphorically in the Mishnah, and ornamentally throughout the centuries in the design of *spiceboxes and other ritual objects.

The rose is especially associated with *Shavuot because it blooms at this season and because its unfolding from bud to perfect flower symbolizes the Revelation at *Sinai. A playful pun highlights the rose's connection to the Giving of the Torah, which is celebrated on this holiday. The Book of *Esther states that "the decree [permitting the Jews of Persia to defend themselves] was proclaimed in the fortress of Shushan."[3] One can also mistranslate this verse: "The Law was given with a '*shoshanah*,' " a rose. Accordingly, roses – and other flowers – decorate the synagogue during this festival. It was also customary to make papercuts, called "*roiselakh*" (little roses) for holiday decorations. The same pun – "Shushan"/"*shoshanah*" – connects the rose with *Purim, especially in the popular song, "*Shoshanat Yaakov*" ("Rose of *Jacob"), which celebrates God's love for Israel (Jacob).

The *Zohar*, the mystical Book of Splendor, interprets the "rose among thorns" mentioned in the Song of Songs as a symbol of the Community of Israel. It claims that "there is a rose above and a rose below," and that God's *thirteen divine attributes of compassion envelop the Jewish People like a "thirteen-petaled rose."[4]

The rose is a popular motif in Jewish folk art, appearing in abundance on *ketubot* and other illuminated or calligraphed Judaica.

[1]Song of Songs 2:1-2; [2]*Bava Kamma* 82b; [3]Esther 8:14; [4]Opening lines of the *Zohar*.

Signifies: BEAUTY, FRAGILITY, GOD, JEWISH PEOPLE, LOVE, MYSTERY, PERFECTION, REVELATION, TORAH

Generic Categories: Botany, Kabbalistic Symbols, Purim, Shavuot

See also: Circle, Flowers, *Ketubah*, Purim, Shavuot, Thirteen, Wedding

ROSH HASHANAH – ראֹשׁ הַשָּׁנָה. Rosh Hashanah, literally "head of the year," which falls on the first and second days of the autumn month of *Tishrei*, is now the primary Jewish New Year, although the Bible originally designated

Nisan, the month of *Passover, as the "first of the months," and listed Rosh Hashanah as a festival of the seventh month, "a sacred occasion commemorated with the blast of *horns."[1] The Jewish *calendar also designates a "New Year of the Trees," the late winter holiday of *Tu B'Shevat.

It was common among Semitic peoples to begin the economic year at the fall harvest, when crops were brought to market. Rosh Hashanah probably began as such a harvest festival, marking the beginning of the agricultural cycle. In time, that function became associated primarily with the festival of *Sukkot, which falls two weeks after Rosh Hashanah. This season was also the time of the annual coronation of the *king. The theme of God's kingship is central to the Rosh Hashanah liturgy.

From late biblical times to our own, Rosh Hashanah has symbolized the season of penitence and renewal, the beginning of the yearly liturgical cycle. When the Jews returned from Babylonian exile, Ezra the Scribe read the Torah before them on Rosh Hashanah, reminding them of the ancient traditions, and Nehemiah instructed them to celebrate the holy day with feasting and joy.[2]

Rosh Hashanah, falling in the seventh month of *Tishrei*, coincides with Libra, the *Scales, the seventh *Zodiac sign, which traditionally symbolizes psychic and cosmic balance, and the equilibrium between good and evil in human beings. It is also a symbol of justice, symbolizing the moderating influence of self-chastisement. All of these themes are central to the observance of Rosh Hashanah.

The rabbis maintain that the world was created on the first day of *Tishrei*; Rosh Hashanah is thus the birthday of the world, *ha-yom harat olam*.[3]

The Mishnah claims that on Rosh Hashanah, the whole world is judged.[4] Each person's deeds over the past year are weighed, and each person's fate is decided for the coming year: "Who shall be well and who shall suffer illness, who shall live and who shall die." On this day, God inscribes our fate in the *Book of Life.[5]

The central ritual of this day is the sounding of the *shofar*, the *ram's horn, calling the people to repentance and God to merciful forgiveness. The *shofar* is blown on several occasions during the synagogue service, adding up to a total of 100 blasts. The *"Musaf"* (additional service) is greatly expanded on this day, focusing on the *three themes of *"Malkhuyyot"* (kingship), *"Zikhronot"* (remembrance), and *"Shofarot"* (*shofar* blasts).

Other customs involve eating symbolic foods — sweet foods, such as *apples dipped in *honey or dates, to symbolize hope for a sweet New Year; foods that grow abundantly at this season, such as leeks and squash, to symbolize hope for a lucky year; sweet round *hallahs* with raisins, symbolizing hopes for a sweet, new "round" of the year; *hallahs* shaped like *ladders symbolizing our spiritual striving, and the ups and downs of our coming fortunes; seeds, such as *pomegranate and anise seeds, to symbolize hopes for fertility and abundant good deeds. It is also customary to avoid certain foods — *nuts, *egoz* (אגוז), whose numerical equivalence in Hebrew is close to the word "sin," *het* (הטא); sour, bitter, or black-colored food such as black olives or eggplant;*fish, *dag*, which in Hebrew is close to "daag," meaning "worry." (However, many Sephardi Jews eat fish heads on this holiday to symbolize their wish to head their community in righteousness.) It is a traditional custom to cast *bread crumbs into a nearby stream or river in a ceremony called *Tashlikh*, symbolizing the casting off of sins.[6]

[1]Exodus 12:2; Leviticus 23:24; [2]Nehemiah 8:1-12; [3]*Rosh Hashanah* 27a; Rosh Hashanah liturgy; [4]*Rosh Hashanah* 1:2; [5]*Rosh Hashanah* 16b; [6]Micah 7:19.

Signifies: ATONEMENT, BEGINNING, BIRTH, CREATION, DIVINE JUDGMENT, FERTILITY, HOPE, REMEMBRANCE, RENEWAL, REPENTANCE

Generic Categories: Messiah, Rosh Hashanah

See also: *Akedah*, Apple, Calendar, Crown, Fish, *Hallah*, Honey, Horn, King, Ladder, Nut, Pomegranate, Ram, Scales, *Shofar*, Water, Zodiac

ROSH HODESH — ראש־חדֶש.

Rosh Hodesh, literally "head of the month," is the festival marking the reappearance of the New *Moon. In ancient

times, moon worship, usually centered around a moon goddess and celebrated at the reappearance of the lunar crescent, was a central part of Near Eastern religion. Although moon worship was outlawed in ancient Israel, the moon still featured centrally in the religious life of the people. The rabbis calibrated the calendar according to the appearance of the New Moon, which was announced throughout the land by a relay of signal *fires on mountaintops. Since Second *Temple times, Rosh Hodesh, the festival of the New Moon, has constituted a minor holiday, celebrated in *synagogue and at home with special blessings, psalms, and readings.

From the talmudic period to our own day, Rosh Hodesh has been especially sacred to Jewish women. According to legend, the women in the *wilderness refused to contribute their jewelry to make the *Golden Calf, and were rewarded for their faithfulness by being granted the New Moon as a day off from work.[1] For many centuries, Jewish women refrained from doing heavy work on this day. They also lit *candles to commemorate the signal torches announcing the New Moons in ancient times. The Talmud declares that one who blesses the New Moon is regarded as one who greets the *Shekhinah, God's feminine aspect.[2]

Rosh Hodesh, marking the moon's return, symbolizes the renewal of hope in the restoration of Divine Unity. A traditional ceremony for blessing the New Moon, called Kiddush Levanah, is recited from the fourth to the fourteenth day after the reappearance of the lunar crescent, preferably at the conclusion of *Shabbat. Its text alludes to an ancient midrash predicting that in the Messianic Age, the moon, diminished in radiance at the beginning of time, will regain its former luminosity. It also includes a reference to King *David, from whose lineage the Messiah will come.[3] Contemporary commentators have reinterpreted the midrash to refer to a future time when Jewish women will acquire full equality within the tradition.[4]

In recent years, Rosh Hodesh has been revived as a special Jewish women's festival. Women have formed Rosh Hodesh groups, which meet on the New Moon to celebrate old and new rituals, to study, and to worship. These groups have created new ceremonies which bring together ancient and modern symbolism of moon, *water, and women.[5]

[1]*Pirke de-Rebbe Eliezer* 45; [2]*Sanhedrin* 42a; [3]Psalm 89:38; *Hullin* 60b; [4]Waskow, *Seasons of Our Joy*, 229; "Feminist Judaism: Restoration of the Moon," in *On Being a Jewish Feminist*, ed. Susannah Heschel, 261–272; [5]Adelman, *Miriam's Well*.

Signifies: FEMININE, FEMINISM, HOPE, RENEWAL, SEXUAL EQUALITY

Generic Categories: Rosh Hodesh, Prayer, Women

See also: Calendar, David, Golden Calf, Messiah, Moon, Water

RUTH — רוּת. In the Book of Ruth, the Israelite widow Naomi urges her two Moabite daughters-in-law, themselves widows of Naomi's sons, to return to their own people when Naomi returns to hers. Although Orpah follows her mother-in-law's advice, Ruth refuses, insisting that "wherever you go, I will go; wherever you lodge, I will lodge; your people shall be my people, and your God, my God."[1]

In Naomi's native Bethlehem, Ruth gleans in the *barley fields of Naomi's kinsman Boaz, who falls in love with her and marries her. Their great-grandson is King *David.

Ruth symbolizes the righteous convert who willingly abandons her people to embrace the Jewish faith. As the ancestor of King David and hence of the *Messiah, she exemplifies the central role proselytes have played within Jewish tradition. Ruth is also invoked at *weddings because of her qualities of devotion, faithfulness, and commitment.

The Book of Ruth is read on the holiday of *Shavuot because of its setting during the harvest season. Ruth also symbolizes the acceptance of the Torah, which is fitting on the festival commemorating Israel's similar acceptance of the Torah at Mount *Sinai.

[1]Ruth 1:16.

Signifies: ACCEPTANCE OF THE TORAH, COMMITMENT, CONVERSION, FAITH, LOYALTY, RIGHTEOUS CONVERT

Generic Categories: Conversion, Messiah, Personalities, Shavuot, Wedding, Women

See also: Barley, Basket, Corners, David, Messiah, Shavuot

SABRA – צָבָּר. Originally imported to Palestine from the American Southwest and Mexico, the "sabra," from the Hebrew for cactus pear, now grows abundantly in the Land of Israel.[1] Native-born Israelis have proudly adopted for themselves the nickname "Sabra," symbolic of their special national character: prickly and tough on the outside, soft and sweet on the inside.

The sabra, pricklypear cactus, OPUNTIA FICUS-INDICA.

[1]Moldenke, *Plants of the Bible*, 5.

Signifies: JEWISH PEOPLE, SWEETNESS, TOUGHNESS

Generic Categories: Botany, Israel (Land of, State of)

See also: Israel

SAFED – צְפַת. Safed, called "*Tzefat*" in Hebrew, is a city located on a high mountain in the northern Galilee region of Israel. Legend claims that its name, which literally means "to look over" (from "*tzafoh*"), is derived from "*tzevi*," deer; "*pe'er*," glory; and "*tiferet*," splendor, emblematic of Safed's famous beauty. Another legend claims that the *three letters of its name stand for "*tzitzit*," fringes; "*pe'ah*, *corners [earlocks]; and "*tefillin*, phylacteries, describing the special piety of the inhabitants of this city. In modern times, the name has been reinterpreted as standing for "*tziyyur*," painting; "*piyyut*," poetry; "*Torah*," learning, decribing Safed's new role as an artists' colony in contemporary Israel.

Safed is most famous as a city of mystics, most notably the 16th-century *kabbalists, whose leader was Rabbi Isaac Luria,

known as the Holy *Ari*, "the *lion." It was said that the air of this city was the purest in Israel, and that the soul of one who died in Safed flew swiftly to the Garden of *Eden. It was in Safed that Solomon Alkabez composed the popular Sabbath Eve hymn, "*Lekha Dodi*" ("Come My Beloved"), and that Joseph Caro composed his influential "*Shulhan Arukh*," the authoritative Code of Jewish Law for Orthodox Jewry, and also received visitations from the "*Maggid*," a heavenly spirit representing the Mishnah and the *Shekhinah*. It was also here that the *Tu B'Shevat *seder* was developed.

Today, Safed still attracts students and scholars of mysticism, as well as many tourists who come to see both the ancient *synagogues of the kabbalists as well as the picturesque Artists' Quarter.

Signifies: ARTISTRY, BEAUTY, HOLINESS, MYSTICISM, PIETY, PURITY

Generic Categories: Kabbalistic Symbols, Israel (Land of), Places

See also: Kabbalah, *Shabbat*, Tu B'Shevat

SALT – מֶלַח. Salt has always been plentiful in Israel because of the Dead Sea, called the "Salt Sea," "*Yam Ha-Melah*" in Hebrew. The Torah's account of how Lot's wife turned into a pillar of salt was probably inspired by the salt deposits found throughout this region.[1]

Because of its quality as a preservative, salt has been regarded in many cultures as a symbol of permanence. Accordingly, Arabs have traditionally sealed their covenants with *bread and salt. Similarly, the *Torah calls the salt required with all sacrifices, the "salt of the covenant."[2] To this day, it is traditional among Jews to bring bread and salt to a new home to symbolize the hope for permanence and blessing.

In popular folklore, salt has also long been regarded as a protective agent and has often been used in rituals performed at vulnerable times such as birth, marriage, and death. In ancient Israel, newborn babies were rubbed with salt.[3] Medieval mystics claimed that salt drives off evil spirits. The

practice of bringing salt to a new home may have originally derived from this belief.

Salt is also used in *kashering (making kosher) meat, since it leaches out *blood which cannot be consumed. Thus, salt serves to purify and consecrate.

Salt also symbolizes sadness or suffering, since tears are salty. At the *Passover *seder, greens are dipped in salt water to symbolize the tears shed by the Hebrew slaves in *Egypt.

Once the *Temple was destroyed, and with it the sacrificial cult, the family *table came to symbolize the *altar. After reciting the blessing over bread, Jews sprinkle salt over it to symbolize the salt once sprinkled over the sacrifices in the Temple; the punishment of *Adam who was condemned to earn his bread "by the [salty] sweat of [his] brow";[4] the tears shed by the Jewish People throughout its history; and the *covenant between God and Israel.[5]

[1]Genesis 19:26; [2]Leviticus 2:13; [3]Ezekiel 16:4; [4]Genesis 3:19; [5]2 Chronicles 13:5.

Signifies: CONSECRATION, COVENANT, LABOR, PERMANENCE, PROTECTION, PURIFICATION, PURITY, SADNESS, SUFFERING

Generic Categories: Birth, Food, New Home, *Shabbat*, Temple

See also: Blood, Bread, *Hallah*, *Kashrut*, Table, Temple

SARAH — שָׂרָה.
Sarah was the first female Jew, the first of the *four matriarchs, the wife of *Abraham, the mother of *Isaac. Her name means "princess," "priestess," or "chieftainness." Some scholars speculate that her name may be derived from goddess cults in the ancient Near East, particularly the cult of the *moon goddess Ishtar, one of whose names was "Sarrat."

Sarah was barren for most of her life, but miraculously conceived a son in her ninetieth year. When she heard God's prophecy of her son's birth, she laughed in disbelief, hence giving Isaac his name: "Yitzhak," derived from the Hebrew word meaning "to laugh."[1] God changed her name from Sarai

to Sarah, promising "I will bless her so that she shall give rise to nations; rulers of peoples shall issue from her."[2] Her name is invoked on Friday nights—together with the other three matriarchs—in the blessing of daughters.

Sarah embodied the spirit of holiness. As long as she lived, the *cloud of the *Shekhinah hovered over her tent, her dough was blessed, and the *lamp that she kindled on *Shabbat eve burned until the following *Shabbat*. These miracles ceased at her death, but returned when Isaac married *Rebecca and brought her into his mother's tent.[3] According to the rabbis, Sarah's gift for prophecy surpassed even Abraham's.[4]

When Sarah left Ur to journey to Canaan with Abraham, she converted many people to her new faith,[5] and when she later gave birth to Isaac, she suckled a hundred additional babies at his *brit (circumcision), many of whom grew up to be pious proselytes. The *midrash* claims that all converts who ever lived came from these children whom Sarah nursed.[6] Sarah also symbolizes hospitality, because her tent was always open to wayfarers in the desert.

Sarah is also recognized for her great beauty. When Abraham went down to *Egypt during a famine, he concealed Sarah in a *basket for fear that the Egyptians would try to ravish her. When the basket was uncovered, her beauty filled the whole of Egypt. *Pharaoh himself desired her and gave her the province of Goshen as a bridal gift, but his lustful designs were ultimately thwarted by an *angel, and Sarah left Egypt safely with her husband.[7]

When Abraham took Isaac to Mount Moriah to offer him as a sacrifice at God's command, *Satan tricked Sarah into believing that Abraham actually killed her only son. One *midrash* claims that her soul flew out of her body at his words; another that she died of happiness when she discovered that Isaac had been spared.[8] Sarah is the only woman after whom a Torah portion is named—"Hayyei Sarah" ("the Life of Sarah"), and the only woman whose age at her death—127—is given in the Bible.[9] Sarah's story is read at *Rosh Hashanah. In recent years, many Jews have paired the phrase *ezrat Sarah* or

pokeid Sarah with "*magen Avraham*" in the *Amidah* prayer.

[1]Genesis 18:12–15; [2]Genesis 17:16; [3]*Genesis Rabbah* 60:16; [4]*Exodus Rabbah* 1:1; JT *Sotah* 7:1; [5]Genesis 12:5; [6]*Pesikta Rabbati* 43:4; [7]*Genesis Rabbah* 40:5; 41:2; [8]*Pirke de-Rebbe Eliezer* 32; Ginzberg, *Legends of the Jews* 1:287; 5:256, n. 259; [9]Genesis 23:1.

Signifies: BEAUTY, BLESSING, CONVERSION, FERTILITY, HOLINESS, HOSPITALITY, MOTHERHOOD, PROPHECY

Generic Categories: Conversion, Personalities, Rosh Hashanah, Women

See also: Abraham, *Akedah*, Four, Isaac, Ishmael, Lamp, Rebecca, Rosh Hashanah

SATAN — שָׂטָן.

Satan, in the Jewish tradition, is not the red-faced, long-tailed devil of popular Western folklore. In the Bible, Satan means "adversary" or "accuser," a supernatural being who assumes the role of prosecuting attorney during heavenly tribunals, most notably in the Book of *Job.

In the Bible, Satan is subordinate to God's power. In later Jewish texts, he appears as the impersonal force of evil, but never with an independent personality as powerful as the Christian Satan or the Anti-Christ. In the Talmud and *midrash*, he became more prominent, often called "Samael" or "Asmodeus," King of the Demons. He was frequently identified with the "*yetzer ha-ra*," the Evil Inclination, or the *Angel of Death. In the *midrash*, all the sins in the Bible were attributed to Satan. In *kabbalistic lore, Satan is identified with the *Sitra Ahra*, the Other Side, that dimension of the world from which the divine spirit has been exiled or encapsulated in the shells of sin.

The rabbis claimed that one of the reasons Jews sound the *shofar on *Rosh Hashanah is "in order to confuse Satan."[1] But on *Yom Kippur, Satan is completely powerless over humanity, as his very name suggests: the numerical equivalent of "*Ha-Satan*" (the Adversary) equals 364, exempting the day of Atonement, out of all the days of the year, from his influence.[2]

Medieval Jews, influenced by the customs of the European and Oriental peoples among whom they lived, developed *amulets, incantations, and rituals to protect them from the power of Satan. Transitional spaces (thresholds and other boundaries) and times (birth, marriage, death, twilight, dawn, seasonal solstices) were considered most vulnerable to his influence.

Because their separate laws, customs, and language have kept Jews on the margins of the majority culture, Jews have often been unjustly linked by other peoples, notably medieval Christians, with Satan or the Anti-Christ, likewise defined by their separateness from societal norms.

[1]*Rosh Hashanah* 16b; [2]*Yoma* 20a.

Signifies: EVIL, SEDUCTION, TEMPTATION

Generic Categories: Rosh Hashanah, Yom Kippur

See also: Amulet, Angels, Angel of Death, Evil Eye, Kabbalah, *Mezuzah*, Portal

SCALES — מֹאזְנַיִם.

The emblem of scales is very ancient, probably originating in Mesopotamia. Scales suggest the equivalence and interplay of guilt and punishment. When balanced, the scales suggest harmony and equality. The *Zodiac sign of Libra, corresponding to the period between September 23 and October 23, is typically represented by two equal scales balanced on a central pivot. The Greeks also identified this symbol with Astraea, Goddess of Justice. Moderns know the scales as the classic symbol of law and justice.

Scales in balance.

In ancient Jewish depictions of the Zodiac, most notably in mosaic *synagogue floors, *moznayim* (scales), the *seventh sign, is represented by a figure (sometimes naked) holding two scales balanced from a horizontal rod. Significantly, the Jewish New Year festival of *Rosh Hashanah, which falls in the seventh month of *Tishrei*, centers upon the theme of Judgment, rep-

resented by the scales. In the High Holiday liturgy, the metaphor of human deeds being weighed by God figures prominently. It is likely that the imagery and themes of Rosh Hashanah developed in connection to the associations already identified with this season in the ancient world. In addition, the fate of the earth and its people "hangs in the balance" at this time of year, contigent upon the arrival of the winter rains to bring forth the next spring's crops.

Signifies: BALANCE, DIVINE JUDGMENT, EQUALITY, HARMONY, JUSTICE, LAW

Generic Categories: Rosh Hashanah

See also: Rosh Hashanah, Zodiac

SEDER – סֵדֶר. *Seder* means "order." The traditional Jewish prayer book is called the "*Siddur*," derived from this Hebrew root, because its order was prescribed by the rabbis. For over two thousand years, the term *seder* has specifically referred to the home ceremony held on the first night of *Passover—and on the second night as well, in most Diaspora communities—consisting of the retelling of the *Exodus from *Egypt; rituals and symbols commemorating this festival and its history; prayers, hymns, and songs; and a festive meal. A special book, the *"*Haggadah*," serves as the script and text for this elaborate ritual feast. It is traditional for the leader of the *seder* to wear a *kittel*.

Seder plate.

Following the Israelites' deliverance from Egyptian bondage, God tells them to tell their children "on that day [that is, Passover]: 'It is because of what the Lord did for me when I went free from Egypt.' "[1] From this injunction developed the custom of reciting this ancient story each year during the Passover holiday meal. In addition to specifying the foods and rituals required for this ceremony, the Mishnah set out *four questions that children should ask their parents about this ceremony, advising parents to answer their children according to their levels of understanding. In the Middle Ages, this part of the *Haggadah* was embellished, and a permanent order was established (the "*seder*" of the *seder*), including rabbinic texts, table and liturgical hymns, popular folksongs to appeal to children, and the prescribed order of blessings and rituals.

The highlights of the *seder* consist of drinking four *cups of *wine corresponding to each act of divine redemption (probably derived from the common Roman custom of toasting the gods, the guests, the host, and the Caesar at banquets); explaining and, in some cases, partaking of various symbolic foods: the *three ritual *matzahs* (representing the three major divisions of the Jewish People or the two *Temple *hallot* and the paschal sacrifice), a shankbone and roasted *egg (also reminders of the paschal sacrifices in Temple times), *salt *water (symbolizing the Israelite slaves' tears), bitter herbs (*maror*, symbolizing the bitterness of slavery), *haroset* (symbolizing the mortar used by the slaves), green vegetables and hard-boiled *eggs (symbolizing spring), the *afikoman*, the broken middle *matzah* (symbolizing the hope for messianic redemption); reciting the *Ten Plagues while spilling out drops of wine; and narrating the Passover story. It is also customary to add a fifth cup of wine for *Elijah, who according to legend will come to the *seder* to announce the *Messiah and the final redemption.

The *seder* is more than a recitation of the events of the Exodus; Jews are commanded to regard themselves as actual participants in these events: "In every generation one is obligated to look upon oneself as if he or she personally had gone forth out of Egypt."[2] In many Sephardi communities,

everyone marches around the *seder* table carrying a pack and staff to reenact the Exodus. Other rituals – such as reclining in one's chair as did free Roman citizens; eating *matzah*, the bread of haste eaten by the slaves at their moment of freedom; and drinking liberal amounts of wine at dinner – help participants experience first-hand the joys of freedom. Other actions – such as inviting in the poor, tasting the bitter herbs, adding a fourth *matzah* for those Jews still oppressed, and hoping for messianic redemption heralded by Elijah – remind them of past and present limitations on their freedom. It is also customary to spill out ten drops of wine at the recitation of the Ten Plagues, symbolically diminishing one's own joy in remembering the Egyptians' suffering.

The Passover *seder* is the principal home ritual of the Jewish festival calendar, an important assertion of Jewish identity and family unity. It also embodies the ideas of spiritual freedom and resistance so central to Jewish tradition. Significantly, it was on *seder* night in 1943 that the Jews of the *Warsaw Ghetto began their courageous final uprising against the Nazis, an event now commemorated at many *seders* throughout the Jewish world.

In addition to the Passover *seder*, many Jews also celebrate a *Tu B'Shevat *seder*, modeled on the Passover ceremony. Developed by the *kabbalists of 16th-century *Safed, this *seder* consists of drinking four cups of wine (symbolic of the mystical Four Worlds of Divine Emanation as well as the coming of spring), reciting passages from mystical and other traditional texts, singing spring songs, and eating foods symbolic of the mystical theology of the Kabbalah.

[1]*Exodus* 13:8; [2]*Pesahim* 10:5.

Signifies: FAMILY, FREEDOM, HOSPITALITY, JEWISH IDENTITY, JEWISH PEOPLE, ORDER, REDEMPTION, RESISTANCE, SPRING

Generic Categories: Food, Passover, Tu B'Shevat

See also: *Afikoman*, Cup, Egg, Egypt, Elijah, Exodus, Four, *Had Gadya, Haggadah, Hametz, Haroset*, Kabbalah, *Maror, Mat-*

zah, Messiah, Moses, Passover, Pharaoh, Salt, Table, Tu B'Shevat, Warsaw Ghetto, Wine

SEFIROT – עֶשֶׂר הַסְּפִירוֹת. The

author of one of the earliest Jewish mystical texts, *Sefer Yetzirah* ("The Book of Creation" – 2nd–6th century C.E.) wrote that God created the world with the 22 letters of the Hebrew *alephbet* and the *ten primordial numbers called the *Sefirot*, from *saphor* ("to number") or *sappir* (sapphire). These ten powers consisted of the four basic elements – the Spirit of God, air, *water, and *fire – and the six dimensions of space; or in another interpretation, ten dimensions: six spatial, two temporal, and two – Good and Evil – moral. By contemplating these mystic numbers and letters, one could unlock the divine mysteries.

With the development of *Kabbalah in medieval France and Spain, the theory of the *Sefirot* took on a more central and complex role in Jewish mysticism.[1] The *Sefirot* were regarded not merely as *powers* created by God, but as *emanations* of the divine spirit itself, a mystic unfolding of God's cosmic being from the "*Ein Sof*" (literally, "the Infinite"), the primal Godhead, into the material world. Contemplating the *Sefirot* could lead not only to an *understanding* of God's essence, but might even *influence* divine action. The mystics of 16th-century *Safed elaborated further on this theory, developing what became known as Lurianic Kabbalah – after its most famous exponent, the charismatic Rabbi Isaac Luria – claiming that "*Ein Sof*" had accepted exile to make room for a material creation, and that the ten *Sefirot* represented a chain of being in a spiritual hierarchy. Humanity's task was to effect a *tikkun*, reuniting the disparate *Sefirot* into their original primordial unity.

To make this esoteric theory more concrete, the kabbalists developed the image of the sefirotic *tree, a geometric mandala representing the hierarchy of divine emanations descending from *Keter* (*Crown) down to *Shekhinah* or *Malkhut* (*Kingship), that aspect most accessible to human experience. Over the centuries, numerous sefirotic systems have evolved, reflecting

The sefirotic tree.

Mother, the Womb, and the *Palace. The waters of *Hokhmah* flow into the river of *Binah*. These aspects, known as the upper *three *Sefirot*, represent God's actions in the upper world.

The lower *seven *Sefirot* begin with *Hesed* (Mercy), which represents the Source of Divine Blessing, God's Loving *Light, and *Shefa*, the abundance of divinity which overflows into our world. Its counterpart is *Din* (Judgment), sometimes called *Gevurah* (Power), which symbolizes Restraint and Discipline. When balanced with *Hesed*, it effects Reconciliation; when too strong, it is the root of evil. *Tiferet* (Beauty) is the harmonizing principle between *Hesed* and *Din*. It is also the son of *Hokhmah* and *Binah*, the masculine principle in the lower world. *Netzah* (Lasting Endurance) and *Hod* (Majesty) are two aspects of God's Kingship: Compassion and Nobility. *Yesod* (Foundation) represents the phallus, the channel of divine vitality, the balance between *Hod* and *Netzah*. At the bottom of the Sefirotic Tree is *Malkhut* (Royalty), also known as the *Shekhinah*, the female principle, which receives nourishment from the other nine *Sefirot*. This *Sefirah*, which is the closest to our world, is also known as the Lower Mother, the Daughter of *Hokhmah* and *Binah*, the Princess, *Queen, Bride, Matrona, *earth, *moon, the lover of *Tiferet*, and *Knesset Yisrael*, the Community of Israel. The union of *Tiferet* and *Malkhut* represents the eternal

differing interpretations of kabbalistic cosmology and using various clusters of symbols, derived from human anatomy, biblical personalities, *colors, natural symbols, language, and the *names of God.

The highest *Sefirah*, *Keter* (Crown), is identified with *Ein Sof*, the Primal Will. It is that aspect of God beyond the limit of human comprehension. The second *Sefirah*, *Hokhmah* (Wisdom), is associated with Creation and the waters of *Eden. It is also called the Upper Father. The third *Sefirah*, *Binah* (Understanding), is the female counterpart of the masculine principle of *Hokhmah*, also called the Upper

The Ten Sefirot

Sefirah	Human Anatomy	Biblical Personalities	Colors	Natural Symbols	Names of God
Keter	Head		black/white		Ehyeh
Hokhmah	Part of Intellect				Yah
Binah	Part of Intellect/ Womb				YHVH (vocalized as Elohim)
Hesed	Right arm	Abraham	white/silver	water	El
Din (Gevurah)	Left arm	Isaac	red/gold	fire/blood	Elohim
Tiferet	Torso	Jacob	green/ purple	sun/heaven/ light/wind	YHVH
Netzah	Right leg	Moses			YHVH Tzevaot
Hod	Left leg	Aaron			Elohim Tzevaot
Yesod	Phallus	Joseph			El Hai/Shaddai
Malkhut	Female genitalia/ Heart	David/ Rachel	blue/ black	moon/earth/ darkness/ ocean/tent/ apple orchard	Adonai

dialectic between male and female principles.

¹See Scholem, "Kabbalah" in *The Encyclopaedia Judaica*, 563-579; Idel, *Kabbalah: New Perspectives*, 136-153.

Signifies: DIVINE MYSTERY, GOD, MYSTICISM

Generic Categories: Kabbalistic Symbols, Messiah, Numbers

See also: Aaron, Abraham, *Alephbet*, Blue, Body, Colors, David, Earth, Fire, Gold, Head, Isaac, Jacob, Joseph, Kabbalah, King, Light, Moon, Moses, Names of God, Numbers, Queen, Rachel, Red, Seven, Sun, Ten, Tree, Water, White, Wind

SERPENT — נָחָשׁ . Throughout the world, the serpent, because of its venom, strangling coils, phallic shape, and predatory nature, has often been a powerful symbol representing fertility, power, shrewdness, strength, the forces of chaos (as opposed to creation), and ethical evil. In the ancient world, serpents were often worshiped. The Egyptians divined the future by interpreting the hissing of serpents.¹ The *tree and the serpent were sometimes associated with each other because a serpent resembles a tree when erect; its body resembles the root of a tree; and serpents often live in holes at the base of trees.

In ancient Israel, the serpent was frequently deprecated, perhaps to differentiate the religion of Israel from neighboring pagan cults who worshiped serpent gods. In the Garden of *Eden story, the serpent tempts *Eve into disobeying God and eating from the Tree of Knowledge of

Good and Evil. It is punished for its deception, and declared an eternal enemy of humankind.[2] According to legend, *Satan himself seduced Eve through the mouth of the serpent.[3] Another legend claims that God originally made the serpent *king of the beasts, but it lost its privileged status because of its envy of human beings.[4] In *Egypt, *Aaron's rod turned into a serpent and swallowed the serpent rods of *Pharaoh's magicians.[5] According to the Talmud, once every *seven years, serpents spring forth from human backbones which did not bow in prayer.[6] Of all the animals, the serpent is considered the most wicked.[7]

Because of its capacity to shed its skin, the serpent is also a symbol of immortality and resurrection. Serpents have frequently symbolized the conjunction of life and death because of their deadly venom. The emblem of the Greek physician-god Asklepios was the caduceus, a serpent coiled around a staff, still the symbol of medicine and healing. Rituals to avert the serpent's evil power or counteract its venom date back to ancient Egypt and Mesopotamia. After sending fiery serpents to punish the people for blasphemy and rebellion in the *wilderness, God commanded *Moses to fashion a copper serpent to heal their snake wounds when they gazed upon it.[8] This copper serpent eventually became an object of worship in the *Temple until it was destroyed by King Hezekiah (8th century B.C.E.).[9] Although the rabbis agreed that this *"Nehushtan"* cured snake bites as well as other animal wounds, they endorsed Hezekiah's action because the serpent had become an object of idolatry.[10]

In legend, the *Angel of Death is sometimes described as having a serpent's head.[11]

[1]Note the Hebrew word for "divination" in Genesis 44:15; [2]Genesis 3:1-15; [3]*Zohar* 1:36b-37a; [4]*Genesis Rabbah* 20:5; [5]Exodus 7:11-12; [6]JT *Shabbat* 1, 5b; [7]*Bekorot* 8a-b; [8]Numbers 21:6-10; [9]2 Kings 18:4; [10]*Rosh Hashanah* 3:8; *Berakhot* 10b; [11]Ginzberg, *Legends of the Jews* 1:306.

Signifies: DECEPTION, ENEMY, EVIL, HEALING, IDOLATRY, IMMORTALITY, LUST, POWER, RESURRECTION, SEDUCTION, TEMPTATION

Generic Categories: Animals

See also: Adam, Eden, Eve, Tree, Twelve Tribes

SEVEN – שֶׁבַע. Seven was a sacred number to civilizations of the Near East and India. Numerous theories have been suggested to explain its appeal: the ancients claimed that there were seven planets in the heavens: Mercury, Venus, Mars, Jupiter, Saturn, the *sun, and the *moon; the lunar cycle divides into *four quarters of approximately seven days' duration; the constellation known as the Pleiades, by whose course ancient peoples tracked the equinoxes and agricultural cycles, had seven *stars. Seven is also the sum of two other sacred numbers: *three and *four. There are also six directions—north, south, *east, and west, up, and down, which add up to seven if one includes the center as a vantage point. There are seven *colors of the *rainbow and seven notes in the Western musical scale.

The Bible is filled with sevens, suggesting its mystic power in the eyes of the Israelites: the days of creation,[1] the *Noahide laws,[2] the ancestors of Israel (*Sarah, *Rebecca, *Rachel, *Leah, *Abraham, *Isaac, and *Jacob), the cows and ears of corn in *Joseph's *dream, the period of priestly ordination[3] and many other priestly functions and measurements, the *seven species, the Sabbatical year,[4] the circuits around Jericho,[5] and the seven chords of *David's *harp,[6] to mention only a few.

The Jewish *calendar also abounds in sevens: The Hebrew word for week is *shavua*, derived from the word *sheva*, meaning seven. On *Shabbat, whose other name is "the seventh day," the *Torah portion is divided into seven sections. The High Holidays fall in the seventh month. Both *Sukkot and *Passover are seven-day biblical holidays. There are seven processions with the Torah on Simhat Torah. At the conclusion of *Yom Kippur, the phrase "the Lord He is God!" is called out seven times. The Jewish calendar follows a nineteen-year cycle, which includes seven leap months. Tradition assigns the seventh day of *Adar* as both Moses' birthday and date of death (*yahrzeit*).

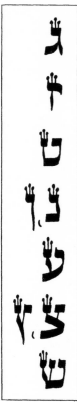

The seven Hebrew letters that have *tagin*, decorative crowns, in Torah script (*gimel*, *zayin*, *tet*, *nun*, *ayin*, *tzadi*, *shin*).

Numerous other rituals come in sevens: There are seven *wedding blessings, sometimes followed by seven days of feasting, inspired by Jacob's example when he married Leah (for whom he had labored for seven years).[7] It is customary for the bride to circle the groom seven times under the *huppah. There are seven days of mourning after a funeral, called *shivah* (literally, "seven"). Sephardi Jews circle a coffin seven times.

Ritual objects also reflect this fascination with sevens: The ancient *menorah* in the *Temple had seven branches. The straps of the *tefillin* are wrapped around the arm seven times. Seven letters of the Hebrew *alephbet — gimmel, zayin, tet, nun, ayin, tzadi, shin — are embellished with *crowns (*tagin*) in the Torah scroll.

Similarly, multiples of seven abound within the tradition: forty-nine — the Jubilee year, the seven weeks of the *Omer*; *seventy — languages and nations of the world, members of *Jacob's clan, elders who advised *Moses, members of the Sanhedrin (the ancient Supreme Court), and years of a person's life.

For the *kabbalists, the seven lower *Sefirot* represented God's immanent presence in the physical world; the upper three referred to the transcendent world.

The Talmud lists seven prophetesses: *Sarah, *Miriam, *Deborah, Hannah, Abigail, Hulda, and *Esther.[8]

In Jewish folk culture and magic, seven is associated with good luck.

[1]Genesis 1:1-2:4; [2]*Genesis Rabbah* 34:8; *Sanhedrin 56a*; [3]*Leviticus 8:33-35*; [4]*Leviticus 25:2-7*; [5]*Joshua 6:15-16*; [6]*Psalm 119:164*; *Numbers Rabbah* 15:11; [7]*Genesis 29:27*; [8]*Megillah 14a*.

Signifies: DIVINE PRESENCE, GOOD LUCK, HOLINESS, MYSTERY

Generic Categories: Astronomy, Death, Kabbalistic Symbols, Numbers, Passover, Rosh Hashanah, *Shabbat*, Shavuot, Sukkot, Wedding

See also: Calendar, Colors, Four, Kabbalah, *Menorah*, Noah, Numbers, *Omer*, Seventy, *Shabbat*, Shavuot, Sukkot, Three, Ten

SEVEN SPECIES – שִׁבְעַת הַמִּינִים.
In the Bible, seven species of agricultural produce are specified to sym-

The Seven Species: 1. Barley. 2. Dates. 3. Figs. 4. Grapes. 5. Olives. 6. Pomegranates. 7. Wheat.

bolize the fertility of the land: *wheat, *barley, *grapevines, *figs, *pomegranates, *olive (*oil), and *honey (from dates).[1] Once the Israelites settled in Canaan, they were commanded to bring their first fruits ("*bikkurim*") to the Levites as offerings.[2] Although no specific fruits or grains are mentioned in the Bible, the rabbis dictated that this law applies only to the seven species mentioned in Deuteronomy 8:8.[3]

In ancient times, Israelites would march in procession from the country to the *Temple in *Jerusalem carrying their first fruits on the holiday of *Shavuot, also called *Hag Ha-Bikkurim* (Festival of First

Fruits).[4] An ox, his *horns wreathed in silver and *gold, and his head with olive branches, headed the procession; musicians playing flutes accompanied the travelers; rich pilgrims carried their offerings in silver and gold *baskets, and the poor in *willow baskets; and a levitical choir greeted them at the Temple Mount. In modern Israel, *kibbutzim* celebrate Shavuot with "*bikkurim*" processions.

[1]Deuteronomy 8:8; [2]Exodus 23:16; 34:22; Numbers 28:26; Deuteronomy 26:1-11; [3]*Bikkurim* 3:9; [4]*Bikkurim*, chapter 3 passim.

Signifies: AGRICULTURE, FERTILITY, THANKSGIVING

Generic Categories: Botany, Israel (Land of), Shavuot, Temple

See also: Barley, Basket, Fig, Grapes, Honey, Oil, Olive, *Omer*, Pomegranate, Shavuot, Wheat

SEVENTY – שִׁבְעִים.

From biblical times, the *number seventy, the product of two sacred numbers, *seven and *ten, has appeared frequently in Jewish texts and rituals. *Moses was instructed to appoint seventy elders to help him lead the Israelite People through the *wilderness.[1] These seventy elders, with Moses at their head, became the prototype of the great Sanhedrin, consisting of seventy-one judges, which acted as the supreme court of ancient Israel. Solomon's *throne was reputed to have seventy *golden thrones for the members of the Sanhedrin. The Heavenly Court was also said to have seventy judges.

The *midrash* designates seventy nations of the earth, each with its own language and own guardian *angel. *Jacob's family consisted of seventy souls when they went down to join *Joseph in *Egypt. From these seventy came the 600,000 Israelites who left *Egypt at the *Exodus. There were seventy vessels in the *Mishkan*, which measured seventy cubits, corresponding to the seventy holy days celebrated in the Jewish year: fifty-two *Sabbaths (only according to the Christian calendar!), seven days of *Passover, eight of *Sukkot, and one day each of *Shavuot, *Yom Kippur, and *Rosh Hashanah.[2]

*Adam was originally granted 1,000 years of life, but gave *King *David seventy of his years when he learned that this noble

soul was destined to live only three hours.[3] *Abraham was seventy years old when God made a covenant with him.[4] At the time of David's rule, it was decreed in heaven that the normal span of a man's life would be seventy years, which is divided into seven stages.[5] The First *Temple lay in ruins for seventy years before it was rebuilt.

According to the mystical tradition, there are seventy angels who protect one from all sorts of dangers, seventy attributes of God, and seventy names of the powerful angel Metatron. Invoking these "seventies" has long been practiced in "practical Kabbalah," that is, popular magic.

Legend claims that a *carob tree takes seventy years to mature. The wonder-working rabbi Honi the Circle-Maker was said to have slept seventy years under a carob tree until it bore ripe fruit.[6]

[1]Exodus 24:1; Numbers 11:16; [2]Ginzberg, *Legends of the Jews* 3:165-166; [3] *Pirke de-Rebbe Eliezer* 19; [4]*Genesis Rabbah* 39, 7; [5]*Yevamot* 64b; *Ecclesiastes Rabbah* on verse 1:2; [6]*Taanit* 23a

Signifies: HOLINESS, LIFE, LEADERSHIP, MAGIC, PROTECTION, WHOLENESS

Generic Categories: Numbers

See also: Angels, Carob, Kabbalah, Numbers, Seven, Ten

SHABBAT – שַׁבָּת.

Shabbat, also called "the Seventh Day" (*Yom Ha-Shevi'i*), derives from the Hebrew word meaning "to rest or cease." Some scholars speculate that the Israelite practice of resting on the seventh day was borrowed from the Babylonian "Shabattu," a day when no one worked because the seventh day was considered unlucky, a notion probably derived from superstitions about the quarterly changes of the *moon. (The Greeks held similar beliefs about the influence of the planet Saturn, after which Saturday was named.) But unlike the lunar-based Babylonian calendar, the Israelite calendar introduced a seven-day week, culminating in a day of rest, an innovation later adapted by Christians and Muslims. In dissociating the week from the natural cycle and instead regulating it by an artifical mathematical rhythm, Jewish culture symbolically af-

firmed the belief that God transcends even nature.[1] *Shabbat* represents eternity, God's time, both the beginning and the end of nature.

The Bible declares the Sabbath a memorial of creation, an imitation of God's own Sabbath: "On the seventh day God finished the work which God had been doing, and God rested on the seventh day."[2] It is also called an everlasting sign of the divine covenant with the Jewish People and of their consecration to God.[3]

The fourth of the *Ten Commandments mandates the observance of the Sabbath, both as a memorial of creation as well as of the redemption from *Egypt.[4] Later generations elaborated on the biblical injunctions against working on the Sabbath, creating a complex system of prohibitions and safeguards designed to "hallow the seventh day." One is not to create anything new on this day in order to appreciate the wonder of the universe as it exists, free of human intercession.

Above all, the Sabbath is regarded as a day of joy and holiness, a day of spiritual refreshment and peace. The customary greeting on this day is "*Shabbat Shalom*"— "[May you have] Sabbath Peace." The tradition considers the Sabbath a supremely holy day, and makes extraordinary claims about its importance to Jewish redemption: "If Israel [the Jewish People] keeps one *Shabbat* as it should be kept, the Messiah will come. The Sabbath is equal to all the other precepts of the Torah."[5] It has also been valued as the key to Jewish national survival in the Diaspora: "More than Israel has kept the Sabbath, the Sabbath has kept Israel."[6]

The observance of the Sabbath is filled with many symbolic actions, objects, and ideas. The number "two" is important because the Fourth Commandment is repeated twice in the *Torah with slightly different wording—"*Remember* the Sabbath Day" as well as "*Observe* the Sabbath Day"—and because the single daily portion of *manna in the *wilderness was doubled on Friday to sustain the Israelites over the Sabbath. Therefore, two Sabbath *candles are traditionally lit, and two *hallah loaves are set on the table.[7] The Sabbath table is adorned with a special *hallah* cover, often embroidered with biblical verses or blessings; ornamented *hallah* boards; fine dishes and silverware; a tablecloth, often *white;

and *wine *cups for reciting the *Kiddush* (blessing over wine). Traditional Sabbath foods include *hallah*, wine, *fish, chicken, meat, cholent (a slow-cooking bean stew), and sweets. It is customary to sing special table songs after each of the three main Sabbath meals: Friday evening, Sabbath lunch, and *Shal'shudes* or *Seudah Shlishit*, the Third Meal before the close of *Shabbat*. Sabbath activities include prayer with the community, study, singing, conjugal intimacy, festive meals, rest, family time, and visiting. Inviting guests to one's Sabbath table is especially encouraged.

The Bible characterizes ancient Israel's agricultural bounty as stemming from its harvest of grain, wine, and *oil.[8] Each week, Jews reexperience the blessings of this harvest through eating *hallah*, drinking wine, and kindling the Sabbath lights, which were originally oil *lamps.

The *kabbalists, especially those living in 16th-century *Safed, introduced a number of ideas and practices which still remain central to *Shabbat* observance. They interpreted numerous biblical verses and rabbinic teachings about *Shabbat* as referring to the divine union of the feminine and masculine aspects of God. According to their readings, the Sabbath represents a *wedding of the *Shekhinah and the Godhead, whose union rains down *light like *dew upon the Jewish People. On the Sabbath, each Jew receives an additional soul. On this day, the *Sitra Ahra*, the Other Side, is powerless to do evil. Just as the feminine and masculine *Sefirot* of God achieve union on this day, so the union of husband and wife is doubly blessed on *Shabbat*.

The kabbalists also introduced several customs that have become immensely popular over the centuries. They referred to this day as *Shabbat Ha-Malkah*, the Sabbath *Queen, as well as the Sabbath Bride, whom they welcomed in with a special service called "*Kabbalat Shabbat*," the Welcoming of the Sabbath. It was customary in Safed to go out to the fields and face west to receive this divine presence. They also introduced the hymn "*Lekha Dodi*," "Come My Beloved," the most popular song during the Friday evening service, at whose final stanza congregations stand and bow toward the door to greet the arriving Sabbath Queen.

The liturgy calls the *Shabbat* "a foretaste

of the World to Come" and prays for the End of Days, which will be a continuous *Shabbat*, a paradise on earth. This *messianic hope became associated with the last moments of the day, especially the Third Meal and *Havdalah*, during which the name of the prophet *Elijah, herald of the Messiah, is invoked. To prolong this bittersweet moment of longing for redemption, some Jews celebrate a fourth meal after sundown called *Melaveh Malkah* (Escorting of the Queen). This meal is associated with *David, ancestor of the Messiah. Among *hasidim*, the Third and Fourth Meals are characterized by special sanctity and fervor.

[1]Zerubavel, *The Seven Day Circle*, 6–20; [2]Genesis 2:2; [3]Exodus 31:13, 17; [4]Exodus 20:11; Deuteronomy 5:15; [5]*Exodus Rabbah* 25:12; [6]Ahad Haam, *Al Parashat Derakhim* 3:30; [7]Exodus 20:8; Deuteronomy 5:12; Exodus 16:22–23; [8]Deuteronomy 11:14; also in second paragraph of *Shema*.

Signifies: COMPLETION, CONSECRATION, COVENANT, CREATION, ETERNITY, FAMILY, HOLINESS, HOSPITALITY, JOY, LOVE, PEACE, PERFECTION, REDEMPTION, RENEWAL, REST, UNION

Generic Categories: Kabbalistic Symbols, Messiah, Prayer, Ritual Objects, *Shabbat*

See also: Bread, Candles, Cup, David, Elijah, Fish, *Hallah*, *Havdalah*, Kabbalah, Lamp, Light, Manna, Messiah, Oil, *Pardes*, Queen, Safed, *Sefirot*, Seven, *Shekhinah*, Table, Three, White, Wine

SHAVUOT – שָׁבוּעוֹת.

The Festival of Shavuot, literally "Weeks," sometimes translated as Pentecost ("the fiftieth day"), occurs in late spring, fifty days after the commencement of *Passover. Jewish tradition ultimately established its observance on the sixth day of *Sivan* (as well as the seventh in the Diaspora), after centuries of sectarian controversy about its dating based on its biblical description.[1] Like the other two biblical pilgrim festivals (Passover and *Sukkot), Shavuot is an agricultural holiday (hence its name *"Hag Ha-Katzir"*—Harvest Festival), probably derived from a Canaanite celebration, marking the end of the *barley and beginning of the *wheat harvest. It is also known

as *Yom Ha-Bikkurim*, the Day of First Fruits. On this day, pilgrims would march into *Jerusalem from the countryside, carrying *baskets of ripe fruits and *bread baked from the newly harvested wheat. In modern Israel, *kibbutzim* have revived this custom, adding to their agricultural offerings monetary contributions to the Jewish National Fund, which plants *trees in Israel.

In rabbinic times, Shavuot became identified with the Giving of the Torah on Mount *Sinai, based on the biblical verse: "On the third New *Moon after the Israelites had gone forth from the land of *Egypt, on that very day, they entered the *wilderness of Sinai."[2] Accordingly, the Torah reading in synagogue for this day includes the *Ten Commandments. In some communities, people observe an all-night vigil, called *"Tikkun Leil Shavuot,"* during which they study passages from the Bible, Talmud, and other sacred texts, climaxing their observance with the only sunrise service of the Jewish year, perhaps symbolic of the light of the Torah.

It is also traditional to read the Book of *Ruth on this festival because the story takes place during the harvest; because Ruth, as a proselyte, accepted the Torah, just as Israel accepted it at Mount *Sinai; and because Shavuot marks the birth and death of King *David, Ruth's great-grandson.

It is customary to eat dairy foods during this festival because the Bible compares the Torah to *milk, and because the law of the first fruits is paired with the biblical law about not boiling a kid in its mother's milk.[3] A legend also claims that when the Israelites received the laws of *kashrut at Sinai, they realized that their pots were not kosher and so ate uncooked dairy foods until they could procure new pots.

It is customary to adorn the *synagogue with plants and *flowers on this holiday, both in their natural forms as well as in the form of papercuts called *"roiselakh"* (little *roses) or *"shavusalakh."* Such decoration celebrates the harvest; the early summer's flowering; the image of the Torah as the *Tree of Life; the legend that Mount Sinai burst into flower at the giving of the Torah; and the rabbinic notion that Shavuot is the Judgment Day for the fruit of the tree.[4] In some Sephardi communities, a special *"ketubah"* (marriage contract), celebrating

the marriage between God and Israel at Mount Sinai, is read before the *ark.

It has long been a custom to inaugurate a Jewish child's education at Shavuot. In medieval communities, a child was introduced to the Hebrew *alephbet on this day (usually at the age of five) and then given *honey and sweets so that "the Torah might be sweet on his lips." In contemporary American Jewish communities, confirmations and graduations usually take place at this time.

¹Leviticus 23:15-16; ²Exodus 19:1; *Pesahim* 68b; ³Song of Songs 4:11; Exodus 23:19; ⁴*Rosh Hashanah* 1:2.

Signifies: COMPLETION, CONVERSION, EDUCATION, REVELATION, THANKSGIVING

Generic Categories: Food, Shavuot, Synagogue, Temple

See also: Basket, David, Fig, Flowers, Grapes, *Ketubah*, Light, Milk, Olive, Pomegranate, Rose, Ruth, Seven Species, Sinai, Synagogue, Temple, Ten Commandments, Torah, Tree, Wheat

SHEEP – אַיִל, טָלֶה, כֶּבֶשׂ, שֶׂה.
Sheep were important domestic animals in ancient Israel, providing *milk, meat, wool, and hides. The curved *horn of the male *ram was fashioned into a *shofar. Sheep were often used as sacrifices in the *Temple.

Because of their association with sacrifice, sheep came to represent the innocent victim, especially when used in the expression "like a sheep being led to slaughter."¹ This phrase appears frequently in reference to Jewish martyrdom, from biblical times to the Holocaust.

The Bible uses the metaphor of a shepherd tending his flock, to refer

A ewe, the female sheep.

either to God or a human *king caring for the Jewish People.² *Moses and *David, who were once actual shepherds, are described in these terms. In the High Holiday prayer, *Unetaneh Tokef*, the divine shepherd caring for his sheep is a central image.

When the Children of Israel were about to leave *Egypt, God commanded them to sacrifice a lamb and smear its *blood on the doorposts as a sign for the *Angel of Death.³ This paschal sacrifice became an integral part of the *Passover ritual until the Temple was destroyed. After that, a roasted shankbone was placed on the *seder plate as a symbol of the slaughtered paschal lamb.

Because lambs are born in the spring and are also associated with the spring holiday of Passover, the Festival of National Redemption, they are symbols of rebirth and regeneration. Although the pagan *Zodiac represents the first spring month as Aries the Ram, early Hebrew mosaics depict this sign as a *taleh*, a lamb.

¹Isaiah 53:7; ²Jeremiah 23:2-3; Ezekiel 34; Psalm 23; ³Exodus 12:3-11.

Signifies: INNOCENCE, JEWISH PEOPLE, MARTYRDOM, REBIRTH, SACRIFICE, VICTIMIZATION

Generic Categories: Animals, Passover

See also: *Akedah*, David, Moses, Ram, Sacrifice, *Seder*, Shofar, Zodiac

SHEKHINAH – שְׁכִינָה. *Shekhinah*, meaning "resting" or "dwelling," refers to the Divine Presence, usually characterized as the feminine aspect of God. Although this name for God does not appear in the Bible, God is often described as "dwelling" (*shohen*–שׁוֹכֵן) among the people or in *Jerusalem.¹ The name of the portable sanctuary in the *wilderness, the *Mishkan*, "the dwelling place," derives from the same Hebrew root.

In rabbinic literature, the *Shekhinah* refers to God's manifestation in the material world, especially through the image of *light: "Just as the *sun radiates through the world, so does the *Shekhinah*."² The rabbis sometimes characterized the *Shekhinah* as God's *face or *wings.³ Although the *Shekhinah* can be found everywhere, they maintained that Her presence is especially strong among the Jewish People, among the righteous, and among the vulnerable.⁴ However, some rabbis maintained that the *Shekhinah* absented Herself from the Jewish People after the First *Temple was destroyed, or that She went

into exile after the destruction of the Second Temple, waiting to be redeemed, like the People Israel, by the *Messiah.[4]

Fearful of the polytheistic implications of the concept of the *Shekhinah*, medieval Jewish philosophers, such as Saadiah Gaon, Maimonides, and Yehudah Halevi, insisted that the *Shekhinah* was not actually divine, but was rather a divinely *created* being, serving as an intermediary between God and humankind. Thus, they explained that when *Moses and the Prophets encountered God, it was actually the *Shekhinah* with whom they spoke.

In contrast, *kabbalists placed the concept of the *Shekhinah* at the center of their mystical system. The *Shekhinah*—also called *Malkhut* (Kingship), Princess, Daughter, Bride, Wisdom, and Divine Speech—is the tenth and most immanent of the *Sefirot, the feminine principle of God acting in the world. Just as the *moon receives the sun's reflected light, so She receives the divine light from the other *Sefirot* and radiates it upon the earth. The kabbalist Gikatilla even claimed that She appeared on earth in the forms of *Sarah, *Rebecca, and *Rachel.[6]

According to kabbalistic theory, the original divine unity was shattered at the beginning of Creation so that God's masculine aspects (the *Sefirot* called *Tiferet* and *Yesod*) were separated from the feminine, the *Shekhinah*. The Jewish People's task is to bring together—through prayer, study of Torah, and performance of the *mitzvot* (commandments)—the *ten separate *Sefirot*, thereby restoring that original divine unity. Because the *Shekhinah* is the part of God closest to the physical world and thus to us, it is most vulnerable to the *Sitra Ahra*, the forces of evil, and to suffering. As the Jewish People wanders in its exile, so too does the *Shekhinah* remain exiled from the Godhead; as the Jews suffer, so does the *Shekhinah*.

Hasidim further developed this idea of the exile and suffering of the *Shekhinah*, claiming that heartfelt prayer and good deeds have the power to ease her travail. The Komarner Rebbe taught: "He who voluntarily leaves his home and wanders about as a beggar, living a life of discomfort, but trusting always in the Lord, becomes a partner in the 'Exile of the *Shekhinah*.' "[7]

Kabbalists also associated the *Shekhinah* with the Torah, especially the Oral Law, that is, the rabbinic traditions interpreting the Bible for later generations and setting out the halakhic system governing Jewish behavior. Through good deeds and meditation, a righteous person illumines the *Shekhinah*, "stripping her of the somber garments of literal meaning and sophistry and adorning her with radiant garments, which are the mysteries of the Torah."[8]

According to folk belief, the *Shekhinah* is present in the *ner tamid above the *ark, in the light of *Shabbat* and holiday *candles, in a *minyan (prayer quorum), in a home blessed by marital harmony, in a person performing good deeds, and in the light shining through the *Kohen*'s fingers as he recites the *Priestly Blessing.

In modern times, Jewish feminists have embraced and elaborated upon the image of the *Shekhinah*, contending that it serves as an important counterweight and alternative to the predominantly patriarchal, male imagery of traditional Jewish texts and liturgy. The *Shekhinah* has long been associated with the moon, another key feminine symbol within Jewish tradition and one especially popular in contemporary feminist theology and ritual.

[1]Exodus 25:8; 29:45; Numbers 5:3; 1 Kings 6:13; Isaiah 33:5; Ezekiel 43:9; Zechariah 2:14-15; 8:3; Joel 4:17, 21; Psalm 135:21; [2]*Sanhedrin* 39a; [3]*Avot de-Rabbi Natan* 2:6; *Shabbat* 31a; [4]*Bava Batra* 25a; *Shabbat* 67a; *Berakhot* 7a inter alia; [5]*Yoma* 9b; *Megillah* 29a; [6]*The Gates of Light*, chapter 5, Part I, 230 (Yosef ben Shlomo, 2nd revised edition, 1981); [7]Newman, *The Hasidic Anthology* (1987), 502; [8]*Zohar* 1:23a-b.

Signifies: DIVINE GLORY, DIVINE PRESENCE, EXILE, FEMININE, FEMINISM, GOD, INTERCESSION, ORAL LAW, SUFFERING

Generic Categories: Kabbalistic Symbols, Messiah, Women

See also: Bird, Kabbalah, Light, Moon, *Sefirot*, Sun, Western Wall, Wings

SHIFRA AND PUAH – שִׁפְרָה

וּפוּעָה. As the Israelites in Egypt greatly increased in number, the Torah relates that *Pharaoh, fearful that their growing population posed a threat to his power, ordered

the midwives Shifra and Puah to throw all Hebrew male babies into the Nile. When he discovered that they had disobeyed his orders, Pharaoh first tried to seduce, then to threaten the midwives into obedience. They protested that the Israelite women were so vigorous that they had already given birth before the midwives could arrive to carry out Pharaoh's command.[1]

Because of their courage, God rewarded Shifra and Puah by making them the ancestors of *priests and *kings. Legend claims that Shifra and Puah were none other than Yoheved and *Miriam, mother and sister of *Moses, whose line includes the *Davidic monarchy.

In our own day, Shifra and Puah have been regarded as models of spiritual resistance and civil disobedience. For example, Brandeis University Hillel has conferred a "Shifra and Puah Award" for courageous acts of civil disobedience.

[1]Exodus 1:15-21; *Sotah* 11b.

Signifies: CIVIL DISOBEDIENCE, COURAGE, RESISTANCE

Generic Categories: Passover, Personalities, Women

See also: Miriam, Moses, Pharaoh

SHOFAR – שׁוֹפָר.

The *ram's horn, known as the *shofar* (from the Hebrew root meaning "beauty"), is one of the oldest Jewish symbols. The *Torah states that the Giving of the *Ten Commandments was preceded by loud *shofar* blasts upon Mount *Sinai.[1] Joshua brought down the walls of Jericho with *shofar* blasts.[2] The Bible calls *Rosh Hoshanah, *Yom Teruah*, a "day of blowing,"[3] acknowledging the centrality of the *shofar* on this festival. The *shofar* was also used in biblical times to proclaim the Jubilee Year, to accompany other instruments, to induce fear, to call the people to war, to escort processionals, and to solemnize coronations.[4]

Of all the *shofar*'s associations, none has been so enduring as its connection to Rosh Hashanah, the New Moon of the New Year. This holiday continues to center around the sounding of this ancient instrument. Although the Talmud permits that *shofars* be made from the horns of the *sheep, domestic and wild *goat, antelope,

and gazelle, as well as the ram, it strongly recommends that the latter be used because of the ram's association with the story of the *akedah*, the binding of Isaac, which is read in synagogue on this festival.[5] When the *angel stayed *Abraham's knife before it killed *Isaac, God commanded Abraham to sacrifice a *ram instead of his son. In remembrance of Abraham and Isaac's willingness to do God's will, and of God's mercy—an appropriate model for this season of repentance— the rabbis favored the ram over other animals. They also forbade the use of the cow's horn, which might tempt *Satan to remind God of Israel's previous sin of the *Golden Calf and so bias God against forgiving their current sins.[6] The *shofar* is also blown every morning—except on *Shabbat*—during the month of *Elul*, which precedes Rosh Hashanah, reminding Jews to repent. A single long blast signals the end of *Yom Kippur, the Day of Atonement.

Varying shapes of the *shofar*. Traditionally, a *shofar* can be carved or gilded, but not pointed; its mouthpiece must be left natural.

According to the hasidic master, the Baal Shem Tov, the *shofar* teaches us that repentance must come from the depths of the soul: "There are many halls in the king's *palace, and intricate keys to all the doors, but the ax is stronger than all of these. The master key [to God's house] is the broken heart."[7]

From biblical times, the *shofar* has been associated with *messianic redemption. The *midrash* claims that the left horn of the ram sacrificed by Abraham was sounded on Mount Sinai and the right will be blown "in a time to come at the assembling of the dispersed."[8] Isaiah prophesied: "And in that day a great horn shall be sounded, and they who were lost in the land of Assyria, and they who were dispersed in the land of

*Egypt, shall come and worship the Lord on the holy mountain in *Jerusalem."[9] In the Middle Ages, the legend arose that *Elijah would herald the coming of the Messiah by blowing the *shofar* three days before his arrival. The *shofar* will also announce the resurrection of the dead. Among some Sephardim, the *shofar* is blown at funerals.

After the biblical period, the *shofar* lost its function in Jewish priestly, military, and civil ceremonies, but continued evolving in Jewish tradition. A special black *shofar* was sometimes used to announce excommunication from the Jewish community. The *shofar* was also blown on fast days, to announce a death, and to signal the time to stop work, light *candles, and usher in the *Shabbat*. In modern Israel, the *shofar* has been used to inaugurate new presidents, to mark solemn occasions, and to celebrate military victories, such as the liberation of the *Western Wall in 1967. It is also sometimes used in American Jewish communities at public ceremonies.

Because of its importance in Jewish life, the *shofar* has long been a popular motif in ceremonial and decorative art. In ancient synagogues, on tombs and ritual objects, *shofars* were often depicted together with the *menorah*, *lulav*, *etrog*, and Temple implements to symbolize hope in messianic redemption.

It was an ancient belief that the loud noise of the horn deterred demons. Jewish tradition has linked the blowing of the *shofar* with this function. The rabbis claimed that the *shofar* is sounded on *Rosh Hashanah "in order to confuse *Satan."[10] *Kabbalists reinforced this notion by pairing the *shofar*-blowing ritual with biblical readings of special mystical significance.

[1]Exodus 19:16, 19; [2]Joshua 6:20; [3]Numbers 29:1; [4]Leviticus 25:9–10; Psalm 98:6; Amos 3:6; Judges 3:27; Joshua 6:4; Saadiah Gaon quoted by Avudraham in Agnon, *Days of Awe*, 71; [5]*Rosh Hashanah* 16a; [6]*Rosh Hashanah* 26a; [7]Buber, *Tales of the Hasidim: Early Masters*, 64; [8]*Pirke de-Rebbe Eliezer* 31; [9]Isaiah 27:13; [10]*Rosh Hashanah* 16b.

Signifies: ANTIDEMONIC, DANGER, DIVINE COMPASSION, HONOR, POWER, REDEMPTION, REPENTANCE, RESURRECTION, ROYALTY, STRENGTH, SUBMISSION TO GOD'S WILL

Generic Categories: Animals, Death, Messiah, Rosh Hashanah, Temple, Yom Kippur

See also: *Akedah*, Horn, Kabbalah, Messiah, Moon, Moses, Oil, Ram, Rosh Hashanah, Satan, Sinai

SHROUD – תַּכְרִיכִים.

Traditionally, a Jew is buried in a shroud, called *tahrihin* or *sargenes*, from the German word *sarg*, meaning "coffin." The simple *white shroud, made of muslin, linen, or cotton, is the same for all, rich or poor, to symbolize our equality before God. The inexpensive white cloth symbolizes purity, simplicity, and honor. There are no seams, *knots, or buttons. The shroud also has no pockets, signifying that it is a person's soul, not wealth, that will be judged in the World to Come.

Traditionally, a man's shroud consists of *seven parts: a headpiece (*mitznefet*), pants (*mihnasayim*), a shirt (*ketonet*), belt (*avnet*), *kittel*, *tallit*, and sheet (*sovev*). (Until modern times, women's shrouds have not included the *kittel* and *tallit*.) The names of some of these garments derive from the *clothing of the High *Priest in the ancient *Temple.

When the body is dressed by the members of the *Hevrah Kadisha* ("the holy [burial] society"), various ties are looped without knots into the form of the Hebrew letter *shin*, standing for *Shaddai*, one of the *Names of God. The *kittel* is stripped of its snaps or buttons; the *tallit*, of its ornaments. One of the *tzitzit* is cut and placed in a corner of the *tallit*, symbolizing the severing of the bond of life.

Signifies: EQUALITY, HOLINESS, HONOR, PURITY, SIMPLICITY

Generic Categories: Clothing, Death

See also: Clothing, *Kittel*, *Tallit*, White

SINAI – סִינַי.

In most religious traditions, *mountains symbolize the place where heaven and earth meet, the world axis (Axis Mundi). Upon mountaintops, religious seekers achieve communion with the divine and spiritual authority.

The most famous mountain in Jewish tradition is Mount *Sinai, also known as Mount Horeb, where God was first revealed to Moses in the *Burning Bush and later revealed the *Ten Commandments to the Children of Israel.[1] The prophet *Elijah also experienced a theophany upon this mountain.[2] Significantly, it is the only mountain sacred to Judaism that lies outside of Israel, and its precise location is unknown, although the Saint Katarina Monastery in the Sinai Desert claims to be built upon that site. Mount Sinai's location outside the Land of Israel bears witness to God's omnipresence in the world.

The description of the Giving of the Ten Commandments on Mount Sinai is one of the most dramatic scenes in the Torah, and has given rise to voluminous commentary. The Israelites prepared themselves for the Revelation for *three days, and were forbidden to set foot on the mountain itself. On the day of the Revelation, the mountain was surrounded by clouds and "consuming fire," and shaken by a violent thunderstorm and earthquake. The people *heard* the lightning and *saw* the thunder.[3] Although the *midrash* boasts that of all the nations, only Israel willingly embraced the Torah, another legend claims that they were actually intimidated into accepting the Law because God held the mountain over their heads and threatened to drop it on them if they did not.[4] So terrified were the Israelites by God's presence on the mountain that, according to another legend, they died upon hearing the First Commandment and had to be resurrected by the *dew. On that great day, even the *birds ceased their song; all other creatures, their speech; the sea, its roar; and the *angels, their praise at the sound of God's voice.[5]

According to another tradition, Mount Sinai was originally a part of Mount Moriah, the site of the *akedah*, but separated itself so that Israel could receive the Torah in the *wilderness. In the Messianic Era, Sinai will reunite with Moriah to be the future site of the *Temple.[6]

One of the most famous legends about Sinai is that it was chosen by God for the Revelation because of its humility, just as God chose to speak to Moses out of the lowly bramble on this very same mountain. Though many other mountains vied for the honor, God chose Sinai because it was the

"smallest and most insignificant of all," a symbol of God's justice and compassion.[7] It was also the only mountain upon which idols had never been worshiped.[8]

Throughout Jewish history, Sinai has been a symbol not only of the Ten Commandments and the Torah, but of the entirety of Jewish Law. According to ancient tradition, not only the Written but also the Oral Law was given to *Moses on Mount Sinai, that is, all the subsequent rabbinic interpretations of the Bible contained in the Mishnah, Talmud, and centuries of rabbinic responsa. The expression *"Torah mi-Sinai"* has come to signify for Orthodox Jews the unchanging authority of the Written and Oral Law.

According to tradition, 600,000 Jews stood at Sinai and heard God's voice. The *Kabbalah claims that these 600,000 souls continuously transmigrate into new Jewish souls throughout the centuries until they achieve ultimate perfection, *"tikkun."* Another interpretation claims that all Jews, even those yet unborn, were present for the giving of the Torah. Thus, Sinai was the meeting place of past and future, as well as of heaven and earth.

[1]Exodus 3:12; chapter 20; Deuteronomy, chapter 5; [2]1 Kings 19:8–18; [3]Exodus 19:16–20; 20:15; 24:16; [4]*Shabbat* 88a; [5]Ginzberg, *Legends of the Jews* 3:94–98; [6]*Midrash Tehillim* 68:9; 87:3; [7]Ibid.; [8]*Genesis Rabbah* 99:1.

Signifies: DIVINE AUTHORITY, DIVINE COMPASSION, DIVINE JUDGMENT, DIVINE PRESENCE, HOLINESS, HUMILITY, LAW, REVELATION, TIKKUN OLAM

Generic Categories: Places, Shavuot

See also: Burning Bush, Fire, Flowers, Kabbalah, Moses, Mountain, Shavuot, Ten Commandments, Torah

SIX HUNDRED AND THIR-TEEN – 613 – תרי"ג.

According to rabbinic tradition, there are 613 commandments specified in the *Torah – 365 negative commandments (prohibitions), corresponding to the days of the solar year or the sinews of the body, and 248 positive commandments, corresponding to the bones of the human body.[1] This number is often referred to by its four-letter Hebrew

acronym — "*taryag*" — whose numerical value equals 613. Throughout the centuries, many scholars have categorized these commandments according to various systems: (1) negative and positive; (2) arranged according to the *Ten Commandments; (3) arranged according to biblical passages. In the *midrash*, the *pomegranate is distinguished by having 613 seeds, making it an especially holy fruit. Pious Jews strive toward total religious observance, represented by these 613 commandments.

Just as Jewish tradition expanded upon the basic Ten Commandments revealed by God on Mount *Sinai, so the rabbis elaborated on the biblical ten plagues in the *Haggadah*. Added together, their count equals 613.

[1] *Makkot* 23b.

Signifies: HOLINESS, MITZVOT, ORTHODOXY, PIETY, SUBMISSION TO GOD'S WILL, TORAH

Generic Categories: Numbers

See also: *Haggadah*, Numbers, Pomegranate, Torah

SIX MILLION. During the Holocaust (derived from the Greek, meaning "whole burnt offering"), 1938-1945, the Nazis murdered six million Jews, along with millions of other Europeans. This number accounts for two out of every three Jews then living in Europe, one million of them children. With their deaths, the vital Jewish culture, which had been thriving in the *yeshivahs*, synagogues, cafes, theaters, and publishing houses (especially in Eastern Europe) for a thousand years, came to a tragic end. Much has been done to memorialize their lives and deaths — in liturgy, ceremony, literature and the arts, museums, and curricula. Holocaust Memorial Day, Yom Ha-Shoah, observed on the twenty-seventh of *Nisan*, has been added to the Jewish calendar. But perhaps one of the most moving testaments to the memory of the victims has been the designation of the number "Six Million" as a perpetual symbol of their loss. The mere mention of this number automatically conjures up the horrifying magnitude of the Holocaust in Jewish history and in the annals of humankind.

Signifies: DESTRUCTION OF EUROPEAN JEWRY, HOLOCAUST

Generic Categories: Holocaust, Numbers

See also: Auschwitz, Numbers, Warsaw Ghetto, Yellow

SOLOMON – שְׁלֹמֹה. Solomon was the son of *David and Bathsheba, the third *king of Israel, the builder of the *Temple, and the hero of many legends in both Jewish and Muslim folklore. Under his dominion, Israel achieved its greatest territorial and political power, but paid the price for such grand expansionism by being split in two after Solomon's death, never to be reunited. Solomon is famous for his wisdom, his many wives, his power, and his writings. Ironically, the Holy *Temple built by him is not known by his name but by his father's name: "the House of David."

Like so many biblical figures, Solomon's reputation reflects his flawed character. On the one hand, he presided over the most prosperous and prestigious regime in all of Jewish history. Legend even claims that his original name, "*Yedidiyah*," the "beloved of God," was changed to "Solomon" — "*Shelomo*" in Hebrew — because of the "*shalom*," peace, that characterized his reign. He extended Israel's borders beyond even their present-day extent (including modern-day Syria and Transjordan), controlled the major trade routes in the Middle East, oversaw a flourishing agricultural and commercial economy, administered an elaborate bureaucracy, built impressive structures — foremost among them the Temple and his own royal palace — and established numerous strategic alliances in the region. He also consolidated political and religious power in *Jerusalem, and participated actively in sacred rites at the Temple.

However, his extravagant taste in women (the Bible ascribes to him 1,000 wives and concubines[1]), horses, and *gold; his oppressive domestic policies, involving taxation as well as military and labor conscription; and his tolerance for pagan practices, largely introduced by his foreign wives, led his own people and later rabbinic tradition to judge him harshly. When he married the *Pharaoh's daughter, claimed the rabbis, the *angel Gabriel inserted a reed in the sea

which ultimately became the site of *Rome, the future destroyer of Israel.[2] Although Solomon is memorialized in countless folk legends, he is hardly visible in Jewish moral texts as a model and teacher.

The one exception is his role as a poet. Tradition ascribes to him authorship of three important biblical books: the Song of Songs (called the Song of Solomon in the Christian Bible), written in his youth; Proverbs, written in middle age; and Ecclesiastes, written in old age.[3] This legendary corpus of his writings is a model of maturing wisdom.

Among the many extraordinary qualities and possessions associated with Solomon are his ability to understand the language of *birds, beasts, and supernatural creatures; his magic Flying Cloak; his mechanized *throne; and his astonishing wisdom. To this day, the "wisdom of Solomon" is used as a proverbial expression signifying ingenious judgment.

[1]1 Kings 11:3; [2]Sanhedrin 21b; [3]Song of Songs Rabbah 1:1, 10; Ecclesiastes 1:12.

Signifies: GLORY, GREED, JUSTICE, POWER, WISDOM

Generic Categories: Personalities, Temple

See also: David, Jerusalem, King, Temple, Throne

SPICEBOX – קֻפְסַת בְּשָׂמִים. All

cultures value spices for their fragrance and taste. In the ancient world, spices were burned at festive meals and with sacrificial offerings. In the days when travel was dangerous and expensive, the people of Europe paid dearly for their spices and guarded them as treasures, usually in spice-towers in the local castle or city hall. Jews in the Diaspora were commonly active in the international spice trade, whose travel routes ran from western Europe to the Middle East and Orient. Spices were also valued for their purported protection against demons.

In ancient times, incense figured prominently in the *Temple service. In medieval times, perhaps in memory of the Temple, it was customary to welcome in and usher out the *Shabbat with fragrant spices, first with *myrtle and later with precious spices,

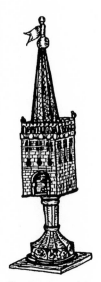

often stored in special glass containers. Because myrtle leaves were originally used, the *Havdalah spicebox came to be known as "hadas," Hebrew for myrtle, although the term is no longer current.

The rabbis called the Sabbath itself a spice.[1] They also referred to the Sabbath as a bride. It has long been customary to greet and bid farewell to one's beloved with pleasant fragrance.

According to tradition, the sense of smell is our most divine sense, our channel to the soul: "What is it

The tower, a classic shape for the spicebox used for Havdalah.

that only the soul and not the body derives pleasure from—it is the odor of sweet fragrance."[2] The rabbis claimed every Jew is blessed with an additional soul—neshamah yeterah—at the beginning of Shabbat, which departs at its close. Smelling the spices at Havdalah comforts the Jew for the loss of this special measure of spirituality. An ancient legend claims that the fires of *Gehinnom are rekindled at the end of Shabbat and produce a fearful stench. In the Middle Ages it was believed that the Havdalah spices would protect one from the odors of hell.

The most common shape of spiceboxes has been the *tower, fancifully linked to the verse from the Song of Songs: "His cheeks are as a bed of spices, as *towers of perfumes."[3] It is more likely, however, that this shape was derived from the spice towers in medieval European towns or from the monstrances (containing communion wafers), thuribles (censers), and reliquary containers used in churches. In the medieval period, most Jewish spiceboxes were made by Gentile craftsmen. Other shapes have included animals holding *crowns; *fish; *flowers; fruit; windmills; or geometric boxes. Sometimes the spicebox has been combined with a candleholder. The incredible variety and whimsy in spicebox design throughout the

centuries testifies to the creativity of the Jewish artistic imagination.

[1]*Shabbat* 119a; [2]*Berakhot* 43b; [3]*Song of Songs* 5:13.

Signifies: HOLINESS, SOUL

Generic Categories: Ritual Objects, *Shabbat*

See also: *Havdalah*, Myrtle, *Shabbat*, Tower

STAR OF DAVID — מָגֵן דָּוִד.

The evolution of the six-pointed Jewish star, the "*Magen David*," literally the "Shield of David," also known as the hexagram, or more rarely, *Solomon's Seal, is long and complex. Although it is now the most common and universally recognized sign of Judaism and Jewish identity, both within and outside the Jewish community, it has only achieved this status in the last two hundred years. Before that it was chiefly associated with magic or with the insignia of individual families or communities. Yet despite its equivocal history, Jews have long been attracted to this design and have sought to ascribe to it venerable origins. In our own day, its universal Jewish popularity, especially as the symbol of the State of Israel, has made the question of its origins moot.

Because of its geometric symmetry, the hexagram has been a popular symbol in many cultures from earliest times. Anthropologists claim that the triangle pointing downward represents female sexuality, and the triangle pointing upward, male sexuality; thus, their combination symbolizes unity and harmony. In alchemy, the two triangles symbolize *"fire" and *"water"; together, they represent the reconciliation of opposites. Some medieval alchemists even borrowed the talmudic pun — *esh mayim*, fiery water, and

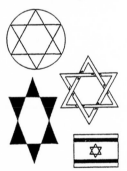

Variations on the Star of David, the most univerally recognized Jewish symbol today, included on the flag of the State of Israel.

shamayim, heaven — to demonstrate the interpenetration of the two realms.[1] Because of this symbolism, the hexagram was even used occasionally as the emblem displayed above a brandy shop.

The earliest known Jewish use of the hexagram was as a seal in ancient Palestine (6th century B.C.E.) and then eight centuries later in a *synagogue frieze in Capernaum. But these early hexagrams may have been only ornamental designs; ironically, a swastika, another popular ancient motif, appears alongside the hexagram on the Capernaum synagogue wall. In the Middle Ages, hexagrams appear frequently on churches, but rarely in synagogues or on Jewish ritual objects. It was the *menorah* that served as the primary Jewish symbol from antiquity until the post-Renaissance period, not the "Jewish star."

Although scholars have attempted to trace the Star of David back to King David himself; to Rabbi Akiva and the Bar Kokhba ("son of the star") rebellion (135 C.E.); or to *kabbalists, especially Rabbi Isaac Luria (16th century), no Jewish literature or artifacts document this claim. Rather, all evidence suggests that the early use of the hexagram was limited to "practical Kabbalah," that is, Jewish magic, probably dating back to the 6th century C.E. Legends connect this symbol with the "Seal of Solomon," the magical signet *ring used by King Solomon to control demons and spirits.[2] Although the original ring was inscribed with the Tetragrammaton, the sacred Four-Letter *Name of God, medieval *amulets imitating this ring substituted the hexagram or pentagram (five-pointed star), often accompanied by rampant *lions, for the sacred Name. The star inscribed on these rings was usually called the "Seal of Solomon."

In addition to such legends about Solomon's ring, medieval Jewish magical texts spoke of a magic shield possessed by King David which protected him from his enemies. According to these texts, the shield was inscribed with the seventy-two letter name of God, or with *Shaddai* (Almighty) or *angelic names, and was eventually passed down to *Judah Maccabee. The 15th-century kabbalist, Isaac Arama, claimed that Psalm 67, later known as the "*Menorah* Psalm" because of its *seven verses (plus an introductory verse), was

engraved on David's shield in the form of a *menorah*. Another tradition suggests that Isaiah 11:2, enumerating the six aspects of the divine spirit, was inscribed on the shield in the outer six triangles of the hexagram.[3] In time, the hexagram replaced this *menorah* in popular legends about David's shield, while the five-pointed pentagram became identified with the Seal of Solomon.

The hexagram was also widely regarded as a messianic symbol, because of its legendary connection with David, ancestor of the *Messiah. On Sabbath eve, German Jews would light a star-shaped brass *oil *lamp called a *Judenstern* (Jewish star), emblematic of the idea that *Shabbat* was a foretaste of the Messianic Age. The hexagram was also popular among the followers of Shabbatai Tzevi, the false messiah of the 17th century, because of its messianic associations.

Among Jewish mystics and wonder-workers, the hexagram was most commonly used as a magical protection against demons, often inscribed on the outside of *mezuzot* and on amulets.

Another use of the hexagram in medieval times was as a Jewish printer's mark or heraldic emblem, especially in Prague and among members of the Jewish Foa family, who lived in Italy and Holland. In 1354, Emperor Charles IV of Prague granted the Jews of his city the privilege of displaying their own *flag on state occasions. Their flag displayed a large six-pointed star in its center. A similar flag remains to this day in the Altneuschul, the oldest synagogue in Prague. From Prague, the *"Magen David"* spread to the Jewish communities of Moravia and Bohemia, and then eventually to Eastern Europe. In 17th-century Vienna, the Jewish quarter was separated from the Christian quarter by a boundary stone inscribed with a hexagram on one side and a cross on the other, the first instance of the six-pointed star being used to represent Judaism as a whole, rather than an individual community.

With Jewish emancipation following the French Revolution, Jews began to look for a symbol to represent themselves comparable to the cross used by their Christian neighbors. They settled upon the six-pointed star, principally because of its heraldic associations. Its geometric design and architectural features greatly appealed

to synagogue architects, most of whom were non-Jews. Ironically, the religious Jews of Europe and the Orient, already accustomed to seeing hexagrams on kabbalistic amulets, accepted this secularized emblem of the enlightened Jews as a legitimate Jewish symbol, even though it had no religious content or scriptural basis.

When Theodor Herzl looked for a symbol for the new Zionist movement, he chose the Star of David because it was so well known and also because it had no religious associations. In time, it appeared in the center of the flag of the new Jewish state of Israel and has become associated with national redemption.

During the Holocaust, the Nazis chose the *yellow star as an identifying badge required on the garments of all Jews. After the war, Jews turned this symbol of humiliation and death into a badge of honor.

Today, the Star of David is the most popular and universally recognized symbol of the Jewish People. In his seminal work entitled *The Star of Redemption* (1921), Franz Rosenzweig framed his philosophy of Judaism around the image of the Jewish star, composed of two conceptual "triads," which together form the basis of Jewish belief: Creation, Revelation, and Redemption; God, Israel, and World. On the popular level, Jews continue to use the Jewish star as it was used for centuries: as a magical amulet of good luck and as a secularized symbol of Jewish identity.

[1]Scholem, "The Star of David: History of a Symbol," in *The Messianic Idea in Judaism*, 271; [2]*Gittin* 68a; [3]Eder, *The Star of David*, 73.

Signifies: CONTINUITY, GOOD LUCK, HONOR, JEWISH IDENTITY, JEWISH PEOPLE, JUDAISM, REDEMPTION, SURVIVAL, ZIONISM

Generic Categories: Israel (State of)

See also: Amulet, Circle, David, Flag, Israel (State of), Kabbalah, *Menorah*, Solomon, Stars

STARS – כּוֹכָבִים.
In the Bible, stars are a symbol of limitlessness. God promises *Abraham that his children will be "as numerous as the stars of heaven and the sands of the sea."[1] For centuries, this verse has been sung at the evening *Havdalah

ceremony when the stars come out, marking the end of *Shabbat*.

Stars are also symbols of prophecy. A *midrash* claims that at Abraham's birth a bright star appeared in the *east.[2] When the pagan prophet Balaam blessed Israel against his will, he foretold that in the future "a star rises from *Jacob, a meteor comes forth from Israel; it smashes the brow of Moab."[3] In the revolt against *Rome in 135 C.E., the Jewish rebel leader, Bar Koziba, was nicknamed "Bar Kokhba," "son of the star," because he was considered by many to be the *Messiah predicted in Balaam's prophecy. (In the same period, Christians interpreted this verse to refer to Jesus, whose birth they claim was announced by the "star of Bethlehem.")

Throughout the Bible, the daily miracle of "the stars in their courses"[4] is cited to demonstrate the order and majesty of God's universe. In the ancient world, Jews were acknowledged as sophisticated astronomers.

In the ancient world, the "science" of astrology had the same authority that "natural science" has with us today. It was believed that the movements and configurations of stars and planets (composed of the same divine "ether") determined a person's fate. According to most ancient cosmologies, the *seven "planets"—Mercury, Venus, Mars, Jupiter, Saturn, the *sun, and the *moon—had a special influence on a person's life. Some scholars have speculated that this fatalism entered the cultures of the Middle East, Greece, and *Egypt when Eastern astral religions, especially from Persia, supplanted the fertility cults of these regions.

Judaism was not immune to these influences. Early in their history, the Israelites found themselves surrounded and seduced by the moon and sun gods central to Canaanite, Egyptian, and Mesopotamian fertility cults. In attacking such idolatrous practices so often and with such vehemence, the Bible clearly testifies to their popularity among the Israelites. In succeeding centuries, Judaism came under the sway of the immensely popular astral religions of both Babylonia and the Hellenistic world, whose religious and philosophical systems relied heavily on the *Zodiac, astrology, and an astral pantheon. Although the prophets and then the rabbis tried to temper these influences, they were too popular among the people to eradicate completely. To this day, astrology is still popular among Jews—as it is in the general culture.

In the talmudic period, astrology was perceived as important and valid, but the rabbis were careful to subordinate the stars' influence to the will of God. Although Raba taught that three things—longevity, fertility, and sustenance—depend not on a person's merits, but on their "stars" (*mazla*, מזלא, from *mazal*, literally "constellation"[5]), the rabbis elsewhere adamantly insist that "Israel does not come under the fate or influence of the stars."[6]

By the Middle Ages, due to the influence of popular folklore and superstition from their neighbors, Jews became even more enamored of astrological beliefs. Jewish mystics believed that God had appointed a star for each person before the earth was created, and that special *angels, governed by the chief Star-Angel Kokhbiel ("My Star is God"), guided each person's affairs throughout life.[7] In many mystical texts, the terms "angel" (*malakh*), "star" (*mazal*), "prince" (*sar*), and "deputy" (*memunneh*) are used interchangeably. Many folk practices, such as the belief in unlucky days, certain words used for spells and *amulets, many superstitions and rituals, were based upon this idea that the stars and their messenger angels controlled people's fates.

Although these folk beliefs have largely disappeared, traces of their influence remain in the popular expression, "*Mazel Tov!*" usually translated as "Congratulations!" or "Good Luck!" but which literally means "Good Constellation."

The Jewish month begins at the sighting of the New *Moon; the Jewish day, at nightfall when *three stars are visible in the sky. When performing the ceremony of *Havdalah*, which separates holy days and *Shabbat* from secular time, one waits to sight these three stars before lighting the *candle.

[1]Genesis 22:17; [2]*Sefer Yashar Noah* 18a–19a; [3]Numbers 24:17; [4]Judges 4:20; [5]*Moed Katan* 28a; [6]*Shabbat* 156a; [7]Trachtenberg, *Jewish Magic and Superstition*, 69, 260–261.

Signifies: DIVINE POWER, FATE, GOOD LUCK, LIMITLESSNESS, ORDER, PROPHECY

Generic Categories: Astronomy, Kabbalistic Symbols

See also: Abraham, Angels, *Havdalah*, Moon, *Shabbat*, *Sukkah*, Sun, Zodiac

SUKKAH – סֻכָּה. As part of the observance of the fall festival of *Sukkot, Jews erect a temporary structure called a "*sukkah*," in accordance with the biblical commandment: "You shall dwell in booths seven days."[1] It is traditional to decorate this booth with seasonal foliage, fruits, and other vegetation, and to eat one's meals within it during the *seven (in the Diaspora, eight) days of the holiday. In addition, the *four species – *lulav* (*palm branch), *willow, *myrtle, and *etrog* (citron) – are blessed in the *sukkah* as well as in *synagogue.

The *sukkah* is the most important symbol of this festival, reminiscent of the desert dwellings of the ancient Israelites as well as of the temporary shelters used to this day by field workers in the Middle East during the busy weeks of the harvest. Rabbinic literature devotes considerable attention to the specific details of the *sukkah*, specifying its dimensions, materials, and use. It is customary to drive in the first nail of one's *sukkah* at the close of *Yom Kippur to symbolize the connection between the two holy days. The walls of the *sukkah* may be constructed of any material, but the roof must be made of natural materials and covered with "*sekhakh*," vegetation that grew from the ground, symbolizing God's care for the earth and its inhabitants. The roof must be uncovered enough to see *stars when looking up, but less than fifty percent open. Although the Torah commanded the

A *sukkah*.

Jews to "dwell" in *sukkot*, rabbinical authorities, mindful of the intemperate climates to which Jews have wandered during their long exile, have permitted sleeping inside the house during this season, as well as eating inside when bad weather dictates.

The 16th-century *kabbalists introduced the custom of inviting seven biblical personalities, called *ushpizin* (Aramaic for "guests"), one each night, to one's *sukkah*, symbolic of the divine *Sefirot* as well as

the *mitzvah* of hospitality. Originally limited to male ancestors, the custom has been expanded in many contemporary communities to include biblical women as well.

The *sukkah* has come to symbolize divine protection in a more general sense. A prayer in the daily evening service asks God to "spread over us the '*sukkah*' of Your peace." In another prayer, Jews pray for the restoration of "David's fallen *sukkah*" (*sukkat David ha-nofelet*), that is, the *Temple. In modern times, the image of "*sukkat shalom*," the *sukkah* of peace, has become a symbol of the Jewish antinuclear movement, whose leaders argue that the whole earth has become as vulnerable to nuclear destruction as the fragile *sukkah* is to the natural elements. Because of the *sukkah*'s construction out of natural vegetation, it also serves as a symbol for Jewish ecologists.

[1]Leviticus 23:42.

Signifies: CONNECTION, DIVINE PROTECTION, ECOLOGY, FRAGILITY, HOSPITALITY, PEACE, SHELTER, VULNERABILITY

Generic Categories: Dwellings, Sukkot

See also: *Etrog*, Four Species, Kabbalah, *Lulav*, Myrtle, Palm, *Sefirot*, *Ushpizin*, Willow

SUKKOT – סֻכּוֹת. Sukkot, meaning "booths," is one of the three agricultural pilgrimage festivals (with *Passover and *Shavuot) mandated in the *Torah.[1] Observed on the fifteenth of *Tishrei*, the full *moon, five days after *Yom Kippur, it celebrates the joy of the harvest and commemorates the temporary shelters inhabited by the Israelites as they wandered through the *wilderness. For this festival, Jews erect a home "*sukkah*," which they decorate with seasonal fruits and vegetation, and in which they eat their meals during the *seven (in the Diaspora, eight) days of the holiday. In addition, the *four species – *lulav* (*palm branch), *willow, *myrtle, and *etrog* (citron) – are carried in procession at *synagogue and blessed in the *sukkah*. On the seventh day of the festival, called Hoshana Rabba, the willow branches are beaten on the ground while prayers invoking God's mercy are recited. This

day is regarded as a second Judgment Day, similar to Yom Kippur, when God's decrees for the coming year are finally sealed.

In biblical times, Sukkot was the most important holiday of the Jewish year, known simply as "the Holiday" ("*He-Hag*"). In *Temple days, it was the most joyous of all the festivals. According to the rabbis, a special festival called *Simhat Beit Ha-Sho'evah* ("the Rejoicing of the House of Water-Drawing") was celebrated during the intermediate days of *Sukkot at the Temple in Jerusalem. The festivities included pouring out water libations, singing, *shofar*-blowing, and dancing around golden *menorahs* with torches whose wicks were made of the priests' worn-out undergarments.[2]

The special prayers and readings for Sukkot highlight the solemnity as well as the joy of this season. On the last day of the festival, known as Shemini Atzeret ("Eighth Day of Assembly"), which the rabbis regarded as a separate holiday, the cantor recites the Prayer for *Rain, wearing a white *kittel* symbolic of the life-and-death importance of rain for the land and people. The Book of Ecclesiastes is read on *Shabbat*, underscoring the melancholy of the autumn season.

The final day of the festival is called "Simhat Torah," "The Joy of the Torah." In Israel, this holiday is celebrated on the same day as Shemini Atzeret; in the Diaspora, on the day after. On Simhat Torah, the community concludes the annual cycle for the reading of the Torah and immediately begins again. The reader chants the final verses of the *Five Books of *Moses over and over until all adult Jews (only the males in Orthodox synagogues) have a chance to recite the blessings over the Torah. All the children are then called up together and stand under a raised *tallit* to recite the blessings. In its symbolism and mood, Simhat Torah resembles a *wedding: the *tallit* held over the children's heads recalls the *huppah*; the last two people receiving Torah honors bear the special titles "Bride or Bridegroom of the Torah" and "Bride or Bridegroom of Genesis"; and members of the congregation dance and sing with the Torah scrolls in seven processionals, resembling the joyous mood of a wedding celebration.

One allegorical interpretation of the long festival season stretching from the beginning of *Elul* (the month before *Rosh Hashanah) until Simhat Torah suggests that this season symbolizes the marriage of God and the Jewish People: *Elul* is the period of courtship; Rosh Hashanah, the betrothal; Yom Kippur, the fast before the wedding; the seven days of Sukkot, the seven blessings of the marriage ceremony; Shemini Atzeret, the breaking of the glass; and Simhat Torah, the consummation.

In the Jewish *calendar, the fall festival of Sukkot serves as a mirror image of the spring festival of Passover: both occur at the full moon of a first month (liturgical and national); both mark a transition in the agricultural cycle; and each delimits a fifty-day counting period—the *Omer*, extending from Passover to *Shavuot, and the penitential period, extending from the first of *Elul* until Shemini Atzeret—culminating in the harvest.

In ancient times, Sukkot became associated with messianic redemption because of Zechariah's prophecy that, at the End of Days, "all who survive of all those nations that came up against Jerusalem shall make a pilgrimage year by year to bow low to the *King, Lord of Hosts, and observe the Feast of Sukkot."[3] Images of the *lulav* and *etrog* were popular motifs in ancient Jewish art, symbolizing messianic hope and the future rebuilding of the Temple.

The Pilgrims based their celebration of Thanksgiving on the biblical harvest festival of Sukkot.

Because of its ornamental opportunities, this festival has inspired a long tradition of Jewish art and creativity—in *sukkah* construction and decorations, *etrog* boxes, *ushpizin* charts, and cuisine.

[1]Leviticus 23:39–43; Deuteronomy 16:13-15; [2]*Sukkah* 4:9-10, 5:1-5; [3]Zechariah 14:16.

Signifies: HOPE, HOSPITALITY, JOY, MARRIAGE, REDEMPTION, SOLEMNITY, THANKSGIVING, VULNERABILITY

Generic Categories: Messiah, Sukkot

See also: Calendar, Circle, *Etrog*, Four Species, *Lulav*, Kabbalah, Moon, Myrtle, Rain, *Sefirot*, *Sukkah*, *Ushpizin*, Seven, Water, Willow

SUN – שֶׁמֶשׁ. From earliest times, the sun, the earth's source of light, heat, and life itself, has been venerated and often worshiped as a god. Solar eclipses have been regarded as terrible omens or expressions of heaven's displeasure. The *moon, reflector of sunlight, has been viewed as the sun's nemesis, helpmeet, or rival. Because the sun shines with persistent brightness and heat, it has symbolized eternity, power, omniscience, and immortality. Riding from the *eastern to the western horizon each day, the sun has been imagined as a *chariot or charioteer. Its *golden sphere encircled by radiating beams of light has been likened to a *lion's mane. Sometimes it has been regarded as a male deity, source of strength and wisdom; other times as female, source of wisdom and life; sometimes these roles have been merged or shared. The shortening of days as winter approaches has always brought anxiety; the increasing light after the winter solstice, rejoicing.

The inhabitants of ancient Palestine worshiped the sun god "Shamash," from whose name derives the Hebrew word for sun. The Torah expressly forbade such sun-worship for the Israelites when they entered the land.[1] But later kings ignored this taboo, even setting up horses and chariots of the pagan sun god in the entrance to the Holy *Temple. King Josiah (621 B.C.E.) finally abolished this cult.[2]

But sun-worship returned in a new form under the influence of Hellenism. With the penetration into the West of Eastern astral religions, with their emphasis on fatalism and immortality, as well as the metamorphosis of Greek and Roman religions from fertility cults to complex astrological systems with the sun, planets, and *stars at their centers, and the growing popularity of logic, science, and rationalism among Greek philosophers, pagan polytheism gradually gave way to a kind of universal monotheism, more and more focused upon the sun god Helios, source of wisdom and immortality. Among Jews of this period, especially Hellenized ones, *amulets began appearing which addressed "God in the Heavens" as "Helios."[3] A number of ancient *synagogue floor mosaics, most notably in Beit Alpha in the Galilee, portrayed Helios in his chariot ("quadriga") pulled by the *four horses of the sun.

The rabbis, sensitive to the immense attraction that the sun exerted on the popular imagination, provided an alternative "mythology" to draw the people back to Jewish monotheism. The sun and moon were personified in legend: at the beginning, these two heavenly bodies were created equal, but the moon's jealousy led to its being diminished in size. The rabbis also claimed that the sun bows down daily to God, and rides in a chariot, led by one host of *angels by day and another by night.[4] They taught that the sun is actually *white, but turns *red in the morning when it passes through the *roses of the Garden of *Eden, and red again at night when it passes through the *fires of *Gehinnom.[5] The sun's rays have the power to heal; and a solar eclipse, the power to prophesy the future.[6] Sunshine is considered a foretaste of the world to come, similar to Shabbat and sexual intercourse.[7]

The Jewish *calendar is both lunar and solar, attuned to the agricultural cycles governed by solstices and equinoxes, as well as the monthly rhythms of the waxing and waning moon. The Jewish day begins at sunset, a practice probably adopted during the Babylonian exile (the 6th century B.C.E.). Once every 28 years, Jews recite Birkat Ha-Hamah, "the Blessing of the Sun," a thanksgiving service for the sun's creation and continued blessings. The next occasion for this service will be the first Wednesday in Nisan, 2009.

The Hebrew word for *east — mizrah — comes from the root "to cast forth rays." Although facing east to worship was once connected with pagan sun-worship, Judaism has reinterpreted the practice as a sign of reverence for *Jerusalem, which lies to the east of most Jewish communities in the Diaspora. (Communities in other regions pray in whichever direction points them toward Jerusalem.)

[1]Deuteronomy 4:19; [2]2 Kings 21:3–5; 23:11; [3]Goodenough, Jewish Symbols in the Greco-Roman Period, 121; [4]Pirke de-Rebbe Eliezer 6; [5]Bava Batra 84a; [6]Bava Batra 16b; Sukkah 29a; [7]Berakhot 57b.

Signifies: BLESSING, GOD, HEALING, POWER

Generic Categories: Astronomy

See also: Calendar, Chariot, East, Gold, Light, Lion, Moon, Stars, Zodiac

SYNAGOGUE – בֵּית־כְּנֶסֶת.

Synagogue – a Greek word meaning "place where people come together" (*kenishta* in Aramaic; *knesset* in Hebrew) – has been the most important institution in Judaism since the destruction of the Second *Temple in 70 C.E. It developed in the Babylonian Diaspora after the destruction of the First Temple (586 B.C.E.), and remained popular even when the exiles returned to Palestine, existing alongside the reconstructed Temple. By the first century of this era, the synagogue was firmly established as an institution in the daily life of the people, a place where they prayed, read the *Torah, and learned from rabbinic teachers. Early synagogues were also established in *Rome, *Egypt, and Babylonia. Wherever Jews wandered in their exile after the Roman conquest, they built synagogues as the centers of their new communities.

After its destruction, the Temple in *Jerusalem remained in the people's memory as a symbol of lost nationhood, monarchy, and the *Priestly Cult. Many of the customs and physical features of the Temple were transferred to the synagogue; others were expressly forbidden as an act of memorial for the Temple. Prayer became a substitute for sacrifice, which was now proscribed. The synagogue became the center for worship, study, and communal activities.

Synagogue architecture has been extremely diverse, usually reflecting the popular styles of the dominant culture in which Jews live. Sometimes these structures have been extraordinarily ornate, rivaling Christian cathedrals or grand mosques; in other times and places, they have been quite simple. Medieval synagogues usually had unpretentious exteriors in accordance with Christian law. In some communities hostile to Jews, the synagogue took on the features of a fortress. No specific requirements or restrictions have been legislated about the synagogue's external appearance.

The interior, however, has been subjected to more rabbinic regulation. Based upon *Daniel's practice of praying by windows facing Jerusalem, the rabbis ruled that a synagogue must have windows.[1] (Twelve are recommended, symbolic of the *Twelve Tribes.[2]) The *Zohar* declares that "a synagogue should have great light."[3] Rashi proposed that worshipers should see

the sky, which inspires reverence.[4] Whenever possible, the synagogue was to be constructed on the highest spot and be the highest building in the city (a goal rarely attained). Typically there is a hallway between the synagogue entrance and the sanctuary to allow the worshiper to make a proper transition from secular to holy space. Although many early synagogues had their entrances oriented toward Jerusalem, this custom was abandoned when the once-portable *ark was fixed in the *eastern wall. The rabbis felt that it was better to enter approaching the ark so that one could bow before it as a sign of respect.

The *Torah scrolls, the holiest objects within the synagogue, are housed in the *ark, the *aron kodesh*, behind the *parokhet* curtain, and illumined at all times by the eternal light, the *ner tamid*, an arrangement reminiscent of the ancient Temple. The elevated reading platform – called the *bimah in Ashkenazi congregations and the *"tevah"* in Sephardi congregations – has traditionally been in the center of the sanctuary, but has been moved in many newer synagogues to the front of the sanctuary before the ark. Women have traditionally sat in a separate section in the periphery, rear, or upstairs, often separated from men by a divider called a *mehitzah*. Liberal congregations have abolished this separation.

Although not as holy as the Temple, the synagogue has acquired a considerable measure of sanctity as its symbolic replacement. Ritual objects and space itself increases in holiness the closer they are to the ark and the Torah scrolls. Synagogues tell the history of Jewish communities and are the repositories of historical documents, memorabilia, folk art, and libraries. Thriving Jewish communities are often symbolized by their main synagogues, which are a source of pride to their members.

The decoration of synagogue interiors has been as diverse as their exteriors. Some are simple; others, lavishly adorned. The *Zohar* ("Book of Splendor") instructed that "a synagogue should be a place of great beauty . . . wonderfully decorated, for it is an earthly copy of the heavenly original."[5] From ancient times, it has been customary to honor donors by inscribing their names on walls, plaques, or Torah ornaments.

The ark is usually elaborately decorated. Early synagogues were often decorated with festival and ritual symbols such as the *lulav, *etrog, *shofar, and *menorah; pictures of the *Zodiac, biblical scenes, and animal and floral designs. Later synagogues added stained glass windows, the *Tree of Life, rampant *lions, the *Star of David, as well as many biblical and rabbinic verses. A unique architectural phenomenon in synagogue history were the fanciful wooden synagogues of Poland, many with lavishly painted ceilings; most of these were destroyed during the Holocaust. In some European communities, several of the many beautiful synagogues demolished by the Nazis have been restored as a memorial to the slaughtered Jewish populations. In our own time, North American synagogues continue to express the spirit of the Jewish artistic imagination and the material prosperity of their communities.

[1]Daniel 6:11; *Berakhot* 34b; [2]*Shulhan Arukh, Orah Hayyim* 90:4; [3]*Zohar* 2:59b–60a; [4]*Berakhot* 34b; [5]*Zohar* 2:59b–60a.

Signifies: CENTER, CONTINUITY, HOLINESS, JEWISH COMMUNITY, JEWISH HISTORY, JEWISH IDENTITY, JEWISH IMAGINATION, JEWISH PRIDE, PRAYER, STUDY, WORSHIP

Generic Categories: Dwellings, Prayer, Synagogue

See also: Ark, *Bimah*, East, Jakhin and Boaz, *Menorah*, *Ner Tamid*, *Parokhet*, Temple, Torah

TABLE – שֻׁלְחָן.
The table is the center of Jewish family life, especially on the *Shabbat and holidays. It is the place where Jews derive both their physical and spiritual sustenance, where generations meet, where moments of consecration and thanksgiving regularly occur.

Although the table no doubt fulfilled these roles even while the *Temple still stood in *Jerusalem, after the Temple's destruction, the rabbis focused on the family table as a replacement for the national religious shrine, designating it *mikdash me'at*, a little sanctuary. Many of the rituals and blessings said over food recall the sacrifices performed at the Temple.

Since the primary purpose of the sacrificial *altar was to "bring one closer to God" — from the Hebrew root *mekarev* — the table also became a place where Jewish moral teachings took on concrete form, notably through learning and *tzedakah*, acts of charity. The table thus came to symbolize Jewish values in action.

The rabbis taught that "if three have eaten at a table and have spoken no words of Torah, it is as if they had eaten of sacrifices to dead idols . . . but if [they] have spoken words of Torah, it is as if they had eaten at the table of the Divine Presence."[1] In hasidic communities, the rebbe's "*tish*" (Yiddish for "table") refers both to the rabbi's table and to the teachings that take place around it during Sabbath and holiday meals.

Hospitality, *hakhnasat orhim*, has been an important Jewish value since *Abraham and *Sarah's time. According to the rabbis, when we invite guests to our table, especially needy ones, we thereby make atonement for our sins, just as the Temple altar used to atone for Israel's sins.[2]

The *Passover *seder, which takes place around the family table, is the longest and most elaborate table ritual in Jewish life today. The Hebrew term for the actual meal, "*shulhan orekh*," literally "prepared table," became the name for the 16th-century code of Jewish law, the *Shulhan Arukh*, arranged by Joseph Caro, which still guides contemporary Orthodox practice.

[1]*Pirke Avot* 3:4; [2]*Berakhot* 55a

Signifies: ATONEMENT, CHARITY, FAMILY, HOSPITALITY, SANCTUARY

Generic Categories: Food

See also: Altar, *Hallah*, *Kashrut*, Salt, *Seder*, *Shabbat*

TALLIT – טַלִּית (ציצית).
The *tallit*, which originally meant "gown" or "cloak," is the traditional prayer shawl worn either after the age of *Bar or *Bat Mitzvah*, or in some Orthodox communities, worn only by married men. Ritual fringes, called *tzitzit*, are attached to each of the *four *corners of the *tallit* in accordance with biblical law, so that the wearer

will "look at [these fringes] and recall all the commandments of the Lord and observe them, so that you do not go astray after your own *heart and *eyes."[1] Traditionally, the *tallit* (called *tallis* in Ashkenazi pronunciation) has been *white with black or *blue stripes, made most often of wool but sometimes of cotton or silk; in recent times, *tallitot* have become more varied in color, inspired by *kabbalistic color symbolism or aesthetic preference. The *number and colored pattern of the stripes have mystical significance. On the High Holy Days (*Rosh Hashanah and *Yom Kippur), it is traditional to wear an all-white *tallit* symbolizing purity.

Tallit katan, or arbah kanfot, traditionally worn under clothes.

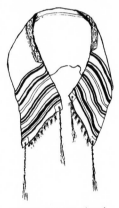

Tallit, prayer shawl.

The collar of the *tallit* has a reinforced band called an *atarah* (*crown), usually inscribed with a biblical verse or prayer, or decoratively embroidered. The special bag for carrying the *tallit* is often elaborately embroidered. Observant Jews, including those under the age of *thirteen, wear a smaller version of the *tallit* called a *tallit katan* (little *tallit*) or *arba kanfot* (four corners) under their clothes.

In ancient times, most garments—shawls, robes, capes, tunics, and togas—were rectangular in form because they were woven on looms. Jews during this period simply added fringes to their everyday clothing. When four-cornered garments went out of fashion, Jews created a special garment with fringes—the *tallit*—to observe the biblical injunction to be mindful

of God at all times. Although the Torah prescribed that the fringes be woven with "a thread of blue" (*tekhelet*), later authorities' uncertainty about the accurate identification of the Mediterranean snail (*hilazon*) from which the blue dye was extracted as well as the precise process of manufacturing the dye led to the abandonment of this practice. (A *"Tekhelet* Movement" in the late 19th century, popular among the Bratzlaver *hasidim*, was short-lived. Some contemporary Jews have reintroduced the practice.) The blue stripes now woven into many *tallitot* symbolize the ancient *"tekhelet"* as well as the blue of the heavens. The Israeli *flag was inspired by this *tallit* design.

Because of its intricate *knots and windings, the *tzitzit* have been the subject of much symbolic interpretation. The eight strings (four doubled over) attached to each of the four corners have been interpreted as symbolizing (1) the transcendental, since this number is one more than the *seven days of Creation; (2) the covenant (*brit*), symbolically enacted through the ritual of circumcision on the eighth day of a child's life (sometimes a baby is laid upon a *tallit* at a *brit*); or (3) taken all together to equal the sum of 32, as the *heartstrings, since the Hebrew word for heart is *lev* (לב), whose numerical value is 32.[2]

The *five knots that are traditionally tied in each set of eight strings symbolize the five senses; the five books of the Torah; or the first five words of the *Shema* prayer, whose sixth word, *ehad*, meaning "one," an affirmation of God's unity, is represented by the sum total of five knots and eight strings, which together equal *thirteen, the numerical value of *"ehad."* Thirteen also equals the number of divine attributes, as well as the age when one first dons the *tallit* and becomes responsible for observing the *mitzvot* (commandments).

Besides the knots, it is customary to wind one of the strings around the other seven, since the Torah specifies a "twisted thread" (*petil*) of blue. There are two different traditions as to the specific order and number of these windings: among Ashkenazi Jews, the pattern is seven, eight, eleven, and thirteen windings. (According to the Talmud, odd numbers are lucky; even numbers unlucky.[3]) The total of these windings equals 39, equivalent to "God

(YHVH) is One." Among Sephardi Jews, the pattern is *ten, five, six, five, representing the letters "YHVH," the Tetragrammaton, God's Holiest *Name, since the Torah commands that one "look at it [the fringe] and recall all the commandments of YHVH."[4]

Some Jews wrap themselves in their *tallitot* when they pray. When the *Kohanim* (descendants of the *priests) bestow the *Priestly Blessing upon the congregation, they cover their heads with their *tallitot*. Being under the *tallit* symbolizes God's protection: thus we are sheltered under the *wings of the *Shekhinah*, a safe sanctuary. When a Torah is moved from one location to another, it is sometimes wrapped in a *tallit* as a sign of respect and protection.

It is a Sephardi as well as a German custom to wrap a *tallit* around the bride and groom under the *huppah*, symbolizing their marital bond. Often a *tallit* itself is used as a *huppah*. Sometimes the bride and groom's *tallitot* are tied together, creating the *huppah* under which they "tie the knot."

On Simhat Torah (at the end of *Sukkot), all the children are called up to the Torah and sheltered under a large *tallit*. The reader says the biblical blessing recited by *Jacob over *Joseph's sons, Ephraim and Manassah: "The angel who redeemed me from all harm—bless the youngsters."[5]

Although traditionally women did not wear *tallitot*, there was a tradition in southern Germany for women to wear a special garment on Yom Kippur called a "woman's *tallit*." In recent times, many women have begun wearing the *tallit* for worship, either at their *Bat Mitzvah* or later as adults. Some design or make their own *tallitot*; others don the traditional *tallit* worn by men.[6] Although *tallitot* for women are not specifically proscribed by Jewish law, traditionalists do not accept this practice.

Observant Jews have traditionally been buried in their *tallit*, of which one fringe is cut, and a *shroud. A *tallit* is sometimes handed down within families, becoming a cherished link between the generations.

[1]Numbers 15:38; [2]Kaplan, *Tzitzit: A Thread of Light*, 84; [3]Trachtenberg, *Jewish Magic and Superstition*, 118; *Pesahim* 109b; [4]Numbers 15:39; [5]Genesis 48:16; [6]*The Precious Legacy*, ed. Altshuler, 27, n. 14.

Signifies: AWARENESS, COMMITMENT, COVENANT, DIVINE PROTECTION, DIVINE UNITY, GOD, MITZVOT, PRAYER, SANCTUARY, SPIRITUAL FOCUS

Generic Categories: *Bar/Bat Mitzvah*, *Brit*, Clothing, Death, Kabbalistic Symbols, Numbers, Prayer, Wedding, Women

See also: *Alephbet*, Blue, *Brit*, Colors, Corners, Clothing, Crown, Five, Flag, Four, *Huppah*, Kabbalah, Knots, Numbers, Shroud, Sukkot, Thirteen, Wedding, White, Wings, Yom Kippur

TEFILLIN – תְּפִלִּין.

Tefillin are two black leather boxes containing *four biblical passages (Exodus 13:1–10; 11–16; Deuteronomy 6:4–9; 11:13–21), which are bound by black leather straps to the forehead and left arm (or in left-handed people, the right arm). The box worn on the forehead (*shel rosh*) contains four compartments, each with a biblical passage written on parchment; that on the arm (*shel *yad*) has one compartment containing a single piece of parchment. *Tefillin* are worn during morning services each day except *Shabbat* and holidays (which are themselves symbols of holiness).

The commandment to wear *tefillin* dates back to the Torah: "It shall be a sign upon your hand and as a symbol on your forehead that with a mighty hand the Lord freed us from *Egypt."[1] The Bible uses three different Hebrew words for *tefillin*: *zikkaron*—memorial; *ot*—sign; and

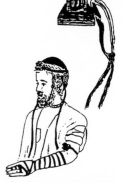

A close-up of *tefillin*, showing the four-pronged *shin*. Below, *tefillin* worn on head and arm in morning prayers.

totafot—frontlets (possibly derived from the Akkadian word for "ribbon"). The Hebrew word *tefillin* either derives from the word meaning "prayer" ("*tefillah*") or "to separate" (פלה), since wearing *tefillin*, once part of a man's daily attire, originally distinguished Jews from their neighbors.

The New Testament uses the Greek word "phylacteries" — *amulet — to refer to *tefillin* disparagingly.[2] In modern times, this Greek word, now bereft of its historical associations, is used by both Jews and Gentiles as the translation of "*tefillin*."

Tefillin are charged with symbolic significance. Their most important function is to remind Jews of the *Exodus from *Egypt and of the Jewish People's continuing relationship with God through history. Binding one's arm with the straps symbolizes submission to God's will as well as commitment to the commandments. The binding also symbolizes God's marriage to the Jewish People. When putting on *tefillin*, one recites: "I will betroth you to Me forever; I will betroth you to Me with righteousness, justice, kindness, and mercy."[3] Placing the *tefillin* on the head and on the arm, close to the heart, symbolizes the dedication of mind, body, and feelings to God's service. The leather straps around the arm and head also suggest harnessing one's will, thoughts, and actions to God.

*Kabbalists added the practice of representing the word *Shaddai* (שדי), Almighty, on the *tefillin*. The first letter, *shin*, is inscribed on the head *tefillin* as well as woven with the arm straps through the fingers of the hand; the second letter, *dalet*, is represented by the *knot at the back of the head strap as well as woven on the hand; the third letter, *yud*, is represented by the end of the head strap as well as the knot near the arm *tefillin*.

The *shin* on the head *tefillin* is written on two sides of the cube. One of these is written the usual way: ש. The other, however, has four prongs. It has been suggested that this peculiar form symbolizes the three Patriarchs (*Abraham, *Isaac, and *Jacob) and the four Matriarchs (*Sarah, *Rebecca, *Rachel, and *Leah); or that the sum of the prongs equals *seven, equivalent to the number of windings of the arm strap (or other symbolic "sevens").[4]

One begins wearing *tefillin* at the age of *Bar Mitzvah*. Traditionally, *tefillin* have been worn only by men (although there is evidence that they were worn by some women in the talmudic period, as well as by the daughters of the great medieval scholar Rashi).[5] In modern times, some women have begun to wear traditional *tefillin* or design their own.

Kabbalists believe that God, too, wears *tefillin*, composed of the prayers (*tefillot*) of the Jewish People.

[1]Exodus 13:16; [2]Matthew 23:5; [3]Hosea 2:21; [4]Lutske, *The Book of Jewish Custom*, 121; [5]*Eruvin* 96a; Henry and Taitz, *Written Out of History*, 88; According to the *midrash* (cf. Ginzberg, *Legends of the Jews* 6:274, n. 143), *David's wife Mikhal wore *tefillin*.

Signifies: COMMITMENT, HOLINESS, INTIMACY WITH DIVINE, PIETY, SELF-RESTRAINT, REMEMBRANCE, SUBMISSION TO GOD'S WILL

Generic Categories: *Bar/Bat Mitzvah*, Prayer

See also: *Alephbet*, Hand, Head, Kabbalah, Knots, Numbers, Seven

TEMPLE — בֵּית־הַמִּקְדָשׁ. The

Temple, both in its historical as well as symbolic reality, has been Judaism's holiest site, located in the holiest city, *Jerusalem. Built by *Solomon on the Temple Mount — which legend identifies as Mount Moriah, site of the *akedah*, and which the prophets named Mount Zion — it replaced the portable *Mishkan* as the site of the *Ark, housing the *Ten Commandments, and the *altar. The Temple rapidly became the religious center of the nation, a symbol of the covenant between God and Israel and of God's Presence.

The Temple existed for a thousand years as a physical structure at the heart of ancient Israel; it has lived on in the memory of the Jewish People for another two thousand years. During this time, it has acquired many names: the House of God, (*Beit Ha-Elohim, Beit Adonai*), the Holy Palace (*Heikhal*), and most commonly, *Beit Ha-Mikdash*, the Holy Sanctuary. From biblical times until the present, worshipers have faced in the direction of the Temple during prayer, even after the Temple was no longer there.

In the ancient Near East, most cultures erected shrines to their gods, characterized by sacred *gates, *portals, and pillars, leading to an *altar. The Babylonians built their temples in the form of a ziggurat, a steplike pyramid symbolic of a holy *mountain. Solomon's Temple echoed many of these architectural motifs of neigh-

boring cults: a series of gates and portals led worshipers and *priests from profane to sacred space. A pair of free-standing bronze pillars called *Jakhin and Boaz, probably symbolic of the *Tree of Life or God's Dwelling, flanked the portico of the Great Hall. The altar was shaped like a ziggurat with *horns at each of the *four *corners, symbolic of honor, kingship, and power. Yet despite these similarities, Israelite belief differed significantly from the beliefs of its pagan neighbors in conceiving of the Temple not as the abode of God, but as the resting place of the Divine Presence. When Solomon dedicated his Temple, he declared: "Even the Heavens to their uttermost reaches cannot contain You, how much less this house that I have built!"[1]

The holiest room within the Temple was known as the Holy of Holies (*Devir*), containing the Ark of the Covenant with its *cherubim perched on top. It was a perfect cube, twenty cubits on all sides. The High Priest entered this room only once a year, on *Yom Kippur, at which time he uttered the Sacred Four-Letter *Name and asked God for atonement for the people's sins. Next to the Holy of Holies was the main room, called the *Heikhal*, adjoined by a porch. Outside was the altar, to which the people brought sacrifices to be offered by the priests. The walls, floors, ceilings, and furnishings of the Temple were made of precious materials—*cedar, acacia, *gold, *olive wood, bronze, fine cloth—and elaborately decorated. Besides the altar, the Temple housed smaller sacrificial and incense altars, the *menorah*, the *twelve showbreads, and a vast bowl called the Brazen Sea supported by twelve bronze oxen. According to some accounts, worshipers removed their shoes upon entering the Temple Mount and wore *white as signs of holiness and purity.

Besides being the site of all sacrifices in ancient Israel, the Temple was also where the people came to pray, confess, seek sanctuary, assemble as a nation, and offer thanksgiving. Here the Levites sang, played instruments (lyres, *harps, cymbals, flutes, and drums) and recited psalms of praise. On the pilgrimage festivals (*Sukkot, *Passover, and *Shavuot), the people came in processions to the Temple. Even Gentiles brought sacrifices to the Temple, whose magnificence was renowned throughout the world.

Solomon's Temple, later known as the First Temple, was destroyed by Nebuchadnezzar of Babylonia in 586 B.C.E. It was rebuilt by the returning exiles in 515 B.C.E., and remained the religious center of the nation—even under foreign domination—until it was destroyed by *Rome in 70 C.E. Originally a pale imitation of Solomon's structure, the Second Temple regained its earlier magnificence due to the reconstruction undertaken by Herod. The Talmud claimed that "one who has not seen the Temple of Herod has never in his life seen a beautiful building."[2]

After Titus burned down the Temple, he carried off many of the vessels to Rome, where they were depicted on Titus's triumphal arch. To this day, many Jews refuse to walk under that arch as a sign of mourning for Jerusalem. The rabbis instituted many such memorial practices: a fast day called *Tisha B'Av; prayers for the rebuilding of the Temple and the restoration of sacrifices; the injunction to remember the Destruction of the Temple even on joyous occasions (which is one explanation for breaking a glass at *weddings); and the practice of leaving a corner of one's house unfinished in memory of the ruined Temple. The only remnant of the Temple, the *Western Wall from the period of the Herodian reconstruction, has been the focus of Jewish mourning over the Temple's destruction during two thousand years of exile. Since the 1967 reunification of Jerusalem, the Wall has become a symbol of Jewish triumph and identity.

Once it was no longer physically extant, the Temple became a symbol of Jewish tragedy as well as hope. Prayer replaced the sacrificial cult, and *synagogues replaced the Temple. Many of the features of the Temple—the ark with its *parokhet* curtain, the *Torah scroll, the menorah, the *ner tamid*—are reminiscent of their Temple source. Practices originally restricted to the Temple—the *lulav, *shofar, and *Priestly Blessing—were transferred to the synagogue. But the Talmud forbade exact duplication of the Temple. The *menorah*, for instance, could not be reproduced in all its original detail. Sacrifice was discontinued and forbidden until the re-

building of the Third Temple in the *Messianic Age. According to legend, God has built a heavenly Temple to replace the earthly one, so that Israel's sins may be atoned for.[3]

In Jewish art throughout the centuries, images of the Temple and its implements have been major symbols of Israel, holiness, and messianic hope. In mosaics and friezes of the Hellenistic period, the *menorah*, incense shovel, and ark figured prominently. In medieval illuminated Jewish Bibles, especially Italian and Spanish ones, it was common to find a two-page montage devoted to Temple imagery: the *menorah*, firepans, pots and basins, ark with cherubim, the altar, and the like. Occasionally there would also be a picture of the Mount of Olives, where the Messiah was prophesied to make his first appearance.

Ritual betrothal rings were often adorned with small replicas of the Temple, sometimes with a hinged roof to reveal the words *"mazel tov"* or the names of the bride and groom engraved inside. This practice was inspired by the biblical injunction "to set Jerusalem above my chiefest joy."[4]

[1]1 Kings 8:27; [2]*Bava Batra* 4a; [3]Ginzberg, *Legends of the Jews* 6:74, n. 381; [4]Psalm 137:6.

Signifies: ATONEMENT, BEAUTY, COVENANT, DIVINE PRESENCE, GLORY, HOLINESS, JEWISH PEOPLE, PERFECTION, PURITY, STRENGTH, UNITY
THE TEMPLE DESTROYED: ABANDONMENT, DEFEAT, DESTRUCTION, EXILE, HOPE, REMEMBRANCE

Generic Categories: Dwellings, Messiah, Prayer, Synagogue, Temple, Tisha B'Av

See also: Aaron, *Akedah*, Altar, Ark, Bread, Cherubim, David, East, Gates, *Hallah*, Jakhin and Boaz, Jerusalem, King, *Menorah*, Messiah, *Mishkan*, Mountain, *Ner Tamid*, Oil, *Parokhet*, Passover, Portal, Priestly Cult, Rome, Shavuot, *Shekhinah*, Solomon, Sukkot, Synagogue, Table, Tisha B'Av, Western Wall, White

TEN — עֶשֶׂר. Human beings have ten fingers. From this basic biological fact has emerged the decimal system, the basis for most of the world's mathematics. The an-

cients attributed symbolic significance to this anatomical model: ten represented perfection and completion. Two sacred numbers, *three and *seven, added together equal ten. The Greek mathematician Pythagoras pointed out that *one, two, *three, and *four added together equal ten, further proof of this number's mystical power.

In the Bible, ten appears numerous times. It usually signifies completeness or wholeness: The *Ten Commandments represent the essential code of human behavior. *Abraham bargains with God over the fate of Sodom and Gomorrah until he reaches the number ten; fewer than this number of righteous souls would not constitute a community worth saving.[1] God brings Ten Plagues upon *Egypt to demonstrate divine power.

In later Jewish tradition (perhaps under Hellenistic influence), ten becomes increasingly significant. The rabbis established ten as the minimum for a *"minyan," a prayer quorum, based on biblical examples.[2] During the High Holy Days, ten figures quite prominently: (1) there are Ten Days of Repentance from *Rosh Hashanah through *Yom Kippur; (2) on Rosh Hashanah, one recites ten verses in each of three special sections of the liturgy (*Malkhuyyot, Zikhronot, Shofarot*); (3) one sounds a hundred (ten times ten) blasts of the *shofar*; (4) on Yom Kippur, the tenth day of *Tishrei*, the liturgy tells of the ten rabbinic martyrs put to death by *Rome, whose punishment, according to one legend, derives from the betrayal of *Joseph by Jacob's ten other sons. In ancient times on this day, the High Priest pronounced the holy *Name of God ten times on behalf of the community.

The rabbinic anthology known as *Pirke Avot*, Ethics of the Fathers, contains many tens: (1) the Ten Sayings by which the world was created; (2) the ten generations from *Adam to *Noah, and from Noah to Abraham; (3) the ten tests of faith by which God tried Abraham; (4) the ten tests of faith by which Israel tried God in the *wilderness; (5) the ten miracles created at twilight of the Sixth Day of Creation; (6) the ten miracles attributed to the *Temple's holiness.[3]

After the conquest of the Northern Kingdom of Israel in 722 B.C.E. by Assyria,

the Jews of that region were scattered throughout the Assyrian Empire and vanished. In time, they became known as the Ten Lost Tribes.

Jewish mystics, largely inspired by Pythagorean teachings, made the number ten the heart of the system of *Sefirot*, the Divine Emanations, usually arranged in the form of a *tree, with *three higher and seven lower *Sefirot*. To *kabbalists, ten represents the perfection and unity of God.

[1]Genesis 18:22-33; [2]Genesis 18:32; Numbers 14:27; Ruth 4:2; *Berakhot* 21b; *Megillah* 23b; *Ketubot* 7a-b; [3]*Pirke Avot* 5:1-6.

Signifies: COMMUNITY, COMPLETION, JEWISH COMMUNITY, PERFECTION, UNITY

Generic Categories: Kabbalistic Symbols, Numbers, Rosh Hashanah, Yom Kippur

See also: Kabbalah, *Minyan*, Numbers, Rosh Hashanah, *Sefirot*, Ten Commandments, Yom Kippur

TEN COMMANDMENTS —
עֲשֶׂרֶת־הַדִּבְּרוֹת. The *Torah recounts that *seven weeks after redeeming the Israelites from *Egypt, God revealed the Ten Commandments to them at Mount *Sinai.[1] These ten moral principles have come to represent the essential code of human behavior in the Western tradition.

In ancient times, it was customary for the priests to recite the Ten Commandments daily as part of the *Temple service.[2] The people outside the Temple precincts, however, were forbidden to recite them so as to refute claims by heretical sects that only the Ten Commandments, not the entire Torah, were revealed at Mount Sinai. After the destruction of the Temple, the Ten Commandments

The two tablets of the law, with the commandments numbered in Hebrew, as typically represented.

were excluded from the liturgy, and are now only recited at the appropriate places in the Torah reading cycle, as well as on the holiday of *Shavuot, the anniversary of the Revelation at Sinai. The congregation stands when the Ten Commandments are read in synagogue.

Many legends expand upon the biblical account: (1) God revealed only the first two commandments, *Moses the remaining eight; (2) God spoke only the first letter, the silent *aleph*; (3) the people died of fright upon hearing God's voice and were revived by the *dew of resurrection; (4) the two alternate versions of the Ten Commandments (Exodus 20:2-14; Deuteronomy 5:6-18)—with their many discrepancies—were recited simultaneously; (5) all Jewish laws ever to be derived from the Torah were written on the two tablets between the words of the Ten Commandments. The rabbis also claimed that the commandments were inscribed on both sides of the stone; one tradition even maintained that the letters were engraved all the way through.[3]

Through time, the Ten Commandments have become synonymous with "Torah," which itself sometimes means all of Jewish law and teaching. Thus, the Revelation at Sinai, which in the biblical text involved only the Ten Commandments, is called in the liturgy "*Matan Torah*," the Giving of the Law (Torah).

Just as the ancient Ark of the Covenant housed the original tablets, representations of *Shnei Lukhot Ha-Brit*, the Tablets of the Covenant, are frequently depicted on arks as well as in stained glass windows and other parts of *synagogue interiors, typically symbolizing the entire Torah. Art historians have suggested that the familiar depiction of the tablets—two attached rectangular slabs with rounded tops—is the creation of early Christian artists. Ancient Jewish descriptions depict the tablets as cubes or even two joined hands.[4] The rounded top design was first used by Jews in a 17th-century synagogue in Amsterdam.

Instead of the entire text of the Ten Commandments, it is more common to find the first ten letters of the Hebrew *alephbet* inscribed on the two tablets representing the numbers one through ten, or

the first Hebrew word of each command-
ment.

[1]Exodus 19:16-25, 20:1-18; Deuteronomy,
chapter 5; [2]*Tamid* 5:1; [3]*Song of Songs Rabbah*
5:14, 1-2; *Rosh Hashanah* 27a; *Shabbat* 104a;
Ginzberg, *Legends of the Jews* 3:94-98; [4]*Song of
Songs Rabbah* 5:14, 1.

Signifies: JEWISH LAW, REVELATION,
TORAH

Generic Categories: Shavuot, Synagogue,
Temple

See also: Moses, Shavuot, Sinai, Ten, To-
rah, Synagogue

THIRTEEN – י״ג, שָׁלֹש־עֶשְׂרֵה.

In many cultures, thirteen is considered an
unlucky number. Friday the thirteenth is a
day to beware; the titles of modern horror
films testify to the persistence of this
popular superstition. In contrast, Judaism
has never attributed any negative qualities
to thirteen. In fact, this number carries
several positive associations within the
tradition.

When *Moses ascended Mount *Sinai to
receive the *Ten Commandments, God
passed before him in a cloud and revealed
to him the Thirteen Divine Attributes, also
known as the Thirteen Attributes of Mercy:
"(1) The Lord! (2) The Lord! (3) a God (4)
compassionate and (5) gracious, (6) slow to
anger, (7) abounding in kindness and (8)
faithfulness, (9) extending kindness to the
thousandth generation, (10) forgiving iniq-
uity, (11) transgression, and (12) sin, and
(13) pardoning."[1]

In the talmudic period, Rabbi Ishmael
developed thirteen principles with which to
explain the Torah. These are often included
in traditional prayer books.

The medieval philosopher Maimonides
formulated thirteen Principles of Faith,
which have been repeated for centuries in
the form of the popular hymn, *Yigdal*.
These principles are (1) God's eternity, (2)
unity, (3) perfection, (4) sole authority, (5)
omniscience, and (6) nonanthropomorphic
essence; (7) the truth of prophecy; (8) Mo-
ses' uniqueness as a prophet; (9) the abso-
lute authority and (10) completeness of the
Torah; (11) divine reward and punishment;

(12) the ultimate coming of the *Messiah;
and (13) the resurrection of the dead.[2]

The "*tzitzit*" (fringes) on the *"*tallit*"
(prayer shawl) consist of *five *knots
binding eight strings, for a total of thirteen.
Thirteen is also the final winding on each
tzitzit, as well as the numerical value of the
letters of *ehad*, the Hebrew word for "one."
Thus, wearing the *tallit* with its fringes
affirms God's Oneness within multiplicity.[3]

The most well known thirteen in Jewish
tradition is the age of *Bar and *Bat Mitz-
vah*. The *midrash* teaches that Abraham
was thirteen when he broke his father's
idols and set out on his own spiritual path,
and that *Jacob was thirteen when he
began his life of *Torah study.[4] According
to Jewish tradition, a boy reaches religious
and legal maturity at the age of *thirteen
plus one day, a girl at the age of twelve plus
one day. In many communities, both boys
and girls become *Bar* and *Bat Mitzvah* at
age thirteen. At that point, each is respon-
sible for fulfilling all the commandments,
the *mitzvot*.[5] This ceremony represents a
Jewish youth's attainment of full member-
ship within the community with all its re-
sponsibilities and privileges.

The *Zohar*, the mystical Book of Splen-
dor, interprets the *"rose among thorns"
mentioned in the Song of Songs (2:2) as a
symbol of the Community of Israel. It
claims that "there is a rose above and a rose
below," and that God's Thirteen Divine
Attributes of Compassion envelop the
Jewish People like a "thirteen-petaled
rose."[6] Among kabbalists, meditating on
the number thirteen as a symbol of unity
serves as a mystical *yihud* (unification with
God), since the numerical value of *ehad*
(one) equals thirteen.

The popular song in the *Passover
Haggadah, "Who Knows One?" begins
with God and ends with the Thirteen Divine
Attributes. Since the numerical value of
"*ehad*" (one) equals thirteen, the song be-
comes a circle, leading back to God.

In some communities, it is customary to
light thirteen *candles at a circumcision to
represent the thirteen tribes (counting
*Joseph's two sons, Ephraim and Manas-
seh), the twelve tribes plus the new child, or
the thirteen occurrences of the word *brit*
(circumcision) in Genesis, chapter 17. Fol-
lowing American folk custom, some fami-

lies light thirteen *candles during a *Bar* or *Bat Mitzvah* celebration.

[1]Exodus 34:6-7; [2]Commentary to the Mishnah, *Sanhedrin* 10:1; [3]Kaplan, *Tzitzit: A Thread of Light*, 84; [4]*Genesis Rabbah* 63:10; [5]*Mishneh Torah Hilkhot Ishut* 2:9-10; [6]Opening lines of the *Zohar*.

Signifies: DIVINE ATTRIBUTES, FAITH, GOD, JEWISH COMMUNITY, JEWISH IDENTITY, MATURITY, UNITY

Generic Categories: *Bar/Bat Mitzvah*, Numbers

See also: *Bar/Bat Mitzvah*, Brit, Kabbalah, Knots, Numbers, Rose, *Tallit*

THREE – שָׁלֹשׁ. In many cultures, three is seen as a symbol of balance or synthesis. It represents the reconciliation of opposites.

In Judaism, three usually represents completeness. There are three ancestral patriarchs (*Abraham, *Isaac, and *Jacob); three major pilgrimage festivals (*Passover, *Shavuot, and *Sukkot); three major divisions of the Bible (*Tanakh* – Torah, Prophets, and Writings); three verses of the *Priestly Blessing; three declarations of God's holiness in the liturgy (*kadosh, kadosh, kadosh*), echoing the *angelic choir.[1] There are also three major prayer services on weekdays: *Shaharit* (the morning service), *Minhah* (the afternoon service), and *Maariv* (the evening service), whose origins are attributed to the patriarchs. On *Shabbat*, there are three formal meals, the last known simply as "the Third Meal" (*Shal'shudes* or *Seudah Shlishit*). At the *Passover *seder*, three *matzahs represent the basic divisions of the Jewish People: Kohen, Levi, and Israel. These three divisions are also recognized during the traditional Torah service. The tradition also speaks of three Passovers: the historical event (*Pesah Mitzrayim*), the festival observed throughout the generations (*Pesah Dorot*), and the ultimate festival of redemption (*Pesah le-Atid*).

Under the influence of popular superstition and magic, Jewish folklore came to regard this number as especially potent. Three appears more often in magical texts than any other number. Magical actions were performed three hours before sunrise, three days before the New *Moon, or three days in a row; magical rituals required three objects; incantations were repeated three times; any experience, especially *dreams, recurring three times was regarded as an omen.[2] Perhaps this protective function gave rise to the custom of making three *circles with the *hands upon lighting the *Shabbat *candles.

Three is especially important for the *shofar* service during *Rosh Hashanah. The *shofar* is sounded three times in combinations of three different notes. One note, *tekiah*, has a single blast; the other two, *shevarim*, and *teruah*, consist of three and nine blasts, respectively.

In *Kabbalah, the *ten *Sefirot* are often grouped together into three higher and *seven lower *Sefirot*. The higher triad is regarded as representing the "hidden" or transcendent aspects of divinity, or the head of the cosmic *Adam (*Adam Kadmon*). The entire sefirotic *tree consists of three triangles of three *Sefirot* each, with the bottom (tenth) *Sefirah* serving as the receptive vessel for all the others. Much of this number symbolism derives from Pythagorean and Gnostic mysticism.

In Jewish law, three judges constitute a *beit din*, a Jewish court. (All Jewish courts consist of odd numbers of judges so that there can always be a majority.)

Jewish festivals conclude with the appearance of three *stars in the evening sky, symbolizing the end of holy and the resumption of secular time.

[1]Numbers 6:24-26; Isaiah 6:3; *Kedushah* prayer in the *Amidah*; [2]Trachtenberg, *Jewish Magic and Superstition*, 119.

Signifies: COMPLETION, HOLINESS, LAW, MAGIC

Generic Categories: Numbers, Passover, Prayer, Rosh Hashanah, *Shabbat*

See also: Crown, Kabbalah, Numbers, Passover, Priestly Blessing, *Sefirot*, *Shabbat*

THRONE – כִּסֵּא. The throne is a symbol of sovereign power and dignity. Just as human *kings and *queens rule their kingdoms upon a throne, so too God rules from the heavenly Throne of Glory.[1] The heavens themselves are regarded as the

throne of God.[2] So is *Jerusalem.[3] On a human level, the throne is often invoked as a symbol of the House of *David.[4]

In spatial terms, the Throne of Glory represents the apex of the celestial kingdom. The prophet Ezekiel describes a vision of this throne: "in appearance like sapphire; and on top, upon this semblance of a throne, the semblance of a human form," surrounded by a *rainbowlike radiance.[5] Based upon this and other prophetic visions, the *merkavah* mystics of 1st-century Palestine practiced a discipline of spiritual "descent" through *seven Divine *Palaces leading to the Divine *Chariot and the Throne of Glory. Medieval commentators claimed that this heavenly Throne was made of spiritual *fire and was a symbol of God's Glory.[6] *Kabbalists identify the Throne with the *Shekhinah*, God's feminine aspect.

The tradition sometimes speaks of two divine thrones, the Throne of Judgment and the Throne of Mercy.[7] Anticipating the future sins of the Jewish People, *Abraham pleads with God to remember the *akedah*, and "get up from the Throne of Judgment, and sit down upon the Throne of Compassion."[8]

The most famous earthly throne was *Solomon's, whose magnificence was dwarfed only by the *Temple itself. Made of fine *gold, marble, and jewels, it boasted an array of mechanized animals, among them *lions, *eagles, a *leopard, wolf, and ox, which roared and bellowed as each supplicant ascended its six broad steps. At the top was the throne itself, surrounded by a hawk snared in a *dove's claws, a giant *menorah*, golden *chairs for *seventy judges, figures of important Jewish ancestors, and a scroll of the Torah. This throne was eventually captured by foreign conquerors and taken to *Rome, where it disappeared.[9]

[1]Psalm 11:4; Isaiah 6:1; [2]Isaiah 66:1; [3]Jeremiah 3:17; [4]Psalm 89:5, 37; [5]Ezekiel 1:26-28; [6]Saadiah Gaon, *Book of Beliefs and Opinions*, 2:10; Maimonides, *Guide of the Perplexed* 1:9; [7]Psalm 89:15; [8]*Leviticus Rabbah* 29:3; [9]Ginzberg, *Legends of the Jews* 4:157-160.

Signifies: DIGNITY, DIVINE COMPASSION, DIVINE GLORY, DIVINE KINGSHIP, GOD, HEAVEN, JUSTICE, POWER, ROYALTY

Generic Categories: Kabbalistic Symbols, Rosh Hashanah

See also: Chair, Chariot, Fire, Gold, Kabbalah, King, Queen, Palace, *Shekhinah*, Solomon

TISHA B'AV – תִּשְׁעָה בְּאָב.

Tisha B'Av, the ninth day of the month of *Av* (corresponding to July/August), commemorates the destruction of the First and Second *Temples in *Jerusalem (by Babylonia in 586 B.C.E. and by *Rome in 70 C.E.). It is the only other full fast day—besides *Yom Kippur—in the Jewish *calendar, and is observed with many customs and rituals associated with mourning. The Mishnah recounts that on this day, the ten *spies brought back their negative report to *Moses, condemning the Jewish People to *forty years of wandering in the *wilderness.[1] Tradition also claims that several other Jewish disasters happened on this day: the final failure of the Bar Kokhba Rebellion against Rome (135 C.E.) as well as the Expulsion of Jews from England (1290) and Spain (1492).

Like *Yom Kippur, Tisha B'Av is observed by refraining from food, drink, leather shoes, anointing with perfume, bathing, and sexual intercourse. It is the only day when even studying Torah is forbidden, since that would result in pleasure. In *synagogue, the congregation sits on the floor or on low benches, reading by the light of *candles or dim lights. *Tallit* and *tefillin* are not worn. The Book of Lamentations as well as mournful prayers called *kinot* are read. People do not exchange greetings upon entering or leaving the synagogue.

Legend claims that the *Messiah will be born on this day, reversing centuries of Jewish suffering.

[1]*Taanit* 4:6.

Signifies: DESTRUCTION OF TEMPLE, MOURNING

Generic Categories: Messiah, Temple, Tisha B'Av

See also: Rome, Temple, Willow, Yom Kippur

TORAH − תּוֹרָה.

The Torah, the *Five Books of *Moses, also known as the Pentateuch, has always been revered as the source of all knowledge, the Word of God. For thousands of years, the Torah has been the foundation of Jewish law, ethics, legend, ritual, theology, art, song, and symbolism. All later generations have derived authority for innovation and reinterpretation by citing "prooftexts" (quotations) from the Torah. The tradition teaches: "Turn it and turn it; everything is in it."[1]

The Torah as a ritual object is a handwritten, unadorned parchment scroll rolled between two wooden staves, wrapped in vestments and decorated with ornaments.

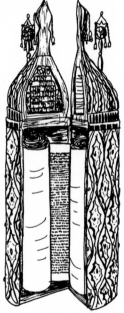

Over time, the term *Torah*, whose name derives from the Hebrew word "to teach" or "to aim," has expanded to mean: all of the Hebrew Bible (*TANAKH− Torah*, *Nevi'im* [Prophets], *Ketuvim* [Writings]); (2) the entire rabbinic tradition− the Written Law (the Pentateuch) as well as the Oral Law; or (3) all Jewish teaching.

In the eyes of tradition, Torah is the heart and soul of the Jewish People, the expression of the divine will.

An Oriental *"tik,"* encasing the Torah scroll.

The rabbis taught that the Torah existed before the creation of the world, and served as a blueprint for its formation.[2] The Revelation that God ultimately granted *Moses on Mount *Sinai was this Torah, not just the *Ten Commandments, but the entire Written and Oral Law.[3] In biblical and rabbinic teachings, the Torah is compared to an elixir, *water, *wine, *oil, *honey, *milk, *light, *manna, and the *Tree of Life.[4] It is personified, often as a feminine figure such as a handmaid, a widow, or a wife.[5] Those who study it will acquire honor, freedom, goodness, happiness, long life, and immortality.[6] No matter how many good deeds a person might do, "the study of Torah outweighs them all."[7] Torah is the source of wisdom and love.[8] Through its precepts, the broken world will be repaired and redeemed. It is a symbol of perfection.[9]

Jewish mystics believe that the Torah contains within it all the *names of God, whose secrets can be divined through proper study. Such study can also lead one to union with God. *Kabbalists have ascribed to the letters of the Torah mystic power and mystery, claiming that these words represent only the outer garments of divine secrets.[10] The mystical Book of Splendor, the *Zohar*, symbolizes the images of the Torah as a beautiful young woman hidden away in a castle, revealing only glimpses of herself to her lover as he comes to seek her out.[11]

Folk customs evolved attributing to the Torah scroll miraculous powers to grant blessing, to heal, and to protect people from harm. Because the Torah is the Tree of Life, there arose a custom of purchasing a Torah on behalf of seriously ill people to help their recovery. As the tradition teaches: "The more Torah, the more life."[12]

After the destruction of the Temple, the Torah replaced the sacrificial cult as the focus of the people's spirituality. The rabbis ruled that Torah study now atoned for Israel's sins.[13] The Torah scroll itself inherited the vestments of the High *Priest: the mantle (*me'il*) replaced the robe of the *ephod*; the binder (*wimpel, hittul, mappah*), the girdle of the robe; the *crown (*keter*) or *rimmonim* (silver handle-covers), the mitre and gold plate; the shield (*tas*), the *breastplate (*hoshen mishpat*).

Many of the ornaments and customs surrounding the Torah derive from the symbolism of royalty and power: the crown and shield; the *yad ("pointer") resembling a scepter; the precious materials; the Torah procession; the gesture of kissing the hem of the Torah's robe. Other rituals and customs emphasize the holiness of the scroll: not touching the parchment with one's bare hand, fasting if the scroll is dropped, draping the scroll in *white vestments on the High Holy Days, burying a burned or torn scroll.

So sacred is the physical Torah itself that

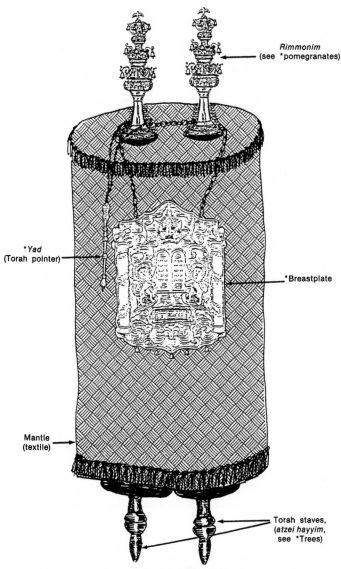

Ashkenazi-style Torah.

a crown or a pair of silver covers, *rimmonim* (literally, pomegranates), often adorned with bells, which tinkle during the procession, reminiscent of the Temple columns and of the High Priest's robe, which was hemmed with *gold pomegranates and bells. The parchment itself is unornamented, the beauty deriving strictly from the words themselves, although certain of the letters are embellished with little crowns called *tagin*. However, artistic energy is lavished on the Torah's garments and accessories.

In Ashkenazi communities, the scroll is wrapped in a cloth mantle, made of rich textiles and usually embroidered with gold or silver threads. In Sephardi communities, it is enclosed in a cylindrical or octagonal case called a *tik*, divided into two pieces and hinged in the back to swing open for reading. Unlike the Ashkenazi scroll, which is unwrapped and laid down, the scroll remains in the *tik* and is read in this upright position. The *tik*, originating in 10th-century Iraq, is usually ornately decorated and inscribed.

The binder, called a *wimpel* ("pennant") in German, dates back to talmudic times.[14] Made of cloth, it is often inscribed with the names of the donor or occasion. In southern Germany, the linen cloth upon which a boy was circumcised was cut and sewn into a *wimpel*, which was presented to the congregation on the occasion of the

scribes lavish extraordinary attention on its writing; artists, on its vestments and ritual accessories; and congregations, on its care and honor. Over the centuries, a rich artistic tradition has developed around every detail of Torah ornamentation. The parchment scroll is wound around two carved wooden rollers, called the *atzei hayyim* (trees of life) or *ammudim* (pillars), modeled on the twin pillars of the *Temple, called *Jakhin and Boaz, whose capitals were adorned with *pomegranate and lily designs. Sitting atop the rollers are either

boy's first visit to synagogue. It was elaborately embroidered or painted with symbols, such as his *Zodiac sign or a picture of a *huppah over a bride and groom, and often inscribed with the verse from the circumcision ceremony: "May he grow up to a life of Torah, marriage, and good deeds." This wimpel bound the Torah from which he read when he became Bar Mitzvah and when he married, symbolizing his binding himself to the Torah and to the Jewish community.

The yad, dating from the 16th century, is usually made of ivory, wood, or precious metals, and often has a *hand with the index finger extended at one end for reading the Torah text.

All of these items have provided opportunities for artistic ornamentation. Common motifs have been *flowers, fruits, *grapevines, *doves, *eagles, *lions, columns (inspired by the "Jakhin and Boaz" pillars of the Temple), crowns, and Ten Commandments. The Torah scroll is housed within the *ark, whose *parokhet curtain and *ner tamid (eternal light) are also usually embellished.

Although the Torah is read every Shabbat, Monday, Thursday, and holiday, two holidays in particular focus upon it: *Shavuot, commemorating the Giving of the Torah on Mount Sinai, and Simhat Torah ("Joy of the Torah"), which falls at the end of *Sukkot, during which the scroll is finished and immediately begun again. On Simhat Torah, every scroll owned by the congregation is taken out of the ark and carried in procession *seven times. It is also customary to sing and dance around the Torahs with great joy.

[1]Pirke Avot 5:25; [2]Pirke Avot 3:14; Genesis Rabbah 1:4; Midrash Tehillim 90:12; Zohar 3:152a; [3]Megillah 19b; [4]Taanit 7a; Kiddushin 30b; Song of Songs Rabbah 1:2, 3; Proverbs 6:23; Zohar 4:166a; [5]Tanhuma Bereishit 1:6b; [6]Esther Rabbah 7:13; Ecclesiastes Rabbah 9:9; [7]Shabbat 127a; [8]Pirke Avot 6:2, 3, 7; [9]Midrash Tehillim 1:18; Psalm 19:8; [10]Zohar 3:152a; [11]Zohar 2:99a-b; [12]Pirke Avot 2:8; [13]Tanhuma B. Aharei Mot 16; [14]Shabbat 133b.

Signifies: DIVINE AUTHORITY, FOUNDATION, GOD, HOLINESS, JEWISH PEOPLE, JUDAISM, LAW, LEARNING, LIFE, LOVE, PERFECTION, REVELATION, ROYALTY, SOURCE, TEACHING, WISDOM

Generic Categories: Bar/Bat Mitzvah, Kabbalistic Symbols, Prayer, Ritual Objects, Shavuot, Sukkot, Synagogue, Temple

See also: Alephbet, Ark, Bar/Bat Mitzvah, Bimah, Book, Breastplate, Brit, Crown, Eagle, Fire, Five, Flowers, Jakhin and Boaz, Kabbalah, King, Light, Lion, Moses, Name of God, Ner Tamid, Parokhet, Pomegranate, Seven, Shavuot, Sinai, Sukkot, Synagogue, Ten Commandments, Tree, White, Yad, Zodiac

TOWER – מִגְדָּל. Towers traditionally symbolize protection, self-aggrandizement, and spiritual ascent. Towers also represent the link between heaven and earth. In alchemy, the tower represents the furnace in which matter is transformed to a higher level. The tower also parallels the human form, its upper windows analogous to *eyes.

The most famous biblical tower is the Tower of Babel, whose builders constructed it in order to "make a name for ourselves, lest we be scattered all over the world." Because of their vanity, inhumanity, and rebellion, God confused (bavel, that is, "babbled") their language, and scattered them over the face of the earth.[1] Scholars suggest that this story was a polemic against ancient beliefs that sacred towers such as the Mesopotamian ziggurat were built by the gods. For centuries, the Tower of Babel has symbolized human folly and hubris.

King David's Tower, located next to the Jaffa Gate in the Old City of *Jerusalem and dating back to the Herodian period, has long served as a central landmark of the city. Depictions of Jerusalem typically feature towers and minarets.

In Europe, rimmonim (*Torah handlecovers) were sometimes shaped as towers, probably influenced by the bell towers common in church architecture. They may also have been inspired by the biblical verse: "My God, my *rock in whom I seek refuge; my shield, my *horn of salvation, my stronghold."[2]

The most common shape of *Havdalah spiceboxes has been the tower, which may have been inspired by the verse from the Song of Songs: "His cheeks are as a bed of spices, as towers of perfumes."[3] It is more likely, however, that this shape was derived

from the spice towers in medieval European towns or from the monstrances (containing communion wafers), thuribles (censers), and reliquary containers used in churches. In the medieval period, most Jewish spice-boxes were made by Gentile craftsmen. These classic shapes have been retained, now often suggestive of the towers of Jerusalem.

[1]Genesis 11:1-9; [2]Psalm 18:3; [3]Song of Songs 5:13.

Signifies: GOD, GUARDIANSHIP, POWER, PRIDE, PROTECTION, SANCTUARY, SELF-AGGRANDIZEMENT, STRENGTH

Generic Categories: Dwellings, Ritual Objects, *Shabbat*

See also: *Havdalah*, Jerusalem, Ladder, Mountain, Pomegranate, Spices, Torah

TREE — עֵץ.

Trees are a universal symbol, inspiring awe and admiration among the people who depend on them for sustenance and shelter. This was certainly so in ancient Israel, a hot landscape where shade was cherished. Ancient Israelites were intimately acquainted with a wide variety of trees and the unique qualities of each. Trees figure prominently in biblical imagery.

Because they are rooted in the earth and reach toward the sky, trees represent the World Axis, connecting heaven and *earth. Many ancient religions worshiped trees in sacred groves and imagined spirits inhabiting them. *Abraham encountered *three *angels under the Oaks of Mamre, and planted a tree which he dedicated to God in Beersheba.[1] The Bible later prohibited such sacred plantings, which were a common practice among the Israelites' Canaanite neighbors.[2] The mythological Tree of Life was a popular ornamental motif in Canaanite, Egyptian, and Mesopotamian art.

Because they grow taller and live longer than human beings, trees also symbolize life, development, immortality, strength, and majesty. Their upright growth identifies them with our own erect stance. Like humans, trees grow slowly, and mature after many years, continually growing new branches. Their protectiveness as sources of shade and shelter, their nurturance of human life, their fruit filled with seeds, and

their tenacity make them apt symbols of maternity. They remain vigorous much longer than most people, and thus symbolize ripe old age. Outliving single human generations, they also symbolize regeneration and eternity. For centuries, a broken tree represented death on Jewish tombstones.

The two most famous trees in Judaism are the Tree of Knowledge of Good and Evil and the Tree of Life, which God planted at the beginning of the world in the Garden of *Eden. Legends variously identify the Tree of Knowledge as the *fig, *apple, *pomegranate, *etrog, *carob, *palm, or *nut tree; the *grapevine; or *wheat stalk.[3] Interpretations similarly abound about precisely what "knowledge" the forbidden fruit conveyed to *Adam and *Eve: moral understanding, sexual knowledge, mature intelligence, rationality. Unlike Christianity, Judaism associates Adam and Eve's sin not with the knowledge bestowed by the tree's fruit, but with their rebellious behavior toward God.

Although the Tree of Life is not identified in rabbinic sources, apocryphal sources claim it was an *olive tree; hence the tradition that anointment ("messiah" in Hebrew) conveys immortality. The *midrash* describes the Tree of Life in extravagant terms: it stands in the middle of Eden, shading the entire garden, covered with *seven *clouds of glory. Its fruit has fifteen thousand different tastes and perfumes.

Tradition associates the Tree of Life with the Torah. The liturgy proclaims that the Torah is "a Tree of Life — *Etz Hayyim* — to all who hold fast to it," and that it represents "eternal life planted in our midst." The wooden rods around which the Torah parchment is rolled are called *atzei hayyim* (trees of life), which are topped with *rimmonim*, pomegranates. The image of the Tree of Life, both as a symbol of Torah as well as of immortality in the World to Come, has long been a favorite decorative motif in *synagogues. It is possible that the *menorah* is a stylized representation of the Tree of Life.

In ancient religious architecture, trees were prototypes for temple pillars. The Holy *Temple in *Jerusalem had two such supporting pillars called *Jakhin and Boaz, crowned with pomegranates. The wooden staves of the Torah scroll are probably modeled on these pillars.

*Kabbalists arranged the names of the *ten *Sefirot (divine emanations) into a tree, suggesting through this organic symbol God's dynamic action in the physical and spiritual worlds.

One of the central tenets of Jewish law is *Bal Tashhit*, an injunction against gratuitous destruction. It derives from the biblical prohibition against destroying fruit trees during military campaigns: "Are trees of the field human," the Torah challenges, "to withdraw before you into the besieged city?"[4] The contemporary Jewish environmental movement, drawing from this tradition, has viewed trees as symbols of human stewardship of the planet and partnership with divine creation.

Because the destruction of trees often accompanied military defeat and exile, the growth of new trees has long been a symbol of messianic redemption. For Zionists, planting trees has become a symbol of the rebirth of the land. It is a popular custom to plant a tree in Israel to mark a birth, *Bar/Bat Mitzvah*, *wedding, or death. For many centuries, it was also customary to plant trees at the birth of a child (*pine or *cypress for a girl, *cedar for a boy), from which branches would be cut for their wedding *huppah, signifying continuity and fulfillment.

*Tu B'Shevat, the fifteenth day of *Shevat* (January/February), is the New Year of the Trees, celebrated with a festive *"seder," the eating of fruits and nuts from Israel, and the planting of saplings, both in the Diaspora and in Israel.

Trees also represent family continuity in the form of genealogical charts tracing family descent.

[1]Genesis 18:1; 21:33; [2]Deuteronomy 16:21; [3]Ginzberg, *Legends of the Jews* 5:97–98; [4]Deuteronomy 20:19–20.

Signifies: CONNECTION, CONTINUITY, ECOLOGY, ETERNITY, FAMILY, GOD, GROWTH, IMMORTALITY, LIFE, MOTHERHOOD, NURTURANCE, OLD AGE, REBIRTH, REDEMPTION, STRENGTH, TORAH

Generic Categories: Birth, Botany, Death, Israel (Land of), Kabbalistic Symbols, Synagogue, Trees, Tu B'Shevat, Wedding

See also: Almond Tree, Carob, Cedar, Cypress, Earth, Eden, Fig, Israel (Land of), Kabbalah, Ladder, Mountain, Nut, Olive, Palm Tree, *Pardes*, Pine, Torah, Tu B'Shevat, Wedding, Willow

TU B'SHEVAT – ט"ו בִּשְׁבָט. Tu B'Shevat, occurring on the fifteenth day, the full moon, of *Shevat* (January/February), is the New Year of the *Trees, which in ancient times marked the new fiscal cycle for tithing fruit trees. Since the winter *rains in Israel end at about this time, trees which blossomed after this date were taxed for the coming year.[1] Tu B'Shevat derives its name from the alphabetic form for the *number fifteen: ט"ו – *tet*, equaling 9, plus *vav*, equaling 6. (This number cannot be spelled *yah*, that is, 10 + 5, because that spelling, though mathematically more logical, forms one of the holy *Names of God.) The *almond tree is the first to flower in Israel, and the holiday is timed to correspond to this event. It is also the time sap begins to rise within the trees.

Tu B'Shevat is a minor holiday. In European communities, it was customary to eat fifteen different fruits, especially those native to Israel, and to recite special psalms: "The trees of the Lord drink their fill, the *cedars of Lebanon, God's own planting, where *birds make their nest; the stork has her home in the junipers."[2] The mystics of 16th-century *Safed developed a special *seder, based on the *kabbalistic theory of the four worlds of divine emanation, which became popular in many communities, and survives to this day. It involves drinking *four cups of *wine, eating various symbolic fruits and *nuts, reciting special prayers and readings, and singing songs appropriate to the season. Different combinations of *white and *red wine symbolize the land's gradual transition from the white barrenness of winter to the full-blooded vitality of spring.

In modern Israel, Tu B'Shevat is an agricultural holiday similar to Arbor Day, focusing on the planting of trees. In the Diaspora, Jews either plant trees in their own communities (if the ground has thawed sufficiently) or send contributions to the Jewish National Fund to plant trees in Israel.

Tu B'Shevat is enjoying additional attention in the contemporary world as an occasion for Jews to focus on environmental issues and to express appreciation of God's

creation and the human role in protecting it.

[1]_Rosh Hashanah_ 1:1; [2]Psalm 104:16–17; also Psalms 120–134.

Signifies: ECOLOGY, LIFE, REBIRTH, REDEMPTION

Generic Categories: Botany, Trees, Tu B'Shevat

See also: Almond Tree, Carob, Fig, Grapes, Kabbalah, Nut, _Seder_, Seven Species, Tree, White, Wine

TWELVE TRIBES – שִׁבְטֵי יִשְׂרָאֵל

Twelve is a frequent division of the whole based on astronomical and astrological principles: the *moon undergoes twelve full cycles in the course of approximately one solar year. The day is also divided into two twelve-hour periods. In the Anglo-Saxon system of measurement, there are twelve inches in a foot, and twelve units in a dozen. Ten fingers plus two *hands equals twelve. Perhaps the fact that twelve results from multiplying the magical numbers *three times *four, whose sum equals *seven, also accounts for its appeal.

Ancient Israel was divided into twelve tribes: Reuben, Simeon, *Judah, Issachar, Zevulun, Benjamin, Dan, Naftali, Gad, Asher, Ephraim, and Manasseh. The first ten were sons of *Jacob/ Israel and his four

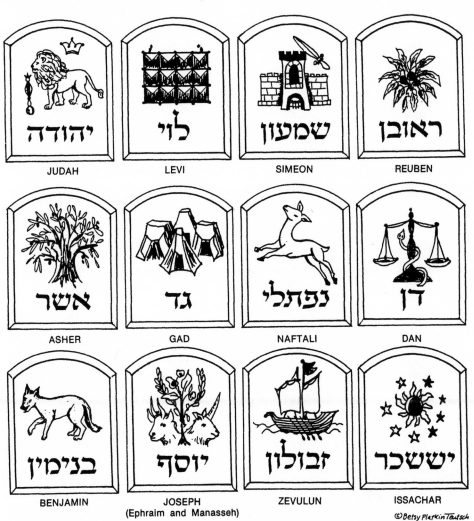

JUDAH LEVI SIMEON REUBEN

ASHER GAD NAFTALI DAN

BENJAMIN JOSEPH (Ephraim and Manasseh) ZEVULUN ISSACHAR

©Betsy Platkin Teutsch

Emblems of the twelve tribes of Israel.

The Twelve Tribes of Israel

Tribe	Gem	Color	Symbol	Source
Reuben	ruby	*red	*mandrakes	Genesis 30:14
Simeon	topaz	green	fortress of Shechem	Genesis 34:25
Levi	smaragd	1/3 *white 1/3 black 1/3 red	*Urim and Tummim *breastplate	Deuteronomy 33:8
*Judah	carbuncle	colors of heavens	*lion	Genesis 49:9
Issachar	sapphire	black	*sun and *moon strong-boned *ass	1 Chronicles 12:33 Genesis 49:14
Zevulun	emerald	white	ship	Genesis 49:13
Dan	zircon	blue	*serpent *scales lion's whelp	Genesis 49:17 Deuteronomy 33:22
Gad	agate	black and white	camp or tent lion	Genesis 49:19 Deuteronomy 33:20
Naftali	amethyst	clarified red *wine	*deer	Genesis 49:21
Asher	beryl	fiery red	*olive tree	Deuteronomy 33:24
Joseph (Ephraim and Manasseh represented together)	onyx	jet black	*Egypt fruitful bough sheaves	Genesis 49:22 Genesis 37:7
Ephraim			bull	Deuteronomy 33:17
Manasseh			wild ox or unicorn	Deuteronomy 33:17
Benjamin	jasper	all twelve colors	wolf	Genesis 49:27

wives, *Leah, *Rachel, Zilpah, and Bilhah; the last two were his grandsons, the sons of *Joseph and Asnat. Levi made up the thirteenth tribe, but because this tribe's inheritance was the priesthood rather than tribal lands, its number was not included as part of the national polity.

During their *forty years in the *wilderness, the Israelites were organized along tribal lines, an arrangement which continued in Canaan. For several centuries thereafter, the tribes remained in a loose federation, which was finally unified and strengthened under a monarchy, especially after *David and his son *Solomon central-ized worship and government in *Jerusalem. After Solomon's death, the country split into a Northern Kingdom with ten tribes, and a Southern Kingdom, including Jerusalem, consisting only of Judah and Benjamin. In 722 B.C.E., Assyria conquered the Northern Kingdom and scattered its population, which subsequently became known as the Ten Lost Tribes, the subject of numerous legends and theories. Today's Jews are the descendants of the two southern tribes, plus the Levites. Beta Yisrael, the Ethiopian Jews, claim descent from several of the lost Ten Tribes.

Tradition claims that each tribe had its

own symbol: a *color corresponding to the twelve stones on *Aaron's *breastplate; an animal, characteristic of its ancestral namesake; and a *flag, which identified the tribes in their camps and in battle.[1]

Throughout the centuries, artistic representations of these tribal emblems have frequently been displayed in stained glass windows and ceiling paintings in *synagogues, sometimes with variants which differ from earlier sources. One midrashic text even suggests that the flags of the twelve tribes corresponded to the signs of the *Zodiac.[2]

[1]Numbers 2:2; *Numbers Rabbah* 2:7; [2]*Yalkut Shimoni*, Leviticus 418.

Signifies: JEWISH PEOPLE, UNITY

Generic Categories: Astronomy, Colors, Numbers

See also: Breastplate, Colors, Flag, Jacob, Judah, Numbers, Priestly Cult, Ten, Zodiac

URIM AND TUMMIM – אוּרִים

וְתֻמִּים. The *Urim* and *Tummim*, a mystical *priestly device used as an oracle, was one of the three fortune-telling methods countenanced by the Torah (the others are *dreams and prophecy).[1] Probably consisting of marked sticks or stones (although the biblical text gives no detailed description), the *Urim* and *Tummim* were kept within a pouch sewn into the High Priest's *ephod* (an apronlike garment) and consulted when divine guidance was needed.[2] However, one tradition claims that they could only give "yes" and "no" answers. By the time the Jews returned to Israel from Babylonian exile, the *Urim* and *Tummim* were no longer in use. But the nation's leaders, Ezra and Nehemiah, expressed the hope that they would be consulted again in some future time.[3]

Various ancient commentators speculated that the *Urim* and *Tummim* worked

Emblem of Yale University, featuring *Urim* and *Tummim.*

either by lighting up or pressing out individual letters in the names of the *Twelve Tribes engraved on the twelve stones of the High Priest's *breastplate.[4] The medieval commentator Ibn Ezra thought that the *Urim* and *Tummim* were astrological devices representing the *seven planets.[5] In this way, God's message was divined by the priest.

Even the names themselves—*Urim* and *Tummim*—are mysterious in origin. They may have meant "yes" and "no." Or the word *Urim* may have meant "Teaching" (from the same root as "Torah") or "*Light" (from *or*). *Tummim* probably meant "Truth" (from *tammim*, meaning whole). Yale University chose as its motto the words "*Urim* and *Tummim*," translated as "Light and Truth," represented within the Levitical breastplate. In Jewish art, this emblem has also symbolized a member of the tribe of Levi.

·[1]1 Samuel 28:6; [2]Exodus 28:15–30; Leviticus 8:8; Numbers 27:21; Deuteronomy 33:8; [3]Ezra 2:63; Nehemiah 7:65; [4]Josephus, *Antiquities* 3:8, 9; *Yoma* 73b; Nahmanides on Exodus 28:30; [5]Ibn Ezra on Exodus 28:30.

Signifies: DIVINE GUIDANCE, LEVITES, PRIESTHOOD, PROPHECY, TRUTH

Generic Categories: Kabbalistic Symbols

See also: Breastplate, Dreams, Light, Priestly Cult, Twelve Tribes

USHPIZIN – אֻשְׁפִּיזִין.

On *Sukkot, it is customary to invite guests into one's *sukkah for festival meals. The 16th-century *kabbalists of *Safed introduced the custom of symbolically inviting *seven biblical personalities, called *ushpizin (Aramaic for "guests," derived from the Latin *hospes*), into the *sukkah* each night, symbolic of the *Sefirot (divine emanations): *Abraham (Loving-kindness, *Hesed*), *Isaac (Strength, *Gevurah*), *Jacob (Beauty, *Tiferet*), *Moses (Victory, *Netzah*), *Aaron (Splendor, *Hod*), *Joseph (Foundation, *Yesod*), and *David (Sovereignty, *Malkhut*). After reciting a special benediction, it is customary to tell stories, sing songs, or study traditional texts about that night's personality.

A 16th-century kabbalist, Menahem Azariah, known as the RaMaH of Fano,

listed seven female figures who corresponded with the seven lower *Sefirot*: *Sarah, *Miriam, *Deborah, Hannah, Abigail (David's wife), Hulda the Prophet, and *Esther.[1] Other female figures have also been suggested as counterparts to the traditional male *ushpizin*, among them *Rebecca, *Rachel, *Leah, Asnat (Joseph's wife), and Tzipporah (Moses' wife). A universally accepted list of seven has not yet been established.

All of the *ushpizin* were wanderers. Just as the *sukkah* represents a temporary dwelling, so, too, these ancient personalities found only temporary shelter during their times of wandering.

Throughout the centuries, Jewish artists have created ornamental *ushpizin* charts, using traditional symbols and calligraphy.

[1]*Sefer Asarah Ma'amarot*, Part 2, Section 1.

Signifies: DIVINE PRESENCE, HOSPITALITY

Generic Categories: Personalities, Ritual Objects, Sukkot, Women

See also: Aaron, Abraham, David, Deborah, Esther, Isaac, Jacob, Joseph, Kabbalah, Leah, Miriam, Moses, Rachel, Rebecca, Sarah, *Sefirot*, Seven, *Sukkah*, Sukkot

WARSAW GHETTO. During the

Holocaust, most major Jewish communities in Eastern Europe were confined to ghettos, where they suffered deplorable living conditions, constant persecution, and mass deportation to death camps. Eventually these ghettos were "liquidated" by the Nazis, their surviving inhabitants killed or deported. For the most part, armed resistance was almost impossible, but in a few instances, notably the Warsaw Ghetto, the Jews tenaciously fought back.

On April 19, 1943, the first night of *Passover, a handful of Jews launched an uprising against the powerful Nazi war machine. For twenty-eight days, using smuggled and homemade weapons, they battled a vastly superior German force, until they were finally defeated, and the ghetto destroyed. Among the few survivors, resistance continued sporadically until August 1943. The heroism of the men and women of the Warsaw Ghetto inspired both Polish and Jewish partisans, and after the war, was commemorated in poems, novels, and art. Many *Haggadahs* include readings about this event.

Signifies: COURAGE, FREEDOM, HOLOCAUST, RESISTANCE

Generic Categories: Holocaust, Places

See also: Auschwitz, *Haggadah*, Passover, Six Million, Yellow

WATER – מַיִם. According to the an-

cients, the world consists of *four basic elements: *fire, air, *earth, and water. The ethereal elements, fire and air, are associated with the heavens and the divine; the solid earth, with humankind. Water is the transitional medium, the channel between realms. In most religions, from ancient times to the present, water is used symbolically for rites of passage, spiritual purification rituals, and sacred ceremonies. Water is also an agent of change, causing dissolution of matter, and by extension, spirit.

Among most ancient peoples, water was considered the source of life, the medium of birth, death, and immortality, the reservoir of wisdom. Fluids provide nourishment for life on earth: *blood, *milk, sap, *rain, and *dew. Water can sustain life as well as destroy it. It can extinguish the destructive element of fire. Legend claims that *angels are composed of a mixture of fire and water.[1] Water was the primordial form of the world before creation. "The roar of mighty waters" is the sound of God's voice.[2]

The biblical story of Genesis parallels those of many other Near Eastern peoples: God first severed the cosmic water with the sky, dividing it into upper and lower waters. Then God gathered together the lower waters, making the dry land appear.[3] The rabbis later located the source of all waters under the Foundation Stone beneath the *Temple Mount.[4] Another legend situated it under the *Tree of Life in the Garden of *Eden.[5]

One of the most ancient and enduring rituals in Jewish life is immersion in the *mikvah*, usually translated as "ritual bath," but actually identical to the word used in Genesis to describe the primeval "gathering

of the waters."[6] The *mikvah* is either a natural water source, such as a spring, lake, or stream, or an artificial pool containing freely flowing *undrawn* (rain or spring) water. Immersion in the *mikvah* brings about spiritual purification, not physical cleanliness.

Although Judaism does not celebrate birth with baptism, it does welcome "newborn" Jews—converts and non-Jewish adopted children—into the community through the ritual of "*mikvah*." Jewish women traditionally go to the *mikvah* before their *wedding. It is customary to immerse new dishes and utensils in the *mikvah* to purify them. Many Jews go to the *mikvah* before *Shabbat and festivals, especially before *Yom Kippur, as an act of spiritual preparation.

Orthodox and some less traditional women, following ancient tradition, regularly immerse themselves in the *mikvah* after the end of their menstrual cycle, marking their rejoining with their husbands. Going to the *mikvah*, along with lighting the Sabbath *candles and separating out a portion of dough (**hallah*) when baking *bread, have traditionally been regarded as the three "women's commandments."

It is customary, especially on *Shabbat* or festivals, to wash one's hands and recite a blessing (*al netilat yaddayim*) as an act of spiritual preparation before eating, since the *table is a symbolic substitute for the *Temple *altar. It is also customary for Levites to wash the hands of *Kohanim* (*"priests") before the latter perform the *Priestly Blessing. Reflecting this practice, a laver has traditionally been the symbol of a descendant of the Levite family.

During the fall holiday cycle in the month of *Tishrei*, water themes abound: the Torah reading on *Rosh Hashanah includes the story of the miraculous *well that saved Hagar and *Ishmael in the *wilderness;[7] on Rosh Hashanah afternoon, Jews go to a river or stream to perform the ceremony of "*Tashlikh*" (Casting), during which they throw *bread crumbs into the water to symbolize atonement. The *fish who eat the crumbs symbolize God, whose *eyes, like theirs, never close. As part of the *Tashlikh* ceremony, various biblical passages about sin and water are recited, such as the verse from

Micah: "You will cast all their sins into the depths of the sea."[8] This ceremony originated in medieval Germany, probably derived from an ancient custom designed to appease river demons.

On *Yom Kippur, the Book of *Jonah is recited. During Temple times, a special festival called *Simhat Beit Ha-Sho'evah* ("the Rejoicing of the House of Water-Drawing") was celebrated during the intermediate days of *Sukkot—just prior to the winter rains—and included pouring out water libations, singing, *shofar*-blowing, and dancing with torches around golden **menorahs*.[9] On Shemini Atzeret, the last day of *Sukkot, a special prayer for rain is chanted.

Jews have traditionally solemnized death with rituals involving water. In Europe, Jews borrowed the superstitious custom of pouring out water from all vessels in the house of the deceased, so that the departing soul or the *Angel of Death might not contaminate it. From ancient times to the present, it has been customary to wash the bodies of the dead before burial. It is also customary for people involved in this *taharah* (purification) ceremony to wash their hands a second time—without reciting a blessing—as a symbolic act of purification.

Water has long been associated with women. The growing fetus lives in the amniotic fluid in the womb and emerges from the birth "canal" after the mother's "water breaks." Women's bodies produce two other nurturing "waters," *milk and menstrual blood, both essential to life. Biblical women are often linked with *wells, especially *Rebecca and *Miriam. Through the tides, water is connected with the *moon, another central feminine symbol. Because of these numerous associations, Jewish feminists have incorporated water in many contemporary rituals, especially to celebrate *Rosh Hodesh and to mark rites of passage.

Like his sister Miriam, *Moses is prominently associated with water. He was saved by the waters of the Nile, rescued by God at the Sea of Reeds, and met his doom at the waters of Meribah, where he struck the *rock in anger and lost his right to enter the Promised Land. According to the Bible, his name means "drawn out [of the water]."[10]

As an agricultural society, ancient Israel depended upon rain for its sustenance. Prayers for rain in Israel are inserted in the liturgy, even in the Diaspora. On Hoshana Rabba, the seventh day of *Sukkot, the *willows of the *lulav are beaten to the ground. Willows grow near water; this ritual anticipates the winter rains, for which a special prayer is recited with great solemnity. A special prayer for dew is recited at *Passover, marking the end of the rainy season. Dew has long been associated with resurrection.

The Torah is traditionally compared to water, as they both (1) attract those who thirst; (2) extend over the whole earth; (3) are the source of life; (4) come from heaven; (5) restore the soul; (6) purify; (7) flow from high to low, and prefer common vessels to costly ones; and (8) nurture growth.[11]

Often the Torah is referred to as "*mayim hayyim*," living waters. The rabbis elsewhere compared the Talmud, and by extension, Jewish Law, to a sea in its vastness.[12]

In recent times, some families have included foot-washing and immersion in *Brit Ha-Bat* (naming ceremonies for daughters) because of the connections between women and water.

[1]*Rosh Hashanah* 2:5; [2]Ezekiel 43:2; [3]Genesis 1:6-7, 9-10; [4]Vilnay, *Legends of Jerusalem*, 7-11; [5]Ginzberg, *Legends of the Jews* 1:70; [6]Genesis 1:10; [7]Genesis 21:14-19; [8]Micah 7:18-20; Isaiah 11:9; Psalm 118:5-9; 33; 130; [9]*Sukkah* 5:1-4, 5:1-5; [10]Exodus 2:3-10; Numbers 20:2-13; [11]*Song of Songs Rabbah* 1:2, 3; [12]*Song of Songs Rabbah* 5:14, 2.

Signifies: ADOPTION, ATONEMENT, CONVERSION, DEATH, FEMININE, FERTILITY, GOD, HOLINESS, JEWISH LAW, LEVITES, LIFE, MOTHERHOOD, PURIFICATION, RESURRECTION, TORAH, TRANSITION

Generic Categories: Adoption, *Brit*, Conversion, Death, Menstruation, Natural Phenomena, Prayer, Rosh Hashanah, Sukkot, Temple, Wedding, Women

See also: Angels, Blood, Bread, *Brit*, Dew, Fire, Fish, Hand, Milk, Miriam, Moses, Moon, Rain, Priestly Blessing, Priestly Cult, Rachel, Rebecca, Rosh Hodesh, Rosh Hashanah, Sukkot, Torah, Well, Willow

WEDDING – חֲתֻנָּה, נִשּׂוּאִים. A wedding is the symbolic union of two separate individuals who enter into a covenant of mutual responsibility, protection, and caring. According to Jewish tradition, the purpose of marriage is not only to provide couples with companionship and children, but also with fulfillment: "He who has no wife [lives] without joy, blessing, goodness . . . Torah, protection . . . and peace."[1] The sages considered marriage the ideal human state, a fitting model for the relationship between God and Israel, Israel and the *Torah, and Israel and *Shabbat. God is the ultimate matchmaker, for making a good match is said to be as difficult as splitting the Red Sea.[2]

Ornamental marriage ring, lent by the community for the wedding.

Although there is no biblical description of a wedding ceremony, certain customs derived from hints in the *Torah text: *Rebecca covered herself with a veil when she first met *Isaac.[3] She is invoked at the "*bedeken*," the Veiling of the Bride before the *wedding ceremony, symbolic of female modesty. *Jacob and *Leah feasted for *seven days after their wedding,[4] a practice which continues among many Jews to this day.

Over the centuries, an elaborate wedding ceremony has evolved, rich in ritual acts and objects. Originally, the bride entered the marriage covenant by physically entering the groom's house and beginning her new life with him. In time, the *huppah (marriage canopy) became a symbolic substitute for the groom's house. A custom arose of planting a *cedar *tree at the birth of a son, a *pine or *cypress at the birth of a daughter, from which branches were cut to make the poles of their *huppah*.[5] In some communities, the bride and groom are covered by or wrapped in a *tallit, symbolic of God's sheltering love. It is customary to face *east under the *huppah in order to turn one's heart toward *Jerusalem.

The marriage contract, called a *ketubah, literally "document," is a legal

agreement recording the financial obligations which a husband undertakes toward his wife. To the couple whose marriage it celebrates, the *ketubah* represents their covenant of love. Beginning in 10th-century Egypt and continuing to our own day, a folk art of illuminating the text of the *ketubah* with a decorated border has evolved. Such *ketubot* have been prized for generations as family heirlooms and works of art.

Many customs have arisen designed to bless the couple with fertility: eating *fish; throwing rice, *wheat, *nuts, or candies.

Although not explicitly acknowledged, a major concern of the wedding ceremony is protection from evil. Because the *Evil Eye is activated by jealousy, particularly at joyous occasions and transitional moments, numerous customs have arisen to deflect or distract its gaze: painting the bride's *hand with *red henna; circling the bridegroom seven times to create a magic *circle of protection; veiling the bride's beauty; breaking a glass to scare off evil spirits; even holding a secret wedding ceremony before the public one.

Many other explanations have been proposed for the well-known custom of breaking the glass at the conclusion of the wedding ceremony: a sign of mourning for the *Temple; a tempering of excessive levity[6]; a symbol of the fragility of marriage; the breaking of the hymen; a symbol of a broken world still in need of redemption.[7] Two other less common customs also symbolize mourning for the Temple: placing *ashes on the groom's forehead or an *olive wreath on his head (since olives are bitter).

Other features of the wedding ceremony include immersing oneself in a *mikvah* prior to the wedding as an act of spiritual purification; fasting before the wedding, symbolic of the close connection between life and death; reciting a *"viddui"* (confessional prayer) as at a deathbed; wearing a *white *kittel (for the man), symbolic of purity and vulnerability, since the *kittel* will also form part of his burial *shroud; reciting seven blessings to invoke good luck and blessing; the groom's giving a ring or the couple's exchanging rings, symbolizing the material and spiritual terms of the marriage covenant; sharing the same *cup

of *wine, symbolic of holiness, joy, and union. A traditional ornament atop the marriage ring has been the figure of a house, symbolic both of the Temple and the couple's future home. In the West, Jewish brides traditionally wear white; brides from North African communities wear boldly colored, highly ornamented garments.

[1]*Yevamot* 62b; [2]*Genesis Rabbah* 68:4; [3]Genesis 24:65; [4]Genesis 29:27; [5]*Gittin* 57a; [6]*Berakhot* 31a; [7]Genesis 15:17.

Signifies: BLESSING, CELEBRATION, COMPLETION, COVENANT, DIVINE PROTECTION, FAMILY, HOLINESS, HOME, LOVE, RELATIONSHIP BETWEEN GOD AND ISRAEL, UNION

Generic Categories: Clothing, Wedding, Women

Sea also: Ashes, Candles, Cedar, Circle, Clothing, Crown, Cup, Cypress, Evil Eye, Fish, Flowers, *Huppah*, Jerusalem, *Ketubah*, *Kittel*, Pine, Portal, Rebecca, Red, Seven, *Tallit*, Temple, Water, White, Wine

WELL – בְּאֵר. Ancient wells served as the focal point of community life. Here people gathered to obtain *water for themselves and their flocks, as well as to exchange news, transact business, and socialize. Several important romances in the Bible began at wells: *Abraham's servant Eliezer met *Rebecca at a well, where she revealed her chosenness as *Isaac's bride through a divine sign; *Jacob met *Rachel (whose name means "ewe" in Hebrew), at a well and watered her flocks by rolling a great stone off the well; *Moses met his wife Tzipporah at a well, driving off the hostile Midianite shepherds harassing her and her sisters.[1] When Abraham sent away Hagar and *Ishmael, they were rescued through the appearance of a divine well.[2]

In Hebrew, the word for well is the same as the verbal root, "to understand." Wells have often been traditional symbols of wisdom.

Legend claims that at twilight on the Sixth Day of Creation, God created a miraculous well that passed from Abraham to Hagar to Isaac but was lost during Egyptian captivity. Because of *Miriam's merits—her powers of prophecy, her pro-

tection of the infant Moses, her skillful midwifery among the Hebrew slaves, and her victory song at the Sea of Reeds — this well was restored to the Jewish People during its wanderings in the desert and was now called Miriam's Well. The well disappeared when Miriam died.[3] Another legend claims that God then taught the people how to summon it up by singing its song: "Spring up, O well, sing to it."[4] The *kabbalists of *Safed and certain *hasidim* believed that they had discovered the well's whereabouts.[5] Miriam's well has become a symbol of women's creativity, spirituality, collective experience, and wisdom.

Feminists have introduced the custom of singing "*Miriam Ha-Neviah*" (*Miriam the Prophet) during the *Havdalah* ceremony, inspired by an ancient folk tradition that Miriam's *Well fills all wells at the end of *Shabbat* and endows the water with miraculous curative powers.[6]

The well is also a symbol of Torah, which is regarded as a source of living *waters.

[1]Genesis 24:12–20; 29:1–11; Exodus 2:16–22; [2]Genesis 21:19; 25–31; [3]*Pirke Avot* 5:6; Ginzberg, *Legends of the Jews* 3:52–54; [4]Numbers 21:17–18; [5]Adelman, *Miriam's Well*, 63–64; Vilnay, *Legends of the Galilee, Jordan, and Sinai*, 130–132; [6]Kitov, *The Book of Our Heritage* 2:162.

Signifies: DIVINE LOVE, LIFE, RO-MANCE, TORAH, WISDOM, WO-MEN'S SPIRITUALITY

Generic Categories: Natural Phenomena, Women

See also: *Havdalah*, Kabbalah, Miriam, Rachel, Rebecca, Water

WESTERN WALL – הַכֹּתֶל הַמַּעֲרָבִי.
The Western Wall, also known as the Wailing Wall or simply "the Wall," is a section of the western supporting wall of the *Temple Mount, the only remaining part of the destroyed Second Temple. It is built of mammoth stones from different historical periods and is invested by Jews with great holiness. For centuries, it has been the focus of mourning for the destruction of the Temple and the exile of the Jewish People. In legend, it is regarded as the dwelling-place of the *Shekhinah*. In the 1967 Six Day War, the

Wall was wrested from Arab hands by Israel and has since become a symbol of strength, survival, and triumph, for the Jews of Israel as well as the Diaspora. Recently, the Israeli army changed the site of its swearing-in ceremony for new recruits from *Masada to the Wall.

It has long been customary to insert small petitionary notes, called "*kvitlakh*," in the cracks of the Wall, which are credited, due to the Wall's sanctity, with having special power to reach God. The Wall is also a popular site for *Bar Mitzvah* ceremonies.

Beginning in the 19th century, images of the Wall began to appear in Jewish folk art, a motif which remains popular to this day. It symbolizes a link with the past, particularly with the Temple, and the continuity of the Jewish People.

Some liberal and secular Jews regard the Wall as a problematic symbol because Orthodox rabbinical authorities in Israel refuse to allow women full religious expression within the Wall's precincts.

Signifies: CONTINUITY, DEFEAT, EXILE, HOLINESS, INEQUALITY, MOURNING, RELIGIOUS INTOLERANCE, STRENGTH, SURVIVAL, VICTORY

Generic Categories: Places, Temple, Women

See also: Jerusalem, Masada, *Shekhinah*, Temple

WHEAT – חִטָּה.
Wheat cultivation originated in Mesopotamia and *Egypt, and has been a central crop in Israel since ancient times. Wheat is mentioned as one of the *seven species symbolic of Israel's fertility.[1] It is a symbol of settled life, since raising it requires the sedentary habits of a farmer rather than the nomadic ones of a shepherd. In biblical times, Palestine was a grain-exporting country. Wheat was considered a superior grain; it was more valuable than *barley or other ancient crops.

Wheat requires fertile, well-tilled soil and abundant winter *rains. In Israel, wheat is harvested after the barley crop, from late April until June. A good wheat harvest represents abundance and peace. The valuable heart of the wheat symbolizes God's favor.[2] Separating the wheat kernels — the

righteous—from the righteous—from the useless chaff—sinners—is a popular biblical metaphor.

In the West, wheat is called "the staff of life." In its finished form as *bread, wheat has long been a dietary staple among Jews, and plays a central role in religious life in the form of *hallah and *matzah. The traditional braided form of *hallah* resembles the configuration of kernels on a wheat stalk. So basic is wheat to human existence that the rabbis use "flour" metaphorically to symbolize a person's livelihood, which they sensibly considered a prerequisite to effective learning: "Where there is no flour, there is no Torah." However, they also pointed out that the obverse was also true: "Where there is no Torah, there is no flour."[3]

A stalk of wheat, TRITICUM. Wheat exists both bearded and without spikelets (called "awns"). Bearded wheat and barley closely resemble each other, though their grains have very different characteristics.

[1]Deuteronomy 8:8; [2]Psalm 81:17; 147:14; [3]*Pirke Avot* 3:21.

Signifies: AGRICULTURE, BLESSING, FERTILITY, FOOD, DIVINE GRACE, PEACE, PROSPERITY, RIGHTEOUSNESS, SUSTENANCE

Generic Categories: Botany, Food, Israel (Land of)

See also: Barley, Bread, *Hallah*, Seven Species

WHITE—לָבָן. White—the *color of *light, the *moon and *stars, life-giving *milk as well as the absence of color—has

figured prominently in most religious symbol systems. Paired with black, the two colors symbolize the positive and negative aspects of the human and natural world. In many cultures, black and white are balanced as agencies of divine process; in others, including most Western cultures, black is associated with night and the demonic, white with good.

According to the *midrash*, the Torah was created two thousand years before the physical world, its text written with black *fire upon white fire, lying in the lap of God.[1] This image is parallel to the Taoist "Yin-Yang" symbol, representing the reconciliation of positive and negative aspects.

In the Bible, black and white by themselves usually describe purely physical features: *hair, skin, the diseased *body, animal hides, food, textiles, *clouds, the sky. However, white occasionally symbolizes purity. Isaiah teaches: "Even though your sins be like crimson, they can turn snow-white; be they *red as dyed wool, they can become like fleece."[2] An apocalyptic oracle in the Book of *Daniel prophesies: "The knowledgeable will fall, that they may be refined and purged and whitened until the time of the end."[3]

White eventually became generally associated with holiness and purity. In the rabbinic period, white garments were worn on *Shabbat and the High Holy Days, and it was customary to clothe the dead in a white shroud.[4] It has long been traditional to use a white *hallah cover and tablecloth on *Shabbat* to symbolize the double portion of *manna that fell on this day on the white desert sands.

White is also frequently associated with death, perhaps because white is the color of bone or lifeless (Caucasian) skin. Burial *shrouds are white. Jewish men wear a special white garment called a *kittel on *Yom Kippur, to lead the *Passover *seder, to recite the special prayer for *rain, to marry, and to be buried. Jewish women in the West have long worn white for their *wedding. The traditional *tallit is white with *blue or black stripes. Wearing white clothing symbolizes simplicity and the close connection between life and death.

On the High Holy Days, the usual *ark and *Torah covers are exchanged for white ones in honor of the solemnity and purity

of this season. Many Jews wear special white *tallitot* during these services, and a *kittel* on Yom Kippur to symbolize penitence.

On *Tu B'Shevat, the New Year of the *Trees, the special *seder* developed by the mystics of *Safed calls for the mixing of white and red *wines, symbolic of the barrenness of winter and the coming vitality of the spring.

One of the names of the moon is *levanah*, from the Hebrew word for white. A special ceremony called *Kiddush Levanah* ushers in the New Moon each month. Because the moon is a female symbol in Judaism, white takes on this association as well.

[1]*Midrash Tehillim* 90:12; [2]Isaiah 1:18; [3]Daniel 11:35; [4]JT *Rosh Hashanah* 1:3; *Genesis Rabbah* 96:5; 100:2.

Signifies: BIVALENCE, DEATH, FEMININE, HOLINESS, INFERTILITY, PURITY, RECONCILIATION, SOLEMNITY, WINTER

Generic Categories: Clothing, Colors, Death, Rosh Hashanah, *Shabbat*, Tu B'Shevat, Wedding, Women, Yom Kippur

See also: Clothing, Colors, Fire, *Kittel*, Manna, Moon, Rosh Hashanah, *Shabbat*, Tu B'Shevat, Wedding, Yom Kippur

WILDERNESS — מִדְבָּר. In Jewish tradition, the wilderness has been both a positive and negative symbol. On the one hand, it has represented freedom from *Egyptian slavery, the Revelation at *Sinai, the covenant with God. After the destruction of the *Temple, inaugurating another period of Jewish wandering, God reassured the Jewish People: "I accounted to your favor the devotion of your youth, your love as a bride — how you followed Me into the wilderness, in a land not sown."[1] The wilderness was where the nation and its religion were formed, free from the seductions of foreign gods. When *Elijah wished to escape the power of Baal and to meet God, he returned to Sinai in the wilderness.[2]

On the other hand, the desert represents danger and vulnerability. It is a place ruled by thirst, beasts, and outlaws. The Torah describes it as "an empty howling waste."[3] Isaiah describes it as a haunted region where the "goat-demons shall greet each

other, [and where] the *lilith shall repose and find herself a resting place."[4] The prophets constantly hark back to Israel's sins in the wilderness, especially the sin of the *Golden Calf. The wilderness also represents the present and future punishment of Israel: "Zion has become a desert, *Jerusalem a desolation."[5]

On *Yom Kippur during Temple times, a *goat was chosen by lot to bear Israel's sins into the wilderness of Azazel. A *red thread was twisted around its *horns, and another red thread was tied to the entrance of the Temple. The Talmud claimed that this latter thread would turn *white when the goat reached the wilderness.[6]

Yet the wilderness is also a symbol of universalism, a no-man's land and therefore an everyman's land. According to the *midrash*, the *Torah was given in the wilderness, "for if it had been given in the land of Israel, the nations of the world could have said, 'We have no portion in it.' Therefore it was given in the wilderness, publicly and openly, and in a place to which no one had any claim. Everyone who desires to accept it, let him come and accept it."[7]

[1]Jeremiah 2:2; [2]1 Kings 19:3–18; [3]Deuteronomy 32:10; [4]Isaiah 34:14; [5]Isaiah 64:9; [6]*Yoma* 67a; [7]*Mekhilta, Bahodesh*, 1, on Exodus 19:2.

Signifies: COVENANT, DANGER, FREEDOM, PUNISHMENT, PURITY, SIMPLICITY, SIN, UNIVERSALISM, VULNERABILITY

Generic Categories: Places, Yom Kippur

See also: Golden Calf, Lilith, Red, Sinai, White, Yom Kippur

WILLOW — עֲרָבָה. The most significant characteristic of the willow tree is its association with *water. Isaiah prophesies that *Jacob's descendants will sprout up as rapidly as willows grow by running water.[1]

On the seventh day of *Sukkot, known as Hoshana Rabba, it is customary to separate the willow branches from the other three species carried in procession on the previous days of Sukkot and beat the ground with them. On this day, according to the Talmud, the "world is judged for the water to be received," that is, for the coming winter *rains.[2] This judgment will

determine the yield of the spring harvest. Willows aptly symbolize our dependence on these rains, because they quickly wilt without water.

On the day after Hoshana Rabba, known as Shemini Atzeret, a special prayer for rain is recited. In the Middle Ages, a folk belief arose that willows from the Hoshana Rabba ceremony would induce conception because their association with rain suggests fertility, as does the *gematria* (numerical equivalence) of *aravah* (willow) and *zera* (seed).

A willow branch, SALIX. Many species of willow are permissible for the four species of Sukkot.

A *midrash* about the *four species suggests that the willow, because it has neither taste nor fragrance, symbolizes the Jew who has neither learning nor good deeds to his credit. The willow is also likened to the mouth because of the shape of its leaves.

When the Jewish exiles came to the shores of the Euphrates River in Babylonia, the Levites hung their *harps upon the willow branches, crying: "How can we sing a song of the Lord on foreign soil!"[3] This image is portrayed in Jewish art as a symbol of mourning over the destruction of the *Temple. It is also an appropriate symbol for *Tisha B'Av, the fast day commemorating the destruction of the Temple. The English idiom "weeping willow" similarly expresses the connection between the willow and mourning.

There is a tradition of starting the fire to bake *matzah* for *Passover, or burn the *hametz* before *Passover, with willow branches saved from Sukkot. This custom links both the spring and fall harvests, as well as the *Exodus from *Egypt with the Israelites' subsequent wanderings in the *wilderness. It also highlights the vulnerability inherent in freedom.

The willow's slender, tall form is a symbol of grace. Since ancient times, it has been a very useful tree, providing wicker

for *baskets, nonrotting timber for building boats, and wicks for *lamps.

[1]Isaiah 44:4; [2]*Rosh Hashanah* 1:2; [3]Psalm 137:1-2.

Signifies: FERTILITY, GRACE, GROWTH, MOURNING, VULNERABILITY

Generic Categories: Botany, Sukkot, Tisha B'Av, Trees

See also: Four Species, Rain, Sukkot, Tisha B'Av, Tree, Water

WIND – רוּחַ.

The Hebrew word for wind, *ruah*, also means "spirit," "ghost," "enthusiasm," and "breath." It refers to natural forces as well as divine. From earliest times, "*ruah*" symbolized the connection between natural, human, and divine realms.

Because it seems moved by an invisible *hand, the wind symbolizes God's agency in the natural world.[1] God is described as riding upon the *wings of the wind.[2] In the liturgy, God is characterized as the One "Who causes the wind to blow and the rain to fall." Sometimes God intensifies the wind to demonstrate divine power, as when God addressed *Job out of a whirlwind, or bore *Elijah to heaven in a storm.[3] But the Bible insists that the wind is only a *symbol* of God, not itself divine, as Elijah discovered in his encounter with God on Mount *Sinai: "There was a great and mighty wind, splitting mountains and shattering rocks . . . but the Lord was not in the wind . . . [but] in a still small voice."[4]

In other places, however, "*ruah*" is synonymous with God. At the moment of Creation, God's "*ruah*" hovers over the *face of the *waters.[5] The phrase *Ruah Ha-Kodesh* (Spirit of the Holy) has long been an important term in Jewish theology (Christianity translated this term into "Holy Spirit" and regards it as part of the Trinity). First appearing in the Bible, it came to designate the spirit of prophecy and divine inspiration, bestowed upon *Moses and Joshua, upon the prophets, upon the righteous and saintly, and even upon the whole Jewish People.[6] It is sometimes identified with the *Shekhinah*.

According to *Kabbalah, the human soul is divided into *three parts: *nefesh*, the vital

force common to both animals and human beings; *ruah*, a uniquely human spirit aroused when a person rises above pure animal nature; and *neshamah*, the divine spark (literally, breath) deriving from God.

Wind can also symbolize vanity and the fragility of human life. Job laments that his life is but wind, as does the world-weary Ecclesiastes.[7] This image is central to the *Yizkor* (Memorial) and funeral service.

The whirlwind has come to symbolize the Holocaust.

[1]Psalm 147:18; [2]2 Samuel 22:11; Psalm 18:10; 104:3; [3]Job 38:1; 2 Kings 2:1, 11; [4]1 Kings 19:11–12; [5]Genesis 1:2; [6]Deuteronomy 34:9; 2 Kings 2:9–10; *Leviticus Rabbah* 15:2; *Tanhuma Va-Yehi* 14; *Tosefta Pesahim* 4:2; [7]Job 7:7; Ecclesiastes 1:17.

Signifies: DIVINE INSPIRATION, DIVINE POWER, GOD, HOLOCAUST, PROPHECY, SOUL, VANITY, VULNERABILITY

Generic Categories: Death, Kabbalistic Symbols, Natural Phenomena

See also: Kabbalah, Names of God, *Shekhinah*

WINE – יין.

In ancient Israel, wine was valued not only because it "gladdens the heart," but also because it, along with *milk, provided important dietary liquid in a hot region characterized by scarce and frequently contaminated *water.[1] But too much wine threatened to provoke the drinker into acts of desecration, and thus, priests were forbidden to drink wine while performing their sacred duties.[2] An ordinary Israelite, wishing to assume a life of special holiness, could take a Nazirite vow to abstain from drinking wine or cutting his hair.[3] The rabbis approved of drinking wine in moderation, even suggesting that it yielded wisdom, but warned that excessive drinking was unhealthy and imprudent.[4]

Because of its power to overwhelm the senses and the will, wine is sometimes a symbol of God's anger, which is also described as *"grapes of wrath."[5]

Most pagan cultures in the ancient world used wine in their religious ceremonies. In the Greek cult of Dionysus, devotees, known as bacchanals (after the Roman wine god Bacchus), used wine as a central sacrament in their orgiastic rites. Because

its *red color suggested *blood, and thus sacrifice and death, while its chemistry temporarily restored youthful vigor, wine functioned as a symbol for life and immortality, allowing the worshiper literally to "incorporate" divinity within the physical *body. This symbolism later became central to Christian ritual.

Probably influenced by the Greeks, Jews appropriated wine for ritual purposes during the Hellenistic period. However, to distinguish Jewish from pagan practices, the rabbis instituted numerous restrictions: a special blessing was to be recited before drinking wine; wine was generally to be drunk in moderation, and it was not to be prepared by Gentiles, lest Jews accidentally drink wine intended for pagan libations.[6]

For the past two thousand years, wine has been a central part of Jewish ceremony, symbolizing gladness and celebration. The *Shabbat* is welcomed in and ushered out with a *cup of wine, as are all major holidays. There is a folk custom that placing wine from the *Havdalah* ceremony on one's eyelids and in one's pockets brings good luck. Wine is also the focal point of the *Passover *seder*, during which *four cups of wine are drunk, and the *Tu B'Shevat *seder* with its similar four cups of wine. It is used at circumcisions (*brit*) and daughter-naming ceremonies, at *Bar and Bat Mitzvah* celebrations, and at *weddings. In prior times, it was given to mourners during the meal of consolation. Vines and grape clusters have long been a popular decorative motif. Cups designated for *Kiddush* wine are often lavishly ornamented.

In European folk culture, spilling wine on the ground was thought to appease demons, especially at transitional moments such as weddings or births. The Jewish custom of spilling out wine at the recitation of the *Ten Plagues and overfilling the *Kiddush* and *Havdalah* cup may have developed out of this belief. Another explanation for overfilling one's cup is to symbolize one's thankfulness: "My cup runs over."[7] Spilling out wine while reciting the plagues also symbolically diminishes one's own joy at another's, even an enemy's, destruction.

[1]Psalm 104:15; Ecclesiastes 10:19; *Berakhot* 35b; Leviticus 10:9; [3]Numbers 6:3; [4]*Eruvin* 65; [5]Psalm 60:5; Jeremiah 25:15; [6]*Berakhot* 6:1; *Pesahim* 105b–6a; *Sanhedrin* 106a; *Avodah Zarah* 29b; *Megillah* 7b; [7]Psalm 23:5.

Signifies: CELEBRATION, EXCESS, GOOD LUCK, HOLINESS, JOY, LIFE, THANKSGIVING, VINICULTURE, WISDOM

Generic Categories: *Brit*, Food, Holidays, Passover, *Shabbat*, Tu B'Shevat, Wedding

See also: Blood, *Brit*, Cup, Grape, *Havdalah*, Milk, Passover, Red, *Seder*, Seven Species, *Shabbat*, Tu B'Shevat

WINGS – **כְּנָפַיִם**. Because of their association with celestial flight and speed, wings symbolize spirituality and thought in many cultures. The Greeks depicted numerous deities with wings. Victory was also portrayed as a winged figure.

Pagan temples in the ancient Near East abounded with figures of winged gods, especially in the form of bulls and sphinxes. Early Judaism absorbed this motif in its depiction of the *cherubim which hovered above the *ark as well as the *seraphim* and other *angelic beings which are described in the prophetic books. The *midrash* greatly elaborated on this theme of winged heavenly creatures, explaining that ordinary angels had six wings, one for each day of the week during which they chanted praises to God, but none for the *Shabbat* during which the praises of Israel filled the heavens.[1] Legend attributes *twelve wings to *Satan.[2] Another legend claims that the *serpent, who is often identified with Satan, once had wings but lost them when he seduced *Eve.[3]

Even God, one of whose *names is the "Lord of the Heavenly Hosts," is described as having wings (although later commentators, particularly Maimonides, insisted that such anthropomorphic language was only a concession to our limited human imagination). The Bible uses the image of *eagle's wings to represent God's mercy. (Eagles teach their young to fly by carrying them on their wings.) In the *wilderness, God reminds the Israelites that "you have seen what I did to the Egyptians, how I bore you on eagles' wings and brought you to Me."[4] In recent times, when the Jews of Yemen were brought to Israel after the establishment of the state, they regarded the airplanes that flew them to the Holy Land as a modern version of these same "eagles' wings," a symbol of God's strength and salvation. The

Psalmist exults that "under the shadow of Your wings, I shout for joy."[5]

These protective divine wings are usually called *kanfei ha-Shekhinah*, the wings of the *Shekhinah*, God's feminine aspect. This phrase appears frequently in the liturgy as a symbol of God's love and nurturance. In English, the phrase "to take someone under one's wing" conveys the same idea.

The Hebrew word "wing" also means *"corner," used to describe the *four corners of the *tallit* as well as the four corners of the *earth. Although this term probably derives from ideas in ancient geography, it has evolved into a metaphor of God's sheltering Presence whose wings cover the Jewish People and, indeed, the whole earth.

[1]Ginzberg, *Legends of the Jews* 5:110; [2]*Pirke de-Rebbe Eliezer* 13; [3]Ginzberg 5:123–124; [4]Exodus 19:4; [5]Psalm 63:8.

Signifies: DIVINE COMPASSION, DIVINE LOVE, DIVINE POWER, DIVINE PRESENCE, DIVINE PROTECTION, PROTECTION, SALVATION

Generic Categories: Kabbalistic Symbols, Prayer

See also: Angels, Bird, Cherubim, Corners, Eagle, Satan, Serpent, *Shekhinah*, *Tallit*

YAD – **יָד**. The *yad*, meaning "*hand," is a special pointer for reading from the *Torah scroll, to keep the reader's place as well as to protect the sacred parchment's holiness by not allowing it to be touched by the human hand.[1] Typically, the *yad* hangs by a chain from one of the Torah rollers.

For centuries, Jewish artists have beautified the *yad*. Traditionally made of wood, ivory, or precious metal, especially silver, the *yad* consists of a long, slender shaft crowned by a *hand with one finger outstretched. Beginning in the 16th century, Jewish artisans began to model Torah ornaments after royal apparel, stressing the majesty of God and the Torah. The

Torah pointer used when reading the scroll.

rimmonim (Torah handle-covers) resemble a *crown; the Torah cover, a sumptuous mantle; and the *yad*, a royal scepter.

In ancient Hebrew, *yad* also meant "memorial."[2] This use of the term has been revived in modern Israel. In *Jerusalem, the institution commemorating Holocaust victims is called Yad Vashem, literally, hand and name.

Originally only a communally owned implement, the *yad* has recently become a personal ritual object, often given as a gift to Torah readers, for example, to a **Bar* or *Bat Mitzvah*. This gift in part represents the owner's personal commitment to Torah.

[1]*Yaddayim* 3:2; 4; 6; *Shabbat* 14a; [2]2 Samuel 18:18.

Signifies: DIVINE PRESENCE, DIVINE POWER, REMEMBRANCE, POWER, ROYALTY

Generic Categories: Ritual Objects, Synagogue

See also: Five, *Hamsa*, Hand, King, Torah

YELLOW – צָהֹב.

Among the nations of Europe, the *color yellow has long been used to identify Jews for purposes of discrimination. In the 9th century, the Saracen governor of Sicily required his Jewish subjects to wear yellow belts. Edward I of England (13th century) compelled Jews above the age of seven to wear a piece of yellow taffeta in the form of the *Ten Commandments above their hearts. A century later, French Jews wore circular yellow badges on their chests, as did the Jews of Barcelona, theirs with a *red bull's eye in the center. Barcelona Jews were also required to wear pale green clothing as a sign of mourning for the *Temple, whose de-

Six yellow tulips used to commemorate the *Six Million Jews lost in the Holocaust. Tulips bloom in northern Jewish communities around the time of Yom Ha-Shoah, Holocaust Remembrance Day, and honor the role of Scandinavian countries in rescuing and saving Jews.

struction was thought to have made Jews turn their back on Jesus. Roman Jewish men wore a yellow patch. Pope Paul IV (16th century), who inaugurated the ghetto system in Italy, required Jewish men to wear a yellow hat; women, a yellow kerchief. German Jews first wore pointed hats, then yellow *circles; women wore pointed yellow veils. Many of these practices continued until the Emancipation, which followed in the wake of the French Revolution. The Nazis revived the old symbolism of the yellow badge, requiring Jews to wear a yellow *Star of David.

In modern times, there have been several attempts to "rehabilitate" yellow as a positive color. Theodor Herzl deliberately chose yellow for the cover of the first Zionist journal, *Die Welt*. Some contemporary communities have instituted the custom of distributing bouquets of six yellow tulips on Yom Ha-Shoah, (Holocaust Memorial Day), to honor the memory of the *Six Million Jews killed during the Holocaust, and the Dutch and Danish communities who helped so many Jews.

Signifies: ANTI-SEMITISM, OPPRESSION, PERSECUTION

Generic Categories: Clothing, Colors, Holocaust

See also: Clothing, Colors, Six Million, Star of David

YOKE – עֹל.

In an agricultural society, yokes naturally symbolize enslavement and subjugation. The Bible speaks of the yoke of *Egypt as well as the *"iron yoke" of Israel's current and future enemies.[1] Legends and rabbinic teachings lament the heavy yoke of *Rome.

Significantly, this same metaphor, so negative when applied to human rulers, functions as a positive symbol when applied to God. The rabbis taught that "one should first receive upon oneself the yoke of the Kingdom of Heaven, and afterwards receive upon oneself the yoke of the commandments,"[2] meaning that Jews should declare their faith in God's Unity (through the "*Shema*") and then pledge themselves to a life committed to the *Torah and its strictures. The liturgy even

includes a reference to the *angels taking upon themselves this "heavenly yoke of God's kingdom" (*ol malkhut shamayim*).

[1]Leviticus 26:13; Deuteronomy 28:48; Isaiah 9:3; [2]*Berakhot* 2:2.

Signifies: COMMITMENT, MITZVOT, SLAVERY, SUBMISSION TO GOD'S WILL

Generic Categories: Prayer

See also: *Bar/Bat Mitzvah*, Rome, Six Hundred and Thirteen

YOM KIPPUR – יוֹם כִּפּוּר. Yom

Kippur, the Day of Atonement, is a fast day devoted to individual and communal repentance, *teshuvah* ("returning"). It climaxes a long period of self-examination, beginning with a month of spiritual preparation during *Elul*, and then becoming more intense during the *ten days from *Rosh Hashanah to Yom Kippur. During this twenty-five-hour fast, Jews over the age of *thirteen refrain from all physical pleasure, specifically: eating and drinking, bathing, anointing the body with *oil, wearing leather shoes, and engaging in sexual activity. The individual must instead spend this period taking spiritual inventory (*heshbon ha-nefesh*) and returning to the right path. Yom Kippur is the holiest day in the Jewish *calendar, the "Sabbath of Sabbaths."[1]

The tradition teaches that on this day, Jews become as pure as *angels, liberated from worldly needs.[2] The rituals and symbols of this day also emphasize human mortality: wearing the *white *kittel* in which one will ultimately be buried; and abstaining from food and drink.

In ancient Israel, young women would dress in white on the afternoon of Yom Kippur and dance in the fields; young men would meet them there and choose brides.[3] This ancient custom may have given rise to the practice of reading about forbidden sexual relations during the afternoon Torah service on Yom Kippur (Leviticus 18).

The holiday begins with the service called *Kol Nidre* ("all vows") during which the liturgy introduces the main themes of communal confession of sins, human atonement, and divine compassion. During the rest of the day, these themes are repeated. The special Yom Kippur liturgy contains biblical excerpts describing the ancient scapegoat ceremony performed by the High Priest on this day as well as the awesome ritual during which the High Priest would enter the Holy of Holies in the *Temple and utter the Four-Letter *Name of God on this one day of the year. Since the theme of repentance is central to the Book of *Jonah, it is recited during the afternoon service.

Yom Kippur marks the end of the special period of repentance; as such, it is characterized by a sense of urgency and solemnity. The phrase "Write us in the *Book of Life," which is recited throughout Rosh Hashanah, is changed on this day to "Seal us in the Book of Life." The final service, *Neilah*, reminds worshipers that the *Gates of Compassion are about to close. The day ends with a long blast of the *shofar*, sounding a final appeal for God's forgiveness as well as proclaiming the hope for messianic redemption.

It is traditional to begin building one's *sukkah* immediately after the end of Yom Kippur to symbolize the link between the two festival periods and to affirm the continuity of life.

[1]Leviticus 23:26–32; [2]Yehudah Ha-Levi, *Kuzari* 3:5; [3]*Taanit* 4:8.

Signifies: ATONEMENT, DIVINE COMPASSION, DIVINE JUDGMENT, FATE, HOLINESS, REDEMPTION, PURITY, REPENTANCE, RESPONSIBILITY, VULNERABILITY

Generic Categories: Death, Messiah, Prayer, Synagogue, Temple, Women, Yom Kippur

See also: Angels, Book, Fish, Gates, Goat, Jonah, *Kittel*, Name of God, Priestly Cult, Rosh Hashanah, Scales, *Shofar*, White

ZODIAC – גַּלְגַּל־הַמַּזָּלוֹת. The

Zodiac (from the Greek word meaning "little animals") is a *circular pattern of twelve symbols corresponding to the twelve constellations which, according to the ancients, govern the heavens and human fate through the course of the solar year. Each symbol has a Greek name, a pictorial emblem, and a set of characteristics which were thought to describe the personality and destiny of the person born "under" that sign. The study of these and other heavenly patterns is called

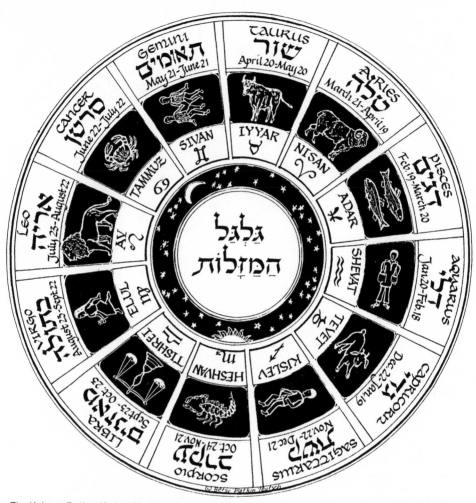

The Hebrew Zodiac (*Galgal Ha-Mazalot*, "wheel of the constellations"). The equivalencies of signs and Hebrew months are approximate, as the Hebrew calendar is lunar, and the Gregorian calender, solar.

astrology, whose practice continues to exert a powerful appeal even today.

Jews have long been interested in the meaning of celestial signs. Legend tells of a heavenly portent accompanying the birth of *Abraham.[1] *Joseph dreamed of his future in images of the *stars, *sun, and *moon. The Talmud is filled with advice and anecdotes about astrological matters. Medieval Jewish writings similarly debate the relative importance of the stars, the planets, and the moon on human fate.

Under the pressure of Hellenism, which itself was markedly influenced by the astral religions of the East, Judaism absorbed many astrological theories and symbols, among them the Zodiac. Several early *synagogues feature Zodiacs on their mo-

saic floors, consisting of the twelve pagan symbols with Hebrew translations of their Latin names. In a square around the Zodiac circle are the *four seasons, each represented by a female figure surrounded with agricultural symbols and designated by the name of a Hebrew month. Significantly, the symbols in the Zodiac usually do not correspond to the Hebrew season with which they are aligned. Usually, the Jewish mosaicists oriented both the Zodiac and the seasons from right to left—that is, counterclockwise—according to the pattern of Hebrew writing, but contrary to the sundial and its conventional representation in the Zodiac. However, in Naaran in the Jordan valley, the artists not only aligned the fall season of *Tishrei*, the month of *Rosh

Hashanah, with the pagan New Year in March, but also reversed the Zodiac to run clockwise while the seasons continued to run the other way, indicating that the Jews of this community had come to live in two completely separate *calendars.

The Zodiac circle also represented the wheel of life: the twelve months of the year and the twelve hours of the day and night. The image of the "squared circle" on the synagogue floor—the Zodiac surrounded by the seasons—represented the sphere of the heavens and the four *corners of the earth, a common pictorial motif in the ancient world, representing the cosmos.

Although Christian art soon "legitimized" the pagan Zodiac by substituting saints, *angels, and other Christian symbols for the twelve original signs, Jewish art retained the pagan images—with unique Jewish variations—even inserting Zodiacs into (Ashkenazi) prayer books alongside the special prayers for *dew on *Passover and *rain on *Sukkot. Rabbinic authorities rationalized its inclusion by allegorizing the signs in terms of Jewish history.[2] Kabbalistic literature, especially the ancient *Sefer Yetzirah* and its many commentaries, derives mystical significance from the astrological settings of Jewish events. Another commentary claims that the *flags of the *Twelve Tribes correspond to the twelve signs of the Zodiac:[3]

The Twelve Tribes and the Signs of the Zodiac

Tribe	Zodiac sign (Greek)	Zodiac sign (Hebrew)	Zodiac sign (English)
*Judah	Aries	*Taleh*	Lamb or Ram
Issachar	Taurus	*Shor*	Bull
Zevulun	Gemini	*Te'omim*	Twins
Reuben	Cancer	*Sartan*	Crab
Simeon	Leo	*Aryeh*	Lion
Gad	Virgo	*Betulah*	Virgin
Ephraim	Libra	*Moznayim*	Scales
Manasseh	Scorpio	*Akrav*	Scorpion
Benjamin	Sagittarius	*Keshet*	Archer
Dan	Capricorn	*Gedi*	Goat
Asher	Aquarius	*Deli*	"Bucket"
Naftali	Pisces	*Dagim*	Fishes

The Zodiac was a popular design in Italian *ketubot*, symbolizing both a propitious time for the marriage and the joining of mates with harmonious signs. Many of the brightly painted wooden ceilings of Polish synagogues featured Zodiacs among their designs.

Several symbols of the Zodiac correspond with traditional Jewish holiday motifs. (However, because the Zodiac is calibrated by a solar calendar, whereas the Jewish calendar is lunar with solar seasonal adjustments, the two time frames do not always coincide.) The sign of Libra, which roughly corresponds with *Rosh Hashanah, is the *scales, symbolic of Justice, likewise a major theme of the Jewish New Year. The sign of Aries, which corresponds with *Passover, is the lamb, which once served as the paschal *sacrifice. This season is also the time when *sheep give birth to their young. (Some Jewish sources depict Aries as a ram, which represents this month in the pagan Zodiac.)

Another connection between the Zodiac and the Jewish calendar occurs on *Purim, which usually falls during the month of Pisces—the *Fishes. For centuries, Jewish folk artists have depicted fish on Purim ritual objects. Both *Adar*, the Hebrew month during which Purim falls, and fish are considered lucky.

An ancient legend compares the stages of human life to the signs of the Zodiac: we are born "tender as a lamb" (Aries); the evil inclination splits our will in two (Gemini); repentance makes us virginal again (Virgo); after we die, we become once again as tender as a kid (Capricorn) and happy as a fish in water (Pisces).[4]

Although much of the astrological rationale for the signs has been lost over time, the Zodiac continues to play an important role in both general and Jewish popular culture. Joyous occasions such as births, *weddings, and *Bar/Bat Mitzvahs* are still celebrated with the phrase: *"Siman tov u'mazel tov!"* which literally means "[May you be blessed with] a good sign and a good constellation!"

[1] *Sefer Yashar Noah* 18a–19a; [2] *Pesikta Rabbati* 27–28; [3] *Yalkut Shimoni* Leviticus 418; [4] *Tanhuma, Haazinu* 1:339b.

Signifies: GOOD LUCK, ORDER, TIME, WORLD

Generic Categories: Astronomy, Passover, Purim, Rosh Hashanah, Sukkot

See also: Calendar, Circle, Fish, Goat, Lion, Moon, Ram, Scales, Sheep, Stars, Sun, Twelve Tribes

GLOSSARY

Note: Words or phrases marked with an asterisk can be found under their own headings in the Glossary. Words or phrases marked with a number sign (#) can be found in entries within the *Encyclopedia*.

Aggadah: Nonlegal sections of the *Talmud and *midrash*, including stories, legends, animal fables, folklore, proverbs, wordplay, medicine, astronomy, astrology, etc.

Akiva: One of the greatest talmudic sages (50–135 *C.E.). Noted for his scholarship, humanity, tolerance, and martyrdom at the hands of the Romans.

Amidah: Literally, Standing Prayer. One of the most ancient prayers in the liturgy. Because it is central to all Jewish services, the Talmud calls it "the Prayer." Also called *Shemoneh Esrei* (the number 18), because it originally consisted of eighteen blessings.

Amoraim: Spokesmen (Aramaic; singular—*Amora*). Rabbis of the postmishnaic period (200–500 *C.E.) who interpreted the *Mishnah. Their interpretations comprise the bulk of the Babylonian and Jerusalem *Talmud.

Apocrypha: A collection of anonymous historical and ethical works, including the Books of the Maccabees and #Judith, dating from the period of the Second #Temple. The term "apocrypha" (from Greek meaning "hidden away") was used by non-Jews; the rabbis referred to these works simply as "extraneous books." Although considered worthy literature, Jewish tradition does not include these works in the biblical canon.

Ari: See *Luria, Isaac.*

Ashkenazi: Literally, native of Germany (Hebrew). Refers to Jews originating from European countries, with their own distinctive customs, artistic traditions, Hebrew pronunciation, and foods.

B.C.E.: Before the Common Era. Traditional Jewish term designating the centuries before the birth of Jesus.

Bar Kokhba: Son of the Star (Aramaic). Leader of Jewish revolt against #Rome in 2nd-century Palestine. Defeated at Betar in 135 *C.E. Many of his contemporaries, notably *Rabbi Akiva, declared him the #Messiah.

Blood Libel: False allegation that Jews murdered Christians to obtain their #blood for #Passover rituals. Such accusations often led to pogroms in the Middle Ages. Cases of blood libel have been reported up until modern times.

C.E.: Common or Christian Era. Traditional Jewish term designating the centuries after the birth of Jesus.

Cantor: *Hazzan* in Hebrew. Leader of the prayer service. In modern times, the *hazzan's* role has been primarily that of musical leader of a congregation.

Diaspora: Dispersion (Greek. *Galut* or *Galus* in Hebrew). Exile. Jews living outside the land of #Israel.

Derash: To seek (Hebrew; root of **midrash*.) To decipher and present the latent meanings of a sacred text, usually the Bible. *Derashah* is a sermon or interpretation derived by this method.

Elul: (Hebrew). Sixth month of Hebrew calendar, preceding #Rosh Hashanah. A time of spiritual preparation and repentance.

Emancipation: Period following the French Revolution and the Napoleonic wars, after which European Jews began acquiring greater civil and personal rights within the larger Gentile community.

End of Days: The Messianic Era. (*Aharit Ha-Yamim* in Hebrew.) The end of human history and the beginning of the reign of the #Messiah, a descendant of King #David. Generally viewed as a time of political and religious reconciliation. Traditional Jewish sources also speak of the resurrection of the dead and a universal return to #Jerusalem.

Enlightenment: (*Haskalah* in Hebrew). European movement beginning in the late 18th century and lasting until the late 19th century, based on the belief that secular studies should be combined with religious studies in the education of Jews.

Gematria: (Hebrew; derived from the Greek). A system that sets up equivalences between Hebrew words of equal numerical value, each Hebrew letter having an assigned value. Using these equivalences, the *rabbis and kabbalists derived moral, ritual, and philosophical principles.

Haftarah: Excerpt from one of the prophetic books chanted after the #Torah portion is read on #Sabbaths and holidays.

Halakhah: The Way (Hebrew). Jewish law as articulated in the Bible, *Talmud, codes, and subsequent rabbinic rulings.

Hallel: Praise (Hebrew). A special section of liturgy, composed primarily of Psalms 113–118, recited in synagogue on most holidays.

Hasidism: Religious movement founded by Rabbi Israel ben Eliezer, also known as the Baal Shem Tov, in the 18th century. Members of this movement are known as "*hasidim*" (singular, *hasid*).

Havurah: Literally, fellowship (from *haver*, Hebrew for friend; *havurot*, plural). Collective of Jews who gather together to pray, study, celebrate, or engage in other Jewish communal activities. Although based upon earlier models, *havurot* are a new phenomonen in the Jewish community, committed to egalitarian, participatory principles of membership.

Hazzan: see **Cantor*.

Hillel: The greatest sage of the Second #Temple period (late 1st century *B.C.E.–early 1st century *C.E.). Noted for his wisdom, tolerance, humility, and conciliation. In the many legal disputes between Hillel and his chief rival, *Shammai, rabbinic tradition has almost always sided with Hillel.

Hiddur Mitzvah: Adornment of a commandment (Hebrew). The idea that it is praiseworthy to beautify the performance of a divine commandment, based on the biblical verse: "This is my God whom I will adorn" (Exodus 15:2). This verse is invoked as a justification for Jewish ritual art.

Hoshana Rabba: The great *hoshana*. Derived from two Hebrew words meaning "Save, I pray!" (Hebrew). Seventh day of #Sukkot, marked by a mood of solemnity. Traditionally regarded as the day when God finally seals the verdict passed on #Yom Kippur and allots the year's rainfall. The synagogue service includes processions and beatings of #willow branches.

Kabbalah: The Jewish esoteric tradition, based on a cosmology of divine emanations and secret names of God. Although the kabbalistic tradition stretches back two millennia, it received its fullest elaboration in the 13th-century mystical work, the **Zohar* (Book of Splendor), and in the writings of the 16th-century Jewish mystics of #Safed.

Kabbalist: One who studies and practices *Kabbalah.

Kaddish: Derived from the Hebrew word for "holiness." (See also *"*Kedushah*.) Aramaic prayer recited to commemorate the dead, to mark divisions in the prayer service, and to conclude a period of study.

Kavvanah: Directed intention (Hebrew). The act of focusing one's thoughts and feelings during prayer or the performance of a commandment.

Kedushah: Holiness (Hebrew). The Hebrew root suggests both sacredness and separateness.

Kibbutz: Voluntary collective community in #Israel, mainly agricultural, but often producing manufactured goods as well. Begun in the early part of this century, *kibbutzim* are run primarily on socialist principles, including communally owned property, cooperative decision-making, and communal caretaking of members' children.

Kiddush: Sanctification (Hebrew). The prayer over #wine recited at the beginning of #Sabbath and holiday meals.

Kiddush Ha-Shem: Sanctification of (the Divine) Name (Hebrew). Religious martyrdom.

Kol Nidre: All vows (Aramaic). The prayer opening the #Yom Kippur evening service at the start of the holiday.

Kosher: Ritually acceptable (Hebrew).

Luria, Isaac: Sixteenth-century *kabbalist, also known as the Holy "Ari" (Lion). Greatest teacher of Jewish mysticism in #Safed (#Israel), whose reinterpretation of *Kabbalah greatly influenced later Jewish spiritual movements, particularly *Hasidism.

Maariv: Evening *Prayer (from root *erev* — evening, in Hebrew). Recited every evening at sundown. See also *Prayer*.

Mahzor: Special prayer book for the High Holy Days and the three pilgrimage festivals.

Maimonides: Twelfth-century Spanish philosopher, rabbi, legal codifier, and royal physician. Also known as the RaMBaM, an abbreviation of his name, "Rabbi Moses ben Maimon." Best known for the *Mishneh Torah*, a codification of Jewish law, and *The Guide of the Perplexed*, a monumental philosophical and theological treatise.

Merkavah Mysticism: The earliest school of Jewish mysticism, dating back to the *talmudic period, whose practices and teachings are based upon Ezekiel's vision of the divine #chariot, the *merkavah* (Ezekiel, chapter 1).

Micrography: The art of creating designs out of miniature Hebrew letters, usually verses from the Bible, the traditional liturgy, or *kabbalistic texts.

Midrash: That which is sought out (Hebrew). The genre of rabbinic literature deriving meaning out of biblical texts or embroidering traditional teachings. The term refers both to the method of interpretation and to the literature itself.

Minhah: Offering (Hebrew). The afternoon *prayer service, recited between mid-day and nightfall. See also *Prayer*.

Mishloah Manot: Sending Gifts (also called *shalah manos*). On #Purim, it is traditional to send plates of fruits, #nuts, and three-cornered pastries called #hamentashen (#Haman's pockets) as well as small bottles of spirits to friends and family in honor of the holiday.

Mishnah: Study by Repetition (Hebrew). Earliest code of Jewish oral law, arranged by Judah the Prince in 200 *C.E.

Mitzvah: Commandment (Hebrew; plural, *mitzvot*). One of the #613 divinely ordained commandments articulated in the *#Torah. *Mitzvah* also means a "good deed."

Mohel: Circumciser (Hebrew). The person who performs a ritual circumcision.

Musaf: That which is added (Hebrew). The additional service on #Sabbath and Festivals. See also *Prayer*.

Nasi: Prince (Hebrew). *Talmudic term for president of the *Sanhedrin; also the spiritual and political leader of the Jewish people in the rabbinic period.

Neilah: Closing (Hebrew). Concluding service of #Yom Kippur.

Nisan: First month of the ancient Hebrew calendar. #Passover occurs on the fifteenth of this month.

Notarikon: Shorthand writer (Greek). A method of interpreting biblical words and phrases by reading them as acronyms or combinations of smaller words.

Pidyon Ha-Ben: Redemption of the son (Hebrew). A ceremony symbolically compensating God for not sacrificing a firstborn son. The parents of the child pay a *Kohen* (descendant of the priestly class) a token coin, which is then donated to charity.

Pilgrimage Festivals: (*Shalosh Regalim* in Hebrew). The holidays of #Passover, #Shavuot, and #Sukkot, during which festivals it was customary, in ancient times, for Jews to bring agricultural offerings to the #Temple in #Jerusalem.

Prayer: Jewish tradition requires that a Jew pray three times a day: *Shaharit* in the morning, *Minhah* in the afternoon, and *Maariv* in the evening. On #Sabbaths and festivals there is an additional service called *Musaf*. On #Yom Kippur, there is a fifth service, *Neilah*, which concludes the holiday. Prayers recited with proper *kavvanah* can effect great changes in the world. The three main functions of prayer are petition, praise, and thanksgiving.

Prooftext: A verse, usually biblical but occasionally rabbinic, used to justify a legal or ethical point.

Rabban: Master (Hebrew). Honorary title higher than rabbi, used for the head of the *Sanhedrin.

Rabbi: Master, Teacher (Hebrew). In the singular, a Jewish teacher, leader, or decisor of Jewish law. In the plural, the term usually refers to the sages of the *Mishnah and *Talmud whose legal judgments and interpretations of Jewish tradition shaped mainstream (also called rabbinic) Judaism as it is practiced today. See also *Amoraim*, *Tannaim*.

Rashi: Acronym for "*Rabbi Shlomo ben Isaac*," 11th-century French scholar whose Hebrew commentary on the Bible and *Talmud is still considered the most authoritative in the Jewish tradition.

Rebbe: Rabbi (Yiddish). The leader of a *hasidic community. A rebbe's followers are called his *hasidim*.

Rosh Hodesh: Head of the Month (Hebrew). The first day of a Hebrew month, celebrated as a minor holiday.

Sages: Term usually referring to the rabbinic scholars quoted in the *Mishnah and *Talmud.

Sanctuary: Refers to the #*Mishkan*, the portable tabernacle constructed in the #wilderness to house the #Ark and #altar. In later times, this term refers to the prayer room of a synagogue, which contains the ark.

Sanhedrin: Council (Greek). An assembly of seventy-one sages who served as the supreme religious, legislative, and political body in #Jerusalem during the Roman period.

Sephardi: Literally, native of Spain (Hebrew). Refers to Jews native to Southern Mediterranean, Northern African, and Middle Eastern countries, with their own distinctive customs, artistic traditions, Hebrew pronunciation, and foods. Sometimes Jews of Middle Eastern origin bear a separate designation as *Edot Ha-Mizrah* (Eastern communities).

Seudah Shlishit: Third Meal (Hebrew; also called *Shal'shudes*). The final #Sabbath meal preceding the concluding ceremony of #*Havdalah*, during which time it is customary for the rabbi to speak words of *#Torah to his students.

Shabbatai Tzevi: Seventeenth-century Turkish Jew who declared himself the #Messiah, inspiring a widespread following among Diaspora Jews, which ended when he converted to Islam rather than submit to the sultan's executioner. Sabbatean messianism persisted for another century as an underground movement among some Jewish mystics, although it was considered heretical by the mainstream community.

Shaharit: Morning (Hebrew). The morning *prayer service. See also *Prayer*.

Shalah Manos: See *Mishloah Manot*.

Shal'shudes: See *Seudah Shlishit*.

Shammai: Prominent sage of the *Mishnah (50 *B.C.E.–30 *C.E.), known for his legal stringency and personal strictness. In most legal disputes with his chief rival *Hillel, the rabbinic tradition ruled against *Beit Shammai* (the House of Shammai) in favor of *Beit Hillel*.

Shema: Hear! (Hebrew). The first word of the Hebrew *prayer called by the same name: *Shema Yisrael, Adonai Eloheinu, Adonai Ehad* — Hear O Israel! *Adonai* is our God, *Adonai* is One." The *Shema* is one of the central prayers of the liturgy, and is traditionally recited at the moment of death.

Shehehiyanu: Who has kept us alive (Hebrew). Thanksgiving prayer recited upon reaching a significant moment in one's life such as a #wedding, holiday, #*Bar* or *Bat Mitzvah*.

Shemini Atzeret: Eighth Day of Assembly (Hebrew). Final day of #Sukkot, during which the congregation recites a special prayer for rain. In Israel, this day is combined with Simhat Torah.

Shtibl: Small Orthodox synagogue, often a storefront or other small room.

Shtetl: Small town (Yiddish; plural, *shtetlakh*). Small village in Eastern Europe where Jews lived prior to World War II.

Shul: Synagogue (Yiddish).

Shulhan Arukh: The Prepared Table (Hebrew). The most authoritative code of Jewish law, compiled by Joseph Caro in the 16th century.

Siddur: Prayer book (Hebrew).

Simhat Torah: Joy of the Torah (Hebrew). The day after #Shemini Atzeret, during which the annual reading of the *#Torah is completed and begun again. In synagogue, the congregation sings and dances with the Torah scrolls.

Talmud: Teaching (Hebrew). Collection of discussions on the *Mishnah by generations of scholars in Babylonia and Palestine, redacted in 500 *C.E. *Gemara* refers to the postmishnaic portion of the Talmud.

Tanakh: Abbreviation for *#*Torah* (Pentateuch), *Nevi'im* (Prophets), and *Ketuvim* (Writings). The traditional Jewish term for the Hebrew Bible; called by Christians "the Old Testament."

Tannaim: Teachers (Aramaic; singular, *Tanna*). Rabbinic teachers of the *mishnaic period. Followed by *Amoraim. See also *Rabbi; *Sages.

Tashlikh: Casting Out (Hebrew). Ceremony performed on the first day of #Rosh Hashanah, during which Jews toss crumbs into a stream to symbolize the casting off of their sins.

Ten Lost Tribes: When Assyria conquered the Northern Kingdom of #Israel in 722 *B.C.E., the ten tribes living there were exiled to foreign lands and subsequently lost their national identity. Many legends have arisen about their fates.

Teshuvah: Returning (Hebrew). Repentance.

Tetragrammaton: Four-letter Word (Greek). The Sacred #Name of God consisting of the letters *yud, heh, vav, heh* (YHVH), often mistakenly translated as Jehovah.

Third Meal: See *Seudah Shlishit*.

Tikkun: Repair (Hebrew). According to *Kabbalah, world harmony was shattered at the beginning of time; it is now humankind's task to effect a *tikkun olam*, cosmic reparation. The term also describes the all-night study session held on the holiday of #Shavuot, called *tikkun leil Shavuot*, as well as the book used to study *#Torah cantillation.

Tishrei: Seventh Hebrew month (corresponding to September/October), during which occur the holidays of #Rosh Hashanah, #Yom Kippur, and #Sukkot.

Torah: Teaching (Hebrew). The five books of Moses, also called the Pentateuch or *Humash* (#"five" in Hebrew), read in synagogue every Monday, Thursday, #Sabbath, and festival. The Torah is the foundation of all Jewish law and practice. The term is very elastic, referring sometimes to the Pentateuch, sometimes to the entire body of Jewish teaching and literature, and occasionally to an individual's teachings based upon traditional texts.

Tzaddik: Righteous One (Hebrew; sometimes written *zaddik*). An especially pious individual. In more recent times, the term sometimes refers to the leader of a *hasidic community.

Tzedakah: Righteousness (Hebrew). Charity.

World to Come: (*Olam Ha-Ba* in Hebrew). The heavenly realm where righteous souls go after death. A person's deeds earn him or her a "portion in the World to Come."

Yeshivah: Sitting (Hebrew). Traditional *talmudic academy.

YHVH: See *Tetragrammaton*.

Zohar: The Book of Splendor (Hebrew). The central work of *kabbalistic literature, attributed to the *talmudic sage Shimon bar Yohai, but more probably composed by the Spanish mystic Moses de Leon in the 13th century.

APPENDIX A
SYMBOLS LISTED BY GENERIC CATEGORIES

Animals
Ass
Bear
Behemoth
Bird
Deer
Dove
Eagle
Fish
Goat
Had Gadya
Hare
Horn
Leopard
Leviathan
Lion
Locust
Messiah
Ram
Serpent
Sheep
Shofar

Astronomy
Calendar
Chariot
Circle
Earth
Light
Mezuzah
Moon
Seven
Stars
Sun
Twelve Tribes
Zodiac

Body Parts
Almond tree
Beard
Body
Corners
Eye
Face
Four Species
Hair
Hamsa
Hand
Head
Heart

Botany
Adam
Almond tree
Barley
Burning Bush
Carob
Cedar
Cypress
Etrog
Fig
Flowers
Four Species
Grapes
Honey
Lentil
Lulav
Mandrakes
Messiah
Myrtle
Nut
Olive
Palm tree

Pine
Pomegranate
Rose
Sabra
Seven species
Tree
Tu B'Shevat
Wheat
Willow

Clothing
Amulet
Breastplate
Circle
Clothing
Corners
Crown
Kippah
Kittel
Knots
Priestly Cult
Shroud
Tallit
Wedding
White
Yellow

Colors
Adam
Blue
Colors
Flag
Priestly Cult
Rainbow
Red
Twelve Tribes
White
Yellow

Dwellings
Ark
Cedar
Mezuzah
Mishkan
Palace
Portal
Sukkah
Synagogue
Temple
Tower

Food
Afikoman
Almond tree
Apple
Barley
Bird

Blood
Bread
Chickpea
Circle
Cup
Egg
Etrog
Fig
Fish
Goat
Grapes
Hallah
Hamentashen
Hametz
Haroset
Honey
Kashrut
Manna
Maror
Matzah
Messiah
Nut
Oil
Olive
Palm tree
Passover
Purim
Salt
Seder
Shavuot
Table
Wheat
Wind

Holidays
Calendar
Candles
Cup
Wine
Hanukkah
Candles
Dreidl
Hallah
Hanukkah
Judah Maccabee
Judith
Light
Menorah
Messiah
Milk
Nut
Oil
Rock
Lag B'Omer
Carob
Lag B'Omer

Manna
Passover
 Afikoman
 Angel of Death
 Apple
 Barley
 Chickpea
 Circle
 Dew
 Egg
 Elijah
 Exodus
 Four
 Goat
 Had Gadya
 Haggadah
 Hametz
 Haroset
 Maror
 Matzah
 Moses
 Messiah
 Nut
 Omer
 Passover
 Pharaoh
 Ram
 Seder
 Seven
 Sheep
 Shifra and Puah
 Three
 Wine
 Zodiac
Purim
 Amalek
 Chickpea
 Esther
 Fish
 Gragger
 Hallah
 Haman
 Hamentashen
 King
 Mask
 Megillah
 Purim
 Queen
 Rose
 Zodiac
Rosh Hashanah
 Akedah
 Apple
 Bird
 Book
 Bread

Chickpea
Circle
Hallah
Head
Honey
Horn
Isaac
Ishmael
King
Mezuzah
Nut
Rachel
Ram
Rosh Hashanah
Sarah
Satan
Scales
Seven
Shofar
Ten
Three
Throne
Water
White
Zodiac
Rosh Hodesh
 Moon
 Rosh Hodesh
Shavuot
 Alephbet
 Barley
 Basket
 Flowers
 Kabbalah
 Ketubah
 Ladder
 Leviathan
 Light
 Milk
 Omer
 Rose
 Ruth
 Seven
 Seven Species
 Shavuot
 Sinai
 Six Hundred and Thirteen
 Ten Commandments
 Torah
Sukkot
 Circle
 Etrog
 Flag
 Flowers
 Four Species
 Grapes

Hallah
Kittel
Lulav
Messiah
Myrtle
Palm tree
Rain
Seven
Sukkah
Sukkot
Torah
Ushpizin
Water
Willow
Zodiac
Tisha B'Av
Egg
Jerusalem
Messiah
Temple
Tisha B'Av
Willow
Tu B'Shevat
Almond tree
Carob
Four
Grapes
Kabbalah
Nut
Olive
Palm Tree
Pomegranate
Seder
Tree
Tu B'Shevat
White
Wine
Yom Kippur
Ark
Bird
Book
Brit
Clothing
Gates
Hallah
Jonah
Kittel
Ladder
Light
Messiah
Priestly Cult
Satan
Shofar
Ten
White
Wilderness

Yom Kippur
Yom Ha-Shoah (*See* Holocaust)
Yom Ha-Atzma'ut (*See* Israel)

Holocaust
Akedah
Auschwitz
Burning Bush
Candles
Fire
Six Million
Warsaw Ghetto
Yellow

Israel, Land of
Carob
East
Fig
Four Species
Grapes
Honey
Israel
Jerusalem
Milk
Oil
Olive
Palm Tree
Pomegranate
Sabra
Safed
Seven Species
Tree
Wheat

Israel, State of
Blue
Deer
Flag
Grapes
Israel
Jerusalem
Menorah
Sabra
Star of David

Kabbalistic Symbols
Aaron
Adam
Akedah
Amulet
Angels
Apple
Beard
Chair
Chariot
Cherubim
Clothing

Cloud
David
Dreams
Elijah
Face
Fire
Four
Golem
Had Gadya
Hand
Head
Heart
Jerusalem
Kabbalah
King
Lamp
Light
Menorah
Messiah
Mirror
Names
One
Palace
Pardes
Queen
Rainbow
Red
Rose
Safed
Sefirot
Seven
Shabbat
Shekhinah
Stars
Tallit
Ten
Throne
Torah
Tree
Urim and Tummim
Wind
Wings

Life Cycle
 Adoption
 Basket
 Water
 Bar/Bat Mitzvah
 Bar/Bat Mitzvah
 Tallit
 Tefillin
 Thirteen
 Torah
 Birth
 Amulet
 Blood

Brit
Cedar
Chain
Chickpea
Iron
Knots
Lilith
Names of God
Salt
Tree
Brit
 Abraham
 Akedah
 Blood
 Brit
 Chain
 Elijah
 Tallit
 Water
 Wine
Conversion
 Abraham
 Brit
 Ruth
 Sarah
 Water
Death
 Angel of Death
 Ashes
 Candles
 Clothing
 Egg
 Hair
 Kittel
 Knots
 Lentil
 Leviathan
 Light
 Messiah
 Mirror
 Mountain
 Pine
 Portal
 Priestly Cult
 Seven
 Shofar
 Shroud
 Tallit
 Tree
 Water
 White
 Wind
 Yom Kippur
Menstruation
 Blood
 Water

New Home
Bread
Mezuzah
Salt

Wedding
Ashes
Bread
Candles
Cedar
Circle
Clothing
Crown
Cup
Cypress
Hair
Huppah
Ketubah
Kittel
Leah
Olive
Pine
Portal
Rebecca
Ruth
Seven
Tallit
Tree
Water
Wedding
White
Wine

Messiah
Afikoman
Behemoth
Brit
Daniel
David
Dew
Dreidl
Earth
Eden
Elijah
Fig
Fish
Grapes
Had Gadya
Havdalah
Horn
Israel
Jerusalem
Joseph
Kabbalah
King
Leopard
Leviathan

Lion
Moon
Mountain
Myrtle
Oil
Passover
Rachel
Rosh Hashanah
Ruth
Sefirot
Shabbat
Shekhinah
Shofar
Sukkot
Temple
Tisha B'Av
Yom Kippur

Natural Phenomena
Cloud
Dew
Earth
Fire
Rain
Rainbow
Rock
Water
Well
Wind

Numbers
Alephbet
Calendar
Eighteen
Five
Flag
Forty
Four
Four Species
Minyan
Numbers
One
Sefirot
Seven
Seventy
Six Hundred and Thirteen
Six Million
Tallit
Ten
Thirteen
Three
Twelve Tribes

Personalities
Aaron
Abraham

Adam
Amalek
Beruriah
Bezalel
Daniel
David
Deborah
Elijah
Esau
Esther
Eve
Haman
Isaac
Ishmael
Israel
Jacob
Job
Jonah
Joseph
Judah
Judah Maccabee
Judith
Leah
Lilith
Miriam
Moses
Names of God
Noah
Pharaoh
Rachel
Rebecca
Ruth
Sarah
Shifra and Puah
Solomon
Ushpizin

Places
Auschwitz
Chelm
Eden
Egypt
Gehinnom
Greece
Jerusalem
Masada
Mountain
Rome
Safed
Sinai
Warsaw Ghetto
Western Wall
Wilderness

Prayer
Angels
Ark
Book
East
Eighteen
Gates
Havdalah
Heart
Isaac
Jacob
King
Kippah
Kittel
Messiah
Minyan
Moon
Names
Passover
Priestly Blessing
Priestly Cult
Rain
Rock
Rosh Hodesh
Shabbat
Synagogue
Tallit
Tefillin
Temple
Three
Torah
Water
Wings
Yoke
Yom Kippur

Ritual Objects
Breastplate
Brit
Candles
Crown
Cup
Gragger
Lamp
Menorah
Megillah
Mezuzah
Ner Tamid
Parokhet
Pomegranate
Spicebox
Torah
Tower
Ushpizin
Yad

Shabbat
Angels
Bread
Candles
Chickpea
Clothing
Cup
David
Fish
Flowers
Hallah
Havdalah
Lamp
Light
Messiah
Myrtle
Oil
Queen
Salt
Seven
Shabbat
Spicebox
Three
Tower
White
Wind
Wine

Synagogue
Ark
Bimah
Breastplate
Crown
East
Flowers
Gates
Jakhin and Boaz
King
Kippah
Light
Lion
Menorah
Minyan
Ner Tamid
Parokhet
Pomegranate
Portal
Priestly Cult
Synagogue
Temple
Ten Commandments
Torah
Tree
Yad

Temple
Aaron
Afikoman
Akedah
Altar
Ark
Basket
Bezalel
Blood
Bread
Breastplate
Cedar
Cherubim
Crown
Cypress
David
Earth
East
Egg
Esau
Flowers
Four Species
Gates
Gold
Harp
Horn
Jakhin and Boaz
Jerusalem
Lamp
Light
Lion
Menorah
Messiah
Mishkan
Mountain
Ner Tamid
Palace
Parokhet
Pomegranate
Portal
Priestly Cult
Salt
Seven Species
Shavuot
Shofar
Solomon
Temple
Ten Commandments
Tisha B'Av
Torah
Water
Western Wall
Yom Kippur

Trees
Almond Tree

Carob
Cedar
Cypress
Fig
Myrtle
Nut
Olive
Palm Tree
Pine
Pomegranate
Tree
Tu B'Shevat
Willow

Women
Amulet
Apple
Beruriah
Blood
Brit
Candles
Chickpea
Circle
Clothing
Deborah
Esther
Etrog
Eve
Fountain
Four
Hair
Hallah

Hanukkah
Iron
Judith
Ketubah
Kippah
Knots
Leah
Lilith
Messiah
Milk
Miriam
Moon
Names
Palm tree
Pine
Queen
Rachel
Rebecca
Rosh Hodesh
Ruth
Sarah
Seven
Shekhinah
Shifra and Puah
Tallit
Ushpizin
Water
Wedding
Well
Western Wall
White
Yom Kippur

APPENDIX B
SYMBOLS LISTED BY ABSTRACT CONCEPTS

APPENDIX C
TIME LINE OF JEWISH HISTORY

Note: C.E. = Common Era (A.D.)
 B.C.E. = Before Common Era (B.C.)

(The biblical dates are only approximate and reflect a traditional reading of Jewish history, although modern archaeology has corroborated many of the events in the biblical account.)

Event	Secular Year
Creation of the World (Jewish Year 1)	3760 B.C.E.
Abraham and Sarah leave Mesopotamia	1800 B.C.E.
The Exodus from Egypt	1400 B.C.E.
David becomes king in Jerusalem	1000 B.C.E.
First Temple/First Commonwealth	967–586 B.C.E.
Exile of Ten Northern Tribes by Assyria	722 B.C.E.
Destruction of First Temple	586 B.C.E.
Second Temple/Second Commonwealth	536 B.C.E.–70 C.E.
Maccabean Victory	164 B.C.E.
Destruction of Second Temple/Exile	70 C.E.
Completion of the Mishnah	200 C.E.
Completion of the Talmud	500 C.E.
Arabs conquer Palestine	637 C.E.
Decline of Babylonian Academies	1000 C.E.
First Crusade	1096 C.E.
Rashi	1040–1105
Maimonides (Rambam)	1135–1204
Jews expelled from England	1290
Spanish Expulsion	1492
Shulhan Arukh (Code of Jewish Law)	1563
Chmielnicki Massacres	1648
Shabbatai Tzevi (False Messiah)	1665–1676
Baal Shem Tov/Birth of Hasidism	1700–1740
The Enlightenment begins	1780
Napoleon liberates the ghettos	1800–1815
First Aliyah to Israel/Mass immigration to America	1880
Balfour Declaration	1917
Kristallnacht/Holocaust	1938–1945
Establishment of State of Israel	1948
Six Day War/Reunification of Jerusalem	1967

SOURCES

Adelman, Penina. *Miriam's Well*. Fresh Meadows, NY: Biblio Press, 1986.

Agnon, S. Y. *Days of Awe*. New York: Schocken, 1965.

Altshuler, David, ed. *The Precious Legacy: Judaic Treasures from the Czechoslovak State Collections*. New York: Summit Books, 1983.

Amichai, Yehuda. *Selected Poetry of Yehuda Amichai*. Ed. and trans. Chana Bloch and Stephen Mitchell. New York: Harper and Row, 1986.

Appelbaum, Simon. "The Minor Arts of the Talmudic Period." In *Jewish Art: An Illustrated History*, ed. Cecil Roth, rev. ed. Bezalel Narkiss, pp. 93–101. Greenwich, CT: New York Graphic Society, 1971.

Avigad, Brakha, Berliner, S., and Silberstein, Z. *Trees and Shrubs in Israel*. Haifa: Department of Education, Municipality of Haifa, 1963.

Avi-Yonah, Michael. "Synagogue Architecture in the Late Classical Period." In *Jewish Art: An Illustrated History*, ed. Cecil Roth, rev. ed. Bezalel Narkiss, pp. 65–82. Greenwich, CT: New York Graphic Society, 1971.

Bickerman, Elias. *From Ezra to the Last of the Maccabees: Foundations of Post-Biblical Judaism*. New York: Schocken, 1962.

Blunt, A. W. F., et al. *Helps to the Study of the Bible*. 2nd ed. London: Oxford University Press, 1932.

Braunstein, Susan L., and Weissman, Joselit, eds. *Getting Comfortable in New York: The American Jewish Home 1880–1950*. New York: The Jewish Museum, 1990.

Buber, Martin. *Tales of the Hasidim*. 2 vols. New York: Schocken, 1947.

Cirlot, J. E. *A Dictionary of Symbols*. New York: Philosophical Library, 1962.

Davis, Eli, and Davis, Elise. *Jewish Folk Art Over the Ages*. Jerusalem: Rubin Mass, 1977.

De Breffny, Brian. *The Synagogue*. London: Weidenfeld and Nicholson, 1978.

De Saulcy, F. Caignart. *Histoire de l'Art judaique*. Paris: Didiers et Cie, 1858.

Douglas, Mary. *Natural Symbols: Explanations in Cosmology*. New York: Vintage, 1973.

––––––. *Purity and Danger*. London: Routledge and Kegan Paul, 1966.

Dresner, Samuel. *The Jewish Dietary Laws*. New York: Rabbinical Assembly of America, 1982.

Eder, Asher. *The Star of David*. Jerusalem: Rubin Mass, Ltd., 1987.

Eliade, Mircea. *The Sacred and the Profane*. New York: Harper and Row, 1959.

Falk, Marcia. *The Book of Blessings: A Feminist-Jewish Reconstruction of Prayer*. San Francisco: Harper, 1993.

Fine, Lawrence. "Kabbalistic Texts." In *Back to the Sources*, ed. Barry Holtz, pp. 305–309. New York: Summit Books, 1984.

Firth, Raymond. *Symbols: Public and Private*. Ithaca, NY: Cornell, 1973.

Fredman, Ruth Gruber. *The Passover Seder: Afikoman in Exile*. Philadelphia: University of Pennsylvania Press, 1981.

Gaster, Theodore. *Festivals of the Jewish Year*. New York: William Morrow and Company, 1952.

_____. *The Holy and the Profane: Evolution of Jewish Folkways*. Rev. ed. New York: William Morrow and Company, 1980.

Geertz, Clifford. *The Interpretation of Cultures*. New York: Basic Books, 1973.

Ginzberg, Louis. *Legends of the Jews*. 7 vols. Philadelphia: Jewish Publication Society, 1909–1938.

Glazerson, Mattityahu. *Above the Zodiac*. Trans. M. Kalish. Jerusalem, 1985.

Goodenough, Erwin R. *Jewish Symbols in the Greco-Roman Period*. Ed. and abr. Jacob Neusner. Princeton: Princeton University Press, 1988.

Gottlieb, Freema. *The Lamp of God*. Northvale, NJ: Jason Aronson, 1989.

Green, Arthur. "Bride, Spouse, Daughter: Images of the Feminine in Classical Jewish Sources." In *On Being a Jewish Feminist*, ed. Susannah Heschel, pp. 248–260. New York: Schocken, 1983.

Greene, Gloria Kaufer. *The Jewish Holiday Cookbook*. New York: Times Books, 1985.

Gross, Rita. "Steps Toward Feminine Imagery in Jewish Theology." In *On Being a Jewish Feminist,* ed. Susannah Heschel, pp. 234–247. New York: Schocken, 1983.

Grossman, Cissy. *The Jewish Family's Book of Days*. New York: Abbeville Press, 1989.

_____. *A Temple Treasury: The Judaica Collection of Congregation Emanu-El*. New York: Hudson Hills Press, 1989.

Gutmann, Joseph, ed. *Beauty in Holiness*. New York: Ktav, 1970.

_____. *Jewish Ceremonial Art*. New York: A. S. Barnes and Company, 1964.

_____. "Wedding Customs and Ceremonies in Art." In *Beauty in Holiness: Studies in Jewish Customs and Ceremonial Art*, ed. Joseph Gutmann, pp. 313–319. New York: Ktav, 1970.

Hadas, Moses, ed. and trans. *Letter of Aristeas*. New York: Harper and Row, 1951.

Hall, James. *Dictionary of Subjects and Symbols in Art*. New York: Harper and Row, 1974.

HaNakdan, Berechiah ben Natronai. *Fables of the Jewish Aesop: From the Fox Fables of Hanakdan*. Trans. M. Hadas. New York: Columbia University Press, 1966.

Hareuveni, Nogah. *Nature in Our Biblical Heritage*. Kiryat Ono, Israel: Neot Kedumim, Ltd., 1980.

_____. *Tree and Shrub in Our Biblical Heritage*. Kiryat Ono, Israel: Neot Kedumim, Ltd., 1984.

Henry, Sondra, and Taitz, Emily. *Written Out of History: Our Jewish Foremothers*. Fresh Meadows, NY: Biblio, 1983.

Heschel, Abraham Joshua. *Man's Quest for God: Studies in Prayer and Symbolism*. New York: Scribners, 1954.

Heschel, Susannah, ed. *On Being a Jewish Feminist*. New York: Schocken, 1983.

Hirsch, Samson Raphael. "A Basic Outline of Jewish Symbolism." In *Timeless Torah*, ed. Jacob Breuer, pp. 303–419. New York: Philip Feldheim, 1957.

Hoffman, Lawrence. *The Art of Public Prayer*. Washington, DC: The Pastoral Press, 1988.

Huberman, Ida. *Living Symbols*. Israel: Massada, 1988.

Idel, Moshe. *Kabbalah: New Perspectives*. New Haven: Yale University Press, 1988.

Isserlin, Benedict. "Israelites During the Period of the Monarchy." In *Jewish Art*, ed. Cecil Roth, rev. ed. Bezalel Narkiss, pp. 273–285. Greenwich, CT: New York Graphic Society, 1971.

Jamilly, Edward. "The Architecture of the Contemporary Synagogue." In *Jewish Art*, ed. Cecil Roth, rev. ed. Bezalel Narkiss, pp. 273–285. Greenwich, CT: New York Graphic Society, 1971.

Jung, Carl. *Man and His Symbols*. London: Aldus Books, Ltd., 1964.

Kaplan, Aryeh. *Meditation and Kabbalah*. York Beach, ME: Samuel Weiser, 1982.

_____. *Tzitzith: A Thread of Light*. New York: National Council of Synagogue Youth/Orthodox Union, 1984.

Kaplan, Mordecai. "The Future of Religious Symbolism: A Jewish View." In *Religious Symbolism*, ed. F. Ernest Johnson. Port Washington, NY: Kennikat Press, 1955.

Kashtan, Aharon. "Synagogue Architecture of the Medieval and Pre-Emancipation Periods." In *Jewish Art*, ed. Cecil

Roth, rev. ed. Bezalel Narkiss, pp. 103–117. Greenwich, CT: New York Graphic Society, 1971.

Katz, Karl, Kahane, P. P., and Broshi, Magen. *From the Beginning: Archaeology and Art in the Israel Museum*. New York: William Morrow, 1968.

Kitov, Eliyahu. *The Book of Our Heritage*. Rev. ed. New York: Feldheim, 1978.

Kon, Maximilian. "Jewish Art at the Time of the Second Temple." In *Jewish Art*, ed. Cecil Roth, rev. ed. Bezalel Narkiss, pp. 51–64. Greenwich, CT: New York Graphic Society, 1971.

Kushner, Larry. *The Book of Letters*. New York: Harper and Row, 1975.

Lamm, Maurice. *The Jewish Way in Death and Mourning*. New York: Jonathan David, 1969.

Landsberger, Franz. "A German Torah Ornamentation." In *Beauty in Holiness: Studies in Jewish Customs and Ceremonial Art*, ed. Joseph Gutmann, pp. 106–121. New York: Ktav, 1970.

_____. "Hanukkah Lamps." In *Beauty in Holiness: Studies in Jewish Customs and Ceremonial Art*, ed. Joseph Gutmann, pp. 283–312. New York: Ktav, 1970.

_____. "Illuminated Marriage Contracts." In *Beauty in Holiness: Studies in Jewish Customs and Ceremonial Art*, ed. Joseph Gutmann, pp. 370–416. New York: Ktav, 1970.

_____. "Old Hanukkah Lamps." In *Beauty in Holiness: Studies in Jewish Customs and Ceremonial Art*, ed. Joseph Gutmann, pp. 283–312. New York: Ktav, 1970.

_____. "The Origin of the Decorated Mezzuzah." In *Beauty in Holiness: Studies in Jewish Customs and Ceremonial Art*, ed. Joseph Gutmann, pp. 468–485. New York: Ktav, 1970.

_____. "The Origin of European Torah Decorations." In *Beauty in Holiness: Studies in Jewish Customs and Ceremonial Art*, ed. Joseph Gutmann, pp. 87–105. New York: Ktav, 1970.

_____. "The Origin of the Ritual Implements for the Sabbath." In *Beauty in Holiness: Studies in Jewish Customs and Ceremonial Art*, ed. Joseph Gutmann. New York: Ktav, 1970.

Lauterbach, Jacob Z. "The Ceremony of Breaking a Glass at Weddings." In *Beauty in Holiness: Studies in Jewish Customs and Ceremonial Art*, ed. Joseph Gutmann, pp. 340–369. New York: Ktav, 1970.

_____. "The Origin and Development of the Sabbath Ceremonies." In *Beauty in Holiness: Studies in Jewish Customs and Ceremonial Art*, ed. Joseph Gutmann, pp. 204–261. New York: Ktav, 1970.

Lutske, Harvey. *The Book of Jewish Customs*. Northvale, NJ: Jason Aronson, 1986.

Mann, Vivian, ed. *Gardens and Ghettoes: The Art of Jewish Life in Italy*. Berkeley: University of California Press, 1989.

Moldenke, Harold, and Moldenke, Alma. *Plants of the Bible*. New York: Dover Publications, 1986.

Montefiore, C. G., and Loewe, H. *A Rabbinic Anthology*. New York: Schocken, 1974.

Nadich, Judah. *Jewish Legends of the Second Commonwealth*. Philadelphia: Jewish Publication Society, 1983.

Namenyi, Ernest M. "The Illuminations of Hebrew Manuscripts After the Invention of Printing." In *Jewish Art*, ed. Cecil Roth, rev. ed. Bezalel Narkiss, pp. 149–162. Greenwich, CT: New York Graphic Society, 1971.

Nathan, Joan. *The Jewish Holiday Kitchen*. New York: Schocken, 1979.

Newman, Louis. *The Hasidic Anthology*. Rev. ed. Northvale, NJ: Jason Aronson, 1987.

Patai, Raphael. *The Hebrew Goddess*. New York: Avon, 1978.

_____. *Tents of Jacob*. Englewood Cliffs, NJ: Prentice-Hall, 1971.

Petrie, Flinders. *Decorative Patterns of the Ancient World for Craftsmen*. New York: Dover Publications, 1974.

Plaskow, Judith. "The Right Question is Theological." In *On Being a Jewish Feminist*, ed. Susannah Heschel, pp. 223–233. New York: Schocken, 1983.

Plaut, Gunther. *The Magen David*. Washington, DC: B'nai B'rith Books, 1991.

_____, ed. *The Torah: A Modern Commentary*. New York: Union of American Hebrew Congregations, 1981.

Podwal, Mark. *A Jewish Bestiary*. Philadelphia: Jewish Publication Society, 1984.

Posner, Raphael, and Ta-Shema, Israel, eds. *The Hebrew Book: An Historical Survey*. Jerusalem: Keter, 1975.

Reich, Rosalie, trans. *Tales of Alexander the Macedonian*. New York: Ktav, 1972.

Reznick, Leibel. *The Holy Temple Revisited*. Northvale: NJ: Jason Aronson, 1990.

Roth, Cecil, ed. *Encyclopaedia Judaica*. Jerusalem: Keter, 1972.

_____ *Jewish Art*. Rev. ed. Bezalel Narkiss. Greenwich, CT: New York Graphic Society, 1971.

Sabar, Shalom. *Ketubbah*. Philadelphia: Jewish Publication Society, 1990.

Salomon, Kathryn. *Jewish Ceremonial Embroidery*. London: B. T. Batsford, Ltd., 1988.

Scherman, R. Nosson, ed. *Complete Artscroll Siddur, Nusach Sephard*. New York: Mesorah Publications, Ltd., 1985.

Scholem, Gershom. *Major Trends in Jewish Mysticism*. New York: Schocken, 1961.

_____. *The Messianic Idea in Judaism*. New York: Schocken, 1971.

_____. *On the Kabbalah and Its Symbolism*. New York: Schocken, 1965.

Schwartz, Howard Eilberg. *The Savage in Judaism*. Chicago: University of Chicago Press, 1990.

Schwarz, Karl. "Jewish Sculptors." In *Jewish Art*, ed. Cecil Roth, rev. ed. Bezalel Narkiss, pp. 313–327. Greenwich, CT: New York Graphic Society, 1971.

Siegel, Richard, Strassfeld, Michael, and Strassfeld, Sharon. *The Jewish Catalog*. Vol. 1. Philadelphia: Jewish Publication Society, 1973.

Spiegel, Shalom. *The Last Trial*. Trans. Judah Goldin. New York: Pantheon, 1967.

Steinsaltz, Adin. *Strife of the Spirit*. Northvale, NJ: Jason Aronson, 1988.

Strassfeld, Michael. *The Jewish Holidays*. New York: Harper and Row, 1985.

Tishby, Isaiah, ed. *The Wisdom of the Zohar: An Anthology of Texts*. Trans. David Goldstein. Oxford: Oxford University Press, 1989.

Trachtenberg, J. *Jewish Magic and Superstition*. New York: Atheneum, 1939.

Tsachor, Yakov, ed. *Israel Postage Stamps 1948–88*. Jerusalem Postal Authority, 1989.

Turner, Victor. *The Forest of Symbols*. Ithaca, NY: Cornell University Press, 1967.

Ungerleider-Mayerson, Joy. *Jewish Folk Art from Biblical Days to Modern Times*. New York: Summit Books, 1986.

Vilnay, Zev. *Legends of the Galileee, Jordan, and Sinai*. Philadelphia: Jewish Publication Society, 1978.

_____. *Legends of Jerusalem*. Philadelphia: Jewish Publication Society, 1973.

Walker, Barbara. *The Woman's Dictionary of Symbols and Sacred Objects*. New York: Harper and Row, 1988.

Waskow, Arthur. *Seasons of Our Joy*. New York: Bantam, 1982.

Wischnitzer, Rachel. "Jewish Pictorial Art in the Late Classical Period." In *Jewish Art*, ed. Cecil Roth, rev. ed. Bezalel Narkiss, pp. 83–92. Greenwich, CT: New York Graphic Society, 1971.

Zerubavel, Eviatar. *The Seven Day Circle: The History and Meaning of the Week*. Chicago: University of Chicago Press, 1985.

INDEX

About the Authors

Ellen Frankel is the Editor-in-Chief of The Jewish Publication Society as well as a free-lance writer and professional storyteller. She received a Ph.D. in comparative literature from Princeton University in 1978 and has taught writing and literature at several colleges and universities. Her previous works include *The Classic Tales: 4,000 Years of Jewish Lore* and *Choosing to Be Chosen*, a collection of stories for preteens. Dr. Frankel lives in Philadelphia with her husband and two children.

Nationally known American Jewish artist and calligrapher, Betsy Platkin Teutsch first received recognition for her custom-designed *ketubot* (marriage contracts). She is a designer of Jewish ritual objects, a Jewish educator, and the illustrator of numerous publications, including Michael Strassfeld's *The Jewish Holidays*, *Had Gadya — One Little Goat* — a presentation of the traditional Passover song that she translated and hand-lettered as well as illustrated — and *Kol Haneshamah*, the new Reconstructionist prayer book. In addition, her work has been frequently featured by UNICEF greeting cards. Born in Fargo, North Dakota, Ms. Teutsch now lives in Philadelphia with her husband and two children.